PRINTS
AND THE
PRINT
MARKET

PRINTS
AND THE
PRINT
MARKET

A HANDBOOK FOR BUYERS,
COLLECTORS,
AND CONNOISSEURS

THEODORE B. DONSON

THOMAS Y. CROWELL, PUBLISHERS
ESTABLISHED 1834
NEW YORK

DESIGNED BY JUDITH WORACEK

MANUFACTURED IN THE UNITED STATES OF AMERICA

LIBRARY OF CONGRESS CATALOGING IN PUBLICATION DATA
Donson, Theodore B
 Prints and the print market.
 1. Prints—Marketing. I. Title.
 NE62.D66 769'.1 76-14487
 ISBN 0-690-01160-1

 79 80 81 82 10 9 8 7 6 5 4 3 2

FOR GAIL—

AND EVERYONE ELSE
WHO HAD FAITH IN ME

Contents

Foreword

I did not seek to write your typical Print Collector's Handbook. There are lots of those, and most of them dwell on printmaking processes, the history of printmaking, the right way to frame a print, and so forth. Those subjects hold great interest for me as a person interested in works of graphic art, and they should be pursued by anyone who owns or wants to own a print.

But this book skirts those interesting topics to expose and explain the difficult issues and choices that a person, whether a novice or a professional, will face in the marketplace. It is full of details and grit, and I hope it will both arm the novice with enough information and savvy to venture courageously into the print market and provide the professional with fresh insights and information. The book has turned out to be a fairly sophisticated volume. It treats complex subjects with respectful complexity.

Though my taste in prints and Print People pokes through the text here and there, this is not a book of art criticism. I did not write it as a professional critic; there are crackerjack books by people who are. One of the most perceptive of them, the late Curator of Prints at the Metropolitan Museum of Art, William M. Ivins, Jr., once wrote with great self-effacement that "if I were rewriting my criticisms, I would concentrate on the intellectual and imaginative background of the work that produced it. The rest is bookkeeping." Compared with the intellectual and imaginative work of Ivins, my work is, frankly speaking, bookkeeping.

I have omitted consideration of Japanese woodblock prints (Ukiyo-e) and art photographs. Japanese prints are, technically speaking, printed works of art on paper, but they recall a history, proclaim an esthetic, and demand a connoisseurship somewhat different from the history, esthetics, and connoisseurship of Western art. Experts and scholars in Japanese prints tend not to be learned in the prints of Europe and the United States, and vice versa; the collecting and trade fraternity for the most part gathers under different roofs, and the marketplaces for Japanese prints are separate and distinct. Photographs are also outside the ambit of this book. During the 1970's a large number of people all of a sudden discovered vision and inventiveness in fine art photography. Many of the awakened devotees of photographs in fact came to photography from the Print World. I suspect that much of the belated recognition and appreciation that art critics, curators, connoisseurs, and dealers have in recent years been bestowing on fine photographs were offshoots of the recognition and endorsement by such people of the use by 1960's artist-printmakers of photography and photoreproductive techniques for the creation of printed images. Photographs, though multiples on paper, are different from works of graphic art. While the best works of graphic art

demonstrate a perfect fusion of conception and execution, photographs primarily assert acts of perception, with craft playing a distinctly minor role in the transmission of the image. Photography appreciation and connoisseurship are exercises far different from print appreciation and connoisseurship.

While preparing this book, I formally interviewed 73 people and talked with hundreds more (quotes not attributed to other sources derive from these interviews and conversations). A number of persons, however, gave me large amounts of support, assistance, or commentary, and these I should like specially to acknowledge. I have great debts to Elizabeth E. Roth, Keeper of Prints at the New York Public Library, and Roberta Waddell, her assistant, who extended their hands when I most needed help. I owe much to Marc Rosen, in charge of prints at Sotheby Parke Bernet New York, and Martin Gordon, print dealer and freshman auctioneer, for their humanity and their expertise. To dealers O. P. Reed, Jr., and Aldis Browne, auctioneers Eberhard Kornfeld and Noël Annesley, paper conservator Mary Todd Glaser, and printer-publisher Kenneth Tyler, for their wise and friendly counsel and comments on my manuscript. I am obliged to Deborah Dennis of Weyhe's, Robert Berger, Professor of Art History at Brandeis University, and Angus Whyte, Boston dealer, for their early support. I extend thanks to my literary agent, Oscar Collier, for his representation; my editor, Hugh Rawson, for his perceptive shaping and pruning; my copy editor, Elizabeth C. Bigelow for her improvement on the manuscript; and my research assistants, Diana Hanson and Dorothy Kosinski. I am grateful to Donald Gerard for enlightenment on matters of heart and mind. And I reserve the benediction for my brother, Nathaniel, my oldest and most loyal friend, who has stood by me through all the hurly-burly.

PRINTS
AND THE
PRINT
MARKET

PART ONE
ABOUT THE PRINTS IN COMMERCE

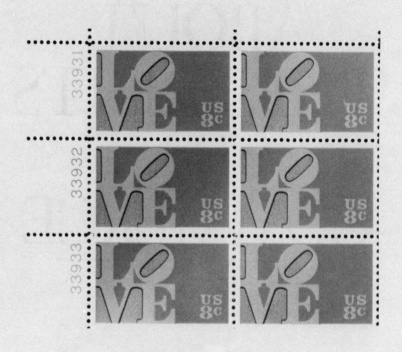

After Robert Indiana, "LOVE." Photogravure (U.S. postage stamp), 1973. 21.5 x 36.5 mm; $^{13}/_{16}''$ x $1^{7}/_{16}''$.

Chapter One

Of Autographic Prints, *Afters*, and Reproductive Prints

As we look back from the middle of the twentieth
century all that kind of talk and opinion seems
very silly, for it has become obvious that what
makes a medium artistically important is not any
quality of the medium itself but the qualities of
mind and hand its users bring to it. . . . I have
sometimes wondered whether there is any field of
art collecting which is more hidebound and
hamstrung by arbitrary definitions than that of
prints.
—WILLIAM M. IVINS, JR., *Prints and Visual
Communication* (1953)

The perils of the Print World have not gotten the same ex-
posure that consumer advocates and *Consumer Reports* have lavished on
the auto industry, television repairmen, and detergents. Perhaps people
feel that anyone who splurges on something of purely esthetic worth
should be left to his own devices. Perhaps people recognize that cars,
television servicing, and soap—mundane, practical necessities—can be
more readily gauged in terms of value promised and value received.
Whatever the reason, one is told that anyone who spends a lot of money
on art had better know what he is doing. That, of course, is very true,
but it does not mean that the art buyer does not deserve assistance. The
print buyer, especially, needs help to enable him to ascertain that he is
getting what he thinks he is paying for.

A short guided tour through the New York City graphics demimonde
can be instructive to the unwary and inastute:

The brochure of one "Simpro Graphics" advertising $125 prints in
color of Picasso, Chagall, Braque, Marino (sic), and others, encased "in a
coordinated wood frame magnificently reflecting the quality of the
work," is entitled D'APRES ART and carries this information:

What is D'APRES ART.

D'APRES ART is a hand numbered Limited Edition of an artist of significance whose signature is plate signed to the piece. The Limited Edition is silk screened or "Pochoir". Each individual piece bears the following legend on the back. "This is a highly faithful rendition made by skilled artists in a Limited Edition after (D'APRES) the work of art depicted. This piece is copyrighted and registered with the Library of Congress."

Definition of Pochoir.
 This ancient printing technique has been achieved by ver few master printmakers. It is a European method which pro duces depth and quality which no other printing technique can attain.

Notwithstanding the fancy verbiage, these "hand numbered" (no less!) pictures are reproductions made by photomechanical process of oil paintings by the painters named, similar to the copies of oils on view in every secondary-school lunchroom, which are likewise "plate signed to the piece" (i.e., the artist signed his painting!). Notwithstanding the puffery about that exotic "ancient printing technique," *pochoir* is just French for "stencil" print—a silkscreen. There is no affinity whatsoever between the technique of the originals and the "European method" of graphic reproduction used, so these pictures at least have the merit of not being deceptive.

The shop windows of a graphics emporium on Third Avenue, where not obscured by stickers trumpeting "ORIGINAL ART PRINTS—REDUCED 20–50%," sparkle with graphics in metal frames and a few legitimately expensive Mirós and Chagalls. In the brightly lit interior, the framed prints are tiered on the walls and clustered on the floor. Tags on two of them read "Original lithograph—Chagall" and "Original signed lithograph by Norman Rockwell $350." These goods are lifeless photomechanical reproductions of drawings, the first by an artist who probably never saw the original; the second by one who does not seem to be particularly concerned with the perfect wedding of conception and execution.

Upstairs at School of Paris Graphics Ltd., a wholesale operation owned by the former sales manager for Consolidated Fine Arts, which runs the mail-order Collector's Guild, Ltd., the order form states "ROUAULT—TROIS VISAGE—Original Woodcut—Plate signed—. . . Retail price $50—Dealer Cost $15"; "DEGAS—HEAD—Original Wood Engraving—B&W—. . . Retail Price $35—Dealer Cost $10"; "LAUTREC—FOOTIT ET CHOCOLAT—Original Lithograph—Plate signed—Sepia—. . . Retail Price $75—Dealer Cost $20." The first piece of merchandise described is a wood-engraving illustration for the 1932 book, *Réincarnations du Père Ubu*, incised by craftsman Georges Aubert *after* a design by Rouault bearing his signature; the Collector's Guild obtained the block for unlimited printing and sale to distributors, such as School of Paris Graphics Ltd., as well as to their own "members." The second is a contemporary photoreproduction of an 1877–78 monotype by Degas, and the third, a recent photoreproduction of a drawing made by Toulouse-Lautrec in the 1890's. The proprietor of School of Paris Graphics re-

fused to discuss his business. He did not want to "give out any information my competitors can use."

In the Fontainebleau Art Gallery on Madison Avenue at 72 Street, the proprietors offer an elegantly framed "lithograph by Toulouse-Lautrec" for $450. Orally they confirm that "it is an original print, signed in the plate." More precisely, it is a collotype reproduction of a drawing that hangs in the Albi Museum in France. The Albi Museum shop itself sells the single sheet, as well as an illustration of its progenitor in the book *The Treasures of the Albi*, for a few francs.

In the art gallery of the Rizzoli International Bookstore on Fifth Avenue, a $450 14-color picture, annotated A 129/250 with a lithographed signature, "Picasso," is described by the saleslady as an "original lithograph by Pablo Picasso" in a tone of voice that conveys impatience with the questioner. Upon further interrogation, she asserts that, yes, Picasso performed the work on the stone, but fails to recall who published the edition. The print is in truth one of 29 lively pictures entitled *Portraits Imaginaires* made in 1972 by a lithographer named Salinas *after* gouaches that Picasso painted on cardboard. Picasso took no active part in their production other than permitting Salinas to copy them, suggesting a few corrections, and implanting his signature on one of the stones. Abrams Original Editions, the American licensee for the 250 copies, numbered A 1 through A 250 "for the United States" (250 more, numbered F 1 through F 250, were issued by Cercle d'Art "for France"), offered the whole suite in 1975 for $12,500 retail. When told these facts, the saleslady indignantly queried, "Why are you telling me this?"

On fashionable 57 Street, off Fifth Avenue, the New York branch of the Paris-based Denise René Gallery, which attracted such artists as August Herbin and Victor Vasarely to its patronage in the post-World War II years, displays a suite of eight technically excellent multicolor "original serigraphs," each revealing in the place where artists customarily sign their prints what on extremely close inspection turns out to be a facsimile of Herbin's signature. The prints are recent photomechanical reproductions by silkscreen process of gouaches that Herbin painted before he died in 1960. The $525 price tag which each print bears is presumably justified by the facsimile signature—authorized, we are told, by Herbin's heirs—and the limitation of the edition to 150 impressions, since posters translating other Herbin gouaches into images of identical size and quality retail at Denise René for $45.

Someone called "Jean-Paul Loup, the Original Editor of Art," buys a full-page ad in *The New York Times Magazine* to announce a "milestone event," the "investment opportunity of a lifetime for only $475.00!": an "original hand watercolored 'Pochoir' engraving" which "is one of the unparalleled surrealistic flights of fancy Dali conceived and created for 'Fantasia.' " Then comes the customary, disarming, tangible assurance of quality and authenticity: "SALVADOR DALI PERSONALLY APPROVED, NUMBERED and HAND-SIGNED EACH ENGRAVING!" M. Loup, which means

"wolf" in French, was on the fold. What is advertised here is art merchandise of the lowest water: A limited edition of photogravures of an ink drawing that some hired help colored by painting watercolor washes through stencils, the same method a sign painter uses to letter his signs. Dealers, curators, and sensible collectors who once admired Dali for his surrealist inventions and astonishing draftsmanship have for years been groaning under the weight of millions of dubious and spurious "Dali" graphics; unscrupulous publishers, it is said, have bought Dali out for cash. "The serious collector," according to A. Reynolds Morse, a serious Dali collector appalled by the deceptions accompanying the popular "Dali explosion" during the Print Boom of the 1960's and 70's, "must decide which work represents Dali's craftsmanship and how much is really the hand of others translating Dalinian concepts into 'art merchandise.' Dali collectors should be aware of the boundless energies of the entrepreneurs and distributors who quantitatively have set a world record for mass production and rapid distribution of printed art. The print collector . . . is wise who regards 'multiple editions' as a self-serving contradiction and places his primary emphasis on the integrity of the artist and his manufacturing and distribution system. The astuteness of each buyer will determine just how close to Dali's own hand he wishes to come."

O'Reilly's Plaza Art Galleries is a New York 79 Street auction house which, it says, "has endeavored to catalogue and describe correctly the property to be sold," though it disclaims any responsibility for what is said or not said in its catalogs. It displays its "consignments" in tightly sealed frames and forbids their removal from the frame for examination. Plaza catalogued various lots—which are here presented to illustrate a variety of problems and not because of their pervasiveness at the Plaza—for one sale as follows:

PUBLISHED ESTIMATES

GEORGES BRAQUE (French 1882–1963)
1. "VASE OF FLOWERS"
 Aquatint in color. Numbered to 300 proofs.
 Signed in pencil. Arches paper. $700/900

JEAN DUFY (French 1888–1964)
37. "MONTMARTRE"
 Lithograph in color. Rare and fine proof.
 Numbered and signed in pencil Arches
 paper. $300/500

RAOUL DUFY (French 1880–1953)
40. "HORSE RACES"
 Lithograph poster in color. Signed in the
 stone. $100/150

41. "RACES AT EPSOM"
Lithograph poster in color. Signed in the
stone. $100/150

MARCEL GROMAIRE (French 1892–1968)
60. "PIANO CONCERT"
Aquatint in color. Numbered to 200 proofs.
Signed in pencil. Arches paper. $275/350

RENE MAGRITTE (Belgian 1898–1971)
77. "FLYING BIRD"
Lithograph in color. Rare proof. Signed in
ink. $350/450

HENRI MATISSE (French 1869–1954)
84. "NUDE" and "HEAD OF A GIRL"
Two lino cuts. Both signed in the block
with initials. $200/300

JOAN MIRÓ (Spanish 1893–)
98. "OISEAU ZEPHIR"
Lithograph in color by Miró. $100/150

PABLO PICASSO (Spanish 1881–1973)
103. "MOTHER AND CHILD"
Aquatint in color. Early example. Engraved
by Villon. Rare proof on Arches paper.
Signed in crayon. Recorded. $1,100/1,600
112. "JACQUELINE"
Lithograph poster in color. 1956. Dated in
the stone. $100/150

MAURICE DE VLAMINCK (French 1876–1958)
143. "VASE OF FLOWERS"
Aquatint in color. One of 100 proofs. Num-
bered and signed in pencil. Arches paper. $400/600

JACQUES VILLON (French 1878–1963)
147. "WOMAN"
Lithograph in color. Numbered to 200
proofs. Signed in pencil. Arches paper. $350/450

Each of these prints has at least two things in common: each is a
work executed by a professional copyist in Paris, and none of them is
listed in the respected catalogue raisonné recording the graphic works of
the artist under whose name it was submitted to the public by the Plaza.
Numbers 60 and 103 are catalogued, it so happens, not in the oeuvre cat-
alogues of Gromaire and Picasso, but in the catalogue of the graphic

oeuvre of the artist Jacques Villon, who executed them in the 1920's under contract with the Galerie Bernheim-Jeune. Certain of the *traductions* (translations of paintings) made by Villon during this period have acquired more value than most of the etchings, drypoints, and aquatints of his own design (Fig. 1-A). The impressions in the Plaza auction sale that day, however, are currently available unlimited-edition $50 restrikes from Villon's original aquatint plates recently printed by the Chalcographie du Louvre, the French government printing house (Chalcographie N° 6896 and N° 13765), and adorned with phony signatures and annotations to boost their value (the giveaway Chalcographie blind-stamp has been trimmed off or is hidden under the frame). Numbers 41, 77, 143 (Fig. 1-B), and 147, which are reproductions of paintings, at least offer typographic clues about the identity of their creators: Numbers 77 and 147 both reveal an inscription camouflaged within the composition at the bottom left—"Henri Deschamps Lith" and "H. DESCHAMPS LITH 1963"; and Number 143, the most honest of the lot, carries a microscopic legend atop the composition—"Copyrt 1958 by Editions C. Guillard. grve. Rougemont Paris 9ᵉ." The rest of them size up as follows:

1. This intaglio print is a fine *"estampe à tirage limité et justifié"* (numbered *after* from a limited edition) hand-engraved—perhaps with the help of photographic aids—by either Georges Visat or Roger Lacourière *after* a painting by Braque and published by Editions Maeght (Maeght N° 1002) in the 1950's. Maeght's aim was no different from that of many

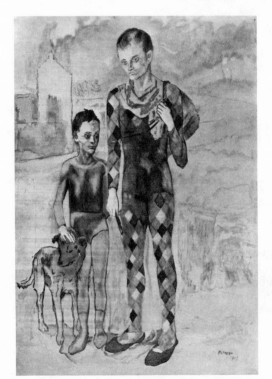

Jacques Villon *after* Pablo Picasso, "Les Saltimbanques" ("The Acrobats"). Aquatint in colors, 1930 (A. & P. 538A). 597 x 425 mm; 23½" x 16¾". Signed in pencil by both Villon and Picasso. One of a number of aquatints executed by Villon after designs by well-known artists. An impression was sold at Christie's in London for 1,100 guineas ($2,772) in 1972. (COURTESY OF CHRISTIE, MANSON & WOODS LTD.) Fig. 1-A

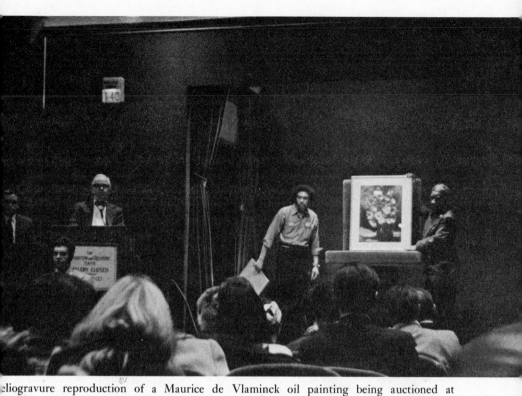

...liogravure reproduction of a Maurice de Vlaminck oil painting being auctioned at ...Reilly's Plaza Art Galleries in New York in 1975. It sold for $185, against a published ...imate of $400/600. (PHOTO BY THE AUTHOR) Fig. 1-B

17th- and 18th-century publishers: to make available to a wide public inexpensive, high-quality interpretations of unique works of art which few people could afford. And Braque signed the edition solely to register his accord with this aim and his satisfaction with the result achieved by the clever craftsman. The *estampe* plainly reveals the copyist's extraordinary skill and experience in analyzing the original painting and reconstructing the appropriate colors by aquatinting plates, but it brings a higher price if listed as a "Braque."

37, 40, and 41. Each of these pretty pictures is an excellent example of offset color photolithography; skillfully retouched screen negatives, used to separate the colors of the original Dufy gouache, are printed down on metal plates for printing on an offset press. Number 37 sold for $350 only because Jean Dufy signed it; Number 40, for $140 because it had no legend disclosing the artisans who made it; and Number 41, the nicest of the three esthetically, for only $50 because it carried the telltale inscription, "CH. SORLIER GRAV." (Charles Sorlier executed it).

84. Like Number 60, the first of these pictures is a $25 reprint, a publication of the Chalcographie du Louvre (Chalcographie N° 13960), and they are both photoreproductions of linoleum cuts, not "lino cuts" as advertised.

98. This is a fine photolithographic offset gatefold which was inserted

in a 1956 issue of *Derrière le Miroir* (Nos 87-88-89), the high-class art review available from Aimé Maeght by subscription. Many back issues of *Derrière le Miroir*, *Verve*, and *XXième Siècle* containing such offsets are still available from the publishers for from $3 to $10 apiece, and out-of-stock issues come up regularly at book auctions for not much more (see Fig. 3-C). Some people make a living by removing and ironing out these folded inserts, framing them, and then selling them at undeserved prices.

112. Picasso drew "Jacqueline's Portrait" (B. 1274; M. 289; Czw. 22) * with litho crayon on three zinc plates, which were printed on an offset press by a Marseilles printer in Mourlot's absence. Picasso signed 100 impressions before letters were added to make the single-sheet zincograph a poster, which itself was struck in an edition of 500 copies. But number 112 here is not *that* lithograph! It is a photoreproduction of that lithograph printed on exhibition posters in an unknown amount on an offset press by a Cannes printer and, later, in an edition of 300 by a German printer (see Czw. 111). Either the Plaza Art Galleries' consignor or his source of supply cropped the letterpress inscriptions off the poster and framed it in the hope of fooling someone into accepting it as the autographic work.

All prints are made by pressing an inked, prepared printing surface or matrix (metal plate, wood block, stone slab, etc.) against a sheet of paper or other material. (Picasso once said, *"Si je grave votre cuisse, c'est aussi de la gravure"* ["If I engrave your thigh, that's an engraving, too"].)

There are four classes of prepared matrices used for printmaking: *relief*, *intaglio*, *planographic*, and *stencil*.

Woodcuts, wood engravings, and linoleum cuts (linocuts) result from a printing surface prepared in *relief*. The master image is drawn on the surface of the matrix, and the printmaker then slices or chisels away the unmarked areas, leaving a raised surface (relief) design to receive a coat of printing ink. A fingerprint is a kind of relief print.

Engravings, drypoints, mezzotints, etchings, and aquatints are printed by metal matrices prepared in *intaglio*. To make an intaglio, the printmaker incises the master image on a metal plate with a special tool or with acid, leaving recessed lines and pitted areas into which printer's ink is rubbed. Excess ink is wiped off the surface of the plate, and the plate and a sheet of dampened paper are cranked under great pressure through the rollers of an etching press, forcing the surface of the paper into the grooves and pits, which are relieved of their load of ink. Wedding invitations are intaglios. To make an engraving, the printmaker scores lines directly on a copper or steel plate with a sharp burin or graver and scrapes the tiny shards of metal unfurled by the engraving tool ("burrs") off the plate. To make a drypoint, he scratches the design

* These references, as well as those that follow other titles of prints in this book, are references to the numbers appearing in the catalogue raisonné of the graphic works of the artist. See the Bibliography for the titles of these sources.

on the plate with a sharp needle and leaves these burrs intact to catch and hold the ink and lay velvety lines on the paper for tonal effect. A mezzotint is an intaglio that results from the systematic scoring of a copperplate with a spurlike "rocker," so that it is traversed with hundreds of rows of burrs, and the subsequent scraping of the raised burrs to produce modulated tones of light and dark values. Etchings and aquatints are intaglios that are the result of the lines having been incised not by human hands, but by acid. To make an etching, a printmaker thinly coats a metal plate with an acid-resistant, waxy ground, draws the design completely through this varnish with a pointed tool, and then places the plate in a bath of acid, which bites into the plate where the drawing has exposed it. To make an aquatint, a printmaker dusts a copperplate with powdered resin, melts the resin particles to form a porous ground, coats those areas that are not to be bitten with "stopping-out" varnish, and immerses the plate in acid. The acid pits the areas of the plate not stopped out, creating an ink-retaining "grain," and the printmaker can create textual or tonal variations by successively stopping out and exposing—and reexposing—specific areas of the plate. The various intaglio processes may be combined for the creation of an intaglio print; aquatint, for example, is customarily used in combination with etching. A design may also be implanted on a metal plate photomechanically by coating it with a photosensitive emulsion, exposing it to a photographic transparency, and placing it in an acid bath.

Lithographs are *planographic* prints; the design is printed on the surface of the paper by a prepared block of limestone or thin zinc or aluminum plate. The planographic process relies on the antipathy of grease and water. The printmaker draws or paints a design on the smooth, porous matrix with a greasy pencil or crayon or with lithographic ink, called "tusche" (or even with the oil from an oily nose!), fixes the image with a gum-arabic solution, sponges the matrix with water, and rolls it up with lithographic printing ink, which adheres only to the greasy image and is repelled by the damp, untouched areas. Dampened paper is then laid over the matrix, which is run through a press whose "scraper bar" presses the paper against the inked design on the matrix. "Hand lithography" may employ either a lithographic press with a hand-manipulated wheel or a motorized press. Commercial offset lithography depends on an "offset" technique for inexpensive high-speed printing. In the normal case, the artist's design is transferred through a screen, which can be either coarse or fine, onto a zinc or aluminum plate coated with a photographic emulsion; for a monochromatic print, the tones of the original design are translated into tiny dots of tonal values ranging from black to white. (The illustrations in this book are photo-offset lithographs.) The metal plate is then wound onto a roller, which rapidly receives coats of ink and transfers (offsets) the ink images to a rubber roller or blanket, which in turn lays the design on paper. There are numerous variants within photolithography.

Serigraphs, silkscreens (screenprints), and *pochoirs* are products of a *stencil* process. Most simply, the printmaker glues cutout patterns on, or stops out with varnish areas of, a framed fabric or silk screen and then squeegees ink through the unprotected areas of the mesh onto a sheet of paper below. It is the uncovered areas that create the design on paper. A multicolor screenprint requires as many separately prepared screens as there are colored portions in the design that the printmaker wishes to transpose to paper.

In printmaking processes, the design on the printing surface or matrix is sometimes implanted there directly by human hands and sometimes by mechanical or photographic means. Sometimes the inventor or creator of the design—the artist—performs or actively participates in the act of transferring his idea for a design to the printing surface or matrix; sometimes he merely supervises or instructs artisans who are masters of the technical complexities; and sometimes he delegates all the manual and technical work to them, much as one might do when ordering custom work of any kind.

The print is the only form of fine art that can be both an artistic and a commercial mode of expression. But whether the print is critically acclaimed as fine or innovative art or repudiated as a poor commercial souvenir of work in another art medium should have nothing to do with what mechanics or people were employed to make it. The work, after all, speaks for itself. To the trained and discriminating eye, the print should assert its own identity, either as estimable art or junk, whatever the nature of its paternity and genesis. Hypothetically a print manufactured by anonymous craftsmen with the aid of sensitive photomechanical equipment is capable of exhibiting greater pictorial imagination and printing quality than an etching printed directly by the artist himself from a copperplate incised by his own hand.

In other words the personalities of the creators (from artist through atelier curator, who culls the proofs for quality), the nature and scope of their creative roles, and the character of their equipment should have significance only in the way we *refer* to a print—how it is represented and commercially valued in the marketplace or museum—and not for its success and quality as a work of art.

The historical attempts to distinguish "original prints" from reproductions, however, have aspired to isolate "fine art" from artifact on the basis of issues other than the success and quality of the image. In relatively recent years, various bodies, including the Print Council of America, *La Chambre Syndicale de l'Estampe et du Dessin*, the Third International Congress of Plastic Arts, meeting in Vienna in 1960, the United States Congress (through the Tariff Act), and several state legislatures, have adopted definitions of an "original print" that reflect concerns about who made the print and how it was made—the print's paternity and genesis. One reason for such rulemaking was disquiet over an increasing tendency toward the removal of the artist—the creator of the design, whom

our ancestors termed the *inventor*—from various printmaking processes. (The traditionalists sought to affirm that graphic art arises not so much from the heart and mind of the artist-*inventor* as from exploitation of process by the artist-*inventor* himself.) Another motive was uneasiness about the increasing intrusion of that device which replaced the traditional printmaking media for illustrating and multiplying visual ideas—the camera—and other labor-saving mechanics and equipment into the print-making processes, either to aid the artist and artisans in execution or to reproduce a design executed in another art medium. (The traditionalists, like the etching connoisseurs at the turn of the century, accepted as "original prints" only those that required manual handling, thereby confounding the art product with the process by which it was produced.) A third motive was concern over the victimization of an unsophisticated public by the advertisement and distribution as autographic works of graphic art of reproductions of an artist's work in another medium, both with and without his personal acquiescence or authorization. (The traditionalists were bewildered and appalled by the growth of a flourishing market in expensive non-"original" prints.)

Under the canons of "originality" promulgated by the traditionalists and those influenced by them, the acceptability of a print as an "original" depended on whether the matrix had been chosen, prepared, and impregnated by the artist-*inventor*, regardless of whether the intercession of timesaving technical processes and proficient technicians might have liberated him to concentrate on the primordial ideas and modes of expression while leaving the manual labor of the printmaking to others. Actual handling and intense supervision of the printing were prerequisite; the impersonality of the new contemporary graphics left the traditionalists cold. The worth of a print also depended on whether it had been executed with proper 19th-century primitiveness, without the use of motorized presses or new-fangled devices like cameras, irrespective of the quality or pictorial appeal of the final product. For a print to be creditable, it was necessary that the artist be involved in the procedures and processes by which the image was created and transferred to paper. As the Print Council spokesman, the late Carl Zigrosser, wrote in 1965 in *A Guide to the Collecting and Care of Original Prints*, "One may say that handwork is bound up with art and original execution, as opposed to automation and mechanical processes." Prints that were executed by instruction or made by remote control for absentee artists who did not seek to become involved in the printmaking process did not, according to Zigrosser and those who shared his views, display "the artist's personal touch" and were not "original."

Traditionalists such as Zigrosser, while well-meaning, are off target, for the elevation of certain prints to superior status by application of a definition for an "original print" is unjustifiable, unworkable, and counterproductive.

THE ROLES OF THE ARTIST AND THE ARTISAN IN PRINTMAKING

The Role of Artisan-Copyists in the Execution of Afters

While today some people still hold the view that the only "original" prints are those on which the artist-*inventor* has worked himself, it is instructive to note that over the centuries relatively few celebrated painters have made their own prints. The notion that the artist should be a graphic artist, as well as a painter or sculptor, is a relatively modern assumption. Among the major Italian painters of the Renaissance, only Andrea Mantegna and Parmigianino ever got much involved with engraving or etching. In the north, Peter Brueghel the Elder made one print himself and turned over drawings to Hieronymous Cock and his Antwerp craftsmen to have more made (Fig. 1-C). Rubens completed one print himself; Van Dyck, five; otherwise, both commissioned professional copyists to reproduce drawings and paintings, primarily in order to circulate their images throughout Europe in inexpensive black and white. During the entire 18th century, only Hogarth, Canaletto, the Tiepolos, and Goya, among the major painters, were engaged by printmaking, though Watteau, Fragonard, and Boucher executed a number of largely undistinguished etchings.

The revolutionary technology which produced what William Ivins, the late curator of prints at the Metropolitan Museum of Art, has most accurately described as the "exactly repeatable pictorial statement" was, after all, invented and for centuries used primarily for purposes of transmitting visual information, not strictly as a mode for artistic expression. When, late in the 15th century, artists like Albrecht Dürer began experimenting with the new technology, woodcuts and engravings had for some time been employed for the dissemination of images of the Stations of the Cross, the Apostles, herbs, flowers, towns, and events. The use of the revolutionary technology by such men as Mantegna, Schongauer, and Dürer to produce and distribute pictures that displayed more artistic prowess and passion than information brought them great fame and appreciation as artists. People prized these prints for their virtuosity and imagery, as well as for their messages.

But if the 15th-century artist and his workshop colleagues were understandably concerned with the mechanics of translating an artistic conception into a multiple edition of distinctive esthetic beauty and quality, those who bought the woodcuts never questioned whether Dürer himself cut the grooves in the wood blocks—he probably did not—or merely drew the preliminary design for a *Formschneider* to follow. After all, the

guild system assigned the craft of woodcutting to woodcutters, not to artists. Likewise, no one queried whether in executing some of the first etchings ever made, Dürer dipped the iron in the acid himself—he did—or engaged some technician to do it. Nor, significantly, when we confront his magnificent woodcuts and engravings and etchings today, do we really care whether Dürer performed or supervised steps A through F of the printmaking process or had craftsmen take over at step B. Artist-*inventors* have long employed expert technician-*sculpsors*—cutters, printers, weavers, metal founders—when specialized technical work was required for the production of salable duplicates.

In fact, since the time of Dürer, there have been hundreds of first-rate painters who declined or were by law or custom barred from involvement in reproductive processes and consequently chose to authorize or commission professional woodcutters, engravers, or mezzotinters to reproduce and publish their paintings and drawings—and incidentally earn some money—by the only methods extant before the invention of photography. Throughout history highly skilled professional copyists have served a utilitarian function by furnishing the public with catchpenny graphic souvenirs of pictures by artists who had no aspiration to try printmaking. These copyists catered to the associative appeal of reproductions of unique works of art in other media, which the print

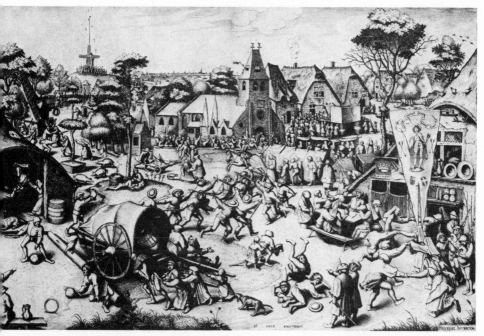

eronymous Cock *after* Peter Brueghel the Elder, "La Kermesse de la Saint-Georges" ("Fair St. George's Day"). Etching and engraving, 1561 (Bast. 207/I; Leb. 52/I). 332 x 523 mm; /16″ x 20⁹/16″. Brueghel delivered drawings to Cock for reproduction in the graphic me- m. The artist executed only one print himself. (COLLECTION OF THE AUTHOR) Fig. 1-C

buyer admired but could not afford. In the century before the refine-
ment of photography, for example, printmaking techniques such as the
mezzotint (the "dark" or "English manner"), stipple engraving, and en-
graving in the crayon manner were employed in the art field almost ex-
clusively to create popular-priced imitations of paintings by famous art-
ists. No one was misled about autography because the artist-*inventor* and
copyist-*sculpsor* commonly disclosed their respective roles on the matrix
itself.

The arrival in the 1860's and 70's of processes for relatively accurate
photographic reproduction—photoengraving, the linecut, and the half-
tone—put art copyists out of business for a while and demanded a new
justification for traditional printmaking, which was considerably more
expensive than the new reproductive processes. The reception publishers
gave to photomechanical reproduction of artists' works catalyzed the rise
of a new caste of *peintres-graveurs* (painter-printmakers), who took up the
traditional printmaking processes, which had been somewhat vulgarized
by long commercial use, to create "original" art in multiple form, as
peintres-graveurs Dürer, Rembrandt, Goya, and others had done before
them, of a quality generally superior to the new photomechanical repro-
ductions. As one awakened *peintre-graveur* wrote in 1873, "Today, now
that . . . nature can be projected on paper by anybody capable of
operating a camera, artists need no longer be enslaved by all that patient
fidelity to detail, all that painstaking imitation. Fancy, ingenuity, fresh
personal impressions, these are what are required now—and this is no
bad thing." While these mid and late 19th-century *peintres-graveurs*—
Degas, Barbizon artists Corot and Daubigny, Manet, Whistler, Pissarro,
Redon, Gauguin, Toulouse-Lautrec, the Nabis artists Bonnard and
Vuillard, Ensor, Munch, and others—were struggling to revitalize as an
acknowledged "art" form what had long been a largely reproductive,
image-spreading medium, the *peintres-graveurs* themselves, their pub-
lishers, supportive critics, and sympathetic fanciers were motivated to af-
firm a distinction between "original" prints conceived and executed by
the artist and "reproductive" prints manufactured by another hand. Two
of the devices that the *peintres-graveurs* and their publishers adopted to
publicize this distinction were the handwritten signature and the limita-
tion of the edition, which underscored an impression's rarity and the
personal touch of the artist.

Of course not every painter became a purist *peintre-graveur* after
photography replaced traditional printmaking methods for the commer-
cial duplication of images. Some artists, even some who were *peintres-
graveurs*, continued to defer to the greater know-how and experience of
artisans, either for relief from printmaking burdens, such as inking
plates, separating colors, and operating the printing press, or oc-
casionally, for the graphic "interpretation" of their paintings, water-
colors, or drawings. (The Paris dealer, Henri-M. Petiet, has recalled that
the Nabis artists Bonnard, Vuillard, and Denis did everything them-

selves only because their publisher, Ambroise Vollard, could not afford the services of professional artisans.) Many welcomed the arrival of photomechanical and other untraditional processes to translate gouaches, watercolors, oils, and drawings into the graphic medium, especially for purposes of book or newspaper and magazine illustration, which gained them a wider audience and a larger income. We know that the etcher Félix Braquemond provided much technical assistance to Millet and Manet and that Séguin executed the background and etched the plate for at least one "Gauguin" etching, "La Femme aux Figues." Winslow Homer authorized the manufacture of wood engravings *after* his designs for use as illustrations in *Harper's Weekly*. Toulouse-Lautrec authorized the production of heliographs of certain of his paintings and the reproduction of certain of his lithographs for the newspaper *L'Escarmouche*, and it is speculated that many of the color separations for his posters were executed by master printer Chaix. In 1885 Degas commissioned the great chromolithographer Auguste Clot to make his color pastel of "Jockeys" into a color lithograph, and no one is really sure what part Cézanne played in having his 1899 drawing for "Les Baigneurs (Grande Planche)" (Fig. 1-D) transferred to lithographic stones by M. Clot (the curator and critic Carl Zigrosser once categorized this master print as "more than half original," which has all the logic of being "a little pregnant"). Felicien Rops had heliogravures made *after* his drawings. Rodin contented himself with high-quality facsimiles when his time became too precious for printmaking; he authorized the skillful Clot to transcribe certain of his wash drawings to lithographic stones and approved a number of other excellent photographic facsimiles. Kandinsky permitted Tendences Nouvelles to issue a portfolio, entitled *Xylographies*, of heliogravure reproductions of five previously published woodcuts. George Grosz authorized an offset edition of certain drawings that were later reproduced as illustrations for his book *Ecce Homo* (Fig. 1-E). Deliberately using photoreproduction as an artistic medium, Max Ernst illustrated a number of Surrealist books in the 1920's with photomechanical reproductions of his collages and frottages. The foregoing sampling is merely illustrative; one could go on and on before even approaching the middle of the 20th century.

It is unquestionably true that esthetically the prints that spring from designs implanted on a matrix by *peintres-graveurs* who themselves fused conception with execution—engravings by Dürer, etchings by Rembrandt, lithographs and aquatints by Goya, woodcuts by Munch and Gauguin, lithographs by Daumier and Lautrec, etchings, lithographs, aquatints, and linocuts by Picasso, among others—are, all in all, the most successful. They reflect an inventiveness, spontaneity, sensitivity, and skill that few copyists have ever achieved. The artist's total creative involvement with—and response to—his medium often shines through the completed work. We can in fact usually distinguish autographic works from those by copyists on the basis of artistic merit alone—Van

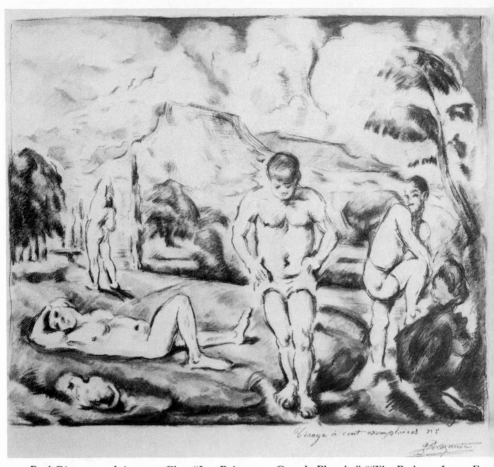

Viraye à cent exemplaires n°

Paul Cézanne and Auguste Clot, "Les Baigneurs, Grande Planche" ("The Bathers, Large Format"). Lithograph in colors, 1898 (V. 1157; S. 8; L. & M. 6). 410 x 500 mm; 16⅛" x 19⅝". It is believed that Clot, the master lithographer, executed the stones for each of the six colors after a proof in black that Cézanne watercolored for use as a prototype. (COURTESY OF SOTHEBY PARKE BERNET INC.) Fig. 1-D

Dycks from portraits by other hands in his *Iconography*, for example. Rembrandt, who employed the burin and needle to realize etchings and drypoints that have never been equaled, was the archetypical *peintre-graveur*. He performed every step, from preparation of the printing surface to the printing itself. He drew on the ground covering the copperplate, etched the plate with acid, inked, and wiped it, selected the paper, and printed and culled the proofs. In the process, as the successive states of his intaglios reveal, he acquired the technical virtuosity—unprecedented skills in using tools and acid to score lines that had never been seen before, wiping the inky plate to achieve tonal effects, burnishing and reworking areas to alter compositional elements—to realize uniquely expressive works of art. But just because the graphic works of *peintres-graveurs* like Rembrandt are splendid does not mean that graphic works executed wholly or partly by technicians cannot be admi-

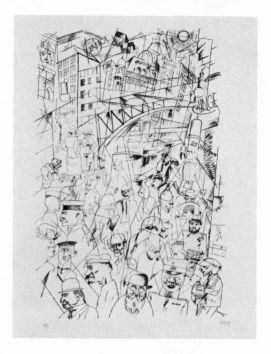

George Grosz, "Friedrichstrasse." Photo-offset lithograph, 1918 (D. 85). 465 x 310 mm; 18⁵/₁₆" x 12³/₁₆". This print is a photoreproduction of the drawing reproduced as plate 1 in Grosz's picture book, *Ecce Homo* (1923). It was published with several other related images from *Ecce Homo* in an edition of 50 and signed in pencil by the artist. An impression fetched 2800 deutsche marks (about $1250) at the 1976 Hauswedell & Nolte auction. (COLLECTION OF THE AUTHOR) Fig. 1-E

rable, too. No one refuses to listen to a Chopin piano concerto because Chopin is not playing the piano.

While most of the thousands of prints conceived and executed as reproductive works (the French call them *gravures d'interprétation*, or *estampes*, or *éditions d'après;* the Germans designate them as *nach*, as in *nach* Braque; and we call them *afters*, though one American publisher concocted the phrase "facsimile re-creations") do in truth lack any interest, imagination, or intrinsic value as art—some artists chose or accepted mere copying machines or insensitive or inferior craftsmen—many are today recognized as inspired artistic works *in their own right*. Many of the hired engravers, woodcutters, mezzotinters, and process cameramen have displayed such truly artistic sensibilities that their graphic interpretations have themselves achieved critical acceptance as art, as opposed to craft. Some copyists are admired because they paraphrased the *inventor's* artistic conceptions—the modeling, proportions, surface finish, and overall esthetic message of the master image—into the graphic medium with great understanding and probity. Some are admired because they transformed the *inventor's* conceptions into works that obtained their own artistic identity through defiant refinement of existing craft conventions or stylistic or compositional modifications (Vasari relates that the painter Baccio Bandinelli once sued Marcantonio Raimondi for straying from his prescribed design). As the early 18th-century professional *graveur*, Charles-Nicolas Cochin (père), once exulted, "One must not regard the skillful *graveurs* as simple copyists; they are rather translators who transform the beauties of one very rich language into another which is less original and offers problems, but which also offers compensations inspired by genius and taste."

The names of a number of such copyists have in fact achieved a renown quite independent from that of the artists whose works they copied. Thus engravings incised by Marcantonio Raimondi *after* works by Raphael and Michelangelo (with some scenery occasionally lifted from Lucas Van Leyden and composed into a pastiche) and woodcuts by Nicolas Boldrini *after* drawings by Titian are prized, not because they reproduce masters who left printmaking to others, but because they are, in their own right, estimable engravings and woodcuts. The same is true of the *Totentanz* wood engravings cut by Hans Lützelburger *after* designs by Hans Holbein the Younger (see Fig. 4-F); chiaroscuro woodcuts by Antonio da Trento and Ugo da Carpi *after* Parmigianino; engravings by Hieronymous Cock, Philip Galle, Pieter Van der Heyden, and other artisans employed at Cock's workshop *after* drawings by Peter Brueghel the Elder (see Fig. 1-C); copies by Jegher, Goltzius, and others employed in Rubens' atelier *after* drawings by the Master; mezzotints by David Lucas *after* Constable landscapes; engraved portraits by Wille *after* paintings by Rigaud and others; color engravings by Bonnet, Demarteau, and Janinet *after* Boucher; watercolored aquatints of *Birds of America* by Robert Havell, Jr., *after* John James Audubon's watercolors; and hundreds of others. Artists themselves—from Edouard Manet to Otto Mueller to Paul Wunderlich and Frank Stella—have also used the graphic media to re-create distinctive versions of those of their own paintings that they considered especially successful.

During the modern era, engineers and artisans, particularly those working in Paris, developed the know-how, equipment, and skills to translate paintings, gouaches, watercolors, and drawings into exquisite color and monochromatic lithographs, aquatints, and screenprints that *look* more like autographic prints than imitations. In the later 1950's and early 1960's, the wholesale adoption by many artist-printmakers of commercial and photomechanical processes for image making reinforced the indispensability and enhanced the authority and influence of the traditional copyist-craftsman—in modern guise, the stencil-cutting printer or offset lithographer or process cameraman—and rendered any automatic inferences about the artist's involvement in the printmaking, which could once have usually been safely drawn from the nature and appearance of the print, untenable. In part because of a popular inclination to accept all signed limited editions as "originals," the public cannot easily discern that the reproductions of Picasso and Braque paintings issued by Paris publisher Guy Spitzer are commercial photocopies; that woodcuts "by" Rouault and Picasso were in fact executed *after* their designs by Georges Aubert, a copyist; that the color aquatint plates for Picasso's "Langouste" were made by Roger Lacourière; that certain "Braque" color aquatints were actually produced by Aldo Crommelynck, and certain "Braque" etchings by Signovert; and that it was master lithographer Fernand Mourlot himself and the talented *chromistes* he employed and trained— Sorlier, Deschamps, and others (see Fig. 6-B)—who devised a large

number of color plates *after* colored trial proofs and other unique works of Chagall, Braque, Léger, Miró, Magritte, and others. And yet precisely what role the *inventor* did play in bringing these creations to life is still very uncertain.

*The Role of the Artist-*Inventor *in the Execution of* Afters

Whether he designed intentionally for a copyist or merely authorized the translation of existing copies, the role that the *inventor* has played in the copying process has ranged historically from abject disassociation to active intervention and participation. No law, either natural or man-made, has ever regulated the conduct of an artist in this regard; there has never been any limitation on the contributions that a technician may permissibly make to the realization of an edition set in motion by the artist. The involvement of the artist has indeed varied with the Zeitgeist of the era, his own motives, and his artistic integrity. J. M. W. Turner himself drew, etched, and engraved a few of the subjects for his *Liber Studiorum*, and after crudely sketching the main outlines, before turning the sepia sketches for the others over to his copyists, he superintended the progress of each plate, corrected ("touched") proofs with black or white chalk, and oversaw the printing of the edition. Though he reputedly "etched as much copper as would sheath the British navy," Rowlandson did little more than the preliminary etching, leaving the aquatinting and hand-coloring to the French refugees employed by publisher Rudolph Ackerman, who were guided by a working proof Rowlandson had colored. Constable fussily returned as many as 13 corrected trial proofs to his mezzotinter, David Lucas; yet there are few surviving proof impressions of interpretive mezzotints that reveal any corrections by any other 19th-century English painters. Regarding the signed, limited-edition *estampes after* original works by Braque, Matisse (Fig. 1-F), Chagall, Miró, Rouault, Kandinsky, and others that Editions Maeght began publishing after World War II, Aimé Maeght has advised that "in most cases the artist himself chose the works and the print medium which seemed to him to suit them. He intervened himself in the execution of the *estampes*, oversaw and directed the work of the etcher or lithographer, revised certain parts by hand, corrected proofs and finally gave his definitive approval by placing his signature on each copy." (Maeght's hedge, "in most cases," might well be heeded; Kandinsky, for instance, died in 1944.) Though Picasso turned over crayon drawings to Mourlot for reproduction in the 1950's (on one, M. 406, a Mourlot technician adroitly corrected Picasso's misspelling of the English word County for a Los Angeles County Museum poster by slipping in the *o*!), in the last decade of his life Picasso became extremely cavalier with his signature.

1502 - ODALISQUE
Eau-forte en couleurs.
Format : 41,5 × 55.
Tirée à 300 ex. sur Arches 57 × 76,
numérotés et signés.

**1503 - FEMME A LA ROBE
BLANCHE**
Lithographie en couleurs.
Format : 55 × 35,5.
Tirée à 300 ex. sur Arches 65 × 46
numérotés.

**1507 - LA BLOUSE
PAYSANNE**
Lithographie en couleurs.
Format : 55,5 × 43,5.
Tirée à 300 ex. sur Arches 65 × 48,
numérotés.

1505 - NU
Lithographie en couleurs.
Format : 47 × 39.
Tirée à 300 ex. sur Arches 64 × 48,
numérotés.

1501 - INTÉRIEUR BLEU
Eau-forte en couleurs.
Format : 51 × 42,5.
Tirée à 200 ex. sur Arches 76 × 57,
numérotés et signés.

1504 - LES TROIS BOUQUETS
Lithographie en couleurs.
Format : 50,5 × 41.
Tirée à 350 ex. sur Arches 63 × 48,
numérotés.

**1506 - LES MILLE
ET UNE NUITS**
Lithographie en couleurs.
Format : 54 × 90.
Tirée sur vélin du Marais

A page from the 1956 catalogue, *10 Ans D'Edition: 1946–1956*, illustrating the etchings and lithographs *after* Matisse's designs, published by Maeght Editeur in Paris. Other catalogue entries, as well as the Maeght Editeur catalogues published annually, list and illustrate all the Maeght *estampes after* Braque, Chagall, Miró, Picasso, and other School of Paris artists. Fig. 1-F

Among other charitable acts not involving any direct participation or supervision, he consented to autograph an edition of reproductions of a crayon drawing falsely advertised after his death as "the last known work of Pablo Picasso" (Fig. 1-G), in exchange for a $100,000 donation to a friend's charity, and five editions of sorry photoreproductions of paintings for the Museo Picasso in Barcelona (Czw. 130–34). Usually it is impossible to deduce the nature and extent of the artist's involvement in the completion of a print from the surface appearance of contemporary photoreproductive graphics—offset lithographs, silkscreens, collotypes, and the like. Some artists, such as Salvador Dali, put their signature on blank sheets of paper so craftsmen can fill them in with lithographs during their absence (in 1974 French customs agents on the Spanish border seized a truck loaded with blank sheets presigned by Dali), while others, such as the people working at Landfall Press, Kelpra Studio, Editions Domberger, and similar ateliers, normally supervise and participate in the technical transfer processes.

Discerning the Roles of Copyist-Sculpsor and Artist-Inventor

Pre-20th century *afters* don't cause many crises of identification. In accordance with common practice at the time, or as required by copyright law, a disconcerting—to the modern eye—inscription disclosing the identity of both the *inventor* and the *sculpsor* was normally printed on the face of the work itself, either within the composition or in "letters" below it. For example, one of the first authorized *gravures d'interprétation*, a 1546 engraving by Giulio Bonasone after a "Judith" of Michelangelo (B. XV. 9), candidly asserts at the bottom, "I. Bonaso. *Imitado. pinsit. Q. celavit*" (drawn and engraved copy). Thorough documentation takes over where typographic disclosure leaves off; the scholarship recorded in available literature has in most cases successfully sifted autographic works from copies and specified the extent of the artist's personal involvement and, when known, the identity of the copyist. Fakes, forgeries, and deceptive facsimiles are the major authenticity problems for old master print buyers, not *afters* posing as autographic works.

It is the production of 20th-century copyists, and especially the work done after World War II, that caused serious Print People to place on a pedestal something defined as an "original print." Of course, there are purists who contend that, as a matter of absolutes, the more remote an artist is from the execution of his conception, the more the product reeks of commercial manufacture and the less it partakes of art. Such people despaired and bristled when the gaps between conception and execution lengthened and multiplied during the Print Boom of the 1960's and 70's. But debate on a metaphysical level leads nowhere; the brouhaha about

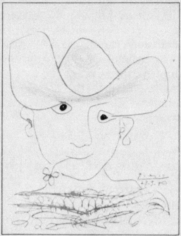
Ad for a lithographic reproduction of a crayon drawing by Picasso, who took no part in the execution of the print. Picasso signed proofs from a deluxe run apart from this edition of 2,500. Some dealers sell this autographed version for thousands of dollars. Fig. 1-G

originality results principally from the fact that today the art-buying public attaches great *monetary value* to autography.

The crucial problem in the Print World today is that of fraud and deceit, intentional and accidental, which demeans the art form and provokes critics into dismissing printmaking as a commercial method for exploiting the celebrity of painters and reproducing styles and images that were affirmed in other media. Few twentieth-century *afters* or their publishers publicize the hand of the copyist as old master prints so often do; the late 19th-century mystique over the "original print" wiped out this laudable practice. Some early 20th-century prints are in fact as blatantly misleading as the ones stocked by contemporary opportunists. For example, though the 1915–16 periodical *Zeit-Echo* captioned each Feininger illustration an "Original-Steindruck" (original lithograph), they are in fact photoreproductions of Feininger drawings.

To profit from the premium which the art-buying public places on the personality of the artist—especially the modern superstars—and the "original print," many artists, publishers, printers, and purveyors of prints have conspired to conceal the identity and labor of highly skilled copyists from public view. They play up to the public's craving for a famous name and promote the name rather than the imagery to exact a fatter price than the work might otherwise deserve or obtain. In the marketplace these prints thus get endowed with the same character and appeal as successful fakes, which also pretend to be what they are not. The result is that many people think they are buying a handmade Dali, Picasso, Chagall, Dufy, Calder, or Rockwell, when what they are actually acquiring is a clever translation of a work in another medium, which the artist may or may not have even scrutinized—let alone helped execute. Often no documentation or other disclosures are available to someone sophisticated enough to want verification of the print's pedigree; indeeed some particularly diabolical ateliers and publishers have worked hard to preserve the anonymity of their artisans—latter-day Marcantonios, Cocks, Havells, and Clots—and their work in order not to jeopardize the marketability of their manufacture.

This deception—which, to repeat, is a modern phenomenon—is furthered by the increased public acceptance of printmaking as an art form and the popular conception that artists being artists and not contractors, our artists are *peintres-graveurs* whenever they "make" prints. The unsophisticated public expects that all the "art" prints marketed under an artist's name are imbued with his own personal autographic touch, as distinguished from the poorer-quality illustrations in art books and reproductions and posters for sale in museum shops. Prices in many cases are set at levels designed to accommodate this popular misconception, to assure the uninformed public that the artist actually took an active part in the execution of the print proffered for purchase; when dubious photoreproductions of Picasso paintings are priced on a par with Leiris editions having a fair market value of thousands of dollars, it is natural to

accept them as autographic works. The deception is further reinforced by the usual absence of any confessional typographic legend on the recto or verso of the print (though Paris chromolithographers—Sorlier, Deschamps, and others—have occasionally attested their handiwork in typescript), the double-talking advertisement of an *after* in the name, exclusively, of the artist who designed it, and the employment of those pernicious devices, the manual signature and the limitation of the edition, to connote autography and preciousness. Money is the great compromiser. For their part, the originators of the designs routinely aid and abet the deception by hogging the attribution even when their supervision or participation has been token or nonexistent, contributing their signatures, and even occasionally taking an active role in promoting the popular misconception. Hans Bellmer was so indignant over the honorable refusal of a New York publisher, Alex Rosenberg of Transworld Art, to advertise a 1974 photolithographic *after* ("Etreintes") as an "original print" by Bellmer that he held out from signing the edition for eight months.

It should therefore be evident that the artist's signature cannot as a general rule be viewed as a representation of the artist's involvement in the creation and execution of the print. The signature of an artist, whether printed with the design or added afterward, in and of itself conveys no reliable information about who implanted the design on the printing surface, unless corroborating evidence appears elsewhere. Twentieth-century artists have not as a rule given proper and accurate credit on the face of a print to their printmaking craftsmen-collaborators (or to machinery), and leading artists have sometimes signed work executed entirely by others. While the signature in no way improves the esthetic appeal or quality of a print, if facts about its genesis are important to the purchaser, he should seek confirmation outside the signature.

Moreover, the indicated scarcity of an edition—the number of impressions pulled—generally implies no information about who did the work on the matrix (or what reproductive processes were employed). An unlimited edition, or an edition larger than 500 or so impressions of a modern print, might indicate resort to impersonal "commercial" reproductive techniques and processes which preclude the total involvement of the artist, but not necessarily. Conversely, a small edition does not insure intimate work by the artist. Inasmuch as the size of the edition, whether small or large, may have no bearing on the success or quality of the image, if information about the role of the artist and the printmaking techniques employed are required to substantiate labels or other representations, direct or inferable, one should consult other authorities or demand fuller disclosure.

THE ROLES OF MACHINERY
AND MECHANICS
IN THE EXECUTION OF PRINTS
Historical Use of Tools and Processes

Some people today still cling to the notion that prints resulting from relatively new-fashioned transfer techniques, photomechanical means of achieving separation of colors and implanting a design on a stone or plate, gravure printing, commercial silkscreen processes, and photo-offset lithography, are not "original prints." But old-fashioned woodblock printing, the etching process, and stone lithography were once newfangled technology, too. Cutting, inking, and printing a block of wood was a technological and educational advance of the early 15th century in Europe; Urs Graf executed the first dated etching, in 1513, two years before Dürer's first; and Senefelder invented lithography in 1798. When the public was presented with the commercial results of these wonderful innovations in chemistry and mechanics, no one scorned them for having been machine-made. A preference for the handmade would have been considered eccentric during the first 400 years of printmaking. It is only in fairly recent times that we have been so imbued with Romantic notions about the artist's personal struggle with his materials, so overwhelmed and dulled by automation, and so anxious to restore the industrial world to its pristine ecological state that we glorify the handmade and are refreshed, when scanning a print, by the appearance of a smudgy thumbprint in the margin.

Use of *any* graphic reproductive medium, old or new, requires the interposition of special tools, matrices, and machinery between the artist's initial conception and the completed graphic work. A print cannot take form directly from the movements of an artist's hand with the same spontaneity as a painting or a drawing. Every print, like every multiple, is the offspring of a union between art and technology; all prints, technically speaking, are industrial products. Every print is partly machine-made; even a monotype—an artwork created to print one or two impressions—has to be *printed*. Toward the end of the 19th century, developments in chemistry and mechanics emerged to permit the modification, streamlining, and circumvention of the antiquarian printmaking techniques and processes then in general use and made the impersonal industrial aspects of printmaking more pronounced. During the third quarter of the present century, intrepid artists and printer-technicians—process cameramen, stencil cutters, *chromistes*, offset-lithographers, and the like—changed the face of the art of the print by inspirationally converting banal, non-art mechanics and resources to art making and thereby em-

phasizing, to the chagrin of the traditionalists, their character as works of industrial manufacture (Fig. 1-H). Yet the prints and multiples of the 1960's and 70's, processed with the help of modern commercial processes, techniques, and mechanical aids, were no more industrial products than hand-drawn etchings and stone lithographs. They simply depended on contemporary rather than old technological resources.

Josef Albers, Miniature of "Gray Instrumentation II" (one of twelve from the portfolio). Silkscreen, 1975. 128 x 128 mm; 5″ x 5″ (full-size print is 19″ x 19″). Printer-publisher Kenneth Tyler and his assistants executed the matrices, mixed the inks (according to Albers' prescriptions and some of their own suggestions), and did the printing for many Albers designs showing the interaction of color. The print illustrated was included in a Tyler Workshop prospectus. It is a precise miniature of a larger version from the signed edition limited to 46. (COURTESY OF TYLER WORKSHOP LTD.) Fig. 1-H

Association of Handwork with "Originality"

Historically, technology has always offered new opportunities for artistic creativity rather than inhibited it. Since the full flowering of the Industrial Revolution in Western Europe during the mid-19th century, however, critical acceptance of the graphic art produced by the new technology has lagged behind its appropriation by artists and printmaking craftsmen. (As Aldous Huxley observed, "It is the customary fate of new truths to begin as heresies.") The lithographs by Daumier and Gavarni which appeared on the pages of the Paris periodical *Charivari* in the middle of the last century were mostly used to wrap up fish, before their credentials as legitimate art were recognized. Until 1936, when it grudgingly admitted lithographs for consideration, the American annual *Fine Prints of the Year* confined its purview to impressions from copperplates, and the Society of American Etchers changed its name to the Society of American Etchers, Gravers, Lithographers and Woodcutters only in 1947. Fifty years earlier—in 1897—Whistler and Joseph Pennell thought they had settled the issue of the "originality" of lithographs made by "transfer" technique. Whistler, Pennell, and the French Impressionists Pissarro, Renoir and Sisley, who usually drew and painted outdoors, often made drawings with lithographic crayon on special transfer paper for later application to the lithographic stone (Fig. 1-I), because they did not want to bother to lug cumbersome stones into the fields and had no urge to polish and etch the stones themselves. A purist, the English etcher Walter Sickert, in 1897 pilloried Pennell in the *Saturday Review* for passing off transferred drawings as the real McCoy. Pennell sued for libel, called Whistler as a witness, and won, but it was Whistler who really triumphed: today many of his transfer lithographs sell for five to ten times as much as Sickert's etchings. Yet in 1965 Carl Zigrosser categorized as a "questionable practice" the *re*transfer of a drawing fixed on one lithographic stone to another stone or plate for the purpose of producing a large edition, even though lithographs Whistler had drawn directly on the stone had been transferred to other stones for the relatively long runs of *The Studio*, *The Albemarle*, and *The Art Journal*, magazines published in the 1880's and 90's. While American and British Pop and other artists were contributing to the Printmaking Renaissance of the 1960's by having striking images photographed by clever graphic-arts technicians onto zinc or aluminum plates for printing on high-speed commercial rotary offset presses (in an offset press the printing is not done by the original matrix; the matrix, itself mechanically inked, deposits the image on a rubber roller, and it is the latter that actually lays the ink down on the paper), Zigrosser was still classifying offset lithography as "a borderline case more slanted toward reproduction than toward

James McNeill Whistler, "The Garden." Lithograph, 1891 (W. 38; L. 63). 170 x 187 mm; 6¾″ x 7⅜″. This delicate lithograph was made by transferring Whistler's drawing on specially coated transfer paper to the lithographic stone. Walter Sickert, against whom Whistler later testified for denouncing transfer lithography as a reproductive process, is the man standing. (COURTESY OF SOTHEBY PARKE BERNET INC.) Fig. 1-I

original production." The Print Council of America, for whom Zigrosser spoke, had in fact been publicizing its requirements that the artist alone create the "master image in or upon the plate, stone, wood block or other material," since the late 1950's, and European organizations had followed suit. In 1952 the French trade union of engravers refused membership in the "original print" club to anything produced by "any process based on photomechanics," and in December 1964 the Comité National de la Gravure Française of la Chambre Syndicale de l'Estampe et du Dessin adopted a definition of an "original print" that excluded prints made by "all mechanical or photomechanical processes." Not surprisingly, an official at the 1965 Biennale des Jeunes in Paris wanted either to disqualify or to exile British artist Patrick Caulfield's screenprinted designs from the competition because they were manufactured by "commercial" reproductive methods.

Artistic Utility of Modern Reproductive Processes and Techniques

This particular association of the notion of "originality" with *manual* labor, which caught fire when the *peintres-graveurs* of the late 19th century sought to distinguish their art from photoreproductions, never made much sense. In the first place, artisans have persisted in manually executing reproductions that merchandisers could then legitimately dub "original reproductions"! Moreover, the new mechanical and photoreproductive processes have had an inspirational and not a repressive influence on many artists, who have found them uniquely suited to the most expeditious and expressive realization of certain effects. During the renascence in printmaking that took place during the third quarter of this century, while the authorities were announcing standards that insisted on the hand-made, contemporary artists and printers were ignoring these sticklers and producing whatever best suited their artistic urgencies—photolithographs, screenprints resulting from screens prepared by photographic process, collotypes, vacuum-formed, three-dimensional transparent polyurethane prints—*whatever*. The modern innovations were extremely attractive to those artists who balked when faced with a copperplate or lithographic stone or who wished to avoid the slowness and drudgery of traditional printmaking methods. They also appealed to artists who wanted to originate multiple images conveniently, without having to spend a lot of time in a studio or workshop, wished to achieve unconventional effects, or sought to *eliminate* every manifestation of their personal touch.In printmaking the artist's hand had finally become replaceable as a practical matter, and in many cases he could now become simply the active manager of complex industrial technics for transferring and transcribing visual conceptions (Fig. 1-J).

Top: Roy Lichtenstein working at Gemini G.E.L., Los Angeles, on a proof of "Peace through Chemistry II." Lithograph and silkscreen in colors, 1970 (Gem. 241). 946 x 1600 mm; 37¼" x 63". *Bottom:* Gemini craftsman Tom Papaleo hand-chasing the mold for "Peace through Chemistry Bronze" *after* a design by Roy Lichtenstein. Bronze multiple, 1970 (Gem. 222). 692 x 1175 x 32 mm; 27¼" x 46¼" x 1¼". (COURTESY OF GEMINI G.E.L.) Fig. 1-J

The transfer of a design from paper or canvas to a stone or plate is most successfully accomplished when there is a close affinity between the original medium and the graphic medium employed by the copyist. Thus pen drawings reproduce well by photogravure; gouaches, watercolors, and crayon drawings by lithography; and acrylics by screenprinting. Electrotype reproductions of woodcuts are virtually indistinguishable from imprints made directly by the inked woodblocks. Transfer lithographs may sometimes suffer in clarity, freshness, and painterliness from the transfer process—to wit, some of those by Alberto Giacometti and Raphael Soyer—yet some by Renoir and Whistler achieve a certain softness and delicacy in exchange.

If some of the contemporary photoreproductive processes, in comparison to the traditional hand processes, tend to produce prints that have a more sanitized and machined appearance, transmit coldness, clarity and bright flat colors instead of more subtle textural and tonal effects, and hide the traces of spontaneity of execution that some people cherish, it is precisely these qualities that have frequently satisfied contemporary artistic urgencies. Artists have deliberately selected offset lithography for its light touch and subtlety, and a skillfully composed and printed contemporary offset lithograph is often distinguishable from one pulled from a stone only by the direction of the words or signature, if any, appearing within the design (hand lithography reverses the drawing; offset re-reverses it). Always a stickler for quality printing, Tatyana Grosman, the director of Universal Limited Art Editions, herself modified a steadfast championship of hand lithography by buying photographic plate-making equipment and an offset press for her workshop in 1972, and Kenneth Tyler began in 1975 increasingly to resort to the high-speed offset press for lithographs composed by Robert Motherwell and others, because the images proved indistinguishable from hand-printed ones, but were printed more speedily and less expensively.

THE PRIMACY OF QUALITY AND ESTHETIC APPEAL

Though the definition of an "original print" can be made elastic, it can be stretched only so far.

The specifications for an original print that have thus far been formulated are misbegotten. Their rigidity rebuffs new discoveries and denies exploding technology; their obsession with permissible technique and procedure disallows consideration of the final product—the work of art itself. If one's focus is properly guided by esthetics, it should fall not on the *inventor* but on the intrinsic appeal of the imagery conceived and presented; not on the mechanics of the achievement, but on the quality of

the finished work on paper that the technology has yielded. The intrinsic quality and pictorial appeal of any particular print are critically severable from its origins; its origins are significant only for its historical and commercial evaluation and for technical appreciation.

A work of art is nothing but an esthetic concept expressed in materials through the use of tools. The technics employed—the tool use—are interesting but immaterial to any esthetic judgment. No one needs to know the origins of a mural or fresco (who did what work, what equipment was used, and so forth) in order to pass critical judgment on it; no one misses the personal touch of the sculptor on posthumous or bootleg casts of Daumiers, Remingtons, and Rodins, if they are pleasing; no one rejects the Rose Tapestries of Cluny because anonymities did the weaving. A rose by another name smells just the same. Ultimately a print or any other objet d'art can be no more than what it is—res ipsa loquitur ("the thing speaks for itself"). Experiencing a print or multiple esthetically does not benefit from reference to a formula for authenticity. It takes an eye exercised by education and experience, and—if verbalizations helpful to appreciation are desired—guidelines for "quality" and "expressive success" pertinent to the art of the print and akin, if you please, to the critical criteria by which all art is measured.

When tested against the critical criteria underlying judgments about any art, including the art of the print, that which is fine will shine besides that which is lackluster, whatever its origins. If quality is measured by the compatibility and inseparability of visual idea, mode of graphic expression chosen and technical virtuosity of execution and printing, it is certainly true that many signed and numbered *afters* on the market have about as much quality and pictorial appeal as a postcard of the Empire State Building—they disclose their identity, at least to the cultivated eye, by appearance alone. Yet it has been said that Charles Sorlier, the master lithographer/*chromiste* at Mourlot Imprimateur, has made more beautiful "Chagall" lithographs than Chagall, and Picasso was more than once astounded by the results of Mourlot Frères' virtuosity (see, for example, the "Picasso" color lithograph, "Picador II," M. 350). Many of the machine-made graphics on the market today are in truth junky prints. But who can quarrel with the progeny of such ateliers as the Tyler Workshop, Gemini G.E.L., Petersburg Press, or Advanced Graphics, where some of the most dextrous contemporary artists have willfully forsaken printmaking's traditional hand skills to collaborate as a "co-processor" with technicians in accomplishing a felicitous transformation of an image from one medium to another?

The point is, that while many *afters* and photoreproductive prints have no more artistic—or investment—value than the offset illustrations in a good art book, there are *afters* fabricated by gifted copyists with the aid of photoreproductive or other mechanical devices that, to the most sensitive eye, demonstrate a perfect wedding of idea and technique, that as-

sert a validity and impact as distinctive works of art through appealing imagery, appropriateness of the graphic medium selected to the imagery conceived, artful preparation of the printing surface, and deft printing. Many *afters* and photomechanical reproductions will no doubt survive in historical perspective as very estimable accomplishments.

Moreover, the whole mystique about "original" prints has given fine reproductions that make no pretense to be autographic works a bad name. The propaganda that insisted that to be appreciated a print must be an "original print," as defined, has not only made people vulnerable to fraudulent and deceitful claims of "originality," but has turned them away from perfectly respectable prints, such as posters, photoreproductive book illustrations, and other pictures, which are honestly advertised as "facsimiles" or reproductions. The splendid hand-colored collotype reproductions of Blake's illuminated books, commissioned by the William Blake Trust and published by the Trianon Press, for example, have reached a fraction of the customers they would have attracted if they had been stridently touted and marketed as original prints. It is unquestionably true that most reproductions are of very poor quality. Yet even cheap, poor-quality reproductions that display pictorial imagination can entertain and impress. Matisse once wrote, "I have known and profited from the Japanese only through reproductions, the poor editions bought in the boxes by the doors of the printsellers on rue de Seine; Bonnard told me the same thing, and he added that, when he was shown the originals, he thought he was being deceived, given the surface mellowing and discoloration of the old editions."

The wholesale exclusion of *afters* and nonhandmade graphics and the inclusion of everything else, as ordained by institutional standards for the "original print," are historically inappropriate, factually inapposite, specious, and overly subservient to ephemeral orthodoxy, taste, and vogue, the state of preexisting technology, and the progress of reevaluation. To adhere to such formulae is like condemning a train for not being a horse or a tapestry for not being a painting. They are like the tail trying to wag the dog: disjointed by exceptions, technological innovations, and real market practices.

FRAUD, DECEIT, AND OTHER ABUSIVE PRACTICES

Information about the degree to which the *inventor* participated in the appropriation of available technology for the execution of the print—its relative autography—*can* be very relevant to its *monetary* value, given the psychological factors that underpin the commercial value the marketplace will assign to the print. The facile definitions of the "original print"

devised in the 1950's and 60's overlooked the primacy of this inquiry and so became counterproductive.

The Scope of the Problem

The most unfortunate—and ironic—consequence of all the proselytizing about "originality" was the adoption by opportunists of the syntax and vocabulary of the "original print" for the promotion of overpriced, poor-quality reproductions as beautiful investments. Not only did the most cynical of the print merchandisers survive unscathed while well-meaning Print People tried to educate the public about "original prints," but they benefitted from the popularization of the phrase. Hundreds of artful publishers, distributors, and merchants operate in a demimonde where duplicity, mystique, the smug verbiage of pretended expertise, an investment pitch, and the blessed word "original" are used to define the "investment quality" and to validate the inflated price levels of certain *afters* and photomechanical creations whose values would immediately collapse if not so supported (Fig. 1-K). Outright misrepresentation about facts that print buyers *should* know, if they are to make intelligent judgments about the extrinsic, or monetary, value of a picture, are not uncommon in the low end of the business. But unscrupulous merchants and auctioneers are more discreetly successful with the even more insidious concealments (silence), half-truths, euphemisms and innuendos. Words like "original" and "lithograph" and proper names of great painters are drained of all meaning for service in the kinds of deadly games Alice was pressed into in Wonderland. In the marketplace for "art prints," many people who normally think clearly tend to be so respectful in the presence of a work associated with a famous name and so fearful of appearing gauche that the right questions, should they think of them, stick in their throats.

In the marketplace, deceptive labeling, advertising, and marketing practices in fact come close to transforming many worthless (and many estimable) *afters* and photoreproductions, which may have first entered this world innocently and without pretense, into fakes, which are things priced and passed off as works made by someone who never saw them. One gesture which eliminates the distinction between *after* and "fake" is the consent, or at least the complicity, of the artist under whose name it is advertised to lend his name to its advertisement and promotion. That consent or toleration supposedly gives a work "authenticity." But some artists, Dali for one, apparently have no qualms about selling their names; anyone with the right amount of cash can buy a package deal consisting of a gouache for reproduction and 250 signatures. Pragmatically speaking, therefore, is there any valid distinction between designs designated by the artist as appropriate for reproduction (*afters*, once

Facade of an "original print" mart in New York City. Such establishments are to be avoided. (PHOTO BY THE AUTHOR) Fig. 1-K

translated) and designs selected by someone else for reproduction (fakes, once translated and offered under the artist's name without his OK)? And if not, how shall we designate posthumous editions made *after* preparatory drawings for prints that the artist expressly intended but never got the opportunity to execute? What about reproductions of drawings, gouaches, or paintings authorized by an heir—widow, daughter, or grandson—with a facsimile signature of the dear-departed affixed to the margin? Labels aside, should not the public at least be able to have essential facts about the autography of the piece whose worth is up for consideration, without being bamboozled by silence or double-talk?

There is, in fact, no current workable substitute for experience, knowledge, research, common sense, perspicacity, sensitivity, and taste when it comes to detecting and judging the credentials of prints. It is such qualities, that certain

dealers, curators, and connoisseurs will gladly share, and not captious and facile definitions of an "original print" or the slick language of print merchandisers, that should guide what value is placed on a print both in the halls of academe and in the marketplace. The common law and the Code Napoléon have been ineffective against abusive practices in the Print World; self-regulation is opposed by cynical, unscrupulous merchants and ethical practitioners alike; printers keep mum and promote the cult of the artist's personality by meekly following publishers' orders; and most artists, the people whom the undiscriminating public accords the uncontested authority to be the judges and attestors of "originality," have not shown much concern about the corruption of their names or indignation over the fraudulent and deceitful practices that have brought decadence to the Print World. In the absence of coercive law, the probity and adequacy of any disclosures or inducements made by the seller are only as incontestable as the integrity of the artist, the printer, the publisher, and the seller himself.

What would be at least helpful to the vast public that lacks or fails to resort to the knowledge of attributes essential for judgments about relative pictorial appeal and quality and relative autography would be adequate consumer-protection legislation against fraud, misrepresentation, and deceitful omission. If the artist has the right to have his work protected against fakes and forgeries, does not the naïve consumer have the right to be protected against deceptive labeling, advertising, and marketing practices? If the print buyer is at least forearmed with essential data concerning a print's paternity, genesis, and existing relatives, then he has only his own bad judgment to blame should he be duped. What seems most needed is an enforced disclosure concerning the degree of involvement of the artist in the realization of the print, information about exactly what the artist has done—between conception and printing—to make the work "his" work, so that everyone can determine for himself whether the indicated measure of "originality" is worth the price.

Only two legislative bodies in the world have seen fit to compel written disclosure of facts essential to a consideration of the monetary value of a print—the states of California (1971) and Illinois (1972). The California and Illinois statutes mandate the inclusion of specified information or of a disclaimer professing honest ignorance about these facts in all promotional literature and in a certificate or invoice that must accompany every sale. They oblige the seller to accept the return of a print innocently misrepresented and to pay the purchaser triple the price of any print willfully misrepresented. The disclosure requirements, however, apply only to editions issued after the effective dates of the statutes (July 1, 1971, and July 1, 1972, respectively); the statutes themselves are poorly drafted; and they contain enough ambiguities and loopholes to permit the shadiest practitioner to pursue his trade unmolested. Moreover, since proof of willful misrepresentation, worth a triple refund, is

difficult to muster in a civil suit, unscrupulous dealers in Los Angeles, San Francisco, and Chicago have continued their old abusive practices with impunity, risking only the possibility of a refund. Instead of protecting the unwary and intimidated, the gilt-edged certificates have served merely to entice them, and the seediest graphics emporia continue to prosper in Southern California. By 1975 California legislators and interested citizens were drafting amendments, especially new enforcement provisions, to strengthen their law's effectiveness.

Any print legislation promulgated in New York would have repercussions throughout the Print World, but similar though much improved legislation remained in limbo in the New York State legislature through 1976. Whereas the Southern and Northern California Art Dealers Association supported the West Coast legislation, the prestigious New York-based Art Dealers Association of America stalled efforts in New York. Respected New York dealers grumbled that a truth-in-print labeling law would saddle them with oppressive paperwork and bothersome, difficult research. "This 'labeling act,' " stated Sylvan Cole, when he was president of the Association in 1970, "is impossible to comply with because of the cumbersome amount of information required." "How can a dealer here control or even know what went on in the printshop?" asked the late Peter Deitsch. "You only find out when one of Mourlot's printers quits or gets fired." The dealers also complained that compulsory disclosure would compromise the professionalism of the reputable, ethical dealers, whose distinctiveness would be undifferentiated if everyone was made to come up with a fancy piece of paper. They would, moreover, be sandbagged into making embarrassing honest confessions to gaps in their knowledge concerning matters which they knew were not pertinent to a fair and proper appraisal of certain prints. Some dealers also viewed the proposed law as an unconscionable intrusion into private enterprise, which would require them to reveal their supply sources and trade secrets. Others were offended by the prospect of a legislated equation of art with commodity, by the relegation of fine prints to the same consumer status as a used car or a container of yogurt.

The parade of horrors strung out by the dealers is not, in truth, all that dreadful. A law that pushes every dealer toward the professionalism that a small number practice as a matter of course would act as an indirect licensing procedure—which has also been talked about—segregating those marginal people who are too busy hustling prints like used cars to acquire any expertise or a working library. The California and Illinois legislation has in fact provoked reputable publishers, distributors, and retail dealers into establishing procedures for gathering and recording the required data and designing forms for communicating the information to purchasers. Conscientious printsellers normally use their scholarly thoroughness as a selling point anyway, and the reputation and connoisseurship of reputable people quickly become known to potential cus-

tomers, who even now readily accept their explanations regarding any deficiencies in knowledge. To be actionable, any misrepresentation or omission would have to be material, and any disclaimer, disingenuous (scienter, or guilty knowledge, has always been an element essential to proof of fraud). The objection to the revelation of "trade secrets and sources" carries the arrogant presumption that art-world mysteries are inherently entitled to greater solicitude than, say, those of automobile dealers. Any shopper determined to try to get a print wholesale will be able to unearth the relevant information anyway—especially once he has read this book.

Legislation or not, unless one knows what one is doing or has confidence in the seller's reputation, before buying any print, one should always obtain specific and categoric assurances or disclaimers of knowledge (preferably in the form of a signed piece of paper, which one can produce later if necessary) about the following matters:

1. The specifications of the impression, including its catalogue-raisonné number, if any, and the date of printing.

2. The role of the artist in the realization of the edition, including the degree of participation and supervision of the artist in its execution, and if possible, the identity of any copyist or master technician who played an instrumental part.

3. The processes and techniques used to transfer the artist's conception to the printing surface or matrix, and the name and address of the publisher and printer.

4. Whether the impression is signed manually, is stamped with a signature or monogram or otherwise, and if it is signed or stamped, whether that motor action was performed by the artist or someone else.

5. (a) Whether the impression is a restrike, or a posthumous or late impression, or results from a printing surface reworked, retouched, or otherwise "improved" by other hands after the death of the artist, and (b) the size of all editions reproducing the image appearing on the impression (including, without limitation, signed and unsigned editions, numbered and unnumbered editions, editions on different paper and in different colors, artist's proofs, reprints, prior and subsequent states), and the location of the impression in this chronology.

6. Whether, to the attestor's information and belief, the printing surface or matrix still exists, is lost, or has been destroyed, defaced, canceled, mutilated, or effaced—or restored.

At the very least, unless one knows what one is doing when buying prints, adherence to the following general rules of thumb will prove wise.

Never buy a print from a dealer who does not exhibit the characteristics of professionalism described in Chapter 9 (which include refraining from touting prints as investments) or from any auction firm that fails to describe *afters* as such.

Never buy a print unless it is recorded in the standard catalogue raisonné, assuming that such a catalogue exists and is up-to-date, or in other scholarly literature.

Never rely wholly on the signature as a guarantee of autography or on the number of a print as a promise of scarcity.

Always comparison shop.

Detail from James Ensor, "La Vengeance de Hop-Frog" ("Hop-Frog's Revenge"). Etching, 1898 (T., D. 112; Cr. 111). 350 x 242 mm; 13¾" x 9½". (COURTESY OF SOTHEBY PARKE BERNET INC.)

Chapter Two

Signatures on Prints

Duchamp exploded the notion that a work of art must be a piece of craftsmanship. Art, he established, is what the artist says it is. Not all urinals are art; only the one signed by him.
—GIULIO CARLO ARGAN, 1976

A signature on a print may appear printed with the composition, within or below the design, or handwritten, as an autograph, outside the image in the lower margin of the proof. If an artist signs by hand, he generally signs just below the composition, at the lower left or right, so that the autograph accommodates itself to the standard aperture in a mat. But some artists so position their signatures that a framer must cut out a special window to disclose the name. James Ensor countersigned his etchings by scrawling his name diagonally across the verso, so that the absence of a countersignature raises suspicions about the authenticity of any signature on the front.

Autographs themselves come in various forms and styles. Artists may sign or stamp their full names or simply their initials. They may—like Toulouse-Lautrec, Maillol, and Pissarro—have editions imprinted with a monogram, in black, blue, or red. Whistler, who helped introduce the handwritten signature to the Print World, signed many of his prints with a distinctive squiggle in the shape of a butterfly, often on a tab protruding from the lower edge of the paper. Dali vainly uses flourishes and curlicues.

SIGNATURES IN THE COMPOSITION

Before the end of the 19th century, when the possession of manually signed proofs became fashionable, an artist never thought of blessing each impression with an autograph. He was content—or obliged by guild law—to identify his handiwork, if he did so at all, by inscribing his name, monogram, or emblem on the matrix, written backward so it would appear forward when it was printed. In fact, many 15th-century masters are known only by their initials, such as the Masters E. S., IB with the Bird, L Cz, or MZ, which, like the hallmarks of the goldsmiths

to whose guild they belonged, were engraved on plates simply to identify the maker of a particular piece of craftsmanship.

With the full flowering of Renaissance humanism, the personality of the artist became a subject of fascination and admiration, and the names of individual artists became familiar and consequently merchandisable. Antonio Pollaiuolo was probably the first artist to inscribe a plate with his complete Christian name; his monumental engraving, "Battle of the Nudes" (1460–75) has a tablet bearing his name and his citizenship—"Florentini." A generation later, Albrecht Dürer, who signed every graphic work but two with a monogram, proudly suspended a signpost bearing his full name and the date, 1504, from the branch of the Forbidden Tree in his engraving "Adam and Eve" (B.1; M.1) (Fig. 2-A). During the 16th century, in certain municipalities in Western Europe the imposition by guilds and government authorities of an *obligation* to sign gave signatures, monograms, and other identifying words a role broader than that of a mere indication of creative authorship and helped cultivate a spiritual and material value for the signature in the mind of the public. By the early 17th century, Rembrandt is found regularly incising finished copperplates with his name or monogram and the date of execution (yet a number of plates disclose Rembrandt's authorship only by style and execution). Almost 400 years after Dürer placed his name on a sign, James Ensor wrapped a beauty-contest sash lettered ENSOR around one of the figures in his etching "Vengeance de Hop Frog" (Cr. 111; D. and T. 112), though by then it had become *de rigueur* for Ensor and his contemporaries to sign proofs manually in pencil or ink as well.

Whistler's graphic oeuvre, which spanned the turn of the century, reveals the introduction and affirmation of the *manual* signature as an element of the spiritual appeal and material value of a print. Whistler's earlier etchings, such as the 1858 French set and the 1871 Thames set, were printed and distributed before autographing prints became customary, although Whistler did sign a number of impressions with his "butterfly." However, "lifetime" (nonposthumous) impressions of the Venice set of 1880 were always signed, and for this reason, as much as for esthetic ones, they are on the whole more coveted than their predecessors. In 1887, in order to profit from the signature snobbism which he had helped greatly to promote, Whistler introduced a policy of charging twice as much for signed lithographs as he did for unsigned ones of identical quality. Today the unsigned lifetime impressions of the lithographs, as well as the reprints struck in 1903 after Whistler's death by Goulding, the printer, are valued at a fraction of the price of the signed lifetime impressions, though in most cases there is no discernible difference in quality.

The motivations that may in any particular case have induced an artist to inscribe his name on the copperplate, wood block, or lithographic stone—exploitation of his reputation, desire for publicity, confirmation of authenticity or quality, desire to evidence the completion of his work,

Albrecht Dürer, "Adam and Eve." Engraving, 1504 (B., Holl. 1 V/V; M. 1(3)). 252 x 195 mm; $9^{15}/_{16}''$ x $7^{11}/_{16}''$. Dürer customarily inscribed his plates and wood blocks with a monogram. Here he proudly proclaimed the identity of this work's creator. (COURTESY OF KORNFELD UND KLIPSTEIN) Fig. 2-A

legal obligation, pride, vanity—are so variable that no consistent, logical inferences bearing on a print's value can ever be drawn from the *absence* of a name "in the plate," "in the wood block," or "in the stone." Thousands of marvelous examples of graphic art, from the 15th century to the present day, whether bound into books, integrated into portfolios, or issued as single sheets, in fact bear no mark to identify the personality of the man who conceived or created them, other than the style of the design and the form of the medium.

If the absence of a signature in the matrix has no bearing on the artistic or monetary value of a print, then conversely, its *presence* "in the plate," "in the wood block," or "in the stone" should add nothing to a print's value either. After all, the sorriest printed reproductions of paintings and drawings also reproduce the artist's signature if—and as—it appears in the original work of art. The press-printed signature—the appearance of a signature as part of the composition—is in fact redundant, for the very existence of the impression attests to the creation of the image by an artist or artisan. (Though a signature within or below the design can signify that the work on the matrix has been completed, artists have often revised their conceptions by retouching or reworking the matrix into one or more states *after* the addition of the signature.) Dealers' descriptions of prints as being signed "in the plate," "in the wood block," or "in the stone" are hence at best circumlocutions to make unsigned prints seem more distinctive (i.e., surplusage or window dressing) and at worst euphemisms to make people think unsigned prints are signed (i.e., deception). That is why New York State made it a misdemeanor, effective January 1, 1976, for anyone to use the word "signed" to describe a print that has not been manually signed.

The hand signature satisfies several human cravings. As a unique appendage on a nonunique creation, the signature of the artist or his heir purposely contradicts the nature and purpose of the print as an exactly repeated statement owned by *lots* of people. It endows a print with an individual personality. For some, it satisfies a desire to capture and hold a fleeting moment of a creative life, to possess a trace of the artist's footprint—a shard of the true Cross, a relic in a reliquary, as it were. It caters to the human urge to possess the better of two alternatives—the electric blender with the most push buttons, the premium scotch, the imported brand, the one that is *signed*—without bothering to make a rational choice based on the relative difference in value between the lesser and the premium product. It relieves the exhibitor of the print from the tiresome, annoying necessity of having to respond bravely to such questions as "Who did this painting?" and "How come it isn't signed?"

The practice of manually autographing proofs in pencil or ink was a historical outgrowth of the desire of 19th-century *peintres-graveurs* to confirm the integrity of a print as an "original" work of art, distinctive from a "reproduction," and to verify and account for authorized proofs. Indeed, the manual signature—the artist personified—has often been used

solely to promote an aura of preciousness. How, for example, can one make each copy in an edition of 10,000 *special?* Hundertwasser did it by signing, dating, and numbering all 10,000! The commercial utility of the manual signature becomes manifest with the simultaneous publication or release of an unsigned edition (often in or as a book) together with a more expensive signed edition absolutely indistinguishable in quality or condition. The artist makes no qualitative judgment in such cases. It cannot be said, for example, that Chagall signed the deluxe, wide-margin, *hors texte* (separate from the book) impression of his *Daphne and Chloë* suite of color lithographs (M. 308–49) (see Fig. 3-B) because they more closely conformed to his artistic intentions than the narrower-margin impressions in the book; or that Rouault signed only a portion of the 300-copy edition of *Automne* (K. 43; S. 83) (see Fig. 2-B) because they were perceptibly different or better than the unconsecrated impressions. Or that Picasso "approved" the impressions from the *Vollard Suite* (Bl. 134–233) he was paid to sign but not the ones he did not have time to sign. In each such case, the signatures were ordered or exacted to make the pictures more appetizing, more valuable, more salable. Given the choice, the market always prices the autographed version appreciably higher. The manual signature somehow instantly endows the signed copies with substantially more monetary value than that of their unblessed brothers.

SIGNATURES OF ARTISTS AND ARTISANS

Over the centuries, as a result of both the refinement of contractual relationships and the development of guild and statutory law, artists, copyists, printers, and publishers built a vocabulary of phrases and abbreviations to identify for the public the roles of the various people involved in the design of the image, the work on the medium, the operation of the press, and the distribution of the edition. During the first centuries of printmaking, these terms served, like film credits, to advertise the various creative skills brought to bear in the production of the print. They began to fade from common use when developments in photoreproductive technology during the second half of the 19th century rendered traditional printmaking obsolete as an industry for the reproduction and dissemination of images and, accordingly, more desirable to painters as a strictly artistic vocation. Appearing as "letters" toward the bottom of the composition or beneath the platemark or border, and printed simultaneously with the picture itself, they included

———— *aq.*, *aquaf.*, or *aquafortis* (etched it)
———— *celavit* (engraved it)
———— *d.*, *del.*, *delin.*, or *delineavit* (drafted it; designed it)
———— *des.*, *desig.* (designed it)

———— *direx.*, *direxit* (directed the work)
———— *ex.*, *exc.*, *excu.*, *excud.*, *excudit, excudebat* (published it)
———— *f.*, *fe.*, *ft*, *fec.*, *fect*, *fecit, fa.*, *fac.*, *fact*, *faciebat* (executed it)
———— *grav.* (executed it)
———— *imp.*, *impr.* (printed it)
———— *inc.*, *inci.*, *incid.*, *incidit, incidebat* ⎫
———— *inv.*, *invent.*, *inventor* ⎬(designed the image)
lith. de ———— (———— or ————'s shop ⎭drafted or printed it)
———— *p.*, *pictor, pin.*, *pingebat, pinsit, pinx.*, *pinxt*, *pinxit* (painted the
original image)
———— *s.*, *sc.*, *scul.*, *sculp.*, *sculpsit, sculpebat, sculptor* (engraved it)

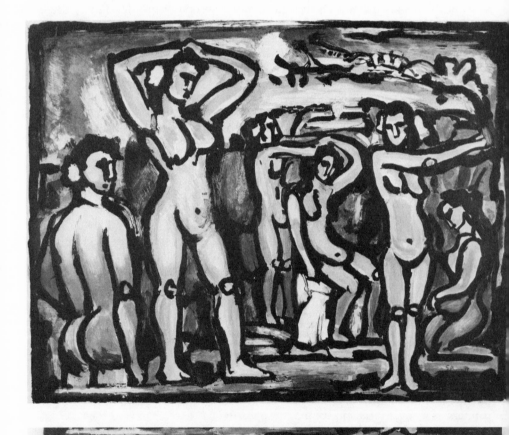

Georges Rouault, "Automne." Etching in colors, 1936 (K. 43; S. 83). 513 x 660 mm, 20¼" x 25⅞". 175 impressions were presumably signed and numbered; another 31 were later signed for Paris dealer Henri Cazer. (COURTESY OF REISS-COHEN INC.) Fig. 2-B

Thus a typical engraving by the 17th-century engraver, Hieronymus Cock, after a design by Peter Brueghel the Elder has the in-the-plate announcement, "H. COCK EXECUDEBAT" and "BRUEGEL INVENTOR." These inscriptions made it clear that Brueghel made a drawing, and Cock had a copy of it made on copper with the use of a burin. Hence no one then could—or today can—palm off reproductions of Brueghel drawings as "Brueghels," for they announce themselves as "Cocks," or "Galles," or "Van der Heydens," although a subsequent publisher would sometimes impiously replace the name of the true copyist with his own to promote sales. Cock once had an engraving reproducing a Brueghel drawing, "Big Fish Eat Little Fish" (B. 139; L. 16), inscribed with the name of Hieronymous Bosch, perhaps to profit deceitfully from the greater celebrity of Brueghel's stylistic ancestor, perhaps to accord recognition to the inspirer of Brueghel's design (Brueghel's name was restored in a second copy of the design done 60 years later). The only print by Brueghel's own hand, the etched "Landscape with Rabbit Hunters" (B. 31; L. 62), is distinctive, eloquent, and rare, but the prints by engravers *after* Brueghel are valued on their own terms, not simply because they are Brueghel-inspired.

The requirement or custom of open disclosure of the identities and roles of *inventors* and *sculpsors* had the commendable effect of precluding most misrepresentations about such matters. However, copying another artist's work, without fraudulent exploitation of his name, was recognized as perfectly legitimate during the Renaissance; it was confirmed when Albrecht Dürer sued Marcantonio Raimondi, who had reproduced and marketed several editions of unauthorized copies of Dürer's *Life of the Virgin* and *Passion* series with the famed "AD" monogram before Dürer caught up with him. In 1506 Dürer hauled Marcantonio before the Doge of Venice, but the authorities only granted an injunction forbidding the Italian from using Dürer's name or monogram on his copies. Only Marcantonio's forgery of Dürer's signature was arrested; his plagiarism remained unchecked.

SIGNATURES OF ARTISTS ON CRAFTSMEN'S PRODUCTS

In modern times the crucial roles of skilled copyists and craftsmen have often been concealed by the handwritten autograph of the person who sets the printmaking process into motion—the artist. The important and innovative technical work of such 19th-century master printers as Roger Lacourière, Auguste Delâtre ("If Rembrandt were alive, he would get his etchings done at Delâtre's," etcher Seymour Haden remarked), and Auguste Clot, who performed the transfer lithography for the Impres-

sionists and others, was often not publicized by any *excud.* or *imp.* on the print, in modest deference to the creator of the design. Even those collaborating craftsmen who have been invited by the artist to cosign usually have refused, for fear of impairing the marketability of the edition. Artists who rail and carp over the alterations that printers impose on their visions and concepts persist in claiming absolute ownership of the product by signing it alone. As Jo Miller, a former curator of Prints and Drawings at the Brooklyn Museum, once observed, "In many cases, overly slick printing gives some justification to the often heard criticism that many contemporary 'big names' are selling their signatures rather than fine original prints."

Recent technological advances in printing, particularly those making use of photoreproductive techniques, have tended to put even more distance between the artist's initial conception and the resulting graphic work. Many modern artists "make lithographs" the painless way, in three easy steps. They grant a publisher the exclusive rights to engage an atelier to reproduce a painting or drawing; they look over the trial proofs to verify their approximation to the original work of art; and they sign the edition—that is to say, they pencil or ink a signature on some sheets of paper with the reproduced pictures on them made by someone else. Some contemporary artists, Salvador Dali among them, have in fact manifested such confidence in their atelier's ability to translate their conceptions, that they sign and number blank sheets for the artisans later to fill. When, as he told it, Jack Solomon, the founder of the Circle Gallery chain of print marts, proposed to Norman Rockwell, Middle America's consummate illustrator, in 1969 that he make his art available to the folks across the land who missed his *Saturday Evening Post* covers, Rockwell protested, "I've never made lithographs in my life!" "That doesn't matter," replied Solomon. "We *have* someone to do *that*." So, with Rockwell's consent, the Circle Gallery entrusted "Spelling Bee" to a Paris workshop, which adroitly created the first "limited edition lithograph" by Norman Rockwell, aptly entitled "Spelling Bee." Ever since, while the Parisian *chromistes* have been working like bees, Rockwell has been spelling his name for fatter and fatter fees. Owning a signed reproduction of an "original" (says the Circle Gallery promotional literature) Norman Rockwell drawing is thus somewhat like owning an *autographed* Norman Rockwell *Saturday Evening Post* cover—which isn't much different from owning a Hank Aaron signature model Louisville Slugger or a can of STP oil treatment created, designed, and autographed (albeit in facsimile) by Andy Granatelli.

In all fairness, the paragons of modern art have also raised the eyebrows of purists by signing some facsimiles and reproductions themselves. They commonly autograph a "limited" number of those photo-offset souvenir posters commemorating a museum or gallery exhibition of their work. They also have signed "interpretations" of their paintings, gouaches, watercolors, drawings—and prints. During the 1920's Jacques

Villon, an artist whose 1913 Cubist drypoints are coveted as master-pieces of graphic art, occupied himself with the creation of color aqua-tints *after* original works by such celebrated artists as Manet, Van Gogh, Signac, Dufy, Matisse, Gromaire, Picasso (see Fig. 1-A), Vlaminck, and Laurencin. Though his contemporaries courteously signed these repro-ductions, they are today valued as clever and attractive "Villons." George Grosz signed offset lithographs made by technicians from ink drawings reproduced in his book of illustrations *Ecce Homo* (see Fig. 1-E). Käthe Kollwitz, always more interested in making cheap copies of her pictures available to the public than preserving the integrity of her graphic oeuvre, also signed photolithographic reproductions of her prints: the aquatint series *Ein Weberaufstand* (Kl. 34, *et seq.*).

After World War II, when the Parisian publisher, Aimé Maeght, in-troduced a program of commissioning skilled copyists to reproduce School of Paris paintings, Paris-made *estampes à tirages limités et signés after* Chagall, Picasso, Braque, Matisse, Miró, Léger, Giacometti, Kandinsky, Vlaminck, Bonnard, Villon, and others invaded the print market. They continue to trap unwary buyers who take them for autographic works. Chagall signed 12 *Jerusalem Windows* and a number of other color litho-graphs "interpreted" (as his atelier, Mourlot Frères, termed it) from *maquettes* (models) created by the Master, prepared and printed by mas-ter chromolithographer Charles Sorlier—and most people call them and price them as "Chagalls." Picasso signed whatever he pleased, for what-ever reason or cause he fancied: several multicolor *pochoirs* (stencil prints, similar to screenprints) copied from gouaches in the Cubist style (pub-lished by Paul Rosenberg in Paris in the 1920's), photoreproductive cop-ies of paintings published by reproduction companies such as Guy Spitzer and Cercle d'Art of Paris, color lithographs made in Fernand Mourlot's workshop by copyists long since forgotten *after* crayon and other drawings, color woodcuts by one Gérard Angiolini *after* certain oil paintings, and a fine lithographic reproduction of another graphic—his etching "Le Répas Frugal" (Bl. 1). None of these *afters* are recognized by the definitive oeuvre catalogues as Picasso graphics, but they are offered and sold everywhere as very expensive "Picassos." Georges Braque signed, among other replicas of Braques, a number of splendid reproduc-tions of his oils and gouaches in multicolor skillfully engraved on cop-perplate by Aldo Crommelynck; and a Paris court, which later had the occasion to adjudge the artistry of the painter and the artisan, heaped praise on Crommelynck for *his* inventiveness and expressiveness.

Signed pseudo Chagalls, Mirós, Légers, Braques, Picassos, and their ilk are always colorful, are often skillfully executed, and if not misrepre-sented as autographic works, can be relatively inexpensive. They are plentiful; most were created in editions of from 200 to 300 for sale to those attracted to signed decorative art by blue-chip School of Paris artists. But signed School of Paris and made-in-Paris *afters* are spurned by the most scrupulous dealers and collectors and are reluctantly tacked on at

the tail end of an artist's representation by the reputable auction houses. They generally populate the same undiscriminating frame shops, print parlors, and auction salesrooms that display French art-magazine gatefolds of Chagalls, Calders, and Mirós and other lackluster photoreproductions "signed in the stone," where advertised as "original, signed graphics," they can command thousands of dollars (see Fig. 1-K). While the Paris court rightly called a "Crommelynck" a "Crommelynck," unprincipled merchandisers find it easier and more lucrative to sell good, inexpensive Crommelyncks as high-priced "Braques," Angiolinis as "Picassos," Sorliers as "Chagalls," and God-knows-whos as "Rockwells"— and they have the artist's signature to back them up. Of course the most that can be inferred from the signature in such cases is that the artist, pleased with the translation of his otherwise unobtainable, unique original piece into "poor man's art," signified either his satisfaction with the faithfulness of the copy or his pleasure with the reproduction as a work of art with its own integrity. But other inferences are also available. Artists, who are much of the time no different from you or me, have often sold their signatures for cash or given them away for the benefit of some charity or another good cause.

Though these copies, or *afters*, are always advertised under the name of the artist who signed them rather than the artisan who made them, the margin of the print itself sometimes provides the public with the identity of the copyist, printer, or publisher, as in the old days. It is in fact refreshing at a time when overpriced deceptive reproductions abound to see the personality of gifted copyists and printers acknowledged on the print itself, rather than suppressed in order to have the name of the "name" artist exploited for commercial gain. Thus the photo-offset lithograph of a wood engraving after a drawing by Ben Shahn of Martin Luther King (P. 216) happily cannot be palmed off as a "Shahn," though signed by him, because it is lettered, "Engraved by Stefan Martin." Charles Sorlier—in his own right one of the most skilled and innovative lithographer-copyists alive today—likewise usually identifies *his* "Chagalls" by a typographic line, CH. SORLIER. GRAV. LITH. or CH. SORLIER SCULP. MARC CHAGALL PINX., in the margin (where it is nonetheless generally overwhelmed by Chagall's fluid scrawl). Aldo Commelynck normally announces his role with a typographic ALDO CROMMELYNCK GRAV. within the lower platemark of his color reproductions in intaglio of Braque oils and gouaches.

The signature of the printer can also serve to corroborate the authenticity of the impression. It can be comforting to see a Kollwitz etching or a Munch lithograph manually countersigned by the printer Felsing; a Bellows lithograph countersigned by his printer, Bolton Brown; a Signac or Luce lithograph hand-stamped by the Parisian publisher of color lithographs at the turn of the century, Gustave Pellet. More recently, responsible contemporary workshops, following the 1960 lead of the Tamarind Lithography Workshop of Los Angeles, have revived the old

practices by imprinting the distinctive "chops" or blindstamps of the workshop and the collaborating artisan-printers on their editions. Each print in Hundertwasser's *Regentag* portfolio, published in Germany, proudly bears the chops of no less than six craftsmen and organizations involved in its production (see Fig. 3-A).

SIGNATURES BY HEIRS AND MACHINES

In order to capitalize on the easily drawn inference that an autograph signifies the satisfaction of the artist, posthumous editions authorized by the next of kin often are signed or stamped with the name or monogram of the artist or marked with an estate stamp. Posthumous impressions of Pissarro lithographs are stamped "C.P." in dark gray; those of Vallotton woodcuts are monogrammed "f.v." on the lower left and marked with an atelier stamp at the lower right. Fine impressions of Bellows, Kandinsky, Kollwitz, Macke, Marc, and Marsh prints are inscribed with the name of the artist or an estate stamp and countersigned or initialed by an heir. Some Orozco prints are inscribed on the verso by his son, "I certify that this print was made under the supervision of the estate . . ."; and Magritte etchings and aquatints ordered from Atelier Visat by his widow, Georgette, are marked with a facsimile signature of the artist and an oval stamp that reads, GRAVURE ORIGINALE ATELIER RENE MAGRITTE. Schiele reissues are monogrammed by his modern republisher and publicist, Otto Kallir. In 1974 Galerie Denise René published, with the consent of the heirs, we are informed, an edition of eight screenprint reproductions of Herbin color gouaches, numbered and stamped with a facsimile signature that looks very real. The price? $525 each—for a *facsimile* signature. Trim the letters off a Galerie Denise René Herbin poster, and one gets precisely identical quality for 5 percent of the price!

The purpose of these posthumous signatures, naturally, is to insinuate that the license to authorize the propagation of an artist's work and to endorse proofs has rightfully descended. It is useless to speculate whether or not had the artist lived, he would have abjured publication or rejected the quality of an impression as inappropriate to his esthetic intentions or withheld his name for entirely specious or personal reasons. The imprint of the same last name simply gives restrikes, posthumously printed impressions, unsigned proofs, and unauthorized reproductions marketable cachet, whether the result is seemly and meritorious or not.

One of the most shameful prostitutions of a great family name occurred in 1972, when Paul Renoir, the grandson of Pierre-Auguste Renoir, sold out his grandfather's name for the hard sell of a "limited edition" of bad-quality color photoreproductions of six Renoir oils, touted falsely in the promotional literature of that predatory publisher, Jean-

Paul Loup, as "the only official Renoir lithograph collection." Not only did the grandson authorize the publisher to emboss "the only official Renoir signature and Atelier Renoir Seal" on each print ("This signature stamp rests in a vault in a large European Bank," we were told), but with each purchase he manually signed and issued a "Certificate of Authenticity" deceptively declaring, "This lithograph represents an authentic work of my grandfather Pierre Auguste RENOIR" (Fig. 2-C). Worse, he engineered the attainment of an "auction value" to justify as an "investment" the $375 cost of each of these mediocrities. The promotional literature strove to dispel any accusations of price manipulation in connection with this ploy:

> Before committing the tremendous sums of money necessary to produce the Collection, Paul Renoir decided to determine whether or not the Art World would appreciate their special value. To do this he had auctioned 2 single lithographs in October of 1972, at two separate government controlled auctions (the French Government supervises art auctions to insure their honesty) held at the prestigious Hotel Rameau in Versailles: 'Gabrielle In A Hat' brought $567.00—one week later 'Woman With A Rose' brought $745!

When the carnivorous M. Loup pitched the prints mail-order to the American market from a Chicago address in March 1975, he included an engraved "Certificate of Guarantee" certifying that the "six lithographic stones used for the Renoir collection were destroyed on May 13, 1974," which was a year after the sham was denounced by the irate Paris art press. In December 1975 he agreed to the settlement of charges of fraud brought against him by the United States Department of Justice. He promised full refunds to the 326 Americans who had bought the Renoir illustrations at prices ranging from $225 to $450 each.

BUYING AND BEGGING SIGNATURES

Dealers and collectors have naturally found it worth their while to submit an unsigned print to an artist for "authentication." Seymour Haden, who with Whistler helped initiate the practice of autographing prints, would affix his name to any of his early unsigned proofs—for a guinea. Degas, perhaps more an aristocrat, added his signature for no fee on request.

Between 1950 and 1969 Picasso sold signatures to Henri-M. Petiet, the Paris dealer and publisher, for some 15,000 impressions of the *Vollard Suite* like bishops once sold indulgences. Petiet is the amazingly prescient print dealer who took a plunge during the tense "phony war" period in France by purchasing the entire unpublished series of 100 prints, now dubbed the *Vollard Suite*, from the estate of publisher Ambroise Vollard.

One of the photoreproductions of oil paintings by Renoir promoted by Jean-Paul Loup in 1972 as an "authentic" Renoir, bearing the "only official Renoir signature," with a fraudulent "Certificate of Authenticity." Fig. 2-C

AUL RENOIR
GNES-SUR.MER (o6)

ATTESTATION D'ORIGINE

Je soussigné, Paul RENOIR, certifie que cette lithographie représente une œuvre authentique de mon grand-père Pierre Auguste RENOIR.

Le numéro *6o/15o* qu'elle porte en bas à gauche et le cachet d'atelier de Pierre Auguste RENOIR en bas à droite garantissent l'authenticité de cette lithographie.

Fait à Cagnes-sur-Mer, le 22 MAR 1972

Paul RENOIR

Vollard had 300 impressions of each plate on paper (as well as three on parchment)—50 on paper with large margins and 250 on paper of a smaller size—struck just before his death in the summer of 1939. Prior to Vollard's death, Picasso had managed to sign only 15 copies each (on large paper) of ten of the 100 subjects, numbering them 1/15 to 15/15. The balance, including five sets that Petiet claims were stolen by Vollard's chauffeur and found their way to a Geneva dealer, remained unsigned throughout World War II and the postwar years. When France's economy began to recover after the war, and Paris dealers again became active, Petiet coaxed Picasso into beginning the task of affixing signatures on the unsigned hoard. Over a period of almost 20 years—from the autumn of 1950 until July 1969—Petiet carried packets of *Vollard Suites* to Picasso, at first to Picasso's residence on rue Grands-Augustins in Paris and later to Vallauris and "Californie," Picasso's Cannes estate.

During this time Picasso signed but did not number Petiet's entire stock on wide-margined paper of 31 of the subjects (48 sets; Petiet had already sold two unsigned sets: one to Lessing Rosenwald and one to Eberhard Kornfeld), his entire stock on smaller paper of the nine most important subjects (241 impressions of each; five were missing, and Petiet had sold four unsigned sets to "a New York museum") and a large number of impressions of the relatively less important subjects. Petiet "doesn't know" exactly how many of these latter impressions were signed. He never kept an accurate count of the signatures. But he has estimated that over all Picasso worked his way through about half—15,000 signatures! "His signatures were not free," Petiet once affirmed during an interview. "I gave him money in banknotes; he wanted to hide it from the tax authorities." Nor were Petiet's golden eggs easily gathered. "It was always difficult to obtain Picasso's signature," Petiet continued, thinking back to the years of coddling and wheedling and the pilgrimages to the south of France. "It had to be done secretly, because he did not want people to know he was signing prints."

In 1969, by which time Petiet had prospered fabulously from the flow of signatures, his well ran dry. From July 1969 until his death, Petiet mourned, "Picasso was almost totally absorbed with signing the 347 plates of 1968" for his dealer, Galerie Louise Leiris of Paris, and Petiet was compelled to release unsigned impressions. Thus "there were two signatures missing from the set sold to Berggruen in 1969 and 15 from the set sold to Knoedler's." By the summer of 1974—a time when a signed impression of plate 27 (Bl. 230) fetched 45,000 Swiss francs ($16,750 then) at auction and an *un*signed impression found a buyer at £3,500 ($8,300), and a fully signed *Vollard Suite* was probably worth about $300,000 on the auction market—"signed" sets still held by Petiet contained only 25 signed proofs, most of his remaining supply was unsigned, and Petiet, an octogenarian, was still eagerly and anxiously negotiating with Maurice Jardot, director of Galerie Louise Leiris, for the right to employ a facsimile signature stamp. Such a stamp would satisfy

the market's craving for an autograph and accordingly boost the value of Petiet's treasure. It would also at least have the incidentally useful function of curtailing the volume of fake signatures whose appearance has increased alarmingly since Petiet was forced by business necessity to release unsigned *Vollard Suites* into the market.

Picasso was evidently more munificent with others among his friends and acquaintances in the trade than with Petiet. Frank Perls, the late Beverly Hills dealer, once recalled in the pages of *Art News* how with a casual friendly gesture of but a few moments' duration the Master ensured an immensively successful—read "profitable"—sale at the Kornfeld und Klipstein auction in 1969 of the Bergiensten collection of Picasso graphics (and incidentally assured the further enrichment of Paris dealer Heinz Berggruen):

> Berggruen pocketed the book Picasso had given him and then suddenly produced a little package. He opened it and some heavenly unsigned lithographs appeared. He told Picasso they belonged to a Scandinavian collector and that he would like Picasso to sign them. Picasso took out his keys, went to the adjoining room, came back with a tiny stump of pencil with which he quickly signed this rather large group of graphics. That following summer the Scandinavian collector's graphics brought record prices at Kornfeld in Bern.

Tales of his expeditions to Picasso's for merchantable autographs wind through much of Perl's autobiographical writings. He evidently conceived of his requests as a form of homage: "It would be a friendly gesture toward Picasso, one that would give him pleasure," he wrote.

But as every stage-door Johnny knows, even strangers get autographs if they ask nicely. In 1970 New York dealer Martin Gordon used the good offices of a contact close to Picasso to obtain the Master's signature on an unsigned impression of plate 27 of the *Vollard Suite*. The favor, transacted by mail, improved the value of the print by $2500 (then!). And in 1971 Anne Richards Nitze, another New York dealer, solicited a signature from Dubuffet for a rarely signed lithograph during a visit to his studio in Paris. One should note that signatures, like the red paint on the roses of the Queen of Hearts, have been known to disappear as well as to appear. Léger's initials in blue ball-point pen, done before the pens were perfected for writing underwater, and some Kandinsky signatures in unstable white ink have simply faded out of sight!

PHONY SIGNATURES

A signature can be forged on an unsigned print just as it can be forged on an unsigned check, and a phony signature, unless chance or circumstances place it under suspicion, usually passes unapprehended. The de-

tection of a fake signature often requires a subtle blend of long experience and reasonable caution. Artists, after all, occasionally autograph proofs from an unsigned edition on request, so not every questionable signature is fraudulent. (Nor is every signature on a fake or reproduction a forgery, since artists have been known to acknowledge pictures that they did not create.) "I would not get caught, but others would get caught" is the way Henri-M. Petiet, who knows Picasso's hand and its historical modulations as well as any man alive, describes his reaction to "one very good example of a fake signature" on a *Vollard Suite* subject. "It just doesn't *look* right" is how the wise and prudent Print Person might typically express his rejection of a suspicious-looking signature. Yet even experts can be taken in, usually when they are distracted or pressed to make a decision. James Goodfriend, a New York dealer not ordinarily deceived, unwittingly bought a Villon with a "posthumous" signature at a small auction: upon removal of the print from its frame, he discovered an estate blindstamp (an embossed stamp evidencing a printing after the death of the artist) in the lower margin! The late Robert Dain once bought a Kuniyoshi lithograph cheaply from Martin Gordon because its signature differed from the signature on the impression in the Museum of Modern Art—but Dain's follow-up detective work authenticated his Kuniyoshi's signature and proved the *Modern's* false!

Any unsigned impression with an image identical to a valuable signed impression offers an inviting target to the chirographer. One New York dealer has admitted witnessing a Madison Avenue colleague gleefully forging Picasso's signature on unsigned impressions of the *Vollard Suite*. Restrikes, both unmarked and inadequately blind stamped, such as the reprintings of Kollwitz (e.g., Kl. 122) (Fig. 2-D), Ensor (T. & C. 96), and Renoir etchings, and the reprints of Villon color aquatints ("Maternité" after Picasso and "La Femme à la cruche" after Léger), Foujita etchings ("La Femme au Chat" and "Portrait de l'artiste"), Raoul Dufy ("Sirène"), and many others struck by the Chalcographie du Louvre, France's official reprint atelier, provide an inexhaustible, inexpensive inventory for conversion into high-priced merchandise. So do the large unsigned editions that have signed sister editions, such as tear-out Mirós and Chagalls from issues of *Derrière le Miroir*, *Verve*, and *XXiem Siècle*, the Paris art periodicals; and gatefold Calders and Rauschenbergs from 1970 issues of *Art in America* (it seems merchants will be stocked for a long time with "signed" tear-outs from those 60,000-odd runs of *Art in America!*). Such falsely signed copies are at least usually distinguishable from honestly signed copies by quality of printing, smaller margins, different paper, or a large crease down the center. Gaffes such as misspellings and wrong attributions (Wally Reiss and Aldis Browne each swear they once saw a Miró lithograph signed "Chagall"!) are dead giveaways, more amusing than deceptive. But often the print itself emits no warning bleeps, and a visual memory, a comparison of signatures, good connoisseurship (see Chapter 5), or a bit of book learning are essential for au-

Käthe Kollwitz, "Selbstbildnis" ("Self-portrait"). Etching, 1912 (K. 122 VIIe). 140 x 99 mm; 5½" x 3⅞". Restrike (the blindstamp of printer-publisher von der Becke is at the lower right corner) with forged signature. (COURTESY OF MARTIN GORDON INC.) Fig. 2-D

thentication. "Signed" impressions of Picasso *Saltimbanque* drypoints (B1. 1–15) which are not supposed to exist signed (except for those he dedicated to friends) have appeared, and Whistler etchings with his "butterfly" signature tab *appended* to the paper (Fig. 2-E) (Whistler fashioned *his* tabs by cutting the margins away) appear on the market with surprising frequency. All things being relative, however, false signatures on unsigned authentic prints are not a major problem.

Forgers, however, have occasionally attempted to convert inexpensive facsimiles of prints and reproductions of graphics, drawings, and gouaches into high-priced fakes and forgeries by the addition of a signature. The collection of fakes and forgeries assembled by Martin Gordon includes a "signed" photoreproduction of the hand-colored Klee lithograph, "Ein Genius serviert ein kleines Früstück" (K. 79), and a "signed" copy of the Kandinsky *estampe*, "Composition sur Fond Rouge," published by Galerie Maeght after Kandinsky's death. Here and there one sees a "signature" on a poster with the letters cropped off—Berggruen's 1966 lithographic poster (Czw. 228) sliced to look like Picasso's "Buste de Femme d'après Cranach le Jeune" linocut (B1. 859), and Galerie

Synthetic Whistler "butterfly" signature tab attached to an authentic etching. (COURTESY OF O. P. REED, JR.) Fig. 2-E

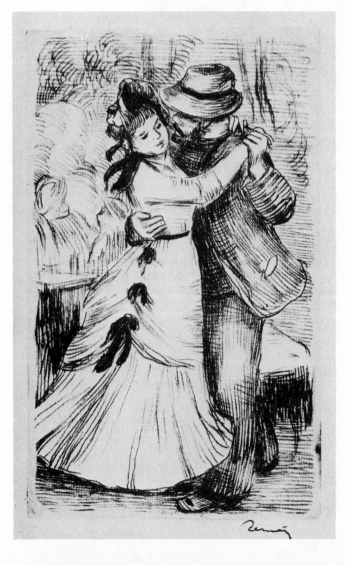

Auguste Renoir, "La Danse à la Campagne" ("Country Dance"). Etching, 1890 (D. 2; L. & M. 3). 220 x 138 mm; 8¹¹/₁₆" x 5⁷/₁₆". Stamped with a facsimile signature. (COURTESY OF WILLIAM WESTON GALLERY LTD.) Fig. 2-F

Matarasso's 1957 offset poster (Czw. 111) tailored to ressemble Picasso's "Portrait de Jacqueline" (B1. 827, M. 289, Czw. 22), for example. Such and related impostors are not common, however, and they can be unmasked by application of print connoisseurship proper rather than solely by handwriting analysis.

Facsimile signatures, whether added to the margin at printing time by the publisher or at a later time by an enterprising dealer, can be troublesome. Anyone who has ever intently peered at what at first looked like a personal letter from a life-insurance agent knows how deceptively genuine facsimile signatures can seem. Some years ago, a London merchant stamped Chagall signatures and serial numbers on huge edition color lithographs cut out of *Verve* and sold them as signed prints. Certain Kollwitz etchings, Renoir etchings (Fig. 2-F), Pissarro lithographs, and Herbin screenprints, among others, have stamped script facsimile signatures that can easily be carelessly read as real. A recent sales catalog of a small Geneva auction house in fact described several of these Renoirs simply as "signed." Printed facsimiles, contrary to handwritten signatures, usually do not glint with reflected light and do not show any variations in shade, depth, or weight of strokes.

Sharp art sellers also make use of terminology such as "signed in the stone," "signed in the plate," or just plain "signed" in labels, advertisements, and promotions in order to mislead buyers into supposing that a print bears an autograph, and they have unwitting (?) allies in those photolithographs and *pochoirs* with press-printed signatures that look like crayon or pen autographs, particularly when they are printed in a color different from that of the image. Unscrupulous publishers and dealers will continue to feed the public's appetite for autographs by obliging it with sham, illusory facsimile signatures (and phony numbering) so long as the market cherishes signed prints over equally worthy unsigned ones.

SIGNIFICANCE AND VALUE
OF SIGNATURES

In the marketplace, therefore, the handwritten signature can be an ambiguous, pernicious thing, because we can always logically infer a number of alternative motivations from its presence. Since artists as a breed (even Dadaists and anti-art types) generally have no propensity toward compromising or prostituting their names, the two-pronged inference that can most reasonably be drawn from the presence of a signature—that the creation before us *is* the artist's and that he *liked* it—is in most cases probably correct. The man in the street, who understands the symbolic authority of seals, signets, and signatures, is in fact naturally predisposed to read the signature on a picture as a proud acknowledgement and guarantee of finished and consummate personal work-

manship. On its face therefore, the manual signature at least contributes, along with *provenance* (the chain of title of an artwork), to the argument in favor of authenticity of the picture *and* attempts to persuade the beholder, for whatever reason he may fancy persuasion, that the named artist ratified both his conception and its execution.

However, the facility of this inference and its usual correctness blind the print-buying public both to its logical fallaciousness and to the existence of other possible inferences, and so make the public vulnerable to signed reproductions and other prints that are not the handiwork of the signer. To recapitulate, the inference of authenticity and approval can in a particular case prove to be wrong. Some artists have been known at times to bestow their signatures arbitrarily or indiscriminately on the graphic work of others, so that while the signature looks like a certificate of authenticity, it is not. Then, too, some artists blithely delegate quality control to others, so that while a signature may seem to reflect the personal examination and approval of the signer of the impression on which it appears, in fact it does not do so. Nor does the autograph on a work of graphic art signify the artist's involvement in or supervision of its production or represent an acknowledgement of sole paternity. Life would be simpler if there were a uniform code of signatures that artists dutifully followed, but there is not, and the significance of the signature to questions of quality and authenticity should be considered and determined on a case-by-case basis.

If the signature affects acceptability of an impression or is an important factor of price, what is one to *do* in the face of all this ambiguity? Labels are often nonexistent or incomplete or misleading or untrustworthy, and the context may call for skepticism. Refer then to the catalogue raisonné describing the artist's graphic work and to other reliable references. They will often state if and how a print should be signed, whether unsigned impressions exist as well as signed ones, and if the artist can justifiably claim sole ownership of the final printed product. Oeuvre catalogues frequently reproduce examples of an artist's autograph from different periods of his productive life (Fig. 2-G). It is also a help to consult and deal with reliable and knowledgeable people. Ask questions. Check answers. Double-check information. Compare available copies. One might discover that the unsigned print which should come signed is a valuable trial proof (or a posthumous restrike!) or that the signature on a print which is normally unsigned is a unique autograph (or a phony!).

It is always useful to remember that the manual signature, which after all is a relatively recent phenomenon in the history of printmaking, is unnecessary for the recognition of a print as a masterpiece of graphic art. If the work is good, the absence of a signature should be irrelevant. Autographs have nothing to do with imagery and quality (though they may help verify authenticity). This obvious proposition unfortunately is also put to noxious use by those who push unsigned refuse. "People who

1904–1911

Zwanziger Jahre

1918

Zwanziger Jahre

Stempel seit etwa 1921

1927

1922

1930

ELK
Zwanziger Jahre

Stempel für Botho-Graef Stiftung, Jena

1932

Frau Erna Kirchner

NACHLASS
E.L.KIRCHNER

Nachlaßstempel
des Kunstmuseums
Basel

Nachdruckstempel
der Staatl. Kunsthalle
Karlsruhe

9

Page from A. & W-D. Dube, *E. L. Kirchner: Das Graphische Werk*, illustrating the development of the artist's signature. (COURTESY OF PRESTEL-VERLAG, MUNICH) Fig. 2-G

know art," declares the canny proprietress attempting to peddle a ten-dollar unsigned tear-out from *Verve* for $100, "don't buy the autograph."

The fact remains that in the mentality of the print marketplace today, the autograph on a print *is* worth a premium—even to most "people who know art," who are aware that they can find unsigned prints of comparable quality a lot cheaper. Those who pay for it, however, ought not to be under any illusions about what they are paying for; as Picasso once commented, when asked about the high market prices of his prints, "*Ce ne sont mes oeuvres qu'on a acheté mais ma signature.*" ("It's not my art that they are buying but my signature.") Those who can manage, through a confrontation with first principles and reality, to exorcise the demonic itch for that scrawled personification of the artistic genius, will find some great prints available in the market at big discounts.

CODA: DID PICASSO SIGN ALL THOSE SIGNED PICASSOS?

Did Picasso, the Prince of Prints, himself sign the 100,000-odd impressions that bear his name? At the arbitrary rate of seven signatures per minute—Henri-M. Petiet's estimate for rapid *Vollard Suite* signings—Picasso would have had to have dedicated about 240 hours of his life to the exercise of a purely ministerial function. Would not a man so occupied with creative work have delegated such a tedious formality to a subordinate? O. P. Reed, Jr., a smart, straight-talking dealer from Los Angeles, is convinced that Picasso's secretaries—and perhaps a few of his wives and sweethearts—signed some of the prints.

Yet Picasso's enormous graphic oeuvre—some 2,000 prints—stretched over 75 years of vigorous work. During four days in January 1934, for instance, he executed no less than 11 of the plates that were later included in the *Vollard Suite*. One afternoon in 1957 he dashed off 26 aquatints for the *Tauromaquia*. Henri-M. Petiet recalls how amazed he was to see the rapidity with which Picasso worked his way through a stack of proofs during sessions of *Vollard Suite* signings. Picasso also loved ceremonies and rituals, and his intimates, guests, and biographers have advised us that the work of signing his creations was a pleasant diversion during the course of such an active life. Signing pictures, we are told, gave him pleasure, even signing *estampes* whose existence depended on his imagery rather than his labor. The late Frank Perls, the itinerant Los Angeles dealer who often solicited signatures from Picasso, twice for prints commemorating exhibitions of his graphic oeuvre (Bl. 1297 and 1302), has told how precise and circumspect the man was about dispensing his signature. Thus, when Perls offered Picasso a drawing to authenticate:

He took his keys and went through two doors with cowbells on them (careful you thieves . . .) and brought out the tiniest stub of a pencil I have ever seen. He signed the drawing, took his keys, went through the doors, and took the pencil back to the studio. I had offered *my* pen and pencil, but no. . . . Try to understand *that*.

Perls also described a more typical, ritualized signing session:

Well, this afternoon, Crommelynck had brought with him the print now known as Bl. 1522 for Picasso to sign. A great gesture by Picasso followed. Picasso went with his keys back through the two doors with the cowbells to get the same little pencil. Crommelynck stood behind him and let the print's right corner fall on the table. Picasso signed, Cartier-Bresson photographed, the Gaspars chatted with Jacqueline, and the Pignons and I watched Picasso silently. All the while Crommelynck counted. "Twenty-five," he said, and Picasso took a sip of the carrot tea he now drinks and continued to sign his name until Crommelynck said: "Fifty." Picasso got up, took his keys, went back through doors with the bells and put the fifty Bl. 1522s into the next room. Then came the great gesture. He sat down and signed one proof with his name and added: "para Sabartés." He then dedicated one to Crommelynck and others to absent friends.

Rather than blanch at signing hundreds of impressions, Picasso personalized his prints as a confirmation and validation of the acts of human creation that brought them to life.

Jasper Johns, "Figure 3." Lithograph in two colors,
1968 (Gem. 90). 940 x 762 mm; 37″ x 30″. Published by
Gemini G. E. L., Los Angeles. (COURTESY OF SOTHEBY
PARKE BERNET INC.)

Chapter Three

Rarity and the Limited Edition

Une gravure mérite toujours d'être faite, même si l'on ne devait en tirer qu'une seule épreuve. ("A print always deserves to be made, even if one pulls only a single proof.")

—PABLO PICASSO

The number of impressions of each print at any particular time, like the number of copies of this page printed to date, is always limited. An issue of a print may by stipulation be published as an edition "limited" to a certain quantity of proofs, irrespective of demand or the capabilities of the printing material. Limited editions are in vogue today, both for quality prints and printed merchandise. The publication of a print may, on the other hand, be limited only by demand, human inclinations, or the state of technology. In such cases, the number of impressions that may be struck remains, like sales by an open-end mutual fund, unspecified and unpredictable—that is to say, "unlimited." Available data on the aggregate quantity of an unlimited publication obviously depends on the diligence of record keeping and the accomplishments of scholarship. In fact we have no knowledge of either how many copies were originally made or how many survive of most of the prints pulled before the 20th century.

EDITION OF ONE OR 10,000?

Whether the number of copies of a print is unlimited or artificially limited has no bearing on the magnitude of the total issue. Though limited may possibly someday mean rare, it does not necessarily mean rare at the beginning. Limited editions, as well as unlimited ones, come in small, medium, large, and extra-large sizes.

An unlimited edition can turn out to be a small edition. Some artists, particularly those who made prints as a diversion or sideline and those who during some period of their lives lacked buyers for their art, pulled

impressions only when the spirit moved them or when gifts were needed for friends and colleagues. We still remain uncertain about the numerical production of certain prints by such once-unappreciated artists as Rodolphe Bresdin, Paul Gauguin, and the German Expressionists Ernst Kirchner and Emil Nolde, although in some cases scholars have managed to estimate the eventual quantity produced. We do know that the number struck was small, although the printing possibilities were unspecified and open-ended.

Other artists who issued unlimited editions simply keyed their output to demand, and the extent of their production varied accordingly. William Blake and his wife created illuminated books and Albrecht Dürer ran off engravings and woodcuts as they were required to satiate their public. Blake didn't get many orders, however, and scholars have been able to ascertain his output with some precision. Dürer's market, on the other hand, was unsatiable, and except in the few cases where documentation of his printings and distributions has survived, we do not know how many hundreds or thousands of copies he put in circulation or were distributed by the successors to his plates and blocks. In a September 13, 1523, letter to Cardinal Albrecht of Brandenburg, Dürer complains about the Cardinal's failure to acknowledge receipt of the 500 impressions of the engraved portrait (B. 103; M. 101) which Dürer had earlier transmitted, along with the plate; but today we can infer from the thousands of copies which have appeared over the centuries that the Cardinal undoubtedly received Dürer's package. Käthe Kollwitz, who used the graphic media largely to broadcast her message of militant pacifism and sympathy for the poor, propagated her views through frequent printings. She probably would have approved of the numerous and large posthumous editions of her lithographs and etchings, too, whatever their quality.

Limited editions, despite the implication of the term, may be huge. The Austrian contemporary, Friedrich Hundertwasser, né Stowasser, authorized the publication of his "Good Morning City" in an aggregate edition of 10,000, counting all the various color and glo-in-the-dark variations, causing one dealer to dub him with a new nom de guerre— "Zehnhunderttausendwasser" (Fig. 3-A). The offset museum poster, a salesman says, indeed "is a limited edition of 5,000; in fact at least half were reserved for Europe." There also are some limited editions that as the result of deceptive practices or the survival of an intact matrix, turn out to have an unlimited limit. A limited edition may also end up even more limited than planned. Sometimes an artist or publisher will optimistically plan, announce, and commence a tidy limited edition, only to have the project interrupted or subverted by lack of money, interest, time, or the delicacy of the printing surface. Although the 1954 prospectus for Curt Valentin's publication of a set of 22 drypoints by Elie Nadelman indicates an edition of 50, the prints are so uncommon that one suspects the full printing never took place. Among the 66 Picasso prints listed by cataloguer Georges Bloch as unpublished (Bl. 1306–68)

ndertwasser, "Mit der Liebe warten, tut weh, wenn die Liebe wo-anders ist." ("It Hurts to it with Love if Love is Somewhere Else."). Silkscreen (27 colors), metal imprint (6 colors) and osphorescent stamping (2 colors), 1971 (H. 630A). 400 x 610 mm; 15¾" x 24". One of ten prints m the *Regentag* portfolio, a limited edition of 3,000. Three hundred impressions of each print re manually signed. (COLLECTION OF THE AUTHOR) Fig. 3-A

are three of which paradoxically *"le chiffre exact du tirage n'est pas connu"* ("the precise number printed is unknown") and one for which the *bon à tirer* (master proof) indicates a planned edition of 15 proofs (Bl. 1351). Unsigned proof impressions of two of the first three of these "unpublished" works turned up, not surprisingly, at the 1973 Bern sale of material from Bloch's personal collection, and one at a 1975 Sotheby Parke Bernet sale. Although the printed tirage sheet and the first four signed and numbered impressions of one recent Sol LeWitt four-color etching announce an edition of 25, only 8 were actually struck. The copper plates began to show signs of wear during printing, and the attentive printer, Kathan Brown, stopped the presses and halted the edition. Parasol Press, the publisher, sent explanatory letters to select subscribers, who were delighted to have a proof from an edition of 8 for the price of one from an edition of 25.

NUMBERING

The size of a limited edition of prints struck during or after the end of the 19th century may be indicated on the lower margin of the proof. Some artists, such as American etchers Reginald Marsh, John Sloan, and

Joseph Pennell, carefully noted the extent of the edition in the margin (as, for example, "100 proofs") but did not number each proof progressively. Conversely, other artists, such as José Orozco and Toulouse-Lautrec, occasionally annotated each proof in the edition with a serial number, without indicating the size of the edition. The appearance of such numbers can signify either an intended unlimited edition or a limited edition whose proofs were numbered only as they were sold. The bulk of the 1919 Avalun-Verlag limited editions of Egon Schiele drypoints and lithographs are unnumbered and without the signature stamp; only the few prints that were sold at the time were stamped and numbered, and consequently all of them bear low numbers.

A margin annotation in the form of a fraction that combines a serial number with a specification of the size of the edition—199/300 or IX/XXV—has become conventional with artists and publishers who wish to advertise that the multiples in an edition of prints are "originals" just like paintings, drawings, and watercolors. Each print is made distinctive by a serial number, like a run of "original" automobile engines.

And just as the first automobile engine is no better—or worse—than the last in the series, serial numbers on prints do not signify rank. Low numbers are of no better quality than high ones. Since no record is ordinarily maintained of the order in which proofs emerge from the press, the numerators of the annotated fraction rarely evidence the order of actual printing. In the usual case (and in almost every case in color printing, where an entire edition is run through the press as many times as there are colors), the actual sequence of printing disappears with stacking and shuffling, so that the numbers simply identify the order in which the proofs were numbered by the artist or somebody else. The order of printing would be significant in any event only if later proofs were of consistently poorer quality than earlier ones, as was once true when copperplates were printed before the discovery of the steelfacing process. But since the choicest synthesis of proper inking, printing pressure, and preparation of the stone, or plate, may appear only after a number of passes through the press, later impressions of modern and contemporary prints can in fact be perceptibly superior in quality to earlier ones. Where a fixed edition is printed in one swoop by a printer who keeps a steady eye on the *bon à tirer* (the working proof designated by the artist as the master for the printer to duplicate in quality, termed the "Right to Print" proof in America), all the impressions are usually of identical strength and quality. Nor does the serial number ever represent someone's *judgment* about the order of quality of the impressions in the group.

The serial number written in the margin has in fact no real utility whatsoever. Numbering does not discourage cheating on the announced size of an edition, because unscrupulous publishers have subtle ways of extending it. The denominator of the fraction—the number that is supposed to reveal the magnitude of the printing—may well fall short of the

truth, for that Arabic-numbered proof may have close or distant relatives sporting Roman numerals, special annotations, their *own* series of numbers, or no numbers at all. Moreover, even ethical printers and publishers cannot always prevent employees from secreting bootleg impressions under the press. Not every printer is presided over by hawks like Odilon Redon, Toulouse-Lautrec, and Georges Rouault, who shredded or defaced imperfect and unauthorized proofs so that they could not be sold, and not every atelier controls output as tightly as the American Bank Note Company. Numbering may perhaps help preclude fraud, forestall theft, or one day enable an owner to trace a print's *provenance* (many of the Picasso prints that Picasso authority Georges Bloch sold in 1973 bear the number 1/50, for instance), but since it is unlikely that except in the case of a relatively small edition, the same two numbers will pop up under circumstances affording someone an opportunity to verify which number is the true one, numbering as an antifraud measure is not very effective either.

To preclude the abuse of the limited edition, the Paris publisher Editions Art Extension arbitrarily selects a disinterested citizen, whose name is kept in an open registry, to countersign every impression of an edition. Its colleague, Editions Vision Nouvelle, as well as many other ethical publishers, issues a certificate executed by the artist and/or the publisher that attests to the precise size of the edition. Another publisher has had each signature and number notarized: the inscriptions by Mexican artist José Luis Cuevas on each of the 100 impressions of his 1974 lithograph "El Secreto de Walter Raleigh" were verified and sealed by a notary public at a charge of two dollars per proof.

The practice of numbering began during the latter half of the 19th century, when painters attracted to printmaking sought a means of individualizing quality impressions of "original prints" and both artists and publishers became awake to the psychological value of numbering as a marketing aid. The annotation in the margin supplements the esthetic appeal of the picture itself by at once individualizing what is, after all, a multiple (even when it is unsigned); it serves to assert, rather than deemphasize, the uniqueness and originality of a nonunique object. The number also attempts to insure the potential buyer or owner against dilution of his investment (sometimes falsely), and by visually proclaiming the scarcity of the edition, presumably justifies the price or value to those in need of such solace. While well-meaning and scrupulous publishers have used the serial number purposefully to assert the individuality of the print as a work of art, in many instances, the inferences logically attributable to the serial number—that it may signify the relative quality of the proof or the totality of a printing—serve to render *this* particular marketing device confusing and misleading. An uneducated public continues to ask for low numbers and to read the annotation as a warranty of the number of impressions in circulation.

Worse, the purveyors of endless restrikes and of cheap, machine-

made, high-priced reproductions of paintings, drawings, and the like, by "name" artists—the *pochoirs* and photo-offset "original lithographs signed directly in the stone"—sometimes attempt to convey a false impression of rarity and preciousness by numbering their merchandise serially in pencil. That slight touch of a human hand can give a handmade appearance to a machine-made product, and the uninformed mind, alas, quickly imagines that hand to have been the artist's or someone who worked directly under his direction. The uninformed, like some of those who prefer "steak tartare" to spicy hamburger meat, think they are getting more than what they see.

"HOW MANY ARE THERE ANYWAY?"

Knowledge of the number of identical or similar impressions of the print under consideration, the elements that distinguish those impressions from the print at hand, and the possibility of additional printings of the same image are facts that may be essential for an intelligent determination of the value of most modern (19th- and 20th-century) and many old master prints. One limited edition of a print may have brothers and sisters and cousins in the same or a related limited or unlimited edition. The edition size, noted if at all on the margin of the proof, gives no hint of the actual size of the family, and the uninformed buyer may to his chagrin one day find his "limited-edition" lithograph on the market in a number of different guises: the same rose, but by other names, looking just the same.

Sometimes these blood—and bastard—relatives are disclosed, but more often they are not. The laws of California and Illinois require that data on editions of prints, or a categoric disclaimer of knowledge of such data, must accompany the offer and sale only of fine prints (and signed limited-edition reproductions) pulled after July 1, 1971. To its credit, commencing in September 1974, Sotheby Parke Bernet Los Angeles began to include the required disclosures in the description of every lot listed in its catalogs. Otherwise everywhere in the world today the would-be purchaser is mostly left to his own devices and to reliance on dealers and catalogs to ascertain the facts on supply and scarcity. Sometimes these facts are truly unknown or are not readily ascertainable by the seller. But whether from assumptions about the sophistication of its clientele, reluctance to incur extra cataloguing expense, nonchalance, laziness, or a conscious desire to mislead, most dealers, auction firms, and other purveyors of prints omit these details, even when known, from their advertisements, stock lists, and catalog entries.

Editions are often extended by prologues and addenda, signed and unsigned sets, variations and varieties, additional states, reprints and twin editions.

1. PROLOGUES AND ADDENDA. An edition may itself have a prologue and an addendum composed of "working" or "trial" proofs, "color trial" and "separation" proofs, "state" proofs or other proofs (all of these are pre-edition working or trial proofs), and "artist's proofs."

The release and circulation of working and trial proofs or overruns that are not recorded or properly disposed of by the artist, printer, or publisher can swell an edition far beyond its prescribed limit. Impressions of such lithographs as Bonnard's "Boulevard" (R-M. 74) and "Place Clichy" (R-M. 77) and Redon's "Profil de Lumière" (M. 61) and "L'Intelligence Fut à Moi! Je Devins le Buddha" (M. 145) appear in dealers' and auction catalogs with such regularity that it is difficult to believe that the runs were limited to 100 or 50 proofs, as the catalogues raisonnés state. Trial proofs or overruns? The number and depth of multicolor variations of Renoir transfer lithographs that appear on the market also seem to dispute the extent of the editions specified by the two cataloguers of Renoir's graphic work, Loys Delteil and Claude Roger-Marx. Many of the unrecorded impressions that abound of "L'Enfant au Biscuit" (D. 31; R-M.6) and "Enfants Jouant à la Balle" (D. 32; R-M. 7), for example, are probably part of long runs of color trial proofs. Likewise, the number of impressions of Cézanne's lithograph "Les Baigneurs, grande planche" (V. 1158; S. 8) (see Fig. 1-D), for which master printer Auguste Clot probably devised the color stones, undoubtedly reflects the printing by Clot of a substantial number of trial color proofs. New York dealer Martin Gordon, who some years ago based his judgment that the market on "Les Baigneurs" was cornerable on Venturi's tabulation of 150 prints, soon discovered he was in over his head. The number actually released, he deduces from the market activity that challenged him, is probably closer to 250, which includes numerous color trial proofs.

Artist's proofs (and presentation proofs) are impressions reserved as remuneration or gifts primarily for the artist, but also, occasionally, for the printer, editor, hangers-on, and others involved in the production or success of an edition. As the creators' percentage of the pull (normally 5 to 20 percent of the regular edition, depending on how many impressions in the overrun survived editing for quality), these impressions are usually distinguished from the regular edition by the margin notation "Artist's Proof" ("A.P."), or in Paris and where flamboyance is desired, "*Épreuve d'Artiste*" ("E.A.") or "Hors de Commerce" ("H.C."—apart from the commercial edition). Not surprisingly, artist's proofs, ostensibly *hors de commerce*, always seem to find their way *into* commerce. Ethical publishers, such as Tamarind Lithography Workshop, have therefore attempted to prescribe stringent standards for the limitation of artist's proofs:

> It is Tamarind Institute policy that the number of artist's proofs included in an edition should never exceed five, or 10% of the size of the numbered edition, whichever is greater. The purpose of this policy is to provide as-

surance that the number of proofs essentially comparable to the published
edition has been sharply limited. When presentation proofs are included in
an edition they are counted as artist's proofs in application of this rule.

Such standards, customary with scrupulous publishers long before
Tamarind came on the scene, are regularly ignored by publishers more
interested in profits than ethics. Some cunning contemporary publishers
have in fact had their artists write "Artist's Proof" on the bulk of the edi-
tion to exploit the common belief that artist's proofs are more desirable
than other proofs. In 1974, one diabolical publisher spawned several
"artist's proof editions" of flashy Calders to complement the "regular"
and "large-format" editions, each of which was separately numbered, as
well as the one "suitable for framing" included in the book *Homage to
Alexander Calder* (Tudor Publishing Company). Artist's proofs are no
more spiritually annointed and no more pampered than any other copies
in the run; they are in fact customarily extracted from the overrun (most
printers and publishers hate to throw out perfectly good proofs). Like all
other impressions in an edition, they should ideally be comparable to the
bon à tirer.

Sales catalogs and even some catalogues raisonnés sometimes omit art-
ist's proofs when describing the size of an edition. The entry in the 1972
Kornfeld und Klipstein auction catalog for the book containing etchings
by Chagall, *Les Ames Mortes* (Boston 50; R. 146), typically states that the
lot is one of 285 examples on wove paper. Presumably Eberhard Korn-
feld, who after all directed the preparation of the excellent catalogue
raisonné of Chagall's work in intaglio, is confident that the pros who at-
tend his sales will know that the total edition consists of 50 sets with an
extra suite of the etchings on *Japon nacré* paper, the 285 copies of the reg-
ular edition, and 33 copies *hors de commerce.* This data is given by the
Boston Museum catalogue, *The Artist and the Book,* which, in fairness, is
cited as a source by the Kornfeld entry. But anyone too shy to question a
knowledgeable dealer would not know that most editions of Matisse
lithographs include—at least—ten copies *hors de commerce* in addition to the
usual 50 indicated by the only useful checklist of Matisse prints around,
the *Pully* catalogue published by Kornfeld und Klipstein.

The absence of a universal norm establishing a permissible limit to art-
ist's proofs and the deficiencies in public disclosure and in records con-
cerning artist's proofs have been the cause of much misunderstanding
and misjudgment.

2. SIGNED AND UNSIGNED SETS. The totality of a contempo-
raneous printing may include both a signed and an unsigned edition or a
monogrammed and an unmonogrammed edition. Catalog descriptions
are often incomplete. For example, the catalogue raisonné of Roy Lich-
tenstein graphics describes the offset lithograph "CRAK!" (B. 5) as a
signed and numbered edition of 300, but omits mention of the Leo Cas-
telli Gallery offset exhibition poster which used exactly the same image.

The signed lithograph by Chagall from his *Daphnis and Chloë* suite
(M. 308-49), described in the May 1976 Sotheby Parke Bernet New
York catalog as "numbered 55/60" is simply, as anyone who consults the
Mourlot catalogue raisonné will be aware, the deluxe, wide-margin,
signed, and more costly version of the identical image removable from
one of the 270 copies of the illustrated book (Fig. 3-B). And the edition
of 100 impressions of certain lithographs by Chagall, Miró, and other
masters of the School of Paris, authoritatively signed and numbered, are
twins of the far less expensive impressions *sans* autograph (unless it has
been faked) but carefully framed and titled, which have been snipped out
of copies of *Verve* or *Derrière le Miroir*, magazines that were published in
Paris in editions of some thousands (Fig. 3-C). Both the limited and un-
limited editions were fathered by the same zinc plate.

The identical images offered in signed, limited editions sometimes
greet us in unsigned posters (Fig. 3-D) and exhibition catalog covers (see
Fig. 9-E). Picasso's transfer lithograph, "Fleurs dans un Vase," is one of
a number of Picasso prints that appears in all three formats: as a signed
edition of 100 with margins (Bl. 674; M. 189); as an unsigned poster in

c Chagall, "Le Jugement de Chloé" ("Chloë's Judgment"). Lithograph in colors from the
bnis et Chloé suite, 1961 (M. 315). 420 x 640 mm; 16½" x 25¼". Each of the 42 prints in the
e was published as a wide-margin, manually signed edition of 60 (plus) and an unmar-
d, unsigned book edition of 270. The signed impression illustrated was bought at auction
976 for $4,750; an impression from the book would sell for less than one tenth that price.
RTESY OF SOTHEBY PARKE BERNET INC.) Fig. 3-B

Joan Miró, "Femme au Miroir" ("Woman at the Mirror"). Lithograph in colors, 1957. (
242; Maeght 442). 375 x 550 mm; 14⅞" x 22". The illustration shows the print as a gatefold
the Maeght Editeur 1956 catalogue, *10 Ans D'Editions: 1946–1956*. An edition limited to 1
copies with wide margins, serially numbered and signed, was published separately. T
Maeght catalogue today sells for about $50; an impression from the deluxe limited edit
was bought in for $3,000 at the Martin Gordon auction in May 1976. Fig. 3-C

an edition of 750 with letters advertising a pottery exhibition in Vallauris
(Czw. 5; Bl. 1261); and folded in two, as a frontispiece for the deluxe
copies of the catalog for an exhibition (M. 189). Exhibition posters them-
selves are occasionally available in signed and unsigned versions (e.g.,
Czw. 43-5).

Unsigned prints, which include restrikes (see number 5 below), that
have signed sisters have the same appeal to signature forgers that public
lavatories have to Kilroys.

3. VARIATIONS AND VARIETIES. The same image may exist in
a color variation, or on different paper, or with different-sized margins,
or with or without "letters" (any inscription printed below the composi-
tion), or with or without "remarque" (those cute margin sketches that
presumably evidence the testing of the needle or crayon on the plate or
stone, but which in the late 19th and early 20th century were often
added to make the print more enticing).

The existence of editions in other color variations may be determin-
able only upon investigation. The 25 impressions of the Maillol litho-

Two pages from a Kennedy Galleries catalog. Fig. 3-D

graph in sanguine (G. 272), one of which was offered at the 1973 Korn-feld auction as one of 25, is supplemented, according to the Guérin catalogue raisonné, by 35 more copies in sanguine, but on paper of a different stock, the 35 copies in black on that same paper, and 125 copies in a book dedicated to the artist. Andy Warhol's silkscreen "Marilyn" (C. 619) appears in ten color combinations—2,500 Marilyns in all. Hundertwasser's "Good Morning City" was printed in 50, for an aggregate 10,000 cheery Good Mornings. Some 19th-century color variations resulted from experimentation with color lithography when it was in its infancy, before the rules and procedures for making an essentially harmonious edition in color became systematized. Renoir's "L'Enfant au Biscuit" (D. 31; R-M. 6), for example, may be chosen in blue eyes or brown, according to one's taste in children eating cookies.

Often a small quantity will be published as a *tirage de luxe* on a paper rich to the touch, a fine Japan or China. It may be important that one knows that the Dubuffet lithograph numbered "4/5" on *Japon nacré* com-

plements the less classy run of 20. Even some restrikes offer a choice of paper. The Max Beckmann plates reprinted in 1966 by his old patron, Günther Franke, produced an edition of 80 impressions on *Bütten* and 30 on Japan. Yet a typical copy on *Bütten* has the simple notation on the recto, "60/80" (Fig. 3-E).

Editions may come with or without remarque. Yet the entries in the 1971 sale catalog prepared for the auction in Paris of the print collection of D. David-Weill, which was written with somewhat more care and attention to detail than the copy for most Paris auction catalogs, state that each Signac lithograph is one of 20 proofs with remarque, and with no further reference to quantity (albeit with a reference to the Kornfeld-Wick catalogue raisonné), while the entry in the 1973 Kornfeld catalog discloses that the 20 copies with remarque are part of the larger edition of 60 proofs.

The identical image may be found signed or unsigned, bound into a book or periodical, included in a suite separate from the book (*hors texte* or *hors livre*) to sweeten special copies of the book, and issued in individually numbered proofs with the artist's signature. Many fine French illustrated books were published in this triple format: Dali's *Les Chants de Maldoror*, Chagall's *Les Ames Mortes*, Picasso's *Eaux-Fortes Originales pour Textes de Buffon*. Since a separately issued impression is normally prized more than one removed from a book, the origins of any print published in multiple format should always be verified.

4. STATES. An edition of an image in one "state" may be complemented by another edition of the same image in a different state. Where the modification of the printing surface achieves a significant alteration of the design (Fig. 3-F) or the addition of words or an inscription ("letters") (Fig. 3-G), knowledge of the number of copies in other states might not be germane. But where, as is often the case, variations merely involve the reinforcement of lines or changes in details that are artistically insignificant—that is, do not substantially alter the image—the size of all printings might well be relevant. Thus, apart from a slight freshness of color, the only substantial differences between the second and third states of the Toulouse-Lautrec color lithograph "Mlle Marcelle Lender, en Buste" (D. 102; A. 131) are the absence of the red-stamped monogram and the addition of the *PAN* blindstamp or of a typographic legend in the lower left-hand margin. The second state was an edition limited to 100 impressions; the third appeared in the German art publication, *PAN*, in an edition of 1,100 copies, plus 111 copies for fanciers. Yet impressions of the former normally sell for much more than impressions of the latter.

5. REPRINTS AND RESTRIKES. The stated size of the edition of which the copy at hand is a part may fail to take into account the exis-

Max Beckmann, "Die Gähnenden" ("Yawning"). Etching, 1918 (G. 100). 307 x 255 mm; 12¹/₁₆″ x 10¹/₁₆″. A restrike from the posthumous edition of 110 impressions bearing the estate stamp and the signature of Peter Beckmann. The technical quality of these reprints is very good. (COLLECTION OF THE AUTHOR) Fig. 3-E

Joan Miró and Louis Marcoussis, "Portrait de Miró." Etching and drypoint, 1938 (W. Musée d'Art Moderne 11). 325 x 276 mm; 12¹³/₁₆″ x 10⅞″. *Left:* trial proof before additions the plate. *Right:* impression from the edition of 53. (COURTESY OF SOTHEBY PARKE BERNET IN Fig. 3-F

Henri de Toulouse-Lautrec, "La Modiste" ("The Milliner"). Lithograph, 1893 (D. 13I; 17I). 425 x 270 mm; 16¾″ x 10⅝″. *Left:* first state. *Right:* second state, after its conversion in a menu for the May 23, 1893, banquet of Société des Indépendants. The exact same meal w served by Eberhard Kornfeld to guests at the Kornfeld und Klipstein banquet following firm's 150th auction in 1973, and a facsimile of this lithograph was used as the menu. It is t Kornfeld menu that is illustrated. (COURTESY OF KORNFELD UND KLIPSTEIN AND OF SOTHE PARKE BERNET INC.) Fig. 3-G

tence of limited or unlimited editions of reprints or restrikes. Such prints are not reproductions. They are impressions struck, with or without the artist's consent, from the original matrix after a period of time has elapsed since the first or original printing was made. The new edition may be struck during the artist's life or after his death. Although a print that results from the reworking or reinforcement of the printing surface is more technically classified as an impression from a subsequent state, such a print can be referred to generically as a restrike or reprint, if the image has not been significantly altered. If the matrix is rendered unusable after the reprinting, the restrike may be referred to as a "final edition."

Where progressive qualitative differences between printings are readily apparent—where the restrike is clearly inferior in quality to its predecessors—even a sizable new issue may not dilute the value of the original or prior edition. But a restrike of a quality not noticeably inferior to an earlier or "lifetime" impression can have the same impact that a new offering of common stock has on the stock market, and awareness of the aggregate quantity of all printings may well be essential to a determination of value and influence selection among alternative choices, all other factors, such as a craving for an autograph or wide margins, being excluded. The differences between some first editions, comprising some 12 or 15 proofs, of most Whistler lithographs and subsequent and posthumous editions are so imperceptible (apart from a signature) that they are in fact valued equally. In 1973, Paris dealer and publisher Sagot-Le Garrec entrusted one of the most talented etching printers in the world, the atelier of the Crommelynck brothers, with the exacting task of reprinting four of the copperplates from Goya's *Disparates* series (H. 266-9; D. 220-23), which Edmond Sagot had purchased in 1907. These plates had miraculously suffered only one previous printing: publication in 1877 in the short-lived French periodical *L'Art*, with titles, in an indeterminate quantity. The superb 1973 restrikes, each limited and numbered to 320 impressions and distinguished by the initials of the publisher—S.L.G.—would of course be unknown to anyone who relied exclusively for information on the definitive 1964 catalogue raisonné of Tomás Harris.

Contemporary editions do not escape dilution either. Thus it is useful to know when weighing the price of an Andy Warhol "Cambell's Soupcan" measuring 35 by 23 inches, signed and numbered, from the 1968 ten-print portfolio in an edition of 250, that there are other scrumptious varieties of signed and numbered soupcans, also measuring 35 by 23 inches, that are equally good, in the 1969 ten-print portfolio of 250.

6. TWIN EDITIONS. Certain sharp publishers have recently sought to capitalize on the limited-edition psychology by issuing several identical limited editions of the same print that differ only in their as-

signed birthplaces. Thus one multitude of Calder artist's proofs is inscribed "A.P." (the "American edition"), while its look-alike is inscribed "E.P." (the "French edition"); one half of an Agam edition is numbered 1-153, and the other, I-CLIII; the "American" half of a Dali run of 600 or so is annotated A 1-295, and the "French" half, F 1-295—for no apparent practical purpose other than to mislead buyers into believing the edition is one half its actual size.

The welter of confusion over the question of the number of copies in a limited edition is aptly illustrated by the well-intentioned, albeit misguided, attempts by the Art Information and Appraisal Service, operating out of Montclair, New Jersey, to set the record straight with regard to the "discrepancies between the 'true' edition and the editions which appear on the market." The "discrepancies" enumerated by this service in its quarterly *Buy-Sell Newsletter* (subscribers received a free copy of *How To Successfully Invest in Art & How To Do Your Own Appraisals*—the organization professes expertise in such matters) in reality reflect an appalling ignorance of "true" editions, as the following typical example from the November/December 1973 issue reveals:

> MARC CHAGALL: 'Cirque' suite, lithographs, (Mourlot 490-527).
> —Karl u. Faber, 5/69, (C4-279*), lists an edition of 250, apparently not signed, printed by Mourlot, 1967.
> —Kornfeld & Klipstein, 6/70, (A1256-270*) lists an edition of 270, signed in colophon, printed by Teriade, 1967.
> —Roten, 11/67, (B12-47*) lists a signed and numbered edition of 250.
>
> While most of the above listings did not give sufficient information to check the total number printed, one could safely state, that until proven otherwise, there must be at least over 500 printed.

Woe to subscribers who look to the Art Information and Appraisal Service for guidance! The Karl und Faber sale took place prior to the publication of the definitive Mourlot catalogue raisonné in 1969; the Kornfeld und Klipstein catalog, while indicating an edition of 270, says nothing about a signature "in colophon"; and no stock catalog of Ferdinand Roten Galleries, Inc., a mail-order business that also sells graphics in Brentano's bookshops, can be cited as an authoritative source of information. Whether as the result of the lack of a good complete library or some misunderstanding about the way auction firms and dealers themselves prepare their print sales catalogs, these "experts" adopted the incredibly illogical procedure of arriving at the size of an edition by *adding up* the various edition sizes mentioned in various catalog descriptions relating to the sale of one impression. Apart from the threshold error of drawing information from relatively unscholarly, unreliable, or deficient sources, such as Roten and pre-1968 Parke Bernet catalogs, one simply cannot, as a matter of logic, discover the number of shares of General Motors common stock issued and outstanding by adding each of the totals indicated by Standard & Poors, Moody's, the com-

pany's annual report, and a Merrill Lynch investment advisory report. The Mourlot catalogue, which curiously the Art Information and Appraisal Service evidently neglected to consult, gives in fact the most complete up-to-date information about Chagall's *Cirque* suite (M. 490-527):

> 250 copies of this book, numbered 1 to 250, were printed on Vélin d'Arches paper, and 20 copies not for sale, with roman numerals from 1 to 20, were kept for those who had worked on the book. The artist signed all the copies. A few proofs of the 23 coloured lithographs were also printed with wide margins, and kept for the artist and the editor.

Clear enough? Perhaps. Yet the Mourlot catalogues are not infallible. They fail, for example, to disclose the edition of 60 sets of the *Daphnis et Chloë* suite (M. 308-49) commissioned by dealers Frank Perls and Heinz Berggruen.

PRACTICAL AND ARTIFICIAL LIMITATION

The limitation of an edition may be imposed by the limitations of the medium itself, a practical assessment of demand, a wish to assert the preciousness of a work of graphic art, a reluctance to devote valuable time and effort to hand printing, the existence of a marketing system incapable of finding buyers for large quantities of prints at inexpensive prices, or a lack of capital to support a more extensive printing and distribution.

For hundreds of years, since that time in the 15th century when artists and artisans began gouging and inking copper and iron, printmakers were saddled by the built-in limitations of a delicate printing surface. Preciousness in those days was not a deliberate choice or a business calculation but the practical consequence of the deterioration of the matrix. There is, of course, evidence of the existence of large editions. Dürer's output of engravings, etchings, and woodcuts was prodigious. In the 1557 inventory of one Boyvin, if it can be believed, prints by an assortment of artists are catalogued in lots of 1,000 and more. And Dughet's proposals for the production of *gravures d'interprétation* (reproductions) of the drawings of Poussin included plans for striking 3,000 impressions of each. Yet the first centuries of printmaking were not generally hospitable to large editions in media other than the woodcut.

The maximum number of acceptable impressions that may be pulled depends on the medium selected, the craftsmanship of the artist, the skill and care with which the printer both prepares the matrix for printing (for example, the inking and wiping of a copperplate) and operates the press, and the quality of the paper and press utilized. Although copper

was more durable in the old days, because it was beaten flat on an anvil rather than rolled, copperplates yielded only a limited number of suitable proofs before the pressure of the heavy rollers began to wear down the thin incised lines. Adam von Bartsch, perhaps overly generous, estimated in 1821 that an engraved copperplate could give up some 500 faithful impressions; a mezzotint, about 150 that displayed proper "bloom"; an aquatint, about 200 before the erosion of the grain became discernible and offensive. The drypoint, most fragile of all, whose furls of ink-catching burr weaken and flatten with each pull, sometimes yielded only a paltry few—perhaps 15 or so—that conformed with the artist's original conception of its proper contrast, tone, color, and space (Fig. 3-H). The woodblock, being sturdier, could provide thousands of proofs, but did not appeal to many innovative artists or illustrators after the 16th century, until it was resuscitated in the late 1800's and early 1900's by Gauguin, Munch, Vallotton, and those direct descendants of Dürer, the Cranachs, and Baldung Grien—the German Expressionists. The introduction of lithography at just about the year 1800 greatly increased productive capacity, although the deterioration of the delicate drawing in greasy crayon, tusche, or litho-wash on the stone or zinc plate under the pressure of the flat-bed press, in combination with repeated chemical treatment of the printing surface, placed practical limits on the size of possible editions in most cases. Lithography, which en-

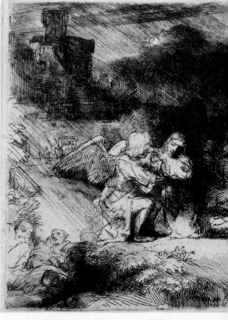

Rembrandt Harmensz. van Rijn, "The Agony in the Garden." Etching and drypoint, c.16 (B. 75; H. 293; BB. 57-3). 111 x 84 mm; 4⅜" x 3⁵/₁₆". *Left:* the superb impression, rich with bu that brought $70,000 at a Sotheby Parke Bernet New York auction in May 1973. *Right.* fairly good but later impression, with a few minor defects, auctioned for $3,600 at the sa▮ sale. (COURTESY OF SOTHEBY PARKE BERNET INC.) Fig. 3-H

courages fast execution, made illustration cheap and brought artwork and political cartoons to the masses for the price of newsprint. Though nobody then knew they were "art," since everybody could have them, the 4,000-odd lithographs (and "Gillotypes") by Daumier which appeared in *Charivari* during the mid-1800's were limited in number only by the number of Parisians, averaging about 3,000, who regularly bought issues at the kiosks. By the end of the 19th century, Cheret, Toulouse-Lautrec, and Mucha had made lithographic posters the "art of the streets."

The perfection of steelfacing (*l'acièrage*)—the deposit by electrolysis of a microscopically fine coating of steel (today, usually chrome or nickel) on a metal plate to prolong the strength and life of the graven image—in the mid-19th century freed the intaglio plate from its previous constraints. The soft metal plate could be relieved now from the inevitable rapid wear and harmful stress caused by the repeated rubbing of ink into the grooves and wiping of ink off the surface and the ponderous rollers of the etching press, and relatively large editions of intaglios of even quality could be successfully printed for the first time. However, steelfacing—particularly when applied to drypoint—can somewhat dull the rich tones and suppress the subtle contrasts scored on the plate by the intaglio too. For this reason sensitive publishers, such as Parasol Press and Petersberg Press, today enjoin their printers from steelfacing copperplates incised by certain of their artists. The plate for Chuck Close's mezzotint "Keith" (see Fig. 8-C) thus yielded only 14 acceptable proofs at Kathan Brown's Crown Point Press, which prints intaglios for Parasol, before the unsteelfaced copperplate began to "break down," and a scheduled 25-copy edition of Sol LeWitt etchings at Crown Point Press in 1973 was halted at 8 to maintain consistency of quality. In that same year, 1973, an impression of Picasso's "Répas Frugal" printed by Delâtre *avant l'acièrage* (before steelfacing) and before the edition defectively printed by Fort in 1913 (G. 2/II, Bl. 1) brought the highest price ever paid for an intaglio: 465,000 Swiss francs, or about ten times the then going rate for a copy *après l'acièrage* (after steelfacing).

Dissatisfaction with steelfacing; scorn for lithography as a commercial process; weariness with stylized steel engraving; disdain for banal wood-engraved illustrations, photomechanical "reproductions," and the reprints of the state printshops—the *chalcographies*—of Rome, Paris, and Madrid, and nostalgia for rare and intimate prints nurtured a new cult of American and British traditionalists in the late decades of the 19th century who were obsessed with the notion that the smaller the edition, the more unique the print as a work of art. This craving for unique proofs contributed to the resurrection of creative etching, which was furthered by the founding of the Societé des Aquafortistes (Association of Etchers) in Paris in 1862, and gave rise to the glorification in England and America of the finely etched line and proofs exhibiting robust, black

velourlike burr. Until the time of the Great Depression, an inky, first-state Rembrandt etching was the archetype, and modern pseudo-Rembrandts were accommodatingly produced for the market in multiple "rare" states. One Muirhead Bone drypoint passed through no less than 29 states, only a shade less than the aggregate number of impressions printed! The print market before and after the turn of the century was fed by dozens of genteel, conservative, technically proficient American and Scottish etchers, such as Seymour Haden (Whistler's brother-in-law; "second in drypoint only to Rembrandt," crowed one writer in the *Print Collector's Quarterly*, the Establishment periodical of the day), Muirhead Bone, William Strang, Frank Brangwyn, James McBey, D. Y. Cameron, and—perhaps the sole innovator among them—James Abbott NcNeill Whistler. In 1911, the year after Haden's death, some of his "rarer" etchings sold for prices as high as those then paid for premier Rembrandts.

During these decades, small editions of prints exuding technical competency and fastidiously hand-printed by the artist himself became inextricably associated with "originality" in England and America. When in the middle of the current century, technological developments in reproductive processes—photo-offset lithography, silkscreen (serigraph, screenprint, *pochoir*) processes, mechanics for embossing, laminating, tearing, folding, and using photographic aids and new materials—offered serious artists the opportunity to mass-produce innovative and esthetically pleasing editions of perfectly even quality without extensive involvement in printmaking, the association of an "art print" with a *limited* edition of hand-pulled proofs was well rooted in the public mentality. The Print Establishment of the 1950's and 60's, appalled by the displacement of artists' fingerprints by artisans' machinery and worried about deceptions and misrepresentations, responded with reactionary definitions of "originality" which spurned the unlimited-edition technology and wistfully demanded the handmade à la Rembrandt and Haden.

Hundreds of artists in America and Europe fortunately ignored the imbroglio and persisted in creating what they wished. But in choosing—by eschewing mass-marketing and ordering publication in tidy limited editions—to reach for an artist's rather than a commercial illustrator's price for their editions, they asserted that their untouched-by-human-hands creations were indeed as "original" as that quiet etching caressed by the hand of Seymour Haden. Yet some of the artists using mass-production processes have opted for mass production. In 1971, Eduardo Paolozzi, proclaiming that in this age of the computer one does not expect the aerodynamist to construct his own wind tunnel, let dealer-publisher Dorothea Leonhart of Munich hire stencil cutters and process cameramen to reproduce his constructions in 15-color silkscreen-and-collage editions of 3,000, which complemented the editions of 5,000 and 10,000 that she published for Richard Hamilton and Hundertwasser.

For over a century and a half, since the perfection of stone and zinc-

plate lithography and steelfacing through the refinement of stencil techniques and the development of high-speed commercial offset presses and Xerography (yes, in 1973 Andy Warhol contributed a Xerox based on a drawing of Chairman Mao for one $3,000 limited-edition portfolio), artists and publishers have been able to command a technology for producing "unlimited" impressions of identical quality.

Why then today do we continue to have limited editions with relatively high prices rather than large or unlimited editions with relatively low prices?

Well, many creative artists devote a great deal of time and effort to printmaking because they are involved with the print as an art form available for the realization of certain unique kinds of effects and images, and not simply as a means by which images can be repeated for widespread distribution and sale. June Wayne, founder of the Tamarind Lithography Workshop, who is partly responsible for the recent resurgence of printmaking as a process for artistic expression in America, once issued the English-language version of Picasso's manifesto for serious printmakers: "Hopefully, the public will come to know that the reason for making a print—from the artist's point of view—is that it is the medium of choice for certain kinds of images. I would make a lithograph even though only one impression could be pulled: the work of art is the raison d'être and the edition is merely a secondary benefit." Of course many artists who do not have the luxury or sufficient public acceptability to overlook the more mundane occupation of making a living are content to wring the most income possible out of the repeatable image. Nevertheless, the attempt by many inventive contemporary artists to experiment with the developing technology of printmaking to obtain images that are exactly repeatable only with the input of large amounts of time and taxing work has, perforce, resulted in some pretty small editions. Lithographs by Frankenthaler, Glarner, Motherwell, and others executed at Universal Limited Art Editions, for example, were created and pulled in batches of 16, 22, 25, etc., not to boost prices by enhancing the preciousness of the print, but because either only that number of proofs of acceptable fineness could be summoned forth from a stone coated with thin and easily worn litho washes or the amount of skill and time required for a larger edition would not be yielded to market demand. ULAE artists and printers quit when they or the printing surface have had enough.

Then, too, much graphic art is esoteric and reaches only a small sensitized audience; there are only a limited number of customers for many limited editions. Stuart Davis and Charles Sheeler produced their few lithographs in editions of only up to 30 impressions because few people in the 1930's wanted them. Edith Halpert kept them in boxes at her Downtown Gallery for sale at five to ten dollars apiece (one can still see her hand-penciled price notation on the verso). The skills of printmaking, especially hand lithography, must also be acquired and practiced,

and printing takes a lot of time and devotion. Most editions of prints, like issues of common stock, are today offered in sharply limited numbers because the market cannot absorb more, yet the price must cover royalties, costs, and profits. The limitation of the edition, in the peculiar economics of the art world, makes the inevitability of small sales and big prices a virtue! Most ateliers and publishers are unwilling to commit large amounts of valuable shop time and labor to the production of a long run of one image anyway; they would rather spread the time and energy they devote to the oeuvre of any one artist over a diversity of small editions (although in some instances, printing and publishing costs, the large fee an artist commands, and the practical price ceiling for his prints compel larger editions than would ordinarily be desirable). And given the generally archaic character of the distribution system for graphics, distributors find it much easier to sell 100 prints for $250 apiece than 1,000 for $25. In addition, neither publishers nor artists wish to exhaust an artist's market by glutting the galleries with one huge offering, but would rather leave room in the marketplace for future accomplishment and occupy themselves with fresh work. The limited edition is above all a marketing device, focusing attention on the preciousness of the print as a work of art and permitting the distributor to market the print as some-thing rare—a piece of investable property—rather than as an industrial product that can be appreciated esthetically. The major purpose for the formation of the Printsellers' Association in London in 1847 was to en-courage and enforce arbitrary restrictions on edition sizes in order to ver-ify the preciousness of the print as a work of art and to justify its price.

This marriage of art and commerce has always been unholy to some people, who perhaps think that artists do better work when they are hungry. The late curator and critic Carl Zigrosser, who as a print seller in the 1930's stocked limited editions of five- and ten-dollar prints that few "art lovers" wanted at Weyhe's in New York City, once lamented that "it is ironic that in an era when there are more and more potential customers for their work, there should be a definite trend toward ar-tificial limitation." Leonard Baskin, whose expensive hand-signed and numbered limited editions (plus a multitude of artist's proofs marked "A.P.") of woodcuts and lithographs easily sell out in the American market, cries, on the way to the bank:

> It is corrupt that plates and blocks which can give tens of hundreds are re-strained to tens or a bit more. It is not only corrupt, it is stupid. The various print media were developed just because they yielded larger and larger editions. To exploit these very qualities for the perverse conceit of a minuscule edition is a function of an even more spurious species of conspicuous waste. . . .

Well, when our government pays farmers to leave fields fallow, and our society permits oil sheiks and Exxon to get richer by withholding oil, why not let artists and publishers enjoy the same prerogative? Why

shouldn't artists be capitalists, too? Our print market has a few mass merchandisers who market some attractive "unlimited"-edition graphics. But the limitation of the edition permits a publisher to promote and the artist to create, if they so choose, a work of art in multiple form that retains the qualities of rarity, intimacy, and personality characteristic of the unique art object but lacking in the mass-marketed product. Some artists simply prefer to play to a small, appreciative audience rather than in a big hall, and their modern-day Ambroise Vollards are not interested in tooling up to reach into the boondocks and distribute fine art as if it were breakfast food.

QUANTITY AND QUALITY

The "quality" of any print must always be spoken of in relative terms. Quality may be defined as the degree to which the exploitation of the graphic medium chosen, the condition of the matrix, and the printing of the image maximize the esthetic intentions of the artist, relative to possibly better execution, a pristine matrix, and possibly better printing. (Judgments about comparative quality among impressions of the same print properly result from good connoisseurship—the subject of Chapter 5.)

A small run does not necessarily result in prints of high quality, if the requisite combination of appropriate medium, well-prepared matrix, proper inking, good equipment, and skillful handling is lacking. A poorly printed small edition, at least of a modern print, cannot achieve dignity and glamour solely through rarity. Some of the prints made with meager resources during the Great Depression in the United States by scores of artists, including John Marin and John Sloan, working under the auspices of the WPA Federal Arts Project, are unhappily just poor-quality prints, notwithstanding the limited size of the printings. Even some monotypes, such as those done by Picasso in 1907 and the 1920's, reflect a lack of sensibility about, involvement with, and dedication to the technique. Of course many prints that are carefully and expertly hand-printed in relatively small editions *do* display, whatever one may think of the subject matter or design, a certain richness and radiance of texture, like the body of a pampered Lautrec *"Elle."* The fine small editions pulled at Universal Limited Art Editions and for Parasol Press in the 1960's and 70's are admirable for their luster, even to those who may prefer other schools or other subjects.

But it is also true that a *large* run or several editions may evince little or no change in quality between the first and last impression. Woodblocks, steelfaced and resteelfaced intaglio plates, lithographic stones, zinc plates, and other modern media can deliver enormous editions of uniformly good quality. Stunning lithographic, offset, and screenprinted

posters, as well as less stentorian first-rate graphic works that appeared in magazines, have always been available for pocket change. Around the turn of the century alone, art periodicals in Germany presented, among others, the following: *PAN*, Toulouse-Lautrec (D. 102; A. 131) and Signac (K-W. 20); *Zeitschrift für bildene Kunst*, Nolde (S.M. 38); *Zeit-Echo*, Klee (K. 62-3); *Genius*, Marc (L. 831), Schmidt-Rotluff (S. 175 and 274), and Heckel (D. 264); *Kunstblatt*, Campendonk (E. 24 and 25), Schmidt-Rotluff (S. 199 and 200), and Kokoschka (W. & W. 112). William Ivins viewed many of the impressions of Daumier's lithographs which appeared in *Charivari* in Paris from 1832–72 as "being extraordinarily fine, the poor quality being merely a matter of comparison of paper, of 'newsprint' versus 'Whatman,' 'japan,' or 'china.' " Fine prints also exist as book and catalog frontispieces, covers, and illustrations, as well as unlimited or near unlimited single-sheet issues. Hundertwasser's 1972 *Regentag* portfolio, an edition of 3,000, is a striking tour de force of modern multicolor printing. Each silkscreen print is one from a range of color permutations constructed from as many as 40 stencils painted by the artist, coded by a remarque in the margin that looks like a radio printed circuit. The pride with which the artist, printer, publisher, distributor, and others regarded their work is dramatized by the seven chop marks, logos, and signatures that adorn the margin of each print.

Since prices of editions of the same image are most often determined by factors other than quality, including the presence or absence of a signature and the size of the edition, it sometimes happens that the print of the best quality is also the cheapest. Though connoisseurs may prefer the impressions of Picasso's "Le Repas Frugal" (G.2/II/b; B1. 1) on *vélin* to those on *Japon* paper, copies from the run of from 27 to 29 impressions on *Japon* sell for two to three times the price of copies from the printing of 250 on *vélin*. In Paris in 1974 "Chèvre, danseur et musicien," a 1959 photolithograph reproducing a brush drawing made in India ink by Picasso, sold for (a) 20 francs as one of the numbered edition of 2,000, (b) 1,500 francs as one of the signed edition of 200 on the same paper, and (c) 2,000 francs as one of a small signed edition with classy Roman numerals—notwithstanding the fact that (c) is inferior in quality to (a).

Restrikes can be attractive and successful even when it is the ghost of the artist and not his living presence that has watched over the reprinting. Posthumous editions of many Whistler and Pissarro lithographs are indistinguishable in quality from those struck while the artists were alive. And a posthumous printing in 1941 in no way imperiled the quality of Winslow Homer's engraving "Perils of the Sea" (G. 99). Some posthumous reprintings of Vallotton woodcuts are even more appealing than "lifetime" proofs.

Restrikes are repugnant to connoisseurs of quality only when they reveal the exhaustion of the delicate printing surface, for then they unhappily misrepresent the intentions of the artist. Rembrandt's preserved plates were subjected to such repeated reworking, strengthening of lines,

and reprinting that they ultimately yielded ghosts—"lamentable wrecks," lamented Arthur M. Hind, late Keeper of Prints at the British Museum (Fig. 3-I). Careful printing eked out 12 editions of Goya's *Caprichos* aquatints (notwithstanding the lack of steelfacing until the fourth edition in 1878); the last, released in 1938, is about as seductive as a burned-out movie star. Many of Manet's and Kollwitz's plates and Gauguin's wood blocks were pressed into repeated service, with each harvest displaying a progressive diminution in quality. Gauguin's woodblocks were still being punished for impressions in the 1960's, a half century after his son Pola supervised the restrikes in Copenhagen, which have been condescendingly dubbed the "Pola Prints." Poor quality restrikes of Cézanne's only three etchings are everywhere, cheap. Restrikes of many Renoir etchings are also plentiful, and all lack the sensitivity and delicacy of copies from the first printing that were bound into books by Théodore Duret and others. In 1969, the Whitney Museum of American Art printed a number of its Reginald Marsh copperplates and tendered them to the public as a new edition of 100. In 1971, the Whitney had another four of its Marsh plates "carefully hand-printed by the sixty-year-old firm of Anderson-Lamb (printers of John

ıbrandt Harmensz. van Rijn, "Jan Lutma, Goldsmith." Etching and drypoint, 1656 (B. 276; 290; BB. 56-C). 196 x 150 mm; 7¾" x 5¹⁵/₁₆". *Left:* impression of the first state. *Right:* ıression of the third state, worn, coarse, and reworked, from the edition reprinted by H.-L. ın and included in a *Basan Recueil* published between 1800 and 1810. (COURTESY OF SOTHEBY ᴋE BERNET INC.) Fig. 3-I

James Audubon's plates) on linweave text paper" (according to the promotional brochure) in an edition of 114 impressions. Care notwithstanding, the Whitney's offerings mostly lack the clarity and richness of the "lifetime" editions of from 9 to 17 impressions. Prices vary accordingly. If quality matters, a mental or actual comparison of the reprint—particularly a posthumous reprint and particularly if the price is cheap—with an earlier edition is essential.

Both the merchants who generate and market wretched restrikes of prints by "name" artists and our most hoary institutions also entice the public with outrageously priced "limited editions" of decorative, poor-quality "fine arts" prints. Unredeemable halftone photo-offset and stencil-made junk masquerades in limited editions rendered "rare" by a handwritten serial number and priced to proclaim its "value." Some of these limited editions, which have scarcely more esthetic or monetary value than a good magazine illustration, are marketed under ambiguous labels through uninformed or chicanerous booksellers, framers, and dealers, and some are sold under the pretext of *noblesse oblige*—the benevolent diffusion of great works of art among the great unwashed—by institutions that should know better. A few years ago, the New York art-book publisher Harry N. Abrams promoted its coffee-table tome on Edward Hopper by offering, on a first-come, first-served basis, a "full-color limited edition of 500" copies of a reproduction of the Hopper painting, "Lighthouse at Two Lights," signed and numbered by Lloyd Goodrich, former director of the Whitney Museum. Neither the tantalizing limitation of its production nor the misplaced charitableness of a luminary could brighten this dull, commercial reproduction of a painting. The sales counter at the Metropolitan Museum of Art displays a dreadful photoreproduction of an Arp collage, "Fleur de Visage," advertised as "signed in the plate" and hand-numbered serially to 90 impressions, for $50! One can go on and on. Rizzoli, the elegant Fifth Avenue book salon, offers "Limited Edition Graphics," too. One, in a heavy gold antique frame, numbered in the lower margin "44/150" is a contemporary photomechanical reproduction of a charcoal drawing with brown coloring; labeled "Degas, Ballerinas, color pochoir, 60 limited numbered examples, signed in the plate, $350," it is a tawdry product of the 1950's, not of Degas' 1870's.

The series of six gatefolds by contemporary American artists furnished to purchasers of the approximately 60,000-odd copies of *Art in America* distributed semimonthly throughout 1970 at least came free. Touted in explanatory text by print fancier, critic, and onetime curator Donald Karshan as "original prints," the pictures themselves reached our sensibilities as—in the word used by June Wayne—"junk." Karshan's meticulous recounting in the January-February issue of *Art in America* of the steps of that "very fine version of offset lithography" which was used to approximate an " 'honest pull' from the artist's image, and with enough of his involvement and approval to merit for the work the desig-

nation of 'original print,' " does not overcome, as even he was at length compelled to confess, "a certain varying degree of difference—particularly of images using a wide range of tonality and texture—between the 'bon à tirer,' hand-pulled from the flat-bed press, and its counterpart from the offset press, due to the steps of removal from the original image—photographic, then transfer and then offset printing." It should be noted that the *Art in America* people were not themselves taken in by the validating Newspeak, for, in the tradition of *Verve* and *Derrière le Miroir*, they offered purists, disbelievers, and the more sensitized a limited edition *hors magazine* of 100 impressions hand-pulled from the original stones or plates, pencil-signed and numbered, printed on a "special paper different" from the cheap, coated paper of the magazine, generously margined, boxed, and so on, and so forth.

If anything can be said for it, this "most ambitious publishing venture of its type ever attempted" at least got "art" out to the "masses"—who could then, in the words again of June Wayne, "feel the misery of the images suffering in a prison of inept processing, place the ugly paper in the sun and watch the colors fade" and would therefore, one would hope, be stimulated to appreciate quality prints like those published by June Wayne at Tamarind. Comparing the prints of other discerning publishers with the *Art in America* gatefolds is like comparing leather with imitation leather, Château Margaux with Manischewitz, Rodin's "Thinker" with a replica in plastic.

Some replicas, without any pretensions, are of far better quality than an edition of reproductions seeking prestige by scarcity and autographs. In 1974, New York dealer-publisher Brooke Alexander had a Motherwell lithograph with collage beautifully machine-printed in an edition of 3,975 copies for use as an exhibition catalog cover, complementing the 25 impressions that were hand-printed and serially numbered. Telamon Editions, the proletarian sister of Universal Limited Art Editions, has, similarly, published offset-press popular-priced, unlimited replica editions of prints previously produced in small, expensive, hand-pulled editions by such artists as Robert Rauschenberg, Jasper Johns, and Larry Rivers. To distinguish the high-grade replica, which is printed on an offset press, from its finer limited-edition counterpart, Telamon prints a line of type in lieu of the signature.

REPRINTINGS AND RESTRIKES

The deliberate limitation of an edition is customarily memorialized by the mutilation, scoring, cancelation, or destruction of the metal plate or the effacement of the master image from the stone or zinc (Fig. 3-J). Such measures are often witnessed and certified. A declared, advertised, or implied obligation of the artist or publisher to forego or enjoin addi-

tional printing after the issuance of the announced number of impressions, as reported in sales publicity or scholarly literature, can normally be trusted. In the face of extenuating circumstances like death, debt, or greed, however, otherwise reliable assurances concerning programmed scarcity may prove illusory. Sometimes even the best confirmation of a moribund matrix—the "stone effaced" or "plate destroyed" or "canceled" or "lost"—in the definitive catalogue raisonné is received with skepticism. Four unscathed Lyonel Feininger woodblocks that Leona Prasse had accounted for as "destroyed" in her exceptionally meticulous catalogue raisonné turned up at the May 1976 Gerda Bassenge auction in Berlin. Consequently doubts persist about some Picasso plates, such as those for the *Vollard Suite*, even when their destruction or mutilation has been verified and recorded.

In the absence of a manifested, stated, or unquestionably implied commitment to set a finite limit on the number of copies printed, printing possibilities must be considered open-ended. The owner of a print who lacks substantial evidence of the destruction, loss or deterioration of the printing surface or matrix should be aware that additional limited or unlimited editions of the same print may one day surface on the market. The confirmed existence of an unblemished plate, stone, or wood block, as opposed to the mere absence of current information about its where-

Jasper Johns canceling one of the stones at Gemini G.E.L., Los Angeles, for his four-color lithograph and lead collage, "No," 1969 (Gem. 128). 1422 x 889 mm; 56″ x 35″. (COURTESY OF GEMINI G.E.L.) Fig. 3-J

abouts or protected status, increases the risk of dilution of the value or quality of those impressions already in the public domain. Universal Limited Art Editions cancels or effaces most of its stones and plates (Robert Motherwell once balked during a plate-destruction ceremony, but was persuaded to conform to the already published documentation), although it preserves a good number after printing "for further experimentation."

Most people, however, are mesmerized by the affirmed or imagined scarcity of a print into an assumption that its scarcity is unassailable and will only increase with time. In most cases, that assumption is justifiable. Market lore or judicious investigation and inquiry may confirm that a reprinting is unlikely, or that the printing surface is too worn to deliver competitive copies, or that the publisher is ethical or sensible enough to refrain from imposing reprints on the market. Market values of an artist may be so low, relatively speaking, that a reprint will have no apparent effect on the market. A "second edition" of nine engravings that the "father of contemporary etching," Stanley William Hayter, decided to publish "since the original edition of all these works has become scarce," caused nary a ripple in 1974. Moreover, a deceased artist cannot muddle up the market for signed prints (unless the reprints acquire signatures from enthusiasts touched with his spirit). Thus reprints of the work of such artists as Otto Dix, Christian Rohlfs, and Josef Scharl, which Galerie Nierendorf of Berlin (Florian Karsch, proprietor) customarily includes in its *Sonderkataloge* (special catalogs), have little impact on the demand for signed impressions.

A restrike, however, can cause tremors. Purchasers of prints from Picasso's *347 Series* of etchings (Bl. 1481–1827, issued in 1968 by Galerie Louise Leiris, Picasso's print publisher, in its customary signed edition of 50 plus some) who reasonably assumed that the copperplates had been scored on completion of the regular edition, were shaken by the subsequent appearance of 66 of them as illustrations in a book, *La Célestine,* published by Galerie Beyeler, Basel, in an edition of 400 copies, each signed by Picasso before he died (B1. books 147). Unsigned impressions removed from the book had already begun turning up as single sheets in 1974. Two series of restrikes of excellent quality, thrust on the market in 1973 and 1974, caused whimpering among holders of earlier impressions and small whoops among new customers: the four plates from Goya's *Disparates* (H. 266–9; D. 220–23) previously published only once before—in 1877—and the copperplates of Dali's 1934 *Les Chants de Maldoror* (Boston 67; R. 176). Signed individual proofs of the 42 prints included in Dali's *Chants,* early surrealistic tunes coveted even by the army of detractors of Dali's late style and business practices, were rare in 1973. In 1974, however, Galerie Furstenberg of Paris distributed a "printing of the 80 copies missing from the 1934 edition," each signed by the renowned resident of New York's St. Regis Hotel. Upon learning of this republication, one New York dealer, who had been cagily "warehous-

ing" a signed copy while watching its market value climb, could only mutter, "Those *whores!*"

While an absence of information about the location or cancellation of matrices is commonplace, the number of presumably unscathed plates, stones, and blocks whose undisturbed existence is expressly noted in the catalogues raisonnés is astonishing. For example, possibilities for Picasso restrikes are multitudinous. In his catalogue raisonné of Picasso's graphic work, which was published by Kornfeld und Klipstein in 1963, Bernhard Geiser states simply that "*le cuivre existe*" ("the plate exists") for the two magnificent, rare etchings of 1934, "Femme Torero I" (G. 425; Bl. 1329) and "Corrida" (G. 433; Bl. 1330)—a fact not denied in the catalog descriptions of impressions of these two prints sold at the Kornfeld auction in 1973. Even if the successors of Picasso's master printer, Roger Lacourière, who died in 1967, remain faithful to M. Lacourière's presumed commitment to forbear from an additional printing (and Wallace Reiss, the New York dealer, who in 1973 paid Kornfeld 110,000 Swiss francs for the "Corrida," professed not to be worried), the best of intentions can, over time, be thwarted.

Many unauthorized Picasso reprints of supposedly limited-edition graphics—versus original posthumous editions (the 156 etchings that he drew just before he died will be issued under the imprimatur of an estate stamp)—were circulating well before his death. In November 1973, New York newspapers carried the story of the arrest of three men who had reportedly fought over a "black and white drawing," which was retrieved by the police from a garbage can after they had received a phone tip from an anonymous caller. The police detectives, who were unacquainted with art books and perhaps could not detect that the mirror-writing of the inscription on the image, "yboR ruop ossaciP," connoted a print, not a drawing, sought a valuation by telephone from Alfred H. Barr, Jr., the doyen of Picasso painting and sculpture experts, who allegedly opined (he later denied it) that the "drawing" was worth $40,000. It turned out that the print—for indeed it was a print—was a copy of an etching (Bl. 680) which had first appeared in 1950 as the frontispiece of a book published in Paris at the expense of the author in an edition of 124 copies, including ten packaged with five extra states "*en noir et en couleurs.*" Notwithstanding these assurances, stated on the justification page of the book, the copperplate turned up 17 years later in the hands of Collector's Guild, Ltd., the New York-based mail-order print club which was a subsidiary of Consolidated Fine Arts Ltd. The Guild had apparently bought the plate through channels beginning at a Paris printshop. It subsequently obliged its new dues-paying initiates with copies, "authenticated on the back" as an "original etching," for $45.

Some years later the Collector's Guild again dipped into its sources, and along with other plates and blocks and stones by or *after* Braque, Rouault, Villon, Dali, Miró, and Derain, came up with the copperplate

for Picasso's "Femme Nue de Dos" (Bl. 822), which, Bloch notes, had been put to use as a frontispiece for a book in a limited edition of 125 copies and further printed to obtain 29 additional proofs. The Guild offered its reprint of the "Femme," "worth a minimum of $200.00 (by independent appraisal)" for *less than half* that price!" (It was New York dealer Robert Horn, whose Greenwich Village gallery, Graphis Inc., was a good customer for Consolidated Fine Arts graphics publications, who accommodated the Guild with the "independent" valuation.) This Collector's Guild restrike "edition" was apparently limited only by the number of club members eager to pay "half price" for something whose value seemed miraculously unaffected by the potentiality of unlimited supply. After "rethinking" the $200 appraisal pitch, the current Consolidated Fine Arts management concluded that "its price is justified by the expense of distribution and promotion"—not, evidently, by its fair market value.

To help secure outlets for their unlimited supply, publishers in need of cash, like Consolidated Fine Arts, are perfectly willing to lease or license their golden egg-laying geese. You don't have to join the Collector's Guild to be eligible for Bl. 680's and Bl. 822's. Among other suppliers of restrikes, prints unrecognized by or unknown to the catalogues raisonnés and reproductions touted as "originals," New York's School of Paris Graphics Ltd., operated by a former employee of Consolidated Fine Arts, offers all you want of "Pour Roby" ("Retail price $150—Dealer Cost $25") and "Femme Vue de Dos" ("Retail Price $150—Dealer Cost $50"). And the management of Macmillan Original Prints, an affiliate of the publishing concern, priced *its* bunch of "Femmes," which "we were fortunate in obtaining," for "what the market will pay"—$80.

Reprint entrepreneurs also include museums and other public institutions and the heirs and successors of the artist. Museums, which obtain reusable blocks and stones by bequest or purchase, sometimes go into the publishing business themselves. The sale of reprints raises cash for acquisitions and operating expenses, and at the same time helps to popularize and circulate at reasonable prices prints that might otherwise appear infrequently on the market, or because the artist was little appreciated at the time of the initial edition, have been discarded. The Print Club of Cleveland once distributed 300 posthumous impressions of the Feininger woodcut "Gelmoroda" (P. W237), struck from the unscored block that Mrs. Feininger had given to the Cleveland Museum of Art. The Whitney Museum of American Art, as already noted, has published restrikes of a number of Reginald Marsh etchings, each embossed with a "WM" blindstamp. The Maryland Institute College of Art in 1970 supplemented the original edition of the six known impressions extant of Rodolphe Bresdin's 1871 etching "Rest on the Flight into Egypt" (B.N. 66; N. 55d) with an edition of 57 copies "on rare China paper," according to the promotional literature. In 1946, as stamped on the verso, the Art Institute of Chicago published for its Print and Drawings Club an

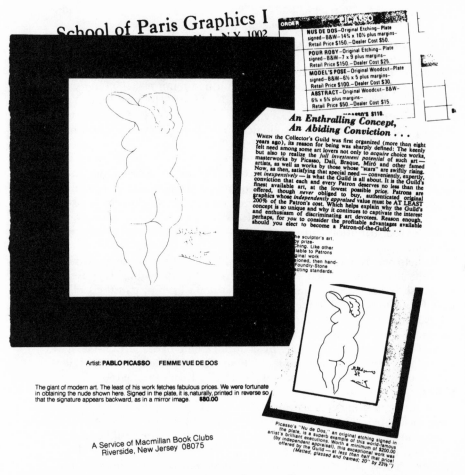

Promotional literature for reprint of Pablo Picasso etching, "Femme Vue de Dos" ("Woman View of Back"), 1956 (B1. 822). 380 x 280 mm; 15″ x 11″. *Moving clockwise from left:* Macmillan Original Prints offers the unlimited restrike for $80; School of Paris Graphics, for $1, and the Collector's Guild Ltd. says it's worth a minimum of $200. Fig. 3-K

edition of the Gauguin woodcut "Maruru" (G. 24 & 92) "from the original woodblock in the collection" of the museum. The Museum of Modern Art possesses a number of zinc plates and woodblocks of Lyonel Feininger, many of them in fairly pristine condition. The Rosenwald collection of the National Gallery of Art owns Whistler copperplates. And a few years ago the Whitney was willed a large number of the copperplates etched by Edward Hopper. Speculation about restrikes may not be unrealistic.

The French government owns and operates the richest reprint mart in the world. The Chalcographie of the Louvre Museum is a unique institution that prints and sells to the public excellent—compared with most

restrikes—though relatively inexpensive reprints from the some 14,000 *planches gravées*, for the most part copperplates, in its storerooms. The Chalcographie as a publishing venture got its start during the Directory of 1797, when democratic forces merged the inventory of the *Cabinet des Planches Gravées du Roy*, the royal atelier and collection of copperplates established by order of Louis XIV's minister, Colbert, in the 1760's, and that of the *Académie Royale de Peinture et de Sculpture*, which had been dissolved in 1793. The Louvre took over in 1812 when Napoleon ordered the 2,505 plates then held at the *Cabinet des Estampes* transferred over to Vivant Denon, head of imperial museums. From the time of the Third Republic to the present day, the Chalcographie has been further enriched through acquisitions and donations of plates, blocks, and stones for both "original prints" and *gravures d'interprétation*. The Chalcographie is richly endowed with material from the 17th and 18th centuries; it offers Callot etchings, Van Dyck engravings, and 35 dukes and princes by Jost Amman. But it has missed out on most of the luminaries of the 19th century; it has no Delacroix, Daumier, Manet, Degas, Lautrec, Gauguin, or Redon. Among moderns, it does possess Arp, Avati, Raoul Dufy, Foujita, Friedlaender, Georg, Gromaire, Hayter, Laboureur, Matisse, Marcoussis, Poliakoff, and Villon. Enterprising merchants have bought large quantities of the following reprints from the Chalcographie at prices ranging from $20 to $50 apiece, arranged to have Chalcographie officials leave off the giveaway blindstamp or place it in a corner where it can be cropped off, embellished the reprints with phony signatures and numbers and sold them at ten times their cost:

HANS ARP, "Composition" (woodcut)—N° 14125
RAOUL DUFY, "Sirène" (etching)—N° 14114
T. FOUJITA, "Portrait de l'Artiste" (etching and drypoint)—N° 6822
T. FOUJITA, "La Femme au Chat" (etching)—N° 6821
L-C. MARCOUSSIS, "Portrait de Serge Lifar" (engraving)—N° 13857
HENRI MATISSE, "Baigneuse au Collier" (reproduction of linocut)—N° 13960
JACQUES VILLON, "Maternité" (color aquatint *after* a painting by Picasso)—N° 13765

These and other prints may be purchased at the Louvre bookshop on the second floor next to the library. Chalcographie stock lists, catalogs, and reprints may also be ordered by mail from *Services Commerciaux des Musées Nationaux*, 10, rue de l'Abbaye, Paris 75006.

The reprint concern with the largest collection of plates is Rome's *Calcografia Nazionale*, which houses 20,000 of them. It was founded as the *Calcografia Camerale* in 1738 by Pope Clement XII, dubbed the *Regia Calcografia* when confiscated from the Papal State in 1870, and renamed the *Calcografia Nazionale* after World War II. *Calcografia* reprints can thus be dated, roughly, by the name appearing on the margin inscription, or blindstamp. The *Calcografia*'s pride is its almost complete holding of Piranesi plates, some 1,180 of which it purchased in Paris in 1839. Since

the *Calcografia* adheres to a policy of delaying any reprinting until 50 years after the death of the printmaker, it poses less of a threat to the market for modern prints than its French sister institution. Merchandisers will have to wait until 2014 for fresh batches of Morandi etchings.

Sometimes the wife or other heirs of a deceased artist will, for the same reasons as a museum, authorize restrikes or release a previously unissued edition. Many of the lithographs of George Bellows were inscribed with the artist's name and initialed by his wife, Emma, or his daughter, Jean Bellows Booth. Reginald Marsh's widow, Felicia, inscribed his name on a number of trial and other proofs. So did Mrs. Marc and Mrs. Kandinsky. Restrikes of Käthe Kollwitz lithographs bear the signature of her son, Hans. But sometimes, especially if they do not own the plate or stone themselves, indignant heirs will object. In 1975, Sara Kuniyoshi, the widow of the artist, not only refused to sign the posthumous edition of "Still Life and Vaudeville," but demanded its destruction and published her disapproval of it in the art press.

There has always been a small commercial traffic in reusable plates, blocks, and stones, particularly copperplates, which are more easily stored and transported than bulky blocks and stones. The transfers and travels of Rembrandt copperplates from entrepreneur to entrepreneur—one of the best-recorded trails of *provenance* in the history of art—left a wake of tens of thousands of reprints. Most transactions in matrices are private, but occasionally the public is offered the chance to vie with entrepreneurs for the materials placed in commerce. Some of them are offered by dealers through their sales catalogs. The late Los Angeles dealer, Frank Perls, consigned his woodblock for the Matisse Fauve-style woodcut "Nu de Profil (Grand Bois)" (P. 77) for sale at Galerie Kornfeld (Zurich) in 1973; the Lumley Cazalet Gallery in London reoffered it through their exhibition catalog in 1974. An offering of the 31 scored plates for Picasso's *Buffon* intaglios of animals (Bl. 328–58, Bos. 231, R. 61) was widely advertised in 1972, a time when impressions of *"La Puce"* (Bl. 359, an unused plate), her *derrière* itself bitten by a large X, were already on the market for $250, by Weintraub in New York at a price reflecting their potential to be milked anew. The story is that the Paris dealer, A. C. Mazo, "had acquired them from someone who had found them in a Paris warehouse after the war."

Kornfeld und Klipstein has from time to time auctioned blocks and plates. Kornfeld sold the uncanceled woodblock for the Gauguin woodcut "Te Atua (Les Dieux)" (G. 60–61) in 1961 for 27,000 Swiss francs; two drypoint zinc plates, properly scored and marked *"Biffé,"* from Picasso's 1905 *Saltimbanques* series (G. 10 and 12; Bl. 8 and 10) in 1971 for 11,000 and 9,500 Swiss francs; and Georges Bloch's lightly canceled plate for Picasso's "Groupe de Trois Femmes" (G. 102; Bl. 57) in 1973 for 18,000 Swiss francs. All the *Saltimbanques* plates once belonged to Ambroise Vollard, and appropriately enough, it was Henri-M. Petiet, who had bought what has come to be known as the *Suite Vollard*

after Vollard's untimely death in 1939, who bought the two *Saltimbanques* at the 1971 Kornfeld sale. Impressions of *Saltimbanques* overlaid with an unsightly grid (the cancellation lines) are already in the market, priced at about $250 retail in the early 1970's, and the day may come when the inheritors of other *Saltimbanques* zincs will themselves assume the role of mountebanks and put their *Saltimbanques* back to work. Soon after their purchase of the "Groupe de Trois Femmes" plate, a minisyndicate of three New York dealers committed it to an etching printer for trial proofs: one in black, one in sanguine, one in a soft gray. Not such hot quality, but salable. . . .

Kornfeld truthfully described the *Saltimbanques* plates in his auction catalog as *"höchst seltenes Dokument"* (exceedingly rare document). Plates, blocks, and stones certainly have great value as documents and as models for students and scholars and may even be viewed, like the woodblocks sculpted by Gauguin, as works of art in themselves. But entrepreneurs will have their way. There are respected publishers as well as cynical hungry merchants who disregard the manifest wish of the artist by reprinting plates that have been canceled or mutilated. In 1918, Ambroise Vollard, every publisher's paradigm, who played a vital historic role in the publication and promotion of fine modern prints and illustrated books in the early decades of this century, inserted a proof from one canceled Degas plate in 150 deluxe copies of one of his art books and published editions of others, including "Au Louvre: La Peinture (Mary Cassatt)" (D. 29; A. & C. 54); and in the 1960's Frank Perls, who used to rage over *afters*, fakes, and forgeries, reprinted and sold impressions from a number of canceled Degas plates.

If you do not mind looking at the image through tick-tack-toe lines, you can buy these and similar illegitimate progeny from canceled plates (Fig. 3-L) cheap. And if circular blots within the plate mark do not irritate you, you can also buy inexpensive Morisot etchings: restrikes from plates that were punched with holes. Many years ago Albert Skira, the Swiss publisher, reprinted 100 sets of the 30 canceled plates for Picasso's *Les Metamorphoses d'Ovide* (Bl. books 20; Boston 224; R.54), supplementing the edition of 145 copies that he had published in 1931. This suite of reprints from the canceled plates was estimated as being worth from $2,500 to 3,000 by Sotheby Parke Bernet in February 1973—versus the then going auction price of about $10,000 for an unsullied set—but was not sold.

Enterprising restorers have even been successful in erasing the scored lines on copperplates. Some years ago, the canceled plate for Gauguin's "Portrait de Mallarmé" (G. 14) was uncanceled and reprinted, like the now rare original edition of 79, on *Japon impérial* paper. Though the modern proofs were aged and processed to give them the appearance of impressions from the original edition—so successfully that a number of expert American, German, and Italian dealers were fooled—close scrutiny of the restrike reveals traces of the burnishing-out of the cancelation

Joan Miró, "Série V." Etching, 1935
(W. 135; Musée 18). 150 x 125 mm;
$5^{15}/_{16}''$ x $4^{15}/_{16}''$. Restrike from the
canceled plate (note diagonal line at
lower right). Fig. 3-L

scratches: a broken line in the ear lobe, a faint line across the raven's
beak, and a diagonal lick at the top of the image. The canceled Degas
plate which produced the edition of restrikes for Vollard of "Mary Cas-
satt au Louvre" was also restored for the publication of deceptive re-
prints (Fig. 3-M).

Connoisseurship in detecting alterations and in distinguishing between
reprints (termed for old master prints "late impressions") and early im-
pressions by, among other old masters, Mantegna, Dürer, Van Leyden,
Callot, Van Ostade, Rembrandt, Canaletto, Piranesi, and Goya, and
among other moderns, Manet, Whistler, Cassatt, Renoir, Munch,
Degas, and Villon—a skill that enables you to tell a $1,000 impression
from a $100 one—can be acquired only through extensive examination
and mental comparison of scores of impressions of the same print, inten-
sive study of catalogues raisonnés and well-documented sales catalogs,
proper application of the tricks and tools of connoisseurship, and a thor-
ough familiarity with paper and watermarks (as described in Chapter 5).

Occasionally a print may by typographic legend, blindstamp, estate
stamp, or other obvious indicia *advertise* itself as a reprint. Israhel van
Meckenem, probably the most prolific engraver of the 15th century,
bought and reprinted under his own name some of the plates of the ex-
traordinary Master E.S., who preceded van Meckenem as an unusually
inventive graphic artist. The Max Beckman restrikes pulled in 1967
under the patronage and benevolent eye of his old Munich dealer,
Günther Franke (see Fig. 3-E); the restrike of Winslow Homer's "Eight
Bells" (G. 96) printed by Charles S. White in 1941; and the restrikes of
four Goya *Disparates* aquatints (H. 266-9; D. 220-3) published by Sagot-
Le Garrec in 1973 were not only expertly printed but are clearly iden-
tifiable, by remarque or stamp, as restrikes. And so are hundreds of
others.

Other entrepreneurs, in contrast, have omitted signifying their spon-
sorship on the plate or the margin of the reprint, sometimes without
nefarious intent but sometimes, by permitting the restrikes to remain at
least superficially indistinguishable from outstanding copies, for the pur-
pose of making them more marketable. The various editions of Piranesi
prints are all fairly readily identifiable by their inscription, number,
blindstamp, or watermark. But the Basans' reissues of Rembrandt etch-
ings, the *Calcographic* reprintings of Goyas in Madrid, the reprints of Os-
tades, Dürers, Claudes, and many others, bear no reissuers' blindstamps
or other obvious clues. Impressions are distinguishable by such elements
as paper, watermarks, size of sheet, platemarks, color, integrity of bor-
derlines, states, and most significant—because they reflect the repeated
reworking, reinforcement, and reprinting of tired copperplates which
should have been given a decent melting long before—quality. In fact,
quality of impression can often be the threshhold determinant. In more
recent times, Whistler canceled most of his plates himself (having printed
all of them himself), but a few, such as "Billingsgate" from the *Thames*

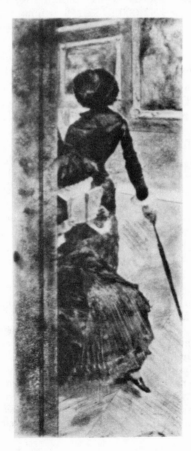

Edgar Degas, "Au Louvre: La Pein-
ture (Mary Cassatt)." Etching and
aquatint, 1879–1880 (D. 29; A. & C.
54). 301 x 125 mm; 11⅞″ x 4¹⁵/₁₆″.
The cataloguers list 20 states. The
print illustrated is a reprint from the
canceled plate, with lines erased to
make it appear like an early state.
(COURTESY OF O. P. REED, JR.) Fig.
3-M

Set (K. 47), escaped his attention and became the source for acceptable but, to the discerning eye, unseductive reprints. Restrikes of Manet etchings, Cassatt drypoints, and Renoir etchings are also more palatable than "late" impressions of old master prints, thanks in part to steelfacing and a gracious abstention from excessive milking, but they are still obviously inferior in quality to "lifetime" impressions.

Without access to the literature, the availability of numerous copies for comparison, and sufficient sensibility, savvy, and experience, any person—a tyro or a dealer—may find it difficult to identify a restrike or a late impression as such or place it within a specific reprinting, especially if no broad hints appear on the margin. The catalog description of the Mary Cassatt drypoint "Looking into a Hand Mirror" (B. 179), offered at the Sotheby Parke Bernet New York sale of February 1974, read, "An impression from the restrike edition printed by Delâtre in 1923 (supposedly in an edition of 9)." At the sale itself, auctioneer Marc Rosen orally amended this description by a concession that the impression "may be from a larger restrike edition." That announcement spread enough doubt and hesitation to evoke a disappointing (to the consignor) winning bid of $750—against a $2,000 to $2,250 estimate.

The introduction into the American market in 1961 of some 60 Kollwitz prints priced at from $8 to $30 by the sole American distributor, Arthur Rothmann Fine Arts, sowed a confusion that is still rife. Legitimate and tolerable reprintings have been made of certain Kollwitz etchings and two of her lithographs. This 1961 distribution, however, which was carried out in Europe as well, included 18 lithographs and 5 woodcuts for which the Klipstein catalogue raisonné affirms that the stones and blocks *no longer exist*, though the illustrated catalog that accompanied the offering fuzzily advertised, "Etchings . . . unsigned prints from original plates. . . . Lithographs. . . . Woodcuts." Over a decade ago, Dr. Hans Kollwitz, the artist's son, attempted to clear matters up, but his explanation has never gotten any publicity, and many dealers and *caveat emptor*-style auction houses still sell as restrikes photomechanical reproductions of Kollwitz prints for *bona fide* prices. Dr. Kollwitz's letter of explanation (here in translation) written to an American lady who was bamboozled, is instructive on the matter of restrikes:

11.1.62

Dear Mrs. Friedmann:

 I am very grateful for your inquiry and will try to explain to you the circumstances regarding the Kollwitz prints "sold and offered" in the United States. The art dealer A. von der Becke, in Berlin, obtained from my mother personally the rights to a large part of her graphic work and also the plates of the etchings and engravings. Some of the latter are still in existence and from them von der Becke pulls additional impressions from time to time which he identifies by a dry stamp as *Spätdrucke*. Her lithographic stones and the blocks of her woodcuts are destroyed. From the original lithographs and woodcuts von der Becke has made *galvanos*, viz., photolithos, which can be identified as reproductions by their low price

and furthermore by their size which is a little smaller than the originals, and also by the dry stamp "von der Becke." It is not true, therefore, when an art dealer claims that I have the original plates and blocks from which I have pulled new impressions. Only from two late works of my mother— that is, "Ruf des Todes" (Klipstein 263) and "Altersselbstbild" (Kl. 265)—have the stones been found after the end of the war, and before they were destroyed the stones were again used for printing an edition. This is also mentioned in Klipstein. These impressions are in general acknowledged by me with the handwritten note: "Aus dem Nachlass von Käthe Kollwitz. Hans Kollwitz."

I do hope that the seemingly complicated situation regarding Käthe Kollwitz's prints is now cleared up, and I would appreciate it if you will give this information as much publicity as you can.

I would also like to ask you to let me know which prints are being offered on the American market that are claimed by the dealer to be printed from the original stones. In order to avoid further deception von der Becke will in the future dry-stamp the reproductions on the reverse side, identifying them as photolithos (galvanos).

Mit freundlichem Gruss
H. Kollwitz (SIGNED)

OK, the Kollwitz etchings are legitimate, identifiable as restrikes by a drystamp overlapping the margin in the lower right corner (see Fig. 2-D). The problem is that the same drystamp, "von der Becke," also appears on the reproductions, where it can understandably be taken for an estate or atelier stamp which customarily legitimizes restrikes. Any "lithograph" (or woodcut) bearing the drystamp "von der Becke," let it here be said, is a r-e-p-r-o-d-u-c-t-i-o-n, not a restrike.

Reprints are often made after the publication of the "definitive" catalogue raisonné of an artist's graphic works, so that a central accessible record of their existence may for a time be unavailable. Self-education, care, watchfulness, and contact with experts who are tuned in on the market are important tools—and may even land you a bargain. Who knows, maybe that Mary Cassatt drypoint that scared everybody off at the Sotheby Parke Bernet auction really *was* one of the small Delâtre reprints, not one of the big edition restrikes, and a savvy buyer aware of the different paper employed for the restrikes landed a $2,500 print for one third of that price!

QUANTITY AND VALUE

The number of impressions of a particular image extant or available or possible, or *presumed* extant or available or possible, is one important determinant of its value. This data is not normally verifiable with much precision. Catalogues raisonnés, checklists, and other literature are usually silent regarding the number of proofs permanently removed from the market by institutions, disappearance, or acts of God and man, and they sometimes antedate restrikes. Although prints denoted as "rare"

generally become rarer over the years, information concerning relative scarcity quickly becomes dated. The catalogue entries on the edition sizes of prints by such German Expressionists as Nolde, Kirchner, Dix, Heckel, Schmidt-Rottluff, et al., are for the most part mocked by the actual rarity of editions that were decimated by war and government decree. Lehrs's much quoted data (published from 1908 to 1934) on the scarcity of 15th-century engravings by German, Dutch, and French masters, and Nowell-Usticke's 1967 rarity ratings for Rembrandt etchings are relatively useless today. Schongauers and Rembrandts are being extracted from the market at an increasing rate.

The absence of reliable information about available or potential supply makes an accurate assessment of current value hazardous whenever the market is thin or undeveloped, or the comparative-price history of other impressions is spotty. In 1969, one collector rejected an impression of M. C. Escher's 1938 woodcut "Day and Night" (L. 102), tendered at what then seemed like the outrageous price of $600, solely because of his discomfort about supply: the edition was thought to be unlimited, for Escher retained the uncanceled woodblock and was apparently dashing off copies on order. It has been reported that the 1,000-odd copperplates by their father that Francesco and Pietro Piranesi brought to Paris in 1798 could be rented by anyone to do a day's printing—and they evidently collected abundant rental fees! Risk of similar dilution in 1969 made a $600 tab for the Escher woodcut seem exorbitant. Of course, over the ensuing years—thanks to the wide circulation of new popular Escher literature, a developing cult of turned-on Escher freaks, the publication of a serviceable catalogue raisonné, Escher's death, and some timely activity from certain new dealers making a market in Escher prints—"Day and Night" became a treasure from a Thousand and One Nights, a $6,000 rather than a $600 print. (More recently, the Escher market has resembled another one of his subjects—"Ascending and Descending"—as it has sought levels induced by actual supply and demand, rather than by speculation and fear of diminishing supply.)

It is not so much the known quantity of copies extant, or the lack of such knowledge, that affects value as the "float"—the number of copies that appears on the market over the span of a few years, ranging from the date of publication to the release of a fresh supply. Fine scarce pieces often make a stir at auction: a fine, early "Landscape with a Watermill" by Altdorfer (H. 92; W. 183) in the May 1974 Sotheby Parke Bernet New York sale; a "Repas Frugal" before steelfacing (G. 2/II/a; Bl. 1) at the June 1973 Kornfeld sale; a scarce Nesch metal-print triptych at the 1974 Hauswedell sale. But too much rarity can create uncertainty for potential buyers, who may be inclined to bid or purchase timidly in the absence of recent price references. When a small consortium bought the first set of Otto Dix's 50-print portfolio, Der Krieg (K. 70–119) at Sotheby Parke Bernet in November 1971, it was aware through catalog research that the portfolio had last been sold at a Kornfeld auction in 1966

for 16,500 Swiss francs and that no set had appeared on the auction market during the intervening five years. Sotheby Parke Bernet New York is not exactly a Mecca for German dealers or collectors attracted to German Expressionism, so the group hoped that the appearance of the portfolio would go relatively unnoticed. They were right, though one alert German dealer cost the syndicate an additional $2,000. At the $5,250 level the bid had only one competitor: Florian Karsch (Galerie Nierendorf, Berlin), who was then occupied with the preparation of the Dix catalogue raisonné and whose firm had published the *Krieg* suite in 1924, had telephoned eleventh-hour bidding instructions to a New York colleague attending the sale. The consortium's winning bid of $7,250 still gained a bargain: $145 apiece for prints that would retail at prices of from $200 to $1,200 each. That first *Krieg* kindled the outbreak of other *Kriegs*, until in December 1973 a set auctioned by Ketterer in Munich brought 60,000 deutsches marks (about $26,000 then, reflecting a full buyer's commission), or three and a half times the price of two years earlier. By the spring of 1974, Galerie Nierendorf had its *Krieg* priced at 90,000 deutsche marks (about $34,000 then), and in the spring of 1976, one sold at Kornfeld und Klipstein for 75,000 Swiss francs (about $33,500 then, including commission).

The uncertainty about value caused by a thin or nonexistent "float" can also pose pricing problems for sellers, including the pros. A year before the celebrated sale of his other Picasso prints in Bern in 1973, Georges Bloch, who prepared the most up-to-date books on Picasso's graphic works, sold his impression of Picasso's marvelous lithograph, "Paloma et sa Poupée" (Bl. 727), to one collector for $3,100, half the amount that a dealer in Picasso prints offered for it the following day. The absurdly low purchase price, from a man who is hardly a novice, can only be explained by the absence of regular sales of the print during the immediately preceding years. Bloch was probably not even aware that the only previous auction sales of the print had taken place in New York in 1965 and in Paris in 1969.

These tales are not intended to suggest that rarely sold pieces may always be picked up at bargain prices. Indeed, the contrary is more often the case, as competitors jostle and jockey for the scarce prize. But they are intended to show that the lack of "float" can create uncertainties about value from which a shrewd, informed person can gain an advantage, even in the company of pros.

Sometimes relatively too much "float," like a big sell order overhanging the stock market, can temporarily depress market values or retard a price rise. A fat price for a scarce print, or at least one *assumed* to be scarce, can bring others out of the woodwork. Winslow Homer's "Eight Bells" (G. 95–6) was an engraving seldom seen on the market when Sotheby Parke Bernet New York sold it for the sweet price of $9,000 in February 1971. Over the next few years, several more "Eight Bells" tried for that near $1,000 per Bell record, but Parke Bernet never again wrung

out that price. Just the *right* amount of "float"—a relatively predictable market, neither too few nor too many sales of a print—at once keeps the image before the public's eye, its appetite whetted and certainty as to value assured. Too much "float" can reduce an otherwise attractive image, like the Mona Lisa, to banality. One simply got tired of seeing Brockhurst's naked innocent, "Adolescence," repeatedly described in every Sotheby Parke Bernet catalog of the late 1960's and early 1970's as "Brockhurst's most important print" (if it was so important, why was everyone willing to let theirs go?), and for years the auction price remained unchanged. Similarly the emergence and frequent sale of a new edition or restrike can cheapen the value of the fine, original impressions both by watering the supply and dampening desire for the commonplace image. Who wants a *signed* impression from the "limited edition" of Picasso's "Pour Roby" (Bl. 680) or "Femme de Dos" (Bl. 822) when reprints, and ads for the reprints, are everywhere you look? A feel for the extent of the international "float" and the ability to detect and predict possible changes in "float" are crucial requirements for rendering appraisals and executing timely purchases. As New York dealer David Tunick once put it, "The only way to gain a sense of the availability of individual prints is to be in constant touch with the market."

Quantity, or "float," of course shares company with demand as an element of value; and demand, in turn, is tickled by such factors as admiration for the design, condition, quality, signature, *provenance*, vogue, chauvinism, and the nature, economic health, or relative isolation of the marketplace (see Chapter 11). Demand is in fact undoubtedly the weightiest element in the value equation, and within the element of demand, for modern prints at least, fondness for the image is the most decisive factor. Among prints from the 303-copy *Vollard Suite* that commonly appear on the market with equal frequency, plate 27 will normally sell for twice as much as plate 26, and plate 26 for thrice as much as plate 25. If no one *wants* a monotype, it's worth nothing in financial terms, and that usually means it's not worth much artistically either, at least by the standards of that day's tastemakers. Without a ready buyer—which usually means an active and easily accessible resale market—your numbered limited-edition print isn't worth the paper it's printed on, at least not in terms of current monetary value. It simply does not necessarily follow, as stated in the booklet *This Is Circle Gallery Ltd.*, that "since most prints sold at Circle are numbered limited editions (only the specified number exist), there is a built-in rarity which creates investment value." If you have been convinced by the promotional literature of the Limited Editions Original Fine Art Graphic Print Society that your $75 signed and numbered original lithograph by an artist not yet admitted to the auction circuit is worth something, just try to sell or consign it back to the Society, or to the publisher (if you can find him), or to any dealer or auction house, and you will quickly learn the truth about the constancy of the relationship between arbitrary rarity and in-

vestment value. Though something—anything, really—*may* have current investment (potential) value because it is scarce, whether it actually does or not depends on a myriad of other factors, most of which are unpredictable. Calling a scarce thing "art" does not *ipso facto* make it covetable or coveted.

ANSWERS TO QUERIES
ABOUT QUANTITY

You may be the sort that pooh-poohs consumer advocates and thinks that Ralph Nader is an emissary of godless Communism, or you may lack the disposition or the fortitude to practice healthy skepticism. But if you recognize that the matter of available or potential supply and the position of a print under consideration within the limits of supply is consequential to your well-being or to an appraisal of value, some research and investigation are in order. The exact number of related copies printed may not be ascertainable with precision. In many instances, the quality and quantity of current data about available or potential supply are deficient. Information may be unreachable. But in most cases inquisitiveness can pay off.

Repair to your Sources of Information. *First,* check whatever up-to-date literature you can locate: catalogues raisonnés, exhibition catalogs, reputable dealers' and auction-houses' catalogs, articles in the trade journals. Unquestionably, not all catalogues raisonnés are terribly helpful or reliable on matters of edition sizes and the existence of restrikes, particularly those that were carelessly prepared in the first place, those that make no pretense about being definitive, and those that have been dated by the emergence of new facts and materials. Even the most scholarly books have mistakes. But diligent, responsible dealers and auctioneers, such as Eberhard Kornfeld, as well as curators and academicians are constantly modifying and supplementing existing knowledge through catalog descriptions and the art press. Of course an *awareness* of the state of scholarship about such problems as edition sizes comes only by experience, attention to new discoveries and conclusions, and resort to the greater knowledge of some knowledgeable Print People.

So, *second,* talk with Print People who are *qualified* to answer questions: dealers who are recognized experts, the staff of auction firms, curators, scholars, critics, collectors.

Third, if you still have doubts, obtain a document from the dealer or private seller (if you buy at auction, you're stuck) that contains the statements or disclaimers suggested at the end of Chapter 1. An account of the *provenance* and a copy of the documentation, if any, furnished the seller by the publisher or *his* seller may also be useful at resale time.

Fourth, if uncertainty persists, pass the print up. As Ko-Ko trills in the *Mikado,* "There are lots of good fish in the sea."

Paul Klee, "Komiker" ("Comedian"). Etching, 1904 (K.
10). 153 x 168 mm; 6″ x 6⅝″. (COURTESY OF SOTHEBY
PARKE BERNET INC.)

Chapter Four

Spurious Prints: Fakes, Forgeries, and Falsified Proofs

Things are seldom what they seem; skim milk
masquerades as cream.
—GILBERT AND SULLIVAN, *The Sorcerer*

Because the print, unlike the unique work of art, is in a medium that presupposes multiplication, the notion of a spurious print somehow seems less sensational, less offensive, than the idea of a fake painting or a forged document. And perhaps because one of the functions of the print, whether executed and printed by hand or by more mechanical means, has always been the illustration of paintings or drawings and scarce etchings and lithographs (the print can be—let us always remember—both work of art and commercial product), the faking and forging of prints have always flourished with relative impunity. For even if the professional copyist conceded the lack of authorization for his replication, he could avoid an insinuation of fraudulent intent by asserting the reproductive, information-spreading function of the print. All printed images are illustrated designs, after all, and the copies were simply "reproductions" or "replicas" with more fidelity than your average illustration. No fraud here, would go the rationalization, just greedy, foolish buyers.

In truth the aggregate damage done by spurious prints to two groups of citizens—artists and purchasers—has probably been more extensive and insidious, quantitatively, than the harm done by all the Van Meegerens, de Horys, and similar unique hoaxes put together. Living artists are hurt because the distribution of unauthorized merchandise contaminates their legitimate work and robs them of customers; dead artists, because the circulation of illicit prints sullies their names and artistic reputations; their heirs, because such sales dilute the market for the inheritance. As for buyers, spurious prints cheat them out of what they have paid for most, since the price of prints depends less upon pictorial values than upon the social and psychological values that our society attaches to authenticity. Lots of fakes and forgeries of prints are esthet-

ically pleasing; indeed, it is idiomatic that the most convincing hoaxes offer the greatest esthetic rewards! Visitors to the office of Eduard Trautscholdt, the former owner of the great old master print firm of C. G. Boerner, used to marvel at the exquisite impression of Dürer's "Melencolia" that hung in a place of honor on the wall behind his desk. Few people knew that Trautscholdt, one of the world's leading experts, was so apprehensive about exposing valuable proofs that he had framed and hung a facsimile printed by the Berlin Reichsdruckerei (state print-shop)! Nor do the throngs that pass by the fine "Rembrandt etchings" adorning the entryway to the Amsterdam Rijksmuseum realize they are admiring almost flawless modern heliogravures, not 17th-century wonders. Esthetically the Reichsdruckerei and Rijksmuseum photoreproductions are more agreeable than most impressions of Dürer engravings and Rembrandt etchings that appear on the market. But if art lovers were satisfied with esthetics alone, the business of fakes and forgeries would be less profitable than it is.

The art world thrives on appearances; it is the aura of authenticity, which radiates until a piece is unmasked, that attracts the tremendous sums that the art-buying public pays for works of art. The identification of a deception drains the splendored thing of all enchantment; consequently, of all monetary value. Paradoxically, therefore, just as good shines brighter when juxtaposed with evil, the manufacture of fakes, forgeries, and facsimiles in fact *serves* the art world by making a virtue of connoisseurship. The uncovering and denunciation of spurious works of art sustain and reinforce the prodigious spiritual and monetary value which the art world attaches to that intangible—authenticity.

The pernicious deception is not in the creation of the work of artistic character itself. The deception and the hurt begin at the point where a significant quantity of money is exchanged for an intangible quality of authenticity that is false. The solicitation of payment for something which is something else is not always "fraudulent." "Fraud" is a legal concept requiring the intent to deceive, a guilty knowledge ("scienter") of the deception, an ingredient that is often missing when spurious prints change hands and is always very difficult to prove. The focus here will therefore range beyond fraud to certain amoral and quasi-fraudulent transactions that take place from time to time in the print market.

Obviously, deceptive practices succeed when conditions are conducive to deception: When the necessaries of connoisseurship—eyes, caution, experience, sensitivity, documentation, time, a "good" copy for comparison, a magnifying glass—are lacking or neglected; when sales talk and polemics overcome natural care and skepticism; when a professional charity auctioneer tugs pursestrings coercively or vacation euphoria stimulates unguarded, light-headed acquisitiveness; when a "bargain" stimulates greed; when requesting the removal of the print from its frame for examination seems like an imposition on the dealer or auctioneer; when all seems plausible and spuriousness is unexpected; or

when the preview of auction material is necessarily cursory, time pressures exhaust the senses and fatigue disarms alertness.

In the crush and rush of the auction preview, even the professionals, deprived of calm surroundings, time for reflection, their library, and possession of the print, make the mistakes that, in fact, are indispensable for learning. The late Peter Deitsch, an admired expert, was taken in by the counterfeit Morandi etchings auctioned at Christie's in December 1969 (Fig. 4-A) because he was too pressed for time to examine them carefully. The erstwhile New York dealer in German Expressionist prints, Scott Elliot, bought a facsimile of the Nolde woodcut "Frauenkopf" at a 1970 Sotheby Parke Bernet New York sale, even though it bore an inscription identifying the 1919 periodical from which it had been removed—*Der Anbruch* (Parke Bernet canceled the sale). Frederick Mulder, formerly with the London firm of Colnaghi's, admits to having been fooled before he joined Colnaghi's, by Dutuit (Charreyre) heliogravure of a Rembrandt etching, hand-touched with drypoint, skinned on the verso, and laid down on old paper—and what old master print expert hasn't? Aldis Browne recalls buying an impression of Dürer's

toengraving of Giorgio Morandi, "Grande natura morta con la lampada a destra." Autic print is an etching, 1928 (V. 46). 349 x 252 mm; 13¾" x 9¹⁵/₁₆". Forgeries of a number Morandi etchings, including this one, appeared at Christie's in 1969, where they fooled ral experts. (COURTESY OF SOTHEBY PARKE BERNET INC.) Fig. 4-A

"Melencolia" which turned out to be two halves expertly spliced together.

Spurious prints prosper in the establishments of dealers who are uneducated, unperceptive, lax, or unscrupulous, as well as at country and charity auctions and the print sales of small auction firms, sometimes because the staffs of the smaller firms lack the expertise to detect frauds, sometimes because the proprietors lack the willingness to reject them. Today, however, one can feel reasonably safe, description problems aside, with the consignments offered by the major auction firms, in part because their staffs possess both the expertise and the ethics to determine authenticity and in part because there are enough independent connoisseurs previewing the material who will not hesitate to make a ruckus about a phony. Though during a period of a few years, Christie's—among the most circumspect of the auction firms—innocently catalogued the Morandi forgeries, a facsimile published by William Young Ottley in the early 1800's, and a photogravure of a Rembrandt etching, "La Petite Tombe," which was withdrawn, spurious prints appear at the major auction firms infrequently.

The major auction firms at least back up their offerings with written or practical guarantees. Sotheby Parke Bernet New York boldly abandoned a "buyer beware" policy in 1973 for a guarantee of authorship good for five years. Two years later its London parent, Sotheby's, began offering five years of protection against "a deliberate forgery," defined as "an imitation made with the intent of deceiving." Sotheby Parke Bernet Los Angeles, as well as Christie's, Sotheby's London rival, which dislikes long-term commitments, have continued rigidly to enforce the traditional British policy of limiting claims of forgery to a period of three weeks following the sale. Strict adherence to this rule by Christie's left Peter Deitsch and another colleague holding $8,694 worth of Morandi forgeries in 1970. The German firms, Hauswedell und Nolte, Karl u. Faber, and Galerie Wolfgang Ketterer, offer no guarantee of authenticity "in the sense intended" by German statutory law, but notwithstanding the legal verbiage in their catalogs, each will entertain claims for at least three or four weeks after the sale. Eberhard Kornfeld, similarly, considers his reputation more important than hard-nosed adherence to his stated rule permitting the submission of claims during the limited period of three weeks after purchase.

Although people, not pictures, commit most deceptions, it is helpful to categorize the three kinds of spurious prints:

A *fake* is an original work in the graphic medium not made or authorized by the artist to whom it is expressly or implicitly attributed. A fake can take the form either of a newly conceived image, or fabrication, or of a transfer into the graphic medium of a work already existing in another medium.

A *forgery* is a work in the graphic medium duplicating an existing graphic work but passed off as the existing work. A forgery can take the

form either of a manual re-creation, or imitation, of the original print or of a photomechanical replica of the original print.

A *falsified proof* is any impression bearing any material alteration or resulting from any alteration to the original matrix, which has not been made or authorized by the artist to whom it is expressly or implicitly attributed.

FAKES—IDENTIFICATION
AND AVOIDANCE

The money-extracting deception that characterizes a print as a *fake* is the transmittal of the illusion that the print under consideration—and not merely its conception—is autographic. If the artist, the person who conceived the design, was not in any way involved in the production of the print, or if the design for the print is someone else's invention, and it is passed off as a work of the artist, then we have a fake on our hands. Who would doubt, for example, that the representation of any illustration of a painting or a drawing from a coffee-table art book as an autographic print would constitute the offer of a fake?

The problem is that the border line between fake and *after* gets very fuzzy when an artist forgoes the manual labor and simply donates his name to a project. A reproduction of a drawing with a phony signature is easy to label as a fake, but what about signed *afters* to which an artist has contributed little except his acquiescence and signature? What if the artist executes a certificate attesting that he ratifies the copy and appropriates it as part of his graphic oeuvre? Would the response be different if the artist accepted nothing for these gestures? If he accepted $100? $10,000? What if he signs 120 blank sheets of paper and an order to a trusted master copyist to fill them in with a reproduction of a gouache? Would such prints be "fakes"? How about a lithograph of exceptional quality struck posthumously from a drawing that the artist, perhaps intending its multiplication, completed on special lithographic transfer paper? On drawing paper? What about a screenprint made from a design that a dead artist had marked, "For conversion into a screenprint," or perhaps a suite of screenprints, each impression stamped with a facsimile signature, reproducing gouaches selected from a dead artist's legacy by a print publisher who has a written contract for the production of a suite of screenprints? If the heirs protest, is the edition less authentic? Suppose an heir who inherits simply all right, title, and interest in and to an artist's oeuvre proceeds to deliver the gouaches and a facsimile stamp to a publisher to satisfy the dead artist's debts? Obviously the degree of harm caused by these pictures depends on how they are represented in the marketplace: How much cash is exacted for false or half-true indicia or innuendos of authenticity.

Many prints that were honestly intended as *afters*, reproductions or illustrations, are converted into fakes by the words, inscriptions, deeds, or silence of sellers, both innocent sellers and rogues. Though copyists inspired by paintings and drawings of Pieter Brueghel the Elder continued to engrave reproductions of them decades after death ended his personal delivery of drawings to Antwerp engravers for reproduction, inscriptions on the face of the posthumous *afters* have always inhibited their sale as Brueghels. Yet for centuries people have been tricked into paying huge sums for a "genuine Michelangelo" or an "original Raphael" that is nothing more than a mundane 16th-century *gravure d'interprétation* (B. XII 150.17 and 120.18) (Fig. 4-B) which unhappily discloses only the name of the *inventor* of the design (neither great master ever made any prints). One 1972 letter to the Milan *Print Collector* magazine begins, "I have in my possession a Michelangelo engraving sold to me by a well-known antiquarian in Paris, along with full guarantee as to its authenticity, and it has been exhibited in a place of pride in the midst of my paintings. . . ."

Unprincipled dealers and auction houses turn handsome printed illustrations and reproductions of modern pictures into fakes through the employment of ambiguous labels and descriptions (such as "original lithograph"), gougingly high prices, and phony signatures. Any well-printed, large-format illustration of a pencil, ink, or crayon drawing can be presented as an original graphic. High-quality lithographic reproductions of drawings by Klimt and Schiele, which Vienna's Albertina Museum published in the 1920's, are metamorphosized into fakes by the ad-

Anonymous *after* Michelangelo, "L'Homme supportant un feston" ("Man Supporting a Festoon"). Chiaroscuro woodcut (B. XII 150.17). 340 x 267 mm; 13⅜" x 10½". Though the inscription identifies Michelangelo as the *inventor* of the image only, many people have assumed he executed the woodcut as well. Fig. 4-B

dition of gilt frames and tags with prices approaching the levels of Schiele's small graphic production (Klimt made no prints). One also finds the etched illustrations of drawings by Picasso in 1920's classical style, which appeared in a 1942 book published by Grosclaude of Lausanne, embellished with pencil signatures not Picasso's. Opportunists crop the inscriptions off posters reproducing Chagall, Picasso, and Miró oils and drawings, ensconce them in fancy frames, dignify them with fancy prices, and advertise them as "Chagall," "Picasso," and "Miró." The rights that Picasso freely granted to reproduce his color crayon drawings of a bouquet of flowers (Czw. 130), a dove nesting on broken swords (Czw. 174), and a suckling babe (Fig. 4-C), all for the cause of peace on earth, have generated more grief than peace in the print market, for they have been freely interpreted by opportunistic print merchants everywhere as a license to advertise them as "signed-in-the-plate Picasso graphics." The three photo-screenprinted panels—the center panel "signed"—reproducing Lichtenstein's painted triptych, "As I Opened Fire

Photoreproduction of a crayon drawing by Pablo Picasso, "Maternité," 1963. Offset reproductions of this and other Picasso drawings are often sold as "original lithographs" by unprincipled picture sellers. Fig. 4-C

. . .," (Fig. 4-D) that Amsterdam's Stedlijk Museum published in connection with its 1967 Lichtenstein retrospective and still sells for five dollars, were offered in 1974 for thousands of Swiss francs by a Geneva gallery which stocks legitimately expensive Picassos and other modern prints. It was also catalogued for a 1975 Sotheby Parke Bernet New York print auction, but was withdrawn. As described, all these prints are fakes.

The refinement of mechanical and photoreproductive techniques and processes for copying oils, gouaches, watercolors, and drawings has in fact made the premeditated manufacture and sale of fakes—whose detection requires a knowledge or scholarly record of an artist's graphic oeuvre—more practicable, more profitable, and less risky than the manufacture of forgeries—whose detection can be accomplished without ado through comparison with a true proof and thorough examination of the print. As the Print Boom lengthened and swelled during the 1960's and 1970's, ravenous publishers rushed to order photoreproductions of the paintings and drawings of dead artists and from time to time bought an heir's endorsement. Among the most ludicrous (and pernicious) of these ventures was the exuberant promotion of poor-quality color illustrations of Renoir oils—numbered serially, stamped with a facsimile signature of Pierre-Auguste Renoir, and accompanied by an ambiguous certificate of "authenticity" (see Fig. 2-C)—by a publisher named Jean-Paul Loup and the artist's grandson as "the only official Renoir lithograph collection!"

With so many paintings, drawings, and watercolors—and other prints—to copy, fabrications imitating an artist's style rather than a specific design have never been as prevalent in the graphic field as in the

Screen photoreproduction of triptych painting by Roy Lichtenstein, "As I Opened F . . . ," published by Amsterdam's Stedelijk Museum (cost—about $5), which owns paintings. Each panel is 610 x 500 mm; 24″ x 19⅝″. The triptych, which resembles some Lichtenstein's more autographic works in silkscreen, is sometimes passed off as an au graphic print. Fig. 4-D

field of painting. Fakes consisting of a woodcut by an unknown crafts-man falsely inscribed with the monogram of Matthias Grünewald or Albrecht Dürer harassed buyers hundreds of years ago but make little headway today. One of the earliest identified pastiches, an engraved "Virgin at the Gate," is composed of a Virgin, God the Father, angels, and landscape excised from Dürer's woodcut *Life of the Virgin* series (his threat of "Woe to you! You thieves and imitators" on the title page notwithstanding) and a plant copied from his engraving "The Prome-nade." At one time, even scholars not deceived by the Dürer monogram and the date "1522" appearing on the tablet within the composition con-sidered that the invention might be a copy of a true Dürer design—an *after*—since the compositional elements are reversed from their direction in the original woodcuts and the engraving. In 1751, an artist named Benjamin Wilson etched a landscape in the style of Rembrandt as a prac-tical joke on Thomas Hudson, the master of Joshua Reynolds and a self-congratulating connoisseur of Rembrandt etchings. Wilson placed his "rarity" in Paris, leaked a report of its "discovery" to Hudson, and watched the enthusiast rise to the bait. After Hudson had proudly dis-played his prize to his London friends, Wilson invited the same company to dinner, where each guest, including Hudson, found an identical im-pression under his dinner plate.

There are modern fabrications, too. The exhibition of fakes and forgeries hosted by the Minneapolis Institute of Arts in 1973 included a "1921" etching by an imitator of Picasso who drew elements from Pi-casso's later works for the composition (Minnesota catalog no. 178) and a drawing in the style of Matisse executed in lithographic crayon and num-bered "6/50" to convey the impression of an edition of lithographs (no. 218). (That exhibition also unwittingly included several *forged* fake signa-tures, but that is another matter!)

The best security against a fake is familiarity with the graphic oeuvre of the artist under whose name the print is offered for sale. The absence of an image from the documentation of an artist's graphic works, either in a compre-hensive catalogue raisonné or other respectable reference material, or conversely, its appearance in a catalogue of the artist's unique works, such as the exhaustive Zervos books recording Picasso's output, creates at least a presumption of a fake (Fig. 4-E). The appearance of a balanced nonbackward signature or a date within the composition of a modern graphic should also stimulate skepticism. Artists sometimes write their name or the date of execution backward on the matrix, so it will read frontward when printed, but unless a print *is* an offset lithograph or transfer lithograph, a signature or date in the right direction probably signals a reproduction of a work already existing in another medium.

Paul Gauguin (?), "Les Singes" ("Monkeys"). Woodcut, 203 x 424 mm; 8″ x 16¹¹/₁₆″. Th
print, which was made by inking and printing a Gauguin wood carving, is not included
Guérin's 1927 catalogue raisonné of Gauguin's graphic work. Eberhard Kornfeld, howev
believes it is an autographic work and sold an impression at his auction in Bern in 197
(COURTESY OF O. P. REED, JR.) Fig. 4-E

FORGERIES—CONNOISSEURSHIP
SIFTS THEM OUT

Forgeries, which are reproductions of existing graphic works passed off
as the originals, harm both the artist and the art consumer.

"Facsimiles," whether redrawn imitations or photomechanical rep-
licas, are copies of existing graphic works which harm no one—assuming
the artist has consented to their replication—because they are made in
good faith and not represented as anything but imitations. Inexact
etched copies of Dürer engravings by Hieronymus Hopfer were enthusi-
astically collected during the 17th century, and impressions of Wensel
von Olmütz's late-15th-century reversed copy of Dürer's "The Dream
of the Doctor" (B.26) were restruck and sold for hundreds of years, into
the 19th century. The *best* facsimiles satisfy immensely for instructional
purposes or as pictures *per se* as substitutes for, or souvenirs of, other-
wise unobtainable or expensive graphic works (Fig. 4-F). (It is a curious
fact that people who would pay a lot of money for a poor-quality restrike
from a steelfaced plate capable of yielding thousands of copies, simply
because it is an "original print," will shun a faithful facsimile of an early
proof or an impression struck from a plate which fairly well duplicates
the original matrix by an electrochemical process. Most Print People,
for example, continue to snub the prints of Gustave Doré, who author-
ized and adopted as autographic matrices electrotype shells that dupli-

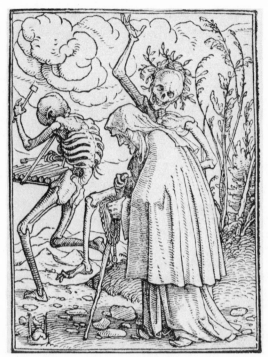

ns Lützelburger *after* Hans Holbein the Younger. "The Old Woman" from the *Totentanz*
Dance of Death) series. Wood engraving, 1538. 66.5 x 50 mm; 2⅝" x 2" (illustrations are
ual size). *Above:* authentic proof. *Below:* Facsimile hand-engraved in wood for Douce's
lbein's Dance of Death (1833). Close comparison reveals slight differences in lines. (COLLEC-
N OF THE AUTHOR) Fig. 4-F

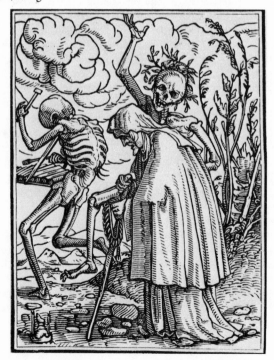

cated his original incised woodblocks for simultaneous mass publication in various European cities in the late 1800's.) The most faithful facsimiles, even if they enter the marketplace with clean hands and an honest face, also eventually get masqueraded as "forgeries" by the same groups of naïve sellers and foxy connivers who convert reproductions into "fakes."

The notion that the *artist* had rights to his design evolved very slowly during and after the Renaissance with the humanistic concept of respect for the creative man. As plagiarized designs that proudly disclosed the hand of their recreator, Israhel van Meckenem's imitations of the engravings of his own master, Master E.S., and those of Martin Schongauer conformed to the acceptable social and legal norms prevailing at the end of the 15th century. Around the turn of that century, printmakers began applying to the ruling authorities for a printmaking "privilege" (*privilegium* in Latin), a benevolent acknowledgement by the government that the engraver had both the right to reproduce the design and proprietary rights in the graphic creation itself for the duration of the grant. In Rome the Pope issued the privilege; in Venice, the Senate; in France, the King; in the Spanish Netherlands, the King or the Infanta. Like modern patented commodities, prints from the 16th to 18th centuries would bear an inscription announcing the grant—*"Cum priuilegio Summi Pontif. . . ."* or *"Avec Privilège du Roi"* ("A.P.D.R.") or *"Cum gratia et priuilegio Regis"*—if the applicant had enough political pull or other wherewithal to procure a privilege. Since the dissemination of printed pictures was desirable for religious, political, and social purposes (being an inexpensive consumer good was the print's chief function on earth), the authoritative privilege would sanction the plagiarism of a design, at least a design not already protected by another locally enforceable privilege (as, for example, the privilege granted by the Venice Signoria to a Nuremberg publisher, Anton Kolb, in 1500 forbidding anyone to copy his immense birds-eye "View of Venice," designed by Jacopo de' Barbari, for four years). But as the artistic personality achieved respect and admiration on the Continent, it also became established that deception, or forgery—the insolent expropriation and sale of a celebrated artist's *name*—could not be sustained under a privilege.

Albrecht Dürer, the most admired printmaker at the turn of the 15th century, spent a lot of time policing the multitudinous forgeries of his prints. He could do nothing about the copy of his *Apocalypse* suite issued by Hieronymous Greff in Strasbourg in 1502, because Greff had signed the woodcuts with his own monogram, "IVF." In 1506, however, Dürer at least got the Venice authorities to make Marcantonio Raimondi stop using the renowned "AD" monogram on Marcantonio's popular Venice-protected plagiarisms. But dozens of less gifted copyists, including German compatriots, ignored both the privilege granted by the Emperor Maximilian and the threat Dürer had printed on the title page of his *Life of the Virgin* in 1511: "Woe to you! you thieves and imitators of other

people's labor and talents. Beware of laying your audacious hand on this our work." Traffic in forgeries became so open in Dürer's hometown of Nuremberg that, upon his petition, on January 3, 1512, the City Council issued this decree:

> A stranger who attempts to sell prints [*Kunstbriefe*] in front of the Town Hall, among which are some bearing the monogram of Albrecht Dürer, copied fraudulently, must engage an oath to remove all their marks and to sell no work of the kind here. In case of contravention all these prints shall be seized and confiscated as spurious."

After Dürer's death, his harried widow continued to fence with forgers, soliciting a privilege from Charles V for the publication in 1528 of her husband's *Treatise on Proportions* and entreating the City Council of Nuremberg on numerous occasions to clamp down on pirates.

More than 200 years later in England, William Hogarth appealed to Parliament to halt the piracies of his prints, which were usurping his market and denying him dividends from authorized editions, his principal means of support. Parliament responded in 1735 by enacting a Copyright Act that gave Hogarth the exclusive right to profit from the copying and marketing of his own designs in England. "Hogarth's Act," which imposed a fine of one shilling on every copied impression, stalled print piracies for 14 years after publication. But it had no effect on contemporaneous plagiarisms sold outside England or published within England after the expiration of the copyright. French imitations continued to circulate on the Continent, and no sooner did Mrs. Hogarth's 1767 20-year-renewal copyright for the *Marriage à la Mode* suite expire than Richard Earlom was engaged by the publisher, John Boydell, to make a new set in mezzotint—a production that also happened to be more attractive than the *Marriage* plates engraved in 1745 by professional French copyists on Hogarth's order.

In Europe and America today, all an artist need do to obtain international copyright protection for an initial period of 28 years is to place the word "copyright" or a ©, his name, and the date of publication on each impression. Even if an edition is not copyrighted, the artist, his publisher, and depending on the scope of the law, his heirs can go to court to stop the production and sale of an unauthorized facsimile or forgery. They rarely do. Artists, with few exceptions (Ben Shahn once got an injunction against the piracy of two of his prints, and Robert Indiana once went to court to restrain the exploitation of his "LOVE" image), are by their very nature unlitigious; they have more productive uses for their time and energy. Publishers lose interest after an edition is sold out, unless they have a vested interest in the aftermarket. And heirs are generally indignant only if they themselves possess a matrix fit for reprinting.

The public, on the other hand, remains at risk. If the artist fails to sue or is dead and has no heir entitled or willing to institute a lawsuit on his behalf, the only law that protects the public is the law of rescission,

which entitles the victimized buyer to a refund, or the law of criminal fraud, which must be acted upon by governmental authorities. Even if a prosecutor or consumer-protection agency should receive a complaint from someone allegedly aggrieved, it always has difficulty prosecuting any claim of fraud because the sale of a facsimile is not often accompanied by easily provable fraudulent intent. The words and deeds that convert a facsimile into a forgery have never been spelled out by any statute anywhere in the world. There are no laws, except perhaps the statutes governing the permissible illustration of bank notes and postage stamps, that specify that a facsimile must be in different dimensions or in a medium different from the original, or stamped or otherwise identified as a facsimile, or sold unframed, so that dirty glass won't mask the ways in which it differs from its prototype, or priced so inexpensively that it cannot be taken as the original. Nor would such requirements be particularly helpful. Photoreproductions of Expressionist woodcuts and etchings appearing in certain German periodicals of the early 1900's *have* reduced dimensions; Marcantonio's clever imitations of Dürer's woodcuts were *engravings;* most replicas of Kollwitz lithographs and woodcuts *are* blindstamped; and lots of facsimiles *start off* cheap—yet they continue to trap the neophyte who does not measure, scrutinize lines, or use a foreign-language dictionary and reads any stamp on the verso as a "collector's mark."

Here is how one encounters a forgery on a typical day in the Print World: In the window of an art gallery in the fashionable Madison Avenue art district of New York City, framed in antique gold and handsomely matted, sits a color lithograph by Toulouse-Lautrec, "La Grande Loge" (D. 204; A. 229). The cognoscenti would know that an impression of this rare print had been sold at the 1973 Kornfeld auction in Bern for 490,000 Swiss francs ($180,000 plus commission then) and would immediately wonder how the devil another impression could have found its way into the window of this particular undistinguished establishment, where it was being bathed in color-fading ultraviolet sunlight. If one pressed his nose against the pane, one could detect colors that were simply too bright; a too smooth, overly white paper; a signature "in the plate," and the penciled notation "H.C." in the lower left-hand corner. It was a good facsimile, a heliogravure reproduction of an impression from the regular edition of 12. Pleasing to the eye; from a distance, charming. Its value? The price of the frame plus the price of a good facsimile.

Inside the gallery the following colloquy takes place: "Yes," says the lady proprietor, "it's an original print, signed in the plate." "The size of the edition?" she repeats nervously. "I'll let you talk with my husband." Enter husband; beginning of double-talk in earnest. "An edition after the regular edition, you see, made with reproductive aids, but very limited. 'H.C.,' you see, means 'hors de commerce,' which is French for 'outside of commerce'—that is, an edition apart from the first, regular printing of the lithograph. I don't know who wrote the 'H.C.' Maybe the artist,

maybe the printer. The price? $850." *Eight hundred and fifty dollars!* A "Toulouse-Lautrec"? Sure, in a generic sense: an *original heliogravure replica* of a Toulouse-Lautrec lithograph. The rest are half-truths. *As priced and explicated*, the picture is a forgery. The next day "La Grande Loge" was gone; "sold," we were told.

The best guard against this and other forgeries is a thorough familiarity with the specifications of the original. The characteristics of a bona fide impression can emerge either through scrutiny of an actual impression or through consultation of accurate documentation. It so happens that with few exceptions the prints which copyists reproduce are the popular and expensive images that most easily find buyers, and that happily also happen to be the very prints that populate museum print cabinets and have received the most thorough attention from scholars. Though long visual experience and a strong, visual memory may help immeasurably, with good prototypes, high-fidelity illustrations (including enlargements of details), and accurate specifications readily available in catalogues raisonnés, trustworthy dealer and auction-house documentation, and other materials, all that is needed, basically is some incentive to use this wealth of information and some fundamental understanding of the ways in which copies of existing prints may differ from their prototypes. Though differences may be subtle rather than radical, by following the simple guidelines that follow, a child of six (print connoisseur O. P. Reed, Jr., reminds us that only "a child's eyes saw the naked Emperor") will be able to distinguish an original from a counterfeit with fair certainty—or at least succumb to imitations with a frequency more appropriate to a highly experienced expert than an ignoramus.

The following tools are always helpful: a pair of keen eyes, sensitive fingers, definitive documentation, a 10–20 power magnifying glass, a millimeter tape measure, and a strong light such as direct sunlight or the beam of a high-intensity lamp. A "black light" (ultraviolet lamp) helps spot falsified proofs, but except for confirming paper differences, is not much help in authenticating forgeries. An unwillingness to jump at bargains or judge prints through glass and an initial skepticism about weathered physiognomy, mat stains, labels, and pedigreed antique frames, all of which can lower resistance to forgeries (have the paper and trappings been doctored?!), are indispensable.

1. IDENTIFY THE PRINTMAKING PROCESS. With the exception of those copyists who reproduce an image manually—a guild of craftsmen which has dwindled since the perfection of photomechanical copying processes made their skills superfluous—most copyists have made their replicas in a medium different from the medium of the original print. The various printmaking techniques and processes are briefly described in the opening pages of this book, but a more detailed explanation of the characteristics of an intaglio print, a lithograph, a linoleum cut, a woodcut, a screenprint, and the like, a grasp of which is necessary for a com-

parison of printmaking methods, is available from the excellent sources listed in the Bibliography. Each method in almost every case may be inferred from the image it creates. It is evident that something with the essential quality of a lithograph cannot be a woodcut, and that a printed surface that feels like an etching cannot be a lithograph.

Test One: Close your eyes and gently caress the surface of the print with your (clean) fingertips. A flat, smooth surface is not an etching, a drypoint, or a mezzotint, which should suggest instead the raised lines of a wedding invitation; nor is it a woodcut or a linocut, which should reveal indented areas, feeling like Braille on the verso, where the incised block impressed the paper. The lines of a heliogravure replica of an etching will of course repose in relief upon the paper just like the lines of the etching it reproduces, since both are intaglios (Fig. 4-G). Now move your fingers beyond the border of the composition to feel any indented lines that give an embossed perimeter. A stone lithograph may sometimes be evidenced by slight traces of the somewhat rounded edges and corners of the stone on which the design was drawn, and the zinc plate sometimes used for lithography is not subjected to the same pressure to which metal plates used in intaglio processes are and will not leave a conspicuous plate mark. Consequently an obvious plate mark with square corners on a "lithograph" (not just a slight depression) betrays the possible use of a photographic metal plate.

Test Two: Hold the print at a distance and keep changing both your angle of view, the direction of the light, and the focal distance. A photomechanical replica is most convincing when there is a close affinity between the original technique and the reproductive technique used for the copy: photoengraving (photogravure, rotogravure, or heliogravure, which involves more handwork) for intaglio; collotype (a photoreproductive process related to lithography) or photo-offset lithography for a lithograph; electrotype (zinc line block) for a relief print such as a woodcut. But the photoreproductive processes generally produce an image that appears flat, relatively lifeless, crude, harsh, or grainy when compared, mentally or actually, with an original (see Fig. 4-G). Usually the tonal range is either reduced or expanded by photography, so that the tones appear either too homogeneous or too contrasted. Photomechanical replication cannot, for instance, capture the three-dimensional quality of a hand-incised intaglio line (the ink printed from a hand-incised plate sits on the surface of the paper in contours that reflect the varying depths of the incised lines); all the ink on the surface of a photogravure is of even height, on the same plane, giving the surface of the print a homogeneous appearance that is not characteristic of the subject copied. Photography also tends to narrow the tonal range of a lithograph.

Test Three: Examine the print closely with a magnifying glass. Photography generally coarsens details. Collotype, which has been used maximally to replicate lithographs and, less deceptively, to reproduce intaglios, produces a flat, puckered grain ("reticulations") resembling

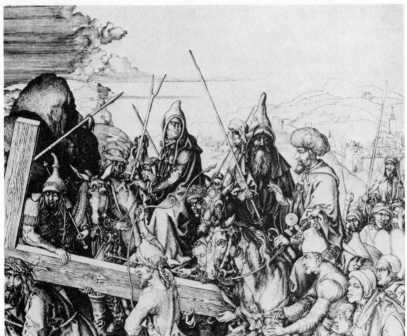

Detail of Martin Schongauer, "The Bearing of the Cross." Engraving, c.1475–85 (B. 21; L. 9). 286 x 431 mm; 11¼" x 17". *Top:* authentic impression. *Bottom:* heliogravure replica printed by the Berlin Reichsdruckerei, celebrated for its first-rate facsimiles. Both prints are intaglios, but the replica appears flat, crude, and grainy when placed alongside an authentic impression. (COLLECTION OF THE AUTHOR) Fig. 4-G

swarms of minute maggots, which can be detected best along the edges
of lines and in medium tones that would otherwise print with smooth
clarity. Photolithography that makes use of the line technique tends to
produce a flatter, softer, duller, cloudier image, which on close compara-
tive examination shows extraneous tone at the crossings of lines or be-
tween tiny areas of ink. The camera tends to lose delicate work al-
together. Photolithography that employs a screen technique and the
silkscreen process itself generate minute halftone dots. Photoengraved
lines tend to be thicker, fuzzier, and blunter than the sharp lines printed
from a hand-incised plate; they tend to break and vanish when the actual
lines become willowy and faint (Fig. 4-H). (As a result the velvety tex-
ture of mezzotint and the grains of aquatint do not reproduce as well as
etched and engraved lines. The rocked and the grained areas tend to blur
in photoreproduction.) However, first-rate heliogravures, especially ones
lightly etched, finished with the burin and touched by hand with a
drypoint needle, and zinc linecut reproductions of wood engravings and
woodcuts that don't portray the grain of the wood, can be incomparable
replicas (Fig. 4-I). Some Dutuit "Rembrandts" are simply so exquisite
that as forgeries they are self-defeating—so good that given the rarity of
flawless impressions, they are improbable!

2. LOOK FOR THE INTEGRITY OF THE DESIGN. This exercise
presupposes some familiarity with the style and visual character of the
original print.

Test One: Hold the print at varying focal lengths. Hand-drawn copies
usually reflect the nervousness, impatience, or irresolution of the copy-
ist, whatever his technical skill. It is really impossible to make a perfect
copy by hand, if only because each line and tone has its own life, like a
fingerprint, and the muscular coordination of every printmaker expresses
itself idiosyncratically (see Fig. 4-F). If the copyist attempts slavishly to
imitate each line or tonal gradation, his handiwork will usually assume
the stiffness of his own muscular constraint; attempted literal imitations
normally result in copies that look mechanical, flat, or dull and lack the
tonal subtleties of the original. If the copyist tries a more flexible ap-
proach, one that harnesses rather than stifles the natural vibrations of the
hand in order to capture the spirit rather than the precise details of the
picture, he will usually end up with a clumsy or comical imitation that
dramatizes rather than diverts attention from his mistakes. From the
16th through the 19th centuries, copyists often made use of a mirror, so
that the redrawn imitation would not print in reverse (though a woodcut-
ter could slice through a skinned original woodcut pasted face down on a
new block). But since a copyist was usually reluctant to destroy the pro-
totype and a mirror tends to blur reflected lines disconcertingly, many of
the most exacting copyists were compelled to produce undeceptive fac-
similes in reverse rather than look-alikes.

Although most facsimiles and counterfeits suffer from a failure to

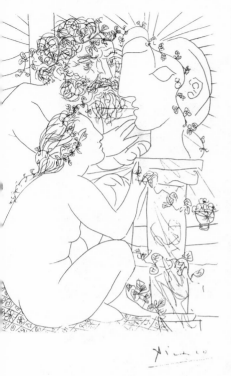

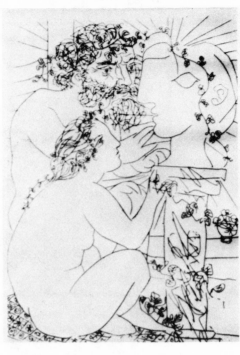

Pablo Picasso, "Sculpteur, modèle accroupi et tête sculptée" ("Sculptor, Crouching Model and Sculpted Head"). Etching, 1933 (G. 308 III; B1. 155; S.V. 39), from the *Vollard Suite*. 269 x 194 mm; 10⅝" x 7⅝". *Left:* authentic impression. *Right:* photoreproduction. Note the thickness of the lines in the copy, as well as how in comparison with the lines of the original, certain lines break in places and disappear. (COURTESY OF SOTHEBY PARKE BERNET INC. AND O. P. REED, JR.) Fig. 4-H

GALERIE DANIEL KEEL

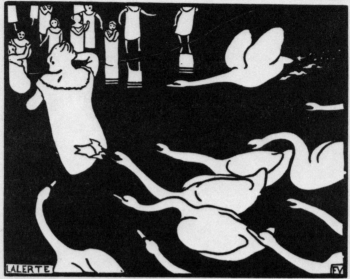

Jugendstil

Aquarelle, Zeichnungen, Graphik, Plakate
und Drucke von

Franz v. Bayros, Aubrey Beardsley, Beggarstaffs,
Hans Boehler, Pierre Bonnard, Jules Chéret, Maurice Denis,
Stefan Eggeler, J.-L. Forain, Th. Th. Heine, Ferdinand Hodler,
Ludwig v. Hofmann, Rudolf Jettmar, Max Klinger,
Käthe Kollwitz, Alfred Kubin, Aristide Maillol, F. Michl, Alfons Mucha,
Emil Orlik, Félicien Rops, Franz v. Stuck, Richard Teschner,
Toulouse-Lautrec, Felix Vallotton, Edouard Vuillard, Franz Wacik,
Karl Walser, J.M.N. Whistler u.a.

8001 Zürich, Rämistrasse 33, Telefon 01 32 31 82
Geöffnet 10–12 und 14–18.30 Uhr, Samstag bis 16.00 Uhr
Sonntag und Montag geschlossen

Poster reproducing Félix Vallotton, "L'Alerte" ("The Alarm"). Woodcut, 1895
(V. & G. 166). Prototype is 179 x 224 mm; $7^1/_{16}''$ x $8^{13}/_{16}''$. Some dealers shear
the letters from posters and sell the resulting prints as originals. Fig. 4-I

achieve the stylistic unity of the prototype—"for most," says auctioneer Eberhard Kornfeld, whose wise eyes can spot an imposter at three meters, but who admits to being victimized now and then, "you look at them and you *know* they are wrong"—the overall integrity of design, standing alone, is not a sufficient assurance of authenticity. Skillfully utilized photoreproductive processes compatible with the original method are capable of regenerating the spontaneity and rhythmic integration of compositional elements perfectly, and some redrawn imitations are so deceptively precise that Adam von Bartsch (1757–1821), that indefatigable cataloguer of old master prints, found it practical to diagram in his 21-volume catalogue, *Le Peintre-Graveur* (1803–21), scores of tiny comparative details—the shading of a toenail; a flag turned the wrong way; a few lines off just a smidgeon—to illustrate minute discrepancies (Fig. 4-J).

So perform *Test Two:* Examine the details of the composition here and there, line for line and spot for spot against a detailed description, an accurate illustration, or an authentic copy of the same state. The lines that convey facial expression and the lines that build foliage are often fruitful places to begin a critical comparison. Some prephotography copyists intentionally altered a detail or inscribed their own name on the matrix to evade any accusation of deceptive intent. Jan Wierix (1549–1615), a progenitor of a family of Antwerp copyists, who as a teen-ager engraved imitations of Dürer engravings mostly to practice and demonstrate his extraordinary technical prowess, always left clues: his name at the bottom margin of the print; the omission of the date appearing on the tablet in "Knight, Death and Devil"; the small flourish between "MELENCOLIA" and "I" in "Melencolia"; the "update" of the year of execution engraved on his copies in reverse (on one of these, however, "The Virgin with the Swaddled Child" [B. 38], a forger has substituted a "proper" 1520 date in lieu of Wierix's 1565). But not every copyist is so titillating, and although these days the discovery of an unrecorded state is as rare as a total eclipse of the sun, for centuries before the publication of definitive oeuvre catalogues, deft imitations were enthusiastically welcomed as newly discovered states. Ink specks, wispy hairlines, or tonal spots on the surface of the paper—to be distinguished from foxing, rust marks, or paper blemishes—could connote dust and dirt that were transcribed by a camera from the photocopied original or the camera's own lens or adhered to an emulsion or printing plate, but they could also signify a late impression from a deteriorating or soiled printing surface. Inexact registration of color plates can sometimes give away a reproduction of a color print.

3. MEASURE THE DIMENSIONS OF THE IMAGE, THE MATRIX—IF REFLECTED IN THE SURFACE OF THE PAPER—AND THE SHEET OF PAPER ITSELF. Copyists who intend to make replicas and not forgeries often enlarge or reduce the dimensions of the subject print. Since, however, all

Page from Volume XIV of Bartsch, *Le Peintre-Graveur*,
illustrating subtle distinctions between authentic Dürer
woodcuts and copies by Marcantonio Raimondi. Fig.
4-J

paper may shrink somewhat differently after printing and contract or expand under various atmospheric conditions or restorative measures, only variations in excess of half a centimeter should be considered suspect. An old master print with considerable space between the border of the composition and the platemark at the top and sides is probably an anachronism, since pre-19th-century artists customarily used the entire surface of the costly matrix. Unless the reference literature discloses that the plate edges have been broadly beveled (more than $^1/_{16}$ inch) to keep them from knifing into the paper, a practice which did not commence until the 1820's or so, an inordinately wide space *within* the ordinarily narrow boundaries of the plate mark is also suspect. And a relatively excessive distance between the outer edge of the plate mark and the edge of the paper (old master prints rarely have wide margins) is suspicious if *bona fide* impressions regularly have different specifications. A *correct* circumference is not conclusive, since margins can be trimmed to the plate mark or border.

Replicas that have been printed from plates whose size is greater than the dimensions of the paper on which they appear—a modern photogravure, for example—may even lack a plate mark entirely. The absence of a plate mark on a lithograph or relief print may perhaps confirm its authenticity, while the absence of a plate mark on a wide-margined intaglio should raise doubts. However, stretch-drying of etching paper in a few cases has removed the plate mark. Phony plate marks of the correct dimensions can be impressed into the paper before or after printing, and knaves will trim the margins of a facsimile to within the known perimeter of the printing plate to do away with evidence of the broad beveled plate mark or wide margins that would herald a reproduction.

4. IDENTIFY ANY BLINDSTAMP, INSCRIPTION, SIGNATURE, OR OTHER MARK, that appears on the verso and recto of the print, assuming it has not been erased, bleached out, trimmed off, ironed out, or covered by a thin sheet laminated to the verso. Some blindstamps and marks are highly communicative; others are merely disconcerting. The circular stamp on the verso of the Berlin Reichsdruckerei (after World War II, the Staatsdruckerei; since 1951, the Bundesdruckerei) facsimiles clearly states "Faksimile Reproduktion." But the red-stamped cipher of the publisher Amand-Durand on the verso of his 401 late 19th-century heliogravure reproductions of old master prints (including Meryon) looks like any other collector's mark, and the small rectangular "Von der Becke" blindstamp that this German publisher impressed on his facsimiles of Kollwitz lithographs and woodcuts was used indiscriminately on his restrikes of Kollwitz etchings as well. In his two tomes, *Les Marques de Collections*, Frits Lugt catalogued thousands of the collector's marks, stamps, and inscriptions placed on impressions of prints before 1955, and many of them can be checked out there. Stamps and other marks on prints can of course be spurious also, so any marking recorded by Lugt

should be compared for solidity and clarity—if a mark—and for spontaneity and flow—if a signature or initial—against Lugt's illustration. If the collector's mark is bona fide, the provenance thus verified is a good though not definitive assurance of authenticity. Zealous collectors are after all sometimes gullible collectors.

5. DIAGNOSE THE PAPER AND ANY WATERMARKS IN IT. Since the duplication of the paper used for the original editions is such a formidable burden, a diagnosis of paper is often conclusive, for the paper must be contemporaneous with the print. Print experts in fact often commence an examination by scrutinizing and fondling the paper and peering through it from the verso against a sharp light (See Fig. 5-A). For centuries copyists have successfully scrounged for paper that matches the era and manufacture of the original; conscientious modern forgers still "age" new paper to make it look old (they used to do it with tea or coffee, which turned print testers into tasters) and ransack old records and registries for genuine old paper with writing that can be bleached out; and while no 20th-century paper mill can exactly duplicate the patina, type, and color of 15th- to 17th-century papers, excellent imitations of old, mellowed handmade paper have been manufactured on order. Amand-Durand, for instance, ordered some very deceptive custom-made antiqued paper for a number of his replicas, and Eugène Dutuit published a few deluxe suites of his Rembrandt facsimiles *hors* his *catalogue* on a thin Japan paper that defies dating except through chemical analysis of fibers. Where such genuine or excellent imitation "proper" paper is used, scrutiny of the paper, without supplemental inquiries, can spring, rather than defeat, the trap. Fortunately careful attention to paper by copyists is relatively rare, if only because most copyists were not counterfeiters, and paper diagnosis is normally an effective measure for verifying authenticity.

Paper and its watermarks are not the esoteric subjects that some specialists would have people believe (they are discussed in the next chapter), and a serviceable familiarity with the basic varieties of paper and identification of specific paper mills and paper runs through watermarks (the working tools of millions of stamp collectors) is easily acquired and can aid greatly in the detection of spurious prints (Fig. 4-K). Each variety and manufacture of paper has a distinctive composition, construction, sizing, texture, tone, gloss, opacity, thickness, and feel. A machine-made paper (post-1812), wove paper (post-1757), or imitation laid paper of the 19th or 20th centuries has a character wholly different from that of pre-19th-century laid paper or Oriental paper, so any rich impression of a "Rembrandt etching" on thin, smooth, light-browned, unmellowed white wove paper cannot have been printed by Rembrandt.

The dangerously deceptive photoreproductions of old master prints issued in the late 19th century by Amand-Durand, Eugène Dutuit (manufactured by Charreyre), the Autotype Company, and the Reichsdruck-

erei (some of which were printed in London) can be identified (see Fig. 4-G) by their machine-made simulated laid paper alone. These publishers used imitations of old paper manufactured either by the Arches paper mill in France (watermarked "ARCHES" and/or a crowned shield enclosing the letters "A.M."), the Van Gelder Zonen mill in Holland (watermarked with its name, the "V.G.Z." logo and/or a crowned shield decorated with a fleur-de-lis), the C. & I. Honig mill in Holland (watermarked with its name), or the J. Whatman mill in England (watermarked with either its name and/or "TURKEY MILL"). In such machine-made laid papers the chain lines (the widely spaced lines in laid papers) are always evenly spaced (they are simulated, being superfluous): 28 mm apart in Arches, 28–34 mm apart in Van Gelder, and 29 mm apart in Honig. (The distance between chain lines on pre-1812, handmade laid paper varied from between 20 to 30 mm.) Moreover, Arches has 8 to 9 laid lines (the narrowly spaced lines in laid papers) per cm and Van Gelder and Honig, 7 to 8 (as opposed to from 8 to 15 laid lines per cm in old handmade laid papers). If the paper of the print under examination does not match the paper actually used for the edition—if, for example, a Picasso *Saltimbanque* after steelfacing appears on paper that was not manufactured by Van Gelder, or a Matisse lithograph appears on an uncharacteristically thick paper—mental alarm bells should ring. It is possible, however, than an impression on the "wrong" paper could be a trial proof, which printers often run on any junky paper that happens to be

Photoreproduction of Mary Cassatt, "Sara Wearing Her Bonnet and Coat," seen from verso. Authentic print is a transfer lithograph, c.1904 (B. 198). 508 x 418 mm; 20″ x 16⁷/₁₆″. The backlighting highlights the watermarks (inappropriate to an authentic impression), widely spaced chain lines, and narrowly spaced laid lines in the machine-made laid paper. (COURTESY OF MARTIN GORDON INC.) Fig. 4-K

lying around the shop. Although a denunciation by the formidable American dealer and expert, Robert M. Light, induced autioneer Marc Rosen to remove from a November 1971 Sotheby Parke Bernet sale a suspicious unrecorded impression "before letters" (before the inscription was printed) of Bonnard's "Salon des Cent" poster (R.-M. 45) on uncharacteristically smooth, yellowish paper, Rosen later reinstated the impression as an authentic trial proof.

Since the proprietary designs that paper manufacturers sometimes embedded in their sheets as watermarks have been extensively recorded, paper can be identified and often roughly—and sometimes precisely—dated by its watermark, if it has one. If the watermark in the paper is known to be of a date later than the supposed time of printing of an authentic impression, the paper is evidently not contemporaneous with that time of printing. The presence of a specific watermark may be essential to a proof of authenticity in any individual case. If the paper lacks the watermark that it *should* have, then the impression is either a replica or a later impression (restrike). The 300-copy regular edition of Picasso's *Vollard Suite* was printed on Montval paper watermarked either "Montgolfier," "Picasso," or "Vollard," and a copy without one of these watermarks is a phony. However, many old master prints lack the watermark appearing in impressions of the same or other prints printed contemporaneously. Not all paper is watermarked by its mill; fine impressions of Rembrandt etchings, for example, are printed on papers with and without watermarks. Moreover, the piece of paper on which the subject print appears, if cut from a larger sheet, might not have received the wire imprint of the watermark design.

It is the paper itself and not its watermark that should be primarily relied upon for guidance. It is far simpler for a printer to reconstruct the correct watermark mold than it is for him to imitate the paper. A 19th-century Milan printer named Vallardi duplicated the early 16th- century "anchor in circle" watermark for restrikes of two engravings by Robetta, but the yellowing effect of light upon his paper as well as its wood-pulp content give them away as products of the 19th century. Moreover, because paper mills have frequently reused the same watermark over many decades or even centuries, an otherwise comforting early watermark can appear on late paper. In fact, the confirmation of a recorded watermark can be so reassuring to many people that swindlers have devised methods for forging watermarks on existing reproductions. One way is to press a heated stencil coated with wax, glycerin, or vaseline onto the verso of the paper. Such a false emulsion watermark appears as a shiny relief, rather than as a properly opaque, slight indentation on one side of the sheet. Another way is to use a blank metal stamp, which will make a nicely deceptive indentation on one side of the sheet but will appear in almost imperceptible relief on the other. (The stationery industry uses this method today to produce an elegant watermark economically.) A third method, which can be detected only through chemical and mi-

croscopic analysis, involves the application of a rubber stamp wet with a dilute solution of nitric and sulphuric acid. Unwanted watermarks can be obliterated by sandpapering, which will leave a telltale thin spot— unless covered or filled in by a restorer—visible against a strong light.

More difficult to detect than counterfeit or erased watermarks is a replica whose verso has been evenly skinned to onionskin thickness and laminated with either genuine or imitation "correct"—often watermarked—paper. What will be apparent, unless the overlaid verso and its watermark obtain facile acceptance, is a difference in the color or texture of the two sides (they may also fluoresce differently under ultraviolet radiation), paper blemishes and tiny wrinkles that do not show through to the other side, and a rapid curl in the sheet when it is exposed to even heat (careful!), caused by the differing coefficient of linear expansion of each side.

6. MATCH THE INK TONES. Inks may change tonality with age and exposure to light, but a comparison of ink tones may reinforce tentative conclusions based on other factors. The inks used by the late 19th-century printers of old-master print facsimiles are generally browner in tone than the blacks used in the 15th to 17th centuries. And as contemporary art-book publishers know all too well, it is exceptionally difficult and extremely costly to match the shades of a color print precisely.

Careful application of the six steps outlined above should uncover any facsimile or forgery at the threshhold, far from the laboratory. Chemical analysis and microscopic and spectroscopic examination of paper fibers, ink, and marks on the paper can deliver the *coup de grâce* to any impostor, but require skills and equipment that are not readily accessible in most cases. They are also costly.

UN BAL MASQUÉ: A SHORT PARADE OF IMPOSTORS

MANUALLY DRAWN RE-CREATIONS. No hand-drawn imitation can withstand the meticulous examination of the integrity of the design. There have been few, if any, 20th-century graphic artists with the inclination, drafting skills, and technical prowess to execute formidable re-creations of modern prints manually. And while an uncatalogued imitation of an old master print occasionally turns up, thousands of pre-20th-century re-creations of Schongauers, Dürers, van Leydens, Callots, Rembrandts, Van Dykes, Hogarths, Goyas, Meryons, and others are noticed and distinguished in the authoritative reference materials listed in the Bibliography.

Some of these deceptions, however, have been made with such re-
markable fidelity that scholars have unwittingly reproduced them as
illustrations for the catalogues raisonnés themselves! Arthur M.
Hind, curator of prints at the British Museum, photographed Professor Paul
Sachs's (later Lessing Rosenwald's) forgery of Pollaiuolo's "Battle of the
Naked Men" for his definitive *Early Italian Engraving* because—before its
unmasking—all the experts thought it the finest existing impression.
Rovinski illustrated an imitation of Rembrandt's "Little Polander"
(B. 142) for his 1890 catalogue of Rembrandt etchings (another impres-
sion of this forgery found its way into a Kornfeld auction catalog in
1970). Hollstein included a photograph of an imitation "Calvary" (H. 74)
in his standard catalogue raisonné of Van Leyden. And Bouchot showed
an absurdity to illustrate "The Temptation of St. Anthony" (L. 1416) in
his 1889 book on the life and work of Jacques Callot. Adam von
Bartsch classified a copy of Dürer's engraved "Small Round Crucifix-
ion" (B. 23) as the prototype, while describing the original (as later es-
tablished by Passavant) as a "copy . . . so perfect that the sharpest con-
noisseur can be mistaken."

Among the cleverest of redrawn copies are some of those William
Young Ottley included in various books on engraving and collections of
bound facsimiles that he published in the early 19th century. The 57
Ottley imitations of Italian nielli engravings—printed on tin, silver, or
some other metal foil to resemble a genuine work in niello—are particu-
larly effective, even though they are reversed from the originals, because
many of them have never been illustrated. These and other spurious old
master prints turn up from time to time on the print market. New York
dealer David Tunick once rushed off to capture a rare Schongauer "Bear-
ing of the Cross" at an estate auction in Milwaukee, Wisconsin, only to
watch some rash dealer pay several thousand dollars for what was in actu-
ality a 19th-century replica.

Re-creations of modern prints and multiples are rare, since photog-
raphy can do the job better and more easily. In the May 1972 issue of
the *Print Collector's Newsletter*, Judith Goldman wrote about a part-
bootleg, part-forged construction of Claes Oldenburg's "Baked Potato,"
one of the *Seven Objects in a Box* published by the Tanglewood Press in
1966. (The Barnett Newman and Tom Wesselman multiples from this
collection have also surfaced in bootleg form with forged signatures.) A
redrawn copy (with photographic aids?) of Toulouse-Lautrec's "Divan
Japonais" poster (D. 341; A. 11) (Fig. 4-L) turned up at German auctions
and galleries in 1974, identifiable as such through slight variations in
forms and lines, a greenish caste to Jane Avril's yellow dress, the wrong
color for M. Dujardin's hat, and registration cross hairs at the top and
bottom margins to induce acceptance as a trial proof. (Paris dealer Hu-
bert Prouté has seen several other photomechanical replicas.) In 1974, a
Chicago enterprise called Artco Master Prints issued a catalog illustrating
some 50 old master and modern prints, advertising them as

an exceptional collection of line for line etched and engraved copies of the masters. Most plates cut by professional engravers contemporary to the masters, others later. All prints printed on laid papers. One cannot distinguish these pieces from originals. In fact, through the centuries some dealers sold them as originals.

Although Artco's catalog deceptively illustrated impressions of the original prints, rather than the imitations, and the copies themselves do not disclose their identity as facsimiles, they are all coarse, clumsy imitations, printed on harsh, white, unwatermarked paper, and therefore, contrary to claim, easily distinguishable from the originals. Among modern prints, they include Goya *Caprichos* plates 5, 10, 25, 36, and 41; Meryon D.-W. 24, 25, 33, 36, and 37; Whistler, K. 24, 41–3, 45, 46, 66, 187, and 195; Manet M.-N. 2 (G. 21; H. 18); Renoir D. 2, 4, 8, 15, and 23; Pissarro D. 13; Picasso B. 1, 64, 95, 134 (S.V. 1), 172 (S.V. 63), 230 (S.V. 27), 267, 269, 270, and 1015–17 (M. 348–50); and Nolde woodcut S.-M. 110.

PHOTOMECHANICAL REPLICAS. To list the hundreds of old master print subjects that were issued in photogravure facsimiles in the late 1800's by Amand-Durand, Dutuit, the Reichsdruckerei, and the British Museum—let alone the more contemporary publications of the Eugrammia Press in London, Verlag Karl Thiemig of Munich, and

ri de Toulouse-Lautrec, "Le Divan Japonais." Lithograph in colors, 1892 (D. 341; A. 11). x 600 mm; 31½" x 23⅝". *Left:* authentic impression. *Right:* hand-drawn reproduction h surfaced in Germany in 1974. (COURTESY OF SOTHEBY PARKE BERNET INC. AND ALDIS VNE FINE ARTS LIMITED) Fig. 4-L

others—would be of no great help to anybody. Anyone who buys an expensive old master print must simply be alert to the possibility that photoreproductions do exist and must test every impression.

Deceptive replicas of modern prints perhaps today present a greater problem, quantitatively, because of their greater popularity and patent innocence (most people are naturally cautious about old master prints). The most common modern forgeries, too numerous to list here and daily increasing, are the offset or silkscreen posters that reproduce prints, some of which enjoy either an approved or bootleg run "before letters" or get their letters shorn off before becoming adorned with forged signatures and annotations (See Fig. 4-I). Czwiklitzer catalogs over 30 Picasso posters alone that replicate Picasso prints, and they pop up everywhere under frames that reveal only Picasso's image and no typography.

What follows is a checklist, without any pretense to comprehensiveness (other spurious prints are no doubt being manufactured at this very moment), of a number of the deceptive copies (exclusive of cropped posters) of prints of the last 100 years or so, that have surfaced on the market in recent years:

BELLOWS, "Dempsey and Firpo" (lithograph, B. 89). The Metropolitan Museum of Art, which possesses the stone, published a convincing replica and sold it in its gift shops through the early 1970's. (New York dealer David Tunick surprisingly bought one of these at auction in 1976 for *only* $230, while other experts stared.)

BONNARD, "La Revue Blanche" poster (lithograph, R.-M. 32). An exact-size replica published by Graphis in Switzerland in the early 1960's sometimes appears with its typographic legends cropped, though it should be stamped "Graphis" on the verso. A flat photolithograph with the typical homogeneous tonality of a photoreproduction. The paper is too smooth and glossy.

See also VUILLARD below, for reference to the Roger-Marx catalogue-raisonné illustrations.

CASSATT, "Sara Wearing Her Bonnet and Coat" (transfer lithograph, B. 198) (see Fig. 4-K). A photoreproduction on wove paper very similar to the original, but of different stock. The paper of the replica is water-marked "MBM MADE IN FRANCE"; that of the original, "MBM (France) (Velin d'Arches)."

CHAGALL, "Der Akrobat mit der Geige" ("Acrobat with Violin"; etching, K. 40). Lithographic reproduction (image flat), with false beveled platemark 1.2 cm. from the composition.

———, "L'Auge" ("The Trough"; lithograph, M. 25). Photo-offset lithograph (see MATISSE below).

There have been reports of photoreproductions of color lithographs.

DAUMIER lithographs. Commencing with the publication in Munich in the 1920's of 216 facsimiles of Daumier lithographs, printshops in Europe and America have probably sold as many reproductions as originals, the latter until recently being not much more expensive than the former. The bulk of the replicas, torn from books illustrating Daumier lithographs, are harsh images on relatively heavy, overly white paper.

DELAUNAY, ROBERT, "La Tour" ("The Tower"; lithograph, L. & P. 3). A poor screen-process, photo-offset replica that reveals the halftone dots, most obviously in the "signature," under which Sonia Delaunay penciled the title, "La Tour." This edition of replicas, numbered to 75 copies, signed by Mrs. Delaunay and stamped with the oval atelier mark of her deceased husband, was offered ambiguously in 1969 as a *"réédition."*

GOYA, plate 3 from *Caprichos* (etching and aquatint, H. 38, D. 40) and other plates. There are Spanish-made lithographic reproductions of some of these aquatints, on laid paper watermarked "GUA RRO" as in the eleventh edition of 1929, with heavy-cut false plate marks. They generally have somewhat reduced dimensions.

HECKEL. See NOLDE below.

KLEE, "Ein Genius serviert ein kleines Frühstück" ("A Genius Serves a Small Breakfast"; watercolored lithograph, K. 79) and "Seiltänzer" ("The Tightrope Walker"; color lithograph, K. 95) (Fig. 4-M). These photolithographs, with dimensions slightly reduced and on different paper from the originals, are two of several Klee reproductions with good color fidelity published by J. B. Neumann with Klee's approval. The first was colored through stencils, rather than freehand, as the originals were. Some of the replicas reproduce the pencil signature of the prototype.

KOKOSCHKA, five-color lithographic poster for the Kunstschau of 1908. A replica, folded and refolded to book size, normally with typography on the verso, was inserted in a book on poster art published in Germany in the 1950's.

KOLLWITZ, many of the lithographs and woodcuts. Somewhat crude, cloudy reproductions of ten of the lithographs, some in exact dimensions, were published in New York in 1941 as *Ten Lithographs* (K. 190, 196, 199,

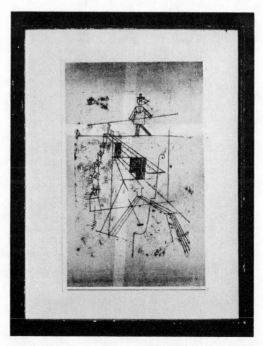

Photolithographic copy of Paul Klee, "Seiltänzer" ("The Tightrope Walker"). 402 x 250 mm; 15¾" x 9⅞". Authentic print is a lithograph in colors, 1923 (K. 95). 440 x 268 mm; 17⅜" x 10½". Prints should always be removed from frames for proper examination. (COURTESY OF MARTIN GORDON INC.) Fig. 4-M

203, 226, 246, 252, 258, 259, and 263). All the lithographs and woodcuts photoreproduced in slightly smaller size by the German publisher, A. von der Becke, bear his rectangular blindstamp in the lower corner of the composition. (The "von der Becke" Kollwitz *etchings* are, by contrast, true reprints [see Fig. 2-D]). Some bear a drystamp on the verso identifying them as photolithographs ("galvanos"), but many of the reproductions of the *Krieg* woodcuts (K. 177–83) do not.

MATISSE, lithographs. The following forgeries of Matisse lithographs were manufactured in California in 1970 by photo-offset process. Some were printed on paper watermarked "ARCHES" (Matisse lithographs customarily appear on Arches, *Chine appliqué*, or *Japon impèrial*). They were sold throughout Europe and consigned for sale at Sotheby Parke Bernet New York, where Marc Rosen, aided by several Print People, alertly screened them out as counterfeit. The handwritten "plate number," which customarily appears on the verso of originals, if not accidentally erased, is missing on the forgeries.

"Odalisque debout, Jupe de Tulle" ("Standing Odalisque with Tulle Skirt," Plate 53, Pully 107).
"Nu aux Fauteuil, les Bras levés" ("Nude with Raised Arms in Armchair," Pl. 55, P. 108).
"Nu assis á la Cheminée" ("Nude with Raised Arms Seated before Fireplace," Pl. 63).
"Danseuse assise" ("Seated Dancer," Pl. 91).
"Odalisque au Samovar" ("Reclining Odalisque before Samovar," Pl. 122, P. 153).
"Le Renard" ("The White Fox," Pl. 123).

MERYON, etchings D. 23, 24, 26, 30, 34 (IV), 34 (X), 36, 38, 42, and others. Apart from highly deceptive hand-drawn copies, the ten subjects listed were reproduced in heliogravure in exact sizes on laid papers by the Autotype Company in London in 1887. Untrimmed copies carry the inscription, "Autotype Company London 1886 (AUTO-GRAVURE FAC-SIMILE)," close to the bottom margin. D. 36 is on paper watermarked "Fortune"; D. 34 and 38, on "VAN GELDER" paper; and the balance, on other papers. Amand-Durand published a heliogravure of D. 29, and André Marty included heliogravures of D. 23, 24, 26, and 38 in his book, *L'Histoire de Notre-Dame de Paris.* . . . There are other photoreproductions as well.

MOORE, "Ideas for Sculpture" (etching, C. 54) and "Two Seated Figures II" (etching and drypoint, C. 56). These are photogravures printed on a poor quality, almost translucent paper. Genuine impressions of C. 54 are on opaque Arches and of C. 56, on *Japon nacré*.

MORANDI, etchings V. 14, 25, 32, 36, 46 (see Fig. 4-A), 53, 65, 66, 78, 83, 92, and 93. These etchings were reproduced in actual sizes by photogravure, enhanced by handwork, and the forgeries were marked "prova di stampa" in pencil and provided with false signatures. Several were sold at Christie's in December 1969.

MUCHA, color lithographs. There are numerous photoreproductions, most of which are easily distinguishable. A photo-offset facsimile of the Champenois Calendar (H. 128) printed in Italy in exact size can be differentiated by its blurry calligraphic line, overly yellow background, and

inappropriate, bluish offset paper. A New York dealer has enhanced the deception by soaking 117 of them in tea and backing some with muslin.

MUNCH, "Die letze Stunde" ("The Last Hour"; woodcut, S. 491) and "Begegnung in Weltall" ("Meeting in Space"; color woodcut, S. 135). The first facsimile, not too deceptive but with a very good photoreproduced gray signature, has been offered to and rejected by auctioneers Marc Rosen and Eberhard Kornfeld. The second, in slightly reduced format, appeared in a book.

NOLDE, "Prophet," "Frauenkopf" ("Girl's Head"), "Ziehende Krieger" ("Erect Soldier"), and "Junges Paar" ("Young Couple") (woodcuts, S.-M. 110, 116, 129 and 133). Excellent replicas of these four Nolde woodcuts, as well as of woodcuts by Pechstein, Rohlfs, and Schmidt-Rottluff, appeared in the 1919–20 newsprint issues of the short-lived German periodical edited by J. B. Neumann, *Der Anbruch*. The Noldes have dimensions extremely proximate to the originals. Each, however, has magazine text on the verso and a disclosing inscription in the lower margin, such as "NACH DEM ORIGINALHOLZSCHNITT," which of course gets trimmed off when the picture is framed to convert a fine reproduction into a forgery.

PECHSTEIN. See NOLDE above.

PICASSO, *Saltimbanque Suite* (etchings, G. 2–18; B. 1–15), including "Le Repas Frugal" ("The Frugal Repast"; G.2; B. 1). An exact-size collotype replica of "Le Repas Frugal," printed in Berlin and provided with a false bevel mark to give it the appearance of an etching from the beveled plate, was included in *The Living Arts* portfolio (500 folios) published by Dial Press in 1923. Similar copies have been made of other *Saltimbanques*. At one small New York auction sale in 1974, someone bid $2,250 for an impression of B. 2 with the smooth surface, dull linear quality, and overly deep, heavy, added plate mark characteristic of a photolithographic copy.

———, "Homme et Femme" ("Man and Woman"; etching, G. 118/b; B. 77). A photolithograph in a format slightly smaller than the original, reproducing the "Picasso" signature of the prototype.

———, *Vollard Suite* plates 6, 39 (Fig. 4-H), 42, 44, 46, 48, 49, 50, 51, 53, 54, 57, 59, 61, 63, 64, 65, 73, 93, 100, and possibly others (etchings, B. 139, 150, 152, 155, 156, 157, 158, 159, 160, 162, 163, 166, 168, 170, 172, 173, 174, 186, 201, and 233). The counterfeits are heliogravures, some of which have been embellished with superb forged signatures (legitimate *Vollard Suite* impressions of all these subjects except S.V. 93 (B. 201) exist unsigned also). Most are on unwatermarked paper similar to the original Montval, but more translucent. Some, however, bear forged "PICASSO" watermarks. The lines are too thick, lack variable depth, and have uncharacteristic blunted ends.

———, "Le Pigeonneau" ("Squab"; linoleum cut, B. 326). See MATISSE above. The photo-offset lithograph is distinguished by numerous tiny flecks (accidents of the reproductive process) and a smooth surface (linecut is a relief technique).

———, *347 Series*, B. 1646, 1766, 1789, and 1788 (etchings). In 1974, United States Customs officers at Los Angeles County Airport seized four canceled copperplates, four "signed" impressions marked "épreuve d'essai avant édition 50 EX + HC" and four "signed" impressions marked

"épreuve cuivre rayé après 50 EX + HC." None of the actual plates for the *347 Series* has been canceled.

———, *Portraits Imaginaires* series (29 lithographs after gouaches executed by Marcel Salinas, not considered "original" by Bloch). These are replicas of *afters!* Photoreproductions, and in an edition presumably limited to 400 copies, no less, of the edition (limited to 500 plus impressions) of the Salinas lithographs made in Atelier Guillard, Gourdon & Cie., Paris, after gouaches that Picasso casually painted on cardboard in 1960.

RENOIR, black and white lithographs. Some of the illustrations, both screen process and line process photolithographs printed by Mourlot, in Roger-Marx, *Less Lithographies de Renoir* (1951), are almost exact size. All have text on the verso, however, except, of course, proofs of the illustrations.

———, "Le Chapeau épinglé" ("The Pinned Hat"; color lithograph, D. 30; R.-M. 5). A fine screen-process (close inspection reveals the tonal dots) photolithograph was offered to auctioneer Martin Gordon in New York in 1976.

RODIN, D. 1, 3, 5, 6, 7, 9, and 10 (drypoints). Rather flat, heavy heliogravure replicas of these drypoints, titled "Point Sèche," in dimensions either somewhat larger or somewhat smaller were used as illustrations in the 1908 book, *Auguste Rodin, l'Oeuvre et l'Homme* (see *Appendice* to Delteil catalogue). There are also two additional, near exact-size replicas of "Victor Hugo, de Face" (D. 7) and one of "La Ronde" ("The Round"; D. 5), which are meticulously distinguished by Delteil.

ROHLES. See NOLDE above.

SCHMIDT-ROTTLUFF. See NOLDE above.

SHAHN, "Laissez-Faire" and "Silent Night" (serigraphs, P. 8 and 10). There are silkscreen reproductions with forged signatures which appeared on the market soon after publication of the originals in the late 1940's.

———, *Rilke Suite (For the Sake of a Single Verse* portfolio): "Many Cities," "Many Things," and "Memories of Many Nights of Love" (zinc-plate lithographs, P. 115, 117, and 131). New York attorney Martin Bressler, executor of the Shahn estate, in 1972 obtained a consent judgment prohibiting the publication and sale of letterpress-printed replicas of impressions from the edition of 750 on Vélin d'Arches paper that included a printed "Ben Shahn" signature within the composition.

TOULOUSE-LAUTREC, color lithographs. There are heliogravure reproductions of a number of color lithographs, including the replicas of the *Elles Suite* (D. 179–89; A. 200–210) published by Verlag Piper of Munich in 1924, all of which are of slightly smaller size than the originals.

———, "Blanche et Noire" ("White and Black"; lithograph, D. 171; A. 214). The impressions annotated 1 through 190, I-X or H.C., which were included as "restrikes" in the deluxe edition of the 1964 Huisman & Dortu book *Lautrec par Lautrec* are actually photolithographic replicas.

———, "May Milton" poster (lithograph, D. 356; A. 149) and other posters. See BONNARD above for the Graphis reproductions, which have telltale color-registration cross hairs at the top and bottom within the composition. The "May Milton" also exists in a collotype reproduction whose disclosing inscription just below the composition gets trimmed off.

VUILLARD, lithographs. The line-process lithographic illustrations, especially the color plates, in the Roger-Marx catalogue raisonné are oc-

casionally sold as originals. All have slightly reduced dimensions and text on the verso.

The Boston Book and Art Shop also published a portfolio of facsimile reproductions of 19 Vuillard lithographs, which was printed in Paris.

WARHOL, "Marilyn" (silver and gold variation from the 1967 portfolio of ten screenprints, *Ten Marilyns*). A bootleg publication measuring 33¼" square (versus a proper 36" x 36"), with imprecise reproduction of the hair and the halftone dots comprising the face, was manufactured in Stuttgart. It is stamped "Sunny B. Farms" and "Sign your own name" on the verso.

WHISTLER. Beware of photogravures of a number of the etchings.

FALSIFIED PROOFS: COSMETICS AND COSMETIC SURGERY

The third breed of spurious print, the falsified proof, results either from a material alteration to an existing impression or any alteration to the printing surface neither made nor ordered by the artist to whom the print is ascribed. There are very few falsified proofs of modern prints, since quality and condition among surviving impressions are generally even. There are many falsifications of old master prints, where earliness of state, qualitative excellence and condition are proportionately more consequential to commercial value.

As defined, the garden variety of falsified proof is a restrike printed from an original plate or stone retouched, reworked, or otherwise renovated or revived by hands other than those of the artist or his authorized proxy. Of course, the point where "restoration" of a matrix becomes "falsification" is often as elusive as the point at which *after* becomes "fake"; it depends on how the impression is represented in the marketplace. Before steelfacing came along to give incised lines much more longevity and obviate later recourse to intermeddlers, the extension of the life of copperplates by renovation of the lines was as customary and inoffensive as the facelifting acquired by modern aging movie queens. It is not the practice of renovating the printing surface, which can be as laudable as the skillful restoration of any work of art, but deception about what work was done that causes damage in the marketplace. One may be simultaneously indignant about a proof sold as a "Degas" which comes from a Degas plate whose cancellation lines have been removed and complacent about a proof openly offered as a Watelet or Basan rework of a Rembrandt copperplate, not so much because in the first case the manifest wish of the artist has been thwarted, but because the contravention, which alters the artist's conception and expression, is hidden from the buyer in order to exact a price commensurate to the value of a pre-resuscitation proof.

Another variety of falsified proof results from modification of the matrix to re-create a coveted trial proof or earlier state, create a new state,

or compose a different design. Craftsmen have blocked, masked out, chalked, varnished, or removed the ink from the "letters" (the inscription at the bottom of the composition) or a portion of the design, burnished or scraped away lines and replaced them with new ones, or superimposed a design from another plate or stone to create a pastiche. Such work was often performed in good faith. A publisher reprinting the plate or stone might have wished to substitute his own name and address for the letters disclosing the identity of the previous publisher. Successive publishers might have wanted to make use of the same ornamental border or costume for another portrait, just as Hollywood studios make use of the same set for different films. Thus Trouvain's 1695 portrait of Huet, the Bishop of Avranches, became Saint Exupère, the Bishop of Bayeux, when Huets failed to sell; Schenck's 1670 portrait of Charles II *after* Lely became transformed into John II—then, into William of Orange; Louis XVI became Robespierre; Louis Philippe became Napoleon III; and Charles I became Oliver Cromwell! An artist might also choose to use existing work as the foundation for a new image, as Rembrandt used a plate etched by his master, Seghers.

Much of the tampering with printing surfaces was, however, done to deceive. The graphic oeuvre of Rembrandt and Van Dyck, among others, suffered the entire repertoire of abuses. We have a Rembrandt "La Petite Tombe" with the toy of the child in the foreground missing, which duped Bartsch into classifying it as a first state; a "Rembrandt and Saskia" with Saskia's face replaced by her mother-in-law's; and a "View of Amsterdam" with an errant bunny in the landscape.

Other varieties of falsified proofs result from deceptive doctoring of the prints themselves to make them appear more valuable than they are. Late impressions of old master prints have been touched with India ink or watercolor to simulate the burr or the rich inking of early impressions. Missing portions of damaged impressions—usually the corners but now and then big chunks—have been replaced with pieces adroitly hand-drawn in matching ink by restorers so dexterous that they can meld papers as invisibly as Gogol's tailor could darn trousers.

Clumsy restorers sometimes create falsified proofs unwittingly. Instead of repairing tears and creases in the margin, New York painting conservator Daniel Goldreyer, not known for competency in paper restoration, once sliced the margins off a Picasso linocut, pasted the marginless composition down on another sheet and furnished a fresh "Picasso" pencil signature and annotation for the new lower margin! (See Fig. 12-D) Incompetent restorers entrusted with Redon lithographs printed on *Chine collé* laminated to a support sheet have negligently floated the thin China paper off its support sheet and remounted it on a new sheet, losing edges of the image, which was customarily bled over the edge of the *Chine collé* to the support sheet, in the process. Such a maltreated Redon lithograph, "Tête d'Enfant avec Fleurs" (M. 169), was sold at the Lempertz auction in Cologne in the fall of 1975 without any revelation of its true condition. In the fall of 1976, Wolfgang Ketterer

engaged a restorer to furnish an impression of Toulouse-Lautrec's "Au Moulin Rouge (La Goulue et sa Soeur)" (D. 11; A. 2) with a missing red oval publisher's stamp —and then advertised it in his auction catalogue as "with the red stamp of the printer Ancourt."

A hand-colored print can be an enigma. A few artists such as Ensor regularly colored impressions of their prints, but in most cases one must wonder whether the artist or someone's child did the coloring at a time when prints cost not much more than the illustrations in a child's coloring book. There are a few scholars and connoisseurs who will offer their opinion as to whether the coloring on an old master print is contemporary and by the hand of the artist, or later and by somebody else, based on an analysis of the coloration, style, and pigments, but such an opinion can rarely approach certainty.

The detection of falsified proofs requires a combined dose of the measures prescribed for the verification of authenticity, as set forth above, and the exercise of the kind of print connoisseurship that relates to the ascertainment of quality and condition, discussed in the next chapter. Lines drawn with a pen or brush, for instance, do not look like printed lines, and a drawn line crosses over a printed line like a bridge traverses a road. Since different inks usually catch and reflect light differently when scanned at eye level against a light source, the "improvement" of the inked lines or a redrawn patch, unless created with a perfectly matching ink, will often be evident to the naked eye. Different inks and papers will also fluoresce with different lumination, both intensity and shade, under a black light because of their differing chemical composition, no matter how slight.

We close this chapter with the following exchange between one astute collector and the editor of the *Print Collector's Newsletter:*

"Have you ever bought a fake?"
"Sure."
"How'd you find out?"
"Well, gradually we had a chance to see authentic prints and ask others who had more experience."
"What would you do?"
"Send ours to London for sale."
"So someone else bought a fake?"
"Sure. That was their hard luck—the calculated risk."
"That's what some dealers do, too. They find they have a fake . . . they try to put it up for auction. Did you have any remorse?"
"Well, I had no guilty feeling, none. Because the auction house sold it *as is*—not guaranteed. There's a suave phrase "attributed to." Actually that phrase depends on who says it. It's a ruthless sport. Anybody that's in it should know what's going on, and he should know that a lot of prints being sold are imitations. Its up to him to find out."

There is no central scrap heap for fakes, forgeries, and falsified proofs. Though some end up in dealer's scrapbooks and museum cabinets, most keep right on circulating, like the hot potato in the parlor game.

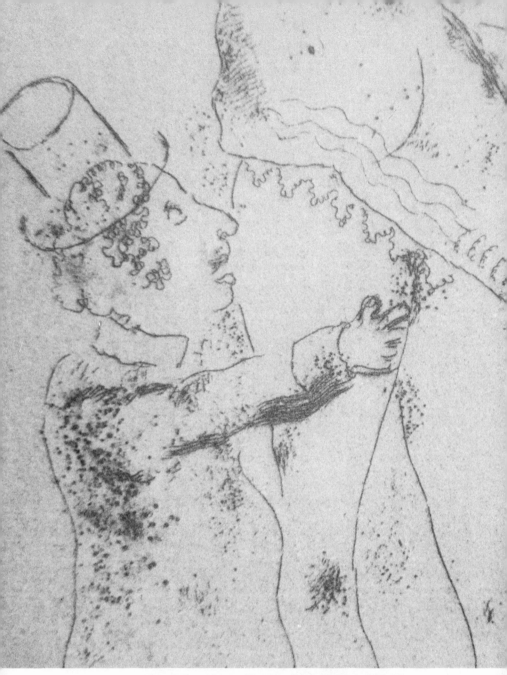

Detail from Marc Chagall, "Die Wollust. III" ("Lust.
III"). Etching, 1925 (Plate 16, *planche libre*, from *The
Seven Capital Sins* suite; K.62). 170 x 117 mm; 6¹¹/₁₆″ x
4⅝″.

Chapter Five

Connoisseurship: Detection of Identity, Comparative Quality and Condition

Connoisseurship, like life itself, is a matter of making judgments. . . . No collector, historian, or curator has avoided his share of errors. We hope you make many—and thereby learn.
— RICHARD S. FIELD, 1973

Print connoisseurship is the science of determining the identity, authenticity, comparative quality and condition of a print. Connoisseurship may be pursued for academic or commercial purposes; it ascertains the relative worth of the proof, both esthetic and monetary. Since the visual appeal of the print will often turn on the degree of its technical excellence and state of preservation, an impression of high quality and pristine condition will normally have greater value, both esthetically and monetarily, than one that is flawed. People have always paid more for impressions that seem closest to the ideal intended by the artist than for those that seem, because they are of comparatively poorer quality and/or have undergone wear and tear, less the intended expression of the artist. In 1567 the Parisian dealer-publisher Plantin explained that "even though they are from the same plate and from the hand of Dürer," proofs of "Saint Eustache" sell at different prices as the result of the "judgment and partiality of artists and connoisseurs." The notion of *la belle épreuve* ("the fine impression") is as old as print collecting itself.

Connoisseurship cannot be avoided by anyone faced with the need to evaluate an impression, whether that impression is an old master or a contemporary print. A contemporary print with an ink blemish that escaped the notice of the printer's curator or with creases in its margin will be depreciated in the marketplace, regardless of whether the defect materially affects its esthetic appearance or not, even if outside the Print

World such mundanities may seem to be arrant quibbling. The practice of good connoisseurship stimulates self-restraint and a healthy discrimination *against* impressions of prints, and what is rejected—the avoidance of mistakes—may well be more important than what is acquired or admired.

The equipment required for the determination of a print's identity, comparative quality and condition, is much the same as that already prescribed for the ascertainment of its authenticity: reliable documentation (including, if appropriate, information about paper and tables of watermarks); other impressions and good illustrations for comparison; a 5–10 power lens; a metric tape measure; a good raking light (sunshine, a high-intensity bulb, or a strong light under a frosted glass); an ultraviolet lamp ("black light"); and a sharp visual sense. Long experience in viewing and handling prints also can help a lot. In recent years there has been an increase in the number of educational exhibitions of prints designed to stimulate and hone the visual acuity and sensibilities requisite for discriminating connoisseurship, and the print-department staff of every public collection is accessible for consultation and advice.

An impression cannot be judged under glass, but must be scanned naked from many angles, directions, and distances (see Fig. 5-A). The conclusions set forth in sales-catalog descriptions should be suspended—or used simply as guidelines—for the duration of the examination. Prose is always subjective, especially when it is employed to enhance the positive and deemphasize the negative. Lots of dealers and auctioneers are not very clever or careful practitioners of connoisseurship themselves. And some ruthlessly withhold information when they possess it, either to grease the sale or to shift the burden of an indiscretion to the unwary customer and escape a loss.

Since fingermarks can stain and an inadequately supported proof can crease and tear, prints under scrutiny should be handled with washed hands and, if unmatted and large enough to bend, gripped gingerly with two hands on opposite sides, near the corners. In his 1881 monograph on Bartolozzi, Andrew W. Tuer gave detailed instructions on lifting prints:

> Nothing is easier than to handle a print, and nothing is more difficult. . . . In handling an engraving use both hands, securing a corner tenderly between the thumb and first *or* second fingers of each; but in doing so, care must be taken not to place the thumbs *between* the two fingers, or . . . disastrous results will most probably follow.

The experts themselves sometimes disregard such injunctions and become dangerously cavalier about handling, even more so when they have no personal interest in the property being handled. Johann Wolfgang von Goethe, a print enthusiast who wrote about, among other things, print collecting, once observed how "they [the curators] grasp an invaluable copper-engraving . . . with one hand, as the politician grasps a paper and crumples it." Dealers assault consignments at auction previews that

wing a print from the verso against a bright light, such as daylight, aids in ascertaining its
dition. Here the author's daughter shows how this is done. *Left:* Wood engraving illus-
ed in Fig. 4-F. *Right:* Albrecht Dürer, "Michaels Kampf mit der Drachen" ("St. Michael
hting the Dragon"), showing the Latin text on the verso. Woodcut from the 1511 edition
he *Apocalypse* (B. 72; M., Holl. 174). 392 x 283 mm; $15^7/_{16}''$ x $11^3/_8''$. (PHOTOS BY THE
HOR) Fig. 5-A

they would handle reverently at home. The ash on connoisseur Lessing
Rosenwald's cigarette once ripened to such a length that while respectful
onlookers watched in horrified silence, it dropped off onto a rare
Schongauer engraving he was inspecting; unperturbed, Rosenwald
flicked the cold ash off with his pinky. When examining a print, best put
out cigarettes and put away pens. In the 1920's, the Print Room of the
British Museum posted a notice with this language:

> All prints, etc., must be carefully handled, so as not to soil or otherwise
> injure them. Visitors *must take off their gloves*, and must refrain from resting
> their hands or elbows, and from laying books, etc., upon the prints.

That is still good advice.

THE IDENTITY OF THE PROOF

The first task of connoisseurship is the confirmation of the identity of the
proof, including its date—a cataloguing process. The corpus of graphic
works of many artists has been recorded by catalogues that serve the
Print World the way *Scott* and *Yvert et Tellier* serve stamp collectors.
While current scholarship is constantly upgrading and updating the data
in these standard catalogues, which vary greatly in accuracy, compre-
hensiveness, and utility, they are the indispensable touchstones for con-

noisseurship. A description of any particular impression should include its edition (and publisher), state, date of realization and printing, catalogue raisonné number or documentary reference, if any, and its *provenance*, if available.

Every change which is made on a matrix (printing surface), whether a modification to the design, alteration to a line, retouch, erasure or substitution of inscription, renovation to conceal wear or damage, trimming or beveling of a plate edge, signals a new *state (état, Zustand)*. And because some states are coveted for their rarity and scholarly import alone, and the indicated state may constitute a *prima facie* shorthand reference to quality (early states are as a rule better than late states), the state of an impression may be a significant ingredient in its value. The state of an impression may, however, have as little to do with its quality as a handwritten signature may have to do with its value as art. In certain cases, impressions of later states may be of superior quality (not to speak of condition) than impressions of earlier states. And there may be a wide swing in the technical excellence of printing within any one state as the result of, among other variables, a deteriorating matrix.

Certain catalogues raisonnés, such as Meder's *Dürer-Katalog* and Harris' catalogue of Goya's graphic oeuvre, chronologically list, in addition to the states of a print (which in Dürer's and Goya's cases are evidenced mostly by trial proofs), the aggregation of all printings (as they might have been recorded or as they might be revealed by the quality of inking and printing, the appearance and disappearance of scratches, wormholes, or other blemishes and defects of the matrix), and the variety of paper (and its watermark, if any) on which the impression appears. It should be remembered that the order of such indices is simply chronological and not qualitative: a Meder "b" may in some particular case be of better quality than a Meder "a," and a Harris "Sixth Edition" *Disasters of War* is better than a "Third." There is also often no across-the-board consistency of quality among similar designations; thus a Meder "g" of one print may be brighter than a Meder "c" of another. Moreover, although cataloguers such as Meder and Harris have been wondrously thorough, they understandably missed some things. One frequently comes across a watermark or a vicissitude of image that doesn't quite fit Meder's prescriptions, making one ponder whether one is interpreting Meder's guidelines correctly or, more likely, possesses something which escaped that incredibly painstaking scholar. Such cataloguers donate a universally understood vocabulary for communicating data about an impression, but their work cannot preempt the exercise of examining and comparing impressions. "In this business," Sinclair Hitchings, Curator of the Boston Public Library Print Collection, once commented, "book learning helps, but seeing is knowing."

The kind and manufacture of paper on which the impression appears, besides providing clues for the verification of its authenticity, can help place the impression within the chronology of the print's states or edi-

tions. Shiny, soft-surfaced, gossamerlike, durable Oriental papers—
Japan, China, and India papers—have been manufactured from long,
sinewy vegetable fibers (not rice) for 2,000 years; unwatermarked Japa-
nese kozo (from the bark of the mulberry tree) and gampi (from the inner
bark of the gampi plant) papers were first imported into Europe in bulk
by the ships of the Dutch East India Company in 1643. *Chine collé* (*Chine
appliqué*) is a sheet of China paper (the English erroneously call it "India"
paper) of onionskin thinness laminated to a heavier European stock,
which the French themselves began to manufacture in the 19th century.
Chine volant is thin China paper.

Virtually all papers are either "laid" (*vergé; Bütten*) or "wove" (*vélin;
Velin*—to be distinguished from vellum, which is treated calfskin or
lambskin). *Laid* paper, handmade in single sheets in a wooden mold cov-
ered by a screen constructed of horizontal and vertical brass wires, was
for centuries the only variety of paper manufactured in Europe, until
English papermakers learned how to spread pulp on a finely woven mesh
screen in 1755. When held up to light, laid paper reveals distinctively
translucent, closely spaced parallel "laid lines" crossed perpendicularly
by thicker parallel "chain lines," from one-half inch to two inches apart,
made by the long wires of the screen that supports the draining matte of
pulp (Fig. 5-B). *Wove* paper has an evenly mottled surface. A watermark,
made by a filigree in wire threaded to the screen, may be impressed in
either laid or wove paper, where it haunts the sheet as a ghostly, translu-
cent vision that materializes when held against the light or placed on a
black surface.

Papers are either handmade in a wooden rectangular mold, mold-made
on a moving cylindrical mold, or machine-made on a power-driven con-
tinuous belt. Paper made by hand, sheet by sheet, has always been ex-
pensive. The scraggly deckle edges of handmade paper, caused by the
seepage of liquefied pulp into the cracks between the mold frame and the
overlapping removable deckle frame, are usually sheared off prior to
printing, though it is fashionable today to bleed a lithograph right off the
deckle edge and leave the deckle edges intact. Paper-making machines
came into general use in Europe in 1812 and began turning out a cheap
wove paper (which could be impressed with artificial laid and chain lines
and watermarks by a cylindrical dandy roll) that was smoother, evenly
thinner, and of more homogeneous consistency than handmade paper.
Cotton and linen rags were recycled throughout Europe until the mid-
19th century, when papermaking technology was sufficiently refined to
admit wood pulp as the basic raw material for papermaking. For cen-
turies before the age of newsprint, the scarcity of rags, which during one
era made interring a corpse in linen or cotton a criminal offense in En-
gland and rag-mongering a lucrative profession throughout Europe, ren-
dered paper a precious commodity that could not be squandered. Old
master prints normally have very small margins. The use of wood pulp
made users of paper more profligate, but the paper itself less durable,

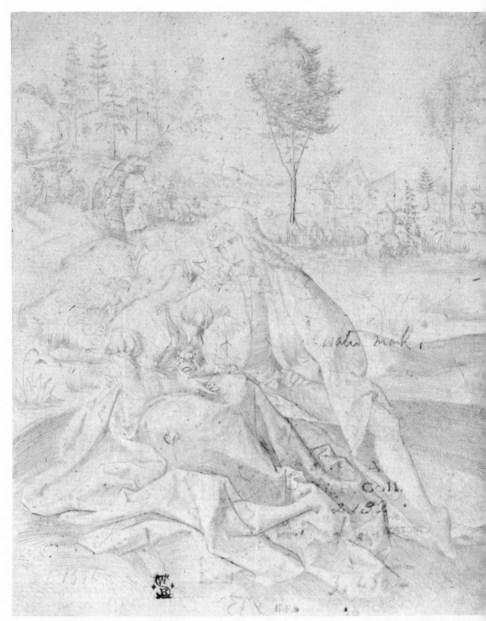

Meister M.Z. (Martin Zasinger), "Das Liebespaar in einer Landschaft sitzend" ("Lovers S
ting in a Landscape"), seen from the verso and backlighted. Engraving, c.1500 (B. 16; L. 1
149 x 122 mm; 5⅞" x 4¹³/₁₆". The Arms of Cleve with a Lion watermark (Lugt. 43), chara
teristic of late printings, and a number of collectors' marks, including that of the Bost
Museum of Fine Arts (Lugt 1820), show on the verso. (COLLECTION OF THE AUTHOR) Fig. 5

highly susceptible to tearing, deterioration, and fading. Any proof badly yellowed or browned by light and air most probably consists of paper manufactured after the middle of the 19th century from strongly bleached cellulose.

Each batch or make of paper, whether laid or wove, European or Oriental, handmade or machine-made, has a distinctive personality. Each has its own peculiar, identifiable chemical composition, structure, texture, surface appearance, color, hardness, strength, weight, pliability, opacity, absorptive and reflective capacity, erasure receptivity, durability, light-fastness, stability on exposure to air and smog, and sizing (the glue, resin, or gelatin that gives paper its hard surface) resistance to absorption, and flexibility. A paper can often be identified, and hence states and editions of prints verified, through identification of these characteristics.

A watermark (filigrane; Wasserzeichen or Wz.) in the paper, or the absence of a watermark, can sometimes aid in pinning down the period and region of printing and the specific printing itself. Watermarks, however, have always crossed borders. Paper has long been a commodity in international trade, and while the protection of papermaking trade secrets inhibited intercourse among competing mills, from time to time sales of papermaking molds, with their embedded wire designs, would remove watermarks from their place of origin. Furthermore, although paper mills sometimes used the precise same watermarks or slight variants over many, many years, paper mills and printers have habitually warehoused runs of paper for long periods of time (the pages of an old book can show a score of different watermarks); and artists and publishers themselves have often employed papers much older than the date of the edition. Depending on the particular print, impressions of the same state can appear on papers with a diversity of watermarks, and impressions of different states or editions can appear on papers with the same watermark. So the best clues to the time and place of printing in most cases where frequent reprintings have occurred are the nature of the paper and the quality of the impression, and not the presence or absence of a particular watermark.

Over the centuries, watermarks were probably used for a variety of trade purposes—as a logo, trademark, autograph, customs declaration, or inventory stamp for a specific batch of a certain size or composition of paper—though one writer once romantically speculated that old watermarks were "emblems, imperishable thought-crystals in which lie enshrined the traditions and aspirations of many generations of papermakers." Catalogues raisonnés typically specify the kind of paper and the watermark filigree, if any, which should be expected; but even some of the most scholarly and reliable do not impart such information, and some that do, contain information that is incomplete or misleading. Several compilers have indexed and illustrated the thousands of emblems, symbols, decorations, places of origin, coats of arms, monograms,

and trade names which inhabit the paper of old master prints. C. M. Briquet listed and reproduced the 16,112 of them that he could confirm were used in Europe between 1282 and 1600 in his four-volume reference work, *Les Filigranes* (1923; 1966 reprint) (Fig. 5-C). Heawood covered about 4,000 17th- and 18th-century watermarks in his 1950 tome, *Watermarks;* and more recent works, *Ochsenkopf Wasserzeichen* ("Oxhead Watermarks"; 1966) and *Kronen Wasserzeichen* ("Crown Watermarks"; 1961) have meticulously detailed all the permutations of oxheads and crowns—thousands of them—that lurk in old German paper. There is no encyclopedia of the watermarks found on 19th- and 20th-century papers.

Once the identity and date of the particular impression has been established through the configurations of its design, its paper, and other characteristics, its *provenance*—its chain of title and record of exhibition—may be noted. A good *provenance* may be vital to the verification of the authenticity of a painting or drawing, but it has little relevancy to the authenticity of a print. Yet the art world also attaches a certain measure of cachet and, consequently, value to the onetime public exhibition of a work of art and its onetime ownership by some celebrated personality, great collector or connoisseur, hoary institution or sagacious dealer. Much like the beds that George Washington slept in, the thing gets endowed with the distinction of the human whose hands caressed it. An extensively recorded *provenance* both conveys a comforting supposition

A page from C. M. Briquet's four-volume work, *Les Filigranes*, illustrating seven of the 1,390 oxhead watermarks pictured. A watermark may help to date the paper and consequently the time of printing. Fig. 5-C

about the sustentation of value and invites the potential owner to join the parade of recorded history. Good *provenance* gives a print extrinsic appeal: romance, a little bit of history, and snob appeal. If the King of Saxony collected it, it is at least superior to something nobody collected, goes the thinking, even if in reality the King was no great connoisseur.

While some "collector's marks" do transmit a justifiable expectation of high quality (e.g., the etcher Seymour Haden would possess only the finest Rembrandts, rich with burr), people have sometimes misguidedly used *provenance* as a vicarious judgment about quality. In truth, the quality and condition of an impression speak for themselves; no boost from the past can modify current fact. The most illustrious pedigree adds nothing to the esthetic appeal of the print. It is in fact ludicrous when dealers and auctioneers trumpet an impression's lineage to exalt its "importance," much as they bruit a recorded watermark, when there are weak links in the chain of title, when logically the prior ownership by certain personages should deprecate, and not distinguish, the impression. While the collections of Rembrandt etchings amassed by Nowell-Usticke and the Viscount Downe, which were sold at auction a few years ago, were more noteworthy for their comprehensiveness and uneven quality than for uniformity of fineness, some printsellers even now use "ex Nowell-Usticke" and "ex-Viscount Downe" generically as sales points. Many old and famous collections were similar mixed bags, and a celebrated name should not be relied upon as an assurance of quality. The King of Saxony and hundreds of other eminent possessors before and after were not very fussy about consistency of high quality. And merchants regularly peddle cheap reprints imprinted with the blindstamp of the Chalcographie du Louvre as "ex Collection Louvre Museum"!

Snob appeal and a sense of history aside, information about a print's *provenance* may at least establish a rebuttable presumption about identity and authenticity—pro or con. Since, however, dealers and auctioneers are customarily silent about their sources, *provenance* can normally be confirmed only by any ink stamp, blindstamp, or other notation that the printer, the publisher, a dealer, or a former owner may have placed on the recto or verso of the impression (see Fig. 5-B). (Some prints do evidence their *provenance* in other ways. Some are inscribed; some are known to have enjoyed successive auction sales and appearances in dealers' catalogs; some display identifying idiosyncrasies. Most of the numbered Picassos formerly owned by Georges Bloch, the cataloguer of his graphic works, for example, are numbered 1/50.) Frits Lugt listed and illustrated thousands of such "collector's marks," narrated their social histories, and related anecdotes about their originators in his two-volume work, *Les Marques de Collections de Dessins et d'Estampes* (1921 and 1955).

QUALITY OF THE IMPRESSION

The quality of a print is an important determinant of its value. Quality is one factor on which esthetics and monetary value enthusiastically concur. The quality of the impression determines both its esthetic and commercial worth, except as it may be depreciated by certain kinds of physical damage. In both esthetic and monetary terms, a "poor" impression is worth a fraction of the value of a "superb" one, all other things being equal.

The quality of an impression of any subject defines the technical appearance of that image relative to the ideal appearance of that or a similar image. Quality among impressions is perforce always comparative and always expressed subjectively. A declaration about quality expresses a judgment about the degree to which a given impression maximizes the esthetic intentions of the artist, as measured by an archetype reflecting the communion of pristine printing surface, perfect inking, ideal choice of paper for the image, and flawless printing. Each image has its own qualitative range. For a contemporary print, the variation in quality within an edition can be negligible; for an old master print—executed before it became fashionable to cancel the matrix to preclude reprinting—broad and diverse.

There have always been print connoisseurs who prefer technical perfection to art. There have also been many cognoscenti—the thousands of etching collectors of the late 19th and early 20th centuries and admirers of fine lithographs and intaglios today—whose great appreciation of masterful execution and high printing quality has inhibited their ability to distinguish between mere technical mastery and the inventive exploitation of a graphic medium for expressive purposes. Much as a talented dancer can make bad choreography look good, technical gimmickry, finesse in execution, and slick printing—great cookery—can make an inferior work of art seem lustrous. A critical eye can be mesmerized by the surface appearance of a print and the wonders of the printmaking process that brought it into being. This is not to underemphasize the importance of technical quality. Just as a bad performance can ruin an exquisite ballet, inept or inappropriate execution, the wrong paper, and poor printing can make the most extraordinary conception fail. At a certain point the absence or fading of quality certainly does render the art unappealing; it becomes impossible to separate the estimable dance from the hapless dancer. William Ivins was undoubtedly overstating his case when he asserted that "the poorest impression of a really great print, no matter how shabby it is, is still a great work of art." A balanced view of the importance of quality in prints is a discriminating view.

The quality of a proof is, naturally enough, defined by qualitative language. In all tongues one encounters a range of adjectives, going from

bad to best, that includes bad or worn, poor, fair or fairly good, good, very good, fine, very fine, excellent, rich, brilliant, superb, and incomparable. Silence about quality should be taken skeptically. Since there are no language norms to impose uniformity of meaning within a language and no Rosetta Stone to equate technical vocabulary interlinguistically, the words used to describe the quality of an impression will only be as plain and reliable as the experience, sensibility, and trustworthiness of the spokesman. One American's "very good" will be another's "fine"; a German's "*prachtvoll*" ("superb") will be a Frenchman's "*belle*" ("good," not "beautiful"). Experienced American and British connoisseurs (except some of German extraction) are apt to be candid. In translation the French tend to be admirably conservative but laconic; and the Germans and Swiss, charitable and effusive. Neither adjectives nor silence can ever replace sight. One does not know an impression before seeing it, nor its quality before seeing other impressions.

The quality of the impression is affected by the condition of the printing surface. A fresh printing surface delivers up proofs that are strong and clear, that maximally display the textures, volumes, tonal ranges, gradations from light to shade, contrasts, and space that the creator presumably had in mind. The impact of repeated inking and printing on the matrix eventually takes a toll, no matter what its durability. The first impressions from a freshly executed, unsteelfaced copperplate sparkle and glow; the incised lines are crisp, three-dimensional, and unbroken; any burr, which gives velvet color and depth to the image, is robust. As the surface of a soft metal plate wears down and its lines flatten out from pressure printing, the printed lines lose definition and depth, and any burr disappears altogether. The once rich blacks and clear forms of an etching, drypoint, aquatint, or mezzotint become pallid and blotchy, as the hatchings, strokes, and pits lose their capability to hold ink and deposit it sharply on the paper. Late impressions, or restrikes, look weak, dull, gray, hard, uncontrasted, one-dimensional, and show the once latent details of the toolwork like an X ray shows the skeleton—scarcely the image the artist intended and ofttimes a travesty (see Fig. 3-H and Fig. 3-I). The image has relinquished its pictorial personality.

With incessant printing, the relief lines of a woodblock wear, break, and splinter, especially in the contour lines and border lines (Fig. 5-D), and the block itself may develop cracks; insects and worms often bore into wood stored between editions in a dark, damp corner. The greasy drawing on a lithographic stone or plate, at first so clear and luminous and delicate, will at some point during a long printing begin to disintegrate, demanding heavier and heavier inking and seeping into the untouched areas until the image loses resolution, becomes muddled, and finally resists any efforts to revive its pristine distinctness by "re-etching." Chemicals coated on the printing surface to preserve it during storage can also promote the "washing-out" of a lithograph, a state when the design can no longer attract and hold sufficient ink. All matrices are

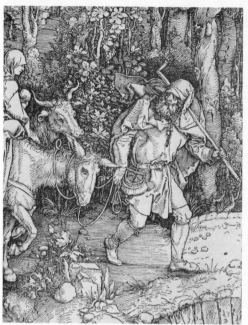

Detail from Albrecht Dürer, "Die Flucht nach Ägypten" ("The Flight into Egypt"). Wood (B. 89; M., Holl. 201). 298 x 210 mm; 11¾" x 8¼". *Left:* a very good impression before 1511 text edition (Meder b/c). *Right:* a poor impression, probably from the sixth editi c.1590 (Meder d/f). The first print bears a bull's-head watermark (Meder 62); the second crowned double eagle (Meder 222). (COURTESY OF THE PHILADELPHIA MUSEUM OF ART [CHAR LEA COLLECTION] AND THE PENNSYLVANIA ACADEMY OF FINE ARTS) Fig. 5-D

bound to acquire scratches, pits, flecks of dust, and other ravages and contaminations over time.

The quality of the impression can also vary with various inkings and printings, for human, mechanical, and chemical capabilities will themselves produce disparate results. The tone and intensity of the inking, as well as its precision and fullness, can differ from one pull to another. Overly heavy inking, sometimes combined with an increase in printing pressure to compensate for a deteriorating printing surface, can clog lines and make an impression seem ponderous, without proper contrast. Overly light inking, sometimes done to disguise worn-out lines or tones, can make an image that is too faint and dry, without appropriate balance between dark and light values, shadows, and highlights. Uneven inking can forfeit traces of the image and, like the thin inking of a healthy matrix, make the proof seem later than it really is.

The relative care and proficiency brought to bear in printing and curating can also make a difference in the attractiveness of the impression. Inexact registration of color plates can cause overlays of colors that can mar their effective integration. Slippage of the paper or printing surface during printing can cause a blurred image or a "printer's crease"; uneven or insufficient pressure can deprive the paper or areas of it of a full complement of ink; excessive pressure will produce impressions that are too dark and thick, like the first proofs off a mimeograph machine; and

inadequate pressure, impressions that are too delicate. Impressions of old master woodcuts in particular often contain lines that were smudged or doubled during printing, weakly printed, or rendered indistinct. Crude printing can make the condition of the printing surface appear to be worse than it actually is. Some of the later editions of Goya's aquatints are of superior quality to earlier ones, though the plates were more worn, simply because they were more carefully and precisely printed. Etchers following the late experiments of Rembrandt have sometimes deliberately left films of ink on clear areas to create tonal effects, and impressions showing such "plate tone" must be distinguished from those that reveal merely sloppy printing (as well as those doctored by foreign hands with India ink or gray wash).

The paper selected for the editions can substantially affect the transmission of the image. Tamarind Lithography Workshop once published a tract entitled *The beauty and longevity of an original print depends greatly on the paper that supports it—*. The surface appearance, texture, color, and absorptive quality of the paper can significantly enhance or spoil the image. Some kinds of paper absorb certain kinds of inks better than others; some are particularly well suited to the etching press or for multicolor printing; some soften the design, and others give it a hard look. Oriental papers (apart from *Chine appliqué*) can impart a certain richness and atmospheric quality, with some consequential sacrifice of clarity and detail. Editions are sometimes printed on two or three varieties of paper, with the run on Japan the most expensive; yet, though it is always less expensive, the impression on the harder, more rough-textured European paper is ofttimes the most appropriate for the image.

Connoisseurship must discern what measures have been taken to "improve" the quality of the impression, since doctored prints have less appeal under our current value system than the earlier proofs they imitate. For centuries, the renovation of damaged copperplates and woodblocks to extend their working lives was considered a commendable and not an outrageous thing to do, and no one was vexed by the generation of restrikes that superficially resembled earlier proofs as long as they were not passed off as early proofs. Today we tend to be incensed over the violence done for commercial gain to Rembrandt's copperplates and Dürer's woodblocks, not to speak of Delacroix's lithographic stones, and uncharitable toward impressions that have been touched with pen and ink by hands other than the artist's.

An exhausted printing surface can be revived, though never returned to its original state. The lines and tones of an expiring intaglio can be strengthened with the burin, drypoint needle, or acid, and drypoint burr regained by light scratching around original drypoint lines. Woodblocks can be patched with recarved chunks of wood and plugged where a worm or insect made its tunnel. Fatigued lithographic stones can be "re-etched" to revive the design. Of course, the design of a renovated printing surface will vary slightly from the pattern of an unrefreshed one, and

impressions from doctored matrices will usually be heavier and coarser than earlier proofs. It is in fact sometimes difficult to distinguish an impression of an old master print resulting from an incompetently retouched or recrosshatched plate from a hand-drawn copy. The catalogue raisonné may provide helpful guidelines.

The heavy inking of a worn plate or stone is another tactic employed to compensate for its senility, and care must be taken not to confuse the heaviness of a richly inked impression from a worn printing surface with the richness of an impression from a relatively fresh one. The simulation of drypoint burr and darkening of shading or individual lines with India ink or a gray wash to make poor impressions of old master intaglios seem finer were measures once commonly undertaken for commercial profit, for until the modern era, when prints at last became sacrosanct art objects, most of them were treated fairly unsanctimoniously. Overlaid ink will repose as a flat layer on top of preexisting ink since it cannot penetrate the old ink; pen strokes have blunt ends (an engraver's burin and the drypoint needle leave tapered ends); gratuitous ink may differ slightly in shade or texture from the printing ink of the impression; the additions will often have contours that are too firmly defined (true burr customarily bleeds imperceptibly into the white of the paper); ink blobs may show through to the verso; and the added ink often will glint or appear glossy when peered at obliquely against a raking light and fluoresce with a different color or intensity from the original ink under a "black light." Retouchings of the printing surface or the print itself are not, however, always conspicuous. The detection of subtle differences in lines, tone, and texture on impressions that have been worked over by highly skillful restorers is by no means simple. One should avoid the lure of rich or brilliant areas by looking away from them to other areas, and suspiciously rich areas should be examined under a microscope. The poor quality of undoctored lines, for example, may expose the artificiality of the treated ones.

CONDITION OF THE IMPRESSION

Condition is another vital element of value, primarily of commercial value. While the damage displayed by an impression can obviously tarnish its allure as a work of art, there are numerous defects and deficiencies—clipped margins, thin spots, hinge stains on the verso, light mat stains, to mention but a few—that detract not one whit from its esthetic appearance and yet depreciate its value in the marketplace. Even more curious, mere *evidence* of repair or restorative ministration, no matter how inobvious to the naked eye and no matter how beneficial, will devaluate the impression. In other words, a reminder that an impression was actually once in less than perfect condition can undermine its desir-

ability even when skillful restoration has brought its apparent condition up to standard. To watch one fancier blanch upon being told that the lower right corner of his "Fair of St. George's Day" *after* Brueghel— which he had proudly displayed as a centerfold illustration for the catalog of his print collection—was a redrawn replacement of the original, is to observe a man absorb a substantial monetary and psychological loss!

The weight the Print World assigns to condition is sometimes about as rational as its constructs about the artist's handwritten signature. The marketplace has again constructed an archetype—in this case, the perfect impression in the perfect state of preservation—for all other impressions to emulate, and those that fall short of the ideal will be coveted proportionately less. Just as a used car without any scratches or dents is more attractive to most people than a banged-up one with a sounder motor, many Print People will pass up a good-quality impression with superficial problems for a mediocre impression that is unblemished. Some of the same people who snub slightly damaged impressions might be shocked to realize just how many of the prints on the market whose condition is represented as perfect have actually been washed, bleached, remargined, or otherwise freshened or patched up, for paradoxically, good restorative work *can* sometimes restore much, if not all, of a print's lost monetary value. To state the obvious, the more successful—i.e., undetectable—a repair or restorative measure is, the more it will be overlooked by the print market. Some dealers—even some of the most "reputable" ones—make enormous profits by buying damaged merchandise and committing it to a restorer for a quick and easy augmentation of commercial value (see Fig. 12-E). Research of an impression's sales history is sometimes instructive. The Emil Nolde etching "Fraulein H" priced in a 1973 P. & D. Colnaghi catalog at £650 and described as having "some creasing and soiling at the edges of the margins" had been bought by that firm for £340 at a 1971 Sotheby auction, where it was described in the catalog as having "the bottom right corner missing." (Conversely, clumsy restoration can reduce rather than enhance a print's market value.) Of course the importance that the marketplace attaches to condition depends upon the relative availability of impressions that approach perfect condition. Few Print People would touch a contemporary print visited with severe damage, but there are few who would not jump at a damaged rare old master print, if only because its scarcity and value would justify the cost of restoration.

When a professional encounters a print, the first thing he looks for, after absorbing its communicative power, are its imperfections, and his first observations commonly consist of what is wrong with it. Familiar with the image, he is quick to focus on the print's shortcomings. Its state of preservation is not a matter for subjective opinion. Though there may be serious disputes over the very existence of a flaw or a repair, since diagnosis can itself be unsure, the factors that determine condition, unlike many of the factors that determine quality, are matters of fact and

not of opinion. One uses nouns and verbs, not adjectives, to describe the condition of a proof.

The amount of detail that forthright dealers and auction-firm staffs employ in their catalogs to disclose the condition of a print will vary with its monetary value. While all the flaws, both major and minor, of a very expensive print will be—or, at least, should be—noted, the minor flaws of an inexpensive print will often be overlooked. Shotgun terms such as "damaged" and "creases" and "heavily restored" ought to be appreciated for their full, ominous generality. The lack of any word, either good or bad, about condition might, prior to an examination of the print itself, be most prudently interpreted as an indication of the presence of a ruin.

Damage or despoilment of the paper or the amelioration of such flaws can best be detected by examination of the verso against both an intense light and a black surface with both the unaided eye and a magnifying glass, and with a black light. Various defects will be obvious to the eye, and various repairs (unless a magician of a paper restorer worked some magic) will reveal themselves through their vestiges or as shadows. By deepening contrasts in light and dark values and causing substances of differing chemical composition or physical character to fluoresce differently, a black light will highlight foxing (those brown spots caused by the action of mold on traces of iron salts in the paper) that has been removed by bleaching, fresh ink, paper patches, ironed-out creases, the paste used to mend a tear or a missing piece, erasures, and the like. An examination by black light is not always conclusive, however. Differences in illumination or fluorescence are sometimes too subtle to appear conspicuous, and some flaws and repairs are not made manifest by exposure to ultraviolet light. Savvy and resourceful restorers also use nonfluorescing pastes and other materials to outwit the black light, and attempt to match papers exactly.

Condition is exemplified by the presence or absence of the following factors:

1. PAPER DEFECTS AND DEFICIENCIES. Physical violence to paper includes loss of paper, tears, nicks in the edges, holes, pinholes within the image, abrasions, thin spots, creases, centerfolds (prints were once tucked into books and albums for safekeeping), trimming of margins or portions of the composition, and adhesion to another sheet of paper or cardboard (what in England is called being "laid down") (Fig. 5-E). An impression backed with, or "laid down" on, another sheet of paper or cardboard for support may or may not be valued less than an unstuck proof. The market has always accepted the backing of oversize, fragile lithographic posters by Toulouse-Lautrec, Mucha, and others with sheets of cloth or muslin, since otherwise they might easily tear and crease from handling. But it rebuffs "laid down" old master prints, which were probably once album displays, in part because of the uncer-

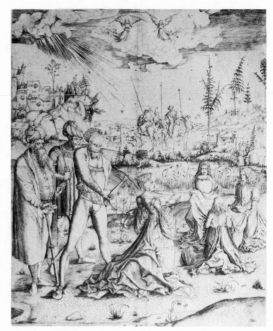

Meister M.Z. (Martin Zasinger), "Das Martyrium der Heiligen Katharina" ("The Martyrdom of St. Catherine"). Engraving, c.1500 (B., L.8). 313 x 258 mm; 12⁵/₁₆" x 10³/₁₆". This engraving has suffered severe damage; it is stained, foxed (the spots in the open sky, center), torn in many places, and bisected and rejoined. Yet it is a rare, brilliant early impression, and its condition may be ameliorated by skillful restoration. (COURTESY OF CHRISTIE, MANSON & WOODS LTD.) Fig. 5-E

tainty about what defects may lie on the verso hidden by the backing sheet, in part as the result of unrealistic predilections that our ancestors would have considered eccentric.

The matter of margins as an element of value is one of the Print World's classic eccentricities. The existence of ample margins on old master prints—except for those, like Canalettos', that were published in bound portfolios—is uncommon because handmade paper was once a dear, conserved commodity and collectors trimmed off any margins on prints to affix them, like decals, to box lids, fans, and screens, and to mass them more economically, like shapshots, in books and albums. Wide margins were first prized when, with the availability of cheap glass in the latter part of the 18th century, prints became somewhat more cherished as glass-covered wall decorations than as scrapbook collectibles. The public's fondness for margins became so acute during the late 19th century that artists such as Signac and Buhot and Luce furnished buyers with special impressions that contained marginal doodles outside the composition ("*remarques*"). None of the practical reasons sometimes offered to explain the preference for wide margins—ease in handling, protection of the image, the endowment of the composition with balance and breathing room—makes any more sense today, when prints are always stored or framed carefully in mats, than it did 100 years ago when Whistler, snorting that his prints were as dignified as margin-short old master prints and that *paintings* didn't have margins, defied the vogue and amputated the margins from his etchings, leaving only his signature tab as a relic. Yet today the presence of wide margins on an old master print remains a matter for special notice in sales literature, and the importance of full margins to the full value of a modern print is unequivo-

cal. Of the two impressions of one Matisse lithograph sold at the 1974 Kornfeld auction, one impression, though slightly light-struck and of relatively poorer quality, fetched 10 percent more than another better impression whose bottom margin, though perfectly ample, was somewhat trimmed. The only explanation for such irrationality is the usual premise that underpins much of the Print World's value structure: An impression with a physical property that another lacks or falls short of is simply worth more *per se!* That may at times seem silly, but it is how the game is played.

Chemical violence to paper embraces brittleness; foxing; rust marks; staining from contact with moisture, dust, smoke, a cardboard mount with high acid content or other pollutants; discoloration (browning, yellowing, etc.) from contact with air or exposure to light; and translucence from contact with Scotch or other brands of household tape. (These matters are covered more thoroughly in Chapter 12.) Many prints have survived in an excellent state of preservation because they were seldom framed and displayed but were stored in boxes and portfolios free from contact with chemicals and materials that can cause paper to disintegrate and discolor. Papers of exceptional durability, stability, and lightfastness are widely available today for contemporary editions.

Much of the physical and chemical violence to the paper on which an impression appears is amenable to treatment by a paper restorer. One encounters thousands of proofs with corners or portions of the composition reconstructed and grafted on (such practices were reviewed at the end of Chapter 4), borderlines redrawn, margins replaced or reinforced, tears mended, holes plugged and inpainted, creases ironed out and thin spots silted over, and with paper bleached (to overcome fox marks and discoloration), washed (to remove embedded grime and stains), pressed and resized (to restore tensile strength, suppleness, and resistance to soiling). A well-"Schweidlerized" print—the artistry of the master restorer of Zürich-Gockhausen—is an astonishing achievement to behold (see Fig. 12-E). There are some paper problems that are resistant to remedial treatment, however. The grip of some adhesives used to glue impressions to an album page or backing sheet can be loosened only at the expense of the print itself; a bad crease will never disappear entirely; and most color prints will not withstand bleaching and must abide, under the regimen of current technology at least, with their stains and fox marks for the millenium.

2. COMPLEXION PROBLEMS. Like teen-agers, the faces of prints tend to have complexion problems. The recto of a print may accumulate ink- or pencil-marks, dust and dirt, scratches and rubbing, and it may at some time have been varnished, as was customary before glass became cheap. Most surface stains, specks of dirt, and soiling will succumb to erasure or cleaning by a restorer, though indelible ink and other organic chemical stains may be impervious to cosmetic treatment. While a good laundering and bleaching can brighten up the surface of a print as effec-

tively as they do dirty linen, such action may flatten, whiten, and devital-
ize the paper, and pressing or ironing can impart an unnatural
smoothness to the surface. The chafing of dark areas of an etching, mez-
zotint, or drypoint may give them an unsightly burnished appearance,
and even a light grazing of the delicate surface of a lithograph or silk-
screen, especially the latter, will leave streaks. Varnish will irreparably
impair the surface tone of a print, and abrasions and the effects of a rub-
bing of the pigment can seldom be wholly rectifed.

3. TROUBLE ON THE VERSO. The verso of the print, which
most people delighted by the recto will never see, may have shortcom-
ings sufficient to deter the fussy *amateur*. The back of the impression
may have stains left by old hinges or the glue which affixed it to an
album page and thin spots caused by erasures, concessions of paper to
the sheet it was peeled from (like the thin areas on an uncanceled postage
stamp removed from an envelope), or the tearing of a mounted impres-
sion from its hinges.

4. FADING OF COLORS. The pigments of many color prints,
such as Toulouse-Lautrec lithographs and Rouault color aquatints, are
susceptible to fading upon exposure to light and air. Hence an impres-
sion with colors still as pristine and fresh as the day of publication may
be valued at double or triple the amount of an impression whose colors
have changed hue and which thus represents something other than the
artist's original conception. Of course what may at first seem like a faded
color may in fact be a color variation. The body of Toulouse-Lautrec's
"The Englishman at the Moulin-Rouge" (D. 12, A. 3) (Fig. 5-F) varies
in shade from violet to chocolate to light gray. Contemporary printers
and publishers have been much more sensitive than their forebears to the
problem of fading colors, and most employ inks that are substantially
more fade-resistant than those used half a century ago. One can gener-
ally rely on the color constancy of prints published during the 1960's and
'70's, without becoming too complacent about it. The oral revelation at
the May 1975 Sotheby Parke Bernet New York auction that the "tonal-
ity" of two Frank Stella lithographs (Fig. 5-G) "was slightly altered by
exposure to light" defeated their sale at the prices expected.

What is ultimately of significance is the relative importance that one
assigns to each bit of information that emerges during the pursuit of con-
noisseurship. The priorities about matters of identity, quality, and con-
dition that are expressed in terms of price by the marketplace may not
realistically correspond to priorities that are ordered according to a stan-
dard, such as esthetics, that differs from traditional Print-World canons,
conventions, and myths. The process of assigning proper weight to the
various elements of value and devaluation (the judgment-reaching pro-
cess) is sometimes aided, in other words, by the posing of incessant

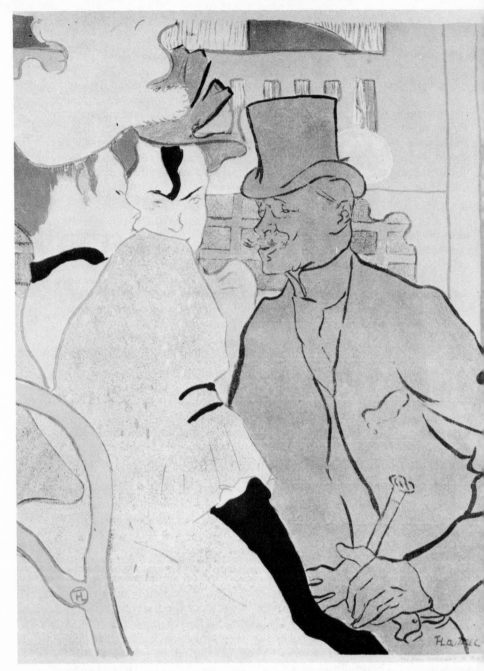

Henri de Toulouse-Lautrec, "L'Anglais au Moulin-Rouge" ("The Englishman at
Moulin-Rouge"). Lithograph in colors, 1892 (D. 12; A. 3). 470 x 372 mm; 18½" x 14
Lautrec's famed Englishman was printed with inks ranging from light gray to deep purple
some, however, the gray pallor indicates faded colors. The colors in this impression are fr
(COURTESY OF MARTIN GORDON INC.) Fig. 5-F

Frank Stella, "River of Ponds III." Lithograph in colors, 1971 (Gem. 272). 965 x 965 mm; 38″ x 38″. Colors on many recently printed Stella lithographs and other contemporary graphics have faded from exposure to light. (COURTESY OF GEMINI G.E.L.) Fig. 5-G

should-it-matter questions. Here are a few: Should it matter that a print is rare if it is an unattractive work of art? (It might, if your primary interest is scholarship, investment, or ego gratification.) Does it really matter if there is a one-half inch tear in the margin? (It might, if the price is the same as the price of an untorn proof, and you do not wish to suffer immediate dilution of your investment.) Is the deluxe edition with wide margins on Oriental paper really worth the increment in price? (It might be, if the Oriental paper greatly enriches the image.) A value system that the Print World at large does not share may be a congenial alternative for the casual buyer, collector, or curator.

PART TWO
ABOUT THE COMMERCE IN PRINTS

Roy Lichtenstein, "Explosion." Lithograph in colors, 1967 (B. 24). 559 x 432 mm; 22″ x 17″. (COURTESY OF LEO CASTELLI GALLERY AND ERIC POLLITZER)

Chapter Six

A Chronicle of
the Print Boom

In the graphic arts everything is much more com-
plicated and difficult, emotionally more demand-
ing, because one does not work by oneself, but is
faced with a team, with many people, with ma-
chines, printers and other technicians; sales and
distribution, too, are more complicated than in the
case of paintings. It is a great emotional and phys-
ical strain to produce works of graphic art. . . .
one has to paint on different materials, on the
stone from which one prints, on transparent foil
from which the drawing will be transposed, or on
the screen; one draws on copper and the result is
never quite what one imagines. It is an art around
the corner.

—HUNDERTWASSER, 1975

We are still, according to the art seismographs, in a Print Boom:
New York City is the center of the worldwide art market, and there
are over 100 art dealers, galleries, publishers, and distributors in New
York City specializing in prints, not including the uncounted dealers in
paintings and proprietors of frame shops that maintain racks of them for
browsers. There are at least 500 establishments outside New York, Lon-
don, and Paris, the major art metropolises, where one can buy a signed
Picasso. Jack Solomon presides over a half-dozen or so Circle Gallery
graphics supermarkets in American cities coast to coast, and Harry Sal-
amon shuttles between *his* galleries in Milan and Rome. In the major
markets, tourist shops that once sold "ivory" bric-a-brac and transistor
radios have been replaced by stores hustling "original graphics" by (?)
Braque, Calder, Chagall, Dali, Miró, Picasso, and LeRoy Nieman
(mostly copies of their paintings) for "investment"—at double and triple
their true commercial values. Prints have become so ubiquitous that the
Euston Gallery in London—a city where no art dealer had the temerity
to champion modern prints until 1955—recently defined its exhibition
policy as "trying to encourage the public to appreciate and buy original
paintings instead of prints and posters."

Prints have become a major feature in the art landscape. In 1973 the Musée d'Art Moderne in Paris turned over all its exhibition space to a retrospective of 634 graphic works by octogenarian Joan Miró, complementing brilliantly the retrospective of his paintings at the Grand Palais, and in 1974 the Whitney Museum in New York donated wall space to the complete graphic oeuvre (36 prints) of Alex Katz, who until then had been overlooked by the multitude of new books and museum catalogs about contemporary prints published during the ten years previous. At the International Art Fair in Basel, Switzerland, each year throughout the 1970's (there were no art fairs at all, anywhere, until 1967), prints have been more conspicuous than work in any other medium, visually dominating the stands of some 300 art sellers from some 20 countries, the ten-pound Fair catalog, and the fliers handed out by those dealers who preferred doing business out of their briefcases alfresco. The *Art News* critic reporting on the art displayed at the Basel Fair in 1973 reserved her highest accolade—"scintillating"—for a portfolio of prints, *A Furnished Landscape*, by British artist William Tillyer. In 1976 no less than three periodicals, published in New York, Paris, and Milan, were devoted to prints. Just a few years ago there was none.

Artists vie for scores of printmaking fellowships, prizes, and awards, from Ljubljana, Yugoslavia, to Honolulu, Hawaii, and there is scarcely an artist working who has not tried his hand at printmaking. Some contemporary artists have become rich from their prints alone. An elderly Salvador Dali commands $35,000 or so for a gouache that skilled artisans will metamorphose into a "lithograph," and relatively new graphics by David Hockney, Robert Rauschenberg, Jasper Johns, Hundertwasser, and Helen Frankenthaler, which could have been bought for about $100 in 1966, are priced a decade later at over ten times that amount and beyond. Newly issued Miró and Chagall lithographs are such consistent sellouts that Maeght Editeur in Paris decreased its trade discount from 30 to 15 percent, the lowest of any print publisher. At the three-quarter mark of this century, there are over 50 major publishers of prints *outside* Paris, some with their own ateliers but most of whom contract out the printing to one of the dozens of recently established graphics printshops scattered throughout America, England, and the Continent. Throughout the 1970's big-name artists have been donating editions of their prints for the benefit of "peace candidates," preschool children, public libraries, Saving Our Planet, and a chair at Columbia University honoring art historian Meyer Schapiro. Charity groups and women's clubs that once organized theater benefits and fashion shows now sponsor print sales as well.

Prints have become very expensive during the 1960's and 1970's, and some became speculations. Prints that were unmarketable a decade ago have been finding new homes. In an era when traditional investment vehicles seem precarious and currency fluctuations make such international units of account as gold and art better bets than currency and

Xerox, art investment trusts have been stocking away Rembrandt etchings and Munch, Picasso, and Toulouse-Lautrec lithographs. During the early 1970's, art dealers were able to build profits simply by "warehousing" inventory and disinterring long-buried stock; Leslie Waddington of London has been hoarding Picasso prints costing thousands of dollars ("they're still cheap," he advises), and farther down Old Bond Street the hoary firm of P. & D. Colnaghi has been finding customers for Muirhead Bone and D. Y. Cameron etchings that it had kept salted away since the Great Depression. A Heckel color woodcut purchased for $6,250 in 1972 cost an auction buyer $21,000 a year later. At the 1973 Kornfeld und Klipstein auction in Bern, Switzerland, three dealers from London, Zurich, and Campione d'Italia dueled for the right to pay $180,000 for a rare Picasso etching they had passed up in 1955 when it cost only $1,000. An at an auction in Munich in 1974, bidders pushed Friedrich Meckseper's "Elephant," which Paris dealer Heinz Berggruen catalogued for $37 in 1965, to 8,000 deutsche marks (then about $3,500)—then let it fall later in the year to a "realistic" 2,500 deutsche marks (then about $1,250).

The popular press has not failed to take notice of this art-market activity. In 1970, the financial reporter on the *New York Post* devoted an entire column to "The Print Explosion," and four years later reported that "The Print Boom Rolls On"; *U.S. News and World Report* in 1974 recorded rising values for prints under the headline, "Now Art Investors Turn Their Taste to Prints"; and Marc Rosen, the head of Sotheby Parke Bernet New York's print department, wrote an article for *The Investing Professional*. All of a sudden, modern prints—and signatures—have become valuable enough to attract counterfeiters.

An understanding of how we arrived at this state of affairs—an acquaintance with the people, the events, and the art that have given this Print Boom sustenance—may refine a person's understanding and appreciation of prints themselves and give new and diverse insights into the personalities, forces, and passions operative in the Print World today. The cultural history—even a very recent cultural history—that surrounds what is essentially an inanimate *objet d'art* can enliven its inert values with humanistic qualities. On a less metaphysical level, an appreciation and familiarity with the people, institutions, and events that have figured in the Boom as it evolved and matured may make anyone's excursion into the Print World easier and more enjoyable.

THE STATE OF THE POSTWAR
PRINT WORLD

When New York dealer-patron-tastemaker Curt Valentin died in 1954, the print market was moribund. Valentin had worked hard to bring it to

life. Audaciously, he had been a print proselytizer. He had shown thousands of imported prints—Klees, Picassos, Beckmanns, Feiningers, Mirós, Arps, priced at from $10 to $100—to his 57th Street sculpture and painting buyers. He himself had published portfolios of prints and books about prints. Yet almost ten years after his death, the Marlborough-Gerson Gallery's 1963 inaugural exhibition of 289 art works, "A Tribute to Curt Valentin," had only one print—a Masson lithograph entitled "Curt Valentin." Some Tribute! Even in 1963, it seemed, not many people in the art world thought prints were very important.

To almost everyone in the 1950's and early 1960's, the graphic arts were arts and crafts, or the kinds of illustrations and designs that artists who were not "serious" artists produced to earn a living. "Serious" artists worked in garrets on paintings and sculptures. Even to most of those who were aware of how Dürer, Rembrandt, Goya, Daumier, Picasso, and others had exploited printmaking's expressive potential and flexibility to create "art," a print was essentially a *media* medium. Lithographs and silkscreens were decorations, posters, handbills, billboards, displays, and advertisements printed in printshops by journeymen who belonged to Local No. 1 of the Amalgamated Lithographers, a closed shop. "Prints" sought everyone's eyes everywhere every day. Graphics were mundane: the interminable chains of "Du . . . Dubon . . . Dubonnet" eye-popping posters lining the Metro tunnels at Châtelet, the reproductions of Van Gogh "Sunflowers" and Self-Portraits-sans-Ear in thousands of school lunchrooms, the "Lovers' Indiscretions" and "Deer in the Moonlight" over motel headboards. William M. Ivins, Jr., the great print curator of the Metropolitan Museum of Art, was not uttering any profundity when he said, "The importance of being able to repeat pictorial statements is undoubtedly greater for science, technology and general information than it is for art." Prints, historically, have always been so much more important for communication than for art, and in the years following World War II especially, the mundane media medium seemed banal as art. Prints were proletarian—with one exception, etchings. And if etchings were, well, concededly "art," they were to the mid-century mentality mostly arid, tiresome pictures to be fussed over by boring old men or used as bait by pseudo-intellectuals who inveigled young innocents to "come see" their collection.

In the competition for appreciation with paintings, drawings, and watercolors, the print also suffered from three additional disabilities. First, it was a multiple, and therefore less rare and valuable, less aristocratic, less cherishable, than the one of a kinds. The first question every neophyte asks about a print is "How many are there?" At a time when unique works were plentiful and relatively cheap, the egos of art buyers found it difficult to tolerate the existence of 99 exact duplicate originals. The mind balked at the concept of a "multiple original." Second, there was a gap, occupied by the work of the artisans who aided the artist and their printing press, between the artist's acts of conception-execution and

the creation itself; the "touch" of the artist's hand was removed from the completed work. Third and last, most prints were frankly and purposely reproductive. Printing was synonymous with *distribution*, not art-making. After all, throughout the centuries, with few exceptions, wood-cuts, etchings, and engravings had been used to reproduce and spread otherwise unobtainable visual messages and images, at least until French *peintre-graveurs* (artist-printmakers), such as Odilon Redon and Toulouse-Lautrec, in the late 19th century seized the graphic media, particularly lithography, as appropriate for strictly *artistic* expression.

The fact that some art historians and print connoisseurs had reevaluated as "art" or at least as technical *tours de force* many etchings, wood-cuts, and lithographs originally conceived as reproductive prints and not as works of transcendent beauty was ignored by an indifferent and uninformed public. To most people who visited museums in the 1950's, "art prints" were the pictures of pictures, the inexpensive room decorations, that you could buy in the Uffizi bookshop, Oestreichers in New York, or the Seine bookstalls in Paris. In the art field, lithography was a printing process used primarily for reproducing and recording and circularizing images of *other* art, not a process for artists to play around with. Most people who had walls to cover could scarcely care less whether a picture on paper was "original" or not. A reproduction of an oil painting of Montmartre à la Utrillo would do just fine.

Most art critics and art historians, with grudging concessions to Dürer, Rembrandt, Goya, Daumier, Lautrec, Munch, and Picasso, treated the print as a distinctly minor art, a diversion or dalliance from the proper and principal business of the art-makers rather than just another way they could create great images. They shunted printmaking to the side of the mainstream of art history. The art history books tended to be occupied with painting, sculpture, and architecture, and the editors of popular art periodicals kept away from the museum print cabinets and the Paris print ateliers. Even today, that traditional attitude relegates prints, no matter how much more desirable and valuable they may be than the offerings of paintings and drawings, to the end lots of the artist's oeuvre for sale at auction.

The people who did talk or write about graphics largely reinforced their own insularity. The available bound literature about prints was of two sorts. There were the catalogues raisonnés of artists' graphic oeuvre: compilations of data and parochial, congratulatory art criticism terribly useful to fanciers, connoisseurs, curators, and dealers, but without much appeal to a more general audience. And there were books on the history of etching and engraving and on the "appreciation" of prints. Stuffy, pretentious, intimidating, largely unreadable books for the most part, deadened with parades of names of forgotten printmakers, laden with long-winded glossaries of esoteric printmaking terms and techniques and enlivened by dull reproductions of stipple engravings, mezzotints, and woodcuts illustrative of the refinement of certain craft techniques at cer-

tain times in history. Books that inhibited appreciation of prints as works of art by defensively assaulting the reader with elucidation of craft and craftsmanship, which drew attention away from pictorial effects by focusing on process and mechanics and technical virtuosity—which gushed over the technics of engraving white beard hairs on a thin sheet of copper. Books that detailed how the bad art was made as well as the good, without much discrimination between; that displayed Dürer's magnificent "Knight, Death and Devil" on the same page as a stylized court portrait by Jean Michel Moreau simply because they were both engravings. It was as if a book on the appreciation of art underscored as prerequisites for choosing and enjoying paintings, drawings, and watercolors the chemistry and fabrication of all the varieties of colors, chalks, washes, canvas and paper, the physical structure and mechanics of various kinds of bottles, brushes, and palettes, and the physics involved in the use of all these materials! As Ivins wrote, "The only two techniques that are really of any artistic importance are rarely or never mentioned in essays and books upon the graphic techniques. They are pictorial imagination and sharp-sighted, sensitive draughtsmanship."

If, undeniably, knowledge of data and techniques heightened the pleasure of those already hooked on fine prints, the accentuation on connoisseurship and expertise encouraged a stultifying elitism which repelled and excluded the average art consumer. Paradoxically, the art that could be widely circulated was mostly claimed instead by a clannish circle of collectors, curators, and dealers, who stored their accumulations in boxes and drawers for quiet private measurement and contemplation, like stamp collections. Very few prints were ever released from museum boxes for display on museum walls: for the most part only the acknowledged masterpieces of the great masters. The Bibliothèque Nationale of Paris, the guardian of the bulk of France's great public collection, continued to violate the face of each new acquisition with its unsightly "BN" ink stamp, as if it were branding cattle rather than preserving images whose visual appeal could be tarnished by such defacement.

The Print World was small, populated by few Print People, in the period immediately following World War II. There was no print publishing industry as we know it today. The print-buying public, such as it was, was serviced by a few department stores and sellers of five-dollar prints, as well as by a small number of wise, sensitive, and scholarly dealers. The first sort included the May Company in St. Louis, Galeries Lafayette in Paris, and Associated American Artists of New York. Sylvan Cole, AAA's president, who first joined the company in 1946, recalls that in the early 1950's it was "almost degrading" for museums and collectors to buy from AAA; "we were *persona non grata* in the art world." The second group of printsellers was comprised of experienced men who offered their modest clientele old master prints and "modern" prints by artists whose reputation and stylistic maturity had been established in the decades prior to World War II.

Several American personalities had somehow survived the Great Depression and the war. New York's Kennedy Galleries, where Albert Reese stocked Americana and fine European prints, was founded in 1874. Erhard Weyhe's, where Carl Zigrosser had published and tried to sell Depression-era young American artists before departing in 1940 for a curatorial position at the Philadelphia Museum, had been in business since 1919. Jake Zeitlin, who had opened in downtown Los Angeles in 1925, was still buying stock from Kennedy's and Weyhe's, as well as in London and Paris. Herman Wechsler, who served his print apprenticeship selling reproductions and a few five-dollar prints at Macy's during the Depression years, helped introduce Lautrec posters to America and accumulated a huge inventory of high-quality French prints. He introduced Sylvan Cole to the supply sources of Paris, and he sold prints to investment banker-art donator Roy Neuberger and art-book publisher Harry Abrams. The Contemporaries, a Lexington Avenue gallery started by Margaret Lowengrund during the war, sold $25-$75 European graphics as well as Collectors of American Art editions of woodcuts, etchings, and lithographs made in its own studio workshop by such artists as Milton Avery, Adolph Dehn, Will Barnet, Seong Moy, and Graham Sutherland. (In 1956 the Rockefeller Foundation financed the takeover of the workshop by Fritz Eichenberg's Pratt Graphic Art Center.) New York also harbored such old master printsellers as Richard Zinser, Helmuth Wallach, Lucien Goldschmidt, Frederick Rockman, William Schab, and Walter Schatzki.

The European Print World was mostly confined to London, a few cities in Germany and Switzerland, and—the heart of the art world—Paris. London had the Redfern Gallery selling fine modern prints and Osbert H. Barnard (heading the Craddock & Barnard firm) and the staff of P. & D. Colnaghi selling old masters. When Colnaghi's legendary Gustavus Mayer died in 1954, the leading expert among European dealers in old master prints was Edvard Trautscholdt, who emigrated after the war from Leipzig to Düsseldorf with his firm of C. G. Boerner while the Iron Curtain still had chinks. There were also three progressive German dealers—Alex Vömel of Düsseldorf, Gunther Franke of Munich, and Galerie Nierendorf of Berlin—who emerged from the ruins still championing the prewar German artists of the avant-garde. Gérald Cramer had been publishing and dealing in *livres d'artistes* with etchings and lithographs by Braque, Miró, and Picasso out of his home in Geneva since 1943, and August Laube was working with his father in Zurich. Paris supported Paul Prouté et ses fils (especially Hubert), Henri-M. Petiet, Marcel Guiot, Marcel Lecomte, Henri Cazer, and Pierre Michel.

Paris in the 1950's was still the focal point for pilgrimages by young artists and art buyers. Alone among art centers, Paris possessed enough workshops and trained, skilled craftsmen and attracted enough artist-printmakers to make the printing and publication of prints a successful industry. In 1945 there was perhaps no other lithography atelier in the

world other than Fernand Mourlot's on Rue de Chabrol where Pablo
Picasso could have found the skills, professionalism, deference, and ma-
chinery (not to speak of a fuel allowance for heat!) that enabled him to
explore the limits of lithography with such audacity and success.

Yet in 1948, deluged by an outpouring of prints that could not find
enough buyers, Daniel-Henry Kahnweiler of Galerie Louise Leiris, Pi-
casso's publisher and dealer, was compelled to secure an outlet for them
by syndicating, upon favorable terms, a group of dealers, including Curt
Valentin (whose New York subscriptions were taken over by Eleanor
Saidenberg following his death), Pierre Lundholm of Stockholm, and
Heinz Berggruen of Paris, who agreed to absorb all of Picasso's graphic
production. Those dealers and their successors, some of whom later be-
came millionaires—in part as a result of Kahnweiler's steadfast adherence
to the deal he had solicited in the face of soaring values for Picassos—
had no idea in 1948 that they were subscribing to a fabulous annuity. In
the 1950's, there was only a handful of places in the world where you
could buy a signed Picasso. As Jake Zeitlin of Los Angeles remembers,
"People just weren't buying black and white graphics. There was just no
market for them until the late 1950's."

Few artists, except Picasso and others of the School of Paris, found
printmaking a particularly appropriate thing to do in the postwar era.
Henri Matisse's 1947 illustrations for his book *Jazz* made by the applica-
tion of splashy colors through stencil forms (what the French call a
pochoir process) served as a harbinger of the silkscreen techniques later
taken up by Andy Warhol and the Pop artists of the 1960's. Georges
Braque, also working at Mourlot's in the 1950's, soon developed a keen
sensitivity for the potentialities of lithography that later would be so
fully exploited in the new ateliers of America in the 1960's. And
Picasso—well, Picasso was, as Mourlot fondly remembers, doing "every-
thing the wrong way . . . yet it always worked!" Still, most artists of in-
ternational renown working in Paris in the 1950's, including Arp,
Chagall, Giacometti, Léger, Masson, and Miró, made—or watched mas-
ter printers and *chromistes* make—prints that were generally either timor-
ous extensions of their work in other media, multiplied drawings, "trans-
lations" or reproductions of paintings and drawings, or duplicated pic-
tures that *should* have been paintings or drawings.

Unless they went to Paris, American, British, German, and Italian
artists found it difficult either to innovate *or* to reproduce in the graphic
medium, even if they cared to. There were no formidable, viable ateliers
or professional craftsmen the equal of those in Paris to attract, stimulate,
advise, and promote artists in America, England, Germany, or Italy in
the early and mid-1950's. In 1959, the year before she established the
Tamarind Lithography Workshop in Los Angeles, June Wayne was
compelled to travel to Paris to make the illustrations for a book of John
Donne's poetry.

Printmaking for public consumption in America and England was

somewhat where macrame and metal jewelry are today. It reposed in artists' cooperative printmaking studios, art-center workshops, and the graphic arts departments of universities and art schools. The artists who taught and worked there, such as America's Gabor Peterdi (a Hungarian), Mauricio Lasansky (an Argentine), Fritz Eichenberg, and Leonard Baskin, were by occupation printmakers, not painters. They were competent spokesmen for craft and texture in printmaking. But like grammarians who are more concerned with how to say it than with what is said, they were academic practitioners working outside the new currents of contemporary art, showing more versatility with the medium than inventiveness with the imagery. Many of them were the progeny of Stanley William Hayter's influential Atelier 17, removed from Paris to New York during the decade 1940–50, where new intaglio techniques had been devised permitting the realization of texture in soft ground etching and deeply bitten lines for color etching. The exhibition catalog, *American Prints Today*, sponsored by the Print Council of America and devoted largely to etching, included no artistic personality then or now considered representative of avant-garde art movements.

In the absence of the level of technical assistance and printmaking traditions (apart from intaglio) that artists could find in Paris and with little incentive to make prints, few young innovative American or British artists, other than those who succumbed to the academic influence of the campus and urban printmaking studios, cared to devote their energies to acquiring and implementing the craft know-how of preparing copper plates and stones, using etching acid and lithographic tusche, and printing impressions. There were no noteworthy avant-garde painters attracted to printmaking outside Paris who possessed the determination, sensitivity, and capability to explore, exploit, and extend the peculiar properties of the printed image for the creation of imaginative and distinctive art.

Jackson Pollack, Robert Motherwell, and Louise Nevelson had experimented with intaglio processes at Hayter's in the 1940's, while their styles were in evolution (Pollack's work was discovered only after his death), but in the 1950's, they and their modernist colleagues were committed to other methods of expression and imagery incompatible with the small scale and discipline of etching. Josef Albers was motivated to translate his painting imagery into multiplied pictures by his commitment to the Bauhaus creed of moving art into the environment. British artist Richard Hamilton thought of himself as a printmaker before his adventures in Pop, but his prints of the early 1950's are, significantly, mostly abstract scratches on copper and celluloid, uneditioned intimacies. Printmaking was not a vehicle for adventurous expression outside of Paris during the postwar years.

Of those American artists, other than the studio graduates, with styles that differed from the late 19th-century esthetic, only a few of the expressionist, representational, and regionalist painters, such as Ivan

Albright, Milton Avery, Will Barnet, Thomas Hart Benton, and Ben Shahn, and stylized favorites of the Depression period, such as Adolph Dehn, Wanda Gág, Emil Ganso, William Gropper, Rockwell Kent, Louis Lozowick, Karl Schrag, and Raphael Soyer, were much motivated to have their images multiplied, and then only sporadically. Avery made lithographic covers for the souvenir catalog of the annual Artists Equity Ball. Benton reproduced his anecdotal paintings. Most of these artists belonged to and exhibited annually with the conservative Society of American Graphic Artists (founded as the Brooklyn Society of Etchers in 1915) which, as the Society of American Etchers, had recognized lithography as an art form only in 1947. In 1953, Associated American Artists, the New York print retailers, abandoned its program of publishing an annual five-dollar print by an American artist (the market simply wasn't there), and until Sylvan Cole reestablished contact in 1958, lost track of the artists who made them. Robert Rauschenberg recalled in 1962 that he "began lithography reluctantly, thinking that the second half of the twentieth century was no time to start writing on rocks." The attitude of Franz Kline, who eventually executed an etching for the Morris Gallery portfolio, *21 Etchings and Poems* (1960), as expressed to *Art News* editor Thomas Hess around 1955, represented that of his fellow modernists: "Printmaking concerns social attitudes . . . like the Mexicans in the 1930's; printing, multiplying, educating; I can't think about it; I'm involved in the private image. . . ."

Franz Kline's temperament and attitude toward his function on earth were typical of the decade of introversion, the decade of the 50's. Creative people tended to hide their feelings or express them, if at all, in private acts of creation, rather than by "letting it all hang out." Young people lived alone, not in communes with strangers; danced mostly closely, not far apart where they would be on exhibition; and did not share "reefers" or water pipes, except on the rooftops of slum tenements. Group therapy and consciousness-raising sessions were frightening disciplinary programs used by the Chinese Communists, not young Americans. People resigned from society when it consumed or oppressed them: they became beatniks rather than activists. Political and social apathy were fashionable; the only campus disorders were panty raids and mononucleosis. Colors in fashions and decor were subdued, and men's styles permitted them to blend into rather than stand out in a crowd. It was certainly not a time for artists to think about "printing, multiplying, educating," as Franz Kline confessed; not a time for avant-garde artists to challenge the cult of the unique.

Most of the young innovative artists of Franz Kline's generation shared his occupation with the unique, intensely personal image. They were artists who preferred to work in isolation, where they could come to grips with their materials without outside interference, advice, or scrutiny. The poets of the action painters were the Beat poets; their writers and philosophers, the existentialists. Their life style was what was then

called "bohemian." They sought to blend art with life, not like Huys-
mans' Des Esseintes, by exchanging the abhorred materialism for a spiri-
tualism full of strange and beautiful sensations, but by concentrating as
much on the act of creation as the nature of the creation itself. Inspired
chance, and not planning, was the foundation of art-making. The procre-
ation of multiple art products through this kind of introspective, only-
one-of-its-kind creative experience was repugnant to these young artists.
They were not interested in making pictures that many people could af-
ford. They recoiled from printmaking's requirements of collaboration
with assistants and publishers, involvement in depersonalized technol-
ogy, multiplication of essentially private gestures, and direct implication,
by launching an edition, in the commercialization and mass distribution
of their art. When in the early 60's, a new generation of artists creating
Pop and Op emerged from the garrets to face, instead of flee from, the
impact on society of technological advances, commercialism, and mass-
media messages, they naturally turned to graphics as a medium for ex-
pression. Many of the older generation relented only reluctantly. "I must
explain," apologized Barnett Newman, after he had been cajoled into
making lithographs in the early 1960's, "that I had no plan to make a
portfolio of prints. I am not a printmaker."

Artists as a class in part ignored printmaking in the immediate years
after World War II because it gave little or no financial return for the in-
vestment of time and effort, and if the artists absorbed them, for the
costs of materials and equipment. If they sold at all, prints sold cheap.
The American artist's slice of his 250-impression edition for Associated
American Artists, which they sold for five dollars each, was only a few
hundred dollars (scores of artists today receive over $10,000 for an edi-
tion). Impressions of Picasso's earlier works, which were plentiful, re-
tailed mostly at the lower end of a range from $50 to $150, and new edi-
tions searched for buyers at from $10 to $25. The market for Picasso
prints was still so bad in the early 1950's that Henri-M. Petiet, who in
1941 had bought the 300-copy edition of the 97 plates of what is now
dubbed the *Vollard Suite*, did not release single sheets into the New York
art market until 1955. Paris dealer Heinz Berggruen's 1954 English-
language catalog, with prices in dollars to make buying easy for Ameri-
can tourists, listed Arps from $8 to $12.50, Bonnards from $6 to $180,
Braques from $75 to $300, Calders at $8, Chagalls from $6 to $75,
Dubuffets from $12 to $17.50, Raoul Dufys from $6 to $25, Ernsts from
$5 to $18, Kandinskys from $5 to $75, Klees from $20 to $250, Matisses
from $25 to $200, and Mirós from $6 to $75, to survey the first half of
the alphabet. Almost all of what are today considered master prints by
great modern masters and are priced accordingly at $5,000 and up could
have been picked up in 1955 for under $100! The bulk of all the prints
sold at auction in New York, London, Paris, Stuttgart, and Bern were
still "catchpenny prints," relatively speaking. Denigrating prints as
"nothing more nor less than pictures and drawings reproduced in quan-

tity," Gerald Reitlinger omitted them from consideration in his otherwise pervasive study of the picture market, *The Economics of Taste*, published in 1961.

THE FUSES OF THE PRINT BOOM

The renascence of interest in prints and the renaissance of printmaking, which were to be triggered by the happy confluence of a surge in demand, the emergence of contemporary artists from their occupation with the private gesture, and the appearance of new support facilities and entrepreneurs, were being kindled during the 1950's and early 1960's by education, experience, the quiet vitality of the established print dealers, and the influence of two young, dynamic auctioneers.

The educated middle class in Europe and America was made increasingly art-conscious during the postwar era. As university enrollment increased, an unprecedented number of young people seeking a liberal arts education were exposed to art history and appreciation. At the same time, museum attendance swelled dramatically, as students and graduates sought confirmation of what they had learned in the classrooms. The Museum of Modern Art in New York mounted comprehensive exhibitions of the graphic works of Redon and Picasso in the winter of 1952. In 1955 students, artists, and museum-goers in Paris, London, and New York, who came to look at the paintings, were bedazzled by a major retrospective of Picasso's graphic work, including the public unveiling of his pre-World War II Vollard Suite of etchings. To bring the opportunities for appreciation and instruction closer to home, colleges and cities that were distant from the major art centers rehabilitated or established their own museums and art centers, and the new curators filled them out, cheaply, with prints.

There were also proselytizers among museum curators and those whom the French call *amateurs de l'estampe:* print fanciers and devotees. Gustave von Groschwitz, print curator at the Cincinnati Art Museum until 1963, staged the First International Biennial of Contemporary Color Lithography at the museum in 1950; he hosted four more biennials thereafter, until 1960, when the competition expanded into the International Biennial of Prints. Of the 250 prints from 14 countries shown in the first Biennial, only 19 sold. But 300 were sold at the Fourth in 1956, which was supported by prints from 32 countries and publicized by *Time* magazine. In 1954, Paul T. Sachs, who taught at Harvard's Fogg Museum, induced the Rockefeller Foundation and the Rosenwald Foundation to finance the acquisition by colleges and museums of prints published by the International Graphic Arts Society for a rental program producing income for the purchase of more prints.

In 1956, Lessing J. Rosenwald, a print enthusiast who devoted most of

his life to generating enthusiasm in others—and donated most of his vast collection to the National Gallery of Art—invited a number of curators and *amateurs* to organize the Print Council of America. The Print Council was designed as an educational and merchandising vehicle to stimulate and promote understanding and appreciation of prints, as well as their creation and dissemination. In its early years, it compiled and distributed information about prints and printmaking, propagandized the appeal of prints as works of art, and sponsored circulating exhibitions and sales of contemporary prints. In its later years, it attempted to deal with the excesses resulting from a hyperstimulated print market by broadcasting a code of fair practice, authenticating the 99 dealers who swore to uphold the code, mass distributing a brochure entitled "What Is an Original Print?" and policing and exposing deceptive practices and abuses. Currently functioning as a loosely knit association of curators, the Print Council is mostly remembered today for its outmoded definition of an "original print," which in the middle of the Print Boom was rendered reactionary by evolving technology.

There were hot pockets of interest in cities with substantial museum print cabinets. The Print Clubs of Cleveland and Philadelpia and the Print Collectors' Club of London, an adjunct of the Royal Society of Painter-Etchers and Engravers, functioned in the 1950's as little hotbeds of activity serving their memberships and communities, so much so that the historian of the Cleveland Print Club has paradoxically labeled the 50's its Golden Decade!

If it flickered brightly only intermittently, the flame of printmaking was kept very much alive during the 1950's. New York's International Graphic Arts Society, a nonprofit print-of-the-month-club organization founded by Theodore J. H. Gusten in 1951, played a salutary role. IGAS invited distinguished Print People to serve on juries in Europe and the United States and charged them with the task of selecting new works by artist-printmakers for publication and submission to members (mostly, recalls former IGAS officer and board member Joshua Binion Cahn, dentist-in-Great-Neck types) for bargain prices at from $4.50 to $15. The artists—none of the avant-garde in those early days, but people such as Hayter, Schanker, Fischer, Lowengrund, Seong Moy, Music, Margo, Peterdi, Lurcat, Dehn, Landeck, Ben Zion, Sister Mary Corita, Amen, Baskin, Florsheim, Erni, Landau, Shahn, Summers, and Escher—were delighted to have the commission for an edition of 210 impressions. In America in the 1950's, no one else except Associated American Artists was publishing prints on a comparable scale or esthetic level.

In Paris, however, the venerable printers and their ateliers were kept humming by the masters and the lesser artists of the School of Paris (as well as a few foreign guests) and by a new breed of ambitious and energetic publishers and dealers who fed them work. Paris' skill and sensitivity in etching and printing copperplates were celebrated throughout the art world. Raymond Haasan (Paul's son), Georges Leblanc (the son

of Charles, who trained at Delâtre's), Lacourière-Frélaut (Roger La-
courière printed for Ambroise Vollard), and the brothers Crommelynck,
to mention only a few, underpinned that reputation. Even Hayter had
moved his Atelier 17 from New York back to Paris in 1950. Aldo and
Pierre Crommelynck were kept so busy by Picasso in the early 1950's
that in 1955 they gave up all other work and installed an etching press in
"La Californie," Picasso's villa *cum* studio outside Cannes.

Paris had long been the center for fine art lithography, too (Fig. 6-A).
There was Georges Clot (the grandson of Lautrec's, Cézanne's, Bon-
nard's, and Vuillard's lithographer), Jacques Desjobert, and above all,
Fernand Mourlot and his extraordinary staff, including master lithogra-
phers and *chromistes* Charles Sorlier and Henri Deschamps (Fig. 6-B).

Henri de Toulouse-Lautrec, "La Lithographie, couverture pour le I^{re} année de L'Estam
originale" ("Lithography: Cover for the First Year of *L'Estampe originale*"). Lithograph in (
ors, 1893 (D. 17; A. 10). 565 x 640 mm; 22¼" x 25⅛". Master lithographer Père Cot
operates the hand lithographic press at the Ancourt printshop, while dancer Jane A
scrutinizes a proof. (COURTESY OF REISS-COHEN INC.) Fig. 6-A

ter Fernand Mourlot looks on while *chromiste* Henri Deschamps executes a reproduction
e Toulouse-Lautrec lithograph illustrated in Fig. 6-A. (COURTESY OF FERNAND MOURLOT;
O BY HERVÉ BORDAS) Fig. 6-B

Imprimerie Mourlot Frères, then situated on Rue Chabrol near the Gare
de l'Est, had a 70-year-old tradition when Fernand Mourlot persuaded
Picasso, Léger, and Marcel Gromaire in 1937 to make lithographs there.
Fernand Mourlot's father had been a Paris printer for decades. But when
Fernand assumed direction of the firm in 1921, he invested all the robust
energy lingering from his youth as an amateur boxer and all the sensitiv-
ity acquired during his days as a drawing student into elevating Mourlot
Frères into the most attractive and capable lithography workshop in the
world. Mourlot spent decades training colorists; he installed and watch-
fully maintained the most sophisticated presses (a dozen of them, includ-
ing two high-speed offset presses by 1975); and he nurtured an ambiance
conducive to mutual respect and profitable collaboration between artist
and printer. Mourlot's, the artist-printmaker Manessier has stated, is "a
place where one feels supported and yet quite free." By 1961, when the
atelier moved into more spacious quarters, and the "decade of lithogra-
phy" was just beginning in the United States, Fernand Mourlot had
thrust Picasso, Braque, Chagall, and Miró into prominence as the four
great modern masters of lithography. Yet in 1958, when Picasso was liv-
ing in the south of France and Mourlot was rushing litho ink and zinc

plates to him and picking up plates for proofing, he could not keep pace with Picasso's demands for rapid proofs, and Picasso turned to linoleum, which a local printer, Arnéra, could print that very day.

There were scores of familiar and new personalities active in the publication of prints and illustrated books, sumptuous *livres de peintre,* in Paris. The poet and publisher Iliazd produced handsome texts enlivened with drypoints by Picasso. After 1943, Tériade made the most substantial contribution to the art of the *livre de peintre* since Ambroise Vollard. He had left the Greek isle of Lesbos for Paris in 1916. In 1925, he was hired by his compatriot Christian Zervos to edit the modern section of the art revue *Cahier d'Art.* Late that year, he left to collaborate with Albert Skira in the publication of Picasso's engraved *Metamorphoses d'Ovide,* and in 1932, he and Skira launched the Surrealist periodical *Minotaure.* He established the art revue *Verve* in 1937. From 1943 to 1961 he published 19 *livres de peintre* in limited editions (seven more in the next decade) glorified by the prints of Rouault, Laurens, Matisse, Chagall, Léger, Gris, Le Corbusier, Gromaire, and Beaudin, including Matisse's *Jazz,* Chagall's *Les Ames Mortes, Bible,* and *Daphnis et Chloë,* and Léger's *Cirque.* Gérald Cramer, working from Geneva, commissioned distinctive works by Braque, Picasso, Miró, and Henry Moore. Commencing in 1946, Aimé Maeght, always searching for the best artisans and the best papers and ever seeking a happy union of artist and poet or writer, also installed the artists whom he supported—Braque, Giacometti, Chagall, Miró, Matisse, and many others—in the finest workshops in Paris to create limited editions of prints and illustrated books of exceptional quality. Both Tériade and Maeght circulated multicolor lithographs inexpensively as covers and centerfolds for their art periodicals, *Verve* and *Derrière le Miroir.*

During the period after World War II, Paris art dealers began to publish prints, too. Denise René became a publisher in 1949 by ordering and distributing prints executed by her own stable of constructivists and kinetic artists, including Vasarely, Herbin, Agam, and Soto. Heinz Berggruen, who had served in Europe in World War II as a cultural officer with the United States Army, and after his discharge, as deputy chief of the art department of UNESCO in Paris, was beginning his quest for knighthood as *chevalier de la légion d'honneur* (he made it in 1971) by varying sales of expensive paintings by modern masters with editions of prints by Pierre Courtin, Hans Hartung, and Hamaguchi. Madeleine Lacourière, wife of the renowned artisan who printed some of the celebrated graphic publications of Ambroise Vollard and Albert Skira— Picassos, Rouaults, Matisses, and others—herself joined their profession in 1953 by publishing, as well as printing, prints by Hartung, Richier, Singier, and Soulages.

Though Rex Nankivell of the Redfern Gallery in London had commissioned and exhibited prints by British artists in 1952, Robert Erskine was particularly active in helping to energize the nascent Print Boom in

Britain. While Erskine primed the pump for his first exhibition at St. George's Gallery Prints in 1954 with what are now classed as blue chips by the Paris big names (about which his banker sniffed, "Does anybody really pay money for things like this?"), "the real purpose of the gallery," as he has written, "was to get things moving in Britain." Erskine had been exposed to fine printing during visits to the Atelier Lacourière, where, as he recalls, "one saluted the printers by touching elbows, their hands and forearms being permanently covered in viscous black ink . . . with the pungent odour of printing-ink hovering in the atmosphere." While shops such as Ganymed Press and W. S. Cowell had done some printing for artists in the early 1950's, Erskine was appalled by the generally sloppy work pulled in London, in comparison with what he had witnessed in Paris, and he searched for English printers who could professionalize the printmaking of his gallery artists. When no clientele materialized for his locally printed multiples, he bombarded critics and journalists with pro-print propaganda and promoted the esthetic potentialities of the medium through a half-hour color film, *Artist's Proof*, showing artists creating duplicate works of art on paper. By 1957, the year Tatyana Grosman began Universal Limited Art Editions (ULAE) in West Islip, New York, Erskine was able to round up enough quality prints reflecting what was going on in British art to inaugurate an annual exhibition of the Best British Prints of the Year. For the 1959 annual, Erskine could draw from the editions being struck at the Curwen Studio, founded the previous year to provide a lithography atelier for British artists.

Of course the prints on view in London in the late 1950's were all lithographs and intaglios. When Christopher Prater set up shop in London in 1959 as a commercial screen printer and began rolling off posters for the British Arts Council, he was scarcely noticed. And when in 1962 Prater at length attracted the attention of artists Eduardo Paolozzi and Richard Hamilton with his first *artist's* print for London artist and typographic designer Gordon House, that commercial process had already been captured in a limited way by Andy Warhol and Robert Rauschenberg in the United States; June Wayne's Los Angeles Tamarind Workshop for lithography was slightly over a year old, and Grosman's Universal Limited Art Editions was five.

In America, as well as England, an increasing number of budding artists crowding the college art departments and art school graphic workshops learned and practiced the whole panoply of graphic techniques and developed into a reservoir of talent ready to incise plates and roll up stones when it became fashionable to make prints in the 1960's. While it is undoubtedly true that, in June Wayne's words, lithographs in America were being made "so poorly, I used to pick them up like dead mice" and that the activities of ULAE and Tamarind invigorated and helped revive a neglected art form in America, it was not exactly, as some witnesses have asserted, a "vacuum"—not in America and certainly not in

Europe—into which Tatyana Grosman and June Wayne moved. June Wayne herself was an early student at Southern California's Kistler Lithography Company, which began to handprint lithographs for American and foreign artists in 1947. The vacuum was locally formed for June Wayne when Lyton Kistler closed his door to artists in 1957 and forced her to journey from Southern California to Marcel Durassier's Paris atelier to make lithographs.

If the print market was moribund in the 1950's, it was not quite *in extremis*. The established print dealers—the staid print trade—continued to furnish prints to a coterie of aficionados. Some of these dealers were so set in their ways and attitudes that, when the Print Boom got underway, they were psychologically unprepared for it, complained about it, resisted it, and watched it pass them by. But the 1950's and early 1960's also produced a new crop of dealers with enough prescience to recognize and champion the qualities of the medium and enough youthful ambition and energy to promote it.

Paris, again, provided the most fertile soil. The Left Bank bookshop of Jacqueline and Bernard Gheerbrant—Galerie La Hune—for the first time supplemented the ordinary inventory of a trade bookseller with fine modern prints by Marcoussis, Villon, Michaux, Dubuffet, Hartung, Hayter, Ernst, and others. Commencing with his 1952 catalog of Klee prints, from his off-the-beaten-path quarters on rue de l'Université, Heinz Berggruen began to seek out customers for the graphic works of his specialties, Picasso and Klee, as well as those of Kandinsky, Matisse, Miró, and Chagall, through seductive posters and slender, richly illustrated stock and exhibition catalogs—the Berggruen *plaquettes*—that became models for his colleagues to emulate. In 1959, Jacques Frapier, whose father had published Bonnard, Denis, Dufy, Maillol, Matisse, Rouault, and Vlaminck in the 1920's, reopened the Galerie des Peintres Graveurs on the Boulevard de Montparnasse. La Gravure opened shop in 1952; La Nouvelle Gravure in 1956.

New dealers were stirring in Germany and America, too. Florian Karsch renounced lepidoptery in 1954 to help his remarried mother, Meta Nierendorf, in Galerie Nierendorf of Berlin. Upon becoming director in 1959, he accelerated the rejuvenation of the celebrated firm that in the years between World Wars I and II had bravely published and showed prints and other works by the German avant-garde artists whom Reichsminister Goebbels later apotheosized as "degenerate." Wolfgang Ketterer split with his brother in 1954 to establish his own firm in Stuttgart (he relocated in Munich in 1965) to sell German art of the 20th century, represent Nesto Jacometti's L'Oeuvre Gravée French artists (Campigli, Soulages, Pignon, Poliakoff, Manessier, and others), and eventually publish German, Italian, and British contemporaries. Several young Americans of exceptional intelligence and discernment also began dealing in high-quality prints in the middle and late 1950's: Peter H. Deitsch of New York and Allan Frumkin of Chicago, specializ-

ing in modern prints by established artists, and Orrel P. ("O. P.") Reed, Jr., of Los Angeles, Robert M. Light of Boston, and Raymond E. Lewis of San Francisco, handling both old master and modern prints.

The existing and developing market channels for the distribution and recirculation of prints were greatly improved in the 1950's through the activities of two enterprising auctioneers, Roman Norbert Ketterer and Eberhard W. Kornfeld. Roman Ketterer established his Stuttgarter Kunstkabinett in 1947, the year Heinz Berggruen opened his first Paris gallery, and subsequently almost singlehandedly (his brother, Wolfgang, worked with him for seven years) revived the market for pre-Hitler 20th-century German art. By the mid-1950's, Ketterer was auctioning Kirchner, Beckmann, Pechstein, Marc, Kokoschka, Heckel, Nolde, Schmidt-Rottluff, Mueller, Dix, Grosz, Barlach, Klee, Kandinsky, Kollwitz, and Feininger to flourishing, awakened young Germans whose parents had been brainwashed and attracting an international following for the prints of Munch, Picasso, and Toulouse-Lautrec with profusely illustrated sales catalogs prepared with characteristically Teutonic thoroughness and accuracy.

Eberhard Kornfeld became Roman Ketterer's competition in 1951 when, upon the sudden death of Dr. August Klipstein, he took charge of the venerable Bern, Switzerland, auction firm of Gutekunst und Klipstein. With the help of an infusion of new capital, Kornfeld quickly struck a dynamic balance between tradition and experience. He enlarged his staff and initiated the acquisition of contemporary art. He developed a thick new catalog for auction sales of *Moderne Kunst*, a catalog replete with the results of meticulous research by Hans Bolliger and other staff assistants, quotes by art historians and cataloguers, precise information on *provenance*, Kornfeld's opinions on rarity, quality, and importance, and abundant illustrations—the classic *Kornfeld Katalog* of today. He began soliciting auction consignments across the Atlantic, amassed inventory for between-auction stock catalogs, such as *Les Peintres de la Revue Blanche* and *Ernst Ludwig Kirchner*, and began publishing prints by Hayter, Singier, Clavé, Marini, Arp, Giacometti, and other European artists, eventually specializing after 1961 in color lithographs by the American Abstract Expressionist Sam Francis. In 1954—the year that Wolfgang Ketterer severed ties with his brother—Kornfeld's sales approached 1,000,000 Swiss francs for the first time. When, in 1962, Roman Ketterer abjured auctioneering for full-time dealing in major pieces and emigrated from Stuttgart across the border to the tax haven of Campione d'Italia bie Lugano (legend has it he left in the dead of night to shake off German tax authorities), Kornfeld's discriminating choices of auction material, his magnetic personality, and the ambience of his villa on the Laupenstrasse had already made attendance at the annual June auction sale at Kornfeld und Klipstein the principal compulsory activity for most Print People on both sides of the Atlantic. Kornfeld was ready for it when the Print Boom struck.

THE GREAT SURGE IN DEMAND

The Print Boom was touched off by a surge in demand in the early 1960's. A prosperous art-conscious middle class in America and Europe became an art-consuming middle class. College-educated young Americans who had learned about Rembrandt, Goya, Daumier, Renoir, Dali, Nolde, Picasso, Rouault, Chagall, and Hopper in school and had seen their work in art museums (20,000,000 visitors in 1961) were surprised and delighted to discover that they could actually *buy* pictures—*original* pictures—by these artists, as well as new Paris lithographs and American silkscreens, on Madison Avenue, by mail, or at traveling exhibitions on campus and in civic centers.

Young Germans exulting in their "Economic Miracle" came upon the old firms and new galleries in the rebuilt storefronts and discovered the auction sales in Munich, Hamburg, Bonn, and Bern. Deprived of national artistic creativity during 25 years of repression, desolation, and postwar torpor, Germans reached back for the indigenous art of the Expressionists—prolific printmakers all—and reached across the waters for the brash new creations of England and America: at first the progeny of Abstract Expressionism, Pop, and Op, and later, that of Color Field, Minimalism, Conceptualism, and Super-Realism (Fig. 6-C). Germany's welcome to new German art—that of Janssen, Hundertwasser, Baumeister, Grieshaber, Wunderlich, Nay, Brauer, Fuchs, Meckseper, Antes, Alt—was tardy and parsimonious.

David Hockney, "The Print Collector" (portrait of Felix H. Man). Lithograph, 1971 (B.-G. 42). 671 x 455 mm; 26⁷/₁₆″ x 17¹⁵/₁₆″. Felix Man edited a number of *Europäische Graphik* portfolios of prints during the 1960's and 1970's, distributed by Galerie Wolfgang Ketterer of Munich. (COURTESY OF GALERIE WOLFGANG KETTERER) Fig. 6-C

But Beatlemania and Carnaby Street jolted Britishers out of their prissy insularity into a realization that the English, too, could contribute to modern art movements and support contemporary esthetics—as well as the Establishment moderns—by purchases. Newly prosperous French retained their traditional chauvinism while forfeiting leadership in the arts to America, but joined the shopping tourists and foreign dealers in keeping the Paris ateliers and art dealers flourishing. The new educated, sophisticated, optimistic, and prosperous middle class in Italy, the Netherlands, and Switzerland became hungry for art, too.

In the 1960's, graphic art became popular and coveted. Prints were the art that the young middle class could best afford—most prints still are. As one dealer then advised his browsers, "You don't take your life in your hands when you buy prints. Paying $5,000 for a painting is serious work. Buying a print for $75 is easy." People also found they could select from a rich variety of schools, periods, styles, sizes, and graphic media: there was a print for every taste and every temperament.

Moreover, as the prestigious respectable institutions began giving prints more shelf space, the very multiplicity of prints, instead of acting as a deterrent, now acted as a stimulus to possession: a commonality existed, which did not exist in the case of paintings and other unique pieces, between what one saw in a museum and what one could actually buy. One could actually purchase and own the *same picture* that was exhibited at the British Museum or the Museum of Modern Art or illustrated in a book or periodical! Conversely, the possibility that a duplicate *might* one day appear on exhibition or as a catalog illustration made the ones available commercially even more desirable. Paradoxically, the very mundanity of the multiple seemed now to increase its attractiveness!

This possibility for satiation was enhanced in the 1960's by a rapidly expanding retail and auction market. The market itself became much more fluid. If you missed one impression, another would probably soon turn up. Prints also appealed to the art-loving consumer's fondness for shopping: since tens of thousands of "museum-quality" prints were for sale, compared with a paucity of "important" paintings, watercolors, and drawings, one's taste was refined, rather than disappointed, by what the dealers and auction houses tendered for sale. Prints could be shopped for, selected from among thousands of other possible choices; past and current prices could be readily compared; impressions could be exchanged or "traded up" for ones of better quality, condition, or visual appeal.

At the same time, as prices began to advance and the relative rarity of any particular image—caused by the scarcity of available impressions or the artificial limitation of the edition—was mentally or actually translated into "value" and "investment potential," those who might have otherwise prized uniqueness and spurned prints because they could afford paintings, became proud to possess printed pictures. Prints, like paintings and drawings, became precious enough to inspire awe, gratify

egos, and promote self-aggrandizement. When prints became valuable, it became easier to appreciate that the multiplication of the image did not necessarily vitiate the strength of the artist's accomplishment. All of a sudden the "poor man's art," once much denigrated as reproductive and unworthy of possession, was being cherished as a major art form, a *unique* multiple!

No one was more surprised at this development, this refreshing shift of taste and preference, than the curators of prints, the print dealers, the print publicists, and the artist-printmakers themselves. The increasing demand for prints stimulated these groups to make fresh efforts, which intensified in rate throughout the late 1960's and early 1970's, to expose prints to public view, enlighten the public about prints and printmaking, and cater in other ways to the public's revived interest in the graphic medium. These efforts were hugely successful, and just as pretzels excite the appetite for more pretzels, aggravated further demand. The possessors and potential possessors of prints were made immensely more knowledgeable and sophisticated—and covetous—by a quickening torrent of exhibitions, dealers' wares, literature, and social activities.

During the 1960's, especially, many art institutions began staging exhibitions that encouraged a greater appreciation for the effectiveness of the print as art, imparted an understanding of the different sensual and pictorial effects various printmaking processes could produce, and simultaneously, conveyed a comforting assurance that the print was indeed a dignified and worthy work of art—a museum piece, as it were. Jean Adhémar, the esteemed curator of prints at the Bibliothèque Nationale in Paris, has reflected nostalgically that "what one did not dare hope for in the 19th century finally happened: the print was hung in the exhibition halls of the greatest museums next to its old rival—the painting." In the 1960's, all the art museums, libraries, and cultural centers rummaged through their print cabinets to choose master prints and new graphics for display on an equal plane, literally, with paintings and sculpture. (Somewhat belatedly, having missed the boat, London's Tate Gallery organized an Institute of Contemporary Prints in 1974 and began soliciting British publishers for donations.)

Public print cabinets happily aired and circulated their holdings. In 1966, the state museums of Munich and Vienna, the Bibliothèque Nationale of Paris, and the Rijksmuseum of Amsterdam for the first time pooled their graphic masterpieces for a stunning public display of "The Most Beautiful Prints of the Occidental World 1410–1914" (an exposition that deliberately excluded "*gravures d'interprétation*" and admitted only "*gravures originales*" conceived and executed by the same person, though the two castes freely mingled in the print cabinets of the institutions themselves). In 1969, Boston's Museum of Fine Arts and New York's Pierpont Morgan Library combined their own and borrowed Rembrandt etchings into what *New York Times* critic John Canaday described as "an

absolutely bang-up show," posing for him only the "question of how to make it sound as good as it is to anyone not already interested in the subject." In 1964, the Museum of Modern Art in New York donated exhibition space to the brand-new work of a single fledgling workshop, Universal Limited Art Editions; in 1969, it rendered a singular "Homage to Lithography" to another youthful American printmaking enterprise, Tamarind; and two years later, extended the same compliment to ULAE's younger competitor, Gemini G.E.L. In that same year, 1971, countless institutions and galleries in Europe and the United States celebrated, graphically, the 500th birthday of the greatest burin man of all time, Albrecht Dürer.

Universities mounted their holdings, new acquisitions and borrowings, too, and in the process prepared their students for postgraduate conspicuous consumption: the complete lithographic oeuvre of Degas at the University of Kansas, new graphic acquisitions at Grenoble, contemporary prints from the collection at the Rhode Island School of Design. We could record the institutional rediscovery of prints *ad nauseum:* a Munch retrospective in Tokyo, Nabis lithographs in London, Dürer in Moscow, and so forth. Today every museum and art center has its periodic print shows, and there are few that do not have at least one print hanging at this very moment.

Various other public institutions made people aware of prints. The number of international government-sponsored exhibitions, print biennials, and competitions increased dramatically, and their geographic reach expanded during the late 1950's and 60's, giving millions of people around the world an opportunity to view the most up-to-date developments in the art of the print. The British Arts Council toured Europe with *The British Graphic Scene* in 1963, and the U.S. Information Agency visited Ljubljana in 1965 with a 60-print American show that overpowered in diversity and inventiveness the 1,000 hung in Ljubljana's *Moderna Gallerija* for the sixth Yugoslavian print biennial, the major European competition (Robert Rauschenberg had in fact won the prize at the fifth). Ljubljana, Bath, Bradford, Santiago (Chile), Tokyo, Brooklyn, Paris, Grenchen, Knoxville, Venice, San Juan, Honolulu, New York, San Francisco—new graphics flashed everywhere, with an irrepressible influence on participants and viewers alike. Like a latter-day visit by Commodore Perry, the 1957 Tokyo International Print Biennale for the first time confronted Japanese printmakers and art buyers with the expressive powers of Western etching, lithography, and serigraphy, and helped divert them from a restrictive concentration on the native woodblock. As always in Japan, assimilation was swift. The array of alien imagery at that first competition and subsequent Tokyo biennials inspired many Japanese artists to replace the typical Japanese images of naturalism and feminine grace with a more "modern" conceptual, intellectual, intensely personal or geometric subject matter, or at least to reinterpret

and thereby revitalize traditional Japanese themes with Western methods and approaches. Thus the Print Boom gained momentum in Japan, as well as in Europe and America.

Books, superb exhibition catalogs, periodicals, magazine articles, and other media commentaries on old master and modern prints, the history of prints and printmaking, graphic processes and techniques, printmakers, and the Print Boom itself proliferated at an increasing rate. Scholarship flourished and nurtured greater interest, understanding, and more scholarship. Scholars contributed over 100 valuable new catalogues raisonnés alone during the ten-year period 1964–74, and obliging publishers reprinted 50 others that had become scarce and costly. The first printing of A. Hyatt Mayor's perceptive, fluent, and delightful "social history of printed pictures," *Prints and People*, which appeared at the start of the new decade, was sold out a week after its review in *The New York Times*. Tamarind Lithography Workshop hired authors, researchers, experts, and management consultants to analyze and report on print manufacture and marketing—the jobs of the printer, publisher, and printseller—and the tracts that the newcomers issued, if they made many hidebound old print hands chuckle and sneer, were put to good use by hundreds: *Gallery Facility Planning for Marketing Original Prints, A Study of the Marketing of the Original Print, A Management Study of an Art Gallery, How a Lithograph is Made and How Much it Costs, The Longevity of the Original Print Depends on the Paper that Supports it, Questions to Ask your Framer and Answers You Should Get*, and so on. Fact Sheets issued by Tamarind and Print Documentations issued by Gemini for the first time openly imparted to retail dealers and the art-buying public comprehensive and accurate data on the production of a new edition, from trial proof to cancellation proof.

The popular art press courted the new enthusiasts. Noncuratorial Print People could order only one specialized periodical in the early 1960's: *Artist's Proof*, the Pratt Graphic Art Center's annual journal of printmaking, which emerged in 1961, went hardcover in 1966, and ceased publication in 1971. But by then New York's *Print Collector's Newsletter* was in its second year and thriving (a circulation of 5,000 by 1972); Paris' *Nouvelles de l'estampe*, affiliated with the Bibliothèque Nationale, was about to turn into a slick and make a new pitch for subscribers with an expanded coverage; and the Italian-language *Print Collector*, edited by Italian dealer Harry Salamon, was spreading the word to Italians. To accommodate more subscribers, Salamon's periodical became an *English*-language bimonthly in 1973. *Auction* magazine—now defunct—gave over its entire March 1971 issue to prints; *Art News*, which had never before devoted an issue entirely to a single medium, paid the Print Boom homage with *two* in the early 1970's. (It now has a prints issue each spring and fall.)

Just as the presence of television cameras often incites the very riot they were sent to cover, the news appearing in periodicals and newspa-

pers about the dramatic developments in printmaking and the growth of the print market—the news of a Printmaking Renaissance and dizzying price increases, among other things—supercharged the growing Print Boom. All the books and words and talk were good for business. "The more books, the merrier!" chimed Wallace Reiss, the New York dealer, whom the Boom had catapulted to wealth and prominence in the late 1960's. Others winced from all the fuss and clamor. "There are too many books already," complained the usually affable August Laube, upon learning of the preparation of *this* book. Herr Laube, whom the Print Boom escalated from international obscurity as a distinguished Zurich dealer in rare books and Swiss views to conspicuousness as an international factor in the market for five-digit old master and Expressionist prints, was simply expressing his longing for the old days when his colleagues were all intimates, his customers were not speculators, his affairs more private, his expertise more uncommon—and his purchase costs and sales prices much, much lower.

But if August Laube found a low profile more congenial to his disposition and business practices, a swelling multitude of more vociferous print dealers and galleries—many of them stocking the same or similar pictures as could be seen in museum collections—jockeyed to exploit and further excite the public taste with their own personalities, exhibitions, and publications. From his home base in the Empire State Building, Abe Lublin stormed the American provinces in the early 1960's with made-in-Paris Dalis, Friedlaenders, Mirós, Levines, and Zao Wou-kis, wholesaling them to dealers of all sizes and preferences, frame shops, and department stores. Some years later, Eugene Schuster and the traveling salesmen of his graphics firm, London Arts, attacked the market in hundreds of cities and over 500 college campuses across the breadth of America. They primed the local media with press releases, hired halls and booked college art galleries for their stacks of matted stock, raised funds for Hadassah chapters and Masonic temples, and motivated customers with talks on prints through the centuries and the glamour of their wares. "A lot of people felt we were demeaning the business," recalls his brother Monis, "especially the dealers who were trying to be your traditional German booksellers. We thought the time propitious to take art to the masses, and we found an intense yearning for people to learn about art." Other dealers, devoting more attention to the art of the print than to the art of merchandising, mounted less peripatetic exhibits that left lasting impressions on metropolitan dwellers. By 1974, Vision Nouvelle, the Right Bank Paris gallery, had opened its weighty doors to an impudent exhibition (accompanied by a first-rate catalog) of more than 200 of the lowly reprints and reproductions printed by the French government printshop, la Chalcographie du Louvre—prints that the Louvre itself always considered too plebeian to display.

As the number of printsellers multiplied during the late 1960's and early 70's, so did their literature. They blitzed art buyers with exhibition

catalogs, fall and spring catalogs, *plaquettes*, stock lists, flyers, prospectuses, advertisements, monthly bulletins, mail-order solicitations, and full-color print-of-the-month-club brochures. Exclusive of auction catalogs, the commercial literature of the decade of the 1950's takes up 20 inches of shelf space. That of the 1960's, well over 20 feet.

Contemporary prints of the 1960's quenched a 1960's thirst. In their conception, execution, and publication, prints responded to both the stylistic and social preoccupations—the *Zeitgeist*—of the era. The lithographs and screenprints that many of the progressive publishers and dealers started to offer in the late 50's and early 60's had the zesty visual appeal, bright and broad colors, and contemporary look of their painted cousins. They were large enough in scale to be attractive to those who could not hang or afford the huge canvases of contemporary painters (the painters' concession to a reduction in scale is partly explained by the ability of the print medium similarly to command the attention of the viewer), and sizable and eye-catching enough to evade association with the intimate, measured, ascetic chic of postwar black-and-white etchings and lithographs, the kind the Society of American Graphic Artists was still exhibiting.

The repudiation of monochromatics, discreetness, and intimacy expressed by many of the contemporary graphics of the 1960's (as well as by the new plastic, metal, and fabric 3-D "multiples") complied with the newly emerging social attitudes. That social mentality was amenable to participation and involvement, intolerant of chic and pretense, and receptive to the penetration of life by art, a disposition that in earlier decades had motivated the artists and designers of Art Nouveau, the Bauhaus and de Stijl, and Marcel Duchamp. It was a cultural climate in which a populist, mass-produced, and mass-distributed object could attain a new esthetic identity, and it fostered prints that were more and more alluring, more decorative, more hangable. Whereas the traditional print collector hid his treasures from the sunlight in folders and boxes, the print buyer of the 1960's tended to put his where they would form part of his environment—affixed to the wall. Prints became vertical, rather than horizontal, attractions. Much of the public purchasing of the new prints and other multiples was prompted less by possession obsession and more by a willingness to let art mingle with people and influence their behavior. All the new buildings wanted the "modern look," and new modernist lithographs and silkscreens with arresting colors and unconventional imagery entered brokerage houses, corporate headquarters, hotel conference rooms, office corridors, apartment houses, and television studio sets which had formerly displayed chromolithographs of Wall Street at Dusk and Sacré Coeur at Dawn.

The social consciousness of the 1960's was also being hounded and molded to an increasing extent by a daily crush of word-and-image messages from the communications media and their advertisers. More than 100 years ago, the makers of prints had been freed by photography from the need to make verisimilar pictures depending on easily readable linear

and pictorial conventions, and so given the opportunity to use, wholly artistically, "a cheap and easy means of symbolic communication without syntax," to quote Ivins. Artists of the 1960's, in turn, captured for themselves the matured media syntaxes and media techniques in the name of art. Artist-printmakers began to paraphrase, both as compositional elements and as subject matter, the kaleidoscope of everyday images and themes, with similar colors, sensual qualities, impersonality, and larger-than-life dimensions, that were bombarding everyone's sensibilities from other directions.

To recycle their media visions, they also began increasingly to put to greater artistic use the commercial duplicating processes—primarily lithography and silkscreen—being used so effectively by the mass media, even if that meant delegating a larger share of the creative activity to the collaborating printer-technicians. By paraphrasing and projecting media particles, references, and clichés—Ben Day dots, TV camera visions, photos, headlines, advertising and journalistic hyperbole, newsprint scraps, capsule views, postcard vues, déjà-vus, repetitive flashes, ephemeral images, verbal fragments, computer printouts, billboard designs—in their graphic inventions, the Pop and Op artists Rauschenberg, Rosenquist, Indiana, Vasarely, Paolozzi, Hamilton, Hockney, Caulfield, Dine, among hundreds of others, not only commented in their graphic inventions on the overwhelming demands for attention emanating from the media and its commercials. By exploiting the commercial processes and visual vocabulary of the printed media and disseminating their creations as multiples, they also joined the crush themselves: graphic art returned to its humble origins as another variety of media message. As print critic Judith Goldman wrote, prints began telling less about art and nature, and more about culture. Artist-printmakers—of the people, by the people, and for the people—simply gave the people what they were ready for.

It is therefore not surprising that the Print Boom not only survived the youth culture, but actually took sustenance from it. In 1970, the year that Charles Reich published *The Greening of America*, New York Surrealist dealer Timothy Baum expressed concern about the extinction of his colleagues. The young people entering society were disenchanted with possessions and conspicuous consumption and disclaimed ostentation in any form. They would not buy art. They would be satisfied with good reproductions of pictures; their new consciousness would compel them, for example, to see the excellent forgeries of Matisse lithographs, which had just been uncovered, for what they really were: as attractive as the real ones, and a commendable parody of the system of investable property, permanency of value, and Art Crowd patronage, with its unctuous, overbearing employment of money. But the Print Boom bulled through the movements of the Hippies, Yippies, and counter-culturists. The Young People somehow distinguished the art being made by their brethren in jeans from the manufacture of the Establishment. Art was Truth and Beauty, a permissible luxury, and prints were an acceptably

plebeian form of art. Wage-earning graduates from the drug culture and engineering schools alike discovered the prints of M. C. Escher, and income-producing liberal arts graduates-turned-consumers renounced psychedelic and hate-Nixon posters for more enduring works of greater sensitivity and higher quality.

The sharp intensification in demand for prints in the 1960's was not purely volitional. The relaxation of the traditional prejudices against the reduplicated image was not simply the result of new attitudes and sudden enlightenment. It was partly the result of the exhaustion of the obtainable supply of high-quality paintings, drawings, and watercolors, which drove the prices of these unique works beyond the reach of much of the art-conscious middle class and most of the art museums and art centers in North America and Europe (numbering 750 in the United States in 1961 and proliferating at that time at the rate of 15 more each year), which desperately wanted pieces that were representative of major schools and important artists or would fill gaps in their collections. When there were no more Franz Hals paintings to be had, and an important Rembrandt drawing had the same price tag the Hals had only a few decades ago, a fine Rembrandt etching would do; indeed the masterpieces of the print medium were about the only masterpieces of any medium any longer available.

Institutions caught between a wish not to slight contemporary movements (no one wanted to make the mistakes of turn-of-the-century curators) and the vigorous demand for American painting and sculpture emanating from the private sector, which sent prices for the American superstars skyrocketing beyond institutional budgets, found they could build and fill out their collections relatively cheaply with prints. Curators allayed their envy of colleagues in older and richer institutions and suppressed their cravings for the prestigious, fancy-priced acrylics of Johns, Rauschenberg, Stella, and Warhol—not to mention old master, Impressionist, Expressionist, and modern French paintings—by buying lithographs, etchings, and silkscreens of "museum quality," or with similar painterly quality and pictorial appeal, and consoled themselves with the realization that Jasper Johns's, Dürer's, Toulouse-Lautrec's, and Munch's graphic art was on the whole more successful and important than their paintings anyway. By the turn of the decade, the market in top-quality prints had replaced the drawing and painting market of a few years earlier.

THE EXPANSION OF SUPPLY—
THE PRINTMAKING RENAISSANCE

The Print Boom was propelled by an ever-expanding supply of old and new prints appearing on the market in the late 1960's.

The 1960's were characterized by a renaissance in printmaking and an expansion of the mechanisms and facilities for the marketing of old and new prints to an extent Ambroise Vollard and Curt Valentin would never have dreamed possible. The changes in social and artistic temper that had occurred in the 1950's provided an environment in which a number of highly professional publishing workshops and publishers outside Paris, some with roots in the 50's, could germinate, thrive, and flourish, and in which artists who once shunned printmaking would be induced to experiment on an unprecedented scale with both the traditional processes and techniques and the new ones then presenting themselves for artistic expression. At the same time the surge in demand for prints spurred both the release into the sales market of hundreds of thousands of impressions of prints which had been sitting in boxes, wrappers, and attics, uncherished and overlooked for decades, and a vast increase in the number, variety, and sales activities of merchandisers of prints of all ages and kinds. Prints cascaded on the art world in the 1960's like a snowstorm: imperceptibly at first, and then with blizzardlike intensity.

The modernist artists who were invited to Tatyana Grosman's and June Wayne's new American ateliers in the late 1950's and early 1960's, and who were summoned to Christopher Prater's London silkscreen workshop and signed up with the fledgling London publishing firm Editions Alecto in the early 1960's, found that the graphic media, primarily the surface printing (planographic) techniques of lithography and screenprinting, were congenial to their esthetics and that the work environment was compatible with their social and artistic temperament. The art styles then gaining currency and acceptance revealed less introspection, autobiography, and torment than the styles that followed World War II. Artists began depending less on inspired chance and more on planning. Styles were more impersonal, contrived, public, political, brassy, sassy—particularly suited to graphic expression.

The work ethic of avant-garde artists was in flux, too. Working artists became less reclusive and more social, more receptive to advice and counsel, more comfortable in the presence of assistants and collaborators, and more willing to exchange an executory role for a supervisory one. In the 1940's, Robert Motherwell found the busy studio atmosphere of Hayter's Atelier 17 uncongenial. ("It embarrassed me to be watched as a performer.") In 1961, he emerged from isolationism to discover rapport with Tatyana Grosman at ULAE. Twelve years later, he could say that "the aspect that I love after a lifetime in the solitude of my studio is the collaboration, the working with other people, the camaraderie, the extraordinary selflessness and sensitivity of very good publishers." Both the new esthetics and the new work ethic thus favored the proliferation and supercommercialization of art, an assault against the unique, irreplaceable art object. While the artist could choose to limit the size of the edition to confirm the identity of the multiple as a personal creation, he

could use the graphic media to achieve the widespread dispersion of his artistic visions.

One circumstance of the gallery system in the 1960's was fortuitous for the Print Boom: most painters of established or emerging international repute were not indentured to any gallery for *printmaking*. The stablemates of Castelli, Marlborough, Janis, and other galleries, though bound to deliver up their paintings and drawings, were generally available to new print publishers and publishing workshops for printmaking; they could sign up with whomsoever they desired. It was the best of times for a renaissance of printmaking and print publishing.

As new printmaking facilities were made available, first in Britain and the United States, and later in France, Germany, and Italy, and the sometimes reluctant artists were coaxed into trying them, they discovered to their surprise and delight that the graphic media could serve them in three ways:

First, the graphic media could be employed to test ideas for painting. Ernst Kirchner had used lithography and etching for such a purpose a half century earlier:

> I am now designing my paintings in graphic form . . . I find it increasingly necessary to express my ideas first in engraving or litho, so that they may develop before I start to paint. Every year my forms and expression become more sensitive, and my ideas frequently have to pass through the three graphic stages before I can start on the canvas. In this way I am absolutely sure of the form when I begin to paint and can build the rest of the picture freely around it . . . it is the inner idea that I try to establish firmly through graphic preparation."

The graphic media could also be used as a proving ground for ideas that had already been tried in painting. Many artists sought to duplicate their work in other media as perfectly as possible, but did so with great integrity by actively working with and taxing collaborating artisans to develop new approaches, new procedures, new machinery, new inks. While Frank Stella's "Stars of Persia" and Josef Albers' "Squares," plotted and executed in collaboration with artisans at Gemini G.E.L., are essentially exquisite translations of "Star of Persia" and "Square" notions achieved earlier in paint, the artists' active participation and concern make them wholly autographic.

Lastly, the print offered pliant terrain both for variations on previously tested themes and the cultivation of new perceptions. Such artists as Jasper Johns, Horst Janssen, and Paul Wunderlich sought to synthesize in idiosyncratic though distinctive ways ideas already expressed in drawings or paintings and got novel and striking results. Still others—Anton Heyboer, Peter Milton, Frederich Meckseper, among others—used the print as a primordial means of expression and eschewed painting entirely.

As the 1960's progressed, more and more painters took to printmaking as a genuine artistic vocation. Printmaking engaged the esthetic sensibilities

of many of them at first, and then challenged their technical prowess. Lots of artists got hooked on printmaking and went off in hot pursuit of ideas that demanded new printmaking techniques and mechanics. Many, in fact, expended a great deal of creative energy on printmaking that would otherwise have been lavished on painting.

But many simply cranked out signed visual souvenirs of their work in other media by the easiest means possible, without getting too involved with the conception and execution of a work of graphic art. Many were content to make their prints—or, rather, have their prints made—in the way Paris ateliers had conventionally made prints. One simply handed in a gouache, a colored proof, or an executed plate or stone and went home, without "experimenting" on proofs or guiding the hand of the expert *chromiste* or *conducteur*, or even rubbernecking in the shop, while the artisans did the drudgery and converted one's homework into a "print"— even if that meant that the *artisans* drew or painted on plates or stones in imitation of one's style or made color separations photographically. Charles Sorlier, one of the great *chromistes* at Mourlot's, typographically signed *most* of the "Chagalls" he executed for Chagall, but no one knows for sure how many Braque-approved and autographed lithographs are "Braques" and how many are "Mourlots" or "Deschamps" or "Durassiers" copied from Braque designs. The printers certainly aren't telling. When Salvador Dali could command a six-digit sum for a portfolio and $35,000 for a photoreproducible gouache, he chose not to labor over lithographic stones. Consequently the lithographs "of" Salvador Dali (and of such American illustrators as Norman Rockwell and Leroy Nieman), in form simply signed photomechanical reproductions of drawings and gouaches superbly constructed *in absentia* by master craftsmen, function as technical reflections of what these artists have accomplished in other media: token souvenirs of their artistic signatures, and that's all. (Many artists "doing" such printmaking in Paris were also, unhappily, disposed to condone the cynical distribution of *afters* as autographic, "original" prints.)

Some artists worked this way because it was traditional. Some did so because, as artists, they had a distaste for "handicraft" and the technical demands of printmaking. Some were lazy. Some wished to reach the masses by the quickest road and bypass—or gull—the wealthy collector-snobs and avaricious curators en route. Miró once explained that he pursued lithography, not because he felt a genuine artistic affinity for its expressive potentialities, but because he wanted to reproduce his cheery graffiti inexpensively for millions to possess and enjoy. (He did not, however, choose to speak out when they were promoted like Arizona real-estate lots and price-inflated like watered stock by the prints-for-investment practitioners.)

The motivations of many other artists and their promoters were less altruistic and more economic. Printmaking *paid* during a Print Boom. The artist could profitably market the renown he had achieved in other

media before the Boom, help finance his work in other media, and supplement his income handsomely. Many artists of artistic and commercial integrity maintained their rectitude during the Print Boom, without compromising themselves or prostituting their art. But many were inspired to make or authorize the manufacture of a print or multiple, not because it was the ideal medium for the image they had in mind or because it could extend the range of their artistic accomplishments, but simply to capitalize on the new mass marketplace. Most prints published since 1965 have been designed and released, not to satisfy artistic urges, but to satisfy commercial urgencies. They have been produced primarily as articles of trade. The "suspicion," which *New York Times* critic Hilton Kramer articulated in 1972, "that much of what passes for printmaking nowadays is simply an ingenious and energetic form of marketing" is indeed well founded. Scores of well-known artists, such as Calder, Dali, Masson, Picasso, Matta—the list could go on and on—have from time to time sold out to a new breed of print publisher which pays tens of thousands of dollars for a quantity of signatures on a "limited edition" reproduction of a gouache, crayon drawing, or oil.

Artists of all persuasions, their artisan-collaborators, their hired technicians, and their publishers jumped aboard the print bandwagon in the 1960's. Sooner or later virtually every American and European artist whose reputation was established in painting or sculpture tried printmaking, whether to exploit the art form or the new art clientele. Roy Lichtenstein later became very creatively involved with printmaking, but many of his first prints are photo-offset lithographs, intended as exhibition posters or announcements. He got involved making fine prints, he recalls, when "somebody said, 'Do you want to come out?' There was no philosophy behind it."

Prints began spreading adaptations of familiar styles, new styles, and unfamiliar names into places where paintings had never ventured. The graphics of some painters reached an audience that knew their art only through illustrations of paintings. Some dealers, such as Richard Solomon at New York's Pace Gallery, set their contract artists to work making prints and established efficient distribution networks for them primarily to attract attention to their "major" works. Some painters, such as Ilya Bolotowsky and Karel Appel, achieved such widespread publicity through their graphics that they became celebrated even before their paintings got much notice, just as Nabokov's *Lolita* excited interest in his earlier, long-overlooked works.

The 1960's was a period of maturing and developing printmaking technology, much of it inspired or engineered by the artists themselves to achieve solutions to special artistic problems and much of it adapted or devised by eclectic, clever, collaborating craftspersons to enable their artists to realize desired effects. Lithography is hardly a new process. It was invented in 1798, adapted for artistic use shortly thereafter, employed with extraordinary artistic success for 150 years by artists from Goya to

Picasso, and perfected as a *process* by the ateliers of Paris well before "lithograph" became an arty household word in the 1960's, even if most Paris-made lithos looked like reproduced paintings or pictures of drawings. "How can you *make* better lithographs than Goya's or Raffet's?" rightly queries Kenneth Tyler, who as master printer, collaborator, and inventor at Tamarind, Gemini, and his own atelier, should know. "I don't know what people would call new techniques," Jasper Johns once responded when asked about his virtuosity with lithography. "I don't know what they mean. All of them are known and are fairly conventional." All Tatyana Grosman, June Wayne, Kenneth Tyler, and others did was to import the basic French know-how and equipment, modify and sensitize it with midcentury refinements and mechanical engineering to obtain more exacting delicate and opaque effects and stimulate and help artists to make lithographs of a quality equal to Goya's and Raffet's (or Redon's and Munch's, for that matter), and which did not look simply like reproduced paintings or pictures of drawings, either. And while publishers, artisans, and artists might have revived lithography as an art form *outside* Paris, "there was no renaissance in printmaking in France," as Tyler wryly observes. "All the French started to do was to *sell* their prints."

Lithography, which can nicely display painterly effects, opacity, flatness, subtle tonal modulations and brushwork, was particularly compatible to the more informal, spacious kinds of expression of certain postwar painters. No artist has to be an expert craftsman to make a successful lithograph; at its basic level, lithography requires of the artist neither the adroit handling of tools (one can use pencils, pens, brushes, toothbrushes, scrapers, fingers—anything) nor the cookery of the intaglio processes. The lithographic stone responds best to the free and spontaneous gestures of the impulsive painter and draftsman: the Venetian, as opposed to the Florentine, to use a Renaissance metaphor. Artists of the 1960's were to rediscover the qualities that Odilon Redon had exulted in over 75 years earlier:

> From first to last, all my prints have been the result of a curious, attentive, uneasy, and passionate analysis of the power of expression contained in the lithographic crayon aided by the paper and stone. I was astonished to find that artists had not developed this supple and rich art which obeys the subtlest impulses of the sensitivity. . . . Lithography stimulates and makes the unexpected appear. . . .

Joseph Pennell's prophecy, made prematurely in 1912, came to pass 50 years after its time: "Lithography is going to be appreciated . . . as it never has been. The signs are all about us—the artists are among us."

The silkscreen, somewhat more sensuous in body and color than the lithograph, had great appeal to the young generation of Pop and Op artists. The silkscreen squeegee, wiping ink through a cut stencil, or a synthetic fiber or plastic screen, lays down a thicker deposit of pigment than a lithographic stone or plate and hence met the needs of those artists

working in hard-edge and Color Field abstract styles and requiring uni-
formly spread colors of great saturation and brilliance. Such painters as
Richard Hamilton and Patrick Caulfield in Britain, Roy Lichtenstein and
Robert Indiana in the United States, and Victor Vasarely in France
could achieve in silkscreen more effectively than in lithography the crisp,
simplified shapes and uniform areas of rich color that characterized their
approach. The silkscreen is a flexible medium. Painters can work di-
rectly on the screen with paint, just as they work on canvas, if they
fancy direct participation in printmaking. Or they can, if they wish,
remove themselves from the process to orchestrate, rather than perform,
execution. The refinement of the halftone screenprinting process, by
which subtle gradations of tone and color can be accurately expressed
through a breakdown of the image into small dots, was also a timely de-
velopment for those painters who were increasingly preoccupied with
paraphrasing banal source material from the communications media: tele-
vision camera visions, photos, films, ads, newsprint, comics, and other
materials. It then seemed entirely appropriate—and a good spoof as
well—to artists such as Andy Warhol, Robert Rauschenberg and Rich-
ard Hamilton to restore to graphic form and multiplicity the iconog-
raphy and rhetoric that they were extracting from the popular media and
hand-painting or phototransferring onto their canvases through stencils
and screens—and the new silkscreen methods were natural extensions of
their painting methodology. To the delight of such artists, the silkscreen,
suppressing the manifestations of the artist's hand, drew attention exclu-
sively to the impersonal imagery. The same screens, moreover, could be
reinked and reprinted to obtain limitless modulations, superimpositions,
and permutations of colors, densities, moods, and structural composi-
tion.

Thus the dominant artistic styles and methodologies of the 1960's fa-
cilitated the transition from painting to prints. If the painters were com-
pelled in the process to concede a reduction in the huge scale of their
works in other media (big prints came later, in the 1970's), that conces-
sion was offset by the capacity of the print to immerse the viewer by its
very intimacy.

Like their Renaissance forebears, many progressive artists in the 60's
were eager to confront and take command of the technological advances
of the era, to extend their technical range to solve visual problems and
create unconventional art. Imaginative artists untrained in printmaking,
and therefore not encumbered by dedication to technical virtuosity,
looked to technique as one means to a specific expressive end and did not
stop at the limits of previous technical experience in printmaking. Artists
attracted to lithography and screenprinting, and the artisans and engi-
neers who advised and serviced them, very quickly seized other commer-
cial and industrial processes, techniques, materials, and equipment for
making and multiplying images, or when the need arose, invented them
themselves. Renoir, Whistler, Giacometti, and Picasso often made draw-

ings with lithographic tusche on special paper for transfer by the printer to the lithographic stone. But in the 1960's Robert Rauschenberg and his collaborators and successors developed new methods for transferring photographic images onto lithographic stones and metal plates. Others adapted photolithography—an offset process used for decades by commercial printers for speedy printing of long runs—to their special needs. Still others utilized the collotype process to lift photo images from acetate sheets. Some explored Xerography. The refined methods for transferring photographic images to paper vastly extended the range of the imagery accessible to printmaking, opened the way for repetition of imagery, and eliminated the indispensability of draftsmanship. (It also helped touch off a revival of interest in photography as an art form, but that is another story.)

Mixed media and 3-D multiples became possible as craftsmen exploited or devised techniques for quality-controlled stamping, embossing, laminating, folding, tearing, and affixing collage elements on paper; molding plastics and metals; silkscreen printing on vinyl, mylar, polyurethane, fabric, enamel, aluminum, and steel; and combining hybrid planographic and intaglio processes to obtain uncommon results. Perfectionists contrived techniques for obtaining extremely accurate color registration, without noticeable overlay, in response to the needs of Color Field and hard-edge artist-printmakers. They concocted new inks of various viscosities and reliable color-fastness and requisitioned or developed papers, both handmade and machine-made, of various textures, tones, absorptive capacities, and light-reflecting qualities. They designed new presses and parts for presses to obtain greater precision in printing and to accommodate the longing of Pop and Color Field painters to make prints as oversize as their paintings.

Graphics became so expertly printed that by the early 1970's some critics began complaining that the images were *too* highly finished, so sterilized by immaculate, uniform printing that they radiated coldness and hardness, even when they were supposed to be painterly, and concealed all evidence of the artist's hand. Jacob Kainen observed that "the least effective prints, both in lithography and etching, are those most immaculately printed, because they fail to take advantage of the media employed." Brooklyn Museum Curator Jo Miller mourned the absence of a personalizing thumbprint on any of the graphics she reviewed for the 18th annual Brooklyn Museum National Print Exhibition. And Brooke Alexander, the New York dealer and publisher, invited artists to violate the immaculate uniform surfaces of a new series of slickly printed graphic editions with personalizing hand-coloring.

By the end of the 1960's, innovative painters who had succumbed to the expressive capabilities of color lithography and screenprinting were motivated to try their hands at other, cooler, more autographic and cerebral graphic media requiring great manual dexterity. They turned to the intaglio processes of etching, drypoint, aquatint, and mezzotint. Jasper

Johns executed his *1st Etchings* in 1967, and Richard Hamilton, his first after a ten-year break the same year. So that artists removed from Paris would not have to make an expedition for professional advice, service, copperplates, or zinc, intaglio facilities such as those at Editions Alecto in London, Universal Limited Art Editions in New York, and 2RC Editrice in Rome, and intaglio workshops such as Kathan Brown's Crown Point Press, founded in 1964 in Oakland, California, emerged to help them with innovative and impeccable printing. (By the early 1970's a few oracles had detected such a sizable shift in avant-garde tendencies and preference for graphic medium, that they were predicting that the 1970's would be the decade of intaglio, much as the 1960's had been the decade of planography.) Though certain older Americans, such as Yunkers, Baskin, Frasconi, and Eichenberg, made popular anecdotal woodcuts and Carol Summers achieved bold, textured, and brilliantly colored patterns with wood, combined with rubbing and stenciling techniques, the only graphic forms fairly neglected during the print explosion were engraving and woodcut, the most artsy-craftsy of the print media. They just could not compete with media that demanded only the congenial tasks of drawing and construction and overseeing.

PRINT PUBLISHING

One of the phenomena of the Print Boom was the development of print publishing as an industry in urban areas outside Paris.

Just as most television or film producers do not own or operate their own production studios, most print publishers, historically, have not owned or operated their own printshops. Print publishing has normally been separated from printing; most publishers have shrunk from the economic burden of keeping an atelier working at capacity. Ambroise Vollard contracted out the printing for the celebrated editions he commissioned. D.-H. Kahnweiler, with a Paris gallery (Galerie Louise Leiris after the Occupation), did not have to commission Picasso to make prints and so acted primarily as the distributor for those that Picasso executed and had printed where he pleased, and after the war Fernand Mourlot's invitation in 1944 to make use of his well-heated, custom lithography workshop had fortunate consequences for both, and for the art world. During those postwar years, other French art galleries with stables of painters, print dealers, and entrepreneurs began commissioning editions of prints; they included Maeght Editeur (prior to 1961), Denise René, Heinz Berggruen, Jacques Frapier, La Hune, and the Genevois, Gérald Cramer. In Vollard's tradition, rather than build and staff an atelier, they commissioned artists to create the graphics in Paris printshops and distributed them wholesale to other dealers and retail through their own galleries.

Perhaps the most influential of professional print publishers, however, have always run workshops as well, combining publishing with printing. In 1548, Hieronymus Cock, an engraver himself, installed a workshop and publishing firm in Antwerp, "Aux Quatre Vents" ("To the Four Winds"), and over the next ten years, he himself engraved, hired other artisans to engrave, and released to the four winds hundreds of reproductions of Italian paintings and over 60 engravings *after* drawings sold to him by Peter Brueghel expressly for multiplication. About 50 years later, Peter Paul Rubens installed a score of engravers, trained in Haarlem by Goltzius, in *his* Antwerp plant to reproduce and disseminate Rubens images throughout Europe. Rubens was a demanding taskmaster and a clever businessman, the sort of print publisher who leaves a lasting impression on the art of the print. As Hyatt Mayor has written,

> He watched over their every motion, correcting their proofs in ink and opaque white, and copying some of his own paintings in tones of gray so that he, and not they, should decide on the black and white values. As he dismissed engraver after engraver, he drove the best one, Lucas Vorsterman, into a nervous breakdown, but managed by deliberate tyranny to impress his style on all of his assistants.

Not every publisher is as imperious as Rubens, but Rubens' approach to print publishing combined two ingredients conducive to success: a keen merchandising sense and a sustained in-shop communion among artist, craftsman, and publisher. With judicious supervision and an expert, efficient staff, the professional publishing workshop, combining atelier and publisher in one entity, can provide, like a ballet company with a skillful director and its own house, an ambience that stimulates creativity, uniform standards of quality printing and curating and the constant linkage and cross-pollenation among artist, supporting cast and director which is most productive of distinctive art.

Three such dynamic enterprises were organized in the United States in the late 1950's and early 1960's: Universal Limited Art Editions, the Tamarind Lithography Workshop, and Gemini G.E.L. Another, Editions Alecto, established in London in 1962, employed artists to work in other printshops as well as their own. At the turn of the decade, while Continental artists such as Clavé, Manessier, Singier, Campligi, Buffet, Poliakoff, and Zao Wou-ki and their Paris publishers waited on line to have their lithos and intaglios done at the Paris ateliers, new and exciting graphic work began coming out of new American and British publishing workshops enforcing high professional standards.

Universal Limited Art Editions

In 1957, 15 years after she and her husband fled from Paris, 53-year-old Tatyana Grosman (Fig. 6-D) intrepidly installed a small lithography

ARTnews Special Prints Issue

March 1974 $1.50

Cover of *Art News* picturing Robert Rauschenberg's "Tanya." Lithograph in colors, 1974. Printed at and published by Tatyana Grosman's Universal Limited Art Editions. Fig. 6-D

press in her white frame two-car garage, not far from the ocean and Fire Island, in West Islip, New York, with the intent of implanting a French *specialité* in American soil: the publication of *livres de peintre* ("artists' books") in the tradition of Vollard, Skira, Iliazd, Tériade, and Pierre Lecuire. She was neither a painter nor a printer, but the sights and smells of her father's newspaper plant had endowed her with a love of ink, print, language, and the magical kiss of paper and printing press; and her exposure to theater as a young woman in Japan and Germany had filled her with admiration for the impresario, the talent that brings creative people together. The grand corporate name she chose for the enterprise—Universal Limited Art Editions—seems to belie the modesty of her ambitions in 1957, though it perfectly describes the pervasive influence that ULAE prints were to have on the Print World in the next decade.

From the start Grosman had a double burden: coaxing American avant-garde painters to make prints and entreating curators and dealers to appreciate the elegance and marketability of ULAE editions. In both tasks she was aided by a publisher's credo that displayed a profound respect for the vulnerability of artists:

> I am very conscious of the fact that I work as a publisher. From the beginning I was aware that lithographs were printed matter, not a unique drawing or painting, that impressions of graphics reach people all over the world. The artist is exposed that many more times; to release a print is a serious decision. My concern is that what is published show the greatest respect to the artist and to the public. That is my obligation as a publisher.

Those kinds of convictions made artists feel very secure in her hands. A South Shore neighbor, Larry Rivers, was the first artist Grosman cajoled into trying stone lithography, and the collaboration with poet Frank O'Hara that resulted in a dozen lithographs was entitled— appropriately enough—*Stones.* Her earnestness and eloquence and tact, her gentle devotion to fine printing, her passion for the tactile and visual properties of fine handmade papers, the intimacy and leisurely pace of her garage workshop, the bountiful lunches on the stone-slab picnic table under the catalpa tree, and the creative breezes stirring the South Shore air soon attracted other initially skeptical painters of the avant-garde. Barnett Newman, Robert Motherwell, Sam Francis, Fritz Glarner, Grace Hartigan, Jasper Johns, Robert Rauschenberg, came to work or had their stones delivered in the early years (only about 20 elite avant-garde Americans were asked to work at ULAE during the decade of the 1960's), and each soon arrived at a "recognition of the unique possibilities in working on stone, not paper and canvas," as Rauschenberg later wrote.

Grosman herself lugged the heavy portfolios of their works around the United States and Canada during the late 1950's and early 1960's, softening up the unresponsive market for uncommon prints and illustrated books. Today it is the curators who do the visiting, and the possession of an exclusive distributorship for an impression of one of the severely limited editions—editions of 14, 23, 32, adapted to the collaborators' time demands and attention span and, occasionally, the limitations of the medium—is a plum awarded to the most cultivated contemporary print dealer in town: Margo Leavin of Los Angeles, John Berggruen of San Francisco, Barbara Fendrick of Washington, among the chosen few.

What American painters did at ULAE in its early years was what Picasso did at Mourlot's: *work* on the stone, not simply draw lithographs. Under Grosman's tutelage they came to view the stone as "a piece of paper," in Newman's phrase, with its own peculiar properties. ULAE lithographs hardly ever look like reduplicated drawings or pictures of paintings. They reveal the energizing of a stone with original art. They tend toward sumptuous delicacy. ULAE prints seem to capture the potentialities of the medium, whether it be lithography, intaglio (an etching workshop and printer, Donn Steward, appeared in 1967), or woodcut. They tend to display a perfect contrapuntal blend of design, color, printing, and paper. Critics have carped over poor printing at ULAE, but the printing and carefully selected paper normally promote, rather than fight against, the image. "Paper is not just something to print on," Grosman has said. "In the right hands it is a live medium of expression. We don't do prints—we create art." The key word here is "we."

The art created at ULAE reflected from the start an admixture of Grosman's patient, watchful, precise control over quality and, under her guidance, the painter's feedback from his experimentation with technique and process. John J. McKendry, the late Curator of Prints at the

Metropolitan Museum, once wrote, "Economy is a word Tatyana Grosman does not know. There is nothing spared in either time, effort or money to achieve the artist's ends. There are no limits to what she will do to get the effect the artist wants." A project at ULAE, from Grosman's surveillance of the working proofs to her rejection of the last imperceptibly imperfect impression, has always been a joint quest for the ideal expression, not a headlong charge for an acceptable marketable edition. The small, uneven sizes of the editions confirm the integrity of the print, in defiance of the demands of the marketplace. Quests are journeys, and journeys take time, "time," as Grosman has stated, "in which to reflect and mature." Art was always permitted to emerge at its own pace at ULAE, without being placed under the time-is-money pressures typical of other printshops. Robert Motherwell labored over the aquatint illuminations and typography for his mammoth 1972 book, *A la Pintura*, for four years (he had first begun *thinking* about it 12 years before), and Sam Francis returned to West Islip to approve proofs for three 1959 lithographs after an absence of 9.

Tatyana Grosman succeeded in great part because her attitude toward print publishing was *simpatico* with the attitude of the American painters toward their art, and her leadership and generous patronage were irresistible. As Robert Motherwell once explained, "Tatyana Grosman brought all together. Her integrity, tenacity, endless patience, extravagance with time and materials are as rare as is the ambience of her workshops, where it is simply assumed, as seldom elsewhere nowadays, that the world of the spirit exists as concretely as, say, lemon yellow or woman's hair, but transcends everyday life. At West Islip, this consciousness permeates every moment." That's how renaissances get started.

Tamarind

Another woman on the opposite shore of the continent, artist and printmaker June Wayne (Fig. 6-E) enlisted not only American artists for her programmed printmaking renaissance, but American artisans as well. "A handful of creative people is all that is needed for a renaissance in the art," she wrote in her 1959 brief for the Ford Foundation, "if that handful comes together at the right time, in the right place. Half a dozen master-printers, scattered around the United States, with a cluster of artists revolving around each, could cause a resurgence and a blossoming-forth of the art of the lithograph that would attract the interests of the world."

June Wayne's ambitions were a bit more grandiose than Tatyana Grosman's. Like the space people shooting for the moon, she set goals that were at once both ethereal and practical: to rescue the art of lithog-

Theo Wujcik, "Portrait of June Wayne." Lithograph with colored pencil, 1973. 546 x 533 mm; 21½" x 21". June Wayne founded the Tamarind Lithography Workshop. (COURTESY OF BROOKE ALEXANDER, INC.) Fig. 6-E

raphy from its slide into oblivion by creating a collection of lithographs that would demonstrate its expressive potential; to excite interest in art dealers and publishers; to turn on and train American artists to become masters in the craft; to accustom artists and printers to work collaboratively in the medium; and to provide a pool of expert craftsmen to help artists make even more expressive lithographs elsewhere in the United States. As things turned out, all the projects required was driving ambition and money.

The Ford Foundation came up with the funding for Wayne's ambitions—over $2,000,000 from late 1959 through 1973—when her nonprofit pilot program called the Tamarind Lithography Workshop dissolved and completed the transfer of its functions and archive to the permanent educational and creative center and custom printshop, the Tamarind Institute at the University of New Mexico in Albuquerque. One of June Wayne's first orders was for the construction of a fully equipped cottage workshop on Tamarind Avenue in Hollywood, California, behind her own studio.

As Tamarind developed, its staff and consultants turned their attention to every problem they could think of related to lithography and the print market: problems involving execution, printing, curating, framing, storage, handling, paper, inks, machinery, accounting of proofs, record keeping, pricing, sales, exhibitions, conservation. Tamarind commissioned a medical analysis of why lithographers got backaches and a recipe for the ingredients of successful printselling. Discovering that dealers push what they have a stake in, a Tamarind consultant advised printmakers to sell prints to dealers rather than consign them for sale for more money. Tamarind technicians studied the properties of rare, fine-grained Bavarian limestone to develop methods for conserving the precious slabs, which lose a fraction of their depth with each effacing and resurfacing, and they searched for quarries outside Germany and experimented with substitute materials like ball-grained aluminum plates.

They tested all-rag papers for durability and light-fastness, tried out embossing, collaging, and folding techniques, and modified presses, rollers, and graining equipment to meet their artists' requirements. The Tamarind directors practiced and promulgated standards for quality hand execution and printing, curating, and the ethical distribution of prints. They published and circularized Fact Sheets on these matters as well as manuals of style and print terminology, dictionaries of the "chop marks" (blindstamps) of Tamarind printers (Fig. 6-F), newsletters, films, tapes, and other documents and records. Like some President documenting and recording his accomplishments for his presidential archives, Tamarind kept track of everything it did.

The focus of print publishing at Tamarind was on image making rather than producing editions. For a stipend of $1,000 plus travel costs, the right to retain 20 impressions (eight were dispensed to other American institutions by Tamarind) of every lithograph they could make and a two-month residency in sunny Southern California, some 200 professional artist fellows and guest artists—a new artist fellow every month—completed some 3,000 lithographs at the Spanish-Moorish cottage on Tamarind Avenue. Exposure to lithography and interaction with versatile technicians at Tamarind prompted many of the artist fellows—Cuevas, Krushenick, Moses, Nevelson, Price, Ruscha, among them—to continue printmaking elsewhere. Most of them, however, were never again heard from by the art market Tamarind was trying to cultivate. All of them provided fodder for Tamarind's most important product—the printers. Indeed, the artists selected for a Tamarind experience were those "mature artists whose styles would be complementary and emphasize different problems for the printers."

Over 75 printers trained on Tamarind Avenue. The printer fellows learned how to accommodate the artists' requirements for image making and, working with scores of artists over their two- to three-year stint, gained valuable experience with varying problem personalities and stylistic problems. For most of the artist fellows, the Tamarind experience was educational rather than education: they learned to work cooperatively with skillful printers rather than do everything themselves as they had in their art schools and studios. Few new ideas emanated from the artist fellows; most of the fertilization was one-way. An artist just wasn't there long enough to tap the potentialities of fine art lithography. Two months was hardly sufficient time for most "to reflect and think," in Grosman's words. The artist would communicate his esthetic needs, and it was the printers who probed and defined the limits of the possible, at least in terms of inks, tonalities, colors, papers, flatness, opacity, and scale. The reaction of John Paul Jones was typical of an artist's experience: "Those guys are real magicians, and I must admit that I don't really know how they pulled it off." Some of the artists felt repressed by the rigorous methodology and strenuous routine at Tamarind. All of them enjoyed their protected freedom on Tamarind's terms. As Kenneth

DEFINITION OF CHOPS: 1960 - 1970 Revised July, 1970

 The TAMARIND Chop (the alchemist's symbol for stone) appears on all lithographs pulled at Tamarind during its decade in Los Angeles. Please note that after July 1, 1970, the Tamarind Chop will be used at the TAMARIND INSTITUTE at the University of New Mexico. However, not all lithographs pulled there will carry this chop. The rules concerning its use appear in separate literature available by writing directly to the Tamarind Institute, the University of New Mexico, Albuquerque, New Mexico.

 UNIVERSITY OF NEW MEXICO. This chop is used alone or in conjunction with the Tamarind Chop on many lithographs pulled at the University of New Mexico in the Tamarind program conducted there between 1960 and 1970. After July 1, 1970, the appearance of this chop is governed by new and distinctly different rules set by the Tamarind Institute.

 JUNE WAYNE, artist and founder/director of the Tamarind Lithography Workshop, has used this mushroom symbol as her chop since 1950. It appears on all her prints and drawings.

When a Tamarind printer-fellow demonstrates that he is able to print an edition of professional calibre, he is given his own chop which, from then on, appears on those editions for which he is responsible. Printer-fellows who complete the full printer training program are certified Tamarind Master Printers, indicating they have the skill to collaborate with artists of every esthetic. Each Tamarind lithograph printed between 1960 and 1970 bears the chop of one of the following printers:

 KINJI AKAGAWA, printer-fellow from January 1965-July 1966.

FRANK AKERS, printer-fellow from September 1967-September 1968; printer at Universal Limited Art Editions, Long Island.

GARO ANTREASIAN, artist, Tamarind Master Printer, Tamarind Technical Director from July 1960-July 1961, Technical Consultant to Tamarind from 1961-1970; Associate Professor of Art at the University of New Mexico, Co-Director of the Tamarind Institute, University of New Mexico, Albuquerque.

JOHN BECKLEY, printer-fellow from June-September 1965; Assistant Professor of Art, Bucknell University, Lewisburg, Pa.

FRANK BERKENKOTTER, printer-fellow from June-August 1964.

A page from "A Definitive List of Chops Used on Tamarind Lithographs for the Ten Years, July 1, 1960, to July 1, 1970." Fig. 6-F

Tyler, who was Tamarind's technical director for two and a half years remembers it, "They did it my way, or they didn't do it at all."

The lithographs made at Tamarind are of more uneven quality than the ones made at ULAE, which had no "master printer" (the printers seem to remain anonymous in most of the literature about ULAE). Most of the prints suffered from the interaction between inexperienced and time-pressured artist fellows and apprentice printers in training, as well as the domination of the Tamarind master printers, who were often unable to avoid an overlap between "technical advice" and esthetic interference. It could not have been otherwise. Tamarind's principal *raison d'être* was education and the development of an environment. Tamarind was, after all, a training institution.

What is important for the history of art is not the quality of the art that issued from Tamarind but the materialization of June Wayne's primary vision. Tamarind furnished the printers for the Printmaking Renaissance in America. Graduate master printers steeped in the Tamarind ethic fanned out across the United States to become professional publishers and self-sustained printers in commercial and educational institutions, not only printers of lithographs but of the other graphic media as well. Tamarind Technical Director Irwin Hollander founded the Hollander Workshop in New York (1964); Kenneth Tyler, Gemini Ltd. in Los Angeles (1965); Jean Milant, Cirrus Editions in San Francisco (1970). Ernest De Soto became master printer at Collector's Press (now Editions Press) in Oakland; Jack Lemon, at Landfall Press in Chicago; and Herbert Fox, at Impressions Workshop in Boston. Some master printers landed at college workshops: Robert Evermon and Robert Rogers at the Nova Scotia College of Art in Halifax; Charles Ringness and Paul Clinton at Graphic Studio, affiliated with the University of South Florida in Tampa. Michael Knigin operated Chiron Press in New York, wrote a book on lithography, and in 1974 became technical director for the Burston Graphic Centre, a nonprofit publishing workshop affiliated with the Israel Museum in Jerusalem. Artists Garo Antreasian, Tamarind's first master printer, and Clinton Adams, an associate director and long-standing consultant, coauthored a definitive tome, *Tamarind Book of Lithography: Art and Techniques*, and teamed up again in 1973 to become Director and Technical Director, respectively, of the Tamarind Institute in Albuquerque, with the hope of making America's Southwest desert bloom with prints. That year June Wayne went back to being merely an artist again, and for her the Tamarind Lithography Workshop became "a form of Conceptual Art." As prescribed by the Tamarind style book, "I signed it."

Editions Alecto

While Tamarind was still a blueprint, two enterprising undergraduates in England, Michael Deakin and Paul Cornwall-Jones, were commissioning and selling art prints of Cambridge colleges and British public schools to nostalgic old boys. In 1962, with four additional partners, they founded Editions Alecto Limited. From its inception Alecto was committed to continuing the pioneering work of Robert Erskine, who himself joined the company in 1963. They would provide the mechanisms whereby British artists could be left free to exploit the artistic potentialities of the graphic media, and they would try to disseminate the results to a wide audience in England and abroad. The Alecto partners agreed to emphasize esthetics over profits and to underwrite contemporary artists with all the collaborative support and up-to-date equipment required for the commitment of unconventional conceptions to paper.

As their first attempt to stimulate, rather than simply satiate, the public taste, they commissioned 16 etchings by young David Hockney on the Hogarthian theme of *The Rake's Progress*, which was a good enough start to win the principal graphics prize at the 1963 Paris Biennale. That year Alecto established an exhibition Print Centre on Holland Street in London, which soon became the major gathering place for contemporary British and foreign prints in London, and sponsored its first European tour of the new United Kingdom graphics; "The only original works of art," asserted the trilingual exhibition catalog, "whose price makes them available to a major section of the community." In 1964, the year that Marlborough Fine Art began its print department and locked its stable doors on some of the more prestigious British artists, Alecto transformed a former wine distillery into bustling workshops for etching, lithography, and screenprinting and living quarters for guest artists. It soon developed into "the most ambitious organization in the field . . . a modern centre for the graphic arts," according to the *London Financial Times*. Within a few years Alecto was producing, editing, and actively promoting editions by Allan Jones, Alan Davie, Eduardo Paolozzi, Bernard Cohen, Richard Hamilton, among other Englishmen, and American visitors Josef Albers, Claes Oldenburg, and Jim Dine.

Throughout the late 1960's Alecto exported Great Britain's avant-garde art on a scale not seen since Britain's palaces and stately homes exported their art heritage to raise tax money—and with unprecedented effect. In 1968, Alecto's display of contemporary British graphics in Milan "made the Italian print galleries look like an ill-lit second-hand book shop," according to one of the London critics whom Alecto jetted over for the opening. By 1969, Alecto's exports to Munich, Düsseldorf, and Hamburg had helped make graphics by Jones, Hockney, Paolozzi, and other gifted British artists sufficiently celebrated to earn them places in German auction catalogs.

In 1965, Editions Alecto employed Christopher Prater to print a silk-screen series by Paolozzi: the Wittenstein portfolio, *As Is When*. That series is recognized, at least in Britain, as "the first major statement made with screen prints." The patronage of Alecto, Marlborough, and several other publishers at that time enabled Prater to lay aside commercial and art-publicity printing and concentrate on making silkscreens for artists. In 1962 Richard Hamilton had induced the British Institute of Contemporary Arts to use Prater's Kelpra Studio for an edition of artist's prints. The impact on many of the 24 artists who over the next two years participated in that project was enormous and spread rapidly among their colleagues in the United Kingdom and the United States. In a few years Prater had his hands full with commissions from other new publishers in London, such as Leslie Waddington and the Petersburg Press, which Paul Cornwall-Jones had established after breaking with Alecto in 1967.

Gemini G.E.L.

Tamarind spin-off Kenneth Tyler (Fig. 6-G) located his new publishing workshop, Gemini Ltd., around the corner, so to speak, from Tamarind because in 1964 Los Angeles "seemed like the place to be." A crack, inventive, impetuous artist-technician, who in the 1950's had trained with Max Kahn at the Art Institute of Chicago and in the 1960's with Garo Antreasian and guest printer Marcel Durassier at Tamarind, Tyler wanted to be close to America's aircraft and aerospace industry and the Southern California precision scientific and engineering community, where the most futuristic technology in the world was unfolding. He had great faith in the benefits of technology for printmaking in those days, and when he gained financial strength and business acumen from accountant Sidney Felsen and manufacturer Stanley Grinstein in 1966, the new company—Gemini G.E.L. (Graphics Editions Limited)—was transformed from a custom shop into an efficient graphics-editioning and -distributing business that would have stirred the admiration of Peter Paul Rubens.

The Gemini partners built the most modern print-making facility in the world. They established the Rolls-Royce, the IBM, the Bell Laboratories, of the print-publishing industry. Their spanking offices and sparkling clean rooms made ULAE's serene, pastoral garage-and-home workshops look un-American in comparison. The Gemini plant, three nondescript buildings on 20,000 square feet of urban landscape acquired in 1965, housed a no-nonsense interior of trim, industrial sterility that made it resemble less a traditional atelier than a space-program machine shop. Under Tyler's direction, Gemini printer-technicians and hired consultants engineered machines, tools and techniques to deliver meticulous, flawless printing and fabricating and unconventional effects. Stimulated by the demands of the artists for faithful renditions of their concep-

David Hockney, "The Master Printer of Los Angeles" (portrait of Kenneth Tyler). Lithograph and silkscreen in colors, 1973 (Gem. 451). 1219 x 813 mm; 48" x 32". (COURTESY OF GEMINI G.E.L.) Fig. 6-G

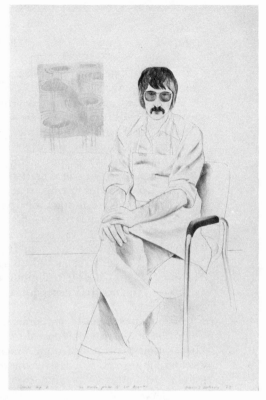

tions, master-printer Tyler and his printer cohorts, some Tamarind grads among them, designed and built or ordered durable hand rolls for hand inking, massive semiautomated presses, flat bed electrohydraulic powered presses to accommodate each of the print media on one press, hydraulic paper-forming machines, powered levigators to grain litho stones.

Gemini poured time and money into Research and Development like any other technology-dependent American corporation. They adapted and devised machinery, tools, and techniques to solve particular problems of precision printing, such as the registration of adjacent blocks of pure color without overlap, the precise inking of aluminum plates, and the exact cutting of silkscreen stencils (each round Lichtenstein dot!). Josef Albers' 1969 *Embossed Linear Constructions* represent a typical Gemini technological achievement. To convert Albers' precise line drawings into accurate furrows on a metal plate (Albers never left New Haven), the artist, Tyler, and an engineering programmer determined the exact dimensions of each line; the latter translated the specifications to a digital mylar tape; and the tape motivated an automatic engraving mill, fitted with specially contoured cutting heads, to cut the mirror image of the drawings into aluminum plates. With heat and tremendous pressure, a hydraulic forming press then embossed the inkless fine lines onto heavy Arches paper. Most central to the Gemini ethic, the product was a response to the prescripts and unremitting surveillance of the art-

ist. (Tyler signed correspondence to Albers, "Your printer."). Albers approved the results.

Researchers and chemists developed an all-purpose Special Arjomari paper of a brilliance, smoothness, and resiliency complimentary to the Gemini "look" and complemented it with specially concocted inks of extraordinary luminosity and even consistency. Gemini printers eschewed traditional hand lithography while that process was being evangelized by June Wayne and old world craftsmanship was being romanticized by Tatyana Grosman, preferring to take advantage of whatever transfer or photomechanical technique, device, or short-cut secured the pictorial effect sought by the artist. Gemini printers, themselves knowledgeable in Albers' theories on the interaction of color, sometimes mailed the Yale instructor proofs of color "Squares" of their own conception, which he accepted! No one ever tacked up a definition of an "original print" on a Gemini bulletin board; technique and the artists' involvement evolved from convenience and necessity, economics, and the wilfullness of Kenneth Tyler.

Gemini developed a corporate mentality, servicing and entertaining their visiting artists like one of *Fortune*'s *500*, merchandising their products through print collecting "Gemini subscribers" and a selection of subscribing retail galleries, wooing the local vice-presidents in charge of office decoration, worrying over (but never manipulating) the aftermarket reception and prices of its releases like a Wall Street underwriter watching the fluctuations of its new stock issues. Tyler introduced a Tamarind-inspired Print Documentation, a verified data sheet of archival coverage and accuracy, to a publishing industry which had always preferred to suppress information about the number of proofs distributed out of the overrun, *hors de commerce*. Gemini prospectuses were elegant reductions of the tidbits they advertised, garnished with text for art historians. A seven-day-a-week production schedule drove the Tyler team to make hay while the moon shone over Los Angeles to get out the 33 lithographs of Rauschenberg's *Stoned Moon* series during 1969 and 1970 (Fig. 6-H). Like their Hollywood neighbors of the back lots and sound stages, Gemini opted for the same approach as *That's Entertainment*. During the first eight years of its existence, Gemini was to ULAE as Stanley Kubrick is to Luis Buñuel: slick manufacture, polish, and flash, much of it astonishing and delighting the eye.

The best lithographs and silkscreens manufactured at Gemini during that period tend to be those that responded well to a generous dosage of engineering skill, methods, and equipment, the input of Kenneth Tyler and his subordinates. (June Wayne once enraged Tyler by advising him to work merely as the "brush" of the artist. Gemini prints sometimes reveal how much the Brush jiggled the artist, like the tail wagging the dog. The accurate sobriquet for Tyler and the other Gemini printers is "collaborator.") Of the 32 talents that Gemini recruited through 1974 among the American and British artists establishing international reputa-

tions (artists were privately ranked "A," "B," or "C" at Gemini according to their art world prominence), most employed geometric, cool, or pop styles that suited the Gemini image and orientation to a T-square: Josef Albers, Ron Davis, Ellsworth Kelly, Roy Lichtenstein, Claes Oldenburg, Robert Rauschenberg, Frank Stella, and David Hockney, in particular. Prints with the clean depersonalized look of the place, reflecting its *modus operandi*. The pristine "Gemini look." Crisp, immaculate, polished, severe, flat-surfaced, hard-edged, impersonal, and linear; little texture, painterliness, emotion, or subtle modulation of tone or color (there are exceptions, of course). Big prints. Perfect laminations. Exquisitely finished multiples of plastics, metals, and fabrics, disgorged from specially engineered molds, jigs, and fixtures, and exuding the formidable know-how, intelligent guidance, and exactitude of a precision manufacturer. Art *ex machina*. "All the steam in the world," observed Henry Adams, "could not, like the Virgin, build Chartres." At Gemini, the Virgin and the Dynamo were united at last.

 Few young unestablished artists got the nod to work at Gemini once it swung into high gear. Gemini prints cost a lot to produce (shop time and artisans' attention are worth money), and its formula for business success discouraged subsidization: the dedication of valuable shop time to un-

bert Rauschenberg looks on while Gemini G.E.L. printers move the lithographic stone for y Garden." Lithograph and silkscreen in colors, 1969 (Gem. 175; F. 74). 2261 x 1067 mm; x 42". (COURTESY OF GEMINI G.E.L.) Fig. 6-H

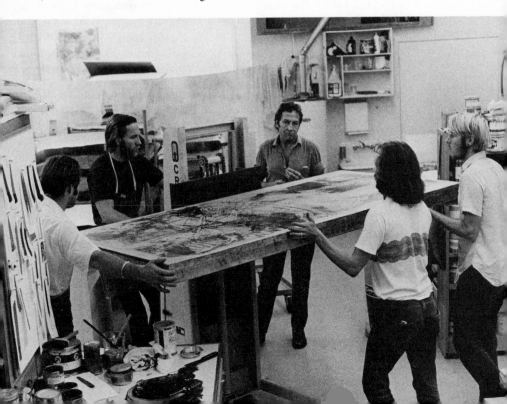

proven young talent who could not yet sell their own weight. Gemini's game plan was generally hostile to fresh personalities and styles, not to speak of "C" artists.

In 1974 Tyler broke with his partners and erected a mini-Gemini in a white frame carriage house off a bucolic country road in Bedford Village, north of New York City, not far from Grosman's suzerainty. Gemini G.E.L., with skilled printers and two of the original partners, maintained high-quality production. In Bedford Village, secluded amid his new apprentices, new papers, huge new stones from Bavaria, new hand-built presses, and New York maple and apple groves, far from the urban landscape of Los Angeles, its smog and the big productions of Gemini, Tyler could for the first time in ten years "take a very hard look at business life" and determine to "create more one-on-one linkage and not give commands, look for less flash and more intimacy," though still mostly with the safe "big boys" of contemporary art that brought him fame and success at Gemini—Albers, Motherwell, Lichtenstein, Stella, Hamilton, Davis.

The successes of ULAE, Tamarind, Alecto, and Gemini, and the confirmation in the 1960's by the traveling distributors of made-in-Paris graphics that there was a huge market in America and Europe—and not merely on Madison Avenue, Bond Street, or Rue Bonaparte—for a process-based art, an art that could be quickly and easily produced, spurred both the rapid expansion of a printmaking industry and the creation of marketing channels and methods to capture existing demand and stimulate more demand. Tamarind's 1964 "Study of the Marketing of the Original Print" was a clarion call for the exploitation of an untapped market:

> Within the billion dollar annual potential art market there is very probably a solid $50 million in yearly original print sales that could be garnered through appropriate sales channels and methods during the next few years. Presuming that the average price for prints continues to rise and reaches a level of $150 this would amount to not much more than 300,000 individual prints per year going into private and public collections. Such a figure could be attained if only 100,000 collectors acquired three new prints each year.

During the 1960's and early 1970's Paris printers, publishing workshops, and enterprising publishers *sans atelier* expanded their operations to meet the expanding needs outside Paris, particularly in the United States and Germany, and new enterprises sprang up outside Paris to obviate recourse to Paris. Small, quality workshops arose everywhere. Among the best were Valter Rossi's 2RC Editrici in Rome, servicing Italian artists Lucio Fontana and Alberto Burri in the early 1960's (Rossi recalls that in 1962 graphics "were still considered just pieces of paper" by Italians) and attracting the more internationally marketable Sam Francis, Victor Pasmore, Max Bill, and Alexander Calder in the second half of the decade; J. E. Wolfensberger and Emil Matthieu in Zurich;

Kathan Brown's Crown Point Press for intaglio in Oakland; Chiron Press and Styria Studio in New York, and the Untitled Press on Captiva Island, Florida. Publishing workshops germinated and expanded operations in Los Angeles, San Francisco, Chicago, Boston, London, Hamburg, and Stuttgart: Cirrus Editions and ADI/Triad Workshop, Collector's (Editions) Press, Landfall Press, Impressions Workshop, Petersburg Press, Meissner Edition, and Edition Domberger. The Chicago-based Circle Gallery chain of graphics supermarkets diversified downstream in 1974 by installing an atelier on New York's Upper East Side, so it would not have to get its Norman Rockwells, Gallos, and assorted School of Paris moderns printed in Paris. By the early 1970's, American printers who had first worked at Gemini and ULAE were traveling to England, Germany, and Italy to make prints; Rauschenberg and Francis had bought their own presses; and Motherwell had set up Robert Motherwell Editions. In 1973 Glarner Tullis founded the International Institute of Experimental Printmaking, a workshop lodged in an 1890 redwood mill in downtown Santa Cruz, California, and dedicated to the creation of "new and inventive graphic vehicles of communication." It did not take Louise Nevelson long to find it.

The Print Boom engendered a new generation of venturesome publishers during the five-year period from 1964 to 1969. In their attentiveness to contemporary art movements, irreverence for stale imagery, devotion to quality printing, and affinity with their artists, they emulated their illustrious Paris forebears of the Golden Age of French print publishing, the decades from 1890 to 1940. In 1964, Billy Klüver inveigled Americans Robert Indiana, Jim Dine, Roy Lichtenstein, Claes Oldenburg, Red Grooms, George Segal, Andy Warhol, Wayne Thiebaud, and James Rosenquist to contribute etchings to the fifth volume of Arturo Schwarz's Milan publication, *The International Avant-garde*. In London that same year, Frank Lloyd began publishing prints to disseminate the names and styles of Nolan, Dorazio, Piper, Tilson, and the other painters of his Marlborough Fine Art stable. In America, Rosa Esman, under the colophon of Tanglewood Press, commissioned her first portfolio of prints by contemporary New York artists, a $100 item entitled *New York Ten*. Later that year, five New Yorkers—Marian Goodman, Barbara Kulicke, Sonny Sloan, Ursula Kalish, and Robert Graham—incorporated Multiples Inc. and began commissioning prints on plexiglas, banners, and editions on paper and—though they weren't called that then—"multiples" by some of America's most celebrated expressionist and Pop artists. Their first project was *Four on Plexiglas:* Oldenburg, Rivers, Newman, and Guston.

Brooke Alexander became Editions Alecto's stateside office manager in 1967, after a few years of organizing Marlborough's New York print department, and departed Alecto a year later to begin his own publishing career, first in a nook on Second Avenue and later off upper Madison Avenue. Two editions by Josef Albers put him solidly in business, and showing canny foresight, he soon began publishing editions by Ed Rus-

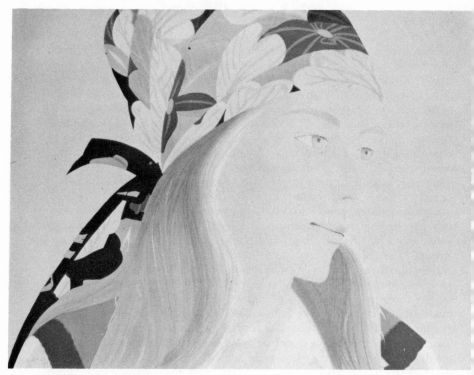

Alex Katz, "Anne." Lithograph in colors, 1973 (F.-S. 31). 686 x 918 mm; 27″ x 36⅛″. F lished by Brooke Alexander, New York. (COURTESY OF BROOKE ALEXANDER, INC.) Fig. 6-

cha, Philip Pearlstein, and Alex Katz (Fig. 6-I) that in five or six years became scarce, coveted, and expensive. After publishing a few editions by Nevelson, Rauschenberg, and Lindner in the mid-1960's, Harry Abrams invited Rosa Esman to head Abrams Original Editions in 1969, and Robert Feldman entered the publishing lists the following year with his Parasol Press. Londoners Bernard Jacobson and Leslie Waddington also became publishers at the end of the decade. Within a span of the few years of the late 1960's, print publishing exploded into a multimillion deutsch-mark business in Germany. Among the more discerning and influential of the German publishers were Wolfgang Ketterer, Heiner Friedrich and Dorothea Leonhart of Munich; Kestner Gesellschaft and Dieter Brusberg of Hanover; René Block and Hundertmark of Berlin; Hans Hoeppner and Hans Brockstedt of Hamburg; Edition Rothe of Heidelberg (founded 1958), Rolf Schmücking of Braunschweig, Dortmund, and Basel. Discriminating New York galleries weighed in at the turn of the decade with commissioned editions and distribution networks, too: sellers of contemporary art such as Martha Jackson, Pace (organized by Richard Solomon), and Richard Feigen, and old-line galleries such as Kennedy and Knoedler.

Countless more publisher-distributors and publisher-distributor-

galleries cropped up throughout Europe and America along the entire spectrum of business ethics and graphic quality and taste, with a considerable number clustered at the "low end," serving that vast public hypnotized by salesmanship or buying the kinds of pictures they liked in public school. (Vignettes of two of America's most energetic print merchandisers—Consolidated Fine Arts and London Arts—each of which nearly expired in 1972—are to be found in Appendix 1.) Hundreds of lonesome printmakers cranked their own etching presses and supplemented the racks of professionally published graphics appearing in every art gallery in Europe and America. Opportunists commissioned tacky figurative and abstract wall adornments from mostly undistinguished European artists and pushed them out through traveling wholesalemen to urban center frame shops and showy, hard-sell galleries employing superpriced safe Mirós and Chagalls, Picasso *afters*, and Vasarely ceramics as window dressing. Limited-edition cabals marketed the same image in "French" and "American" editions, without disclosing the double size to either side of the Atlantic, and released whole editions of "artist's proofs" into commerce to exploit the common misconception about their distinctiveness. Trade-book publishers, newspapers, and graphics distributors, commissioning their own editions and buying up chunks published by others to release "at wholesale prices" to magazine coupon clippers, got into the mail-order business to bypass the gallery system. Quadrangle/The New York Times Book Company urged us to "act today" and enjoy a Jenkins, Sonia Delaunay, Bolotowsky, Nesbitt, Goodnaugh, or Calder on approval "with full refund guaranteed." Fine Arts 260, a division of the Book-of-the-Month Club run by a former employee of the bankrupt publishing distributor, London Arts, gave subscribers the opportunity "to collect original art without investing a fortune in time and money."

Prints replaced occasional poems as commemorative publications for museums, universities, the Olympic Committee, and the American Bicentennial, and it soon became fashionable for a middle-class do-gooding institution—charity group, church, civil rights organization, civil liberties champion, pacifist—to solicit contributions with donated editions. How many tens of thousands of new editions were published over the ten-year period from 1965 to 1975, valued at how many hundreds of millions of dollars, is indeterminable. At the urging of its readers, "who lamented the lack of an overall view of the graphics and prints market," the German art magazine, *Magazin Kunst*, began in 1969 to make quarterly listings of all prints published in Germany "in order to facilitate more systematic collecting and better price comparisons"—but it never counted them up. How many of those new editions remained in publishers' and dealers' racks and drawers at the end of the quarter century is likewise unascertainable, but in 1976, optimistic Print People were predicting that the Print Boom of the prior quarter century was merely the first wave.

Detail from Pierre Van der Heyden, *after* Peter
Brueghel the Elder, "La Chute du Magicien" ("The Fall
of the Magician"). Engraving, 1565 (B. 118; Leb. 58).
222 x 288 mm; 8¾" x 11⁵/₁₆". (COLLECTION OF THE
AUTHOR)

Chapter Seven

The Nature and Scope of the Print Market: A Guide for Buying and Selling Prints

I am almost in despair when I reflect how much
money I spent uselessly before I learned how to
secure what are to me invaluable treasures.
 —WOLFGANG VON GOETHE, print collector,
 in a letter to a friend, 1809.

This is a nutso business.
 —Comment by New York dealer SANDY
 BURR, 1975

Outside the vale of academe and beyond the view of the public,
the Print World is a business world like any other.

That may be so self-evident that it seems tautological to say so. But
too many wayfarers in the marketplace are, to their disadvantage, dis-
oriented because they fail to perceive that fact. Prints are offered and
sold in ways diabolically calculated to evoke the same respect that one
accords to the treasures hanging in a museum; indeed multiple art ob-
jects are the only products of an industralized society that can be simul-
taneously on exhibition in a museum, to be experienced reverently and
esthetically, and on view in a place of business, to be eyed reverently
and selfishly. Moreover, so much of what is written outside the business
by critics, scholars, and museum catalog writers is concerned—and
properly so—with prints as art works in the stream of art history, as cul-
tural manifestations of society, as creative visual phenomena or technical
accomplishments to be explicated and appreciated, rather than as mun-
dane articles of trade similar to cars and groceries, that people are in-
clined to make sentimental judgments, rather than dispassionate business
judgments, when pictures appear in the marketplace as essentially noth-
ing more than priced articles of trade. Those commodities differ from

cars and cereal, to be sure, in having more intangible than utilitarian value to the consumer, but that doesn't alter their marketplace character as price-tagged goods.

Yet it is the very duality of their personality—appearing as merchandise in commerce to the practitioner and as wondrous creations, resplendent in their oversize frames and triple-ply tinted mat boards, to the beholder—that encourages and permits the hardheaded professonals to freight their commerce with the public with feigned genteelness and sentimentality. "You don't sell art like you sell shoes," the gallery owner at once advises and sniffs, embodying the dual role of saleswoman and esthete by implying that her inventory demands more reverence than that of a fashion boutique. The industry exists primarily to exploit a ready-made art mystique—a fiction that Marcel Duchamp transformed into art itself—for profit, much of it windfall and undue.

So in many ways the print business is a business *different* from other businesses. Within an average day one can hear three different practitioners make the same cynical observation about their life's work: "This is a screwy business!" "This is a sucker business!" "This is a nutso business!" It is very difficult for anyone who has been on the inside for very long to keep from becoming jaded and cynical.

The transactions that bring these commodities with intangible intrinsic value but with relatively firm, extrinsic monetary value to the ultimate consumers or return them to the stream of trade are mostly screened off from public view, protected by secrecy and a staged ambience of reverence, as if awareness of how they arrive at becoming price-tagged covetables would somehow tarnish their luster and appeal or make the profits reaped along the way seem unseemly, unconscionable, or illicit. By protecting and sustaining the art-world mythology about the inherent pricelessness of art, the face that the trade shows to the public can present almost any price to the awed and uninformed.

Most people's introduction to the print market is as unplanned and undirected as the Innocent Abroad's introduction to Rome's taxicab drivers, and most, like Goethe, begin by making "mistakes," which consist simply of having paid too much money for what one has obtained. The tyro who pays $250 for a contemporary print just does not know that he can, if he wishes to take the trouble, buy the whole portfolio of ten for $1,000, around the corner or by mail, and sell the nine he does not want at auction, one by one, to recoup his investment. The person who buys the *after* thinks he is getting a "Picasso" cheap, and while the *experience* may be didactic, it isn't the salesman who educates him. The tourist who buys a Rembrandt etching at Harrod's department store in London is not aware that he can buy an impression of equal (that is to say, equally poor) quality for one quarter the price across town at a Sotheby auction that very day.

Here are a few actual transactions and activities (slightly fictionalized, more to protect the author than the innocent) that are representative of how business is carried on by the trade:

$$$ London publisher B offers a limited edition portfolio containing 25 prints to the "trade" for a "prepublication" price of £600 (against an advertised retail price of £1,200). At publication time the stated wholesale price of the set advances to £750 (versus £1,500 "suggested" retail), while B is still making sales to collectors, which undermines his trade customers' market, at the prepub price of £600, "provided they don't say anything." Two years later, after B has dumped his leftovers on a hotel chain, prints from the portfolio begin to sell at auction for about £20 apiece (B's trade customers still have them priced singly in their galleries at £80), while B sits in the auction gallery with his arms folded.

$$$ "Runner" D buys a batch of old *Harper's Weekly*s at a small book auction, removes the two dozen wood engravings *after* Winslow Homer and sells them to New York Gallery K, which pays him $500, $215 of which he uses to pay his bill at the auction firm. K Gallery, an old-line firm, pays a restorer $15 to reinforce the centerfold on "Snap-the-Whip" and at once sells it to a customer for $250. K is already halfway home free.

$$$ New York dealer S, who has a longstanding public reputation for scholarship, acuity, and dignified stuffiness, buys an injured Rembrandt etching at Christie's in London for 650 guineas (then $1,625). The next day he delivers it to his London restorer. Several months later he describes it in his six-dollar catalog as a "very fine impression of this important example of Rembrandt's graphic oeuvre—$4,800," neglecting to mention the restoration, but quoting in boldface type the superlatives and paeans written about the image by various connoisseurs. That June at the Kornfeld banquet in Bern, S gives a little after-dinner speech in French to show how erudite he is. (Our National Gallery and other hoary institutions are devotees of S.)

$$$ Collector-dealer G "finds" a Castiglione etching for $50 at S's in New York City. He sells it to Munich dealer L, who trades it to Boston dealer L, who sells it to New York gallery K, which places it for auction in London, where it is bought by Düsseldorf firm B, which prices it at 2,400 deutsche marks ($800 then)—all within two years. No nonprofessional owned the print en route!

$$$ After cognac, visiting dealer L offers curator S an impression of a Gauguin woodcut which he has marked up to $8,000 (less 10 percent as a courtesy to the institution), 60 percent over his winning bid at the Hotel Drouot auction several months before in Paris. Curator S is grateful to L for giving him first pick of L's choice material (most of which S could have bought for the museum 50 percent cheaper had he attended the auction sales himself and had accession funds readily available to draw upon), and "needing" the woodcut to fill a hole in "his" collection, offers to swap three duplicate Rembrandt etchings, which L at once mentally appraises at $11,500, for the woodcut. L politely agrees and some months later, after S's accession committee rubberstamps the trade, flies off with his new etchings to pay a visit to curator F, who regularly relies upon L's wisdom and judgment and fairness of price in matters of old master prints. F selects two of the etchings, agreeing to request authorization from her committee to pay L $7,500 *plus*. . . .

If some of these scenes seem seamy, it is because they are drawn not from the cloistered world of art and esthetics but from a business world,

where people often behave not much differently from your normal car-lot owner or supermarket-chain manager. The business of distributing, dealing in, and trading prints is a deadly serious business for the professional, every bit as serious as any other kind of business, and not some gentlemanly dalliance engaged in for the good of and welfare of society in general or artists and collectors in particular. The practitioners in the business may be ruthless or considerate, unscrupulous or upright, plebeian or scholarly, Calibans or esthetes, but since they all depend on it for a livelihood and, to a greater or lesser degree, for financial aggrandizement, there are few that would pass up some easy pickings or a good deal. This is not a cynical view of the print market but a realistic view.

AN INTRODUCTION TO
THE MARKETPLACE

The print market is probably the most fluid of all the art markets. Since prints and multiples are published in editions, in almost every case there exists a price history, consisting of current offerings and prior sales of impressions of like quality and condition. Unlike paintings and drawings, whose prices are established by oblique reference to works of similar size, subject matter, quality, and so forth, every impression of a print that appears on the market has an immediately verifiable, relatively secure, current commercial value, at both a retail and a wholesale level, which is based—just as today's stock-market prices are a function of yesterday's—to a great degree on the last recorded offering or sale, if any, of another impression, modified by the various factors (which may or may not be accurately assessable) that may have influenced supply and demand in the interim.

What this means is that a buyer can be both deliberate and cautious. He has the same opportunity to comparison shop, if he knows where other copies can be located, that he does when he contemplates buying a new car or television set, and to wait for another copy if the price of the one at hand seems excessive. For unless the piece is rare or becoming scarce or its value seems to be on the uprise, the possibility always exists of obtaining an impression at a fair market price related to the prices of impressions offered or sold in the past. It also means that a nonprofessional seller can be reasonably certain of obtaining a just price (which is rarely—repeat, rarely—a full *retail* price), whether he sells directly, by consignment or at auction.

Information about offering and selling prices is obtainable both through perusal of auction and dealers' sales catalogs and the popular print literature and conversations (gratis appraisals) with auction-firm staff and magnanimous, trustworthy dealers. The lack of easily retrievable, comprehensive price data, however, compels most potential buyers

to rely on dealers' asking prices and auction-house estimates as price guidelines and permits dealers who wish to profit from the public's ignorance to inflate prices without regard to price history.

Transactions among dealers, both one-way and reciprocal, comprise a large portion of the aggregate commerce in prints. Prints are so easily transportable and storable that many dealers spend a great deal of time rapidly turning over inventory to other dealers for sure though small profits; transferring pieces to dealers in other markets; resettling slow-moving stock; and giving a colleague-competitor who may have a ready customer a shot at making a sale. Many dealers copublish or buy jointly, to avoid nasty fights, to spread the risk, or to pool their resources—financial, social, and intellectual. Multiples Inc. copublishes with Castelli Graphics; Leon Amiel of New York and Alain-C. Mazo (Bouquinerie de l'Institut) of Paris split distribution between America and Europe. Paris dealer Heinz Berggruen, Swiss auctioneer Eberhard Kornfeld, and Stockholm dealer Pierre Lundholm share ownership of Galerie Kornfeld in Zurich. Hubert Prouté and Pierre Michel of Paris, as one team, and Robert Light of Boston and August Laube of Zurich, as another, often work in concert. Some dealers with a street-level gallery, who are not ostensibly wholesalers, in fact act as small clearing houses and information-retrieval centers for the prints of certain artists and certain schools. If you wish to locate a certain print or find out what dealer needs a copy, just ask them. Dealers also sell to each other in the auction market. From 30 to 40 percent of the consignments of the major European auction firms is placed by dealers. Sotheby Parke Bernet New York is more democratic. Only about 10 percent of its material apparently comes from dealers' stock.

Auction facilities contribute greatly to the liquidity of the print market. Auctions are conduits through which tens of thousands of prints flow each year between the trade and private sectors of the market. The print catalogs of the major print auction firms—Kornfeld und Klipstein, Parke Bernet New York and Los Angeles, Sotheby's, Christie's, Hauswedell & Nolte, Ketterer, Karl u. Faber, and Paris' Hôtel Drouot—for the year 1976 occupy more than a foot of book-shelf space, and the minor houses—nine of them in German-speaking areas alone—that year sold thousands more prints themselves.

The acceptance of the graphic work of an artist, whether deceased or contemporary, for an auction sale by one of the major firms increases the artist's visibility and consequently the marketability of his work in much the same way that the listing of a common stock on a major stock exchange makes it more visible to the investing public and therefore a more liquid investment. The major auctioneers thus function indirectly as art critics, expressing approval or disapproval of an artist's style and work ethic by granting or withholding a sales forum. But although an auction market can enhance the liquidity of an artist's work, auction sales can have a depressing effect on the retail market for both prints in circulation and forthcoming publications, if auction prices are consistently substan-

tially lower than retail prices. Some publishers and dealers, who themselves depend on the auctions for inventory, wince when they see prints in which they have an economic stake appear for sale in the fickle, open, uncontrollable auction market (though a few, with more capital and gumption, support auction prices to "protect" retail values). "Basically," says London publisher Bernard Jacobson, "once I sell a print, I would never like to see it again." London publishers were accordingly extremely apprehensive over the first acceptance by Sotheby's, in July 1974, of their recent publications of Peter Blake, William Tillyer, Patrick Caulfield, Ivor Abrahams, and other British artists. (Their concern was borne out when several of their prints sold ten months later at Sotheby Parke Bernet New York for sums equal to 15 percent of their then current retail prices!)

Most of the auction firms accept consignments of whatever material is consistent with the subject matter, quality, condition, and price range of their usual merchandise and will generate a profitable net commission after cataloguing, promotional, and administrative expenses. Accordingly, whereas works by an artist of international repute are consignable anywhere, thousands of inexpensive and decorative graphics are denied any auction market. Some firms even discriminate against expensive *afters* by School of Paris luminaries and contemporary artists of whose styles or work ethic they disapprove. While unsophisticated buyers pay huge sums for *estampes* after Miró, Chagall, and Picasso and limited-edition photoreproductions of paintings and drawings signed by Dali, Norman Rockwell, and LeRoy Nieman, Sotheby Parke Bernet New York bars them from its print sales, though it welcomes photoreproductions of works in other media by Richard Lindner, Andy Warhol, and dozens of others. Marc Rosen justifies his policy as an attempt to exclude the "purely reproductive": those prints in whose conception and production the artist has not creatively participated. As business firms motivated primarily by economic considerations, the auction houses are, however, regularly cajoled into accepting merchandise they don't "like" from dealers who regularly feed them consignments or who sweeten the presentation with a few showpiece items.

The use of the auction market by dealers as an outlet for slow-moving stock, damaged and repaired merchandise (they can thereby transfer the onus of disclosure to the auction house), and portions of purchased collections and estate properties they do not wish to sell themselves has increased immensely since the public started attending auction sales in droves in the early years of the Print Boom. The nonprofessionals began entering the salesrooms in unprecedented numbers in the 1960's, driving up prices and driving away dealers who could once operate in relative isolation or count on forming a "ring" or maintaining a cabal to "knock out" competition and secure merchandise cheaply. Although Marc Rosen still receives telephone calls from people inquiring whether a Sotheby Parke Bernet New York print auction is open to the public, the auction sales of modern and contemporary prints, at least, are no longer the

dealers' tea parties they once were. While today about nine tenths of the purchasers of old master prints at Christie's are professionals, about one third of the buyers at Kornfeld's and three fourths of those at Hauswedell & Nolte's are not.

The democratization of the auction market for prints that took place during the Print Boom of the 1960's was complemented by the development of a truly international dealers' market. During the early and mid-1960's, when the United States dollar was still the Almighty Dollar, the European Common Market was an experiment, and the American print-making renaissance was just shifting into second gear, American dealers in old master and modern prints made their living by buying cheaply in Europe and selling dear at home. In Paris, perfume, gloves, and prints were bargains. By the late 1960's, as more Europeans became customers for their own dealers and the dollar weakened against the strong Continental currencies, that simple exercise in international trade became far harder to manage. In the early 1970's, the advantages reversed: it became possible for Americans to sell European prints for higher prices in Europe than in America, and many American dealers gave up skimming Europe for stock.

If American dealers no longer can scoop up prints at bargain prices in Europe, they still must seek the works of certain artists in their countries of origin. While hundreds of artists today enjoy an international reputation and are marketable worldwide, the graphic work of each artist has a primary market. Thus the market for *Brücke* artists Ernst Kirchner and Erich Heckel and for the prints of Horst Janssen is *centered*—that is, the largest source of supply is located and the highest prices are consistently obtained—in German-speaking nations (try to find a Max Pechstein in Paris; Prouté once had several prints by Karl Schmidt-Rottluff, "but could not sell them"). The market for Dunoyer de Segonzac is centered in Paris (they don't sell to Los Angelinos); for William Blake, in London (there are no Blake engravings to be found in Milan); for Ferdinand Hodler, in Switzerland (many New York dealers have never heard of him); for Jasper Johns and John Sloan, in America (try to unearth a selection in London); and for Umberto Boccioni, in Milan and Rome (Berliners generally prefer Teutonics).

Local preferences and buying habits in America and Europe are for the most part chauvinistic and parochial, resistant to the introduction of works of art popular in another country. Thus the prints of thousands of artists who have obtained regional recognition through exhibitions by local museums and galleries, favorable commentary by local critics, and advertisement in the local art press may seldom venture outside their territory. New York publisher Brooke Alexander sold only about 10 percent of his new American editions to Europe in 1974; London publisher Bernard Jacobson "is not interested" in publishing American artists; and Cirrus Editions of Los Angeles publishes mostly Californians. Few new avant-garde English prints can be found in Los Angeles or Paris. Paris, cherishing its Impressionists, Surrealists, and decorative neo-Surrealists,

remains impervious to almost anything non-French. Yet how many Americans have ever heard of Lanskoy, Courtin, Hartung, Tàpies, Soulages, Van Velde, Carcan, Clavé, Alechinsky, or Avati, contemporary artists among the rage of the Paris galleries in 1976? How many have ever heard of Antes, Bargheer, Baumeister, Bissier, Brauer, Bremer, Dexel, Grieshaber, Molzahn, Morell, Nay, Nesch, Orlik, Purrman, Thoma, Urdlicka, or Zille, thousands of whose prints are sold every year by German galleries and auction houses? By the same token not many Germans have ever heard of Audubon, Avery, Bacon, Baskin, Benton, Castellon, Cuevas, Davis, Hassam, Hopper, Katz, Kent, Marin, Orozco, Perlstein, Pond, Price, Ruscha, Sloan, or Soyer, whose prints—many of them costing in excess of $1,000—are staples in trade for Sotheby Parke Bernet and dozens of American retail establishments. There are scores of San Francisco artists who have no market in New York, and scores more in Quebec that have never had a bite of the Big Apple.

Normally it is the promotion and acceptance of high-priced unique works of art in other art media that cultivate the market for prints to a price level that makes them profitable to export. The print trade in each locality as a general rule is disinclined to handle the graphic work of artists who lack either a regional or an international reputation, preferring to cater to the names made familiar by local media and institutions (though many Americans continue romantically to embrace anything "made in Paris"). Unpublicized and unfamiliar foreign art is often simply difficult to import profitably.

INTERNATIONAL ART FAIRS

Several commercial art fairs held annually help nurture the international traffic in prints. Relatively recent art-world phenomena, these art fairs are trade conventions, art marts, juried exhibitions, one-man shows, and transaction centers all rolled into one, where the trade, collectors, curators, critics, and tourists rove, contemplate, make contacts, gab, swap, deal, acquire eye-and-foot fatigue, and buy next year's art calendars. They provide exhaustive (and exhausting!) stalking tours of 20th-century art and surveys of what's new and startling among new graphic publications. There are formal accolades for best show and best installation and informal consensuses, duly reported by the critics, about what was most banal. There is evidence everywhere of the irrepressible links between art and commerce; the acknowledgement of art as international currency is hourly expressed in dollars, deutsches marks, pounds, francs, liras, and traveler's checks. The fairs bring the art out of the hush and austerity of the gallery into the refreshing clamor and glare of the bazaar, where even the stuffiest of dealers sweat, loosen ties, and confess to harboring a stock of goods with price tags.

The art fairs perhaps serve most of their professional participants best with publicity—a publicity that is visual, personal, and direct—and most exhibitors are content simply to cover their costs to gain this exposure. But they also give print publishers the opportunity to expose editions in an international milieu, and print distributors and dealers an opportunity to observe new trends in both art styles and price structures, to make and renew contacts, and to trade to and among themselves under one roof. For their part the fair-goers, private and institutional, have a unique opportunity to view and procure thousands of pieces from many countries, without having to make the Grand Tour or fly the Atlantic. While a wide array of modern works of all varieties and styles, from tedium to kitsch to safe classics to the most up-to-date avant-garde, is available at the fairs both at the booths themselves and from the ambulatory nonexhibitors trading out of attaché cases like so many hippie bead street vendors, perhaps the best representations at the fairs are the new talents making their international debut. Scores of German and American artists in particular have been elevated to international prominence through exposure at the art fairs in the Rhineland since their organization a few years ago, and the critical eye has an excellent chance to consider and buy the first masterpieces of rediscovered artists and as yet unverified youthful talents before they become the high-priced Big Names of the next decade.

The United States hosted an international art fair, *Wash Art '76* in Washington, D.C., for the first time in May 1976, but the two most substantial fairs take place in the Rhineland. There were separate fairs in Cologne and Düsseldorf prior to their merger in 1975 to form the International Art Fair Cologne. The relatively exclusive October Art Fair in Cologne had emphasized the avant-garde and cold-shouldered graphics, while its rival, IKI (*Internationale Kunst-und Informationmesse*), which had originally been organized as a counter-fair and had been staged concurrently in neighboring Düsseldorf, had offered much variety and more quantity. One large fair now holds forth in Cologne each November. (In fact foreign art buyers tend to cram their visits to Germany into the October-November fair days, leaving German exhibitors nearly bereft of foreign clientele all winter.) The *Verband Deutscher Antiquare* (German Association of Antiquariats), which includes as members many European dealers in old master and modern prints, also stages a fair each fall in Stuttgart.

The principal fairground for modern prints is the International Art Fair in Basel, which lies in the land of the numbered bank account, where three national boundaries meet, and enjoys the most convenient time slot, the end of the spring season in June, when things are fairly quiet in the major metropolitan art centers. The Basel Fair, perhaps the world's most splendiferous flea market, with hundreds of mini-galleries (some of which dematerialize immediately after Art Fair week, nowhere to be seen at any other time or place), has become the art-world pilgrimage

that was once fulfilled by the Venice Biennale and the Kassel Documenta (Fig. 7-A). Its ten-kilo *katalog* and hundreds of stands in two floors of the mammoth Mustermesse Coliseum guarantee an enervating art excursion. Even the participants suffer. The debilitation of mind and body that results from 12 hours of booth-manning on a half-empty stomach can induce even the most uncharitable dealer to concede bargain prices during the waning evening hours.

A multitude of annuals, biennales, and print competitions that take place frequently in various cities and art centers throughout the world from Ljubljana to Tokyo, also permits thousands of new print conceptions to be aired and scrutinized. A review of past prize winners at certain of these juried shows—Miró, Hockney, Rauschenberg, *et al*—shows how helpful they can be in both verifying already recognized printmakers and identifying previously unnoticed talent. Many publishers, searching for fresh faces to promote, screen these juried shows, which are announced by the *Print Collector's Newsletter, Nouvelles de l'Estampe,* and the less-specialized art press, and hasten to sign up the winners for new publications.

A scene at the International Art Fair in Basel, Switzerland. Fig. 7-A

THE FIXING OF COMMERCIAL VALUE (PRICE)

The prices of prints traditionally follow those of paintings and drawings. When paintings and drawings sold for $500 and $50, prints sold for $5. When the paintings of a contemporary artist find buyers at $100,000, his limited editions of prints can be successfully marketed at prices in excess of $1,000.

Yet there is no standard equation that determines the market price of an artist's graphic oeuvre; the value assigned to any particular image will be a function of a number of considerations: (1) its scarcity, more accurately its "float," that is, the number of impressions that the market absorbs or is likely to face over a relatively brief period of time; (2) current demand, which is determined by the relative value of paintings and drawings, appeal of the design, popularity of the artist, sponsorship by museums and critics, investment potential (a self-fulfilling prophecy!), marketability, chauvinism, vogue, and nostalgia, appropriateness of the selling market, economic health of potential buyers, presence of a signature, *provenance*, condition, quality, and so forth, which is reflected by the price history; (3) the success of any measures taken to create or support a price level independently of the free-market forces of supply and demand.

New Editions

Rising printing and distribution costs, quickening demand, the exaction by popular artist-printmakers of fat fees and royalties, and opportunities for large profits have in recent years worked the retail prices of some new editions into high three-digit and even four-digit figures. In 1976 hot-off-the-press Hundertwassers, Jasper Johnses, and David Hockneys carried price tags in excess of $1,200. Mirós were in *multiples* of $1,000. Even graphics by competent though undistinguished European and American printmakers today attract buyers at hundreds of dollars apiece.

Most successful print publishers will discuss pricing, if at all, only with great reluctance and reserve, as if they feared being accused of profiteering. But the profits are often only commensurate with the risk. Launching an edition of prints can be as costly and precarious as any other business undertaking requiring substantial venture capital and facing unanticipated expenses and an uncertain market reception. In 1975 Jack Solomon of Circle Gallery computed that "our average edition costs $5,000, just to put it in the drawer"; some Gemini single-sheet publications have cost over $100,000; and a major Chagall suite might cost Leon Amiel and his partners $1,000,000.

This investment capital may be tied up for a considerable time before it can be recovered. Like a Wall Street underwriter forced to swallow a new stock offering that sold poorly, an ethical print publisher may be forced to "eat" the unsold portion of an issue for a time, rather than dump prints on the market at distressed prices. The average Castelli graphics edition of 100 takes about a year to sell out. Some print publishers will offer an edition to the trade at a "prepublication" price in order to recoup their financial outlay more quickly. But not many print publications are "hot issues." Former publisher Sam Shore (Shorewood Atelier) recalls that in the early 1970's he "couldn't sell Lindner's *Fun City* portfolio worth a damn for the first two years, while on the hook for $300,000 as costs." As Sylvan Cole once explained, during a panel discussion transcribed by the *Print Collector's Newsletter*, "Some publishers go into this thing with the idea that there's millions in it, and they can't understand why they flop all the time. There's no room for a lot of mistakes. If you print 20 prints by artist A and 20 by B and 20 by C, you have 60 prints on the market, and if only A sells, he has to cover B and C, which he can't do because the prices will be out of whack, so you go out of business. The formula can't stretch to failure—it can't stretch to where the return is either too long-term or you've overinvested." Successful publishers are able both to supplement receipts from sales of the edition and defer taxable income by retaining and later releasing their allotment of artist's proofs and—on a more *sub rosa* level—trial proofs accumulated in the printshop.

There is no universally accepted system for fixing the retail ("recommended") price of a new graphics publication. Some publishers price each new issue in accordance with an arbitrary formula, without attempting any rational calculation of what exact confluence of edition size and publication price would be maximally desirable under the precepts taught at the Harvard Business School. The simplistic four-times formula, or variations thereon, which is popular with independent publishers who do not operate a workshop, is based on the assumption that the publisher-wholesaler and the retailer (his trade customer) must each sell at double his costs to achieve a decent profit. Under this prescription, to arrive at a "suggested" retail price, the publisher adds up the direct costs of the edition (the artist's fee or projected royalty payments; proofing, printing, and paper costs; and the advertising, promotional, delivery and other expenses attributable to the edition)—and multiplies by four. The wholesale price is fixed at from 50 to 70 percent of this suggested retail price, and the difference between the wholesale price and the publisher's direct costs (not counting continuing overhead) equals his net profit on the edition. (To decide if publication would be commercially feasible in the first place—whether an artist's fee can be afforded, and so forth—some publishers work backward, dividing the *realizable* market price by four.) The four-times formula is one reason why there are so many prints priced at $200 to $300 which should be on sale for $50.

It works fine, that is, until printing costs or an artist's compensation catapult the retail price to an unrealistic, commercially unrealizable level. It is upset drastically by unplanned proofing and printing expenses and by artists in demand who have the power to demand a high fee or royalty rate—and there are some today who can draw down over $100,000 for a portfolio. But then, if he wishes, the publisher can take the prices of recent publications and the current retail market values of the graphics already in circulation as guidelines and price the edition at the full per-unit amount that the market for an image of that quality will bear, stretching the size of the edition (visibly and honestly, or by running extra "artist's proofs," foreign editions, deluxe editions, etc.) to permit room for a worthwhile profit after a 30 to 50 percent trade discount (the rate may vary with the volume of the order, the steadiness of the business relationship, the edition's cost, the name of the artist, and/or the salability of the issue). In the *Print Collector's Newsletter* panel discussion, Multiples Inc. owner Marian Goodman explained:

> It's very difficult to conceive of a formula for pricing. I like to think of it in relation to the artist's total work, relating prints to the prices of his paintings, drawings, whatever. Prices tend not to relate to costs. It's true that an extremely complicated print with many printings will be priced higher than a less ambitious one, but we try to price by a print's worth, not by its cost. . . . Sometimes an edition will be very costly to make and it just isn't quite as powerful or whatever as another print that can be more spontaneous and less expensive to print, and they end up being the same price, though the costs are different. It gets difficult when a print's terribly expensive to make, and the selling price often does not reflect the costs. Certainly one thing we will do if we're faced with a project whose cost to print is astronomical, we will—and have—raised the size of the edition so that it didn't become so expensive a print for the collector. Instead of printing 50, we would print 80, and we have done that a number of times. That is one way of controlling price—by the size of the edition. . . . You can't always do an edition of 36, the selling price might be way out of line. The most important thing ultimately is for the artist to be able to realize his idea— not the size of the edition. . . . One can, of course, print editions on many different kinds of paper, etc., and handle it that way, but that does not seem valid to me.

Consequently, if a publisher must pay Salvador Dali $35,000 for a gouache for conversion into a graphic, the signatures alone on an edition of 100 impressions would cost an impossible $350 apiece, so he extends the size of the edition to 350 to keep the publication price under $800 (reflecting $100 for the signature plus $100 for expenses *times* four). But then he risks saturating the market. As Kenneth Tyler puts it, the publisher is always faced with a painful choice: "Does he want to publish editions that are small so he doesn't glut the market or does he want to publish a lot of prints and throw them all over the place?" The danger of a high-priced oversupply is price collapse.

There are of course some publishers, especially the publishing ateliers like Tyler's, which have plant and employees to account for, that price

with more sophistication, treating their publications not as individual ventures but as parts of a business flow. To arrive at a price, they take into account, not only the costs directly attributable to a particular edition, but a fair allocation of general and administrative expenses, costs of continuing research and development of graphic techniques, trials and errors, entertainment and travel, etc., and weigh this allocative share against the reception that editions of varying quantities may receive at various price levels. Of necessity, such publishers use some editions to subsidize others, which might anger artists who wish to keep the price structure for their own graphics as low as possible, if they knew. Many publishers presell editions by offering subscription plans or prepublication discounts to their wholesale customers and, if they operate a retail gallery or can get away with undercutting their trade customers, retail customers, to recoup as quickly as possible some of the substantial venture capital invested in a project. Most publishers also raise the "suggested" retail price, and consequently the wholesale price, of an edition once it nears depletion, sometimes to create an impression of rising value, sometimes to squeeze the maximum profit out of proven demand. In the Print World, lowering a stated price, a sales technique not unknown to the rest of the business world, is considered demeaning to the artist and unfair to prior buyers and is consequently unheard of. One simply grants a bigger discount instead, discreetly.

The overpricing of new editions, which means charging the public unconscionable multiples of potential resale value, results either from greed, or costs and/or profit margins so high that the retail price must be jacked to an artificial, indefensible level. Salvador Dali's publishers and the other publishers who tout their issues as good investments milk the market for all they can take while the action lasts, and some dealers grumble about being shut out of the market for the work of Tamayo, Appel, Albers, Hockney, and Rauschenberg by "irresponsible" publishers who have "ruined" those artists' salability by overpricing. Some artists outfox themselves. In 1975, Robert Motherwell, anxious to elevate the prices of his new works to levels commensurate with his international reputation, cajoled printer-publisher Kenneth Tyler to issue them at prices which they could not justifiably command or sustain and which dealers could not tolerate. The artist himself was compelled to withdraw three lithographs that could not find buyers in the trade at their assigned prices.

Some thoughtful artists and their publishers are in fact anxious to maintain a low price structure to keep their dealers and galleries happy (low prices mean easier sales) and avoid an elevation of prices to peaks that may not be sustainable and whose collapse, like a setback suffered by a prizefighter brought up too fast, may irreparably damage the artist's reputation. New York's Pace Editions and Paris' Galerie Louise Leiris (D.-H. Kahnweiler's), for example, conceive of sales of graphics partly as a way of achieving wide exposure for the artists in their stable rather

than as a strictly money-making operation; accordingly, they price edi-
tions as low as possible, for small returns, to reach the public, and so
popularize their artists. As a consequence they also incur the gratitude
and loyalty of their trade clientele. Throughout the third quarter of this
century, Kahnweiler continued to supply the 20 Picasso "subscribers" with
new Picasso editions at the incredibly favorable prices of the 1950's, even
when the subscribers (Heinz Berggruen gets five impressions of each;
Eleanor Saidenberg, five; Marlborough, one; and band leader Mitch
Miller is a "sub-subscriber") began reselling prints for thousands of dol-
lars apiece, both to keep faith with the people who made commitments
to Picasso's copious graphic production in the postwar years, when his
prints were extremely difficult to sell, and to ensure immediate, wide-
spread distribution of Picassos. Thus *347 Series* impressions which
subscribers and undersubscribers were selling to the public during the
late 1960's for several thousand dollars each had been delivered to them
by Leiris for about $175 each! In defense of the pricing practices that
gave Picasso subscribers immense windfall profits, Maurice Jardot, cur-
rently the director of Galerie Louise Leiris, explains that "the prices
fixed by our gallery have always depended on those which Picasso has
asked us, while the prices demanded by the dealers-subscribers are es-
tablished according to the market." Jardot was never very pleased by the
money-making "attitude of certain subscribers who, I must agree, get
easily influenced by the fever of the market," but neither Kahnweiler nor
he was motivated to compel the faithful subscribers to hold down retail
prices. There were never any documents in writing concerning the Pi-
casso subscriptions, nor any unwritten understanding about retail price
levels—at least not between Leiris and its trade customers.

That informal way of dealing with the trade is customary in the print
publishing business. One publisher who has diverged from customary
trade practices is Muldoon Elder, owner of the Vorpal Galleries coast to
coast, who, hard on his phenomenal success in developing and exploiting
the American market for the prints of M. C. Escher, contrived a clever
scheme for the promotion of South African artist Jesse Allen that de-
pended on assurances of ever-increasing retail prices enforced through a
tightly controlled dealer network. Though most print publishers hesitate
to consign rather than sell new editions to the trade, because dealers are
more inclined to push what they own and habitually delay remittances
for consigned prints sold, Elder consigned Jesse Allen prints to retail gal-
leries in a way calculated to maintain tight control over the price struc-
ture—to prop it up from within, that is. Vorpal's exclusive consig-
nee/dealer would contract for ten years to adhere to Vorpal's retail price
structure (which in 1975 ranged from about $2,000 to $5,000—for the
prints!), raise a price when notified by Vorpal of a "price break" (which
was supposed to occur periodically and inevitably at various points dur-
ing the exhaustion of an edition), remit Vorpal's percentage at once fol-
lowing a sale (or be liable for a larger amount if the price was advanced

during the period of procrastination), and take in any Jesse Allen that someone wants to sell on consignment for Vorpal. Since there is no auction market for Mr. Allen's art, or indeed any trade in Allens outside the Vorpal network, Elder embarked on a publicity campaign novel to the print world, employing a half-hour color documentary film, numerous press releases, magazine articles, and advertisements, to forcefeed the Jesse Allen exotica to the world, make them covetable, and thereby justify their exalted prices. Another self-fulfilling prophecy! Jesse Allen prints are the only prints in the world that cost thousands of dollars but have no resale market to speak of. "Esthetics support this market structure," says Muldoon Elder.

Muldoon Elder is an unusual publisher in trying to set up contractual controls over the "aftermarket"—the price action of an edition during the months and years after publication. Publishers have an acute interest in the aftermarket, for it is the aftermarket reception of an artist's past endeavors that determines the price level of his next issue, and publishers generally do not want to get trapped pegging the price too high or too low. Obviously, no publisher can continue to market editions for from $2,000 to $3,000 apiece if the resale market price nowhere approaches that figure, and very few care to eat their hearts out watching prices double and triple within a few months of publication, like some hot new stock issue. Like open-heart surgeons watching their latest heart transplants, print publishers as a class track, fret about and talk about the aftermarket and wonder why it behaves the way it does, but do very little about it.

They make little effort either to enforce a holding of the retail price line or to maintain a lid on prices. A few publishers are active in the second-hand market, however. Some are not strong enough to sell to the trade without a buy-back guarantee, and some, following the trade practices of book publishers, reluctantly accept the return of unsold merchandise to maintain good customer relationships. Robert Feldman of Parasol Press can profitably repurchase his publications in the aftermarket and redistribute them to Parasol customers, and Brooke Alexander requests his dealers to reoffer one of his publications to him first before unloading it on the market at a big discount. Publishers need all their capital for publishing, and with the exception of the publishers of restrikes, who are usually dealers, they cannot afford to "protect" retail values by supporting prices either at auction or on the open market, as some dealers find profitable. Publishers generally act as information clearing houses for the prices and whereabouts of their progeny and stand ready to recommend a retail price to a dealer unsure of current price levels and to advise the public which dealer or gallery may have a particular print in stock.

Prints in Circulation

The retail price of a print with a ready and steady resale or second-hand market should be geared to its price history; resale value should be suggested by past price performance. A fair markup over a recent auction price—a premium of from 20 to 50 percent—should normally provide the dealer or gallery with fair and adequate profit. Most dealers, however, try for a normal markup over their cost even if they paid too much and an immense markup if they paid too little, so that a retail price does not always reflect either a "reasonable" profit for the dealer or a fair market value. As with department stores and gasoline stations, there are dealers and galleries whose stated prices are consistently high (which should be read as an invitation to haggle if the print is readily available cheaper elsewhere) and dealers, often those who are circumspect purchasers, whose prices are generally low. Associated American Artists in New York and R. E. Lewis of San Francisco (now of Nicasio) traditionally have some of the best buys around, and Hubert Prouté of Paris habitually sprinkles his catalogs with a few bargains—veritable loss leaders—to befriend buyers.

Dealers within one geographical market have sometimes attempted to set and control the market prices of an artist's graphic oeuvre or particular prints within their market. The price leadership and purchasing power of Heinz Berggruen of Paris and Reiss-Cohen of New York, along with indiscriminate buying by London Arts, were largely responsible for the substantial and rapid advance of the auction and retail prices of Picasso graphics during the late 1960's and early 1970's. Other dealers still consult the Berggruen and Reiss-Cohen price lists for guidance on Picasso prices and will set theirs slightly below those of the market leaders. In 1967, before Reiss-Cohen was a factor to be reckoned with in the Picasso market and began stocking *Vollard Suites* and linocuts, New Yorkers Robert Dain and Martin Gordon, then among the principal dealers in Picasso prints in New York, agreed jointly to fix and increase the prices for *Vollard Suite* prints, which they were obtaining from Henri-M. Petiet in Paris. When Dain welched by underselling Gordon, Gordon advised Petiet that he would have to cut off one of them or face a price war. Petiet retorted that competition would be healthy, so the New Yorkers began buying and selling *Vollard Suites* for such a small margin that they diverted customers from Petiet. Petiet enjoyed the last laugh, however. When the market price began to skyrocket in late 1968, he still *had* the *Vollard* prints he had not sold.

Perhaps the most fascinating episode of a price acceleration aided by dealer activity occurred from late 1969 to 1972, when the prices of the prints of M. C. Escher, the late Dutch designer of enigmatic and brain-

boggling imagery (Fig. 7-B), rose from a few hundreds to many thousands of dollars apiece. That extraordinary inflation of price levels resulted in good part from the efforts of several American dealers—Muldoon Elder, owner of the Vorpal Gallery, and Simon Lowinsky, owner of the Phoenix Gallery, both of San Francisco; Michael Sachs of Ann Arbor, Michigan; and a few other minor players—to capture the relatively small number of Escher prints on the market, absorb most of the artist's current production and exacerbate demand for Escher's prints at a time when demand for them in America was already beginning to swell.

In 1968, when Escher's work was highly regarded in the United States by only a small number of readers of *Scientific American*, mathematicians, graphic designers, scientists, engineering professors, hippies, tourists who had taken in the retrospective at the Hague Gemeentmuseum, and a handful of American print collectors (his European market consisted largely of Dutch collectors), Muldoon Elder was induced by a customer to write to Mikelson Gallery in Washington, D.C., then Escher's American agent, for some Escher prints. Mikelson replied that they were too difficult to obtain, but by early 1969, Lowinsky was already in communication with the artist, had received a list of prints for sale, priced at from $100 to $150, and ordered batches of them. Though a few blocks, plates, and stones were not reprintable, the bulk of Escher's prints were at that time hypothetically available in unlimited supply, for he did not cancel his matrices and printed on order. When Lowinsky and Elder were unable to get together on a joint Escher show, Elder began ordering his own prints in ever-increasing quantities at prices of from $200 to $300 (repriced at $600, or so, retail). He also launched a heavy promotional campaign, with media advertising, a TV news film, gallery film showings on Escher's work, and much salestalk, and developed what he terms an "oddball sales presentation." Under this program—itself like one of Escher's graphic approaches to infinity—Vorpal customers were

M. C. Escher, "Print Gallery." Lithograph, 1956 (L. 216). 320 x 315 mm; 12⅜" x 12⅜". (COURTESY OF SOTHEBY PARKE BERNET INC.) Fig. 7-B

encouraged to place an order for several subjects at the same time; when one of their choices arrived at the gallery, they could wait for their first choice or accept the arrival with an option to exchange it when their first choice came in—for an additional sum, of course, because by then their preference would be costlier. As Elder explains it, "I presented it as a 'you pay your money and you get your choice' game. We encouraged people to take alternatives. Someone might choose 'Concave and Convex,' 'Flatworms' and 'Print Gallery,' in that order, and if 'Flatworms' came in and he took it, he would have the right to trade it in for 'Concave and Convex' when *it* came in, though 'Concave and Convex' might be higher then. Most people buying Eschers were not thinking of reselling. I told people they're getting more expensive and I don't see prices levelling for a long time." Elder adopted this method of order-taking, which catered to a profound itch for the most coveted images and encouraged speculation (people deferred home improvements to buy Eschers), because he found from a few months of dealing with Escher that he could guarantee neither the price nor the delivery date of any print.

For on the other side of the Atlantic, poor Escher, in and out of the hospital in 1970 and thereafter, could not produce prints fast enough to fill the backlog of orders piling up from San Francisco. Though a master lithographer printed his lithographs, Escher himself printed—oh, so slowly—the woodcuts, wood engravings, and mezzotints. In early 1970, he began raising his prices almost month by month in futile attempts both to stem demand and to realize more for his work. In May 1970, after receiving a gift of Peruvian tapestries from Elder, he wrote:

> Since three weeks home from the hospital, I try to restart working, but I can't do much more than answering, day after day, the many letters of customers asking for prints. The reprinting-job will cost me considerable more time and energy than before my illness. Don't tell me that I should accept the presence in my studio of an assistant to help me. I have worked alone all my life and I don't intend to lose my independence.

In October, after acknowledging a check for $5,800 (he once quixotically returned one for $10,000), he again entreated Elder to be patient: "I am doing my best, but I am no (and don't want to be a) printing-machine!" In May 1971 (proofs were now $250 to $400) he again wrote to Elder:

> The demand of many customers, not only in the U.S., is so great that once more I am forced to raise my prices.
> This new list shows that only 14 subjects are available in this moment.
> Please understand that selling prints is not urgent nor any more necessary or a great pleasure for me. The only thing I want is to work quietly and not to live with continuous hurry to attend to my customers.

By then, the *Graphic Work of M. C. Escher* was on sale in paperback in every college co-op in America, and the Escher convolutions and conundrums, which were still only vaguely familiar to art critics and scholars,

had become the favorite visual perceptions of millions of college gradu-
ates who had enjoyed them while under the influence. During 1971 and
especially after the spring of 1972, when Vorpal hosted a mammoth
Escher show, prices shot up dramatically, and now Elder was being of-
fered Eschers by other dealers, including Mikelson and Michael Sachs,
who had located some out-of-print impressions in Amsterdam. "Within
six months," recalls Elder, "Sachs was on the telephone asking to buy
them back!" Sachs even had a gracious letter translated into impeccable
Dutch (Escher understood and wrote English perfectly) to cajole the
harried artist into furnishing him prints too. Though a few printsellers
had one or two prints, if someone craved an Escher print from 1970
through 1972, he was compelled to deal with Elder, Lowinsky, or Sachs
(or dealers in touch with them) and to pay their price; they had a virtual
lock on supply in the United States and no outside price competition.

Escher's all too brief spate of printing currency took place on bor-
rowed time. It ended abruptly in late 1972 when he died of cancer of the
stomach; nothing may be reprinted under the terms of the transfer of all
but one of his blocks and stones to the Escher Foundation (though Elder
is claiming Escher granted him the reproduction rights for posters, etc.).
At the time of his death, Escher was demanding thousands of dollars for
proofs, and in November 1972, "Day and Night," which probably exists
in over 700 impressions, sold at auction at Sotheby Parke Bernet New
York for $3,500, "Encounter" for $1,700, "Puddle" for $2,400,
"Compass Rose" for $1,500, and "Ascending and Descending" for
$1,900. By early 1975, after two years of impressions coming out of the
woodwork, auction prices for "Encounter" and "Compass Rose" had
fallen to $1,200 and $700 respectively, while Phoenix Gallery's (Lowin-
sky's) asking prices for the five were $7,500, $4,000, $4,500, $3,000, and
$4,000 respectively. But in November 1975 an impression of "Ascending
and Descending," true to its title, was sold at auction for $2,800.
"Eschers will continue to rise for another 20 years," predicts Muldoon
Elder, a man who now looks upon the late M. C. Escher as his "Fran-
kenstein monster."

Dealers can most easily influence the price history of a print, and
thereby "justify" its retail price, by influencing its auction price. Auction
sales are well attended by both the trade and the public, and the results
of the sales are noticed and avidly discussed by all Print People and
widely reported. Auction results are not only universally taken as bell-
weathers, whether justifiably or not (lots of factors can affect bidding
strength, from a *force majeure*—acts of God or man—to momentary disin-
terest to quality or condition), but are consulted as guidelines for resale
values and retail price levels. Even under the most ideal conditions, how-
ever, an auction may not determine what a print is "worth."

This is so because an auction price does not necessarily reflect a pure
and straightforward competition among experts and neophytes "willing"
to pay a certain amount. The auction firm itself may have a direct or in-

direct ownership interest in a piece (auction firms occasionally purchase outright, guarantee minimum proceeds, etc.), so that when it bids from its "book," it might be bidding against the audience for a gain much more sizable than a mere commission. A print dealer who owns a number of impressions or specializes in certain prints or bodies of graphic work, moreover, may himself bid or have accomplices bid at auction to "protect" prices or establish higher values. The Reiss-Cohen Gallery at one time supported the prices of Picasso's linocuts (without, however, ever consigning any of them for sale at auction to fix values), so that if someone wanted one, he had to pay the Reiss-Cohen price. The principals in the Escher story deny using the auction market to manipulate the prices of Escher prints upward, though they admit to bidding at auction to support their retail price structure and, to acquire, as a consequence, additional stock for sale at their levels. "Concerned with making Escher more legitimate and recognized," according to Nikki Arai, Simon Lowinsky's partner, Lowinsky placed several Escher prints at Sotheby Parke Bernet New York for the first time in 1972. At the Sotheby Parke Bernet sale in February of that year, Escher's first test at a major auction, "Belvedere," estimated at $500, was sold for $1,600. Speculative bidding is usually beyond the auctioneer's control, though Eberhard Kornfeld will now and then discourage speculation by making deprecatory comments ("It's too high now. . . .") or even halting the competition and granting an impression to each remaining bidder ("We'll find another at that price")!

A dealer or the publisher of a restrike may also himself consign impressions for sale at auction for purposes of verifying, justifying, or boosting the value of his inventory. In this case he uses the auction house as an ally by exploiting the reserve system. Thus the auction price may simply reflect a high "reserve" ("upset" or "knock-down" price, the lowest amount that the consignor will accept for the sale of his property) which has been agreed to by the auction firm and a high presale estimate reflecting that *sub rosa* amount. If a dealer who wants to sustain or increase the value of a print gives the auction firm a lot of business, the firm will rarely be chaste or courageous enough to refuse a consignment on the dealer's terms and abjure from a simulation of cross-bidding to build up momentum in the house to carry the bidding up to or past the unrealistic reserve he insists on. If the consignor repurchases his lot *over* the reserve (he can do that indirectly through an accomplice on the floor), all it costs him is the auctioneer's percentage. In this way the auction market, which is supposed to be an open wholesale exchange, often becomes a retail price-setting mart. Seated at the auction, one cannot tell, unless the final bid is substantially under the presale estimate, whether the lot actually sold, though the price results, which are distributed a month later, customarily leave unsold lots out.

Some auction houses will reject consignments from known manipulators. But certain firms, such as the Ketterer firm of Munich, have submitted unhappily to abuses of the system, in order to obtain stock for

auction, and regularly host dealer manipulations on their premises. Eberhard Kornfeld, in a position to elude such debauchery if he chooses, affirms that "Ketterer always seems to be the victim of dealers' combinations." "Nothing surprises me anymore," was Wolfgang Ketterer's commentary on the open conspiracy of dealers involving the prints of Friedrich Meckseper (their agents in the house were giggling while holding up their hands), which jacked Meckseper prices to such speculative, unsupportable levels at the Ketterer sale in May 1974. Rumors fly about manipulations even when they are not so visible.

If manipulated prices convey a false notion of "true value" to the world at large, the danger for both innocent and speculating purchasers at prices that do not reflect actual demand is more personal and direct. They may be laying out top dollar—or Swiss franc or deutsche mark—value just before the bottom falls out, as well might happen when support is withdrawn. It is not that print dealers, like securities manipulators, seek to drive prices up so they can bail out at the top for a profit; art dealers normally have a continuing interest in *maintaining* values, even speculative ones. But some dealers have found to their dismay that there was no demand to cash in on at the speculative price plateau, and very few dealers who embark on such a precarious venture have sufficient capital to sustain the drive. At certain price levels large quantities of impressions come out of the woodwork, and undercapitalized speculators can drown in the "float." Meckseper prices tumbled soon after their apotheosis, leaving—to use stock market jargon—a lot of people with paper losses.

HOW TO BUY PRINTS SHREWDLY

Hearsay, hunch, intuition, and faith may be essential for picking horses, but they will becloud proper decision-making about prints. It is essential that anyone interested in making a thoughtful prepurchase judgment about the value of an impression be familiar with the comparative rank of the print in the graphic oeuvre of the artist, the comparative price history, the relative scarcity of impressions, and the relative importance of a manual signature, and be capable of evaluating its comparative quality and its condition independently of any catalog description. Armed with such knowledge and expertise, anyone can enter the auction lists without trepidation, tangle with the sharpest dealer, and acquire bargains.

Buying from Publishers, Dealers, and Galleries

Print dealers are in business primarily to earn their living, and not to serve as benefactors of the arts or divertissements for their customers. The fact that some dealers sell what they love rather than merely what

will sell may influence the way they conduct their business but not their motives for selling.

There was once a time when just the artist and the printer split the take on a new publication, and the retail gallery had little competition from auction firms or mail-order houses for the art public's favor. These days there are five or six levels of distribution for many new publications, with each player extracting a cut, and a whole variety of purveyors of prints in the secondhand market. The only thing that has not changed too much is the inefficiency of the channels of distribution; buying prints remains very much a personal, one-to-one affair, notwithstanding the plethora of magazine coupons, mail-order solicitations from print-of-the-month clubs, and the ads in *New York Magazine* and *Magazin Kunst*.

The printmaking industry today sustains the same range of métiers that one finds in many other industries: designer, manufacturer, wholesaler, retailer, consultant, and auctioneer. The market structure is broadly similar in America and Europe. In the United States, Canada, England, France, Germany, Switzerland, Italy, the Netherlands, Belgium, and Sweden the Print World is populated with printshops, publishers, and distributors of new editions, dealers and brokers of prints of all ages, styles, and distinction, and experts who offer their time and advice for a fee. There are artists who make their own prints and sell what they make themselves; printers who never leave the atelier to become marketeers; publishing ateliers; entrepreneurs and philanthropic organizations who commission editions; commercial subscription "clubs" and museum-affiliated clubs that commission editions and distribute them to "members"; jobbers who supply the retail trade, and "runners" (the latter are the arbitragists of the Print World, people who pay for what they sell to dealers with the very proceeds from the sale), as well as merchants who combine two or more of these functions and sell directly to the public at the same time. Then there are the retail dealers: fine-arts consultants, interior decorators, owners of street-level galleries, dealers by appointment only, managers of limited-partnership investment funds, collector-dealers (scratch a "serious" collector, and you have of necessity a serious dealer), owners of frameshops and antique shops, booksellers, managers of department stores, mail-order solicitors, and proprietors of those *schlock* shops that sell "signed and numbered Original Lithographs" to go with their potted plants and electronic calculators. What are "conceptions" to the artist become a "project" to the publisher, "goods" to the distributor, "important prints" to the dealer, and "lots" to the auctioneer.

The artists themselves, and not only the ones who cannot or do not want to obtain a publisher or contract with a distributor, are sometimes a good source for their works. Artists with a strong bargaining position, such as Miró and Chagall, will often retain a portion of the edition as partial compensation, and it is customary for all artists to keep a small number of "artist's proofs" for private dispersal. Artists are not disin-

clined to sell the impressions from these editions that they do not care to store or give away as gifts. Many artists also donate editions to good causes, and these benefit prints can be both self-serving and philanthropic purchases. There are various directories that list the names and addresses of artists; some may be reached through their publishers; and some are even in the phone book.

It is often possible to buy new publications where the dealers buy them—and at dealers' prices. Unless the publisher or distributor is scrupulous about preserving the retail market for trade customers, has exclusive distributorships, or himself operates a retail gallery, he will not be adverse to selling directly to a private person on trade terms, since his chief aim is a rapid depletion of stock. Publishers are especially amenable to selling *before* publication at "pre-pub" prices to recover capital quickly. They normally grant a discount of from 30 to 50 percent off the "recommended" retail price to dealers and somewhat less to architects and interior decorators. It never hurts to ask for a discount. Some collectors go so far as to have letterhead and business cards printed to constitute themselves "dealers," entitled to a trade discount, much as some housewives constitute themselves "decorators" to gain entry to furniture and fabric outlets that cater to the "trade only." Most publishers will add your name to their mailing list for current and forthcoming editions without demanding any credentials, spurious or otherwise.

The commercial print "membership" organizations, such as the Original Print Collectors Group, Ltd., the Book-of-the-Month Club's Fine Arts 260, The Collector's Guild Ltd., and the Diner's Club, and the mail-order solicitations, such as those made by Quadrangle/The New York Times Book Company and Macmillan Original Prints, are usually the wrong places to buy limited editions. Ordering prints by mail may be convenient for buyers outside the major art centers, but the commercial clubs and mail-order concerns generally offer no price break, since their promotional and distribution expenses will greatly exceed the expenses of the publisher-distributor who sells to the trade, and their selection is severely limited in comparison with what is available in the galleries. Most retail galleries, especially those such as Associated American Artists that specialize in filling mail orders from catalog descriptions, will also mail to a responsible customer any print from stock or a catalog on approval or with full refund guaranteed, so that one gains nothing ordering by coupon or from a print society. Collectors' "clubs" such as Holland's Cercle Graphique Européen and Prent 190, New York's IGAS (it ceased operations in 1973), the German Kunstvereine (art clubs) in various cities, Paris' La Jeune Gravure Contemporaine and London's short-lived Editions Alecto Collector's Club, have demonstrated some daring and independence by promoting graphics aimed to shape rather then simply to pacify the taste of the general public. However, most of the commercial membership organizations and mail solicitations are nothing but vehicles for the merchandising of poor-quality and overpriced, undistinguished,

neo-realist, flashy decorative graphics, sprinkled with a few restrikes by the big names. Most of these enterprises also employ prints-for-investment verbiage of the most insidious kind to sell goods with no immediate resale value whatsoever and precious little investment value.

In fact, one excellent rule of thumb to follow is this: Never buy a picture from any commercial enterprise that goes to great lengths to build a case for its value as an investment. It usually happens that such promoters know little indeed about art, prints, or their value, but have employed ad men to draft their spiels. As a class, the prints-for-investment promoters are simply hard-sell pitchmen in art-world guise—some of them, such as Barry Goldfarb of the Limited Editions Galleries of Los Angeles and Honolulu and Leonard Rosen of Los Angeles' Windsor Gallery, recent transfers or fugitives from the world of securities or Florida-Arizona real-estate speculation, and others, such as Macmillan Original Prints (an affiliate of Ferdinand Roten Galleries, the Baltimore mail-order house), the progeny of professional marketing vice-presidents—who are attempting to justify prices for prints that are, paradoxically enough, *terrible* investments at the prices they are asking. Disbelieve the slick brochures, facile talk, and come-on signs in the windows.

The commercial membership clubs and solicitations are to be distinguished from the publishing workshops and non-profit print clubs and societies, some affiliated with such venerable institutions as museums or foundations, that offer high-quality publications at substantial discounts to members. Los Angeles' Gemini G.E.L., New York's Pratt Graphics Center, and London's Curwen Print Club are three publishing ateliers that offer significant discounts to subscribing members. Cercle Graphique Européen is an Amsterdam society of collectors of contemporary graphic art, founded in 1970 by three foundations under the patronage of his Royal Highness the Prince of the Netherlands, that offers its limited membership new publications by leading European artists upon a commitment that the prints will not be used for commercial purposes. In America the museum-affiliated Philadelphia Print Club, the Print Club of Cleveland, and the Graphic Arts Council of the Los Angeles Museum of Art have for many years furnished their members with editions at cost, commissioned from local and foreign artists and their heirs. Among European artists alone, the Cleveland club has published and distributed limited editions of Laboureur, Matisse, Blampied, Dali, Feininger (two), Dorazio, Boni, and Vasarely. There are also a number of Paris clubs that offer the new works of mostly unknown French artists to their memberships.

Generally speaking, the best places to buy prints outside the auction circuit are the establishments of retail dealers who specialize in prints (Fig. 7-C). The knowledgeable, reputable dealer, whose identifying characteristics are reviewed in Chapter 9, will not hesitate to share his knowledge and help a client to cultivate taste, discrimination, and connois-

Félix-Hilaire Buhot, "Frontispiece for *Les Salle d'Estampes.*" Etching, 1889 (B. 171). 222 x 149 mm; 8¾" x 5⅞". (COURTESY OF MARTIN GORDON INC.) Fig. 7-C

seurship. As Leslie Waddington, the London publisher and dealer, points out, "A good print dealer, as opposed to the dealers in unique items, is usually very helpful to someone just getting involved." There is so much vocabulary, technical understanding, and history of art that a neophyte must master before he can even begin to communicate effectively with the wise and experienced dealer, that the latter is usually eager to advance the novice's education to a level where he can appreciate what there is to buy. Not every cultivated professional will endure greenhorn questions like "How many copies of this painting are there?" or "Do you have any Dalis?" but as a rule dealers are people to learn from and talk with, offering valuable human contact that cannot be found in art books or at auction sales.

The best of the print dealers enjoy associating with their interested clients as much as their clients enjoy bantering with them and listening to their professional advice. Trustworthy dealers not only impart their expertise and conclusions regarding the identity, authenticity, quality, and condition of the prints they sell, but back them up with a long-term, absolute guarantee. Wallace Reiss, for example, justifies his high prices by assuring high quality and flawless condition; the purchase price reflects Reiss's known fastidiousness (though he *has* acquired cleaned Chagalls without knowing it). The buyer has recourse against such a

dealer that an auction firm cannot sustain. "It is risky to spend a lot of money and not be able to rely on what you are buying," Reiss advises.

A print dealer has the entire market from which to select his inventory, and he spends a great deal of time making acquisitions from sources that might be inaccessible to the layman: out-of-the-way and foreign auctions, estate executors who must sell quickly to raise tax money and know nothing about the art market, heirs, collectors, distributors, other dealers, runners, and ignorant people that come in off the street. Much of the average dealer's stock is composed of prints consigned for sale by people who do not wish to wait for or chance an auction sale. He also is in constant touch with the marketplace and its participants and can swiftly acquire a desired piece on behalf of a client. Moreover, unlike auction firms, most dealers will permit customers to take a print home for unhurried examination and private contemplation either on approval or with the contingency of returning it within a reasonable period of time for a refund or exchange. Dealers also offer a number of convenient collateral services, if they are so inclined, such as ordering mounts and frames at trade prices and acting as commission agents for inspection and purchase at auction.

Dealers do not like to extend credit, any more than any other merchant does, but few will resist doing so to clinch a sale. Arrangements to stretch installment payments over a period of time ranging from several months to a year, are fairly common. Certain galleries, usually the same ones that tout art as investment, have devised elaborate investment plans, extended-payment plans, leasing plans, and guaranteed-appreciation-on-exchange plans. One can be sure that such schemes will probably benefit the gallery more than the purchaser. They should be carefully weighed against conventional alternatives for financing purchases, such as a simple personal bank loan, and examined for hidden inequities. The facile "investment programs" explained in elegant brochures by the Reflections Gallery of Atlanta, "a Division of Gallery Investment Corporation," for example, are marvelously deficient in a number of responses to some very real potential problems. It is unclear, for instance, whether a Reflections lessor builds up any equity during the period of lease payments, so that, if payments are discontinued under extenuating circumstances, a credit will be available, or how if the lessor decides to purchase during the period of the lease, rather than wait until the end, his credit and balance due are computed. The director of the Reflections Gallery declined to reflect upon these and other similar questions about his "investment programs."

Every caution operable in connection with the examination of prints at an auction preview and the interpretation of catalog entries should also be exercised when shopping for a print at retail. Since one of the few advantages that a purchase at retail has over an auction is the opportunity for leisurely consideration, one should never buy a print from a dealer or gallery without taking it home for a few days risk-free, or at the very

least, without inspecting it carefully, unframed, at the seller's premises. The dealer would never buy anything blind from you. Those days alone with the print give you the time for unmolested inspection, research, and comparison with other impressions, consultations with experts like curators, auction-firm personnel, and other dealers, and comparison-shopping about price, if you have not checked around already. If the dealer balks at your request to examine the print or refuses to release it on approval, then either he detects that you are not a "serious" customer or that you are a poor credit risk, or he himself has something to hide. Before reaching the point of commitment, the prudent print purchaser obtains assurances or disclaimers, preferably in writing and on the bill of sale, on the factual matters set forth at the end of Chapter 1, so that the dealer's guarantee—another advantage he may have over the auction firm—may be endowed with more than platitudes and provide a clear channel for recourse, should it ever be necessary.

Before making a commitment to purchase, most buyers sense that it should be preceded by a little negotiation over price. The world over, everyone seems aware that one haggles over the price of an automobile, a house, and a work of art. But no one should plunge into a knock-down dispute over price without first taking stock of a print's investment value; a 10 percent discount on a print that may double in value in a few years is a picayune amount to quarrel about, all things being relative. Before initiating any scrimmage, the putative disputant should also appreciate that he may irritate the dealer to the brink of a refusal to sell at any price or find himself lodged in an irretrievable posture that forfeits the piece altogether. There are a few resolute print dealers who promulgate and abide by a no-haggling policy at the outset of their careers to avoid the discomfort of constant price niggling and the encouragement of a bad habit among their clients. Most will, however, like car salesmen, enter into the game because (a) it's good business to let the customer think he's landed a bargain, (b) their asking price already recognizes the likelihood that it will concede a discount (remember, trade colleagues are usually granted a 10 percent discount anyway), (c) the print is held on consignment and the consignor can be bargained down later, and (d) a sale is a sale.

If you must haggle, you can haggle best by convincing yourself that you can live without this particular work at this particular asking price; the supercool negotiator suppresses the constrictions in his stomach by professing disinterest, diverting attention from the sticking points with cheery anecdotes, and desisting from casting longing looks in the direction of the quarry. As any tough union leader can advise, patience is an indispensable weapon: keep up the dialogue, even if it's only chitchat. The experienced haggler tries to read the other side's bargaining position: Is the dealer short of cash? Does he have another customer? Has he had the print a long time? The fluent haggler always comes armed with both good connoisseurship, so that he can carp sensibly and pointedly

about value-diminishing imperfections and defects, and with market lore, so that he can cavil accurately about lower prior prices and the ready availability of other impressions elsewhere. The tactful haggler always gives the dealer the chance to cave in gracefully by conceding that he wishes to "encourage" the budding collector or "reward" the customer of long standing. Edging toward the door may be a good flea-market bluff, but print dealers are a proud lot and may let you leave. Print buyers have two helpful balancers: the frame (a good frame can run to over $100) and the timing of payment (time means interest). At the outset, one should assume for bargaining purposes that the stated price of a framed print includes its frame; if it does not, then a suggestion that the dealer "throw it in" can be a compromiser. And a dealer who won't budge off his asking price may paradoxically succumb to an outflanking thrust by accepting an extended payment plan, which is tantamount to a discount; a $500 debt carried interest-free for over six months, for example, is worth $25, a 5 percent discount, at 10 percent simple interest. Of course every dealer has his own Duveen-inspired repertory of ripostes and counterthrusts, ranging from "perhaps I can show you something less expensive" to shrugs of indifference.

Buying Prints at Auction

Most print dealers caution that the auction market, where they themselves acquire much of their inventory, is a dangerous place for the nonprofessional to venture, a pit inhabited by cunning professionals who recognize and winnow out all the prize material, by profligate and improvident collectors who would do better in the care of a prudent dealer, and—to quote Raymond Lewis' vernacular—by *schlemihls* who vie for inferior merchandise while thinking they are outsmarting everyone else (Fig. 7-D). Auction sales, the argument goes, are dumping grounds for damaged goods, and it is the layman who ends up with the high-priced garbage. "Wise and experienced art dealers also are bidding at the auctions," advises Los Angeles dealer O. P. Reed, Jr., "and they will not let a good print go for a cheap price, so collectors who buy this way are getting the examples the art dealer does not want." Well, that is like telling tourists not to enter the Casbah to buy an Oriental rug: good advice for those liable to be victimized and bad advice for those that have their wits about them. To heed such advice would restore the auction market to what it was decades ago—the suzerainty of the trade.

In truth, for anyone with a modicum of experience and knowledge (obtained, let us say, from the pages of this book), an auction sale is not the fearsome place some dealers would have the public believe. Prints can usually be bought more cheaply at auction than at a retail dealer's, and auction sales have ceased to be private parties for the trade. During the 1960's, when the man on the street began invading what was largely

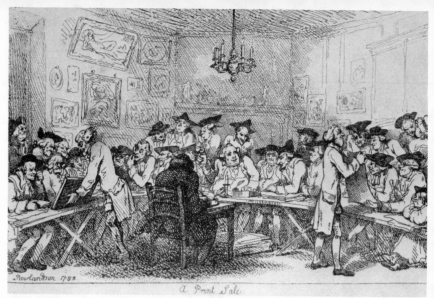

Thomas Rowlandson, "A Print Sale, 1788." Etching (G. I. 241). 188 x 278 mm; 7⅜" x 10¹
(COURTESY OF SOTHEBY PARKE BERNET CO.) Fig. 7-D

a dealers' and wealthy *amateurs'* club, the ratio of trade to public bidders shifted radically. People now intrepidly enter Christie's Great Rooms in jeans, and attending a print sale at Sotheby Parke Bernet Los Angeles is a Sunday's entertainment. The public's mass entry into the auction sales-rooms, together with the universal adoption by the auction firms of the reserve system, has destroyed the viability of the classic dealer conspiracy—the buyer "ring" (called the "knock-out" in London and *"la révision"* in Paris)—whereby dealers abstain from bidding, having designated one of their number to buy a lot for a low price, and then proceed later to auction it off privately among themselves. Distressed by the jostling crowds at auction previews, some dealers now obtain private showings when the hoi polloi is not present, and many oldtimers have stopped coming entirely. Today, unless the dealer is acting as commission agent for a client or is occupied with some price manipulation, the nonprofessional should be able to outbid him, for the dealer has to resell for a 20 to 50 percent profit in order to earn a living. Not wishing to cut their own throats, many dealers will in fact courteously (and helplessly) forbear from bidding when they see a customer or knowledgeable private person with his hand up—or will run him up behind his back out of spite and frustration!

There is enough material presented by the major auction firms in Europe and America each year to provide a comprehensive education in print esthetics, connoisseurship, and the history of prints and printmaking. The auction preview—a presentation of the auction consignments for inspection by potential buyers for a short period prior to the sale—offers everyone a splendid opportunity to learn about prints without being discomforted by the hot breath, sales talk, or intimidating glances of a gallery proprietor or encumbered by the rules of a museum print cabinet. At the preview as much time may be spent as one likes handling

that rare Rembrandt etching, whether one has any interest in owning it or not.

It is important that one allow sufficient time for presale inspection, which can be a debilitating, vision-clouding experience when there are hundreds of impressions to view, and postinspection research to confirm or dispute the accuracy of the auction catalog entries and verify prior prices. Most dealers planning to attend an auction will be pleased to inspect and bid on behalf of a client for a fee that can range from 3 to 15 percent of the winning bid (no fee is normally assessed for a losing bid or advice not to bid), depending on the person requesting assistance, the expert engaged, and the work required. For that fee the expert puts his reputation on the line; you pay for his skill, his advice, and his guarantee that you have bought what he advises you have bought. Many institutions which cannot afford to send their print curators on frequent foreign junkets regularly employ dealers whose opinions and skills they trust, to act as commission agents. Colnaghi's, for instance, has traditionally represented the British Museum and has often represented the National Gallery of Canada. The curators of American institutional print collections generally do not attend foreign auction sales or bid at them through agents, since they can seldom obtain the requisite quick prior approval of their accession committee, but procure most of their new acquisitions from dealers who do, such as Robert Light—at a markup, of course.

The only way to ascertain the identity, authenticity, quality, and condition of an impression coming up for sale at auction is to inspect it. Anyone contemplating a bid at auction must either inspect and evaluate the impression (or employ an agent to do so) or risk disappointment. "When one buys without inspection," O. P. Reed, Jr., cautions, "one usually gets less than expected." Print experts regard the catalog more as an introductory guide than as gospel, for the accuracy and reliability of the catalog entries, written by the staff of the various print auction firms, vary with the expertise, integrity, and traditions of the firm, its assumptions about the sophistication of its clientele, its sense of scope and emphasis, its propensity to eulogize and pontificate, and the communicative force of its jargon. All auction firms have a pecuniary interest in playing down problems—after all, their job is to sell pictures, not to discourage people from buying them—and some serve that self-interest more mindfully than others. The subjective semantics used to tell about the quality of an impression are idiosyncratic with each house, and even expert cataloguers will differ among themselves over when a defect in condition becomes major enough for mention.

Marc Rosen of Sotheby Parke Bernet New York offers this sound advice:

> It should be possible for a prospective order bidder to learn a good deal about a cataloguer's approach from a sensible reading of several entries in a cross-section of recent catalogs. From a careful reading alone one can learn

what kinds of questions of quality and condition the cataloguer at least takes into account and get some feel for whether the catalog entries are clearly inadequate, tend towards fair description or appear excessively lavish and literary. Assuming one has sorted out content from style, it is then good to view *carefully* at least part of a sale (and preferably several sales) with catalog in hand, to see how reliable the descriptions are in signaling points of major importance and to learn what general standards the cataloguer applies in the use of subjective expressions.

One should also not assume that the photograph appearing in the catalog is an illustration of the impression coming up for sale, since most auction firms will sometimes reuse old cuts to save expenses; the illustrations of the Nolde "Kerzentänzerinnen" woodcut included in the 1974 and 1976 Kornfeld catalogs, for example, were not pictures of the impressions sold at the 1974 and 1976 sales.

The examination time and catalog space that the auction cataloguer can economically and appropriately allocate to each consignment impose limits on what can be said about it in the catalog entry. Thus what is left unsaid may have more significance than what is stated. Few cataloguers ever describe an impression as *un*signed, for instance, so if the text is silent about a signature, one should assume the impression lacks it. Adrian Eeles, when head of the print division at Sotheby's, confessed to concise, fair, and comprehensive coverage for prints valued in excess of £1,000 and more cursory coverage for prints worth less. "If you are spending £1,000 . . . you have a right to know everything" about an impression's condition, said Eeles—which unfortunately implies that you don't have the right if you are spending less. Eeles at least struck his balances between overemphasis and underemphasis consciously with the mail bidder in mind. The catalogue descriptions prepared for Hôtel Drouot and other Paris auctions by the certified Paris *experts*, who as *marchands d'estampes* themselves have more of an interest in making auction sales in Paris uninviting to foreigners than in sharing auction spoils with non-Parisians, are, contrarily, traditionally flimsy and inexact— useless to anyone who cannot preview the sale. Nonetheless, *experts-marchands* and auction firm Print People remain accessible for advice and consultation; one can always interrogate the cataloguer narrowly about details by mail or telephone to obtain assurances unobtainable firsthand. When in doubt, *ask*. One should keep in mind, however, that prints sometimes acquire tears and stains, which the cataloguer may not be aware of, through rough or inexpert handling during the preview. The prints safest to gamble on without preliminary inspection are those that do not exhibit a great deal of variation in quality among impressions and whose condition is most likely to be pristine, such as monochromatic contemporary prints.

Even the most knowledgeable, circumspect, and conscientious auction house experts, such as Marc Rosen, Nick Stogdon and Noël Annesley of

Christie's, Louis Karl of Karl u. Faber, Ernst Nolte of Hauswedell & Nolte, and Eberhard Kornfeld and his assistant, Christine Stauffer (the list is by no means complete), will occasionally commit errors of judgment or omission. During one recent season at Sotheby Parke Bernet, there were among a number of unintentional slips an impression of plate 27 of Picasso's *Vollard Suite*, "Faune Dévoilant une Femme," described as unsigned which was actually signed; a Cézanne "Bathers" with undisclosed pinholes; Frank Stella silkscreens with their colors altered from exposure to light; a Wunderlich lithograph with an unannounced one-inch tear; and an Otto Dix print catalogued as a Dali (Fig. 7-E)! (The first two errors were rectified by salesroom notice; the

page from the Sotheby Parke Bernet Los Angeles auction catalog describing prints offered September 23, 1974. The print illustrated is not by Salvador Dali; it is by Otto Dix, "Balanceakt" ("Balancing Act," from the *Zircus* portfolio). Etching, 1922 (K. 35/II). 299 x 197 mm; 11¾" x 7¾". Fig. 7-E

69 **JOHN STEUART CURRY**
JOHN BROWN

Lithograph, (probably from the edition of 250 impressions), with full margins, in good condition

374 x 274 mm
14 3/4 x 10 3/4 inches

70 **JOHN STEUART CURRY**
OUR GOOD EARTH

Lithograph, signed in pencil, (probably from the total edition of 250 impressions), with full margins, in good condition

325 x 260 mm
12 3/4 x 10 1/4 inches

71 **SALVADOR DALI**
(BALANCABLE)

Drypoint, (19)22 (?), signed and titled in pencil, numbered 34/50, with large margins, two horizontal creases one of which runs through image (reinforced), creasing, soiling and several repaired tears and thin spots primarily in the margins

299 x 198 mm
11 3/4 x 7 3/4 inches

See illustration

Lot 71

Dix was withdrawn and subsequently reoffered.) But what is human oversight for a responsible major firm is standard fare for the indifferent minor ones. Out of 29 lots of prints by Rembrandt and Dürer included in a recent sale by Finarte in Milan, 12 were forgeries, and the balance, save one, were impressions from worn-out or retouched plates—falsified proofs. Honorable auctioneers normally retract and supplement printed catalog descriptions orally during the course of a sale, and some, such as Ketterer and Kornfeld, customarily post an errata and addenda sheet for consultation by those attending the preview and sale. No auction firm will rescind a sale because an ambiguous or enigmatic description was misread. But whether or not they acknowledge legal responsibility in writing, to maintain good will, the reputable firms will accept the return of a print that turns out to be materially different from its catalog description. Less scrupulous or more calculating auctioneers, however, regularly take refuge behind the rule of *caveat emptor*. A firm such as Kunsthaus Lempertz of Cologne, for example, customarily refuses to acknowledge responsibility for any error of description.

There is no consistency in accuracy among the presale price estimates which most auction firms publish in their catalogs. There is one school of auctioneers that believes that low estimates will lure bidders and make good press when they are overwhelmingly exceeded by final bids; another that believes that high estimates encourage people to bid high; and a third that believes estimates should not serve as marketing devices but as true price guides which customers should be able to rely on with a fair amount of confidence. Hauswedell's estimates are customarily low; Ketterer's and Karl u. Faber's, high; and Kornfeld's, Sotheby's, and Sotheby Parke Bernet's, as accurate as possible, keyed to prior sales and a hunchy appraisal of present demand. The professionals and connoisseurs who know value ignore the auctioneers' estimates.

One can normally count on being able to purchase a print at a price at or above the low estimate, since auction firms will not normally agree to a secret reserve (again, the amount the consignor will minimally accept as proceeds) higher than their announced assessment of its fair market value. Even though most firms charge a small commission for consignments that fail to reach the reserve figure and are "bought in" (though this provision can be eliminated from the consignment agreement by negotiation), it is usually not worth a firm's expense and trouble to attempt to sell anything at prices propped up to unrealistically high levels. Sotheby Parke Bernet New York's "standard advice to sellers [note that the word is "advice," not "policy"] is that reserves be set at a percentage of the median of the estimates [just *what* percentage, the important fact, it does not say], generally somewhat below the low estimate shown in the estimate sheet. . . . In no case do we permit a reserve to exceed the high estimate." The policy of its Print Department is to set the low estimate higher than the reserve. Kornfeld tries to keep reserves to a level equal to 80 percent or less than the estimate.

Anyone buying at auction should not only be aware that every lot may be subject to a reserve (40 percent of the lots at a typical Sotheby Parke Bernet New York sale), but that one may be bidding for merchandise owned, or almost owned, by the auction house itself. Unless the fact of its ownership or quasi ownership is disclosed, the auction firm hides a conflict of interest: While it is supposed to be acting in an agency capacity to sell as cheaply as competition will permit, it instead has a financial interest much larger than a commission in exciting interest by writing a misleading catalog description, giving overly encouraging advice to potential bidders, and pushing the item on the floor of the house. Neither Christie's nor Karl u. Faber owns any of their auction stock. Hauswedell & Nolte and Ketterer, following European tradition, normally own a small percentage of their offerings; Ketterer lists these items at the very end of his catalog under *Eigenware* (own stock). Contrary to popular belief, Kornfeld does not make purchases outright during the year for resale at auction in June, though he may have indirect or joint ownership interests in certain of the pieces he sells at auction, as he did in the Franklin collection of Toulouse-Lautrec prints sold in 1973. Sotheby Parke Bernet and its parent, Sotheby's, like Kornfeld and other firms, can acquire an indirect interest by buying a collection jointly with a dealer or by guaranteeing a minimum amount to the consignor, and occasionally, by advancing or loaning funds pursuant to such a guarantee. Sotheby Parke Bernet identifies such items in its catalogs, and Sotheby's does not. The former firm has ownership interests in less than 1 percent of its consignments.

All auction firms accept order bids by mail or telephone from persons unable to attend the sale or preferring anonymity. Sales at the Ketterer Villa in Munich or at Hauswedell & Nolte's hired hall in Hamburg can be so drawn-out and enervating and the chairs so hard that rather than fidget from 9:30 A.M. to 7:30 P.M., after previewing, some auction-goers leave their bids with the house or a friend to execute and pass the days of the sale in the mountains of Oberbayern or on the Reeperbahn. The possession of an order bid by an auction firm, like ownership of "consignments," places it in a conflict-of-interest position. To avoid being accused of exploiting that conflict of interest, most firms will take great pains to execute order bids fairly and attentively and obtain the lowest possible price for the order bidder. Louis Karl and Ernst Nolte opened up their books to this writer to prove it. "It's good publicity for us if the written bidder gets it under his highest bid," points out Karl. Yet auctioneers are still accused by distrustful dealers of building up the bid, either inadvertently or deliberately, to the detriment of order bidders, in the process of building up interest in the house. Though Nolte and Karl scrupulously commence bidding with the second highest bid to avoid wasting everybody's time, most auctioneers begin proceedings at a lower level for the assumed theatrical effect—to evoke a crescendo of interest—though the bidding activity under the second highest order bid is aca-

demic and may lead to "jump bids" and other errors and malfeasances damaging to the top order bidder. Though floor bidders make more errors than auctioneers, the trade is also chary of innocent slipups and mix-ups, as well as the possibility that new facts affecting value may come to light after an order bid has been placed, although in such event reliable auctioneers, which include the officers of the major German-speaking, London and American firms, will get in touch with the order bidder for instructions or cancel the order. The safest course is always to attend the sale personally or to entrust bidding to a friend or correspondent who will be there.

Books and confessionals have been written about bidding techniques and ploys, and they all can be seen at print auctions. Like those who play the numbers and the ponies, every auction bidder has his own system. Some think it pays to be loud and visible, to scare off competitors (Fig. 7-F). Others prefer quiet anonymity, to avoid a display of interest that might attract opposition or prompt a dealer to drive the price up out of pique, spite, or sport. New York old master print dealer David Tunick has been seen signaling the auctioneer by twitching a pencil held tightly against his chest and by employing Brooke Alexander, a dealer in contemporary American graphics whom no one would suspect of having any interest in Rembrandt, as his front man, all to evade attention from

The sale of old master prints at Kornfeld und Klipstein, Bern, Switzerland, 1974. Most of t world's leading dealers in old master prints are gathered around the U-shaped table in fr of the podium. (COURTESY OF KORNFELD UND KLIPSTEIN; PHOTO BY KURT BLUM) Fig. 7-F

rival dealers and collectors who might conclude that if Tunick is bidding, the print must be worth the price. Presumably to avoid attracting the predators who stalk the experts, and thereby obtain free counsel and assurances, Arthur Driver sometimes bid by keeping his glasses off his nose and in his hand when he bought for Colnaghi's. Convinced that Los Angeles dealer O. P. Reed, Jr., is too well respected and too tenacious to suffer being "run up" or otherwise abused by the auctioneer and senses from long experience how best to time his bids ("he knows when to hold back, when to come in to prevent running of the price, and so on"), Robert Rifkind, the Los Angeles collector of German Expressionist prints and illustrated books, has always employed Reed to do his bidding even when he himself was present at the sale.

Many suspicious dealers stand in the rear, where they can survey the whole house while bidding, both to avoid being seen by the audience and to discourage the auctioneer from "jump bidding" or "false bidding" ("bouncing the bids off the wall" and running up the price when he¹ detects unrelenting enthusiasm). "There are plenty of so-called reputable auction houses," warns R. E. Lewis, "where even if nobody were there, you're not buying at your own price. One of the greatest European auction houses uses a system of bouncing off the walls which is absolutely incredible. In fact, it's just one man sitting in the middle of the room, who's quite bewildered. . . ." It is certainly true that one can learn and take confidence from following the experts at auction sales. If O. P. Reed or a Colnaghi's staffer or Ruth-Maria Muthmann of Boerner's of Düsseldorf was the underbidder on your old master print purchase, you probably have made a judicious choice. Unfortunately, Christie's and Sotheby's recently halted their tradition of listing buyers' names on the price list distributed shortly after a sale. It is still customary, however, for European auctioneers to call out the names of successful professional buyers, so that one can sometimes profit from observing which experts bought what and how much they paid.

Purchasers must pay auction firms a surcharge (*Aufgeld*) on the winning bid: 10 percent in England and America, 15 percent in Germany and German Switzerland, 16 percent in Amsterdam, 20 percent in Vienna, 10 percent in Milan and on a sliding scale of from 10 to 16 percent in Paris and French Switzerland. On the Continent, professionals and regular auction customers are at least given some competitive benefit by the grant of a discount from the normal buyer's commission; they pay only 10 percent to Kornfeld und Klipstein and 12 percent to the German firms. All potential bidders must of course take their respective surcharge into account when computing their limits. There are knowledgeable and experienced professionals who will accept commissions to inspect and bid at Continental auctions for a modest fee equal to the difference between the standard surcharge and their discounted surcharge (they are there anyway), so that the private client can obtain the benefit of professional services for free, in a manner of speaking. Some jur-

isdictions level a value-added tax or sales tax on the gross purchase price, which is not, however, payable on exported lots or in America by the trade.

Auction firms normally extend credit for 21 to 30 days to trade customers and other credit-worthy clients. The auctioneers seem to agree that old master print customers are the promptest payers, while the young American dealers in modern prints, some of whom must apparently resell their purchases before they can pay for them, are the most consistently delinquent. Like any other business, an auction firm will be sympathetic to a good excuse for a long delay in payment, but some will charge interest for the favor.

Auctions held by the numerous small firms in Europe and America that have no experts and do not publish useful catalogs, country auctions, estate auctions, fund-raising auctions, and the like, can be excellent sources for inexpensive prints, for they do not normally attract the consignments, crowds, and cognoscenti, and lots may be offered without any reserve. During one month in 1975 in New York City alone, there were two scholarship-fund and one educational television station fund-raising auctions with selections of some auction-grade graphics, many of which sold for prices substantially under what they might have fetched at Sotheby Parke Bernet. Some New York dealers scan *The New York Times* auction page each Sunday for announcements of small sales. One must, however, be prepared to expend time and energy without reward. At an auction that took place at O'Reilly's Plaza Art Galleries in May 1975 an impression of Jasper Johns' scarce "Ale Cans," unheralded, mistitled, and misestimated by the house at $400 to $700, attracted enough competition to reach $6,000, a fairly full wholesale price. When Aldis Browne was gallery director of Associated American Artists, he once traveled to Philadelphia to capture an impression of Rembrandt's "Three Trees" at an unpublicized estate sale, only to watch forlornly while the television cameras moved in for evening-news coverage and the auctioneer announced that he had in hand order bids from several prominent New York dealers.

One must always be wary of the auction that is not an *auction*, for some retailers masquerading as auctioneers earn their livelihood by staging that old farmer's-market standard, the mock auction game. Exalted with the arcane language of art expertise and investment potential and radiating art mystique to the soft touches, graphics are the perfect product for an "auction" format, and the hucksters play up to audiences in a mood to act charitably. William Haber has for many years staged bidding competitions on behalf of Temple Sisterhoods and Masonic Temples in the New York metropolitan area for items from his inexhaustible "William Haber Art Collection," featuring among the Chagalls removed from books and magazines, commercial $25 reprints run off by the French government printshop, the La Chalcographie du Louvre, "bearing the authentic seal of the Louvre Museum."

Here is how a day's auction works at a typical sham print auction: The headline on the breakfast menu of Grossinger's Country Club, the dowager queen of the Catskill resort hotels, announces an "exciting" art auction. Later that day an emissary from the Todd Gallery, Grossinger's house art parlor with an outlet in the decorator quartier of New York City, softens up a well-fed, rained-in captive audience with a romantic capsule history of printmaking-thru-the-ages and a mouth-watering account of the profits in print loving. Then, after a few intentional "buy-ins" of showpiece items, the real business gets underway: the hawking of "original-reproduction-by-lithographic-process" graphics, assorted facsimiles, and other "really good investments" out of the Todd Gallery inventory. *Sic transit gloria.*

Where the Bargains Are

A "bargain" is a print that costs less than it would sell for in another market at the time of purchase.

The first thing to learn about bargains is to be wary of them. Fakes, forgeries, falsified proofs, deceptive reproductions, poor-quality impressions, and damaged goods often come cheap; the phony Toulouse-Lautrec "Divan Japonais" impressions that attracted a number of dealers visiting Hamburg and other German cities in the spring of 1974 were irresistibly priced. A great disparity between asking price and fair market value should initially stimulate suspicion rather than lust.

There are print bargains everywhere. All it takes to locate them is work, cunning, and luck. The print dealers and runners, who are at it full time, will probably get there first, but not necessarily. The professionals cannot be at the right time and place all of the time and are not always as informed, vigilant, and spry as one might imagine them to be. Unquestionably the specialist with sure and detailed knowledge and market lore about a narrow corpus of work stands the best chance of recognizing the bargain with the greatest certitude.

Bargains will appear, to repeat the truism, whenever there is a momentary imbalance between a local conception of value and an actual higher value elsewhere. Many a bargain is yielded by the inastute or ill-informed seller. The unknowledgeable person pleased to hear that his heirloom is worth so much will embrace whatever the dealer offers or whatever an auction firm suggests as a reserve—if it suggests any reserve at all—even if such amounts may in truth be substantially lower than realizable value. But laymen are not the only ones who give up prints at bargain prices. One of the best places to look for prints is in the gallery of a painting or antique dealer who knows little about them and has no clientele for them, but who may have acquired some with the purchase of a collection or estate properties. And the uncertainty of any seller, lay or professional, about what price to assign to a print, caused by the lack

of a recent price history or an inability to take an accurate sounding of the market, may lead him to underprice.

Moreover, works that are unfamiliar or unappreciated in one geographic market may be underpriced relative to their value in the locality where they are most recognized and sought after; regional preferences may slight a print for sale out of its natural geographic market, so that it becomes undervalued. Among recent bargains of this sort: a scarce Villon landscape etching at Parke Bernet Los Angeles (its natural habitat is Paris); *Die Brücke* woodcuts in German periodicals of the 1920's at the Swann book auction in New York City (the best market is in Germany and Switzerland, and only a few knowledgeable dealers attended the sale); Expressionist prints at Sotheby's in London; British contemporaries at Sotheby Parke Bernet New York; Jasper Johns in Munich; Hopper and Hassam in Bern; French prints at the Dorotheum state auctions in Vienna; German printmakers Corinth, Slevogt, and Liebermann in Chicago. Though considered his *chef d'oeuvre* in the graphic medium by the French, Rouault's "Crucifixion" sells less successfully in America, where it is unwelcome in Jewish homes, than it does in Catholic France. At one Ketterer auction in Munich, recent publications by Robert Rauschenberg drew derisive catcalls and snickers from a number of Bavarians in the hall, and Wolfgang Ketterer extracted even louder hoots when he pounded his gavel and roared, "Have some respect for the *art!*" In Munich, the Rauschenbergs were bargains. (Based on historical parallels, the disfavor of the residents of the city where Goebbels mounted his exhibitions of Degenerate Art in the 1930's may be the best indication yet that Rauschenberg has created art of lasting significance.)

The same possibility for arbitrage between markets exists when prints are sold at an auction that fails to attract sufficient competitors informed enough to advance the bidding to levels that reflect fair market values. The traditional explanations for a poor auction performance are that "the foreign dealers stayed home" or that "the overall quality of the material was flat." The assortments in the Sotheby & Co. thin catalogs of "ordinary" prints, some of which in fact contain impressions more than ordinary, are picked over by Londoners alone; international buyers save their Channel crossings for the green catalogs of "important" prints. There are a number of small auctions on the Continent which nonresidents of the area generally skip, such as the Gerda Bassenge sales in Berlin and the Galerie Koller sales in Zurich, which as a result occasionally sell some first-rate material at bargain prices. Most surprising, New York dealers themselves tend to refrain from thoroughly canvassing the unexpertized lots at O'Reilly's Plaza Art Galleries and the other small New York general auction firms (perhaps because it is usually not worth the trip across town) and so forsake the occasional bargain to energetic and shrewd hunters. In April 1975, Madison Avenue dealers Martin Gordon and Scott Elliot, who do scout the Plaza regularly, together bought for a mere $1,000 a rare, early Ernst aquatint (the present writer was apparently

the only other person in the room who recognized its value) that they re-sold for $3,000; a few months later, this writer secured a Foujita etching at Tepper Galleries for $450 that he sold at Sotheby Parke Bernet New York in May 1976 for $2,500; and James Goodfriend once found some Blake engravings at a Savoy Art and Auction Gallery sale for a fraction of their realizable value. Auctions also proffer thousands of slightly de-fective impressions—laid-down old master prints, time-stained modern prints, prints of all ages with slight tears or stains—whose market value can be doubled or tripled by a skillful restorer. And since a set or portfo-lio in most cases sells at auction for substantially less than what the sum of its parts would bring separately, some dealers, either alone or in con-sortium, profit very nicely from buying sets and portfolios at auction—a "Basan *Receuil*" of Rembrandt etchings (82 late impressions), a set of Blake's *Job* engravings (21 plates plus the title plate), an edition of Goya's *Caprichos* aquatints (80 prints), a set of Dix's *Der Krieg* intaglios (50), or Robert Indiana's *Decade* portfolio of silkscreens (10)—and selling them off, one by one, at retail or through other auction sales.

Legitimate charity auctions, which the astute professionals usually pass up, also furnish bargains: not so much in the items that go begging for five-dollar bids as in the "auction grade" material that attracts bids in excess of $100, but which would bring much more at a well-attended commercial sale. Prints donated for fund-raising do not as a rule carry any reserve, so they must all sell at *some* price, and the benefit crowd generally lacks the temerity to bid more than $100 for anything. (The prices reached at benefit sales are in fact even higher than they should be because most purchasers improperly take their "donation"—the check is always made out to the charity—as a deduction against income on their tax return. Purchases of art objects are not considered charitable con-tributions under the United States Internal Revenue Code, though most charities hint the opposite.)

Even major auction sales can yield prints at bargain prices at certain times. Acts of God and other disasters, such as a heavy snowstorm or a Presidential assassination, keep people home and depress prices; the Cuban missile crisis of October 1962 proved disastrous for the firm of Karl u. Faber but fortuitous for those who attended the sale. The after-math of the sale of an "important" piece or the achievement of a record price during the course of an auction, before the hubbub has died down and people again become attentive, can also be a good time to snap up something for a low price. So can the tail end of a long day's sale, when many would-be competitors have already repaired to their hotel rooms with a headache and everyone is punchy and worn-out. The Picassos ar-rived at 7:30 P.M. at the end of a full second day of sales at the Hauswe-dell auction in June 1974, producing bargains for dealers such as Harry Lunn who could manage to shake off somnolence.

To learn how to avoid giving someone else a bargain, go on to the next section.

SELLING PRINTS FOR
MAXIMAL PRICES

Anyone with a print to sell generally wants (a) the best price, (b) a certain sale, and (c) a fast sale.

There are three possible avenues open to the nonprofessional individual or the institution with a print to sell: sale to or trade with another nonprofessional; sale, swap, or consignment for sale to a dealer; placement with a consultant/broker; or consignment to an auction firm. The private seller normally has neither the names nor the contacts and lacks the time to ferret them out. The people who have tried to place "Private-Collector-Wishes-to-Sell, No-Dealers-Please" ads in the newspapers to escape a distress sale to a dealer or the uncertainties of an auction have generally not met with much success, and they expose themselves to the same intrusions suffered by the house-seller who wishes to elude paying a commission to a real-estate broker. A few periodicals, such as the English-language Milan-published *Print Collector*, invite subscribers to place "For Sale" notices, but the advertiser can wait forever for publication and response, and must be prepared to release his print on approval to a stranger. Some of the noncommercial print clubs schedule private auctions and swap sessions, but they provide a very limited audience for most private sellers.

The only people able to deliver a full price and a sure and quick sale with fair certainty are dealers, experienced consultants (brokers), and auctioneers. The business of the dealer is to buy cheap and sell dear, however, so he can rarely afford to grant a full price. In fact there are only four sensible reasons why anyone would ever want to sell to a dealer: to raise cash quickly and surely; to accomplish a trade; to get rid of an entire collection, parts of which may be unfit for auction, in one fell swoop; and to extract the same amount that might calculably be realized net (after commission) from an auction sale. On a direct sale, one usually sacrifices a quantity of cash for speed and certainty; dealers, who have other sources readily available for stock at wholesale prices, irrationally even resist paying as much to a private party as they would at auction, where the selection is, one must admit, more broad and the competition visible. It is not so much a matter of rapaciousness—though many dealers are very rapacious indeed—as the need to project a 25 to 50 percent profit over cost and the gratification of obtaining a bargain. "Shopping a print around" to locate the most generous dealer is an unpleasant and usually ineffectual exercise; you may find someone willing to pay your price, but after a while dealers learn through the pipeline that you are coming, and few of them care to participate in a bidding competition or take something a colleague has refused.

Most museum curators trade the duplicates in their collections rather than sell them at auction, where they could obtain higher values, for personal and specious reasons. They do so in order to be able to purchase tidbits from the dealers that woo them; not being particularly astute about the print market, not having any personal financial stake in maximizing proceeds, preferring to deal discreetly and privately—i.e., *sub rosa*—without having to open their transactions to publicity and possible criticism, and enjoying being romanced, wined, and pandered to by their colleagues in the trade who talk their language, the curators—to the disservice of the public and the great profit of a small circle of articulate dealers who work the "institutional market"—are mostly content to exchange their duplicates and deaccessions disadvantageously for kind rather than cash. The curators of European print cabinets at least have honestly selfish motives for trading with dealers: any proceeds from a cash sale customarily become the property of the museum's general fund or the nation's exchequer, rather than of the print room, and consequently unavailable for the aggrandizement of the print collection.

Estate executors and their lawyers, and heirs of the testator and their lawyers, who may know little about the marketplace but may need to raise cash quickly, or may hold properties unacceptable to an auction firm, are also inclined to place themselves in the hands of a "fair and reputable" dealer when the time comes to sell. The properties of the late Peter Deitsch, himself a lionized, marketwise print dealer, were divided between Harry Lunn and Lucien Goldschmidt in 1971; the estate was pressed for funds and burdened with much material, including 150 Wunderlich lithographs that, it was believed, would not fare well at auction. In the late 1960's, the fabulous Rouart Collection of 19th-century French and other prints passed through the hands or under the noses of over half a dozen brokers, finders, and advisers before reposing with Isadore Cohen. Rouart's heirs naïvely entrusted the collection to Wildenstein (self-styled "The World's Foremost Art Gallery"), which knowing nothing about prints, placed it with the ultraconservative William H. Schab Gallery, who discreetly mentioned it to *amateur* Donald Karshan, who "found" Robert Feldman (then with Computer Applications Incorporated), who consulted with Wallace Reiss and paid one third down, only to resell the collection almost at once for a handsome profit to Cohen, who was brought in by Reiss. Naturally each participant took a piece of the action en route; in fact part of Reiss' good fortune was a long-term contractual association with Cohen as a print gallery director—thus the Reiss-Cohen gallery was born. In the words of Parke Bernet's Marc Rosen, who far along the way made a pitch for a special auction sale, which would have enriched fewer people, "The Rouart family took a bath!"

If one has the time and no need to swap, there are two good ways to sell a print privately. One is to entrust it to an experienced consultant/broker, who for a fair commission can negotiate a direct sale to the

right dealer or institution or secure favorable terms for consignment at the appropriate auction. A consultant who acts strictly as a fiduciary and not as a traditional print dealer can have no conflicting interest in the opinions, advice, and services he renders; he cannot profit from misleading anyone about realizable value, since both his interest and that of his client lie in obtaining the highest possible price. A good consultant has a thorough knowledge of prints and the print market, has worldwide contacts and colleagues among Print People, and can discern which local market, whether in America or Europe, would offer the best opportunity to maximize proceeds. He also handles all necessary arrangements, paperwork, and deliveries. Since such a professional is accorded trade terms, a seller can often realize much more through the use of a consultant's good offices than he might realize privately. Paying the commission charged by a consultant is often well worth while.

Another way of expediting a sale is to consign it first to an aggressive dealer for a return equal to or above what it might fetch at auction after commission, and then, should the consignment fail to produce results, to consign it for sale at auction with a realistic reserve. Since prints are multiples existing in more than one impression anyway, and the consignee-dealer will reach only a limited number of customers, the "shopping around" that a consigned print might suffer will in all likelihood not jeopardize its later submission to a wider public at auction, should that alternative be necessary. There are some dealers, such as Wallace Reiss, who will not accept any consignments because consignors "always want top price," but most dealers and galleries conserve capital and fill out their stock by accepting whatever consignments are proffered on reasonable terms. Rather than a commission arrangement, which demands that the dealer honestly report what price or other rewards he has obtained and gives him little incentive to push the consignment over the inventory that he owns, it is better to fix a certain sum as net proceeds and to allow the dealer to reach for whatever additional sum he considers attainable as profit; then if a potential buyer balks over price, the burden of giving way remains with the dealer. A form of consignment agreement for a private seller is set forth at the end of this chapter. Before approaching a dealer with a consignment proposal, it is imperative that the putative seller arrive at conclusions about the fair market value of the work, through research or consultation with Print People, independently of the dealer's opinion.

Consignment for sale at auction at least gives some assurance that a sale will be accomplished fairly quickly at *some* reasonable price, and it is probably the ideal way for the nonprofessional to sell most prints with an auction market. As Marc Rosen also correctly asserts, "The auction market is the one place where a seller can be assured of getting a fair shake, since both he and the auction firm are interested in getting the best possible price." Major print auctions generally take place during the spring and fall, though the English-language houses schedule sales every

few weeks or so throughout the art season running from October through late June. Auction firms will normally accept consignments for cataloguing up to about three months before an auction date and render payment from within 30 to 60 days after the sale, so that one can count on completing a transaction with some certainty within four or five months, if necessary. As auction grounds, Paris' Hôtel Drouot and Palais Galliera, the state-controlled arenas where the licensed *commis-seurs-priseurs* stage their sales, are county fairgrounds compared to the lists in New York, London, Munich, Hamburg, and Bern. The French maintain a bureaucratic procedure, splendidly Cartesian but inconvenient and archaic, for the submission and acceptance of works for auction, involving their "importation" into France and "exportation" from France if unsold, with all the formalities such acts imply; they entrust the preparation of unattractive sales catalogs to dealer-*experts*, who while providing a 30-year guarantee for buyers, draft uncommunicative entries unaccompanied by any illustrations, and then publicize sales only by brief eight-point notices in the Paris press and selective advertisements in elite art periodicals. Most foreign Print People are not even aware when Paris print sales take place, and few receive the catalogs. The Paris auctions are picnics for the Paris dealers—no place to sell.

The negotiability of the terms and conditions of consignment will vary with the value of the proposition and the pitch of the competition among the auction firms in the geographic market of potential sale. For decades before the entry of Martin Gordon as a print auctioneer in 1976, Sotheby Parke Bernet was a monopoly on both the East and West coasts and could afford to be stickier about terms than the London and Continental firms, which vie for consignments among a half-dozen fair-sized competitors and a dozen smaller firms. Every auction house today will consent to a reasonable reserve, normally an amount equal to 70 to 80 percent of what the print auctioneer decides upon as a presale estimate. The firm will naturally argue for the lowest reserve possible, since its interest is in ensuring the attainment of a full sales commission. On his part the seller ought not to demand a figure so high that he obstructs a sale and risks a buy-in. The Continental firms will generally remit the amount of the net reserve, even if the winning bid leaves little or no room for their selling commission, since they will extract a commission from the buyer anyway. (Bidding on one's own consignment to stimulate competition is a pastime tolerated by the European firms but outlawed by the Sotheby Parke Bernet contract: Sotheby Parke Bernet does it for you by bouncing bids off the walls, if necessary, until the reserve is reached.) If the consignor insists upon a reserve that the autioneer believes is unreasonable, he may refuse the assignment; if he concedes the reasonableness of the reserve amount, upon request he may excise from the contract the requirement for the payment of a buy-in commission, normally about 5 percent of the reserve, which the consignor is liable for if the lot fails to sell.

The proposed selling commission rates of the principal print auction firms as of 1979 were as follows:

NAME OF FIRM	STANDARD COMMISSION/LOT	TRADE COMMISSION/LOT
Sotheby Parke Bernet New York	10%	6%
Sotheby Parke Bernet Los Angeles	10%	6%
Christie's New York	10%	6%
Sotheby & Co.	10%	10% or less
Christie's	10%	6%
Kornfeld und Klipstein	15% under SF 30,000; 10% over SF 30,000	10% or less
Hauswedell & Nolte	15%	10% or less
Karl u. Faber	20% under DM 1000 estimate; 15% over DM 1000 estimate	10% or less
Galerie Wolfgang Ketterer	15%	10% or less

The best way to negotiate a lower than standard commission rate is to come in with a large collection or a sensational print, threaten to take your business elsewhere, or assert, if true, that you do a little "dealing" on the side. Most firms will reduce their commission if the offering is attractive enough. The smaller firms on the Continent will make great compromises, sometimes even to the extent of forgiving a selling commission altogether, to obtain an "important" piece, for its prestige and publicity value. In special circumstances some auction firms, upon request and for extra commission, guarantee minimum proceeds, take some form of quasi ownership position or purchase an item outright, and thereby become dealers rather than mere agents. Unless the seller is desperate for an assured disposal of his property or the firm advances funds on its guarantee, the very offer of a guaranteed minimal amount is the best reason to reject it; if the firm is so certain of obtaining the

minimum amount, the seller should rest assured also. The auction consignment contract also specifies which party is liable for illustration and insurance costs, which can sometimes cut relatively substantially into the amount of the proceeds, and the reallocation of such costs may be another matter for negotiation.

For optimal results it is advisable to consign a print to an auction firm that operates in one of the print's natural markets: New York for Edward Hopper, Los Angeles for Ed Ruscha, London for Samuel Palmer, Bern for Lovis Corinth, etc., etc., etc. Old master prints have an international for Louis Corinth, etc., etc., etc. Old master prints have an international market; Kornfeld always has an abundance of fine Munch and Toulouse-Lautrec to attract devotees of these artists; and generally speaking, contemporary British graphics do best in London. For various reasons Eberhard Kornfeld also usually attains very high prices for good-quality French prints. Although the selling commission rates were lower in Europe than in America before 1979, auction prices for prints with a truly international market were also somewhat lower in Europe because bidders had to include in their calculations a buyer's surcharge of from 10 to 16 percent. It is a toss-up among Kornfeld, Ketterer, and Karl each year as to who employs the prettiest girls to enhance the esthetics of the works they hold up for display during the bidding.

Most Americans fall into the lap of Sotheby Parke Bernet, when they might be better off selling overseas, because it is convenient, familiar, and American. The major European firms, however, including Sotheby Parke Bernet's parent, Sotheby's, either maintain offices in New York or send English-speaking representatives circulating around the United States each late summer and winter to accumulate material for the next sale. If you cannot get to New York or miss these emissaries, it is easy to mail the print to the appropriate firm for examination and appraisal; they will return it at once if it is unacceptable for inclusion in their catalog. Negotiation over the terms and conditions of sale can be carried out in English in person, by telephone, or by mail. Each of the auction houses will also remit payment in the currency of choice. The European firms re-mat prints for convenient inspection at the auction preview, but if possible, for the sake of safety and optimal display, it is always advisable, especially at Sotheby Parke Bernet, where the hoi polloi sometimes soil or tear an unmounted impression inserted in an acetate envelope, to enclose a modern or contemporary print within a frame.

Apart from the normal, straightforward ways of disposing of prints, there are several oddball sales approaches that sometimes work. Some dealers occupy themselves at print auctions trying to spot the underbidders so they can approach them with another impression on the spot. Some people bring duplicates of prints being auctioned at Kornfeld und Klipstein to Bern before the sale, so Kornfeld can himself offer another impression to the underbidder; when to everyone's surprise and amuse-

ment, Kornfeld announces from the podium that "you will each get one for that price," he has another in hand leaning against the wall of his office, brought in by a last-minute consignor, or else he knows where he can find one. Galerie Wolfgang Ketterer, which doubles as a retail gallery, will sometimes attempt to sell an unsold piece privately after the auction and will accept it for inclusion in the retail stock catalog which it distributes some months later.

A last method of disposal is appropriate for expensive prints that were worthless when bought or have depreciated greatly in value afterward: give them away to whatever charitable institution will accept them or donate them for a charity benefit as a tax deduction.

[FORM OF CONSIGNMENT AGREEMENT]

<div align="right">_____ (Date)</div>

Mr. Theodore B. Donson
50 West 57th Street
New York, New York 10019

Dear Mr. Donson:

This letter is to confirm our understanding with respect to the following print, which I have delivered to you today:

[Here identify the print, describe its condition, and state whether it is manually signed and numbered.]

I am consigning this print to you for sale under the following terms and condition:

1. You shall use your best efforts to exhibit and sell the print for such price reasonably in excess of $ _____ as you may determine.

2. My selling price to you shall be $[same sum], and you may retain as commission on any sale the difference between such sum and your sales price. You will remit such sum by check payable to me immediately upon receipt and in no event later than _____, 19__.

3. If unsold or unpaid for by the aforesaid date, the print shall be returned to me immediately. If returned, the print shall be in the same condition as when received, and you shall indemnify me for any damage should the print not be in such condition or for any loss of the print.

4. You shall at all times keep the print insured for the aforesaid sum against all risks customarily insured against. This obligation shall not release you from your obligations under paragraph 3.

I represent and warrant that I own the print free and clear of any liens and encumbrances and free of any claims of third parties, and that I have the right to consign it for sale.

Kindly indicate your agreement with the foregoing and acknowledge receipt of the print by signing a copy of this letter and returning it to me.

<div align="right">Sincerely yours,</div>

Accepted and agreed to:

THEODORE B. DONSON

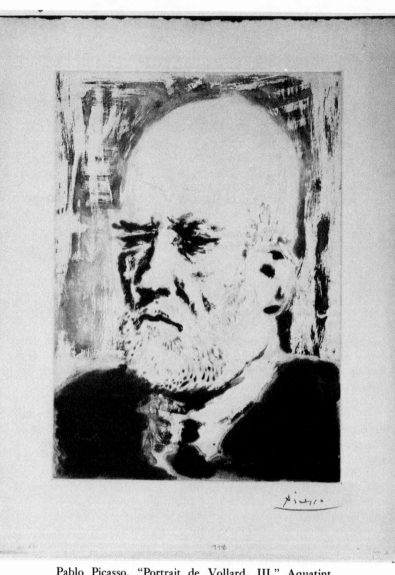

Pablo Picasso, "Portrait de Vollard, III." Aquatint,
c.1937 (S.V. 97; B. 232). 347 x 247 mm; $13^{11}/_{16}''$ x $9\frac{1}{8}''$.
(COURTESY OF REISS-COHEN INC.)

Chapter Eight

People Who Publish Prints

I think there are tons of publishers who know very little about art and care less.
—SYLVAN COLE, 1975

I think we all feel the artist and his freedom to experiment and work and create is the most important thing.
—MARIAN GOODMAN, 1975

These days print publishing is big business, supercharged. Nobody keeps track of all the editions published worldwide each year, but there are currently some thousands of single sheet issues, portfolios, and illustrated books printed annually, with a retail value of some tens of millions of dollars. The 1975 recession stalled the graphic-art presses somewhat, and the soaring costs for the artist's time, paper, printing, and distribution have made the $50 print virtually obsolete, but still the graphics keep coming.

The best way to learn what is forthcoming or has arrived is to subscribe to the publication lists and prospectuses of the publishers (a list appears in Appendix 5), visit dealers and galleries, scan articles and ads in the art periodicals, and consult the New Publications columns in *Print Collector's Newsletter*, *Nouvelles de l'Estampes*, and *Magazin Kunst*.

There are three principal groups of print publishers: printmakers themselves, ateliers, and entrepreneurs.

The artist himself may work and print at home or in a studio, or he may approach and pay a commercial workshop to do his printing. He then has a distribution problem: he either becomes a part-time salesman, or if he does not want to use up much of his time in selling, he tries to engage someone else—often one or more professional publishers, wholesalers, or owners of galleries—to distribute his editions for him for a fee or royalty. Dürer and Rembrandt did a lot of their own marketing, eliminating the middlemen. Contemporary artists who take to the road to peddle their graphics to retail galleries typically find the tripping around time-consuming, exhausting, and unrewarding. Many of the Tamarind Lithography Workshop fellows who tried to market their own

production in the 1960's found they could only sell 20 percent or so within the first few years after publication. M. C. Escher, the Dutch printmaker, who did most of his own printing and publishing without assistance all his working life, waited 70 years for customers to come to him; when the Escher-crazed clientele finally began banging on his door all at once in 1969, he could not print fast enough to satisfy them. Unpatronized, unnoticed artists who are unable to get a publisher enter print competitions for the prize money and the hoped-for celebrity, besiege harassed museum print curators during viewing weeks, and consign wherever they can and wait for the checks while the galleries use the proceeds for working capital—and they usually teach on the side to obtain some steady income.

Some established artists who are not intimidated by administrative niceties and bookkeeping and wish to maximize profits and maintain their independence by controlling production and distribution, also self-publish, choosing among printers and distributors themselves, rather than suffering to be employed by a publisher or distributor on either an exclusive or nonexclusive basis. Lee Eastman, the New York lawyer who has represented such recognized artists as Albers, de Kooning, and Lindner, encourages his clients to retain control over what they create and "keep out of the clutches of benevolent dealers and publishers." He remembers that "Franz Kline used to have a recurring nightmare that Sidney Janis would call him up one day and ask him to get his stuff the hell out of there!" (Some professional publishers acidly comment that Eastman's ministrations of service and advice don't differ much from "publishing.") De Kooning and Lindner today accordingly work for whomever they want, wherever they want.

The *professional* print publisher, whether publishing workshop or entrepreneur or gallery, assumes by informal or written contract the command, dominion, and control over an edition of prints. The artist himself thus becomes the contractee rather than contractor and places himself in a subsidiary control and financial position in relation to his output. Under the happiest of circumstances the artist sells his birthright to a guardian angel for a blessing from heaven: Relief from laying out venture capital to cover "up front" costs and absolution from the irksome business of making arrangements for the production of his work, seeking a market for it, and getting the product to the people. As Editions Alecto's Joe Studholme once phrased it, the ideal publisher "can genuinely act as the catalyst between the artist's creative role and the practicalities of the production problems." Many artists in fact opt for the convenience and steady returns of an exclusive gallery contract.

Professional print publishers serve artists and their public in the same way that opera impresarios serve divas and opera buffs; movie producers serve actors, film-makers, and movie-goers; and book publishers serve writers and readers: They organize, finance, advertise, and popularize a project and distribute the product for cash (Fig. 8-A). These are jobs that

United States representative for Petersburg Press Ltd and Professional Prints Ltd

18 East 81 Street New York New York 10028 212 249 4400 **Petersburg Press Inc**

September 1974

JAMES ROSENQUIST

F-111

We are able to offer an original lithograph in four panels
by James Rosenquist, relating to his 1965 painting "F-111."
The artist began work on the plates in August, 1973; the
completed project involves 59 colors on 29 aluminum plates,
with silkscreen additions on each panel. Each impression is
signed and numbered by the artist.

South West North East

F-111 1974

Four panel lithograph with 59 colors and silkscreen addtitions
Arches mould made paper
Edition 75

1. South
 Paper: 36" x 69½" (91.5 x 176.5 cm)
 Image: 35" x 69" (89 x 175 cm)
 Ten colors on five plates, with silkscreen additions
2. West
 Paper: 36" x 74½" (91.5 x 189 cm)
 Image: 30½" x 74" (77.5 x 188 cm)
 Eleven colors on seven plates with silkscreen additions
3. North
 Paper: 36" x 69½" (91.5 x 176.5 cm)
 Image: 32" x 69" (81 x 175 cm)
 Nineteen colors on ten plates with silkscreen additions
4. East
 Paper: 36" x 74½" (91.5 x 189 cm)
 Image: 30" x 74" (76 x 188 cm)
 Nineteen colors on seven plates with silkscreen additions

Orders will be sent from London, air post, postage and packing extra.

Petersburg Press prospectus for the biggest print ever made: the immense
lithograph in colors by James Rosenquist, "F-111." Fig. 8-A

require specialized talents and assets—and time—that artists generally lack. Moreover, print publishers, like their colleagues in the other creative arts, do more than just draft contracts, make arrangements, pay bills (including, for print publishers, the fee or royalty of the artist, printing bills, air fare to the workshop, hotel bills, paper costs, delivery charges, and outlays for pleasure and frolic), set the price, promote, advertise, vend, police trade accounts, and redistribute the proceeds. By selecting the art-maker and exercising influence or control over the form, character, and execution of his creation, the publishers, in league with the dealers, can function as tastemakers, determining the nature and quality of what the public may and may not see and buy.

Once the artist has been accepted or selected, the publisher can pursue a tastemaking role through his influence over the subject matter of the project—by discussing, influencing, bargaining for or dictating the composition, or by giving the artist his head completely—through the quality of the printmaking facilities and personnel he makes available to the artist, through the encouragement he gives the artist, and through the care with which he promotes and markets the edition. Multiples' Marion Goodman will key the nature and scope of her dialogue to the artist's temperament and her faith in his imagination; she accordingly makes arrangements for Claes Oldenburg to work freely at Kathan Brown's Crown Point Press for intaglio printing with confidence that his intaglio experimentations will be triumphant. Brooke Alexander, Richard Solomon of Pace Editions, and Bernard Jacobson of London, among many other ethical publishers, actively and tactfully participate in the selection of the imagery for their editions. Jacobson will pass hours socializing with his artists, kicking around new conceptions and possible techniques. Solomon might review sketches and talk over what medium would be most appropriate. Alexander might declare, "Hey! This is a terrific image! Let's make it into a print!" Such publishers are interested in the marketability of a project (making a living), to be sure, but they are also committed to inventiveness, fresh imagery, and the artist's integrity.

On the other hand, some well-heeled businessmen-*cum*-print publishers confine their creative role to the determination of what vogues and preferences may be most successfully and lucratively marketed. They contract primarily for commercial value (which they often would not buy for themselves) rather than for art. Sam Shore, who later backed Alex Katz, Lindner, and some Super-Realists, once felt compelled to reject a bloody Christ on the Cross submitted by Dali, not so much because the stigmata were sanguine as because He was equipped with an uncircumcised penis, "which would have made it unsalable to the market I was trying to reach."

The Print Boom of the 1960's encouraged hundreds of people who ini-

tially understood little about art or prints or print publishing to become publishers of limited editions of graphics and illustrated books. Within the industry, vertical integration flowed both upstream and downstream. Job-shop printers once content to let their fingernails accumulate greasy ink scrubbed their hands, erected offices, and hired salesmen overnight to become publishing ateliers. Marketwise graduates of Tamarind Lithography Workshop and the old-line Paris ateliers extended their collaboration with the artist to the commercial world outside the printshop, where they could reap a distributor's share, or even a retailer's portion, and not merely a printer's fee, for a printmaking project. Wholesalers bypassed the publishers who had been their suppliers to commission new stock directly from the artists, whose works they then distributed. Throughout Europe and America, dealers and galleries commissioned artists, hired printers, and ran up huge telephone bills talking up their editions to dealers and galleries in other cities, either to capture the entrepreneurial slice of the profits for themselves or to circulate the names and reputations of stable artists through widespread distribution of popular-priced graphics. People on the periphery of the business—book publishers, collectors, corporate art consultants, interior decorators, collectors, critics, mail-order merchandisers, reproduction publishers, schlock-art promoters, investment bankers, and assorted parvenus— anyone with an ear tuned to the Print Boom, a block of venture capital, and a few contacts—became graphics publishers, too.

But the best of the print publishers who surfaced during the postwar period and subsequent Print Boom chose Ambroise Vollard—the publisher of Picasso, Bonnard, Rouault, and Chagall—who died in 1939, as their mentor and model. They embarked upon print publishing as a sustaining career and devotion, and not just as a sideshow to weightier occupations. Many of them intrepidly sought to stimulate and challenge, rather than merely to satiate, the public taste. Recognizing that the future of printmaking properly belonged in the hands of artists who were making or seeking a reputation principally as painters or sculptors, they tracked down and summoned the innovative artists who were principally image-makers and not simply craftsmen, basing their patronage more on esthetic preference than potential profits and permitting the artists they chose a wide freedom of expression and wide choice of printmaking media. They also functioned as faithful friends, father-confessors, supportive critics, discerning guides, and business advisers for their artists, placed the best facilities and equipment at their disposal, and tried to market their editions ethically, without either injury to their artists' good names or insult to the public's intelligence. Thus they encouraged the creation not only of art appropriate to the era but art of exceptional quality.

It was perhaps the enterprising graphics printers turned publishers

and the entrepreneurs who organized and staffed their own ateliers—
Maeght and Visat in Paris, Prater (Kelpra Editions) and Cornwall-Jones
(Editions Alecto and Petersburg Press) in London, Domberger and Meis-
sner in Germany, Rossi (2RC Editrici) in Rome, Grosman (Universal
Limited Art Editions), Tyler (Gemini G.E.L. and the Tyler Workshop),
Milant (Cirrus Editions), and Lemon (Landfall Press) in the United
States, among the most exacting and influential—who as a class best ex-
emplified these qualities, while encouraging and supporting printmaking
by the Western world's foremost painters and sculptors. (The contribu-
tions of these publishing ateliers to the printmaking renaissance of the
third quarter of this century has been related in "A Chronicle of the
Print Boom," Chapter 6.) Yet there have been a small number of in-
dependent, intrepid publishers, sans atelier and sans galerie in the tradi-
tion of the great Vollard, Tériade, Skira, and Iliazd, who have sought
out unpublicized promising young artists and converted them to print-
making.

One of these young publishers is New York's Robert Feldman, alias
Parasol Press (Fig. 8-B), perhaps the most courageous print publisher in
America today. Parasol Press commissions "difficult" avant-garde art,
primarily by artists who are in style geometricists; prices it at high levels
respectful of the dignity and creativity of its artists; and proudly pro-
claims it the best in the world. Parasol Press has no press. Its sole owner
and chief energizer sends out announcements from a four-story non-
descript tenement (the top is Feldman's bedroom) on Church Street,
south of Canal Street, in New York City. Feldman does not look or talk
like a graduate of Yale Law School, class of 1961. One would not sur-
mise, either, that the man who handed out Parasol Press fortune cookies
and lapel buttons with little parasols on them at the Basle Art Fair had
passed on corporate fortunes for a spell at the Securities and Exchange
Commission.

In the early 1960's—not too many years before Parasol Press was to
pioneer with portfolios of Ansel Adams and Eugene Atget photographs
and take risks with editions of prints by Mel Bochner, Chuck Close,
Richard Estes, Sol LeWitt, Robert Mangold, Brice Marden, Agnes Mar-
tin, Edda Renouff, Don Nice, Dorothea Rockburne, Robert Ryman,
and Wayne Thiebaud—Feldman found himself disenchanted with law,
collecting color prints by the names he knew from school ("though when
Salvador Dali came along, I knew there was something intrinsically
wrong with this") and like a good ex-securities lawyer, making typical
art-world deals. While associated with his father's book and reproduction
publishing businesses, Harlem Book Co. and Penn Print Co., Feldman
set up Trois Anges, a partnership composed of the two Feldmans and
Norman Blaustein, which entered into a joint venture with Leon Amiel,
an importer and publisher of French books, periodicals, and graphics, to
publish and market limited editions by Paris celebrities. Through his as-

Photo of Robert Feldman, owner and director of Parasol Press, by Chuck Close.
(COURTESY OF ROBERT FELDMAN) Fig. 8-B

sociation with Paris printer Fernand Mourlot and certain Paris literati,
Amiel furnished the contacts with the Paris-based artists. Their first
shared project was Chagall's 1966 *The Story of the Exodus* suite. Then
came Ernst, Marini, and Buffet, all printed by Mourlot Frères in Paris.
Feldman's trade clientele liked his integrity, campy bowties, and grin,

which looks as if it were covering a delectable drawn by Wayne Thie-
baud. "Even though they were buying Chagall and Buffet in those early
years," he recalls, "I never stuck people with anything. They bought *me*
when they bought Sol LeWitt the first time around. I liked what I saw,
and if I liked it, maybe I could convince other people to like it, too."

In 1968 an obscure dealer and onetime exhibitor at the Whitney An-
nual named Wallace Reiss, who had sold some two dozen sets of the
Exodus to an investor client, introduced graphics salesman Feldman to the
new American art by convincing him to accept the marketing of a
Graphics U.S.A. portfolio of prints by Lindner (the only contributor Feld-
man had ever heard of), d'Arcangelo, Indiana, and others, published by
the German art critic, Rolf Günter Dienst. To his surprise and everlast-
ing gratitude, "Feldman's Folly," as his associates labeled the portfolio,
sold out. "People actually bought prints by *Americans!*" is how Feldman
remembers his success. Trois Anges quickly went on to commission edi-
tions by Reiss's former colleagues and friends, Larry Zox and Ilya Bolo-
towsky (hard-edge art was then in vogue and sold easily), and Feldman,
as he reminisces, "began to tune in with art."

In 1968 the Feldman family enterprises, including Trois Anges, were
sold to a company named Computer Applications Incorporated, whose
officers had no experience in publishing. As "acquisitions man" for Com-
puter Applications, Feldman bought from Reiss (for $95,000) a collection
of Picasso linocuts, which toured the country as "the Computer Applica-
tions Incorporated Collection" (a short time later he resold them to Isa-
dore Cohen for $185,000). He also bought and forthwith resold to Cohen
the Rouart Collection of mostly 19th-century French prints (from
whence sprang the alliance of Reiss and Cohen as Madison Avenue's
Reiss-Cohen gallery). He then had Computer Applications acquire Leon
Amiel's company, the Paris Book Center, to obtain access to Amiel's
contacts in Paris, and with the prompting and aid of new acquaintances
who urged him to open his eyes to nontraditional art and the counsel of
New York art dealer Allan Stone, discovered and made contracts with
relatively unknown American artists Close, Estes, and Thiebaud. The
acquisition of Amiel's company made Amiel Feldman's boss and proved
to be at once Feldman's undoing at Computer Applications and his ca-
reer's salvation. Convinced that signed and numbered photographs were
unjustifiable and unmarketable, Amiel, who was solely responsible for
approving publication proposals, fired Feldman in February 1970 after
he had signed up Ansel Adams for a portfolio. Feldman plunged ahead
independently, buying back the Thiebaud contract jointly with Stone
after Computer Applications filed for bankruptcy later that year and pur-
suing his Ansel Adams project with the backing of Larry Rosenthal, the
L. M. Rosenthal & Company investment banker.

The birth of Parasol Press in 1970 as publisher of new-direction
American prints and underexposed photographs coincided with Bob

Feldman's education about art and his conversion to status as an apostle of the American avant-garde. Like a pilgrim in a new land, he learned about and became seduced by art he had never realized existed and came to understand that it is the best artists who make the best prints. "If a guy's got it, he's got it; in order to make great prints, you have to be a great artist first," he observes, not as someone who has latched onto an original idea, but as a canny publisher who appreciates what made Ambroise Vollard a revered figure in art history instead of just another art-world businessman. Feldman selects a person and not a subject when he commissions an edition; by buying the artist—financing full freedom of expression—he happily buys, in his words, "a pig in a poke."

The process of acquiring an eye and a nose was for Feldman at times more accidental than deliberate. In 1971, he made a commitment to commission ten prints by Sol LeWitt purely as a way of subsidizing a prestige museum exhibition catalog—only to have the show canceled and hear that LeWitt had enthusiastically executed 47 at the printshop. But finding takers for all those LeWitt Minimalist etchings was itself an educational enterprise which deepened Feldman's appreciation of the new Minimalist trend and committed him to LeWitt as an *artist* and not as a commercial vehicle. Like other successful one-man gangs in the art world, Feldman has a great deal of confidence in his judgment; he rarely reads art history and criticism, as if he feared the texts might divert him from his formula: looking at art with a fresh eye and an open mind and listening to the opinions of artists and colleagues for whom he has respect.

What makes Robert Feldman fly, after a few years of soaring with the Print Boom? "The fun of convincing artists to do prints and the pleasure of not knowing what it is that you're doing until it's done." Such as what turned out to be Feldman's Folly No. II: a $6,000, 200-odd color Domberger-printed screenprint of urban storefronts by Super-realist Richard Estes, the priciest print ever published by an American artist, not counting a previous Parasol publication, Chuck Close's mezzotint, "Keith" (Fig. 8-C). Salable? Appreciable in value? Not vital premeditations. It just *evolved*.

The high quality of Parasol Press publications owes much to the technical competency of the artisans of Kathan Brown's Crown Point Press for intaglio in Oakland, California, and Edition Domberger's screenprinting plant in Stuttgart, Germany. Crown Point Press is more than just a printshop. Like other celebrated ateliers such as Mourlot's and Lacourière's in Paris, it is a place where artists can create. Why progressive artists enjoy creating art in a printshop such as Crown Point Press is perhaps best explained by Kathan Brown herself:

> What I want to do is something, I don't know what, that takes a step, for myself and for the artist I'm working with. The artist doesn't know

what, either, when he first comes to California to work at Crown Point Press—at least I hope he doesn't. . . .

We have learned that the best work does not come from studying a drawing and matching the look of it. What we want to match is something else, the artist's idea, feeling, whatever it is that underlies the look. Then the print will have its own look, and the artist will feel that this work he's done is real work, an important part of his life work, a step.

To start with, the printer in charge of the project must be familiar with

Chuck Close, "Keith." Mezzotint, 1972. 1321 x 1067 mm; 52″ x 42″. Executed and printed at Crown Point Press, Oakland, California. (COURTESY OF PARASOL PRESS, LTD.) Fig. 8-C

and interested in the artist's work. Then, when the artist arrives we spend a few hours or a few days, getting the feel of each other, of the medium as this person can use it. Occasionally everything we do on the first visit is thrown out. The artist has to understand that there is plenty of time to get what he really wants, that we don't want to settle for less than that. Of course everyone is aware that time costs money, and time isn't wasted; we often work ten to twelve hours a day when an artist is with us. The intensity of the experience has something to do with it. We work every day; the artist has nothing else to do here but be totally involved with this medium, and the people working with him have learned to suspend their lives during these periods. . . .

We at the press . . . teach the artists. Etching is a very basic medium, quite comprehensible and logical, at least in theory, and it must be comprehended to be used effectively. The artist must know and understand (not in detail, but in procedure) everything that is done, or even that can be done, to his plates. He does all of the creative work himself, and some of the routine work. When it is over, the artist knows he made those plates. True, he had indispensable help, but there must be no question in his mind that the work is his. . . .

When I started Crown Point Press in 1965 I was printing for myself and my friends. It didn't occur to me, for years, that it was a business. I thought it was a way of making art, and that if I earned something from it to cover my costs, fine, it meant I could keep doing it. I still feel that way, although with six printers working and thousands of dollars being spent every month on materials it clearly has become a business. Nevertheless, I wouldn't go on with it if making the art couldn't come first, before business considerations.

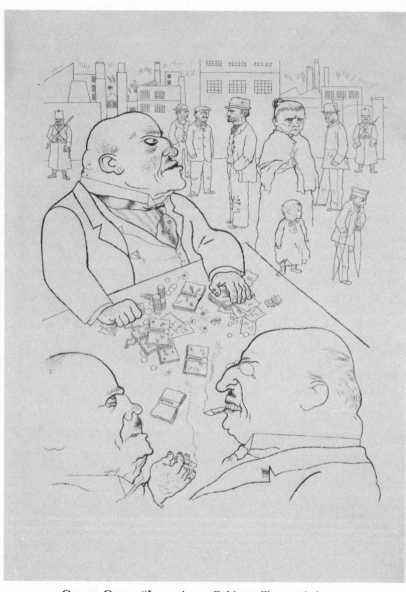

George Grosz, "Im meinem Gebiet soll's soweit kommen . . ." plate 2 from *Die Räuber* ("*The Robber,*") portfolio. Lithograph, 1923 (D. 70). 481 x 376 mm; 18^{15}/$_{16}$" x 14^{13}/$_{16}$". (COLLECTION OF THE AUTHOR)

Chapter Nine

People Who Sell Prints to the Public

We fulfill a sociological function: we absorb rich people's money.
—MICHAEL HASENCLEVER, 1975

When I was broke in London in the fall of
'89. . . .
Down at Noseda's, in the Strand, I found one
fateful day,
A portrait that I pined for as only manaics may,—
A print of Madame Vestris (she flourished years
ago,
Was Bartolozzi's daughter and a thoroughbred,
you know).
A clean and handsome print it was, and cheap at
thirty bob,—
That's what I told the salesman as I choked a ris-
ing sob;
But I hung around Noseda's as it were a holy
shrine,
When I was broke in London in the fall of '89.
—EUGENE FIELD, "Dear Old London"

In the 17th century small boys hawked printed pictures on the streets like sweet red roses to city dwellers who could comprehend the images but not the Latin inscriptions.

Today there are hundreds of galleries and other addresses across Europe and America where prints, very few of which have any inscriptions at all, are sold as "art" and not as "pictures." The 85-member Art Dealers Association of America, which professes to tap for the fraternity only an entity that "shall have established itself as a true 'art dealer' rather than merely a dealer in 'pictures'," lists some 20 members that deal wholly or substantially in graphics. The rising value and increasing scarcity of good prints have in fact all but eliminated the traditional printseller, where one could dally for an hour sifting through thousands of catchpenny prints (Fig. 9-A). Now fine printed pictures are relegated to antiseptic frames, locked sliding drawers, and acetate envelopes,

Jean-Emile Laboureur, "Les Amateurs d'Estampes" (card for the publisher H.-M. Petiet). Etching, 1925 (G. 319). 82 x 115 mm; 3¼" x 4½". (COURTESY OF GALERIE MARTIN SUMERS) Fig. 9-A

where they are to be handled, if at all, with reverence. While a number of printsellers, such as Craddock and Barnard, London; Paul Prouté et ses Fils, Paris; and Associated American Artists, New York, seek to maintain some of that old pleasant casual ambience, no more Daumiers and Gavarnis are to be found in the bookstalls of the Seine, only reproductions, book illustrations, and political cartoons.

The Print Boom of the 1960's made most of the printed pictures that the boys once sold in the streets and fussy shopkeepers later tacked up in booths along the rivers expensive collector's items and at last made all printsellers—and not just the purveyors of Rembrandt etchings and Dürer engravings—"art dealers." In fact, instead of further democratizing the way prints were advertised, promoted, and sold, the Print Boom irretrievably transposed them to a traditional gallery system depending in most cases on intimidated browsers and clients, imperious dealers, velour drapes, posh carpeting, elegant frames, art mystique, signature and limited-edition psychology, secrecy, and selective disclosure to vindicate the price levels to which the "art of the streets," the "poor man's art," has advanced. Most prints changing hands at the retail level now do so through delicate suasion, one-to-one, in a gallery milieu oozing elitism, esthetic snobbery, and the cult of the unique or semiunique *objet d'art*. Doctors overawe us with unintelligible handwriting; lawyers, with legalese; Presidents, by the awesomeness of high office. The effect is to keep us off-balance, sedate us, make us silently respectful, inhibit obvi-

ous and intelligent questions. Art dealers as a class have always been hardnosed, cynical businessmen adept at conjuring and sustaining illusions and bluff to charm and overcome the easily impressed and unwary. Compelled to justify the price of an object with wholly intangible value, they have always brandished enough metaphysics and facile cultivation to make confident men feel unsure. In part to justify the new high prices for prints, print dealers have accepted and pursued the conventional art-world practice of cloaking with wonder and mystery and rarity a product whose basic appeal is sensual, like a symphony, a poem, or a pâté de fois gras. So much for the hope, expressed by many enthusiasts in the Print Boom's early stages, for the mass distribution of graphics and multiples among the folk indifferent to preciousness in art.

While such generalizations may be unfair to scores of print dealers who are genuinely motivated by a heartfelt desire to impart to others their affection and understanding for their stock in trade, most print dealers practice consummate art-dealership. Art dealing is more a trade than a profession; there are no qualifications for entry. No government or self-regulatory association regulates their behavior or prescribes a code of conduct; there is no licensing procedure or certification program or apprenticeship requirement for print dealers anywhere in the world. Some years ago the Print Council of America published a list of the dealers who agreed to subscribe to and uphold its code of standards regarding the "originality" of their merchandise, the content of their catalog entries and their enlightenment of the public, but it abandoned this certification program when it resigned from its self-appointed mission of policing the print market. One inevitable consequence of the Print Boom of the 1960's was the dilution of a trade which once thrived largely on its expertise, cultivation, and candor by people who lusted more for a piece of the action than for prints, who were more adept at making sales than learning about what they were selling. A hundred operators who at one time might have sold Florida real estate or entered the pajama game, entered the graphics game instead. There was big money in prints, especially for people with no knowledge or love of art who had no qualms about squeezing the most profit out of a $100,000 inventory by misrepresenting, encouraging incorrect inferences and overpricing. Maury Symonds sold a reputed $3,000,000 worth of merchandise in 1973 through his Upstairs galleries in and near Los Angeles to dupes apparently too mesmerized by "art" to shop for price.

These days no particular sensitivity toward art, intelligence about art history, regard for connoisseurship or understanding of market values are prerequisites for buying and selling prints. All it takes is a facile handling of rudimentary vocabulary, a working familiarity with some art-world personalities, and a well-oiled mouthpiece—the same sort of qualifications helpful to running a costume-jewelry boutique. Within the trade, knowledgeable Print People have come to distinguish between the relatively small number of knowledgeable, reliable, straight-shooting dealers on the one hand and the craven opportunists (designated the

Print Mafia), ignoramuses, and illiterates on the other. The unschooled buyer can find it very difficult to differentiate, assuming he is sensible enough to be skeptical, between ethical and trustworthy savants and the merchants of scanty sensibility, intellect, or scruples.

WHO ARE THE GOOD DEALERS?

A familiarity with the characteristics of bad art dealers makes the recognition of good ones easier. Bad art dealers mislead customers about facts, induce them to purchase for reasons other than artistic merit or historical value, lack the expertise meaningfully to guarantee the authenticity and condition of the works that they sell, are more interested in cultivating profits than taste and appreciation, contribute little or nothing to the erudition of the community in which they practice and overcharge. There are so many overly publicized plungers, gougers, knaves, sharps, bluffers, and counterbluffers among art dealers that as a class they have traditionally been ranked in the public esteem near the bottom of the heap, somewhat below stock brokers and life-insurance salesmen.

As a consequence, like the wits among New York's financial community who flagellate themselves during the annual Wall Street Follies stage show, the wags among print dealers, not a taciturn lot themselves, take diabolical delight in mock self-deprecation. New York's Scott Elliot, not notorious for bargain prices himself before vacating his Madison Avenue print gallery in 1975, customarily scorned the Kornfeld und Klipstein auction firm as "Kornfeld und Klipjoint." His object of derision, Eberhard Kornfeld himself loves to twit colleagues with twinkling jibes from his podium. He once opened Jost Amman's "Die Allegorie auf den Handel" ("Allegory of the Professions") to bidding with the observation that "all the professions are on it, the art dealers right next to the bandits!" Allan Stoltman, who once managed Rizzoli's New York traffic in dubious *afters* and overpriced School of Paris moderns, candidly confessed, when he became an independent dealer, "I run a bordello with a little art business on the side." But it is really not true that, as Elliot once quipped, "calling any art dealer reputable is like calling Miller's the champagne of bottled beer."

There are indeed reputable, responsible art dealers with an alert and independent critical sense, an instinct for esthetic and technical values, and a respect and affection for art, the people who make it and the scholarship about it. The people in the trade and the museum people know who these dealers are, much as one knew who the good professors were in college—and they are not necessarily the ones wih the big public reputations. They seem to possess the following characteristics:

SCHOLARLY KNOWLEDGE AND VISUAL EXPERIENCE. Having expensive goods for sale does not characterize anyone as a creditable art

dealer any more than having a fancy framed shingle and a paneled office guarantees a competent lawyer.

A good print dealer has learning and visual experience to communicate to his clients and an eagerness to do so. One can usually infer the extent of these qualities at once from the range, tenor, intelligence, and validity of a dealer's talk and catalog entries, which should linger on matters of esthetics, connoisseurship (especially defects), and art history (as opposed, say, to investment claptrap and bombastic superlatives). Secondary clues are provided by the scope and quality of his working art-reference library, which should yield upon request all the pertinent criticism and data extant about any print offered for sale. It may be a harsh standard to apply, but if someone offers, say, a Whistler etching but lacks the expensive Kennedy catalogue raisonné (or a photocopy copy of it) or a Rauschenberg lithograph but lacks the Foster exhibition catalog, he probably does not have the requisite interest, expertise, or experience either to discourse intelligently on Whistler etchings or Rauschenberg lithographs or to assume responsibility for the quality, condition, or authenticity of the impressions he has for sale.

One of the best ways for any young person to learn about any subject is still to serve an apprenticeship, and some of the most knowledgeable and experienced of the new 1960's crop of dealers in prints requiring connoisseurship were nurtured at the bosoms of their elders. Christopher Mendez and Dennis Goldberg of London picked up their lore cataloguing prints for years at Sotheby's; Frederick Mulder, at Colnaghi's. Frankfurt dealer Helmut Rumbler and Munich dealers Michael Hasenclever and Stefan Lennart served apprenticeships with auctioneers Eberhard Kornfeld, Wolfgang Ketterer, and Karl u. Faber respectively. Alice Adam, who headed the Frumkin Gallery in Chicago, and Wolfgang Wittrock, who has a gallery in Düsseldorf, served with Kornfeld, too. Timothy Baum and Aldis Browne worked for the late Peter Deitsch in New York, and Browne subsequently became gallery director for Associated American Artists, under Sylvan Cole. John Berggruen of San Francisco was fortunate enough to grow up as Heinz's son during part of the time that Berggruen père trained Caroline Lumley, now the first half of Lumley-Cazalet of London, in Paris.

TASTE. In the broadest sense, taste in art is like lovesickness: it has to be acquired, and you only really know what it is when you have it yourself. But good taste, whether you have it or not, may at least be recognized in others, whether or not it can be shared. A print dealer's taste is, of course, best exemplified by what he stocks and exhibits and the nature and strength of his convictions about what he stocks and exhibits. Print dealers of taste are identifiable through their serious obsession with esthetics, an articulated capability for artistic judgment, a high regard for quality, and an eagerness to make converts by defending their esthetics, judgment, and view of quality. By these standards, those galleries specializing in contemporary graphics that offer provocative prints

by leading and progressive artists are dealers of taste, while the scores of galleries that display the mundane run of splashy Calders, Chagalls, Mirós, Dalis, Rockwells, Niemans, and assorted School of Paris decorative *afters* reveal no taste whatsoever. Taste is also expressed through the creativity of exhibitions, the informativeness and design of catalogs and other publications, and a concern for the condition and technical quality of the impressions accumulated for resale. As Sylvan Cole, head of Associated American Artists, once commented to an *Art News* interviewer in his self-congratulatory but perceptive way, "There's a big difference in the print business between a gallery that just sells and one that is creative. There's no trick to buying a Picasso. If the market price is $30,000, I can buy it for under $25,000, hold it for two years and sell it for $40,000. I might as well deal in real estate."

INTEGRITY. A print dealer of integrity is someone from whom you can buy with confidence at prices that accurately reflect fair market value. A dealer of integrity will release an impression for consideration on approval without obligation, back up any oral assurances with written representations and warranties covering the matters set forth at the end of Chapter 1 and stand behind any sale with an absolute guarantee of authenticity and condition. As an American emigré in Vienna, Donald Corcoran, once explained, "Reputable dealers back up what they sell; if they are uncertain who watercolored a print, they won't buy it; they operate on the principle that 'the buck stops here.' " They should also be willing upon request to reveal and discuss recent price history, especially previous auction prices, openly and frankly to justify their own price and markup.

ABSENCE OF GIMMICKRY. A good dealer needs no razzmatazz or come-ons to enhance his wares. The Windsor Gallery and the Limited Editions Galleries in Los Angeles press browsers with brochures titled *The Art of Investing in Art* and *The Professional Guide to Graphic Art as an Investment;* Reflections Gallery of Atlanta pushes its Art Investment Program and Art Leasing Program; the "Horchow Collection" of Dallas, a "Member of the Direct Mail Marketing Association," offers dubious decorations and restrikes through a slick, full-color catalog; and Phyllis Lucas of New York advises customers how to register their photo-reproductions of Dali gouaches with the "Dali Archives." It is not surprising that one gets less for his money in personal, commercial, and esthetic terms from such establishments than elsewhere.

WHO ARE THE DEALERS?

The most highly visible phenomenon of the Print Boom of the 1960's and 70's has been the rapid multiplication and expansion in cities throughout Europe and America of printsellers and graphics merchants

dealing directly with the public. About half a dozen street-level establishments in London sold fine prints in 1960. In 1965 the Curwen Studio lithography workshop felt confident enough to open the Curwen Gallery to show its own and other publications. In 1975, there were over 60 London dealers and galleries specialized in auction-grade prints on the retail level, without counting the collectors who deal in prints on the side. There were about two dozen in the United States in 1960; 15 years later there were over 300. Galleries sprang up in the provinces outside Paris, in such unlikely cities as Mulhouse, Clermont-Ferrand, Lyons, and Toulouse.

Attracted by the métier or the money, hundreds of people entered the trade from other walks of life: printers needing a retail outlet (Jean Milant), framers (Ed Sindin), booksellers, retired businessmen (you name them), lawyers (Ronald Feldman), converted corporate types (Jack Glenn), stock brokers (Barry Goldfarb), Florida and Arizona land salesmen (Windsor Gallery's Leonard Rosen), artists (Wallace Reiss and Muldoon Elder), social workers (Margo Leavin), mortgage bankers (Robert Ostrow), college professors (Eugene Schuster, Andrew Fitch, and Jeff Kaplow), music critics (James Goodfriend), auctioneers' daughters and wives (Ingeborg Henze née Ketterer), dealers' wives (Antoinette Castelli) and Long Island housewives (Getler-Pall). Such seasoned and scholarly patricians as Colnaghi's of London and C. G. Boerner's of Düsseldorf diversified from old master etchings, wòodcuts, and engravings into 20th-century master graphics. After a hiatus of decades, Knoedler's— one of the venerable printsellers of New York City before the Great Depression—with new management again began dealing in prints—and contemporary ones at that.

In the late 1960's, print merchandisers from Düsseldorf to Dallas began to employ and improve modern mass-marketing methods for retailing prints to people who rarely entered an art gallery. In America large firms such as Associated American Artists, founded in 1934 and since 1958 a "smallish" Fifth Avenue subsidiary of Rust Craft Greeting Cards, Inc. (total 1974 assets, $80,000,000), and Baltimore-based Ferdinand Roten Galleries, Inc., since 1969 a subsidiary (along with Brentano's bookshops) of Macmillan, Inc. ($400,000,000 in total assets), stepped up their direct-mail approaches with appetizing catalogs and brochures and circulated ready-made print shows among university art centers and small regional museums for a minimum sales guarantee. Sears Roebuck in Chicago, Gump's in San Francisco, Bloomingdale's and Korvette's in New York, Prisunic in Paris, and Loeb in Bern opened graphics boutiques, and Harrods of London touted itself in full-page flight magazine ads as the holder of the world's largest collection (and, upon close inspection, probably the world's shabbiest collection) of Rembrandt etchings. Public-relations firms and the Museum of Modern Art set up consulting departments to sell advice on how tastefully to beautify the corporate environment and adorn vice-presidents' offices with graphics.

New publications and second-hand prints today reach the consumers, curators, and office managers through various channels:

Dealers with a print gallery
Dealers who operate out of an office or home by appointment
Art consultants
Dealer/runner/collectors
Mail-order houses
Department stores or concessions therein
Frame shops and bookshops
Antique shops and craft shops
Museum gift shops and rental services

Most of the traffic in prints of quality is handled by the first four groups of dealers. (A directory of print dealers appears in Appendix 6.)

What follows are ten brief vignettes of representatives from each of these groups that in the aggregate offer a complete range of old master, 19th-century, early 20th-century European prints, American prints, contemporary graphics, illustrated books, and posters. This tiny sampling of dealers (presented in random order) was selected for diversity and geographic distribution and not for presentation as a guide to the World's Top Ten, though each of the dealers described is highly reputable and responsible, and the five European firms are among the leading print dealers in the world.

Florian Karsch's Galerie Nierendorf of Berlin: German Prints of the Early 20th Century

Florian Karsch adorns the walls of Galerie Nierendorf's rooms and fills its drawers with art on paper by the leading German artists of the early decades of this century—Barlach, Beckmann, Corinth, Dix, Feininger, Felixmüller, Grosz, Heckel, Kirchner, Kollwitz, Lehmbruck, Macke, Marc, Marcks, Mueller, Pechstein, Nolde, Rohlfs, Schlemmer, Schmidt-Rotluff—the allied prints of Kandinsky, Klee, Munch, and the lesser-known Germans he strives to revive. He also tenders the works of his father, the sculptor Joachim Karsch. Karsch's mother, Meta Nierendorf, later married Josef Nierendorf, who began the gallery with his brother, Karl, in 1920.

Galerie Nierendorf was one of the most progressive galleries in Europe between World Wars I and II, startling the Berlin bourgeoisie with the works of German Expressionism and other movements of the "degenerate" avant-garde until the advent of Hitlerism. Karl Nierendorf fled to New York in 1936, where a large part of his collection was confiscated and wound up at the Guggenheim Museum. When Josef Nierendorf died in 1949, his widow, Meta, tried but was unable to sustain the

gallery and turned for help to her son, Florian Karsch, who had been raised in the Nierendorf family.

In 1955 Karsch gave up a career in zoology and a passion for butterflies and, at a time when Roman Norbert Ketterer was reviving interest in 20th-century German art through his Stuttgart auctions, rechanneled his organizational talent and scholarship into mounting the exhibitions, authoring the publications, and publishing the posters and reprints for which he and Galerie Nierendorf have become celebrated. Somehow, in between, he has also found time to write the exhaustive catalogues raisonnés of the graphic works of Otto Dix (Fig. 9-B) and Otto Mueller and to sit each year in the very last row through each of the auction sales in Munich, Hamburg, and Bern.

Bemerkung: Ein als »Probe« bezeichnetes Exemplar wies gegenüber mehreren Vergleichsexemplaren aus der Auflage keine wesentlichen Unterschiede auf.
Drucker: Ehrhardt
Verleger: Otto Dix

297 Kind mit Katze
Lithographie 1964
Farbe: Schwarz
Größe der Darstellung: 406 x 427 mm
Blattgröße:
a) 565 x 553 mm, weißes Kupferdruckpapier
b) 715 x 553 mm, weißes Offsetpapier
Auflage: a) 75 Exemplare vor dem Schrifteindruck
b) Plakat-Auflage mit Schrifteindruck:
»Künstlerbund Baden-Württemberg«
Verleger: Galerie Maercklin

298

298 Bildnis Florian Karsch I (in Kreidetechnik)
Lithographie 1964
Farbe: Schwarz
Größe der Darstellung: 273 x 196 mm
Blattgröße: 483 x 382 mm
Weißes BFK Rives-Bütten
Auflage: 40 Exemplare
Drucker: Erker Presse St. Gallen
Verleger: Galerie Nierendorf

297

A page from Florian Karsch's catalogue raisonné, *Otto Dix: Das graphische Werk*. Mr. Karsch is director of Galerie Nierendorf, Berlin. (COURTESY OF FLORIAN KARSCH) Fig. 9-B

Sylvan Cole's Associated American Artists of New York: A Panoply of Prints

While Florian Karsch was rejuvenating Galerie Nierendorf in Berlin, Sylvan Cole was performing the same service for Associated American Artists in New York, and with similar competency.

AAA began life in 1934 publishing five-dollar prints by Depression-era American artists. In a few years it became America's largest mail-order art dealer and contemporary print gallery, with a stable of some 60 artists, ranging from Archipenko to Grant Wood. Cornell graduate Cole joined AAA in 1946 after stints with the U.S. Army and Sears Roebuck. During the next five years, as manager of AAA's mail-order operations, he watched its marketing efforts sputter while he introduced heavyweights Rembrandt (purchased from Knoedler's, then a venerable old master print firm) and Picasso (bought from Kurt Valentin, who then had the American Picasso dealership) into the new Master Print catalogs in an attempt to aristocratize AAA's fare. In 1958 AAA, in the doldrums like most other print establishments, was acquired by Rust Craft Greeting Cards, one of *Fortune*'s 500 largest American companies. Rust Craft injected fresh capital and brought back Cole (who had left in 1951) to take charge, and he began reestablishing contacts with American printmakers, such as Peterdi, Baskin, and Raphael Soyer, and offering their editions, sprinkled with a few expensive Chagalls and Lautrecs, to the American heartland by mail. The Print Boom of the 1960's carried AAA to quantitative preeminence, with the largest and most diversified stock of prints in the world, and Sylvan Cole, its president, to qualitative preeminence as the most visible and quotable pundit of the American Print World.

Cole embraced and helped stimulate the revival of interest in prints (among other activities, he agreed to finance the birth of the *Print Collector's Newsletter* in early 1970). As a creative dealer, he has for decades staged instructive exhibits of graphic works by such American artists as Barnet, Benton, Feininger, Homer, Hassam, Soyer, Weber, Whistler, and Wood, and Europeans Ensor, Rops, Besnard, Vallotton, and the Barbizon School. He has not, however, been a very courageous publisher. It is true that AAA was the first American dealer to publish David Hockney (1964) and Paul Wunderlich (1968). But Cole has generally shunned the major avant-garde trends of the third quarter of the 20th century, partly because he himself prefers the kind of figurative, representational, and decorative art that AAA has always specialized in and partly because he has been unwilling to commit large amounts of capital into costly projects by well-known contemporary artists that most of the firm's customers could not afford to buy. In 1975 Sylvan Cole could still ask, after a great renaissance in printmaking partly attributable to the seizing of the medium by Pop artists, "Why is Johns so

MASTER PRINT
COLLECTION

 ASSOCIATED AMERICAN ARTISTS
663 Fifth Avenue, New York, N. Y. 10022

212-755-4211

cover of one of the annual Master Print catalogs of Associated American Artists (1973),
~~ring George Rouault's "Enfant de la Balle." Etching in colors from *Cirque de l'Etoile
~te* suite, 1935 (K. 145(10)). 310 x 209 mm; 12³/₁₆″ x 8¼″. AAA sells many prints by mail
~ugh catalogs such as this one. Fig. 9-C

spectacular?" His question reflects some resentment toward the price
levels that Johns can command; Cole is sentimental about the bygone
days of the five-dollar print. "I was around in 1949," he recollects, "and
getting $10 to $25 wasn't easy. Feiningers were $15 and Stuart Davises
were $15 and couldn't be sold." So AAA still offers lots of pleasant, if
not very "difficult," $20 prints, the yield from its annual New Talent in
Printmaking selections and other publishing projects, thousands of
mostly inexpensive impressions from the 15th century to the present day
(Aldegrever to Zox), and some of the nicest representational and fair-
priced American talent not yet boosted out of range by rival galleries and
publishers. What one of the best-capitalized art firms is aging in its
warehouse—what Cole calls his "insurance policies"—in addition to an
intact Picasso *Vollard Suite* and untapped estate holdings of Milton
Avery, Stuart Davis, Lyonel Feininger, Grant Wood, and other
graphics, only Cole knows.

If prints are more copious at AAA than almost anywhere else, they
are also highly gregarious. They go out daily by mail (Fig. 9-C) and
frequently by rail as traveling exhibitions. And the staff is even more
gregarious than the prints. It's worth the elevator ride just to take in
Hilda Castellon's smile.

Aldis Browne, Private Dealer of New York: Classical Modern Prints

Aldis Browne assisted the late Peter Deitsch (eulogized in 1970 by Chi-
cago Art Institute Curator Harold Joachim for his "whole-hearted in-
volvement with art, his taste, his profound knowledge and his integrity")
for a year before joining Sylvan Cole as an Associated American Artists
salesman in 1965. Impressed with Browne's good business judgment,
caution, discretion, collector's eye and instinct for quality and value,
Cole made him gallery director and vice-president of Associated Ameri-
can Artists, sent him on numerous foreign junkets, entrusted him with
all aspects of AAA's business, from examination of old master prints to
composition of mail-order catalogs, and gave him the impression that
AAA would one day be his to direct.

When Browne concluded in 1972 that, like Jacob, he might have to
labor another seven years to achieve his goal, he organized Aldis Browne
Fine Arts Ltd. and began stocking it with the prints and drawings he
had learned to love and admire best from AAA's potpourri of graphics:
those by the "modern masters," primarily European, from 1850 to 1960.
Like other young dealers of similar taste and experience, such as Martin
Gordon of New York, William Weston of London, and Karl Vonder-
bank of Frankfurt am Main, Browne will occasionally reach for the
superb image, paying a rich auction price for Munch's "Girl with Long
Red Hair" or Lautrec's "The Englishman at the Moulin-Rouge," just to

have them for sale. Like some of the best private dealers in the world, Browne has no street-level gallery, but works out of an office "by appointment only." And like other independent dealers, he is active and mobile, flying to Japan and Europe on short notice to pin down buyers and merchandise, teaming up with colleagues on purchases and sales, advising regional museums on deaccessions, consulting with corporate collectors, working with collectors who have prints to sell or a list of those they want to buy. He cleverly uses the assets of the Aldine Art Fund, a limited partnership of a dozen or so investors, which he organized and operates as general partner, to augment the capital available for stock purchases.

The very existence of such an investment fund is the best evidence of the trust that Browne commands in the Print World. He is fair and trustworthy beyond reproach; his stock catalog entries are enlightening and candid about condition and quality; his advice is circumspect—like a good lawyer's—all that anyone one might expect from a man who still wears white shirts and striped ties.

Hans Bolliger of Zurich: Livres de Peintres and Literature on the Arts

Another dealer of independence, and of vast learning and experience as well, Hans Bolliger sends out extraordinary catalogs of 20th-century illustrated books and periodicals and books and magazines on the arts from his home on the outskirts of Zurich. With Arthur A. Cohen of New York, Bolliger is one of the few true Print World scholar-dealers; he is a writer, editor, publisher, cataloguer, biographer, and bibliographer. His German-language sales catalogs of rare and hard-to-find publications are texts, crammed with precise data and commentaries.

While employed by Bern auctioneer Eberhard Kornfeld for 15 years as the well-paid house scholar and catalog writer, Bolliger acquired pervasive knowledge about art publications, old exhibition catalogs, books and periodicals illustrated with graphics, posters, and prints, especially by and related to the artists of German Expressionism, Dada, and such French and German Surrealists as Arp, Bellmer, Breton, Duchamp, Ernst, Schwitters, and Tanguy. He has accumulated perhaps the finest and most extensive private collection in the world of Dada documents, the illustrated books of Kirchner, and the prints and drawings of the Surrealists, particularly those of Max Ernst. He is most proud, among his accomplishments, of the texts containing Ernst lithographs and reproductions of collages and frottages, including *24 Frottagen*, which he published in 1972.

In 1969, Bolliger prepared his last *Dokumentations-Bibliothek* auction catalog as an employee of Kornfeld und Klipstein and established his own

Bücher-Grafik firm in Zurich. Desperate for Bolliger's knowledge and skills, Kornfeld engaged him in 1976 to prepare *Dokumentations-Bibliothek* and *Illustrierte Bücher* catalogs and preside over the book sales.

Are the flights of the Surrealists escapist fantasies for the exact, disciplined German mind? Bolliger's Januslike mentality, at once absorbing the fantastic and attentive to the practical, benefits us all by keeping the uncommon in order.

Margo Leavin of Los Angles: Contemporary American and British Graphics and Multiples

Very down-to-earth on the opposite side of the world, far from New York and the European art centers, Margo Leavin also collects what she shows: etchings and lithographs by Jasper Johns, objects and graphics by Claes Oldenburg, and prints by Twombly, Warhol, Arakawa, and other leading American painters. In the face of a somewhat conservative orientation on the part of the Los Angeles County Museum of Art ("Ebria Feinblatt, senior curator of prints, is more interested in acquiring states of a Rembrandt etching than in contemporary prints; as far as I know, she has never visited a local gallery," comments Leavin), domination of its Graphic Arts Council by traditionalist dealers and fair indifference by Angelinos to art in general (they tend to collect boats and cars for prestige instead), Margo Leavin still manages to make more than half her sales locally. While protesting the lack of affirmation and exposure of contemporary art in Los Angeles, she remains optimistic: "A few years ago I felt La Cienega Boulevard (the art quarter of L.A.) was a dying scene, but I see education happening here slowly."

Leavin evaded the La Cienega scene by installing her gallery in a spacious two-story dwelling on Robertson Boulevard, a short distance away, to avoid "going mad with people walking in off the street." She caters instead to a clientele which comes not to pass time gallery-hopping but to view first-rate contemporary art. "People come here," she says, "because they know what we offer." She gave Angelinos a place to see outstanding contemporary American art in December 1970, after dealing privately since 1965, just before Gemini G.E.L. began printing and publishing Josef Albers, Robert Rauschenberg, Frank Stella, and other Americans on Melrose Avenue a half mile away. She soon became the exclusive Los Angeles representative for Gemini and Universal Limited Art Editions publications and began to cultivate the local market for the works of Jim Dine, David Hockney, and other artists making their reputations in New York and Europe. Today the gallery mailing list has over 3,000 names and turns over its entire stock about three times a year. Gallery administration—planning shows, arranging inventory, and cooperating with colleagues in other cities in regard to shows and in-

ventory—keeps Margo Leavin on the telephone at her desk much of the time. She has few hours to spare for the distributing activities required of a publisher, the cultivation of curators, or much travel, though she still manages to maintain contacts with artists, collectors, and curators. A number of her shows have traveled to galleries in Australia and American cities outside Los Angeles. She prints no stock catalog (it would be dated too quickly) but is known among the trade as an excellent source for older Gemini and other hard-to-find contemporary American prints.

Margo Leavin still speaks thoughtfully and moves quietly, like the younger woman who switched from art history of psychology and worked for two years as a social worker, while at the same time diffusing New York sophistication, like so many other New Yorkers who emigrated to Berkeley and U.C.L.A. to study and stayed as immigrants.

Gilles Abrioux of Chicago: Consultant to Corporate Buyers

Gilles Abrioux is also an emigré who sells fine contemporary graphics, albeit of a different flavor. But though he maintains an inventory of several hundred prints, sells several hundred annually, and makes his living on the markup between his wholesale price and a full retail price, Abrioux is not a retail print dealer with a product to sell. He sells a service: the filling of a corporate environment with works of art.

Abrioux is one of a growing number of dealers and consultants with specialized talents, including Ruder and Finn Fine Arts of New York, ADI of San Francisco, and the Art Advisory Service of the Museum of Modern Art, who cater to new Medicis of the 20th century: the corporate executives and business professionals awake enough to want something other than clipper-ship seascapes and portraits of ex-chairmen to adorn the millions of square feet of their office wall space. Businessmen eager to buy art for image and enhancement of employee morale, but apprehensive about offending anyone, especially stockholders, have engaged businesslike consultants whose taste and understanding of investment values they feel they can trust. The consultants, in turn, find themselves educating the traditionalist businessmen, naïve about contemporary trends and intangible values, to appreciate an innovative, abstract screenprint over a dubious representational oil and a signed delicate lithograph over a clumsy reproduction of a Cézanne still life—persuading them to buying "art" to decorate the office rather than just "pictures."

"The executives are very insecure," says Abrioux in his soft French accent. "They want to be safe, but they want to brag about it, too. I'm a straight guy. I wear pinstripes; I don't wear plumes. They like me." Businessmen—the executives at IBM, RCA, PPG Industries, B. F. Goodrich, Esmark, and the partners of such law firms as Jenner &

Block—consequently invest their trust in Abrioux completely when they commission his talents in judging how artworks "work" in space and on walls, selecting the right images and installing them in place. "They come to me because they know I'll put together a good collection. When I do a collection, they leave me alone. I take a new space, and with my designer, try various things and somehow *know* what will work in the space. I work night and day to make the place so beautiful, so fulfilling." Abrioux has enormous affection for his work—and he works very hard to introduce his largely conservative clientele to tasteful contemporary art.

"Good people with good merchandise are few, and you know them," Abrioux says knowingly. He stocks a handful of Japanese graphics, a few Paris-published prints, and a large number of Marlborough Graphics publications—Gottlieb, Motherwell, Bayer, and the like—which he can purchase at favorable prices in quantity, and he holds the Carol Summers dealership for Chicago. He attends the international art fairs to view what's new, while eschewing geometric abstractions, which jar rather than soothe, and the art of the emerging American avant-garde, which stumps most executives. He also avoids very expensive prints, perhaps because they may require justification to businessmen as "good investments," and perhaps because Abrioux himself cannot forget that when in Chicago in 1957 he first began dealing in prints—primarily the publications of Nesto Jacommeti's *L'Oeuvre Gravée* of Zurich: Friedlaender, Clavé, Bissier, Campigli, Marini, Zao Wou ki, and others—most new graphics were as cheap as, and sometimes substantially cheaper than, their frames.

Heinz Berggruen of Paris: Modern European Masters—and a Few Minors

Many of the neglected graphic works of such acknowledged European masters as Klee, Kandinsky, Matisse, Picasso, Miró, Ernst, and Dubuffet that Heinz Berggruen was revealing to American tourists and touring dealers in Paris during the 1950's were then not much more expensive than the contemporary publications of *L'Oeuvre Gravée*. But Berggruen's exhibitions of master prints—comprising over one third of the some 60 exhibitions assembled since he began the gallery in 1947—enhanced by an exceptionally well-documented catalogue with a lithograph as its cover—along with his publications of Picasso, Chagall, Miró, Soulages, Hartung, Wunderlich, Courtin, Meckseper, and Hamaguchi, and his substantial trade in modern prints greatly contributed to the elevation of Berggruen to the status of one of the world's premier art dealers and an art-world multimillionaire.

Berggruen opened his gallery in a diminutive cellar shop at the Place Dauphine, near Sainte Chapelle, at the end of 1947, after having served

overseas during World War II in the United States Army as cultural officer (he was drafted in 1942) and after the war as co-editor of the *Life*-like Munich magazine, *Heute*, and as deputy chief of the art department of UNESCO in Paris. (New York print dealer Lucien Goldschmidt remembers that Berggruen "walked around when he was still an employee at the United Nations [UNESCO], at his lunchtime, trying to sell one or two Miró prints. I bought them from him once or twice for a little bit of money, and he was very glad, because *nobody* bought prints!") People first came to Chez Berggruen to see the collages of Kurt Schwitters, whose work Berggruen introduced internationally, the cut-out designs (papiers découpés) of Matisse, the then unknown early drawings of Max Ernst, and the watercolors of Paul Klee—at that time also unfamiliar in postwar Paris. It was his abiding interest in Klee—a work by whom he had first purchased from a German refugee in Chicago for $100 in 1937 and which he still owns—while he was continuing the studies in art history he had begun in Toulouse and writing avant-garde plays for the New York Theater Guild (he became a critic for the *San Francisco Chronicle* in 1938), that helped generate much of Berggruen's success as an art dealer, before he moved his gallery to 70 Rue de l'Université in 1950.

But it was his dedication to the art of Pablo Picasso and his relationship with Daniel-H. Kahnweiler, Picasso's early intimate and long-term dealer (Fig. 9-D), that—just as Kahnweiler's standing has always been founded on Picasso's loyalty—made Heinz Berggruen a factor to be reckoned with in the international art market. Born in Berlin, Berggruen is of German extraction and trilingual, like Kahnweiler, and the older

Pablo Picasso, "Portrait de D. H. Kahnweiler, I." Lithograph, 1957 (B. 834; M. 295). 645 x 495 mm; 25⅝" x 19½". (COURTESY OF SOTHEBY PARKE BERNET INC.) Fig. 9-D

man admired Berggruen's profound emotional commitment to the heroic
epoch of modern art in Europe (as opposed to the celebrity of the heroic
artists), his intelligence, his sensitivity, and his scholarship. Kahnweiler
became Berggruen's teacher and promoter, as well as his comrade.
Today, as long before Picasso's death, Berggruen has through Kahnwei-
ler's Galerie Louise Leiris a call on five impressions of each Picasso print
published by Leiris. Berggruen was introduced to Picasso by the poet
Tristan Tzara during the early 1950's, when le Maître still worked, lived,
and welcomed comrades on Rue des Grands-Augustins in Paris, and
during the next 20 years, until Picasso's death, he was a frequent visitor
at Picasso's various residences in the south of France, a regular giver and
receiver of small gifts, and a grateful beneficiary of Picasso signatures on
formerly unacknowledged works by the Master. During the Print Boom
of the 1960's, Berggruen found himself in the enviable position of being
the repository for large quantities of Picasso prints and having the capa-
bility of exercising price leadership through both the copious entries in
his annual *Graveurs Contemporaines* stock catalogues, first published in En-
glish in 1954, and open-market transactions.

Berggruen's reputation as a shrewd, strong-minded and influential
print dealer has become as widespread among the trade and savvy collec-
tors as his slender, elegant exhibition catalogues—his *plaquettes* (Fig.
9-E)—his exhibition posters, and his pace-setting stock catalogues of 20th-
century European graphics. As his colleague and sometime coventurer,
the late Frank Perls, once put it, "The flavor that comes from Heinz
Berggruen has permeated much of the art world around us. It is the
flavor of sweet-smelling aggressiveness, restrained by the desire, the will
and the capability not to transgress the limits of propriety."

Though he was knighted by the late President Pompidou Chevalier de
la Légion d'Honneur—for his success and philanthropy—in 1971 and ap-
pointed a director of the prestigious Lambert and de Rothschild-backed
Artemis Fund in 1973, has substantial investments in Galerie Kornfeld
Zurich and other unidentified havens, and is surrounded by paintings
and sculpture by Picasso, Braque, Matisse, Klee, Chagall, and Miró,
Berggruen's trade remains largely unchanged. He still keeps his gallery
racks and cabinets well stocked with the Paris-printed graphic works that
please him—whether images from the great flowering of French art of
the first half of this century or those by contemporary artists, such as
Courtin, Estève, Hamaguchi, Hartung, Manessier, Minami, Mum-
precht, Poliakoff, Soulages, and Tápies, without such a large interna-
tional reputation—inexpensive *pochoir* and lithographic reproductions of
paintings and even more inexpensive posters. He still loves to deal in art,
raising and lowering his hand for Chagalls, Kandinskys, Klees, Mirós,
and Picassos at New York and London sales and at the Kornfeld auction
each year in Bern (see Fig. 10-B) and hoarding Wunderlich lithographs
until the day when the marketplace shall confirm his taste with higher
prices.

The cover of this 1967 stock catalog of Berggruen et Cie. is a lithograph in color by Paul Wunderlich—"Bubble Gum" (B. 246). Galerie Berggruen also published a signed and numbered limited edition of this print, with margins and without the letters. 270 x 285 mm; 10⅝" x 11¼". Fig. 9-E

The mix of three cultures—German-Jewish scholarship, American doggedness, and French sensitivity—has produced an art dealer with the perception of Kahnweiler, the dash of Duveen, and the devotion of Gimpel, now in the seventh decade of a zestful life.

C. G. Boerner of Düsseldorf: Old and 19th-Century Masters and German Expressionists

Heinz Berggruen and Ruth-Maria Muthmann, who now owns the hoary firm of C. G. Boerner, could scarcely ever vie for the same print—perhaps an early Picasso, but not much else. Neither the art nor the atmosphere has ever been stentorian or electric at C. G. Boerner; everything, including the proprietress, is staid and underplayed. Both splashy pictures and flashy visitors are discouraged.

This German institution was founded in Leipzig by C. G. Boerner

Carl Gustav Boerner (1790–1855), founder of C. G. Boerner, the Düsseldorf print firm. (COURTESY OF C. G. BOERNER) Fig. 9-F

(Fig. 9-F) in 1826 and counts Johann Wolfgang von Goethe as one of its earliest steady clients. Mrs. Muthmann took charge of the firm in 1973, after over 25 years of learning about prints and drawings, especially old master prints, at the feet of its retired former owner, Dr. h. c. Eduard Trautscholdt. Trautscholdt, still regarded as perhaps the foremost expert in the world on Dutch etchings, the author of some 130 articles on old master prints, drawings, and paintings, brought his great scholarship to bear on the C. G. Boerner sales catalogs for a period of more than half a century, commencing shortly after World War I, when the firm was Europe's principal old master print and drawing auction house. The C. G. Boerner firm entered the auction business in 1871 with the takeover of another German auction house, became the leading auction firm on the Continent when the Stuttgart firm of H. G. Gutekunst (a predecessor of Kornfeld und Klipstein) suspended auction sales in 1917, and itself cried out a last sale in 1943, when its Leipzig office was leveled by bombs. During the war, Trautscholdt and his predecessor, Dr. Hans Boerner, saved the vital Boerner library by storing the books in the cellars of museums and in the mountains outside of Leipzig.

When Hans Boerner died in 1946, the Boerner Family entrusted Trautscholdt with the management of the firm. A year later, in 1947, while the firm still sat in its ancestral home of Leipzig, Mrs. Muthmann became Trautscholdt's assistant and he, her mentor. Very soon the political situation in East Germany compelled Trautscholdt to consider moving the firm west. He initially leaned toward Munich, a great art and cultural center, but eventually opted for the Rhineland. When in 1950 the firm made

its way west, the art and fine furnishings dealer F. G. Conzen offered the house of C. G. Boerner space in his building, with a spacious, flower-lit courtyard, in the still bombed-out Rhineland city of Düsseldorf, close to the Dutch art that Trautscholdt loved so much.

Mrs. Muthmann continues to emulate Trautscholdt's discriminating taste for prints and drawings of superlative condition, quality, imagery, and rarity and his uncommon talent for analyzing and describing them in the firm's stock catalogs, the *Neue Lägerliste*, that Trautscholdt had commenced in Leipzig in 1948. She tries to buy for stock only those impressions that have no need for restoration. "A print always loses something of its quality when it is cleaned and restored," she advises. C. G. Boerner is always in the running, whether for itself or on behalf of an institutional or private client, for that exceptional magnificent old master, 19th-century, or Expressionist graphic—an engraving by the Master E. S., a Goya trial proof, a Manet lithograph, a color woodcut by Kirchner—to be sold at auction, and maintains its august reputation by winning many of them, in competition with Colnaghi's, August Laube/Robert Light, and a number of other elite, well-capitalized print dealers. But relatively modestly priced prints commingle freely with very expensive prints in the meticulously prepared, richly illustrated Boerner catalogs, which thanks to Ruth-Maria Muthmann's erudition and one of the finest private print reference libraries in the world, are truly more texts than catalogs. How many old master print dealers have a three-inch scrapbook of fakes, forgeries, and simulated proofs on hand for immediate consultation? For all these reasons, there is scarcely a museum print cabinet or substantial collector of old master prints that has not been a C. G. Boerner client at one time or another.

When Dr. Trautscholdt brought C. G. Boerner west to Düsseldorf, he intended to recommence operations, as Mrs. Muthmann relates, in "the old Boerner style." But the character and personalities of the Print World were altered after World War II. Eberhard Kornfeld was building his auction firm into the strongest on the Continent. American and European collectors and curators at first tended to prefer doing business with non-German dealers, many of them recent immigrants from Nazi terror. There were few private collections still available of the size and quality that C. G. Boerner had customarily been called upon to purchase or liquidate before the war. And it was difficult to reassert the old Boerner reputation and reestablish the old international relationships with private and public buyers.

But today Goethe would find the modern C. G. Boerner as congenial a place in which to tarry as it was when he bought prints there in 1827. What Goethe wrote of a print catalog the week before his death, "That catalog gives me an opportunity to ask myself what I had really learned in this field by seeing and studying," can be penned with equal validity about a C. G. Boerner catalog today.

P. & D. Colnaghi of London: Old and Modern Masters

Colnaghi's of Old Bond Street (Fig. 9-G), one of C. G. Boerner's principal rivals today and perhaps the leading dealer in old master to early 20th-century prints in the world, is hoarier than Boerner's by some 40 years.

Colnaghi's traces its direct ancestry back to 1784, when the Milanese Paul Colnaghi opened up a shop in the Palais Royal in Paris to sell prized English mezzotints (*la Manière Anglaise*) *after* British paintings as the agent for a London dealer named Torre. Paul Colnaghi journeyed to London the following year to become Torre's partner and rode out the Napoleonic Wars, which were the ruin of many exporting British print-sellers, by publishing the *Cries of London* after Wheatley's charming London scenes in 1792–97, an engraved portrait of Nelson *after* Hoppner—fortuitously issued the day the news carried the results of the Battle of Trafalgar—and helpful views of Continental cities being besieged by the British armies. Within a few years, Colnaghi was Printseller to the Prince Regent, cataloguer of the Royal collection, holder of Royal Warrants from George IV, and thanks to his French connections, the favorite dealer of the French emigrés then languishing in London. In the early years of the 19th century, when Paul Colnaghi's eldest son, Dominic, became active in the business, Keats, Lamb, Hazlitt, and Thackeray mentioned Colnaghi's in their writings, and the art critic Wainewright would write of an establishment "crowded with beauty and fashion" where "English marchionesses, foreign princes, knights, dames and squires of high degree" assembled. After various declines and retrenchments, Colnaghi's was prospering in the 1870's, when the perfection of steel engraving as a medium for mezzotint established the firm, with Mme. Noseda's on the Strand, as London's leading print publishers before the demise of interest in reproductive engraving.

The modern history of the firm commences with the entry into the partnership of Otto Gutekunst (1894) and Gustavus Mayer (1911). Mayer's exploits on behalf of wealthy collectors and museums are legendary. He had a key voice in the negotiations with the Soviet Government in 1930–31 that brought several of the treasures of the Hermitage to the United States and Amsterdam's Rijksmuseum and passed months in Austria and Hungary during 1935 and 1936 consorting with Hapsburgs and Austrian government officials in an unproductive effort to obtain the fabulous prints and drawings collection of the Albertina Museum—over 250,000 prints and 22,000 drawings!—for his client, the Boston Museum of Fine Arts. So many impressions of old master prints, from the consignments at C. G. Boerner auctions to the huge collection of the Prince of Lichtenstein, came under his scrutiny that Mayer acquired an encyclopedic knowledge of old etchings, engravings, and

The view south on Old Bond Street, London, past the P. & D. Colnaghi clock. The Bond Street area is the fine-arts quarter of London. (PHOTO BY THE AUTHOR) Fig. 9-G

woodcuts (it was said that he knew all the states of Rembrandt's etchings by heart) which was relied upon by institutional curators for decades. Hundreds of peerless proofs traveled through Colnaghi's en route to the British Museum, the Rijksmuseum, the Metropolitan, the Boston Museum of Fine Arts, and the Art Institute of Chicago. Hyatt Mayor, former Print Curator at the Metropolitan, recalls how "Mayer astonished me by recognizing impressions that had passed through his hands 20 or 30 years before, and verified his recognition by the Colnaghi numbers penciled on the back." Gus Mayer also continued the Colnaghi publishing tradition by commissioning editions of etchings by Bone, McBey, Griggs, and many others during the etchings boom of the 1920's and 30's. He died in 1954 at the age of 81, survived by his daughter, Katharina Mayer Haunton, whom he had led to similar expertise in old master prints and a directorship in the firm.

The contemporary history of Colnaghi's begins with its acquisition by the Rothschild Family Trust in 1970 and its entry into the field of prints by late 19th- and early 20th-century Continental artists to supplement its traditional occupation with old master and 19th-century prints and the works of English and French etchers. Rothschild ownership invigorated the old firm with substantial capital and the bright, youthful, energetic, personable talents necessary to meet the sharp competition that had rapidly developed in America and Germany, especially, during the 1960's for the dwindling supply of art of high quality. Colnaghi's began making open-market purchases of modern prints, including, significantly, graphics by German Expressionists, in 1971, engaged young Canadian emigré Frederick Mulder in 1972 to organize a new modern print depart-

ment and launched its first comprehensive exhibition of the new material, heralded with an immensely informative 135-page catalogue entitled *Millais to Miró, European Prints 1855–1955*, in 1973. Pre-1850 graphics remain upstairs at Colnaghi's; the Moderns occupy downstairs.

Mulder attempted to exorcise some of the mustiness out of Colnaghi's Old Bond Street premises, which it has occupied since 1912, by hiring gregarious personalities as assistants and by wearing a colorful sweater to foreign auction sales in lieu of the conservative three-piece gray suit habitually worn by Arthur Driver, who helped handle the traffic in old master prints from 1928 until 1976. In 1975, Mulder and Driver were relieved by Adrien T. Eeles, for many years in charge of print auction sales at Sotheby's.

Colnaghi's remains, in the spirit of Paul Colnaghi and Gus Mayer, a place of great expertise and eminently fair and honest dealing. Many print curators still choose to consult with Colnaghi's before bidding for old master prints at auction (the firm has traditionally acted as commission agent for the British Museum), and they now have a much-expanded stock, elucidated in exquisite lengthy catalogs, from which to choose. The range of material at Colnaghi's is vast, excluding contemporary prints, and the range of prices, from modest to very expensive indeed. "Prices are pitched low and stay firm," Mulder advised before his departure. "We are very careful about raising our prices. People do find bargains at Colnaghi's"—a revelation that would seem less surprising if said about wonderful creaky old Craddock and Barnard's on Museum Street than about P. & D. Colnaghi of Old Bond Street.

James Goodfriend of New York: Inexpensive Old Master Prints and 19th-Century Etchings

James Goodfriend is to P. & D. Colnaghi what the corner grocer is to the A. & P. Their interests overlap; but what Goodfriend deliberates about, takes a plunge with, and happily researches and mounts, Colnaghi's might leave forgotten in some box for years. Goodfriend looks for prints in obscure places that the staff of Colnaghi's would never waste time entering, and he bids at auction feverishly hoping that Colnaghi's will abstain.

Jim Goodfriend has a double business life. When he is not being the Music Editor of *Stereo Review*, which is his daytime profession, or writing a layman's introduction to classical music, which occupies many evenings, he is a collector-dealer of those prints he finds irresistible: proofs by 16th-century German Little Masters (the Behams, Aldegrever, Altdorfer, and such), American, English and French etchers (Pennell, Whistler, Buhot, and the like) and when he can afford them, the celebrated old masters, Dürer and Rembrandt. Goodfriend first became fas-

cinated with prints through the study of music iconography. He began to collect old master prints seriously under the influence of several older and wiser dealers. He became a dealer in 1969 because he was forever finding underpriced prints that he did not covet for himself but could profitably tender to another print dealer.

Goodfriend tries not to be a "runner," which is art world vernacular for a capital-short broker-dealer who regularly sells works he cannot afford to other dealers before buying them himself. He operates more as a bargain hunter, using his keen nose and specialized knowledge to spot and unearth prints undervalued in one market that might bring higher prices in another. Most dealers have neither the time nor the temperament to scout out other dealers or out-of-the-way sources for material they might be able to sell easily. People such as Goodfriend cream the small auctions and olde antiquary shoppes and help shift artworks from places of low demand to places of higher demand. The print which Goodfriend finds, buys, and sells may one day appear in the stock of P. & D. Colnaghi.

If Goodfriend lacks the capital for the bargain purchase, he may be compelled to presell, which is what the runner does in the normal course. In a typical transaction of this sort, he finds 50 Helleu drypoints at one establishment, verifies an interest in them in another, gives a small deposit to remove them on approval, immediately sells and delivers them to his customer, and pays his bill with the proceeds. In the more usual transaction, he will buy a batch of prints at auction or a package of deaccessioned graphics from an institution, clean them up, catalogue them, mount them, and sell them one by one to dealers and collectors. The small dealer's dream is to amass sufficient capital to enable him to forego dependency on lucky finds and quit running.

An art dealer usually has either too much money or too much inventory at any one time. A collector-dealer like Goodfriend is never beset by the first quandary. Over the years, however, as he has accumulated some investment capital through sales, Goodfriend has been able to acquire stock to show, attract a clientele, and place ads in the classified dealers' section of the *Print Collector's Newsletter*. Frank Weitenkampf, the late curator of prints at the New York Public Library, once observed that "collecting is a matter of mind, taste, discrimination, enthusiasm—plus the pocket-book; the last the least important." Jim Goodfriend is an intelligent, informed, alert collector-dealer in the Weitenkampf mold—the kind that can have an impact on the Print World if he can but fill out the pocketbook.

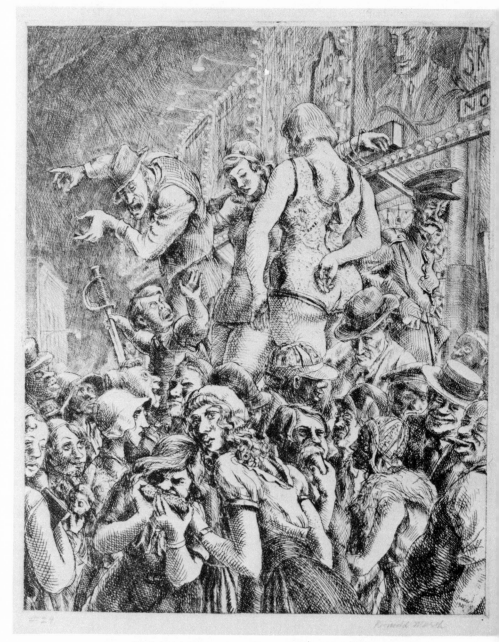

Reginald Marsh, "The Barker." Etching, 1931 (S. 115).
251 x 203 mm; 9⅞″ x 8″. (COURTESY OF MARTIN GORDON
INC.)

Chapter Ten

People Who Auction Prints

Be a little bit clearer; the eyes are not enough!
—EBERHARD KORNFELD to a cagey bidder,
June 1971

Frequent auction sales of prints and books with prints give the print market great liquidity and jell the price levels of the prints of each artist and each school that appear at auction.

Some 30 established firms in the United States and Europe furnish print buyers with at least one sale to attend every month of the year except August. Most sales are clustered at the end of the art seasons; that is, during November and early December in the fall, and during May and June in the spring. Sotheby's scatters about a dozen sales, major (green catalog) and minor (thin catalog and red Victoriana Belgravia catalog), more or less evenly throughout the year; Kornfeld und Klipstein and Hauswedell & Nolte each send out a two-inch slab of catalogs once a year, in the spring. Anyone can attend any auction sale, and anyone can bid.

The auction marketplace has a peculiar geographic diversity. Sotheby Parke Bernet New York and Sotheby Parke Bernet Los Angeles, each affiliated with Sotheby's of London, until very recently monopolized the fine-arts auction business in America; their Prints Departments, but one of many art departments, together stage some eight to ten sales of graphics each year. Martin Gordon, a highly regarded New York dealer in fine prints since 1963, began giving Sotheby Parke Bernet some competition in 1976. He staged his first auction of modern prints and photographs in May of that year (Fig. 10-A), but closed shop the following year, soon after Christie's launched its New York auctions. The Prints Departments of the principal London firms, Sotheby's and Christie's, share the bulk of the British business in old master, English, classical European, and contemporary British prints. On the Continent, eight German firms, five Swiss firms, one Italian firm, a few in the Low Countries, and the French (about 25 small sales per year) and Austrian (about ten per year) state auction monopolies somehow all manage to attract enough art consignments

Martin Gordon Inc.
1000 PARK AVENUE, NEW YORK, N.Y. 10028

DATED
AUCTION CATALOGUE

The mailing envelope enclosing Martin Gordon's catalog for his first auction in May 19
pictures the woodcut by Félix Vallotton, "Le Bain" ("The Bath"). 1894 (V.-G. 148). 181 x 2
mm; 7⅛″ x 8⅞″. (FORMER COLLECTION OF THE AUTHOR) Fig. 10-A

—most of them graphics—to survive in the auction business. Most of the prints sold at these auctions are by artists with strictly local reputations, of interest mainly to locals. However, the house of Kornfeld und Klipstein, situated in Bern, Switzerland, auctions off each June about 1,500 to 3,000 lots of illustrated books, to a largely sophisticated international clientele that always includes emissaries from most of the other auction houses.

The major auction sales, especially the big ones that take place each spring, are more than simply sales of goods. Topped off by the annual five-day convocation in Eberhard Kornfeld's gardens in mid-June, they also serve as Print-World conventions where dealers, collectors, curators, art historians, and other print auctioneers gather with Swiss bankers, Greek shipowners, and camp followers, renewing old ties and making new ones, swapping gossip and anecdotes, showing and viewing slides and photos of stock, making deals and trades, and bragging about past deals and trades. Several of the German and Swiss firms entertain auction-goers with cocktails and hors d'oeuvres during the welcome breaks between dronings and throw a formal bash—complete with toasts, speeches, and pêche Melba—for preferred guests the night before the last session.

The perennial six weeks or so of print auction sales that take place each May and June, commencing with a Sotheby Parke Bernet New York (or Christie's) sale in New York in early May and ending with a sale in London in late June or early July, can be both an educational and enervating experience for anyone with the stamina to stick it out. Diligent previewing of all the auction properties and steadfast attendance at all the sales can lay the most fanatical devotee prostrate with *picturus fatiguus* and a sore rump, and in the words of one long-suffering dealer, "suppress all desire for extramarital romance." Eyes blur after days of examining prints, and at bedtime the cry of *zum!* (short for *zum dritten male*, the German equivalent for "gone!") reverberates in the brain like the intonations of *rien ne va plus* after a night at the gaming tables. New York dealer Peter Deitsch suffered a fatal heart attack some years ago after one debilitating into-the-evening session at Ketterer's in Munich, right near the start of the trek, and many collectors and dealers who survive the full circuit begin to look by the end of June like the couple in Picasso's "Frugal Repast." If one wished to attend only the major auctions following the ones in New York and pass up the less "important" sales in Switzerland and Germany taking place during the same period of time, there are thousands and thousands of prints to be considered at Karl u. Faber and Ketterer's in Munich at the end of May, at Hauswedell & Nolte's in Hamburg in early June, at Kornfeld's villa in Bern immediately thereafter, and after a pause for a few days' looking at the Basle Art Fair, at Sotheby's and Christie's in London in late June or early July. There are so many lots in the sales of the German-language auctioneers that toward the end of a session the fatigued foreigner begins to confuse the lot numbers with the bids. But anyone who unflaggingly adheres to the prescribed itinerary will at journey's end easily be able to count to 100,000 or so in four languages—English, French, German, and Swiss-German (Schweizerdeutsch).

The sales catalogs of the major auction firms are refresher courses on the graphic works they offer for sale to the public. They abound with data, commentary, and illustrations; though being selling tools, they sometimes underplay problems and overpraise virtues, one can learn much from them without ever seeing the actual works themselves. Accordingly, they are indispensable reference material for the accurate identification and pricing of the same or another impression when it subsequently appears in the marketplace, and some of them—Sotheby Parke Bernet's 1967–68 catalogs of the Nowell-Usticke collection of Rembrandt etchings, Hauswedell & Nolte's 1969 catalog of Schmidt-Rottluff prints, and Kornfeld's 1973 catalog of Munch and Toulouse-Lautrec prints and 1974 catalog of *Les Peintres et le Livre* (with Geneva dealer Edwin Engelberts)—have achieved immediate recognition as veritable textbooks. The experts who prepare these catalogs have great specialized competency in cataloguing prints, abundant reference sources at

their fingertips, and long visual experience, and the most assiduous of them, such as Eberhard Kornfeld and his collaborators, and Marc Rosen and his staff, take great pains to survey, synthesize, and unearth existing information and modify it with new discoveries and analyses. The auction-house experts and their assistants spend many months inspecting proofs, checking their characteristics against current scholarship, and carrying out whatever additional research may be essential for an accurate and informative presentation of the consignment. Eberhard Kornfeld and his current right-hand lady, Christine Stauffer, work on their catalogs day and night for months before the June sale, giving up much of their personal life for the duration.

As a result, those people who have worked at the major firms cataloguing prints are among the most knowledgeable and circumspect Print People in the world. Indeed Parke Bernet's Marc Rosen, who studied at New York's Institute of Fine Arts, and Christie's Noël Annesley think of themselves more as print scholars than auctioneers. Ernst Nolte, the general partner of Hamburg's Hauswedell & Nolte—currently Kornfeld's chief competitor for high-quality German graphics—and Wolfgang Ketterer, the Munich auctioneer and dealer, have catalogued tens of thousands of prints. Nolte joined his firm in 1963, and Ketterer has been dealing with prints since 1947, when he and his brother began building their now defunct Stuttgarter Kunstkabinett into the world's principal auction market for German prints and drawings. Print-World graduates of Kornfeld University include auctioneer Louis Karl, who apprenticed with Kornfeld for a year—in 1963—a few years before taking command of his father's Munich firm, Karl u. Faber, in 1966; Alice Adam, who ran the Frumkin Gallery in Chicago; Hans Bolliger, the Zurich dealer; Helmut Rumbler, the dealer in mostly old master prints of Frankfurt-am-Main; Wolfgang Wittrock, the Düsseldorf dealer; and Christoph von Albertini, who managed Galerie Kornfeld Zurich.

I have arranged the auction firms that sell prints into three tiers, according to the magnitude and richness of their auction properties, the connoisseurship of their staff, the excellence and detail of their sales catalogs, the smoothness and efficiency with which they handle commissions and sales, the extent of circulation of their catalogs, and their international reputation for reliability and probity. The order within each group is relatively arbitrary. Most firms sell their catalogs and follow-up price lists either by subscription or individually, and they can be as costly—and as useful—as art books themselves. Kornfeld und Klipstein, whose catalogs are worth more than those of any other firm, gives theirs away free to anyone who expresses enough interest to request them and to all its longstanding clients.

FIRST-LINE AUCTION HOUSES

KORNFELD UND KLIPSTEIN, Laupenstrasse 49, 3008 Bern, Switzerland. Tel. (031) 25 46 73. Chief print expert: Eberhard W. Kornfeld.

Suddenly June is not too far off, and Print People of all nationalities, ages, and callings begin to think about the annual Print World event in Bern—the three and a half solid days of selling at Kornfeld und Klipstein.

If there is no more space at the Hotel Schweizerhof or Bellevue-Palace (some people book their rooms at these traditional rendezvous a year ahead), Eberhard Kornfeld's resourceful staff will find reservations for you. After you arrive, they will mail things home, locate the rack for lot 1287, smile, flirt in five languages—extend every courtesy like some Swiss geishas. The Swiss efficiency of the staff, the friendly greetings, the presale examination of prints in the close company of many experts, the sweet June smells and chirps of birds in the garden, the crunch of the gravel on the garden paths, Kornfeld himself, his sharp blue eyes dancing, welcoming guests in his beige sweater during preview days, the cocktails and canapés during intermissions, the creak of the floorboards in the old villa, the transport of millions of dollars in prints and drawings by wooden wheelbarrow from house to auction auditorium—all make the Kornfeld premises on the Laupenstrasse more art-world resort than art-world marketplace (Fig. 10-B).

erhard Kornfeld's villa in Bern, Switzerland, with some auction-goers lounging on the ss. The man standing with glasses is Paris dealer Heinz Berggruen; the woman seated with pith helmet is Sotheby auctioneer Libby Howie. (PHOTO BY THE AUTHOR) Fig. 10-B

So every year they come; "Each year the same faces, only a little puffier," notes a staffer. First-timers are surprised and enchanted. "Wow! This is the Big Time!" exclaimed Estelle Yanco, representing Associated American Artists for the first time, as she surveyed the bottles of 1959 Bordeaux and art-world personalities at the traditional Friday night banquet in the elegant Schweizerhof ballroom (in 1973, ostensibly to celebrate the 150th auction of the firm, a sale of Toulouse-Lautrec lithographs, Kornfeld bused his guests to Interlaken for a feast replicating a menu designed by Lautrec in 1893 [see Fig. 3-G]). Another lavish touch by the art-world host of hosts, like the last night banquet at sleepaway vacation camp, that reduces all disappointments and regrets to fellowship and goodwill toward the host and brings the veterans back for yet another season.

It is, however, not just the food and the setting and the cordiality that brings them back year after year. Eberhard Kornfeld's charisma lures the best consignments as well. To maintain his reputation for quality, he rejects over half the works proferred for auction and is consistently long on wonderfully fresh impressions of Picasso, Munch, Toulouse-Lautrec, and other French prints, Kirchner and other German Expressionists, and French and German books with prints, rare and lovely tidbits that can easily be overlooked in a quick flip through the catalogs and intact sets and portfolios that can be found nowhere else. He is not looking for contemporary American prints (though he was an early publisher of Sam Francis graphics), but if someone comes in with a substantial collection, he would accept it, though without any reserves. When he took over the venerable firm of Gutekunst und Klipstein in 1951, its June auction of old master prints was probably the most important and best patronized in the world. Kornfeld presciently focused on the rising interest in modern art, catching the boom in full upswing, while the available supply of exceptional old master prints and drawings was drying up. Today his red catalog of old master prints and drawings represents a tiny portion of the total consignments, while his selections of modern prints in the fat gray catalog are unmatched in number, quality, and condition by any other auction house. "It's amazing. There are at least 36 things I *have* to have," New York dealer David Tunick confided to Ruth-Maria Muthmann before one typical sale.

The combination of a coddled clientele in a bidding mood and a rich stock to bid for has an irresitible impact upon the prices reached at Kornfeld auctions, which are widely read and regarded as harbingers for the fall season in Europe and America. In the aggregate, they are always higher than anywhere else, and there are always some that were previously unheard of. To swell a bidder's pride in setting a record—and mollify, at the same time, the bidder's misgivings about paying so much—Kornfeld will direct a pretty assistant to present a dewy rose from the vase on his lectern. The grinning and applause that accompany

the bidder's aplomb and pleasant embarrassment are good for business, too.

Hospitality, rich material, showmanship—that is why the Print World comes for almost a week to a provincial Swiss town like Bern. For Kornfeld is a peerless auctioneer. Signaling bidders, he jabs and swings his pencil like a band leader. Extracting bids, his wise-owl eyes flash, his arched brows arch even higher, he grins puckishly, his head tilts slightly like a puppy's asking for a yummy (Fig. 10-C). Now forceful and impatient, now charming, now witty, refreshing the sagging multitude with wisecracks, shifting into English or French to accommodate the nationality of the target. How many auctioneers can get away with *discouraging* higher bids? "Is it *so* lovely?" he asks a bidder who has raised the price of a Pissarro to triple its estimate. "It's so nice?"—this about an ordinary Marini at double the estimate. And they smile weakly to hide sudden second thoughts induced by the Master's jibe. One lot contains four (more) Chagall black and white lithographs, which, advises the Auctioneer, "You can color yourself" (a snide reference to all the color "Chagalls" whose color plates were actually executed by Paris *chromistes*). Klee's "Truer Hund" is "an expensive dog at that price"; Picasso's

rhard Kornfeld intones the bids while his assistant, Christine Stauffer, looks for them. roses are awarded to record-making bidders. (COURTESY OF KORNFELD UND KLIPSTEIN) 10-C

"Poule" is a "chicken for 10,000 francs?!"; and his "Minotaur aveugle guidé par une Fillette dans la nuit" is a "sign of Woman's Liberation."

There is no other auctioneer with the audacity to stop the bidding when he believes the price is too speculative or foolishly out of line with retail values. Kornfeld peremptorily halts the competition for plate 27 of Picasso's *Vollard Suite* when the bid reaches its retail price that day at Galerie Kornfeld Zurich, which he owns with Picasso-subscriber Heinz Berggruen, Pierre Lundholm, and its director, Christoph von Albertini. Impressions from Chagall's *Arabian Nights* and *Bible* suites each get a fast knock, the first at 6,000 Swiss francs over its estimate and the second at 7,000: "It's too expensive now!" calls Kornfeld, blinking rapidly with irritation. Dealers Paul and Waddington, high bidder and underbidder, see a high bid of 14,500 reduced to 14,000; Mulder and Genstein likewise find themselves braked when they reach over triple the estimate for a Mucha lithograph—"I'll give you each one at that price," announces Kornfeld, who knows where he can find another impression or has one already sitting in his office, brought in too late to be catalogued. (This writer once saw three impressions of Toulouse-Lautrec's rare color lithograph "Aux Ambassadeurs" leaning against the wall of that office after a sale.) The Kornfeld family participates in the business, softening the aura of millions of dollars of art, the Swiss watchworks efficiency, and Kornfeld erudition with a jus' folks, Ma an' Pa image that helps give everyone attending the sales that good feeling of family and comradeship of interest, purpose, and profession. Frau Kornfeld runs the back office and sits next to her husband on the dais, pointing out discreet bids and sweetly prodding him when toward the evening hours he begins to fade. And who doesn't smile when their small daughter gets into the act, holding up a picture bigger than she?

The professionals and the *amateurs*, who are quick to emulate the professionals, soon get very busy at the Kornfeld sales making trade-offs (I won't bid for X if you don't bid for Y), extending gentlemanly forbearances, and forming syndicates to pool resources. Much of the negotiating occurs during the noon hour and after the day's proceedings, when the crowd hikes from the Kornfeld Haus down the Laupenstrasse to the cocktail lounges of the Schweizerhof and the Bellevue. Dealers even bring their wares to Bern, displaying like purveyors of dirty French postcards thousands of dollars of art in cars parked illegally outside Kornfeld's villa and in their hotel rooms. Dueling between friends and colleagues at the sales themselves is *de rigueur*. Some dealers who have reputations to vaunt bid at the Kornfeld auction solely to show their mettle to their colleagues; the honest ones admit to calling it buying for "prestige"—that is, for the attention that the award of a Kornfeld rose will command in the Print World. Kornfeld skillfully exacerbates the peer pressure by furnishing status symbols. He assigns seats in the front rows at the sales of modern art to the most promising bidders and at the sale of old master prints arranges a small U-shaped formation of tables at

the front of the room for the strongest dealers in old master prints: Col-
naghi's representative (for years, Arthur Driver), C. G. Boerner's Ruth-
Maria Muthmann, Robert M. Light, August Laube, Helmut Rumbler,
R. E. Lewis, Hubert Prouté, Pierre Michel, Hellmuth Wallach, David
Tunick, and others (see Fig. 7-F). One can mark a dealer's success by his
entry into this half circle, much as Kremlinologists can determine the
Soviet hierarchy by the presence of the dignitaries on the balcony at a
May Day parade; David Tunick properly took a chair in 1973, but one
small potato who brazenly sat with the elite in 1974 was studiously
snubbed by everyone else, including Kornfeld. With so much peer pres-
sure in the air, the competition can also be savage. Dealers push each
other up in sport or out of spite. In 1971 Associated American Artists'
president, Sylvan Cole, in Bern for the first time, thought he had neu-
tralized all potential American rivals for a Hassam/Hopper lot (unusual
at Kornfeld) during the days preceding the sale, but lost it to Californian
R. E. Lewis, whom he had neglected to approach.

Cole later wondered why respectable dealers succumb to the Kornfeld
mystique and submit themselves to such shenannigans and charades.
Some of those, such as Cole, who now stay away call it a "circus," a
"rip-off," "Kornfeld und Klip*joint.*" They complain about false bidding
(bouncing fictitious bids off the walls to build up the prices), jump bid-
ding, and being trifled with by the auctioneer. They accuse him of com-
plicity in price manipulations by his friends and major consignors in the
trade. They indict him for owning undisclosed properties in the auction,
which would give him a conflict of interest between the opportunity to
profit directly from a high price and the obligation to conduct true com-
petitive bidding to secure the lowest possible price for a buyer.

At the very top of his profession, Kornfeld is naturally the Man They
Love to Hate, and he impatiently denies all accusations. He conducts his
sales briskly, so bidders must be quick and careful; he assumes his
largely sophisticated clientele have precalculated their limits. Many con-
signors—owners of more than half the auction properties—rely wholly
on Kornfeld's judgment as to what price might be obtainable, without
binding him to a net limit (reserve) by written contract, so that he has a
great deal of freedom to induce bidding to levels he considers appropri-
ate. If it seems that he jumps a bid or bounces one off a wall, it is
because he has a higher price or reserve in his "book," actual or mental,
spots a bid on the floor invisible to the skeptic, or honestly but mis-
takenly counts a hand that has come down too slowly. As for encourag-
ing speculation, "In the long run it is not good for business. Overspecu-
lation can damage the market."

Eberhard Kornfeld probably knows more about modern prints and the
print market than any man alive. When not inspecting potential consign-
ments, Kornfeld attends to his own exceptionally rich collection of mod-
ern masters of graphic art (he has a châlet in Davos, where Ernst
Kirchner lived and worked from 1917 until his death in 1938, and where

he is buried). Kornfeld's extraordinary scholarship is expressed not only in the Kornfeld und Klipstein sales catalogs but in his contributions (with Hans Bolliger) to the 1955 standard catalogue raisonné of the graphic works of Käthe Kollwitz compiled by Dr. August Klipstein, his contribution of his assistant Christoph von Albertini to aid Georges Bloch in the preparation of the catalogues of Picasso's graphic works (1968 and 1971), and his own authorship and publication of the definitive catalogues raisonnés of the prints of Paul Klee (1963), the intaglios of Marc Chagall (1970), and the graphic works of Paul Signac (1974; with P. A. Wick). He is currently assembling data for comprehensive studies of works by Munch and Beckmann.

In the years before 1972, when the sales of modern art took place in the garden, country-fair style, under a huge cozy orange marquee, the drumming of raindrops and the boom of thunder used to make Kornfeld shout. The appearance of a nondescript steel-and-glass structure, with motorized blinds and panes that can shut out the elements with flicks of switches, saddened some romantic old hands who remember how their bids were once punctuated by torrents and thunderclaps. But little else has changed at Kornfeld, except perhaps the relative richness of the assortment—the best impressions are being steadily absorbed by institutional and other collectors, never again to come on the block—and the character of the faces who come each year to divide it up. Kornfeld himself—his graciousness, exuberance, acumen, and intelligence—seems immutable.

SOTHEBY PARKE BERNET, INC. (NEW YORK), 980 Madison Avenue, New York, N.Y. 10021. Tel. (212) 472-3400. Chief print expert: Marc E. Rosen.

SOTHEBY PARKE BERNET, INC. (LOS ANGELES), 7660 Beverly Boulevard, Los Angeles, California 90036. Tel. (213) 937-5130. Chief print expert: Travis B. Kranz.

PB-84, 171 East 84 Street, New York, N.Y. 10028. Tel. (212) 472-3583.

These American subsidiaries of Sotheby & Co. and Christie's New York hold the only art auctions that matter much in the United States. The sumptuous upper Madison Avenue galleries, where about 2,500 to 3,000 lots of prints, portfolios, and illustrated books are displayed on velour walls and oak tables and are auctioned in a number of print sales and book sales during the course of a year, offer a full range of inexpensive and very expensive old master, modern, and contemporary prints and books with prints. New York's baby sister on the West Coast has prospered mightily since its first auction of contemporary prints in December 1971. It now offers groups of American contemporary graphics comparable in scope to those catalogued in New York and a diverse assortment of European prints in volume and quality somewhat less rich

than those assembled in New York. PB-84 auctions properties that are normally not worthy enough for inclusion in a Madison Avenue sale.

The New York firm's Prints Department came of age during the late 1960's, when a growing interest in the graphics medium was stimulating the publication of the reference material requisite for adequate cataloguing, the maturing Print Boom was doubling and quadrupling prices to levels that were making the auction of modern prints an extremely profitable business and the development of proper house expertise and sophistication to handle the increasing high-priced volume responsibly became essential. After training with Sotheby's in London for two years, Marc Rosen (Fig. 10-D) joined the firm in 1967, shortly before the firm began opening up the rear section of its salesroom regularly to accommodate the large crowds at print sales. Within a few years he had developed enough connoisseurship and experience to analyse impressions with great

c Rosen, head of the Prints Department at Sotheby Parke Bernet New York, examines an ression of the etching by Rembrandt, "The Three Trees" (B. 212), in his office. It later for $35,000. (COURTESY OF SOTHEBY PARKE BERNET INC.) Fig. 10-D

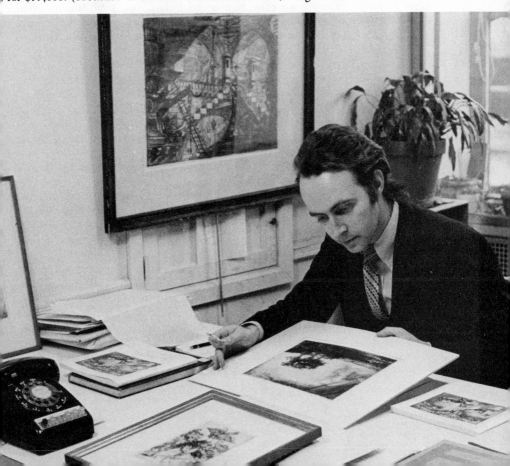

accuracy and enough sense of commitment to Sotheby Parke Bernet's less sophisticated bidding clientele to reveal his findings with great fidelity in his sales catalogs. They are first-rate. It is Rosen who, with the aid of certain dealers and *amateurs*, identified and publicized the manufacture of forgeries of Matisse lithographs and other prints in late 1970, and he has spotted and reported on a number of other spurious prints subsequently.

Rosen assumed auctioneering duties in early 1970, about the time some Americans began to tread PB's pile floors in jeans, and now feels very much at ease attempting a few witticisms from the lectern, dryly spoken. In characteristic PB style, he is assisted by a battery of aides: spotters in brown SPB livery, print department assistants, a representative from the bids and sales records department who jots down winners and winning bids and nods order bids to the auctioneer, a representative of the customer service department who bids for discreet clients, and assorted runners who carry tidings back and forth. Sales of illustrated books are assembled and conducted by the Book Department.

In New York the auctions are daytime affairs; in Los Angeles, where people live out their days in cars and at beaches and want to be entertained in the evening and on weekends, they are nighttime or Sunday social events. Both firms cater to a broad public, less sophisticated than the clientele of most of their European competitors. Rosen is the only print auctioneer who inserts a full-page glossary of terms in the front of his catalogs to explain to the lay public how prints are described.

SOTHEBY PARKE BERNET & Co., 34–35 New Bond Street, London W1A 2AA. Tel. 01-493-8080. New York office at Sotheby Parke Bernet, Inc.; other branch offices around the world. Chief print experts: Nancy Bialler (old masters) and Libby Howie (moderns). Marc Rosen of SPB New York supervises their work.

SOTHEBY'S BELGRAVIA, 19 Motcomb Street, London SW1X 8LB. Tel. 01-235 4311. Print expert: James Miller.

Sotheby's, which owns the two Sotheby Parke Bernet firms and the Amsterdam firm of Mak van Waay, is the largest art-auction organization in the world, with an annual worldwide turnover now well in excess of $200,000,000. Its sales of prints and illustrated books represent a relatively tiny portion of this volume. The London salesrooms (Fig. 10-E) account for "only" several million dollars' worth of prints annually.

The print sales at the New Bond Street headquarters and at Belgravia, somewhat to the southwest, are assembled and managed autonomously. With its arch-rival, Christie's, Sotheby's of New Bond Street constitutes the principal world marketplace for the auction of old master prints, though they each handle modern European prints and high-quality contemporary British graphics as well. Sotheby's Belgravia, near Belgrave Square, has jurisdiction over all Victoriana and Edwardiana—all English

Sale at Sotheby's." Watercolor by Thomas Rowlandson. (COURTESY OF SOTHEBY PARKE ɴET INC.) Fig. 10-E

prints from 1830 to 1925—including, to the chagrin of the Bond Street staff, the much-prized Whistlers. Both Sotheby salesrooms issue carefully drawn catalogs replete with the work product of a cautious, highly qualified staff.

 CHRISTIE, MANSON & WOODS LTD., 8 King Street, St. James's, London SW1Y 6QT. Tel. 01-839 9060. Chief print expert: Noël Annesley.

 CHRISTIE'S NEW YORK, 502 Park Avenue, New York, N.Y. 10022. Tel. (212) 826-2888. Chief print expert: Nick Stogdon.

 James Christie founded this firm in 1766, ten years before the American Revolution. It now has annual worldwide sales well over $100,000,000 and competes with its London neighbor for most of the world's art auction business. Christie's sold oversubscribed stock to the public in late 1973 to raise additional capital and is therefore the only art auction firm in the world that must answer to public stockholders; yet its directors maintain an impenetrable 63 percent controlling interest. To woo consignors away from Sotheby's, Christie's offers the lowest sales commission rates of any auction firm in the world (6 percent and less for trade consignors); to woo bidders, its skilled staff bends over backward to be careful and scrupulous about catalog descriptions.

 Christie's still exudes the grandeur and *politesse* that made it a favorite rendezvous for society for centuries. It has always been especially proud of its elegant skylit Great Rooms, once the privileged domain of the carriage trade in the Age of Elegance. Noël Annesley (Fig. 10-F) conducts with imperturbable British reserve about seven sales there each year (about 2,000 lots of prints) before a respectful, largely professional audi-

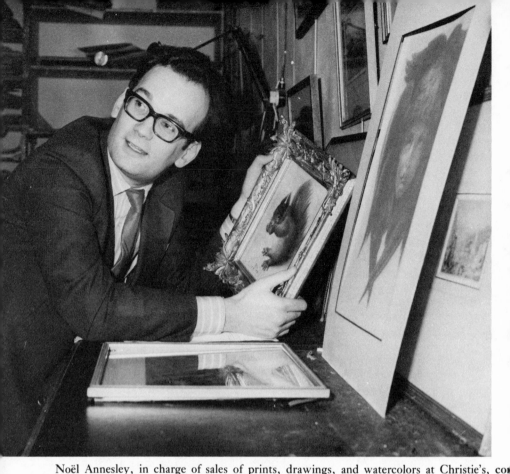

Noël Annesley, in charge of sales of prints, drawings, and watercolors at Christie's, com menting on a 16th-century watercolor. (COURTESY OF CHRISTIE, MANSON & WOODS; PHOTO DESMOND O'NEILL) Fig. 10-F

ence. Christie's commenced auctioneering in New York in 1977, importing Nick Stogdon to contribute his diligence and circumspection to offerings of modern prints.

DR. ERNST HAUSWEDELL & ERNST NOLTE, Pöseldorfer Weg 1, 2000 Hamburg 13. Tel. (040)44 83 66 and 4 10 36 22. Chief print expert: Ernst Nolte. Books expert: Dr. Ernst Hauswedell.

When Ernst Nolte became Dr. Ernst Hauswedell's copartner in 1970 (Fig. 10-G), he aggressively set about building up the firm, which had been established in 1927, to equality with Eberhard Kornfeld's. Within a few years Nolte had doubled the weight of the annual June catalogs (they now list some 2,500 lots of established old master and modern art, mostly prints and drawings of above-average quality) and became Germany's leading auctioneer of modern—especially modern *German*—art. Nolte, who is often wrongly accused of being Hauswedell's son, became the sole general partner (*Komplementär*) in 1973. Young, ambitious, bright, self-assured, he conducts the firm's business, as well as its early June sales, with brisk efficiency. It is symbolic of Nolte's conscien-

tiousness that where Hauswedell preferred to publish unrealistically low estimates to lure people to the sales, Nolte strives for accuracy. A consignor has a strong ally in Nolte; he is an exceptionally skillful auctioneer, with an uncanny sense of what rhythm, voice, and gesture will elicit another bid.

He sprinkles his coated-paper catalogs with hundreds of black-and-white and color illustrations and lards the entries with the perceptions, observations, and opinions typical of the German approach to cataloguing. The crowd that his sales now attract forced them out of the ample Hauswedell-Nolte Haus in the charming Pöseldorf sector of Hamburg on the western shore of the Alster, where many other art galleries congregate, into a large hall downtown. The sales have become a three-day bivouac for Nolte's mostly American, German, and Swiss visitors (there are few pieces to entice the French or English), and Nolte awards their patience and constancy, Kornfeld style, with a splendid banquet the evening before the final sale.

Like many other German and Swiss auction firms that are family businesses and not companies managed by a board of directors, Hauswedell & Nolte is also an *antiquariat*, an establishment that sells art and rare books retail. As an *antiquariat*, the firm accumulates, privately and at other auctions, a small amount of stock which it offers to the public as principal, and it inserts about 100 house-owned items (unidentified) into its auction catalogs each year. The firm also stages auctions of books, a field that remains the special concern of Dr. Hauswedell, who lingers in Hauswedell & Nolte as limited partner (*Kommanditist*).

st Nolte signals a bid during a June sale in Hamburg. Dr. Ernst Hauswedell sits to his t. (COURTESY OF DR. ERNST HAUSWEDELL & ERNST NOLTE) Fig. 10-G

KARL U. FABER, Amiraplatz 3, 8 München 2. Tel. (089)
22 865 66. Chief print expert: Louis Karl.

HARTUNG & KARL, Karolinenplatz 5a, 8 München 2. Tel.
(089) 28 40 34. Expert (in decorative prints and illustrated books): Karl
Hartung.
Until they moved to more spacious quarters in 1976, auctions at Karl
u. Faber took place late each May and November directly across from
the firm's home on Karolinenplatz in a huge stone mausoleum, around
the corner, appropriately enough, from the building that houses Mu-
nich's Graphische Sammlung. Sales at Hartung & Karl took place at
Karolinenplatz 5a itself.
Art historian George Karl and specialist in German literature Curt von
Faber du Faur organized their first auction—a sale of German baroque
literature—in 1927, the same year the predecessor to Hauswedell &
Nolte held theirs. In 1931, von Faber left Munich to become a resident
scholar of German baroque literature at Yale University in New Haven,
and left it to his partner to expand auction coverage during the 1930's to
art of all descriptions, swell the reputation of the house of Karl u. Faber
to international fame and guide it through the lean years of World War
II and postwar regeneration. George Karl's son, Louis, born in 1942 and
his father's junior by a half-century, today owns 51 percent of Karl u.
Faber, which specializes in the auction of old master prints and drawings
and modern (noncontemporary) prints, drawings, and watercolors. Louis
Karl has a minority interest in the kindred auction firm, Hartung &
Karl, managed by the experienced bibliophile, Karl Hartung, which spe-
cializes in decorative graphics, illustrated books, art books, and other lit-
erature.
Louis Karl (Fig. 10-H) is a sober, amiable Municher who despite his
youth brings many years of auctioneering experience to bear rounding
up, in the face of great competition from his German and Swiss col-
leagues, some 3,000 works of art each year. He personally tours the
United States twice each year to ferret out properties to sell in Munich;
the firm is strictly an auction firm and owns none of the properties sold.
Like most other auctioneers, Karl is compelled to take some things "we
don't like" to secure good material, but his conservative training and
taste will not admit very many post-1960 graphics to Karl u. Faber's
block. Like Wolfgang Ketterer's, Karl's schooling was in the field; though
he attended the university for a short while, he worked with his father
throughout the 1960's, except for a year with Kornfeld. ("One does not
become an expert art dealer and auctioneer by studying whether a hand
is better *this* way or *that* way," he advises.) In accordance with his taste
in art—quiet and classical old masters and moderns—Louis Karl is taci-
turn on the rostrum, conducting sales with more British sobriety than
Bavarian zest. His serious, responsible approach to his auctioneering

is Karl consults his "book" during a sale at Karl u. Faber in Munich. (COURTESY OF KARL ₣ABER) Fig. 10-H

duties has helped sustain the position of Karl u. Faber as one of the leading European firms for the auction of old master prints.

GALERIE WOLFGANG KETTERER, Prinzregentenstrasse 60, 8 München 80, Villa Stuck. Tel. (089) 47 20 83. Chief print expert: Wolfgang Ketterer.

The sales of modern art at Wolfgang Ketterer's two-story wing in the lordly Villa Stuck on the eastern bank of the Isar in Munich traditionally follow those at Karl u. Faber on the other side of town each spring and fall. Sales of *Jugendstil* (Art Nouveau and Deco) artworks precede these auctions by several weeks.

The flavor of the auction material and the ambience of the sales, however, are markedly different. Though both Karl and Ketterer accept late 19th- and 20th-century works by artists with international reputations, Ketterer, like Ernst Nolte, accepts hundreds of recent graphic publications by American and British modernists, good Art Nouveau and Art Deco posters and prints, as well as works by German artists whose celebrity is currently confined to Germany. In May 1974, Ketterer was brash enough to attempt a catalog devoted entirely to contemporary American art (this, in provincial, conservative Munich); when 108 of the

Auctioneer, publisher, and dealer Wolfgang Ketterer and artist Horst Janssen share the space in a Munich exhibition poster by Janssen. Lithograph, 1966. 630 x 445 mm; 24¹³/₁₆″ x 17½″. (COURTESY OF GALERIE WOLFGANG KETTERER) Fig. 10-I

194 lots were bought in (not sold), he dared again, inserting them, albeit at lower reserves, in his November sale—again without great success.

Ketterer's doggedness in attempting to create an instant auction market for American contemporary prints, even though Munich may have been the wrong place and 1974 the wrong time, is very much in character. He is a self-made man, resolute, high-spirited, and outspoken like his Swabian forebears. Deprived of a formal advanced education by economic and political circumstances (he entered the army as an apprentice ironmonger in 1939), Ketterer is convinced that brains are no substitute for endeavor, hard work, experience, and a natural affinity for one's vocation.

Ketterer has been an intrepid art dealer, print publisher, and auctioneer for decades (Fig. 10-I). In 1947, after several years of internment as an Allied prisoner of war, he assisted his older brother in helping revive international interest in German Expressionism through the auction and gallery activities of the now defunct Stuttgarter Kunstkabinett. The brothers split up in 1954, when Wolfgang Ketterer organized his own art gallery in Stuttgart. In 1965, he removed his business to the Stuck Villa quarters in Munich vacated by art dealer Günther Franke. During the 1960's and early 1970's Ketterer published hundreds of prints, including graphics by English artists Henry Moore, Barbara Hepworth, Reg Butler, Graham Sutherland, Allan Jones, and David Hockney, and mounted scores of retrospectives of unrecognized German artists and exhibitions of new talent, all accompanied by profusely illustrated and carefully documented catalogs. His semiannual stock catalogs get thicker year by year.

In 1968 Ketterer again became an auctioneer. Today he aggressively solicits for consignments and crams his ponderous catalogs, which are printed by his own print shop, with whatever modern art of value he can obtain (including some of his own stock, identified for bidders); the Ketterer auction is a useful repository for many insignificant and "reproductive" prints that are spurned by the other major firms. But there are many choice pieces mixed into the potpourri. Most people come anyway, Ketterer quips, blue eyes a-twinkle, "because we have the prettiest girls."

SECOND-LINE AUCTION HOUSES

PARIS STATE-CONTROLLED AUCTIONS. Paris lost its leadership in the art world in part because, while the art business boomed, the Paris auction market could attract neither the sales material nor the buyers. Procedures regulating the importation and consignment of artworks for sale at the government-controlled Hôtel Drouot and Palais Galliera auctions remain forbidding and unaccommodating, and consignment fees and taxes are noncompetitive with the commission rates of other Euro-

pean firms. The descriptions of lots for sale in the auction catalogs are insufficient and misleading. Since none of the sales are widely publicized (subscribers often receive their catalogs *after* the sale!), a small cabal of Paris dealers divides up the booty. Things have not changed much since New York dealer Herman Wechsler was warned in pre-World War II days by the Paris syndicate of print dealers that they would outbid him if he ventured to buy anything. "When I don't go to Paris, prices are low, and if I do go, prices are high," commented Frederick Mulder when he was in charge of modern prints at Colnaghi's. "Something's surely going on there." Most of the auctions in Paris take place in the immense Hôtel Drouot on rue Drouot and the gare d'Orsay on the Left Bank. They are organized by firms of *commissaires-priseurs* who engage *experts*—interested Paris dealers—to expertize the material and write the brief catalogs. The principal *commissaire-priseur* holding sales of prints, from old master through modern, is Adar Picard Tajan, 12, rue Favart, 15002 Paris. Tel. 742-68-23. Catalogs for all sales may be ordered through the Compagnie des Commissaires-Priseurs de Paris, 6, rue Rossini, 75009 Paris, and the results of sales are published in *la Gazette de l'Hôtel Drouot*, 37, rue La Fayette, 75009 Paris.

GALERIE GERDA BASSENGE, Erdener Strasse 5A, 1 Berlin 33. Tel. (030) 886 19 32 and 885 29 09. Sale of modern and old master prints each spring and fall. Useful catalogs.

KUNSTVEILINGEN MAK VAN WAAY B.V. Rokin 102, Amsterdam, Netherlands. Tel. 24 62 15 and 16. Sporadic sales of old master and modern prints, especially Dutch ones. The firm is a member of the Sotheby Parke Bernet group.

GALERIE KOLLER, Rämistrasse 8, 8001 Zurich, Switzerland. Tel. (01) 47 50 40. Sale of modern prints each spring and fall. Useful catalogs.

ARNO WINTERBERG, Blümenstrasse 15, D-6900 Heidelberg 1, Germany. Tel. (06221) 2 26 31. Sale of a substantial quantity of prints in the spring.

KUNSTHAUS LEMPERTZ, Neumarkt 3, 5 Köln 1, West Germany. Tel. (0221) 21 02 51. Sale of modern prints each spring and fall. Neither the Lempertz catalogs nor the representations of its American agent, E. M. Werner, should be relied upon, for defects in condition and quality are not accurately disclosed.

DOROTHEUM-KUNSTABTEILUNG (Austrian state-controlled auction house), Dorotheergasse 11, Wien (Vienna) 1, Austria. Write Postfach 528, A-1011 Wien. Tel. 52 31 29 and 52 79 78. Four major art sales and six minor ones throughout the year, old masters and moderns.

Dr. Helmut Tenner, Bahnhofstrasse 63, 69 Heidelberg, Germany. Tel. (06221) 2 42 37. Auctions in spring and fall of old master and modern prints, as well as illustrated books.

Galerie Motte, 10, Quai Général Guisan, 1204 Geneva, Switzerland. Tel. (022) 21 01 51 and 52. Sporadic sales of modern prints.

THIRD-LINE AUCTION FIRMS

Swann Galleries, Inc., 104 East 25 Street, New York, N.Y. 10010. Tel. (212) 254-4710. A book auction firm which has sporadic sales of illustrated and art books.

Galerie Fischer, Haldenstrasse 19, 6000 Luzern, Switzerland. Tel. (041) 22 57 72 and 73. Old master and modern prints.

Plaza Art Galleries, Inc., 406 East 79 Street, New York, N.Y. 10021. Tel. (212) TR 9-1800. Sporadic sales of old master and modern prints. Checklists are unreliable.

Arne Bruun Rasmussen, Bredgade 33, DK-1260 Copenhagen K, Denmark. Tel. 01-13 6911. Art sales include modern prints.

Finarte (Istituto Finanziario per l'Arte), Piazzette M. Bossi, 4 (Administration), Via dei Bossi, 2 (showroom), 20121 Milan, Italy. Sporadic sales of old master and modern prints. Catalogs are unreliable.

Christian Rosset, 29 rue du Rhône, 1204 Geneva, Switzerland. Tel. (022) 25 82 75. Sales of modern prints.

F. Dörling, Neuer Wall 40, 2 Hamburg 36, Germany. Tel. (040) 36 46 70. Old master and modern prints.

Phillips Son and Neale, 7 Blenheim Street (New Bond Street), London W1Y OAS, U.K. Tel. 01-499 8541. Sporadic sales of mostly British prints.

Phillips (New York), 867 Madison Avenue and 525 E. 72 Street, New York, N.Y. 10021. Tel. (212) 734-8330. Commenced operations in 1977.

AB Stockholm Auktionswerk, Norrtullsgatan 6, Stockholm, Sweden (write Box 61 47, 102 33 Stockholm). Tel. Växel 34 07 20. Two auctions with prints yearly.

Félix Vallotton, "Le Poker." Woodcut, 1896 (V.-G. 170). 179 x 224 mm; 7^1/$_{16}$″ x 8^{13}/$_{16}$″. (COLLECTION OF THE AUTHOR)

Chapter Eleven

Prints as Investments

There is no one in the world who would seriously consider betting that a Chagall, Miró, Picasso, Dali, Rivera, or any other 'name' artist's work will go *down* in price.
—Excerpt from the Windsor Gallery brochure, *The Art of Investing in Art* (1974)

(W)ell-chosen prints, bought with a short purse as well as a long, are never likely to lose their value. . . .
—Excerpt from MURIAL CLAYTON, *The Print Collector* (London, 1929), published just before the collapse of the print market

The idea of art as an investment—as an appreciable asset—is abhorrent to some people who are occupied, or claim to be occupied, solely with the appreciation and enjoyment of art. Art historian Kenneth Clark, who has explained the role of art in Civilization to millions of readers and television viewers, has damned the flourishing art market in these terms:

> I hate the whole idea of art being turned into a kind of stock exchange or gambling parlor. I hate the whole thing; I won't go to an auction—one might as well go to a roulette or gambling house. I hate the whole idea of art becoming a form of stock-exchange investment.

Art scholars and critics who shun the marketplace are perhaps understandably upset by having what they consider in emotional and intellectual terms reduced to the footing of a barren investment. But the reluctance to discuss the investment potential of a work of art also extends to many art dealers, who claim to prefer a curatorial role to the execution of commercial transactions for profit.

The joker is that any purchase becomes, willy-nilly, an "investment." Many museum curators who begin their careers with a concern for esthetics and art history and a heartfelt desire to teach appreciation very quickly find themselves spending much of their time aggrandizing "their" collections through the receipt of gifts and open-market purchases and trades—activities that ideally demand constant evaluations of the

worth (and potential appreciation) of artworks ripe for deaccession and available for acquisition. So even the people professionally occupied with esthetics have monetary considerations unavoidably on the brain. "How do *I* know if our collection is successful?" responded one curator, revealing his principal preoccupation. "We never *sell* anything!" Art critics also are not unaware that one of the first questions to enter the mind of a naïve viewer dazzled by a masterpiece or a rich collection is, "How much is it *worth?*"; *The New York Times* critic reporting on the traveling loan of paintings from Leningrad's Hermitage cannot resist calculating their worth as "perhaps $30-million, if they can be assigned a value."

Art has been entering the marketplace for centuries—before it ever gets into a museum or in front of a scholar—as a purchasable commodity with intangible, fluctuating value, so that sooner or later anyone who thinks about possessing or relinquishing a work of art must also think about its price—and price in most cases must be weighed against possible resale value, the price of related works and possible appreciation in value. Most people who spend money on an item of enduring value hope it will turn out to be a good investment, even if it was not bought as an investment. Few of the print dealers who contend that they show the door to people who would like to talk about prints as investments are displeased when their own stock or private collection increases in value. Indeed, while advising customers to buy what they "like," irrespective of investment potential, many of them stash away ("warehouse" in the trade) editions as insurance policies and "age" inventory until prices have advanced enough to guarantee a healthy profit. The truth is that most prosperous dealers are uncomfortable discussing investment considerations because they cannot articulate the reasons for their success and prefer to keep back-office operations curtained off by art mystique.

The Print Boom of the 1960's and early 1970's accelerated the price of graphics with a ready market to levels Print People of the 1950's never imagined possible (Fig. 11-A). Prices doubled, on the whole, for prints sold at auction over the five-year period from 1961 to 1966. They soared during the late 1960's as the market became turbulent. They skyrocketed in the early 1970's. In 1972, the year that Ballantine Beer lost so much money it was sold to a competitor, an impression of Jasper Johns's Ballantine "Ale Cans," published in 1964, sold at auction in Los Angeles for $9,000. Price competition grew so fierce and bidding at auction reached such speculative levels that auctioneer Eberhard Kornfeld occasionally stopped the bidding and offered duplicate impressions to the high bidder and the underbidder at the same record price. All periods, schools, and varieties of graphics with few exceptions shared in the price frenzy, and dealers raced to discover and promote new talent and rediscover and resurrect neglected periods, minor schools, and forgotten printmakers. In a splendid lampoon of price movements during the Print Boom, publisher Rolf Schmücking of Braunschweig celebrated Dürer's birthday in 1971 by distributing a "limited edition" of 100 ten-DM banknotes (which bear

Dürer's engraved portrait), manually signed by artist Horst Antes and blindstamped by Galerie Schmücking—for a "pre-pub" price of 9 deutsche marks, to increase to 11 deutsche marks shortly after "publication." In that same year the Japanese with new yens for Western art began buying prints the way the legendary 17th-century Dutch bought tulip bulbs and drove the prices of a number of Toulouse-Lautrec and Picasso prints up to and over the $100,000 mark.

The heady price spiral for prints of all kinds and ages was the consequence of the most explosive interaction of art and commerce that ever occurred in the history of capitalism: a whirlwind of esthetic value guaranteeing economic value which guaranteed esthetic appreciation which guaranteed esthetic value, presumably ad infinitum. Art being one of those peculiar commodities whose desirability increases directly with its value (how many more people coveted a Picasso when it cost thousands rather than hundreds!), the effervescence of the market in turn helped catalyze fresh demand and caused further price boosts. For a time the upward spiral took on the characteristics of a self-fulfilling prophecy.

By the late 1960's prints were being talked about as the best of all possible investments. The popular press, art critics, and the segment of the trade that touts prints for investment duly reported the price advances with comparative price tables that showed spectacular leaps without setback (a 3600 percent increase for Rembrandt etchings versus 3100 percent for Dürer engravings, and so forth), with graphs whose lines never curved downward, and with the computation of the number of dollars per square inch forked over for one tiny Rembrandt etching. The *London Sunday Telegraph* printed a chart showing that the general price level of old master prints rose 4,500 percent during the third quarter of this century, against a mere 2,500 percent for Impressionist paintings. Financial writers reported on the "bull market" in prints and covered etchings and

)ert Watts, etching 1962, from *America Discovered* portfolio (Vol. 5 of *The International nt-Garde* series). This etching was a harbinger of the boom in print prices during the 0's. (COLLECTION OF THE AUTHOR) Fig. 11-A

lithographs in space that would otherwise have been devoted to clever new investment vehicles like offshore investment trusts and commodity options. *Business Week* wrote how "graphics can fit anybody's budget"; the folksy financial columnist of the *New York Post*, who normally advises widows and orphans about stocks and bonds, counseled that a well-selected purchase of etchings and engravings might "come out far better" than a portfolio of more familiar kinds of investments; and during the 1970's the man who annually tallies the investment winners for *Barron's* consistently gave prints high marks: in 1971 "etchings" were tops, "with an unexpected advance of at least 400 percent above 1972 prices." At the invitation of the inquiring reporters, printsellers and auctioneers joined the poker game, playing dealer's choice in response to queries from the media; New York dealers such as Sylvan Cole, Leo Castelli, and Dorothy Carus naturally picked what they sold, while auctioneer Marc Rosen of Sotheby Parke Bernet remained diplomatically noncommittal. And while the reporters and columnists and dealers recited all the proper admonishments about condition, quality, printseller's reputation, changeability of taste, speculation, the danger of oversupply, and other risks, the message somehow came through that there was no trick at all to taking a plunge with a Picasso lithograph or a Hopper etching.

When prints became "sure things" and "high flyers," in Wall Street vernacular, and transactions in prints became short-term capital gains, Wall Street, whose interest in graphics had theretofore been limited to the appreciation of the engravings on stock certificates, romanced and embraced the print market. (Publisher Robert Feldman returned the compliment by setting the advertisement of his 1971 Parasol Press portfolio of Wayne Thiebaud prints in the format of the traditional Wall Street securities offering "tombstone": "Price $3,000 plus accrued interest") (Fig. 11-B). The unpredictability and sharp decline of the stock markets in the late 1960's impelled a flight of capital in frantic quest for safer and more profitable investment havens. Investors who did not care to become art experts themselves or to reflect why art investment companies cannot perform like mutual funds were offered chances to cash in on the boom without owning a picture, just as speculators bought pork-belly futures without ever seeing the pigs. They could purchase interests in public investment companies that offered, in Wall Street lingo, "capital growth through speculative investment in works of fine art and trading art for profit." The insider advisers hired by these companies would, one Wall Street underwriter intimated, take investors "where the hot money is going." Investors who could not sense that an art business would be ruined if compelled to make untimely sales by pressure to realize short-term profits, were sold shares in companies that merchandized prints, such as Nabis Fine Arts and Reflections Gallery of Atlanta. Most of these companies eventually went out of business.

The sight of all those fast bucks proved irresistible to fast-buck operators and opportunists, who during the 1970's preyed upon gullible newlyweds and inexperienced "beginning collectors" with titillating invest-

NEW ISSUE FEBRUARY 1, 1971

50 PORTFOLIOS

Wayne Thiebaud I

5 ORIGINAL LINOCUTS–3 ORIGINAL SILKSCREENS
EDITION OF 50

Price $3,000
Plus accrued interest

Copies of the Prospectus may be obtained from the undersigned.

 PARASOL PRESS, LTD. 48 EAST 86th STREET, NEW YORK CITY, N.Y. 10028 DIAL 212-988-6870

We maintain future markets in the following preferreds:

ANSEL ADAMS • ILYA BOLOTOWSKY

CHUCK CLOSE • RICHARD ESTES

SOL LEWITT • PAUL MANSOUROFF • BRICE MARDEN

DON NICE • WAYNE THIEBAUD

 PARASOL PRESS, LTD. 48 EAST 86th STREET, NEW YORK CITY, N.Y. 10028 DIAL 212-988-6870

Parasol Press advertisement in the form of a Wall Street "tombstone," 1971. Fig. 11-B

ment representations, the language of expertise and art mystique. They tendered "limited editions" of decorative, worthless stuff; unlimited restrikes; and outrageously overpriced Salvador Dalis, Picassos, Mirós, Chagalls, or Calders with a "built-in rarity which creates investment value" (Circle Gallery), "that can increase dramatically in value as time goes by" (Macmillan Original Prints), that "almost invariably appreciate in value—*when chosen by experts*" (Original Print Collectors Group), or that "more than meet the criteria required of them to be recognized as a *rare* work of art, fully substantiated when you relate a potential market of 300,000,000 (a conservative 7½% of the total population), to a limited edition of 300 for a one-in-a-million rarity rating" (Windsor Gallery, Los

Angeles) (Fig. 11-C). No "downside" risk, either! "There is no one in the world who would seriously consider betting that a Chagall, Miró, Picasso, Dali, Rivera, or any other 'name' artists' work will go *down* in price," assured the Windsor Gallery's free handout, *The Art of Investing in Art*, written by some "Professor Frederick Sauls," no less. Such literature exuded the smooth, persuasive spiel of the snake-oil peddler. It was larded with true-life tales of 400 to 3000 percent increments in value, sweet talk about the pitchman's own acumen about prints as investments, and pretentious, smug explanations of esoteric graphic reproductive processes and "originality" in prints—all for the purpose of selling mostly tasteless unknowns with no resale value and big names with a fair market value of half the sticker price or less to dupes who wanted to get in on the Print Boom. If such promotions made respectable Print People wail and gnash their teeth, they were everyday fare for the ad men who ran them. "People like to know that something they buy is worth it," offered Harold Longman, Macmillan & Co. Executive Vice-President, as justification for his Macmillan Original Prints salespitch.

What's past is prologue, said the Bard of Avon, and all the speculation, hurly-burly, price talk, and sharp practices seemed reminiscent of the mentality that developed during the first decades of this century, when according to one 1910 account, "The world that cares at all for art has become strangely and creditably occupied with original prints." British mezzotints and stipple engravings that no one cares much about today cost thousand of dollars in the teens and twenties, up from their price of a few shillings in the nineties. Reporting that "Wheatley's *Cries*, a set of thirteen prints in colour, have fetched as much as £1,000," the etcher Seymour Haden carped, "Surely all the fools of London must have been bidding against each other." Etchers such as the Swedish Anders Zorn were lionized in terms that today would seem comical if they were not so sobering. In 1911, one rapturous critic crowed, "Zorn

The shop window of a New York graphics mart touts relatively worthless or overpriced merchandise as superb investments with the help of a 1974 *New York Times* feature article. (PHOTO BY THE AUTHOR) Fig. 11-C

stands not only unsurpassed, but unequaled. In the whole range of etching, during the four centuries that stretch from the time of Albrecht Dürer to our own, no one, not even Rembrandt, can approach Zorn." In 1929 first-state proofs of the etchings of James McBey, Sir D. Y. Cameron, Muirhead Bone, Frank Benson, Sir Frank Short, and Frank Brangwyn, the "Scottish School" etchers, brought up to 1,500 1910 dollars: prints that could have been secured during World War I for as little as 10 dollars. New Muirhead Bones were presubscribed at 100 1929 dollars apiece, and in 1929 Cameron's "Five Sisters, York" received the highest price paid for a contemporary etching until the late 1950's—£650. A collection of Whistler etchings amassed by one collector at the turn of the century for an average cost of $20 per proof was sold at public auction in 1913 for $52,000. By 1929, Keppel's and Knoedler's in New York were speculatively pricing the most coveted Whistler etchings at $2,000–3,000.

That print boom peaked when the stock market crashed. Whistler price levels fell 90 percent during the Depression, and 1929 prices were not seen again for another 40 years. The Scottish School sang Auld Lang Syne around 1937, though the current Print Boom has given some of them a new lease on life. In her book, *The Print Collector*, published in 1929 when everything looked rosy, curator Murial Clayton wrote, "It may be said that well-chosen prints, bought with a short purse as well as a long, are never likely to lose their value, if only because the world's supply is limited, and prints are becoming more and more absorbed finally in public galleries and institutions." A comparison of contrasting opinions expressed by two journalists in 1929 is also instructive. First, an article appearing in a November 1929 issue of the art-community organ, *Art News*, under the title "Art as an Investment":

> With the bears running rampant on Wall Street, it must be a comforting thought to collectors that the works which they prize for aesthetic reasons have maintained or increased their monetary value during this time of stress. . . . Today the investments made ten years ago have doubled or trebled in value. . . . We believe that the same conditions and the same possibilities obtain today.

Earlier, on September 28, 1929, the *New York Sun* had reported more apochryphally:

> At the moment there are certain classes of prints which are the vogue, and the value of these is consequently soaring. . . . partly owing to the American demand. . . . the works of Scots etchers, such as McBey, Cameron and others, has caused many of their prints, published at three and four guineas, to realize as many hundreds. That the demand for sporting prints will continue and their value steadily increase is a fairly safe prophecy; but the same cannot be said regarding modern etchings, much of the value of which is artificial.

Pretty sobering stuff, even if there are valid distinctions between the earlier boom and today's Boom (for openers, British mezzotints and Scottish

School etchings were not made by major painters breaking new stylistic ground).

Traditionally, most of the capital that flows into the art market is surplus capital from business and the professions, luxury capital for dissipation on objects of intangible value. Yet while art is a classically postponable purchase, collectors' spending habits for art, like gasoline usage, remain *relatively* inelastic; during brief periods of economic stress, demand will not substantially deteriorate. During the period of severe recession from 1974 to 1976, the demand for art did slacken somewhat. Private art buyers in America and Europe became skittish and realigned priorities as production cutbacks increased, business expansion slowed, real income declined, economic controls materialized, a few banks tottered, and prognostications of worse to come multiplied. Institutions had less money to spend, for the stock market slump had diluted the value of their investment portfolios and many companies had reduced their dividends. Dealers, a class that normally supports the art market by adding to inventory, became more selective and bought less as their sales fell off.

Prices softened during the recession in response to the fall-off in demand, especially the prices of contemporary prints whose investment strength had not theretofore been tested and the prices of prints which had been the targets of the investment invasion of the print market, such as the high-flying Picassos and Toulouse-Lautrecs. In 1971, New York dealer-publisher Brooke Alexander had warned about "the danger that too many prints offered at one time could glut the market, especially when the quality is not carefully watched." The drop in the demand for prints during 1974–75 made the extent of the supply of contemporary graphics more visible, and it became more apparent that the "inevitably increasing" scarcity of an individual print was less significant for its investment value than the availability of images of similar visual appeal, quality, and condition by the same artist, or indeed, by all artists of similar style and period. Fine, rare impressions of old master prints with a secure place in art history naturally displayed more resistance to the turning of the market, just as they had during the Great Depression. On the whole, in fact, prices of prints of investment quality, excluding those that had been chased by speculators, remained remarkably firm during the recession of 1974–76, and new record prices began to materialize in the fall of 1975. In its most severe test since the Great Depression, the print market demonstrated a very reassuring resiliency.

ARE PRINTS GOOD INVESTMENTS?

The construction, interpretation, and use of "past performance" charts as tools for prognosticating the future price trends of prints are subject to so many variables and imponderables—reconciling disparities of quality

and condition among impressions sold, among many others—that such a display would serve no purpose here other than sensationalism. An in-depth study of the methodology and utility of such charts, of a kind that has produced dozens of books and hundreds of devotees in the securities and commodities fields, may indeed be worthwhile, but it is beyond the scope of this book. What anyone who considers investing in prints, either directly or indirectly through participation in a dealership or some investment fund or trust, should be aware of are the variables and imponderables that may make some purchases more auspicious than others (Fig. 11-D) and the advantages and disadvantages of prints relative to other modes of investment, and it is these considerations that are reviewed in this chapter.

The heightened interest in prints as investment vehicles resulted, in part, from a widespread distrust in Europe and America of the more conventional sorts of growth investments: stocks, real estate, foreign exchange, and gold. It is probably true that one could have thrown darts at a board composed of 100 old master and 100 modern artist-printmakers in 1970 and come out better than almost every New York

ter Van der Heyden, *after* Peter Brueghel the Elder, "Le Combat des Tirelires et des ffres-Forts" ("The Battle of the Moneybags and Strongboxes"). Engraving, 1567 (B. 146; Leb. . 236 x 304 mm; 9⁵/₁₆" x 12". Brueghel (on one level) depicts the struggle between the small estor and the tycoon. Fig. 11-D

Stock Exchange listing in 1975. Weakness in the American securities markets during a period of severe inflation and rising prices for art exploded the myth that growth stocks were good hedges against inflation and confirmed the belief that works of art were better ones. Doldrums in the stock market, a traditional repository for fluid capital, have in fact normally benefitted the art market, since the art market is one alternative place where large amounts of sophisticated flight capital may find secure values with a good chance for capital gains. Art also seems a desirable resting place for investment capital when high interest rates and high taxes make real estate a precarious investment; there are normally no property taxes leveled on holdings of art. Moreover, people worried or intimidated by the severe, unpredictable fluctuations in the commodities, precious metals, and foreign exchange markets have found the art market a relatively quieter investment haven, with more durable values.

Art, like gold, is an international unit of account that can also offer protection against currency devaluation. An investment in art with an international market, that is, becomes an investment in, among other things, the United States dollar, the West German deutsche mark, the Swiss franc, the French franc, and the British pound—all at the same time! In other words, in part as the result of the ability of impressions of a print to experience frequent sales in different countries, its current monetary value will always be expressed in the strongest currency among the currencies of those nations that offer it a hospitable market. The value of a print that is marketable in many countries will tend to rise (in terms of currencies) to reflect the buying advantage momentarily enjoyed by nationals of the nations whose currencies are strongest. The owner of a print whose national currency is weakening relative to other major currencies will therefore enjoy a rise in its value (in terms of such currency) if foreign demand remains constant. Thus Americans holding prints marketable in Germany and Switzerland during the years 1973–75 enjoyed an appreciation of up to 70 percent of their value from currency reevaluation alone; as deutsche marks and Swiss francs grew more valuable in dollar terms, so did art marketable in Germany and Switzerland. The debasement of a currency of one country will concommitantly give the holders of a strong currency of a second country a buying advantage *in* that first country, while at the same time the holders of art in the second country may experience some erosion of values as buyers native to the first country encounter rising prices in their country (in terms of their debased currency) and resist paying them. For example, while the British pound weakened sharply against the United States dollar during 1975–76, American buyers could find "bargains" in London; yet American investors and sellers found the London market a difficult place to obtain full values (in dollar terms) because, although Britishers might have been willing to pay the same amounts of pounds, the pounds were worth fewer dollars.

Prints themselves offer certain advantages over other art media as in-

vestments. They have somewhat greater liquidity than paintings and sculpture, since they are more portable and easily storable, are transportable for less cost, and trade more frequently at auction and in galleries. A print is also a commodity whose increasing scarcity in the marketplace is, with few exceptions, assured (albeit in greatly varying degrees) by steady institutional purchases, private withholding, loss and damage of other impressions, though the relative scarcity of any impression at any one point in time must be weighed against the supply of other images flowing into the market that compete for the same acquisition funds.

What, then, are the problems in buying and holding prints as investments? The chief disability a potential investor may suffer is a lack of expertise, market lore, and self-discipline. Few people who would like to trade and invest in prints possess sufficient ability to recognize and correctly assess the economic, social, and psychological factors that determine the proper timing of transactions and the factors of qualitative value that make one proof a more advisable purchase than another. A number of print dealers have themselves become insolvent because they lacked the market sense to make astute purchases, a good working understanding of the factors of value and the emotional self-control to make cerebral rather than sentimental decisions in the marketplace. Buying prints for profit demands very specialized knowledge, good connoisseurship, pervasive knowledge of the marketplace, and constant observation of and involvement in worldwide art market activities. Many people assume that by vying with the experts in the auction arena they will always come out paying fair market value, but an auction purchase is not always a free market transaction, as explained in Chapter 7.

Skills, know-how, and experience, if lacking, can be bought. There are a few good dealers and art traders who have organized investment companies. These enterprises are set up and operated much like mutual funds; they are capitalized with cash contributions from participants, report growth or setback in terms of annual statements of net asset value, and compensate the expert adviser-manager with advisory and management fees calculated at a percentage of net asset value and/or gross profits. One operative in St. Louis who switched from organizing tax shelters to dealing in prints and running a print investment fund even hired business school students to chart prices to guide his management of "graphics portfolios" for investors. Successful print investment funds typically strive for before-tax net income or unrealized earnings of from 20 to 30 percent per year. The problem is that, unbeknownst to their participants, many of the adviser-managers are hacks themselves; few bona fide print-market experts care to serve as investment counselors, preferring to earn profits for themselves and to encourage clients to buy for love and not for money. Even the expert adviser-managers must command a great deal of trust, for they have a constant conflict of interest between enriching the fund and keeping bargain purchases for themselves, while allocating overhasty purchases and "mistakes" to the fund.

Excellent advice about which prints should be acquired, not as securities, but as *art* (and probably a good investment as a consequence) is available free from any good dealer.

But the gratuitous, unsolicited advice that pours out of the art-for-investment promotions and print-of-the-month club brochures is always self-serving and misleading, and most financial journalists, naïve themselves, simply report what they think they heard some print expert say and dramatize the "killings" to be made in the print market even more unrealistically than the fast-buck operators.

Prints don't earn interest or pay dividends and are growth assets of limited liquidity and marketability, though auction sales take place fairly frequently. You cannot not sell prints short like stocks and commodity futures, and since few financial institutions are prepared to accept art as collateral (not to speak of graphics), an investment in prints cannot usually be financed by a secured loan. (New York print collector-investor Paul Schupf relates that when he solicited a bank loan for the purchase of Andy Warhol's *Marilyn Monroe* portfolio, his banker "thought that was so hysterical he loaned me the money immediately.") Unlike other paper investments, works of art on paper are subject to injury and deterioration that can reduce their monetary worth substantially, and they should be insured to preserve their value against damage, loss, and theft. Last, and most troublesome for the investor, is the problem of a profitable sale. Usually a sale can be made only through or to a dealer, who is interested in paying the seller as little as possible, or through an auction firm, which earns a commission and may not obtain the desired price. Even the multimillion dollar art syndicates, such as the Modarco (Modern Art Collection, S.A., a Panamanian company) fund and the Artemis art trading association sell their holdings through a small network of dealers that they "work with"—meaning that they forfeit 10 to 20 percent of the retail sales price to the dealer.

The consequence of limited marketability is a reasonable expectation that one must hold a print for long-term rather than short-term appreciation; though quick turnaround transactions are sometimes possible, any undue pressure for a premature disposition may well compel a sale at a loss. Anyone forced to liquidate a print at the wrong time or in the wrong place may sacrifice gains that might have materialized. An urgency to show short-term profits through in-and-out sales and the unremitting drain of management fees helped cause most of the art-investment companies and funds that were organized in the early 1970's to fail within a short period of time. Investing in art requires staying power.

ECONOMIC, SOCIAL, AND PSYCHO-LOGICAL FACTORS THAT CONTRIBUTE TO INVESTMENT POTENTIAL

PRICE AND PRICE HISTORY. It always helps to buy low. And one way to avoid the rapid depletion of a capital investment in prints is to avoid commitments near the top of a fastly rising, speculative market: Eschers during 1972–73, Mecksepers during the summer of 1974, Toulouse-Lautrecs immediately after the historic peaks reached at the Kornfeld auction in 1973, Picassos during or immediately after any speculative rise, the expensive serigraphs of Richard Estes in 1975. Speculative prices are vulnerable to precipitous setbacks. That is why cautious stock-market traders eschew the latest Wall Street fad and wait patiently for inevitable price reductions to provide buying opportunities and turn their attention elsewhere in the interim. Some of the biggest print dealers got badly burned speculating in Picasso *347 Series, Suite Vollard*, and other prints during the period 1969–71. As far as new issues are concerned, without publisher or dealer support and a sufficient continuing public interest to sustain price levels, an investment in a new graphic publication—even one bought at a "bargain" wholesale price—can be very risky. It is not unusual for a print sold for $500 one year to fail to attract any interest over $100 when it turns up at auction the following year, and most of the "limited edition graphics" foisted on an unsuspecting public by the fast-buck operators—what the trade knowingly terms, in today's vernacular, "rip-off prints"—are worthless, which means that they are unresalable to any merchant at any price and unconsignable for sale at auction.

TODAY'S VOGUE AND YESTERDAY'S FASHION. The buyer who cares at all about capital maintenance would be well advised to avoid the expensive vogue of the moment, even though it may, to be sure, become the *very* expensive immortal of tomorrow. The history of the economics of taste is replete with trendy "high flyers" who collapsed into disfavor when fashion changed: the English mezzotinters which cost thousands of dollars during the decades spanning the turn of the century, the Scottish etchers which cost thousands in the late 1920's, Bernard Buffet of recent memory. Very few high-priced contemporary prints will be high-priced in the year 2000, and very few will sustain or improve upon their retail price.

There is a formidable abundance of great prints on the market and coming onto the market that are not the stellar attractions of the day but have been undervalued in the rush for the superstars (see Fig. 11-E).

New York dealer David Keppel made the kind of astute observation in
1912 that still has relevancy today:

> At this time, when "The Toast" by Zorn has recently sold at auction for
> 10,000 francs, "The Five Sisters" by Cameron for £250 [by 1932 it was up
> to $3,000], and "The Great Gantry" by Muirhead Bone for 183 guineas, it
> is only reasonable to ask whether the prices for which Rembrandt etchings
> can still be obtained are not, in comparison, absurdly low. . . . Here are
> three etchers, working to-day, whose prints have brought prices higher
> than are asked for fine impressions of all but a few of Rembrandt's etch-
> ings.

Among old masters who have secure places in the annals of art history,
there are fine impressions of high-quality intaglios by Altdorfer, Van
Ostade, the Brueghel copyists, Canaletto, the Tiepolos, Blake, and Goya
still available for $250 to $750, while even the most mediocre of the au-
tographed monochromatic Picassos, Lautrecs, Munchs, and Chagalls
may sell for thousands.

The opposite of the deflatable, fashionable high flyers are the
"sleepers": the works of an artist whose time will come, or whose time
once came, then left and might come again. There are hundreds of artists
who created works good enough to engage the sensibilities of the shrewd
observers of their time which, while musty, are still meritorious. A.
Hyatt Mayor has written that his predecessor as Curator of Prints at the
Metropolitan Museum, William M. Ivins, Jr., "like a good lawyer, de-
pended upon the criterion of precedent, consulting past judges of prints
whose opinions had stood the test of time. Their taste might not be
today's, but if they had perceived like true connoisseurs, it might well
become tomorrow's. So if a print had been good enough for Pierre Jean
Mariette, Adam Bartsch, or the Goncourts, it was good enough for the
Metropolitan Museum." By such standards the graphic works of the
18th-century English mezzotinters (the portraits of ladies of fashion *after*
Reynolds, Gainsborough, Romney, and Hoppner); the 18th-century
French color *estampes gallantes*—many of which cost thousands of pounds
in the early decades of this century—the prints by the artists of the Bar-
bizon School; the intaglios of elegant ladies of the turn of the century by
the Paris printmakers Tissot, Helleu, Robbe, and Chahine; and the
works of Scottish etchers—Haden, Cameron, Bone, McBey, et al—may
be considered "undervalued" today, ready for reevaluation.

Then there are artists of enormous talent who have been unfairly
typed because they depicted subjects at one time considered inappro-
priate to "serious" art. It is not difficult, from this perspective, to imag-
ine an elevation of regard (i.e., an increase in market values) for the
prints of such "mere caricaturists" as the English Gillray, Hogarth, and
Rowlandson, the Flemish old master etchers Van Ostade, Bega, Teniers,
and Dusart, and even the great Daumier, as well as those of the fanciful
eroticists such as Klinger and Rops. The stylized Art Deco oeuvre of

Laboureur similarly demands greater appreciation outside Paris. The trick is to recognize undercollected works that by contemporary standards of taste and artistic excellence seem receptive to revival. The "rediscovery" of printmakers Piranesi, Duvet, Nesch, Escher, and Seligmann, to name just a few, has occurred in relatively recent years. Ever hear of Auguste Raffet or Arthur Segal or Robert Bevan?—to mention three almost unknowns who may be tomorrow's "rediscoveries."

GEOGRAPHICAL REACH OF THE MARKET. It is axiomatic that the prints of artists with an established international reputation have a wider market than those with a strictly local reputation. That is not to say that the purchase of works by an artist considered due or overdue to attract a more widespread following might not be a terrific investment, only that it might be a less marketable investment for a while because demand is quantitatively less. Local appreciation and chauvinism may indeed furnish adequate support; there is no market for Swiss views outside Central Europe or Currier & Ives lithographs outside America, but they have proven to be successful investments notwithstanding. However, the lack of any auction market for a print severely limits its marketability and consequently its investment potential.

ECONOMIC CLIMATE. A vigorous art market is a vigorous art-for-investment market. Though there are some economists who claim that people spend more for luxury items and pleasurables during hard times, a recession has a depressant effect on art prices since spendable cash decreases. The art market usually undergoes a healthy shake-down during a period of economic hardship in the West, but it also has demonstrated remarkable resiliency. Inflation and a bear stock market, conversely, generally have an uplifting effect on the prices of art. Sharp monetary exchange-rate fluctuations (devaluation and reevaluation) impel some people to seek refuge in art or gold as an international unit of account, and the resultant influx of buyers spurs prices upward also.

PUBLICITY AND CRITICAL ACCLAIM. Prices often increase in expectation of and during well-publicized and well-attended retrospectives of an artist or school staged by a museum or strong gallery, a spate of critical reevaluations of an artist or style, and concentrated coverage by the popular art press. Anticipation of such attention can prove fruitful. Favorable commentary by art critics and reviewers may operate cumulatively to stimulate appreciation of value, but favorable critical commentary must stretch over a long period of time to have any effect on prices. There are very few journalist-critics with the power to make or break an artist's reputation, though there are some scholars such as America's Clement Greenberg and Meyer Shapiro who have proven well worth listening to.

OPINIONS OF ART AND PRINT PEOPLE. The enthusiasm with which recognized dealers of taste, print curators, certain notable print collectors, and artist colleagues embrace and promote an artist's work can have a signal impact on market reception. The acquisition of a print or portfolio by Riva Castleman, Print Curator of the influential Museum of Modern Art, for instance, if publicized in print gallery promotional literature and especially if exhibited in the Museum itself, will give both the artist's creation and his name great publicity and influence other purchasers to follow her example (Fig. 11-E). Observing what the Print World's smart money is buying or socking away may also be productive. The people who followed P. & D. Colnaghi's and Harry Fischer's lead in buying German Expressionist prints in the early 1970's and Eberhard Kornfeld's decision to buy Lissitsky lithographs in 1972 have done very well, like the professionals. And the known support at auction by a well-capitalized dealer of a specific print or body of work may naturally reduce what stockbrokers call the "downside risk" of any similar commitment.

THE SIGNIFICANT SALE OF A SIZABLE COLLECTION. The sale by an auction firm of a large number of good quality impressions of

Arakawa, color lithograph with collage and silkscreen from *"No!" says the signified* portfolio 1974. 560 x 760 mm; 22″ x 30″. In 1975, the Museum of Modern Art in New York gave th six prints in this portfolio a special showing in its "new acquisition" alcove, promotin Arakawa's reputation and the prints' salability. (COURTESY OF MULTIPLES, INC.) Fig. 11-E

prints by any artist will often produce some record prices, since it serves as a minor retrospective and attracts everyone interested in purchasing the work. Auction history is in fact always written as a succession of sales of major collections. Buying in anticipation of such sales can often be profitable.

THE DEATH OF THE ARTIST. There are no useful studies on what effect the impending demise or death of an artist has on prices for his works. The maudlin popular belief is that death is good news for investors, whether it was expected or not. Stockbrokers tell us, however, that an anticipated event is always discounted by the market before it happens, so that the occurrence of the event is anticlimactic and depresses prices. During the trial of the "Matter of Mark Rothko, deceased," Marlborough Gallery owner Frank Lloyd went on record with the statement that "the death of an artist has nothing to do with the going-up of art prices. There are many records which prove exactly the opposite." Lloyd's opinion of course served his interest in the case, which he lost, but is what he said false? That is anybody's guess. There are so many variables.

FACTORS OF VALUE THAT CONTRIBUTE TO INVESTMENT POTENTIAL

The following factors of value make some prints more prized than others and some increase in value more rapidly than others:

THE IDENTITY OF THE ARTIST. Historically, great prints have been made by great artists whose reputations were established through their painting and/or sculpture as well as their prints. With some exceptions, the market for an artist's graphic works follows the market for his works in the "major" media, though prints themselves have sometimes popularized a reputation. The print prices of the major artists who were as seriously committed to printmaking as they were to painting—Dürer, Rembrandt, Goya, Toulouse-Lautrec, Munch, Picasso, and the German Expressionists—have rarely suffered any lasting, significant setback in the marketplace as the result of changes in taste and fashion in art, except when coerced by official state policy. It is likewise significant that there has been but a handful of artists not primarily painters or sculptors whose work in the graphic medium has over time enjoyed sustained or revived critical and popular appreciation: Old masters Van Meckenem, Robetta, Duvet, Piranesi, Callot, and his pupil, Della Bella, come to mind, as do the more modern Whistler, Meryon, Rops, Mucha, Laboureur, Kollwitz, and Escher.

RARITY AND THE EXTENT OF THE EDITION. Review Chapter 3. The recent price trends of some groups, such as old master etchings and German Expressionist woodcuts, have in great part simply been a function of their scarcity. The prices reached in 1967 at the Parke Bernet sale of Rembrandt etchings owned by G. W. Nowell-Usticke shocked no one more than the consignor himself, who found them "simply amazing." But a few years later, in the face of a rapidly diminishing supply of fine impressions, the price levels of Rembrandt etchings had tripled and quadrupled, *retrospectively* making Nowell-Usticke's sale seem premature. Dealers and collectors were paying tens of thousands of dollars in the early 1970's for proofs of Dürer engravings and Rembrandt etchings that would have cost a few thousand when they were much more common in the 1950's. Even the cognoscenti among them were repressing their traditional squeamishness over dull appearance, imperfect margins, thin spots, and tears to lay out thousands of dollars each for impressions of old master prints that would have been sold in lots just a few years before, and paper restorers engaged to double the value of damaged merchandise had more business than they could handle. Dilettantes paid $500 for late, worn-out impressions of Rembrandt etchings, which had been considered unworthy of framing ten years previously.

Most prints by German Expressionists—to take the other group—were pulled in small editions at a time when almost everyone in the world thought they were insane; many were destroyed during the years of Third Reich repression and holocaust; and the balance appearing on the market in the 1960's and 1970's became very, very valuable indeed. Typically, a Heckel "Franzi Liegend" which Kornfeld sold in 1964 for 2,300 Swiss francs ($500 then) in 1973 went for 52,000 deutsche marks ($24,000 then) at the 1973 Hauswedell auction. A Nolde "Kerzentänzerinnen" Kornfeld sold for 2200 Swiss francs in 1964 (also about $500 then) fetched 27,000 Swiss francs ($10,000) in 1974. And most of the Kirchner woodcuts that Kornfeld sold in 1964 are simply unobtainable at any price today.

SUBJECT MATTER. There is a wider demand for cheery pictures than for morbid ones, etc., etc.

ESTHETIC QUALITY. Some experts advise that the most expensive prints in an artist's graphic oeuvre, which are commonly illustrated and universally admired and whose place in art history is secure, are not only the safest but the best investments. The theory is that there are always customers eager to snap up the most distinguished works, but few collectors, dealers, and curators who are willing to mop up the junk. On the other hand, some people believe that inexpensive works will enjoy a rate of appreciation greater than that experienced by works that are relatively expensive to begin with. (The same people hold that, all

other things being equal, 10,000 shares of a one dollar stock is a better investment than 100 shares of a $100 stock.) No one has plotted the price increases over a period of time of relatively cheap, mediocre prints against expensive, key prints—say, Picassos under $1,000 against those over $10,000—to see which would come out with the best rate of increase, though such a study might prove very instructive to investors. There is, however, some evidence that the most expensive end of the print market got the biggest jolt during the recession of 1974–75, possibly because the investors and dealers who paid speculative prices for top pieces during the 1970's (in accordance with Rosen's view) withdrew to the sidelines when sales tapered off and free cash became short.

COLOR. Comparatively speaking, there is greater demand for color than for black and white. For example, prints in color by Toulouse-Lautrec, Munch, and Renoir, on the whole, are valued appreciably more than their monochromatic works. (People first attracted to color prints typically come to appreciate monochromatic art as their tastes mature.)

PROVENANCE. Who once owned an impression has greater significance, if any, for the value of an old master print than for a modern print.

SIZE. An imponderable. Huge contemporary prints are expensive to frame and difficult to transport and store, but some of the best prints of certain artists are their largest.

Other key factors that contribute to investment potential are discussed under "Autography of the Print" (review Chapter 1), "Presence of a Signature on a Modern Print" (review Chapter 2), "Comparative Quality and Condition" (review Chapter 5).

What it all boils down to is this: the well-advised purchase of a work of art will likely turn out to be a well-advised investment, too.

51.

Se repulen.

Francisco Goya y Lucientes, "Se repulen" ("They Spruce Themselves Up"), plate 51 from *Los Caprichos* ("*The Caprices*"). Etching, burnished aquatint and burin, 1799 (D. 88; H. 86, first edition). 210 x 150 mm; 8¼″ x 5¹⁵/₁₆″. (COURTESY OF SOTHEBY PARKE BERNET INC.)

Chapter Twelve

Preservation, Conservation, and Restoration

When it becomes dry, wet it again thoroughly;
and so on for several days if necessary, in the
same manner as you bleach linen; in which opera-
tion as well as in bleaching prints a hot sun is
best. . . . The foulness from flies may be gently
brushed off with a soft sponge, when the print is
thoroughly soaked. Spirit of sea salt much diluted
will get white wash off prints: take care not to
hold your nose over the vapour of the spirit. Do
not leave the prints on the grass-plot at night for
fear of worms.
—Excerpt from Boydell's recipe, 1807

Works of art on paper are extremely vulnerable and require special care and attention. Most paper can be damaged by atmospheric pollution, insufficient or overabundant humidity, inherent or neighboring acidity, and chemicals, light, mold, insects, and mishandling by humans. Much harm can be avoided by the application of proper safeguards. The best, most comprehensive, and most up-to-date book on the care and restoration of prints is Anne F. Clapp's short text, *Curatorial Care of Works of Art on Paper*, obtainable from The Intermuseum Laboratory, Allen Art Building, Oberlin, Ohio 44074. A less comprehensive though extremely helpful text is the booklet prepared by the conservators of the Boston Museum of Fine Arts, *How to Care for Works of Art on Paper*.

FACTORS INJURIOUS TO PAPER
Atmospheric Pollution

The air in our cities is full of smoke and dirt particles, ozone, and the oxides of sulfur, nitrogen, and carbon emitted by burning fuels. Dirty

air can streak and discolor exposed paper, and the acids, such as sulfuric acid, which form when the gaseous oxides come in contact with moisture, stain paper brown and break down its fiber structure. The airborne dirt and noxious gases easily penetrate the cracks and seams of unsealed Plexiglas boxes, contemporary frames composed of sandwiched sheets of glass or plastic, inadequately sealed traditional frames, and boxes and drawers where unframed prints are stored.

The ill effects of dirty air can be obviated or reduced. Filtering and washing outside air with an efficient air-conditioning unit can greatly improve the interior atmosphere. Sealing a print off from the air by framing it properly behind glass or a rigid plastic (Plexiglas or Abcite) or by storing it in a well-sealed, dustproof enclosure also insulates it from air pollution. To shield a framed print from the infiltration of gaseous pollutants and dust, the cracks between the backing board and its frame housing should be covered with a continuous strip of tape, preferably a gummed linen tape, and the back might be covered with acid-free wrapping paper or Permalife bond or a sheet of synthetic paper, plastic, or aluminum foil.

Relative Humidity and Temperature

Paper is hydroscopic. It swells in damp air and shrinks in dry air. Excessive humidity not only causes acid papers (most papers are acid papers) to be degraded by hydrolysis, but renders the paper vulnerable to the growth of mold. Excessive dryness makes paper brittle, so that its fibers can be injured when it is flexed. The "exercise" that paper undergoes when the humidity regularly fluctuates from one extreme to the other is also debilitating.

A stable relative humidity ranging from 40 to 60 percent is ideal for the welfare of paper, with the dryer air most inhospitable to the development of mold spores. (Mold will flourish and cause possibly irreversible spotting on paper exposed to prolonged relative humidities over 70 percent.) Prints should be kept out of damp places like basements and unventilated rooms and closets. Relative humidity normally changes inversely with changes in temperature; it increases as the temperature in the environment decreases, and vice versa. Thus the air touching a cold surface, such as the floor or an outside wall, will be more humid than the interior air of a room, and if the wall does not have a thermal barrier, water vapor may condense onto any frame hung against it. Because relative humidity varies inversely with temperature, it is inadvisable to stack matted prints directly on the floor or hang a print on any wall that may be subjected to rapid and frequent fluctuations in temperature, such as the wall space covering a chimney or hot-air duct or the area above a radiator. Heat itself causes paper to become brittle and accelerates the chemical and photochemical degradation of paper caused by excessive humidity, air and chemical pollution, light, and mold.

Paper in contact with glazing will take on the humidity level at the cold or warm surface of that glazing. Moisture can therefore condense on the surface of paper which is set against its glazing. A framed print should consequently be set back from its display glass or plastic by a sufficiently thick window mat or a narrow ragboard, or a ragboard-covered wood spacer or fillet inserted around the inside front circumference of the glazing between the glazing and the back mat. The buffer zone of air space that is required—the ply of the window mat board (one window can be recessed beneath another if necessary) or the thickness of the spacer—depends on the dimensions and weight of the print. It is advisable to keep in mind that Plexiglas can bow in response to changes in temperature, and large-scale prints tend to sag at their centers and may touch the glazing if the air spacing is not thick enough.

Acidity

Acidity on the paper itself or in material that touches or neighbors it can "burn" paper, that is, cause it to discolor (turn yellow or brown), become brittle, decompose, and easily crumble or split if handled. Acids break down the chains of cellulose molecules that make up the fibers which knit paper together.

Papers vary in their acid content and propensity to become acid. The rags that were employed for paper manufacture before the middle of the 19th century were largely acid-free, and, despite the gradual introduction after 1650 of acidic alum to harden animal size (size strengthens and hardens paper), the prevailing technology for centuries happily omitted impurities and admitted acid-buffering compounds that helped render most paper used for printmaking largely impervious to acid degradation. Such old papers have remained remarkably neutral over several centuries. The introduction of chlorine in the second half of the 18th century to bleach dirty rags resulted in weakened fibers impregnated with residual acidic chlorides. Resort to wood pulp and the general use of alum-rosin sizing for the machine production of inexpensive papers after 1860 or so has given us papers that are inherently unstable or extremely vulnerable to attack by neighboring acidic substances, especially if they are exposed to heat and moist air. Bleach residues, acid sizings and inks, impurities, such as those present in the noncellulosic part of unpurified wood pulp, and acid-generating metallic particles which get fixed in the paper fibers during the manufacturing process contribute to the general tendency of modern (post 1860) papers to become acidic, if left unprotected. It is a curious fact that notwithstanding the current state of knowledge about paper chemistry, few contemporary prints—and many are printed on expensive "art" papers—are as stable as Rembrandt's etchings. There has been little communication between printers and publishers on the one hand and chemists and conservators on the other; not many people today want to think about making paper that will last 300

years. Of course, apart from the inherent inclination of paper to *self-destruct*, it can assimilate acidity through prolonged contact with acidic substances such as certain mats and mounts, backing cardboards, transparent plastic covering sheets, adhesives, and polluted air.

Acidity in paper might be correctible and avoidable. The life of a print on acid paper can often be extended by the neutralization and buffering of the paper, a treatment commonly termed "deacidification." Some conservators cautiously refrain from deacidifying hand-colored prints, and a few refuse to subject prints of any kind to any deacidification treatment. There is little agreement among the paper conservators and chemists who regularly deacidify prints about which of the various deacidification treatments thus far devised is safest for the practitioner, the paper, and subsequent handlers of the paper. The neutralization and buffering of acid paper—whether by simple water immersion, some "vapor phase" method, or some other method—should therefore be consigned to a skilled and certified conservator, who is aware of the latest findings, can advise whether deacidification is possible or desirable in the first instance, and knows how to test chemicals properly for possible injury to paper. It should never be attempted at home with a commercially available deacidifying agent.

The migration of acidity from external sources of acid to paper can be prevented or retarded by preserving the paper within an environment of neutral materials and atmosphere. The welfare of the paper, not the esthetic relationship between the work of art and its housing and not convenience, should be the paramount consideration when matting and framing prints. The mat boards composed of ground wood pulp or alum, especially the gray and green varieties that ignorant framers seem to cherish, will invariably weaken and stain a print over a short period of time. The brown corrugated "carton" cardboard and other cheap cardboards which the same framers employ as a backing sheet will impart stains to a mount that might bleed through to the print itself. The mount used to enclose and display a print should therefore be composed of multiple-ply all-rag fibered cardboard manufactured from tough cotton fibers (some manufacturers add a buffering agent to give the ragboard permanent alkalinity). The backing sheet, which is supposed to protect the mount, should be made of 100 percent ragboard or a composition of chemically purified wood fibers, neutral sizing, and a buffering agent (a "Permalife" or similar dense, Bristol-weight, white-surfaced cardboard), and if possible, sprayed with magnesium bicarbonate water, to absorb acidity threatening from both within the frame and without. Since all-rag mat board does not accept dye well, it normally comes in colors ranging from light buff to white; any colored mat board or two- or four-ply cardboard that varies in color and texture through its thickness (warning—some cheap cardboard is laminated with all-rag paper) is probably not 100 percent rag stock. A window mat covered with an inert fabric, such as undyed or natural silk or linen (but not burlap), will not

damage a work on paper, so long as a buffer layer of all-rag cardboard or paper is inserted on the verso of the window between the fabric and the print. Matted but unframed prints should be covered with a slightly alkaline transparent or opaque sheet made of acid-free glassine or thin Mylar; the former is preferable, since it is neutral, has no electrostatic charge that might cause it to cling to paper, and lacks a cutting edge, unlike the flexible plastics such as acetate. They should also be quarantined from contact with dust, dirt, air, and acidic substances by storage in dustproof drawers or Solander print cases (black stiff board boxes) lined with acid-free paper. Unmatted prints should be kept in folders or envelopes made of acid-free paper or plastic (Mylar is the most inert of the flexible plastics) while awaiting matting.

The adhesives that come in contact with the print or its mount must similarly be composed of acid-free substances and be soluble in water as well. Many commercial adhesives and synthetic emulsion glues have a high acid content and will infect the paper itself; pressure-sensitive tapes can become encrusted on the paper over time and defy removal; and gummed mounting tabs, such as stamp hinges, are generally cut from acidic glassine, which is fragile, short-lived, and injurious to paper. Pressure-sensitive tapes, gummed-paper tapes and labels, rubber cement, white glue, mucilage, and similar animal glues and synthetics also leave yellow or brown stains on the verso of prints that may be impossible to remove and may exude through to the surface of the print itself. Any stains, whether in the design or margin, and even if confined to the verso, can sharply depreciate a print's market value.

Competent framers cut hinges from a sheet of Japanese mulberry paper for mounting a print to a back mat (the hinge should be weaker than the paper so it, rather than the paper, will rip if the paper is placed under strain) and apply to the hinges a white or cream-colored paste with a rice, wheat, or some other all-vegetable base, such as old-fashioned white library paste or #6 wheat paste, to secure the print to its mat. Many of the most ethical framers and conservators cook up their own batches of paste; some dilute it with magnesium bicarbonate water to obtain a somewhat alkaline mix; and some spike it with a fungicidal solution of methyl alcohol and thymol crystals. (See under "Formulas" in the Clapp book. These practices are still fairly controversial.) The window mat may be hinged to the back mat by a gummed linen tape, so that it may be opened and closed like a book.

Ignorant framers who use acidic cardboards and self-adhering tapes and violate the margins of prints continue to damage and devalue valuable prints. The way to avoid trouble when selecting a framer is to consult a reputable dealer specializing in prints, museum curator or auctioneer, or specifically to prescribe what materials and methods are required for the job.

Light

Light of any kind and any intensity accelerates the deterioration of paper. Paper, like certain creatures of the night, survives best in total darkness. Consequently the less time a print is exposed to view, the longer viewing life it will have. Thousands of old master prints are in good condition today only because, like aggregations of postage stamps, they inhabited the darkness of albums, portfolios, boxes, and books for hundreds of years—until it became more fashionable to exhibit them in sunlit and lamp-lit rooms.

In combination with the oxygen and pollutants in the air, impurities within the paper itself, and high relative humidity and temperature, light breaks down the molecular structure of paper, embrittles it and discolors it. The shade and degree of discoloration depend upon the composition of the paper; light bleaches pure cellulose white, and as anyone who has noticed the effect of sunlight on a newspaper knows, causes lignified cellulose to turn yellow-brown. Light also causes many inks and dyes to fade (see Fig. 5-G), darken, or change color—irreversibly. The radiant energy most harmful to photosensitive materials like paper and ink are the shorter wavelengths (higher frequencies) of the spectrum: invisible ultraviolet and visible blue and violet light. But the longer wavelengths of the spectrum will do damage even if the shorter wavelengths are filtered out. The extent of photochemical damage will vary in proportion with the intensity of illumination and the time of exposure, no matter what the light source; the damage done by a low intensity of light over a long period of time will equal that done by a high intensity light over a short period. It is prudent therefore to keep prints on display (a) for short periods of time, (b) under subdued light, and (c) off walls directly opposite a window. Scientists recommend a limitation of five footcandles, which is the output of a 150-watt light bulb at four feet, for the illumination of works of art on paper. The light level may be checked by pointing an ordinary photographic light meter calibrated in footcandles at a sheet of unglazed white paper.

Three sources of illumination are available: the sun, incandescent lamps (light bulbs), and fluorescent tubes. A print should never be exposed to direct sunlight (or even reflected or indirect sunlight), which has a large quantum of ultraviolet, or to the unshielded cold light emitted by fluorescent lights, which radiate varyingly high levels of ultraviolet, depending on their color. Rigid plastic sheets and tubes that absorb ultraviolet rays are available commercially: the almost colorless Plexiglas UF-1 and the more effective though slightly yellowish Plexiglas UF-3 sheets for use as glazing (Caution: electrostatic charges on Plexiglas pose a serious threat to pastel, charcoal, and loosely secured collage materials); and transparent Plexiglas UF-1 sleeves for insertion over fluorescent tubes. One company also manufactures fluorescent tubes coated with ul-

traviolet-absorbing titanium dioxide. The radiation from incandescent lamps, being largely free of invisible ultraviolet and visible blue wavelengths, is ideal for the illumination of prints. Incandescent lamps do, however, emit infrared light, which tans or scorches human skin when intense. A print should therefore never be spotlit with a light bulb, unless it is a "cool beam" containing a built-in infrared filter which permits only visible light to pass, and it should be sufficiently removed from hot light bulbs to escape the heat transmitted by their long wavelengths.

Mold (fungus)

Mold spores, like cold germs, are everywhere, airborne, and have the capability of remaining dormant until conditions become ripe for germination and growth. Mold spores thrive in organic nutrients (paper fibers, sizing, wood, paste, dirt, greasy fingerprints, etc.) and in an environment with a relative humidity in excess of 70 percent. Mold (taches d'humidité in French; Stockfleck in German) weakens and acidifies paper by hydrolizing its cellulose molecules, consumes the sizing that gives interwoven paper fibers rigidity and discolors paper with brownish stains. The small red-brown spots or measles, called foxing (piqûres; Flecken), which appear on prints left in damp quarters (Fig. 12-A) are iron oxides and hydroxides produced by the chemical reaction between the organic acids discharged by mold and the colorless iron salts and impurities embedded in the paper. Framed prints should be hung in ventilated rooms and dusted frequently. Both unframed and framed prints should be inspected and sniffed periodically for signs of mold or foxing, and new acquisitions that might be afflicted should be quarantined and disinfected to avoid increasing the spore concentration around healthy works.

Mold on prints, even color prints, can be checked and destroyed by fumigation in a hermetically sealed container or chamber. Many museums and libraries employ a vacuum chamber fitted with mechanisms for the introduction and exhaustion of a fungicidal-insecticidal vapor, such as ethylene oxide, a toxic gas. Print conservators generally construct an airtight disinfecting cabinet lined with shelves to hold works on paper and provided with places to hold saucers of thymol crystals, a fungicide that vaporizes when warmed. Four days of fumigation with thymol will kill any mold on paper. Amateurs can fabricate a less elaborate sealed container with troughs to hold flakes of naphthalene or crystals of paradichlorobenzene, the odoriferous moth-killers sold in grocery and hardware stores which housewives still scatter in drawers and closets. Two weeks of exposure will destroy the fungi. Anne F. Clapp gives detailed information, advice, and warnings about the construction and use of disinfecting containers in her text. Fungicides should never be sprayed or placed directly on a valuable print.

Fumigation will destroy the mold but not permanently immunize a

Giovanni Domenico Tiepolo, "The Flight into Egypt: The Holy Family Under a Palm Tree." Etching, 1753 (de V. 6; R. 72). 186 x 244 mm; $7^5/_{16}''$ x $9^5/_8''$. This impression is badly foxed, but the foxing can be bleached and the action of the mold checked. (COLLECTION OF THE AUTHOR) Fig. 12-A

print if it is returned to a damp environment. It also will not reduce the foxing or other stains left by the mold. Stains may possibly be removed by bathing the print in water, a solution of Chloramine-T (a mild bleach), or some more potent bleaching agent, but the decision to proceed with such a remedy, as well as its application, had best be left to a competent conservator, who can analyze whether the particular paper and ink can withstand the preferred treatment.

Insects

Such household pests as silverfish, cockroaches, termites, book lice, and bookworms, which flourish in warm, damp, dark habitats, relish paper sizing, vegetable paste, and bleached wood-pulp paper as much as crumbs and sugar crystals. An inhospitable environment and periodic inspection are the best prophylactics. Infested environments may be sprayed or powdered with an insecticide whose fumes will not harm paper. Insecticides should not be applied directly on valuable paper; infested prints may be treated by exposure in a fumigation chamber.

Mishandling

Paper is so commonplace and disposable that the uninitiated are inclined to handle a print carelessly, like any other throwaway. But paper is easily hurt, and a soiled, stained, rubbed, distressed, punctured, creased, or torn print is a devalued print. Certain kinds of damage will not respond to any restorative ministrations. Nothing, for example, can make scratches, creases, or rub marks disappear from the satin surface of a screenprint (Fig. 12-B), the rich burr of a mezzotint, or the bloom of a black lithograph. To avoid loss, prints must be protected, handled, and packaged with the same attentiveness and solicitude that we accord newborns and crystal brandy snifters.

Prints should be touched and handled as sparingly and infrequently as possible. Loose sheets of paper have an unnerving propensity to acquire creases, tears, and surface dirt and to slip off tables or from fingers and sail to the floor, bumping against legs and furniture en route. Unmatted prints may be stored in acid-free containers or envelopes, but a valuable impression should be matted as soon as possible after acquisition, covered with a thin nonacid sheet of plastic or tissue, and handled, if necessary, by a very firm grip on its mount. Unmatted prints larger than old master etchings should be carried, piggyback, on a clean sheet of cardboard or firmly grasped and lifted with clean, grease-free fingers near the corners at one edge (see Fig. 12-B). If a print hinged to a mount must be

ward Ruscha, "Standard Station." Serigraph in colors, 1966. 645 x 1019 mm; 25¾" x ⅛". The author's son demonstrates the proper way to lift this screenprint, whose delicate face has suffered unsightly creases and splits from tight rolling into a mailing tube. (COL-TION OF THE AUTHOR; PHOTO BY THE AUTHOR) Fig. 12-B

lifted for a peek at the verso, a bottom corner can be fluttered up by a gentle puff of breath to permit insertion of a finger (never flick a corner to raise it, as one does habitually to turn the pages of a magazine), or if the sheet is too heavy to be raised by a jet of air, the bottom corner of the back mat can be flexed slightly to elevate a corner of the paper (Fig. 12-C). One should exercise extreme care, when swiveling a print upon its hinges, in order not to crease the paper, rip it away from its hinges, or tear its hinged edge (see Fig. 5-A).

The integrity of the paper must be safeguarded if the esthetic and commercial value of the print is to be preserved. Under the peculiar code of values that we have inherited, an impression with untrimmed margins is generally prized more than one with deficient margins, so margins should be left intact. Nor should the surface or the verso of a valuable print be abused, no matter what its condition: it should never be ironed, folded, laminated, varnished, sprayed with fixative or protective acrylic, affixed to a back mat with tape or glue or, unless it is in pieces that can be joined in no other way or is an oversize poster, backed with paper ("laid down" in England)—and then never with heat-sealing mounting tissue.

TRANSPORT AND CUSTOMS CLEARANCE

Prints in transport, whether traveling by hand, air freight, or post, should be protected by acid-free tissue, glassine, Mylar or reflex-matte paper; wrapped carefully in waterproof brown paper or plastic sheeting;

The author's son shows the proper technique for lifting a mounted print for a peek at t verso. Théophile-Alexandre Steinlen, "L'Averse" ("Downpour"). Aquatint in colors a drypoint, 1898 (C. 24). 239 x 122 mm; 9⁷/₁₆″ x 4¹³/₁₆″. (COLLECTION OF THE AUTHOR; PHOTO THE AUTHOR) Fig. 12-C

and if practicable, secured *flat* between two pieces of masonite, thin plywood, or stout unbendable cardboard. Any frame should be packaged separately and the glazing left behind. For long-distance travel, air express is more reliable than government postal services and can accommodate an oversize print in a flat package; it is also more costly. There are a number of private shippers that expedite delivery by air freight. If the mails are used, registered mail is preferable.

A print may be sent air mail to any country in Western Europe at the relatively inexpensive postal union (printed matter) rate, if it is enclosed in a package not more than 36 inches in combined length, breadth, and thickness and not more than four pounds in weight. The wrapping should be marked PRINTED MATTER, though a customs sticker need not be affixed, since works of art are nowhere dutiable. Larger and heavier packages may be mailed air parcel post, but the postal rates are much higher than for postal union mail. Insurance for most prints mailed must be secured privately; insurance is not available for postal union mail, and the maximum amount available for parcel post is $395.

Partly because postal regulations limit the dimensions of flat packages, many dealers and auction-firm personnel ship prints rolled into heavy cardboard mailing tubes, with the ends of the roll cushioned against crumpled tissue paper. This longstanding practice has had unhappy consequences for thousands of prints. Some tubes are themselves crushable. Rolling a sheet of paper also puts its fibers under stress, may cause areas of ink—especially the layers of ink on a screenprint—to crack and may cause a sheet of *Chine collé* or *appliqué* to buckle. The ends of a rolled print crammed against crumpled tissue paper also tend to get crumpled themselves, and the print is apt to unroll tightly against the interior wall of the tube, making extraction hazardous. Avoid mailing tubes whenever possible.

Customs regulations differ from country to country, and customs practices within a country may differ from office to office. Practically speaking, imported fine prints, posters, and illustrated books, as works of art, are not dutiable merchandise in the United States, Canada, and the countries of Western Europe. The archaic U.S. Tariff Act provisions and the customs regulations currently in effect thereunder technically permit duty-free entry only for "prints made by . . . hand transfer processes . . . printed by hand from hand-etched, hand-drawn, or hand-engraved plates, stones, or blocks." As a practical matter, however, all the importer need do is satisfy the U.S. customs inspector that the imported article is a work of art. The artist's signature or other mark, a copy of the foreign art dealer's or auction firm's invoice, the very character of the print, and other similar evidence may be marshaled for this purpose. To ease a print through U.S. Customs, the foreign shipper should mark the wrapping of the package with this inscription:

ATTENTION U.S. CUSTOMS:
Original Prints—
Duty Free Under Item 765.10

Any package bearing such an endorsement that arrives in the United States by mail will be forwarded, after due inspection by a customs ·collector at the post office, to the importer without fuss.

Any package that arrives by air freight, however, will be held by customs officials at the airport of arrival for clearance by the importer. What this means is that the importer, either personally or by an agent, must complete, execute, and submit to the customs official an importer's declaration ("Entry and Manifest of Merchandise Free of Duty," U.S. Customs Form 7523, obtainable at customs houses) which describes the imported article and asserts that it is a work of art. A print not imported for commercial purposes will be easily cleared if the importer declares that it is "intended for personal use and not for exhibition and sale" (art dealers must submit to a great deal more paperwork and, consequently, the expenses of customs brokerage). However, if personally attended to, customs clearance is very time-consuming; if delegated to a customs broker, it costs money—from $50 to $100—just to get a print to Manhattan from Kennedy Airport, plus the air freight and insurance charges. The costs and headaches of airport customs clearance alone may make the postal service a much more desirable shipper than the private carrier, and foreign sellers and shippers should be encouraged to use the mails.

PAPER CONSERVATORS AND THEIR SERVICES

Restorative measures serve one or more of three purposes: (1) the elimination of conditions that cause potential or actual deterioration of or irreparable injury to an impression; (2) the recovery of an impression's pristine esthetic appearance, and therefore, *ipso facto*, of its monetary value; and (3) the augmentation of an impression's monetary value alone.

Work within the first category includes demounting or separating a print from an acid-backing mat or paper, the removal of glue and tape residues from the verso, deacidification to safeguard paper against progressive deterioration, fumigation to destroy mold and insects, resizing to stiffen weakened paper and the repair or reinforcement of large folds, abrasions, and tears. Measures in the second category include the elimination of surface dirt and stains by dry erasure, water immersion, application of chemicals and/or bleaching, the repair of minor tears, abrasions, holes, creases, and the like, within the design, the flattening of creases, and the reconstruction of missing portions of the design by interweaving pieces of matching paper into the existing paper and redrawing missing segments of a borderline. Work in the third category includes any aid that goes beyond the rejuvenation of the paper or revivification of a print's esthetic appearance, such as the removal of stains and repair of tears in the margin, removal of a nonacid backing

sheet to which the impression is pasted, strengthening of inked lines, remargining, and reconstruction of portions of the design itself. A bath alone does wonders for children and prints alike! It is truly amazing how much it can perk up a grimy proof.

The prescription and the execution of all these tasks demand the exceptional manual skills, know-how, learning, experience, awareness of risks, and integrity of a top technician specializing in the care and restoration of works of art on paper. The framers who do a little restoration on the side, the painting restorers who do not keep current on the research and findings of experimenting paper conservators and chemists, the uneducated and untrained amateurs, the quacks and the do-it-yourselfers—many of whom do not know what ministration will enhance, and what will depress, the market value of a print—are legion and irreparably damage rather than help hundreds of prints each year. Incompetent restorers routinely overbleach, use harmful solvents, and exceed their limitations in even more insidious ways. An article in the March 1974 issue of the Milan-published *Print Collector* by one "J. K. Pott, restorer" unbelievingly advised that "tears are repaired on the back [by] applying small strips of that sticky paper . . . ," that "burned paper . . . can be avoided by brushing the print (always on the back) with an animal glue" and dusting the glue with talcum powder, that if "the print is all wrinkled everything can be repeated by softening the paper with steam" and that "the best product" for treating spots is "colour remover or failing this, hydrogen peroxide"! A painting restorer named Goldreyer with a large plant in Long Island City, who was entrusted with two damaged Picasso prints, cut the linocut image out of its paper, dry-pressed it down on another sheet of paper and then forged a new Picasso signature and annotation (Fig. 12-D) and simply covered the stains on the lithograph with a "protective" acrylic spray, irrevocably destroying instead of retrieving the market value of each! The inexperienced restorer or home therapist without the learning, training, technical skills, or facilities indispensable for work with paper cannot possibly correctly analyze the condition of a print and know what remedies are necessary, desirable, sufficient, realizable—and worthwhile, relative to the cost of the service.

At the other pole exists a tiny elite of paper conservators of unbelievable proficiency, capable of metamorphosing shabby print Cinderellas into covetable beauties. They can reconstruct a missing corner of the composition by interweaving a complementary scrap of paper, or mend a dirty tear, or replace or renew lines in the image with such deftness and accuracy that little or no evidence of a preexisting defect remains. Certain dealers regularly make use of such wizards to multiply the market values of flawed impressions they buy on the open market (Fig. 12-E), and the restorers, not unmindful of their utility, do their clients' bidding for fees commensurate both with their skills and their role in the augmentation of value.

Incompetent restoration destroyed the market value of this linocut by Picasso. The "restorer" cut the image out and pasted it down on another sheet of paper; a forged signature and annotation completed the job. Fig. 12-D

The ethics regarding such practices are unsettled. Some paper restorers intentionally leave a trace of their work to alert subsequent buyers to the presence of a remedied flaw (such people are shunned by the more rapacious print merchants!), while others, such as one fellow of the American Institute for the Conservation of Historic and Artistic Works (AIC), contend that "it's not unethical to make a perfect restoration," if that's what the client orders. But some obliging European restorers go somewhat farther to please their sophisticated clientele. They purposely leave minor defects untouched to distract potential buyers from searching for major repairs. The most masterful paper conservator in the world, the legendary resident of Zurich-Gockhausen, confesses that "after various consultations with clients of long standing, we have arrived at the understanding that with so much work on a small print, we always leave small, inconspicuous defects alone, so that a potential buyer will believe that the print has not been worked upon by a restorer—otherwise the impression would appear without *any* blemish"; that is, *too* good! In contrast, paragraph 6 of the Code of Ethics for Art Conservators, adopted by the AIC's predecessor organization in 1963, provides:

> In compensating for damage or loss in a work of art, a conservator can be expected to supply little or much restoration, according to a firm previous understanding with the owner or custodian. It is equally clear that he cannot ethically carry this to a point of deceptively covering or modifying the original—whatever the motives for so doing might be.

It is usually impossible for the layman to assess the competency, intelligence, and integrity of a conservator. Yet the selection of a technician need not be left to chance or convenience. There is no reason, except perhaps the magnitude of a particular restorer's fees and the exigencies of time (good paper conservators are *very* busy people), why anyone should not choose the most qualified person available, for prints

Rembrandt Harmensz. van Rijn, "The Three Trees." Etching, engraving, and drypoint, 1643 (B. 212; H. 205). 214 x 282 mm; 8⅜" x 11⅛". This impression, very skillfully restored, brought $35,000 at a 1976 Sotheby Parke Bernet sale. Prior to restoration, it had been sold at a Christie's auction in 1971 (see detail of middle of left side, showing a tear in the left margin visible at that time). (FORMER COLLECTION OF THE AUTHOR; PHOTOS BY THE AUTHOR) Fig. 12-E

are easily and safely deliverable by air freight or, if necessary, by registered or certified mail. Qualified paper experts neither advertise nor solicit clients; they also do not issue appraisals or deal in prints. The best reference sources for competent and ethical paper conservators are the responsible dealers in expensive old master and modern prints, museum print curators, print auctioneers, and the list of paper conservators certified by the AIC.

Though some of the most sought-after paper restorers live and work in London, Munich, and Zurich, on the whole, the American and British professionals remain more in touch with scientific developments in paper chemistry and restorative techniques than their counterparts on the Continent. A goodly number of extremely gifted, reliable Americans have been certified by the AIC. Members of the AIC may obtain certification either through qualification under a "grandfather" clause (so many years of experience and membership) and subscription to the strict AIC code of professional standards and procedures, or by graduation from an institutional training program or private apprenticeship accredited by the AIC Board of Examiners for the Certification of Paper Conservators and a successful presentation to the board of the applicant's learning, skills, conscientiousness, and ethics. The establishment of training programs in the conservation of works of art, first at New York University's Institute of Fine Arts in 1960, and later at several other academic centers, has been an important step toward professionalizing what had long been a sometimes unscientific family craft in the United States. (For a list of AIC members specializing in print restoration, see Appendix 6.)

A professional restorer will examine and analyze a print, often free of charge, report on its condition, explain any proposed treatment and what results may be expected (the most qualified paper experts will never give assurances that the restoration will not show), advise when treatment will be completed, and quote an estimated fee for the work. Expert restoration, like the work of a good lawyer or doctor, does not come cheap. Some conservators base their estimates on time; others, on the ease or difficulty of the required treatment; still others, on the monetary benefit that will accrue to the client. A few have a schedule of fees pertaining to the various restoration and conservation measures available. The cost of one conservator's services for any particular job may of course be higher than another's, and any cost-conscious person may want to take the time to obtain estimates from more than one person. Most of the good paper conservators carry insurance floaters, which protect them against costly misjudgments or slips but not against their own negligence.

APPENDIXES

Appendix One

Tales of Two Print Marketeers

The Print Boom of the 1960's was partly propelled by entrepreneurs seeking to develop and exploit new markets for prints. Two of America's most energetic print marketeers—Consolidated Fine Arts and London Arts—each a success and each a failure of the Print Boom, provide case studies on the difficulties of operating an art business impersonally on a large scale.

CONSOLIDATED FINE ARTS

Consolidated Fine Arts (CFA), the first print market conglomerate, was one of the companies hastily put together at the end of the 1960's to milk the huge market in the gallery-poor hinterlands for low-priced representational and modernesque graphics. The swift rise and fall of CFA is the print market's contribution of a case study in what economists term the dis-economies of vertical integration: the costly inefficiencies and dislocations that result from what would seem to be an advantageous union between interdependent and interrelated operations. Three months after the *Wall Street Journal* reported the rise of Abe Lublin, CFA executive vice-president, "from struggling gallery owner to big-time graphic publisher" with $3,000,000 in sales and "10 salesmen on the road," he had a heart attack from the revelations surfacing about the true state of CFA's corporate health. Lublin did not even realize the trouble he was in when the banks rang the alarum bells.

In 1959, after five years as the proprietor of the Tribune Art Gallery, a browsers' picture store emboweled in the foul-aired Sixth Avenue 42nd Street subway stop, and another five as a salesman for New York Graphic Society reproductions, Abe Lublin found his first moneyman, steel manufacturer Herman Shickman, and opened up Delphic Arts in the Empire State Building. Lublin built a volume business promoting prints to the boondocks: the America west, north, and south of Madison Avenue. Bypassing the Madison Avenue collectors, he commissioned editions of Dalis, Zao Wou-kis, Baskins, Friedlaenders, and nonentities from the Paris ateliers (that way, he could control price), spiced them with purchased "eyewash"—Picassos, Mirós, and Chagalls—and

wheeled and dealed the mix into the American heartlands to dealers and galleries, frame shops and institutions: to Kanegis and Merski in Boston, Frank Perls and the La Cienega galleries in L.A., to Cory and R. E. Lewis and the Achenbach collection in San Francisco, to Dallas, Detroit, Miami. Lublin was America's pioneer print merchandiser, spoon-feeding the people "original" Paris art "to replace their crappy reproductions." He was the only one out there, and the demand was insatiable. "I was the lone wolf," Lublin reminisces proudly; "no one was there to compete with me." Lublin had the mien and the moxie of the quintessential art dealer; he was a consummate horse trader, shrewd and fast. "I used to hit and run," he recalls. He forbade discounting in order to keep price levels steady, yet built in 100 percent profits for his customers and himself: if an edition of 95 cost him $1000 (plus $8 to $10 per print in allocated costs), he would peg the retail price at $80 and wholesale it for $40. Lublin split with Shickman in 1960 after an unsuccessful negotiation with Aimé Maeght in Paris for an exclusive American distributorship for Maeght editions of Chagall, Miró, and other prints ("Shickman wanted a bigger percentage than Maeght wanted to give"), found other backers, and in a few years had five salesmen on the road. By 1968 A. Lublin, Inc., was, according to its own promotional flyer, "The largest publisher and distributor of Original Graphics in the United States," an enterprise which had put scores of American galleries and other wholesalers into the "fast growing field" of selling "bread and butter" prints "that promise enduring and increasing value."

Nineteen sixty-eight was also the year when corporate conglomerates were the darlings of Wall Street investors and the Print Boom was a gleam in the eye of Wall Street promoters. In 1966 mortgage banker John Marqusee and real estate developer Robert LeShufy had approached Lublin with an idea, borrowed from a *Time* magazine survey, for a mail-order print club. Their joint creation, The Collector's Guild, was designed to assail the pocketbooks of those people who remained insensitive to the relatively modern-looking A. Lublin publications, with safe decorative landscapes, seascapes, and nonabstract prints with that made-in-Paris look, promoted with slick color brochures and newsletters and hyped with a sprinkling of cheap unlimited restrikes of Braques, Derains, Picassos, and Rouaults from uncanceled or lightly scored plates and blocks scavenged in Paris. The Collector's Guild was so phenomenally successful, Lublin recalls, "that I saw myself competing against myself"; by 1969 it had enticed 200,000 people to pay the ten-dollar dues. So in May 1968 the three organized Consolidated Fine Arts ("It always sounded to me like a cigar company," says Lublin) to purchase A. Lublin, Inc., and enter the print market at every imaginable level.

Within a year and a half, CFA was a giant Print World conglomerate, "with great cross-pollination in terms of buying power and other advantages," according to Robert Ostrow, the troubleshooter who was later enlisted to lead the company out of chaos, "but with little or no integra-

tion of operations. The true genius of a promoter took hold: the whole would be more than the sum of the parts." Abe Lublin continued to run his publishing and distributing enterprise in relative isolation from the parent company, with little understanding of what it was up to. The Collector's Guild had its own agent-expediters in Paris, commissioning and delivering to CFA's New York offices the prints they were advised Guild members would buy. CFA organized or took over Framecraft to do the framing for the Guild and retail galleries; the Barclay Galleries to establish a chain of 50 retail stores around the country; Touchstone Press to act as the publishing arm for A. Lublin, Inc.; Maecenas Press to publish *livres d'artistes*; Collector's Editions to reprint and publish catalogues raisonnés; the Sculpture Guild; Aquarius Arts, a foundry in New Jersey; Gehenna Press to publish Leonard Baskin exclusively; and a dozen more companies. In 1970 it gave Herman Wechsler promissory notes for his low-key FAR Gallery, which had sold fine 20th-century prints on Madison Avenue for over 30 years. By the time the *Wall Street Journal* glorified CFA in January 1971, it had over 250 employees and its own computer. "We haven't begun to scratch the surface," crowed Lublin, oblivious to impending disaster, to the reporter shortly before his first palpitations.

CFA's biggest folly was its biggest favor for the Print World: the Mourlot/Bank Street Atelier in lower Manhattan. The CFA owners had a number of reasons for inducing the great Paris lithographer Fernand Mourlot to open up an atelier in New York. As Ostrow relates, "The brain trust sat down and figured out that if they could create a Class A atelier they could have a great advantage." In 1967 there was no other big production printshop anywhere in the eastern United States, and a New York workshop with a lustrous Mourlot imprimatur would attract the best talent in America, as well as please CFA artists such as Levine, Siqueros, Shahn, and Tamayo, who were getting weary voyaging to Paris to make editions for the company. Most of all, the atelier would be CFA's showplace, window-dressing for a public offering of common stock. "It was an ego trip," says one former CFA officer bluntly. No one at CFA ever did any feasibility studies or projections of profitability, though they knew from experience that printing was cheaper in Paris; they simply hoped the Mourlot atelier would break even.

To fulfill his end of the 50-50 joint venture, Fernand Mourlot exported to New York some faithful old French presses, four French-speaking artisans, and his son, Jacques. Jacques Mourlot's taste ran to Bernard Buffet; he tactlessly hung a portrait of executed Vichy fascist Pierre Laval over his desk; and trained in the French tradition of the craft, he thwarted the desires of American artists to experiment directly with the lithographic stone. His Gaullic chauvinism was particularly galling. When the first lithograph was pulled at Mourlot New York, he bought four beers for his four compatriots and sang "La Marseillaise" in front of his seething American partners.

CFA spread its showplace atelier bountifully over three floors, and while the younger Mourlot and the CFA owners exchanged insults, artists flocked to Bank Street to make prints. In early 1970, Mourlot pulled his name, expertise, technicians, and son out, leaving the *machine plat* without a *conducteur* and compelling the newly recruited *directeur*, George Goodstadt, until then a NASA space-science researcher, to find printers and apprentice himself to do what Paris apprentices take 10 to 15 years to learn. Goodstadt fed prints to the CFA outlets, hustled other publishers' artists, published and distributed editions in the name of the Bank Street Atelier and did custom work for other New York publishers such as Abrams Original Editions and Transworld Art. "We didn't have to sit and cost these matters out," asserts Goodstadt, though Bank Street was constrained to raise prices so high that few publishers could afford to print there. By the time the white elephant passed through Goodstadt's trusteeship to Sam Shore in 1972 (Shore, in turn, was forced to sell off and shut down his "Shorewood Atelier" in 1974), unused capacity, mismanagement, deficiencies in know-how and personnel, operating inefficiencies, New York-size costs, and the absence of any central creative direction had combined to lose CFA more than $1,000,000 in less than three years—more than half the amount of the Ford Foundation's ten-year funding for the Tamarind Lithography Workshop of Los Angeles.

All that money had to come from somewhere, and much of it came out of Abe Lublin's publishing and distributing division. Lublin's inventory was pledged as collateral for big bank loans, and he was cajoled into stimulating sales by increasing promotional expenditures, salesmens' commissions, and the amplitude of their sales pitch—stretching the capacity of his time-tested methods of operation. Galleries and shops pressured into accepting Lublin editions that did not sell welched on payment or returned the merchandise, causing a severe cash-flow jam and augmenting surplus inventory. "Lublin had too many editions that were bummers," comments Jack Solomon, President of Circle Galleries, a more recent print conglomerate trying hard not to make CFA's mistakes. CFA's Barclay Galleries, which could have taken up some of the slack, never got off the ground, and the few stores that opened lost money from the start. The Collector's Guild, which produced cash and income, was milked. The other operations simply piled on the losses. Framecraft, which at one time was making 50,000 frames a month, could not spread its overhead over enough volume and was sold for a loss in 1970. Collector's Editions buried itself reprinting scholarly works in almost any language except English in twice the number of copies that were salable. CFA tarnished the FAR Gallery with its brands of merchandise and disheartened its former owner, Herman Wechsler, by the profiteering planned for his staid establishment. CFA expanded too quickly, overextended itself, and failed to nurture the separate skills and sensibilities required by each of its divisions.

Contrary to the belief and hope expressed in some quarters of the Print World, CFA never filed for bankruptcy; the banks gained more allowing certain entities to survive and struggle on. In July 1971 Abe Lublin began publishing and wholesaling again as Lublin Graphics of Greenwich, Connecticut. He was helped along with $96,000 of choice hocked CFA inventory, which the banks permitted him to select on credit (the banks *wanted* him to take $250,000 worth—which indicates one man's opinion of the grade of the CFA stock). CFA agreed not to publish certain artists for resale to retail galleries and promised to pay $600,000 of the $1,700,000 it owed Lublin, in the event it ever turned a profit. The shell of the FAR Gallery was returned to Herman Wechsler, who was overjoyed to cancel CFA's indebtedness. The balance of the CFA inventory and the direction of the Collector's Guild were placed in the hands of Ostrow, a lawyer, mortgage banker, and former finance director of a New York investment banking firm, with a practical businessman's nose for profitably marketing Dali and Picasso restrikes and mundane wall decorations by mail order, like phonograph records and vegetable seeds.

LONDON ARTS

The Bank of the Commonwealth in Detroit was not so patronizing to London Arts. It called its $550,000 loan at a time when London Arts owed trade creditors approximately $1,200,000. The bank's demand forced London Arts to file for reorganization under the United States bankruptcy statutes in January 1973, and within a year the trade creditors, including publisher Léon Amiel and New York gallery owners Reiss-Cohen, reluctantly consented to 25¢-on-the-dollar satisfaction. At its zenith in 1970, Detroit-based London Arts boasted an inventory of over 100,000 prints, including its own publications, scores of masterworks, and the thickest portfolio of Picasso graphics in the world; a computer capable of signaling the availability of any particular print at any one of the four London Arts offices or galleries in Detroit, New York, Atlanta, or London; an itinerant sales force second only to CFA's; an elite corps of salesmen; and a cheeky, imperious, brainstorming professor for a leader—the sometime art-history instructor at Wayne State University in Detroit, Eugene Schuster. When Eugene Schuster, a man cursed by many Print People as the Sammy Glick of the Print World of the 1960's, applied to the courts for relief, no one, it seemed, was very sorry except his creditors.

The United States Government indirectly gave Eugene Schuster his start. He was in England on a Fulbright Grant in 1963, working with Professor E. H. Gombrich at the University of London toward a thesis in Renaissance art, when he discovered that etchings and lithographs by the great masters were abundant, unappreciated and cheap in London.

Schuster remained in London to study after his Fulbright expired. But soon he was sending D. Y. Cameron and Chagall etchings back to his brother Monis, a Detroit lawyer, selling Bonnard lithographs through the National Gallery sales desk, and running prints up to Oxford and Cambridge. In 1964 he opened a gallery in a second-story walk-up in Grosvenor Street, off Bond Street.

Back in Detroit in 1965, where Monis Schuster had opened a small print gallery, Eugene Schuster landed a financial backer, William Nitze, renounced studying and teaching art for selling it, and inaugurated London Arts in earnest. To supplement gallery sales in London and Detroit, the Schusters awarded territories to six salesmen, outfitted them with collapsible sawhorse racks and 400 to 500 matted prints from the 15th century to Picasso, ranging in price from $5 to $50,000, and dispatched them across the Continent to conduct exhibition sales at museums and colleges, for fraternal societies and charity groups (the institutions got 20 percent of the gross in cash or kind), and approach the curators of major university collections and museums. They heralded their exhibitions with press releases, posters, and mailings. They pitched art to the masses. Before antiwar and anti-Establishment demonstrators made such capitalistic enterprises unwelcome, London Arts' "school program" attracted tens of thousands of people in a thousand cities and college towns across the United States with exhibitions of purchasable art which they had never before been aware of, accompanied by lectures about what they were looking at by the salesmen and, from time to time, by none other than the Perfesser himself. "It was," recalls one of the salesmen, "an event to come into Skokie, Illinois, with art prints." Before the fall, London Arts salesmen were earning $25,000 to $75,000 a year selling Bresdins in Baton Rouge and Braques in Bartlesville.

In 1968 Eugene Schuster hired Hugh MacKay away from John Barton, another distributor who helped introduce cheap graphics to America, to organize a publishing and wholesaling program for London Arts. MacKay commissioned and distributed prints by COBRA School painters Appel and Alechinsky, who had never received exposure in America, and popularized such artists as Bolotowsky by selling their prints at a time when they were unknown painters. He bought out Bellmer editions from the Paris publisher Visat, Calder editions that Editions Maeght did not want, and the balance of Marini editions left over after Robert Feldman, who was then working for publisher and distributor Léon Amiel, had "creamed" the Marini market. Under MacKay's direction, London Arts salesmen began calling on the shops and galleries in the American "provinces" with these new publications and the old and modern "master prints." Many customers were ignorant of Paris wholesale and worldwide auction price levels and paid the steep London Arts prices; some were content to host the prepackaged London Arts shows for a 20 percent cut. Looking for new outlets, the Schusters installed a print department on the top floor of Macy's in New York,

where Ann Richards and salespersons transferred from the territory attempted to sell fine graphics as if they were dry goods. By 1969, London Arts was the London Arts Group, with a fashionable Bond Street Gallery, a large gallery in Detroit, offices in Detroit and New York, a publishing division, a minority interest in Reflections Gallery of Atlanta, and 20 first-rate catalogs, from *Georges Rouault* to *Collector's 100* to *LGA Editions.*

Eugene Schuster is perhaps best remembered by Print People for his impact upon the market for Picasso prints in the late 1960's. Without consciously seeking to manipulate price levels upward, he unwittingly helped boom auction prices speculatively high by buying lustfully and unastutely, purchasing too many and paying too much. London Arts held amost 200 Picasso prints in 1967, almost more subjects than Paris dealer Heinz Berggruen. Schuster counted on an unabated upward spiral of prices and the London Arts distribution network to cover costs for him, never imagining the day would come when the piper would demand payment. Of course other personalities figured in the Picasso price push, too: Berggruen, New York retired garment manufacturer and collector-dealer Isidore Cohen (who used Eugene Schuster as a buying agent and adviser before engaging Wallace Reiss in 1968 to handle "his goods," as he then called them), a Swedish haberdasher named Lapidus, and the countless other neophytes entering the auction sales rooms to bid for prints. But the highly visible, reckless buying by London Arts in the late 1960's incurred the bitter resentment of many print dealers shut out of the Picasso market by skyrocketing prices. "The print dealer had always been the poor man's relative within the art market," Monis Schuster offers in explanation. "As the market went up, it became a bit heavy for them, bewildering. You take $1,000,000 and put it in the print market, and it was like an earth tremor. As we approached the 1970's that $1,000,000 created a tidal wave." Munich dealer Michael Hasenclever, who was Munich dealer and auctioneer Wolfgang Ketterer's assistant in the late 1960's, remembers it differently: "Schuster muddled up the market, then couldn't keep up the momentum." Peter Deitsch, the late, greatly admired New York dealer, vocally rejoiced upon hearing a rumor that auctioneer Eberhard Kornfeld had cut off London Arts' credit in the spring of 1970. The suspension of London Arts' buying that year undoubtedly contributed to the setback in the auction prices of Picasso prints in 1970–71.

Paradoxically, London Arts was undone by the Print Boom itself. The Boom fostered the proliferation of new dealers and galleries which siphoned off much of the business that the London Arts salesmen helped generate. Moreover, as London Arts' trade and institutional clientele gained awareness about prints and the print market from the media and contact with other Print People, they found they did not have to pay the steep London Arts prices or rest content with a 20 percent cut. They could bypass London Arts. They could themselves buy Mirós directly

from Maeght, Appels from other publishers, and Picassos at auction a lot cheaper. Acclimated to a captive market, Eugene Schuster priced himself out of the market when it became more sophisticated about price. Pitched, arbitrarily, at simply double or more the cost of a print without regard for its fair market value, London Arts prices were so high that they burdened the salesmen, and the consequential lag between purchase and sale (during which time the costs of carrying inventory persisted) became so great that it caused a sizable shortage in working capital. At the same time expenses—multiple rents, gallery and administrative expenses, per-diem costs of keeping 12 men on the road, salesmen's draw and commissions, interest charges, etc.—were so considerable that price levels would not suffer reduction or withstand the increase in commission necessary to induce regional galleries to hold London Arts exhibitions.

Ultimately it was the very size of London Arts that contributed most to its collapse. Notwithstanding the computer, it could not—as a small intimate gallery can—maintain a profitable balance between inventory and sales; there was too large a gap, and too many intervening parties, between point of purchase and point of sale. Buying more Bresdins when the five on the road were unsold weighed the company down. Moreover London Arts could not manage the sustained contact and personal rapport with clients that is apparently required for the most successful sale of works of art, those most delicate and mystical of commodities. London Arts was strangled by costly commodities that would not be sold the way London Arts was geared up to sell them. As Monis Schuster now realizes, "The business is so damn tradition bound! Mystique is really necessary! Going out to the public to sell works of art works only to a point, for the teaching process is too long. You don't sell art in Macy's, like brassieres. It's a terribly personal business. And we grossly underestimated the expenses for the massive distribution of prints on the level we planned."

The revolt of London Arts' unpaid traveling salesmen in the summer of 1970—designated the "Treasonable Uprising" by Eugene Schuster—bottled up its inventory and gave it the *coup de grâce*. The company hastily retrenched, but it was too late. The Schusters sued Hugh MacKay and his fellow mutineers for $750,000, but lost. When the dust had settled in 1974, the American bankruptcy laws left the Schusters—to the chagrin of their Print World enemies and detractors—with their London gallery (shut down in 1976) and Detroit gallery, new sources for capital, a much diminished trade in mostly consigned works of art, and the sunny optimism to publish a portfolio of lithographs by Karel Appel with the timely title of *The Sunshine People*. Hugh MacKay and several other defendants went on in 1970 to form a New York publishing distributor called Nabis Fine Art Limited, which within a few years had sold $500,000 of its stock to a gullible public and expired from terminable bankruptcy, caused among other things by undercapitalization, un-

anticipated expenses, and inadequate controls over inventory and receivables. MacKay was discharged from that sinking ship in time to launch another publishing-distributing enterprise, HMK Fine Arts, in association with publisher Anne Lahumière of Paris. By the end of 1974, MacKay was musing about "integrating art with life" by vertically integrating his company with furniture stores and fabrics shops, and publishing mostly the kinds of graphics such establishments choose to hang on their walls.

Ken Price, "Coffee Shop at the Chicago Art Institute."
Silkscreen in colors, 1971 (Gem. 331). 1016 x 1524 mm;
40″ x 60″. (COURTESY OF GEMINI G.E.L.)

Appendix Two

Where Prints May Be Seen

I think that books don't help the beginning print collector. One should start by simply looking and looking, until something particularly strikes the interest. In pursuing that interest one will want to find out the background of prints that first appealed in and for themselves. At that stage . . . one will want to begin to read. . . . I like the collector who starts all eye and heart, and only later resorts to his brain.
—A. Hyatt Mayor, 1971.

The primary source of information about a print is the print itself. Although good facsimiles and illustrations may exist, to know a print one must really see it.

There are a number of places where prints can be seen. Art galleries and print dealers show prints on their walls and house them in racks and drawers for public scrutiny—at no obligation. A Saturday tour through the chief print establishments in New York City or any other major art center is a trip through the graphic art of five centuries. The presale exhibitions of consignments by the major auction firms—auction previews—also provide excellent opportunities for viewing and handling prints. No invitation to them is required. During a short period from early May through mid-June, some 5,000 fine prints and illustrated books appear at auction in New York, London, Munich, Hamburg, and Bern, providing an educational diversion for the tourist and a refresher course for the most expert professional. Prints can also be seen at art fairs and prize competitions and are regularly on view in museums, libraries, and university art galleries.

Public institutions—and a number of private collections—with sizable collections maintain storehouses of prints in print cabinets or study rooms, where prints not on public view are accumulated, stored, studied, and made available to qualified persons or the public at large for private examination. Many of these public institutions engage a full-time curator of prints to manage and conserve the collection, organize exhibitions, prepare catalogs, advise on acquisitions, aid students and scholars, and answer questions. Print curators—they are called "keepers" in Eng-

land—or their assistants are normally available for consultation about such matters as the identity, authenticity, quality, and condition of a print, but they are reluctant to give advice about monetary value, in part because their function is scholarly and in part because their market lore is often insufficient to support such an appraisal. Print cabinets, however, sometimes house priced catalogs of dealers and auction firms, as well as catalogues raisonnés and other books specializing in prints, so that a visitor may himself attempt to verify current market prices.

Visitors to a print cabinet must normally specify their interests and make an appointment in advance; some institutions discourage all visitors but serious scholars and graduate students and require a formal introduction. The staff of some print rooms generously place boxes of prints at a visitor's disposal for leisurely private contemplation, but most, in order to forestall damage or theft, maddeningly bring out and return requested subjects one by one. Guests in a print room should always wash their hands before handling either prints or their mounts, although the rules of some institutions forbid laying hands upon the prints themselves to preclude soiling and injury, notwithstanding the utility in print connoisseurship of handling and examining the paper and the verso of the print.

The following directory includes all the major and a great many of the minor collections of prints in the United States, Canada, and Europe. In all but a few cases, the information was extracted from questionnaires submitted by and returned to the author by representatives (for the most part, curators of prints) of the respective institutions during the preparation of this book. Consequently the reader should be aware that certain data, such as the names of curatorial personnel and the apportionment of acquisition funds, may become dated.

The following abbreviations have been used:

Amer.	—American	Mod., M.	—Modern (post-1850)
c.	—Century	Mex.	—Mexican
C.	—Contemporary (post-1950)	Neth.	—Netherland
Can.	—Canadian	N. Eur.	—North European
Dan.	—Danish	OM.	—Old Master
Eng.	—English	OM-D.	—Dürer
Eur.	—European	OM-R.	—Rembrandt
Exp.	—German Expressionist	P.	—Picasso
Fr.	—French	Rus.	—Russian
Ger.	—German	Scan.	—Scandinavian
Hist.	—Historical	Sp.	—Spanish
It.	—Italian	Swed.	—Swedish
Jap.	—Japanese		

Collrs., Dlrs., Gen. Pub., Membs., Schols., and Studs. refer to collectors, dealers, general public, members, scholars, and students respectively.

Auc.	—Auction	Indiv.	—Individual
Endow.	—Endowment	Purch.	—Purchase
Found.	—Foundation		

N.A. means information was not available.

PRINT CABINETS IN THE UNITED STATES (continued)

NAME & ADDRESS OF INSTITUTION	NATURE & SIZE OF COLLECTION	STRENGTHS OF COLLECTION	ACCESS TO COLLECTION	NAME, TITLE & SPECIALTY OF CURATOR	REFERENCE LIBRARY	ACQUISITION POLICY & PURCHASE FUNDS	SALE OF DEACCESSIONS & DUPLICATES TO
Baltimore Museum of Art Art Museum Drive Baltimore Md. 21218	15c.–C. Eur. & Amer.; 55,000	19–20c. Fr. Exp.	Gen. Pub.	Victor Carlson, Curator (18–19c. Fr.)	500 vols.	C. (60–75%), M. (10%), OM. (20%), $6,000 annual purch; $5,000 Endow. (incl. drawings)	Dlrs., Auc.
William Benton Museum of Art University of Connecticut Storrs, Conn. 06226	University study collection; 300	20c. Ger., Exp. (104 Kollwitz)	Gen. Pub., except Dlrs.	Frederick den Broeder, Museum Curator	None	C. (10%), M. (60%), OM. (30%); N.A.	Auc., Dlrs. (rarely)
Boston Public Library (Print Department) Dartmouth St. Boston, Mass. 02117	Study, research, exhibition; 60,000	18–20c. Eng. & Amer., 19–20c. Fr., Eng. & Amer. Historical & Political	Gen. Pub.	Sinclair Hitchings, Keeper of Prints (Amer.); Paul Swenson, Assistant Curator (Graphic Techniques)	1,500 vols.	C. (33⅓%), M. (66⅔%).	None
Brooklyn Museum 188 Eastern Parkway Brooklyn, N.Y. 11238	15c.–C.; 25,000	OM., 18–20c. Ger., Jap.	Gen. Pub.		Open to public	N.A.; N.A.	N.A.
Busch-Reisinger Museum 29 Kirkland St. Cambridge, Mass. 02138	20c. Ger.; 10,000	All phases 20c. Ger., Gropius, Feininger, Kandinsky	Gen. Pub. for study, no Dlrs.	Linda V. Seidal, Acting Curator (Medieval Art)	Not open to public	C., M., OM.; N.A.	None
Cincinnati Art Museum (Department of Prints) Eden Park Cincinnati, Ohio 45202	15c.–C. Eur. & Amer.; 18,000	15c. Neth., 15c. It., 18–19c. Fr., 20c. Amer. OM-D., OM-R., Goya, 20c. religious	Gen. Pub.	Kristin L. Spangenberg, Curator of Prints. Prints, Drawings & Photographs (19c. lithographs)	Basic publications	C., M., OM.; N.A.	Dlrs., Auc.
Sterling and Francine Clark Art Institute South St. Williamstown, Mass. 01267	15–19c.	19c. Fr., OM-D., 18c. Fr. & Eng., Homer	Gen. Pub.	Rafael Fernandez, Curator of Prints & Drawings	35,000 vols.	M. (20%), OM. (80%); N.A.	Dlrs.

Cleveland Museum of Art 11150 East Blvd. Cleveland, Ohio 44106	15–20c. Eur.; 1,500	OM–D., Whistler, Meryon, Bellows, Homer	Gen. Pub.	Louise Richards, Curator; Anne I. Lockhart, Assistant Curator	Open to public	C. (small %), M. (small %), OM. (largest, %); N.A.	None
Colonial Williamsburg Foundation (Department of Collections) Williamsburg, Va. 23185	18c. decorative and historical; 3,500	18c. Eng., Amer. & Eur.	Grad. Studs., Schols., Collrs., Dlrs. (intro. needed)	Joan D. Rolmetsch, Curator of Prints & Maps	Small	N.A.	N.A.
Cooper-Hewitt Museum of Design 9 East 90 St. New York, N.Y. 10028	15–20c.; 25,000	18c. Fr. ornamental, 15–17c. Ger. & Neth., 18c. It., 19c. Amer., OM–D., Tiepolo, Pillement	Gen. Pub.	Mrs. Leo J. Dee, Curator of Drawing & Prints (18c. Fr. & It.)	Limited	C. (20%), M. (10%), OM. (70%); None (gifts)	Auc. (once)
Davison Art Center 301 High St. Wesleyan University Middletown, Conn. 06457	University collection of fine quality; 10,000	16c. It., Ger. & Neth., OM–R., Goya, Manet, Millet, Goltzius	Gen. Pub.	Richard S. Field, Curator (15c. woodcuts, Gauguin, C.)	3,000 vols.	C. (30%), M. (20%), OM. (50%); $5,000 annual fund, $1,200 Endow., $2–3,000 annual Indiv. bequests	None
Detroit Institute of Arts (Department of Graphic Arts) 5200 Woodward Ave. Detroit, Mich. 48202	15–20c. Eur. & Amer.; 15,000	19–20c. Fr., early 20c. Amer., Exp., P., Whistler, Manet, Matisse	Gen. Pub.	Ellen Sharp, Curator (M.); Marilyn Symmes, Curatorial Assistant (M.)	1,000 vols.	N.A.; N.A.	None
Fogg Art Museum (Department of Prints and Photographs) Harvard University Cambridge, Mass. 02138	15c.–C.; 50–60,000	19c. Fr., 16c. It. & Ger., Exp., OM–D., OM–R., P., Goya	Gen. Pub.	Henri Zerner, Curator (16c. Fr. & It.)	800 vols.	N.A.; N.A.	N.A.
Free Library of Philadelphia (Print & Picture Department) Logan Square Philadelphia, Pa. 19103	15c.–C.; N.A.	Napoleonic prints, portraits, Philadelphiana, Americana, WPA prints, C.	Gen. Pub.	No print specialist	150,000 vols.	C. (60%), OM. (30%); $3,500 annual fund	Auc.
The Frick Collection 1 East 70 St. New York, N.Y. 10021	Henry Clay Frick Collection; 50	OM–R., OM–D., Meryon, Whistler, Neth., Flem.	Interested, qualified persons	No print specialist	Not open to public	OM. (rarely); Endow.	None

PRINT CABINETS IN THE UNITED STATES (*continued*)

NAME & ADDRESS OF INSTITUTION	NATURE & SIZE OF COLLECTION	STRENGTHS OF COLLECTION	ACCESS TO COLLECTION	NAME, TITLE & SPECIALTY OF CURATOR	REFERENCE LIBRARY	ACQUISITION POLICY & PURCHASE FUNDS	SALE OF DEACCESSIONS & DUPLICATES TO
Grolier Club Library 47 East 60 St. New York, N.Y. 10022	17–19c. Eng., Fr., It., Ger., Amer.; N.A.	Prints relating to printing, portraits of printers, library views	Gen. Pub.	Robert Nikirk, Librarian	2,000 vols.	N.A.; none	Auc. (books)
Grunwald Center for the Graphic Arts University of California, Los Angeles 405 Hilgard Ave. Los Angeles, Calif. 90024	15c.–C.; 25,000	20c., Exp., Fr., Impressionism, 19c. Jap., 17–18c. ornamental, P., Tamarind Workshop	Gen. Pub.	E. Maurice Bloch, Director, Curator (OM. drawings, ornamental); Thomas W. Travis, Assistant to Curator; Francis J. Martin, Curatorial Assistant	Extensive	C., M., OM.; annual fund N.A., Indiv. bequests	Dlrs., Collrs., Auc.
Solomon R. Guggenheim Museum 1071 Fifth Ave. New York, N.Y. 10028	20c.; 500	Kandinsky, Klee	Schol. & Grad. Stud. (intro. needed)	None	10,000 & 20,000 catalogues; but not open to visitors	C. (varies), M. (varies small); Indiv. bequests (occasionally)	Dlrs., Auc.
High Museum of Art 1280 Peachtree St. N.E. Atlanta, Ga. 30309	Mid-19c.–C. Eur. & Amer.; 850	C.–Amer.	Serious persons	Gudmund Vigtel, Director	5,000 vols., not open to visitors	C. (50%), M. (50%); $15,000 annual fund, $8,000 Found. bequests, $10,000 annual Indiv. bequests	None
Hispanic Society of America Broadway and 155 St. New York, N.Y. 10032	Sp.	Goya	Gen. Pub.	Theodore S. Beardsley, Jr., Director		N.A.	N.A.
Houghton Library Harvard University (Department of Printing & Graphic Arts Cambridge, Mass. 02138	15c.–C. illustrated books; 20,000	16c. Fr. & It., 18c. It., 19c. romantic & fin-de-siècle books, 20c. livres de peintres	Gen. Pub.	Peter A. Wick, Curator of Printing & Graphic Arts		N.A.; N.A.	N.A.

Institution	Holdings	Specializations	Access	Staff	Library / Visitors	Funding	Acquisition
Henry E. Huntington Library, Art Gallery & Botanical Gardens 1151 Oxford Rd. San Marino, Calif. 91108	15c.–C. (portraits, topographical, historical); 100,000	17–18c. Eng., 18–19c. Amer., OM-D., OM-R.	Schols. & Grad. Studs. (intro. needed, 2 letters of ref.)	Robert R. Wark, Curator of Art Gallery (prints & drawings)	500,000 vols.; not open to visitors	OM. (less than 1%); N.A.	N.A.
Kimbell Art Museum P.O. Box 9440 Will Rogers Road West Fort Worth, Texas 76107	small collection (begun in 1969); 27	None	Schols., Studs., Dlrs., Collrs.	David M. Robb, Jr., Curator	12,000; open to visitors by app't.	OM. (100%); Endow. (variable)	Dlrs., Collrs., Auc. (to date no prints)
Library of Congress (Prints and Photographs Division) 2nd St. and Independence Ave. S.E. Washington, D.C. 20540	15–20c. fine prints, 18–19c. popular documentary prints; 160,000	19–20c. Amer., OM-D., OM-R.	Gen. Pub.	Karen F. Beall, Curator (fine prints); Milton Kaplan, Curator (historical prints)	Extensive	C. (50%), M. (45%), OM. (5%); varies annually	Exchange with Dlrs. & Insts.
Los Angeles County Museum of Art 5905 Wilshire Blvd. Los Angeles, Calif. 90036	Eur. & Amer.; N.A.	OM-D., OM-R., 16–17c. Neth. Exp., 20c., C.	Gen. Pub.	Ebria Feinblatt, Senior Curator of Prints & Drawings; Joseph E. Young, Assistant Curator	N.A.	N.A.; N.A.	N.A.
Madison Art Center 720 East Gorham Madison, Wis. 53703	15c.–C.; 1300	19c. Jap., 20c. Mex., 20c. Amer., OM-D., Rouault, Kollwitz	Membs., Stud., Schols., Collrs. (intro. needed)	Robert Hendon, Director	None	C., M., OM.; $5,000 Found. bequests, $5,000 Indiv. bequests annually	Dlrs., Collrs., Auc.
Metropolitan Museum of Art (Dept. of Prints & Photographs) Fifth Ave., at 82 St. New York, N.Y. 10025	15c.–C.; over 1,000,000 prints & 10,000 illustrated books	Many	Gen. Pub.	Colta Feller Ives, Curator in charge of prints	Open to public	C., M., OM.; N.A.	N.A.
Minneapolis Institute of Art (Department of Prints & Drawings) 2400 Third Ave. S. Minneapolis, Minn. 55404	15c.–C.; 40,000	16c. Ger., 17c. Neth., 19c. Fr., Jap., botanical & zoological, style, ornamental fashion prints	Gen. Pub.	John W. Ittmann, Curator of Prints & Drawings (19c. Fr.)	1,000	C. (50%), M. (25%), OM. (25%); $10,000 annually	Dlrs., Auc.

PRINT CABINETS IN THE UNITED STATES (*continued*)

NAME & ADDRESS OF INSTITUTION	NATURE & SIZE OF COLLECTION	STRENGTHS OF COLLECTION	ACCESS TO COLLECTION	NAME, TITLE & SPECIALTY OF CURATOR	REFERENCE LIBRARY	ACQUISITION POLICY & PURCHASE FUNDS	SALE OF DEACCESSIONS & DUPLI-CATES TO
Pierpont Morgan Library 29 East 36 St. New York, N.Y. 10016	Rembrandt etchings only; over 400	All but 30 of the subjects	Schols; Collrs.; Dlrs.; Grad. Studs. (intro. needed)	Felice Stampfle, Curator; Cara D. Dennison, Associate Curator; Ruth Kraemer, Curatorial Assistant	None	N.A.; N.A.	N.A.
Munson-Williams-Proctor Institute 310 Genesee St. Utica, N.Y. 13502	15c.–C.; 1,033	19–20c. Amer., 18–19c. Eng., 19–20c. Fr., P., OM–R., Goya, Daumier, Redon, Whistler	Gen. Pub.	N.A.	100	OM., M., C.; annual fund; up to $10,000 annual Endow., Found. bequests	None
Museum of Fine Arts 479 Huntington Ave. Boston, Mass. 12115	15c. C. Eur.-Amer.; N.A.	15c. It., OM–D., 17c. Neth., 19c. Fr., Goya, Bellange, P.	Gen. Pub.	Eleanor A. Sayre, Curator of Prints (Goya); Clifford S. Ackley, Assistant Curator (17c.–Neth.); Stephanie L. Stepanek, Curatorial Assistant (16c. Ger. wood-cuts)	4,000	C., M., OM.; N.A.	N.A.
Museum of Fine Arts-Houston 1001 Bissonnet Houston, Texas 77005	Small collection; N.A.	OM–D., OM–R., 19c. Amer. & Eur., 20c. Amer.	Gen. Pub.	Kent Sabatik, Chief Curator	N.A.	N.A.; N.A.	N.A.
Museum of Modern Art 11 West 53 St. New York, N.Y. 10019	Late 19 & 20c. Eur. & Amer., illustrated books; 65,000	1900–40 Amer., Klee, Exp., P., Matisse, Kuniyoshi	Gen. Pub.	Riva Castleman, Curator of Prints	Extensive	N.A.; N.A.	N.A.
National Collection of Fine Arts Smithsonian Institution Ninth and G Sts. N.W. Washington, D.C. 20560	18–20c. Amer.; 5,600	late 19c.; 1920's & 30's; New Deal art projects	Gen. Pub.	Janet A. Flint Curator (Amer. 20c.); Martina R. Norelli	N.A. (open to public)	N.A.; N.A.	N.A.

Institution	Collection	Subjects	Access	Curator/Staff	Size	Acquisition	Disposal
National Gallery of Art Sixth St. and Constitution Ave. N.W. Washington, D.C. 20565	Late 14c.–C. Eur. & Amer.; 50,000 objects	pre-20c. Eur., OM–D., OM–R., Schongauer, Blake, Daumier	Gen. Pub.	Andrew Robison, Curator of Graphic Arts (Piranesi & Eur.); J. Fred Cain, Museum Curator (19–20c. Eur. & Amer.); H. Diane Russell, Assistant Curator (Graphic Arts, 16–18c.)	N.A. (open to public)	C., M., OM (largest %); N.A.	N.A.
Nelson Gallery-Atkins Museum 4525 Oak St. Kansas City, Mo. 64111	15c.–C.; 4,000 objects	OM–D., OM–R., 15c. Ger., woodcuts, Callot, Goya, Blake, 19c. Eur.	Gen. Pub.	George L. McKenna, Associate Curator of Prints	2,282 vols. (prints) 25,000 vols. (gen. art ref.)	C. (only by gift), M. (33⅓%), OM. (33⅓%); annual fund, some Endow.	Collrs.
New-York Historical Society (Print Room) 170 Central Park West New York, N.Y. 10024	17c.–C. Amer.; 250,000 objects	N.Y. City & State, views, naval, political, circus, theatre	Gen. Pub. (research fee for nonmembs.)	Wendy Shadwell, Curator of Prints	500	Purch. (esp. 19c. N.Y. scenes); varies	Auc.
New York Public Library (Prints Division) Fifth Ave. and 42 St. New York, N.Y. 10018	15c.–C.; 160,000	19c. Amer., 19c. Fr., Jap., OM–D., Goya, Utamaro	Gen. Pub.	Elizabeth E. Roth, Curator of Prints	12,000	N.A.; N.A.	N.A.
Philadelphia Museum of Art Benjamin Franklin Parkway at 26 St. Philadelphia, Pa. 19101	15c.–C.; 100,000	20c. Amer., 18c. Fr., 18–19c. J., 19c. Eur. popular, 18–19c. Jap.	Gen. Pub.	Kneeland McNulty, Curator of Prints; Ellen Jacobowitz, Assistant Curator	6,000	C. (10%), M. (10%), OM. (80%); N.A.	"Policy to be determined"
Portland Museum of Art 1219 S.W. Park Portland, Ore. 97205	Eur., Amer., Jap.; 2,000	18–19c. Jap., late 18–20c. Eur. & Amer., Exp., 20c. Oregon	Schols., Studs., Collrs., Dlrs.	Donald Jenkins, Curator (Japanese prints)	6,700 vols.	C. (c. 75%), M. (5%), OM. (20%) (varies); up to $1,500 endow. & up to $1,000 indiv. bequests annually	None

PRINT CABINETS IN THE UNITED STATES (*continued*)

NAME & ADDRESS OF INSTITUTION	NATURE & SIZE OF COLLECTION	STRENGTHS OF COLLECTION	ACCESS TO COLLECTION	NAME, TITLE & SPECIALTY OF CURATOR	REFERENCE LIBRARY	ACQUISITION POLICY & PURCHASE FUNDS	SALE OF DEACCESSIONS & DUPLICATES TO
Princeton University Art Museum (Print Room) Princeton, N.J. 18540	Gen., for teaching purposes; OM., Eur., Amer.; 7,000	Callot, Goltzius, OM–R.	Anyone with scholarly interest	Robert A. Koch, Faculty Curator of Prints (N. Renaissance); Barbara T. Ross, Custodian of Prints & Drawings	None	N.A.; N.A.	N.A.
Rhode Island School of Design Museum of Art 224 Benefit St. Providence, R.I. 02903	15–20 c.; 8,000	19c. Fr., Amer. C., 18–20c. Eng., expanding, N. Eur. Mannerist, Goltzius, Callot, Van Dyck, OM–D.	Gen. Pub.	Diana L. Johnson, Associate Curator of Prints & Drawings (19c.)	N.A.	C. (50%), M. (25%), OM. (25%); N.A.	None
St. Louis Art Museum Forest Park St. Louis, Mo. 63110	late 15c.–C.; 5,000	16c. Ger., 17c. Fr., 19c. Fr., 20c. Eng., 20c. Amer., OM–D.	Gen. Pub.	Jack Cowart, Assoc. Curator (20c.); Nancy Ward Neilson, Associate Curator (OM–R.)	2,000	OM., M., C. (% varies); $5,000 annual fund, $5,000 Found. bequests	None
San Francisco Museum of Art Van Ness Ave. at McAllister St. San Francisco, Calif. 94102	20c.; 1,400	Amer. 1930's, Exp., Matisse, P.	Schols., Studs. (not Gen. Pub. or Dlrs.)	Suzanne Foley, Curator of Graphics Painting & Sculpture	None	C. (90%), M. (10%); Graphics purch. from general acquisition funds.	Dlrs., Auc.
Smith College Museum of Art Northampton, Mass. 01060	Representative major figures; 7,000	19–20c. Fr. & Amer., Goya, P., Hogarth, Piranesi, Turner, Daumier	Gen. Pub.	Elizabeth Mongan, Curator of Prints & Drawings; Colles Baxter, Associate Curator	College Library (General art history)	N.A.; N.A.	N.A.
Toledo Museum of Art Toledo, Ohio 43697	Representative; 2,200	17c. Neth., 18c. Eng. mezzotints, 19c. Fr., 20c. Jap., OM–D., OM–R.,	Gen. Pub.	Roberta Waddell, Curator of Prints	700	C., M., OM.; N.A.	None

Institution	Holdings; vols.	Collection	Audience	Curator	Library	Codes	Access
		Hassam, Blake, Daumier, Gavarni, Whistler, Hogarth					
Wadsworth Atheneum Hartford, Conn. 06115	16c. Eur., OM., 19c., 20c., Oriental; 5,000	18c. Fr. portrait engrs, 19c. Fr. & Eng, landscapes, 18–19c. Jap., 20c. Amer.	Studs., Schols., Dlrs.	Peter O. Marlow, Chief Museum Curator	None	N.A.; N.A.	N.A.
Walker Art Center Vineland Place Minneapolis, Minn. 55403	20c. master-pieces, Amer. C.; 1,000	C. portfolios, Albers, LeWitt, Graves, Younger-man, Cage, Warhol	Schols., Grad. Studs.	Philip Larson, Curator (Exp., Amer. C.)	None	C., M.; $1,500 annually	None
Whitney Museum of American Art 945 Madison Ave. New York, N.Y. 10021	20c. Amer.; N.A.	1920s & 30s; C.	Gen. Pub.		N.A.	N.A.; N.A.	N.A.
Henry Francis du Pont Winterthur Museum Winterthur, Del. 19735	Pre-20c. Amer. & Eng.; 10,000 vols. (1,500 unbound)	18–19c. Amer., 18c. Eng. mezzo-tints, Amer. & Eng. rare books to 1914	Schols., Studs., Collrs., Dlrs.	E. McSherry Fowble, Associate Curator in Charge of Graphics; Richard R. Schrock, Librarian of Rare Books	43,000 vols. (gen.)	N.A.; N.A.	N.A.
Worcester Art Museum 55 Salisbury St. Worcester, Mass. 01608	Eur., Amer., Jap. of all periods; 10,000	16–17c. chiaroscuro woodcuts, 18–19c. Eur. color prints, 18–19c. Jap., pre-1850 Amer., Goya	Schols., Grad. Studs.	Timothy A. Riggs, Assistant Curator (16c. N. Eur.)	550 vols.	N.A.; N.A.	N.A.
Yale University Art Gallery 1111 Chapel St. New Haven, Conn. 06520	Amer., Eur., Oriental; 20,000	19–20c. Amer., 18–19c. Jap., 19–20c. Fr., Exp., 15–17c. Neth. & Ger.	Gen. Pub.	Alan Shestack, Director (prints, N. Eur.); James D. Burke, Curator (Neth.)	200 vols.	C. (10%), Mod. & OM. (90%); N.A.	Dlrs., Collrs., Auc.

OTHER PRINT CABINETS
(arranged in alphabetical order by country)

NAME & ADDRESS OF INSTITUTION	NATURE & SIZE OF COLLECTION	STRENGTHS OF COLLECTION	ACCESS TO COLLECTION	NAME, TITLE & SPECIALTY OF CURATOR	REFERENCE LIBRARY	ACQUISITION POLICY & PURCHASE FUNDS	SALE OF DEACCESSIONS & DUPLICATES TO
Graphische Sammlung Albertina Augustinerstrasse 1 1010 Vienna, Austria	15c.–C.; vast (over 250,00)	OM–D., OM–R., 15–16c. Ger., 16–17c. Neth.	Gen. Pub.	Prof. Dr. Walter Koschatzky, Director	Extensive	N.A.; N.A.	N.A.
La Bibliothèque Royale Albert 1er (Cabinet des Estampes) 4, Blvd. de l'Empereur 1000 Bruxelles, Belgium	15c.–C.; 700,000	Flem., N.; OM.–D., OM.–R., Callot, Ruisdael, Piranesi	Gen. Pub.	Maria Mauquoy Hendrick, Curator of Prints	Extensive	N.A.; N.A.	N.A.
National Gallery of Canada Lorne Building Elgin Street Ottawa, Ontario, KIA OM8 Canada	c.–C. Eur., 20c. Amer., 19–20c. Canadian	19–early 20c. Eng., 1880–C. Canada, OM.–D., OM.–R., Van Dyck	Gen. Pub.	Douglas W. Druick, Curator of Prints (19c. Fr.); Rosemarie L. Tovell, Assistant Curator of Canadian Prints & Drawings (19c.–C.)	Yes	N.A.; N.A.	N.A.
The Royal Museum of Fine Arts (Department of Prints and Drawings) Sølvgade 1307 Copenhagen K, Denmark	14c.–C. Dan. & Eur.; 250,000 (incl. drawings)	OM–D., OM–R., Toulouse-Lautrec; 20c. Fr., 16c.–C. Danish	Gen. Pub.	Erik Fischer, Keeper; Inger Hjorth Nielsen, Assistant Keeper (Dan., Scan.); Ian Garff, Assistant Keeper (Dutch, Flem.)	36,000	C. (75%), OM. (few); annual fund varies	None
Ashmolean Museum, Department of Western Art (Print Room) Oxford OX 1ZPH England				Jan Wurtz, Assistant Keeper (Dutch, Flem.)			
British Museum (Department of Prints and Drawings) Great Russell St. London WC1B 3DG England	15c.–C.; vast	15–16c. It., 15c. Ger., 17c. Neth. & Flem., OM–D., OM–R., Van Dyck, Callot,	Stud. (application with intro. needed)	J. A. Gere, Keeper (It.); N. Turner, Assistant Keeper (It.); P. Hulton, Deputy	Extensive	OM., M., C., Q; N.A.	Dlrs., Collrs., Auc.

Institution	Collection (periods; size)	Strengths	Access	Staff / Curators	Library	Reproductions; Funding	Endowment
Fitzwilliam Museum Cambridge CB2 LRB England	All periods, Eur.; 100,000–150,000	15–18c. Ger., Fr., Eng., Neth., OM–D., OM–R., Callot, Nanteuil; Van Leyden, Jap.	Gen. Pub.	Eric Chamberlain, Assistant Keeper in charge of prints Flem., Ger., Swiss); A. Wilton, Assistant Keeper (Eng.); F. A. Carey, Assistant Keeper (M., C.)	1,000–1,500	C., M., OM.; None	None
Bibliothèque Nationale (Cabinet des Estampes) 58, rue Richelieu Paris, France	15–20c. Eur., post-1914, mostly School of Paris; 12,000,000	Goya, Daumier, Piranesi, OM–D., OM–R., Whistler, Manet, Goltzius	Gen. Pub. (no under-grads., intro. needed for foreigners)	Jean Adhémar, Conservator in Chief; Michel Melot, Françoise Woiment, Conservators	Extensive	C. (70%), Documentary (20%), OM. (10%); annual Endow., Found. bequests	N.A.
Fondation Custodia 121, rue de Lille Paris, France	16–18c. (some 19 & 20c.); (Coll. Frits Lugt, deposited on loan at Inst. Néerlandais); 30,000	16–17c. Neth., 17–18c. Fr., chiaroscuro woodcuts—all periods.; OM–R.	Gen. Pub. (intro. needed)	Carlos van Hasselt, Director; Maria van Berge, Curator of Drawings and Prints	Staff only	N.A.; N.A.	N.A.
Musée du Louvre Collection Edmond de Rothschild Palais du Louvre Place du Carrousel Paris, France	15–16c. Ger., 15c. It., 17c. Neth., 16–18c. Fr.; 40,000 & 500 illustrated books	16–17c. N.; OM–D., OM–R., Master ES, Nanteuil, LeClere, Cochin, Boucher	Schols., Studs., Collrs., Dlrs., (intro. needed)	Maurice Serullaz, Chief Curator (Delacroix); Françoise Viatte, Curator (It. drawings); Pierrette Jean-Richard, "documentaliste" (Boucher prints)	500 vols., sales cats.	None	N.A.
Musée du Petit Palais Collection Dutuit 1 Avenue Dutuit Paris, France 75008	Ger., Eng., Sp., Fr., It., Neth., Flem., 19–20 C. Fr.; Dutuit, 11,000, municipal, 2,000	17c. Neth., G; OM–D., OM–R., Goya, Nanteuil, Vuillard	Schols., Grad. Studs., Collrs., Dlrs. (intro. needed)	Adeline Cacan, Chief Curator; Marie Christine Boucher, Curator of Drawings & Prints		N.A.; N.A.	N.A.

OTHER PRINT CABINETS *(continued)*

NAME & ADDRESS OF INSTITUTION	NATURE & SIZE OF COLLECTION	STRENGTHS OF COLLECTION	ACCESS TO COLLECTION	NAME, TITLE & SPECIALTY OF CURATOR	REFERENCE LIBRARY	ACQUISITION POLICY & PURCHASE FUNDS	SALE OF DEACCESSIONS & DUPLICATES TO
Fondation Marguerite & Aimé Maeght Saint Paul, France 16570	M., illustrated books	20c. Fr., It., Sp., Flem., Can., Amer., Chagall, Miró	Schol., Grad. Studs. (by intro.)	Jean Louis Prat, Director (C.)	2,500 vols.	C., M.; N.A.	N.A.
Bauhaus-Archiv Schlosstrasse 1 Berlin Federal Republic of Germany (West Germany)	Bauhaus & earlier; 20c. applied arts; 1–2,000	20c. Ger., Kandinsky, Klee, Albers, Moholy-Nagy	Gen. Pub.	Hans M. Wingler, Director (20c.); Peter Hahn (Sociology of Art)	7–8,000 vols.	C., M.; no constant amount	N.A.
Germanische Nationalmuseum (Kupferstichkabinett) Kornmart 1 Nuremburg Federal Republic of Germany (West Germany)	15–19c. Ger.; 300,000 (includ. drawings)	cultural-historical; city plans & views, maps, portraits, playing cards, silhouettes	Gen. Pub.	Fritz Zink, National Curator (Gothic & Renaissance), Monika Heffels, Curator (Baroque, 20c.)	Yes	C., M., OM.; N.A.	N.A.
Hamburger Kunsthalle Glockengiesserwall 2 Hamburg Federal Republic of Germany (West Germany)	15c. to present; 60,000	OM. Ger., OM. It., OM–D., OM–R., 19– 20c. Ger., 20c. Fr.	Gen. Pub. (intro. needed)	Erhard Schaer; Hanna Hohl	Yes	C., M., OM., Museum funds	N.A.
Kunstmuseum Düsseldorf (Grafische Sammlung) Ehrenhof 5, 4 Düsseldorf Federal Republic of Germany (West Germany)	15–20c.; 45,000	16c. Ger., Exp., Düsseldorf	Gen. Pub.	Friedrich W. Heckmanns, Chief Curator; Dieter Graf (It. drawings); E. Bickel; K. Rectz	35,000 vols.	C. (70%), M. (10%), OM. (20%); 50,000 DM. annual Purch. fund, Indiv. fund, bequests vary	Do not
Staatliche Graphische Sammlung Meiserstrasse 10 8 Munich 2 Federal Republic of Germany (West Germany)	14–20c. Eur. & Ger.; 250,000	15–16c. Ger., 16–17c. Neth., Master E.S., OM–D., OM–R, 15c. Ger. woodcuts	Gen. Pub.	Dr. Herbert Pee, Director (20c. Graphics), Dr. Annegrit Schmitt, Oberkonservator (It. drawings); Dr. Wolfgang Werner, Oberkon...	15,000	C. (20%), M. (30%), OM. (50%); 200,000 DM. annual fund, 10,000 DM. Indiv. bequests...	Do not

				servator (Neth.); Dr. Dieter Kuhrmann, Konservator (15–16c. Ger.); Dr. Gisela Scheffler (19c. Ger.) Dr. Richard Harpath (16c. It. drawings)			
Staatliche Museen, Preussischer Kulturbesitz (Kupferstichkabinett) Arnimallee 23/27 1 Berlin Federal Republic of Germany (West Germany)	15c.–C. Eur.	Gen. Pub.	15–16c. Ger., Neth., It., OM–D., Cranach, Schongauer, OM–R., Goya, 15–16c. illus. books	Prof. Dr. M. Winner, Director (16–17c. Neth. & It.); Dr. F. Anzelewsky, Haupt Curator (15–16c. Neth. & Ger.); Dr. P. Dreyer, Ober-Curator (17–18c. It.); Dr. H. Mielker, Assistant (16–17c. Neth.); Dr. A. Dückers, Assitant (19–20c.)	3,000	C., M., OM.; annual fund N.A.	N.A.
Staatsgalerie Stuttgart (Graphische Sammlung) Konrad-Adenauer-Strasse 32 D-7000 Stuttgart 1 Federal Republic of Germany (West Germany)	15–20c.; 300,000 sheets	Gen. Pub.	16–19c. Ger., 20c. Eng., caricatures, posters, Wurttembergica, Exp., Bauhaus, Pop, 19–20c. Fr. illus. books, OM–D; P., Daumier	Dr. Gunther Thiem, Hauptkonservator (16–20c. It.); Dr. Heinrich Geissler, Hauptkonservator (16–18c.), Dr. Ulricke Gauss (19c.)	6,000 vols.	C., M. (10%); OM. (10%); 60,000 DM. annually, 200,000 DM. Endow.	N.A.
Staatliche Kunstsammlungen Dresden (Kupferstichkabinett) Guntzstrasse 34 8019 Dresden, D.D.R. German Democratic Republic (East Germany)	15c.–C., separate royal collection 1560–1720; small non-Eur.; 500,000	Gen. Pub.	15–16c. Ger., 17c. Neth., 18c. Eng., 19c. Ger., 19c. Fr., 20c. Ger., OM–D., OM–R., Goya, 18c. posters	Werner Schmidt, Director (19c. Ger., 20c. Fr. & It.); Glaubrecht Friedrich, Curator (15–18c. Ger.); Christian Dittrich, Curator (15–18c. Neth.)	3,600 vols.	C. (87%), M. (10%), OM. (3%); 10–20,000 DM., Endow. (fractional); Found. bequests (rare)	None

OTHER PRINT CABINETS *(continued)*

NAME & ADDRESS OF INSTITUTION	NATURE & SIZE OF COLLECTION	STRENGTHS OF COLLECTION	ACCESS TO COLLECTION	NAME, TITLE & SPECIALTY OF CURATOR	REFERENCE LIBRARY	ACQUISITION POLICY & PURCHASE FUNDS	SALE OF DEACCESSIONS & DUPLICATES TO
Staatliche Museen zu Berlin (Kupferstichkabinett) Bodestrasse 1/3 102 Berlin, D.D.R. German Democratic Republic (East Germany)	Part of pre-war coll. of Berliner Kupferstich-kabinett), continental & Ger.; 135,000	17–20c. Ger. & Fr., 17–18c. Neth., 20c. Rus., Scan., Cuban	Gen. Pub. (intro. needed for groups)	Hans Ebert, Director (Classical); Sigrid Hinz, Vice-Director (Romantic); Werner Schade, Curator (Renaissance)	11,000 vols.	C. (50%); M. (40%); OM. (10%); N.A.	None
Biblioteca Nazionale Centrale Piazza Cavalleggeri 1 Florence, Italy	15c.–C. (incl. books & manuscripts); vast	16–19c. It., Fr., Eng., Ger.	Gen. Pub. (application & intro. needed)	Borroni Salvadori, Fabia (history of prints & illus. books)	Extensive	N.A.; N.A.	N.A.
Gabinetto Disegni e Stampe Degli Uffizi Via Della Ninna, 5 Florence, Italy	50,000	Core collection Medici-Lorenese prints & drawings	Gen. Pub. (intro. needed)	Anna Forlani Tempesti, Director; Anna Maria Petriolo Tofani, Vice-Director	3,000 vols.	M., OM.; N.A.	N.A.
Civica Raccolta Delle Stampe Achille Bertarelli Castello Sforzesco Milan, Italy 20121	art & documentary, 9c.–C.; 600,000	16–20c. It., city maps & views, historical	Gen. Pub.	Clelia Alberici, Director (Neo-classical, Milan); Arch. G. Lise, Conservator (prints related to archeology)	Yes	C., M., OM.; N.A.	Dlrs., Collrs.
Rijksmuseum (Print Cabinet) Stadhouderskade 42 Amsterdam, Netherlands	15–20c.; 1,000,000	Neth., Flem., OM–D., OM–R., VanLeyden	Gen. Pub.	P. Schatborn, Curator (OM–R. & school); L.C.J. Frerichs, Curator (It. drawings); D. de Hoop Scheffer, Curator (graphic arts history); J. M. de Groot, Curator (19c.)	Extensive	O.M.; annual fund, Endow.	None

Institution	Holdings	Scope	Access	Curator / Staff	Museum Library	Funding / Collection	Acquisition
Stedelijk Museum Paulus Potterstraat 13 Amsterdam, Netherlands	M., 15,000 (inc. drawings)	20c. Neth., Eur., Amer.	Gen. Pub.	J. van Loenan Martinet, Curator in charge of Print Room (M.)		C., M.; annual fund	None
Biblioteca National (Seccion de Estampes) Paseo de Calvo Sotelo 20 Madrid 1, Spain	16–20c.; 250,000	16–17c. Sp., It., Ger., Neth., Goya, OM–R., Piranesi, Callot	Schols., Grad. Studs., Collrs., (intro. needed)	Elena Paez Rios, Curator; Consuelo de Angulo, Conservator; Maria Luisa Molina, Technician	18,000 vols.	C., M., OM.; N.A.	N.A.
Nationalmuseum Stockholm (Print Room) S. Blasieholmshamnen Box 16, 176, S 103 24 Stockholm, Sweden	15c.–C. (weak in 15c.); 150,000	Fr., Swed., OM–R., Callot, Piranesi	Gen. Pub.	Per Bjurtsrom, Curator (Swed. & It.); Borje Magnusson, Assistant Curator (Swed., Neth. & Flem.); Thomas Hall, Assistant Curator (architectural drawings)	Yes	C. (80%), M. (10%); OM. (10%); 42,000 sw Kr. annually for Swed. & 66,000, OM. & foreign prints & drawings	None
Kupferstichkabinett der Oeffentlichen Kunstsammlung St. Albangraben 16, Basel Switzerland	15c.–C.	15–20c. Ger., illustrated books	Gen. Pub.		Largest in Switzerland	C. (80%), M. (15%); OM (5%); N.A.	N.A.
Kunstmuseum Bern Hodlerstrasse 12 3011 Bern, Switzerland	OM., 19 & 20c.; 20,000	18c. Switz. (minor masters), Ger., Flem., Vlaminck, Klee	Gen. Pub.	Katalin von Walterskirchen Curator, Graphics Cabinet; Jurgen Glaesemar, Curator, Paul Klee Found. (graphics)	Yes	C., M., OM.; Found. bequests vary, Indiv. bequests vary	Dlrs; Collrs.; Auc.
Graphische Sammlung der Eidgenossichen Hochschule Zurich Rämisterasse 101 CH-8006 Zurich, Switzerland	15–20c.; over 100,000	OM–D., OM–R., Goya, Piranessi, 19–20c. Switz.	Gen. Pub.	Erwin Gradmann	Yes	C., M., OM.; N.A.	N.A.

Appendix Three

Where Prints
Are Talked About

Though many Print People are reluctant to talk about monetary and investment value, print curators, auctioneers and their staffs, knowledgeable dealers, and well-known collectors are normally responsive to questions and generous with opinions and advice. Major auction sales, such as the ones that take place each May and June in New York, Munich, Hamburg, and Bern, provide assembly grounds for print curators, dealers, and collectors from the United States and Europe, and much can be learned from these people during leg-stretchings outside the salesroom, breaks in the course of the auction, and midday and evening social hours.

Print clubs in America and Europe also provide facilities where prints may be discussed and viewed. Paris has over a half dozen; almost every large city in Germany has its *Kunstverein* (art club); and London has a venerable society—the Print Collector's Club, associated with the Royal Society of Painter-Etchers and Engravers, founded in 1921. Most of the print clubs in the United States have ties with the local art museum and require membership in that institution, as well as local residency, for membership in the club.

The oldest and most active print clubs in America are the Print Club of Philadelphia, organized in 1915, and the Print Club of Cleveland, formed in 1919. The Philadelphia Print Club, which accepts out-of-town members, occupies a charming 19th-century townhouse, where it stages exhibitions of contemporary prints and sells prints consigned to it. It has a sizable full-time staff that renders advice or recommends an appropriate professional for answers to questions. It also stages a juried print competition annually and manages an etching workshop. The Print Club of Cleveland, affiliated with the Cleveland Museum of Art, is perhaps best known outside Cleveland for the prints that it has published and offered to members: among others, a Martin Lewis drypoint (1929), Matisse etching (1934), Laboureur intaglio (1935), Marsh lithograph (1947), Grosz lithograph (1949), Feininger woodcut (1958), Vasarely serigraphs (1967 and 1968), and Hamaguchi mezzotint (1973). Both the club and its individual members have presented numerous substantial gifts to the print room of the Cleveland Museum. The Philadelphia and Cleveland Print Clubs, as well as the other print clubs in America, in addition to commissioning and publishing new editions for members and making gifts to museums, invite guest lecturers, hold meetings, conduct semi-

nars and study sessions, show films, organize tours of galleries and pub-
lic and private print collections at home and out of town, make books
available at discounts, mount exhibitions, and conduct print auctions and
swap sessions. Most of the clubs also issue a periodic bulletin or newslet-
ter; the *Newsletter* of the Graphic Arts Council of the Los Angeles
County Museum of Art is among the most informative.

There are print clubs in the following American cities:

BALTIMORE—The Print and Drawing Society of the Baltimore Museum of Art, Art
Museum Drive, Baltimore, Maryland 21218

CINCINNATI—Cincinnati Print and Drawing Circle, Cincinnati Art Museum, Eden
Park, Cincinnati, Ohio 45202

CLEVELAND—The Print Club of Cleveland, The Cleveland Museum of Art, 1150
East Boulevard, Cleveland, Ohio 44106

DETROIT—The Drawing and Print Club, Founders Society, Detroit Institute of
Arts, 5200 Woodward Avenue, Detroit, Michigan 48202

KANSAS CITY—The Print Collectors of the Friends of Art, Nelson Gallery, Atkins
Museum, 4525 Oak Street, Kansas City, Missouri 64111

LOS ANGELES—The Graphic Arts Council of the Los Angeles County Museum of
Art, 5905 Wilshire Boulevard, Los Angeles, California 90036

The Friends of the Graphic Arts at UCLA, Grunwald Center for the Graphic
Arts, University of California at Los Angeles, 405 Hilgard Avenue, Los Ange-
les, California 90024

MADISON—Madison Print Club, Madison Art Center, 720 East Gorham,
Madison, Wisconsin 53703

NEW YORK—The Graphic Arts Council of New York, P.O. Box 405, Lenox Hill
Station, New York, New York 10021

PHILADELPHIA—The Print Club, 1614 Latimer Street, Philadelphia, Pennsyl-
vania 19103

SAN FRANCISCO—Bay Area Graphic Arts Council, California Palace of the
Legion of Honor Museum, Lincoln Park, San Francisco, California 94121

The Print Council of America was founded by Lessing J. Rosenwald
in 1956. During the first 15 years or so of its existence, it was comprised
of some 20 of the chief print curators in the United States and carried on
an active program for the promotion and stimulation of public interest in
and appreciation of "original prints." During this phase of its life the
Print Council was much occupied with the question of "originality" in
prints and companion issues—forgeries, deceptive reproductions, and
abusive market practices. In this connection it distributed some 100,000
copies of a booklet entitled *What Is an Original Print?* and certified print
dealers who agreed to subscribe to its code of fair practices. The Print
Council closed its New York office in 1973, and today functions as a
loosely knit association of some 60 print curators and conservators. It
holds a meeting (panel discussions, lectures, review of scholarly papers,
etc.) each year in a different city, portions of which are open to the
public, disseminates information among its members, and engages in
other scholarly pursuits, such as the taking of a census of all 15th-cen-
tury prints in American collections and devising a new definition for the
term "original print."

Henri Matisse, "Intérieure, la Lecture" ("Interior, Read-
ing"). Lithograph, 1965 (Pl. 65; Pully 114). 270 x 190
mm; 10⅝" x 7½". (COURTESY OF REISS-COHEN INC.)

Appendix Four

Bibliography:
A Comprehensive
and Definitive Catalog
of Publications on Prints
by Familiar Artists
and Related Matters

The literature on prints is bountiful. It includes periodicals, the commercial literature of dealers, publishers, and auction firms, and the books and other publications issued by book publishers, museums, and universities.

Apart from the art magazines published in the United States, England, France, and Germany, such as *Art News*, *Art in America*, *Artforum*, *Apollo*, *Studio International*, *Arts Review*, *l'Oeil*, *Connaissance des Arts*, *Magazin in Kunst*, and *Kunst Welt*, all of which from time to time devote pages to prints and printmaking, there are three principal periodicals exclusively devoted to prints:

The Print Collector's Newsletter. Bimonthly. 205 East 78 St., New York, N.Y. 10021, U.S.A.
Nouvelles de l'estampe. Bimonthly. Comité Nationale de la gravure française, 58, rue de Richelieu, Paris 75002, France
Print Collector (*Il conoscitore di stampe*). Bimonthly. Salamon e Agustoni editori s.r.1., Via Montenapoleone 3, 20121 Milan, Italy

Each of these publications, especially the first two, have extremely useful articles about prints, catalogues raisonnés of prints, and timely information about comings and goings in the Print World, museum and gallery exhibitions and catalogs, new graphics publications, recent books and other publications, and recent sales prices.

The outpouring of exhibition catalogs, price lists, stock catalogs, prospectuses, and documentation sheets from dealers and print publishers, and the sales catalogs and price lists of the major auction firms are full of

much historical, critical, and market information useful to both the professional and the novice. The exhibition catalogs of certain dealers, such as Dorothy Carus of New York, Robert Johnson of Chicago, P. & D. Colnaghi of London, Hubert Prouté and Pierre Michel of Paris, C. G. Boerner (Ruth-Maria Muthmann) of Düsseldorf and Art Ancien of Zurich, to name only a handful, and the auction catalogs of Kornfeld und Klipstein of Bern normally exhibit a great deal of care and scholarship, and the fact sheets issued by such print publishers as Gemini G.E.L., Tyler Workshop, and Petersburg Press provide indispensable documentation on contemporary prints. Commercial literature that is especially noteworthy for its presentation of new information or its organization of old has therefore been included in the Bibliography.

The aim of the bibliographer was selectively to list, with some qualifications, all the books and other publications that were good introductions for the unknowledgeable, expansions for the experienced, and vital tools for the professional. Although through both choice and necessity a number of works in French and German have been included, texts in English have been favored wherever possible. The Bibliography has been limited to texts concerning those artist-printmakers of the West that are relatively familiar: those of Europe and the Americas whose graphic works are generally found in commerce at the present time. (Japanese Ukiyo-e and other Japanese printmakers of the 17th to 19th centuries are outside the scope of this book and have thus been excluded.) As far as catalogues raisonnés of graphic works, monographs on artist-printmakers, and other texts on the graphic works of artists or groups of artists are concerned, the Bibliography has been confined to the most definitive and up-to-date references and those that furnish either information or illustrations not found in the most definitive source. Anyone using the Bibliography will discover that the recorded information about the graphic works of an artist may in one case be scholarly and exhaustive (e.g., Kandinsky); in another case be sparse or unreliable (e.g., Raoul Dufy); in another, lack illustrations of the prints described (e.g., Pechstein and Schmidt-Rottluff); and in yet another, be nonexistent (e.g., Dali and Foujita). No catalogue raisonné can possibly be definitive until an artist has ceased working, so that books drafted in the middle of an artist's career (e.g., Rauschenberg) await updating—and a number of them have never been supplemented. All things considered, the Bibliography represents the only attempt extant to provide the best sources of readily available information about prints, the history of prints and virtually any print of note that has ever been published.

The Bibiography is divided into the following sections:

I. PUBLICATIONS (Other than Catalogues and Monographs) ABOUT PRINTS AND THE HISTORY OF PRINTS, 407
 A. General
 B. Contemporary Prints (post-1950)

C. Posters
D. Print Collecting
E. Print Publishing, Print Workshops, and the Print Market
F. Printmaking
G. Print Connoisseurship
H. Care and Conservation of Prints

II. CATALOGUES AND MORE SPECIALIZED TEXTS: OLD
MASTER PRINTS, 413
A. General Scholarly References and Treatises
B. Sets of Catalogues Raisonnés and Basic Sources
C. Standard Monographs and Catalogues on Specific Artists

III. CATALOGUES AND MORE SPECIALIZED TEXTS: MOD-
ERN (1850–1950) AND CONTEMPORARY (POST-1950)
PRINTS, 419
A. General Scholarly References
B. Catalogues and Treatises on Modern Illustrated Books
(*Livres de Peintres*)
C. Standard Monographs and Catalogues on Specific Artists

IV. DEALER AND GALLERY DIRECTORIES AND PRICE IN-
DEXES, 438

V. BIBLIOGRAPHIES, 438

I. PUBLICATIONS (Other than Catalogues and Mono-
graphs) ABOUT PRINTS AND THE HISTORY OF PRINTS
A. General

ADHÉMAR, JEAN. *La Gravure Originale au XX^e Siècle*. Paris: Editions Aimery Somogy, 1967.
———; Hébert, Michele; Lethève, Jacques. *Les Estampes*. Paris: Librairie Gründ, 1973.
Archives of American Art, Smithsonian Institution. Microfilm transcripts of interviews
with numerous American artist-printmakers, print dealers, and curators. Offices in Bos-
ton, Detroit, New York, San Francisco, and Washington, D.C.
Art News magazine. Special Prints Issues: Jan. 1972, March 1974, March 1975, Sept. 1976.
Auction magazine. *Prints: A Primer for Collectors:* Vol. IV, No. 7 (March 1971).
AVATI, M. *Album des Peintres-Graveurs Français, 80^e anniversaire*. Paris, 1969.
BAILLY-HERZBERG, JANINE. *L'eau-forte de Peintre au Dix-Neuvième Siècle: La Société des Aquafor-
tistes 1862–1867*. 2 vols. Paris: Léonce Laget, 1972.
BASKIN, LEONARD. *Five Addled Etchers*. Hanover, N.H.: Dartmouth Publications, 1969.
BRION, MARCEL. *Quatre Siècles de Surréalisme: L'Art Fantastique dans la Gravure*. Paris: Pierre
Belford, 1973.
BUCHHEIM, LOTHAR-GÜNTHER. *The Graphic Art of German Expressionism*. Buchheim Verlag
Faldafing, 1960.
CASTLEMAN, RIVA. *Prints of the Twentieth Century: A History*. New York: Museum of Modern
Art, 1976.
CLISBY, ROGER D. *19th and 20th Century Prints and Drawings from the Baltimore Museum of
Art*. Sacramento: E. B. Crocker Art Gallery, 1973.

Cubist Prints from the Collection of Dr. & Mrs. Abraham Melamed. Madison, Wis.: Elvehjem Art Center, University of Wisconsin, 1972.

DELTEIL, LOŸS. *Manuel de l'Amateur d'Estampes des XIX^e et XX^e Siècles.* Supplement. *Reproductions d'Estampes des XIX^e et XX^e Siècles.* 4 vols. Paris: Dorbon-Ainé, 1926.

Department of Prints and Drawings, Philadelphia Museum of Art. *Carl Zigrosser Curatorial Retrospective.* Philadelphia, 1964.

DONSON, THEODORE B. *Uncommon Prints.* New York: Theodore B. Donson Ltd., 1977.

GETLEIN, FRANK and DOROTHY. *The Bite of the Print.* New York: Clarkson N. Potter, 1963.

GILMOUR, PAT. *Modern Prints.* London: Studio Vista, 1970.

HAAB, ARMIN. *Mexican Graphic Art.* English edition. Switzerland: C. C. Palmer, 1957.

HAYTER, STANLEY WILLIAM. *About Prints.* London: Oxford University Press, 1962.

HIND, ARTHUR M. *A History of Engraving and Etching.* London and New York, 1935. Reprint. New York: Dover Publications, 1963.

HOFSTÄTTER, HANS H. *Jugendstil Druckkunst.* Baden-Baden: Holle-Verlag, 1968.

IVES, COLTA FELLER. *The Great Wave: The Influence of Japanese Woodcuts on French Prints.* New York: Metropolitan Museum of Art, 1974.

IVINS, WILLIAM M., JR. *Notes on Prints.* Cambridge: M.I.T. Press, 1967 (first published, 1930).

——. *Prints and Books: Informal Papers.* New York: Da Capo Press, 1969.

——. *Prints and Visual Communication.* New York, 1939. Cambridge: M.I.T. Press, 1953. Reprint. New York: Da Capo Press, 1969.

JOHNSON, DIANE and SCHRADER, J. L. *1450–1550: The Golden Age of Woodcut. The Woodcut Revival 1800–1925.* Lawrence, Kan.: University of Kansas Museum of Art, 1968.

KOSCHATZKY, WALTER. *Die Kunst der Graphik.* Salzburg, 1972.

LARAN, JEAN. *L'Estampe.* 2 vols. Paris: Presses Universitaires de France, 1959.

Les Plus Belles Gravures du Monde Occidental 1410–1914. Amsterdam, Munich, Paris, Vienna print cabinets, 1966.

LIEBERMAN, WILLIAM S. "Prints" in *German Art of the Twentieth Century.* New York: Museum of Modern Art, 1957.

MAN, FELIX H. *Artists' Lithographs.* New York: G. P. Putnam's Sons, 1970.

MAYOR, A. HYATT. *The Metropolitan Museum Guide to the Collections—Prints.* New York: Metropolitan Museum of Art, 1964.

——. *Prints and People.* New York: Metropolitan Museum of Art, 1971.

Meisterwerke der Graphik von 1800 bis zur Gegenwart [Eberhard W. Kornfeld collection]. Chur, Switzerland: Bündner Kunstmuseum, 1976.

MELLERIO, ANDRÉ. *La Lithographie originale en couleurs.* Paris: L'Estampe et l'affiche, 1898.

MELOT, MICHEL. *L'estampe impressioniste.* Paris: Bibliothèque Nationale, 1974.

MÖHLE, HANS. *Das Berliner Kupferstichkabinett.* Berlin: Walter de Gruyter & Co., 1963.

MONGAN, ELIZABETH. *Rosenwald Collection: An Exhibition of Recent Acquisitions.* Washington, D.C.: National Gallery of Art, 1950.

Museum of Graphic Art. *American Printmaking: The First 150 Years.* Washington, D.C.: Smithsonian Institution Press, 1972.

Museum of Modern Art. *The Abby Aldrich Rockefeller Print Room.* New York, 1949. New York, 1958.

Nouvelles de l'estampe. Bimonthly. No. 1: Jan.–Feb. 1972. Paris: Comité national de la gravure français, 58 rue de Richelieu, 75002 Paris.

PASSERON, ROGER. *French Prints of the 20th Century.* New York: Praeger, 1970.

PETERDI, GABOR. *Great Prints of the World.* New York: Macmillan, 1969.

Pratt Graphics Center. *Artist's Proof* (periodicals and *The Annual of Prints and Printmaking* through Vol. XI, 1971). *A Collector's Edition of the First Eight Issues.* New York: Pratt Graphics Center and New York Graphics Society, 1971.

Print Collector. Bimonthly. No. 0; Autumn–Winter 1972. Milan: Salamon & Agustoni editori s.r.l., Via Montenapoleone 3, 20121 Milan, Italy.

Print Collector's Newsletter. Bimonthly. Vol. I, No. 1: Mar.–April 1970. New York: Print Collector's Newsletter, Inc., 205 East 78 Street, New York, N.Y. 10021.

Print Collector's Quarterly. Vols. 1–30 from 1911–1951. Reprints. Millwood, N.Y.: Kraus-Thomson Org. Ltd.

Print Review. Annual. No. 1: 1972. New York: Pratt Graphics Center and Kennedy Galleries, Inc.
Prints: A Handbook to Accompany the Exhibition. Storrs: University of Connecticut Museum of Art, 1972.
REESE, ALBERT. *American Prize Prints of the 20th Century.* New York: American Artists Group, 1949.
ROGER-MARX, CLAUDE. *La Gravure Originale au XIX^e Siècle.* Paris: Editions Aimery Somogy, 1962.
———. *La Gravure Originale en France de Manet à Nos Jours.* Paris: Editions Hypérion, 1939. New York and London (English): Hyperion Press, 1939.
SACHS, PAUL J. *Modern Prints and Drawings.* New York: Alfred A. Knopf, 1954.
SHIKES, RALPH E. *The Indignant Eye.* Boston: Beacon Press, 1969.
SOTRIFFER, KRISTIAN. *Modern Graphics: Expressionism and Fauvism.* New York: McGraw-Hill, 1972.
———. *Printmaking: History and Technique.* New York: McGraw-Hill, 1968.
STUBBE, WOLF. *Graphic Arts in the Twentieth Century.* New York: Praeger, 1963.
WEBER, WILHELM. *A History of Lithography.* London: Thames & Hudson, 1966.
WECHSLER, HERMAN J. *Great Prints & Printmakers.* New York: Harry N. Abrams, 1967.
WEISBERG, GABRIEL P. *Social Concern and the Worker: French Prints from 1830–1910.* Salt Lake City: Utah Museum of Fine Arts, 1974.
WILDER, F. L. *How to Identify Old Prints.* London: G. Bell and Sons, 1969.
ZIGROSSER, CARL. *The Appeal of Prints.* Philadelphia: Leary's Book Co., 1970.
———. *The Book of Fine Prints.* New York: Crown, 1956. 2d rev. ed., 1974.
———. *The Expressionists: A Survey of Their Graphic Art.* New York: George Braziller, 1957.
———. ed. *Prints.* (13 essays.) New York: Holt, Rinehart and Winston, 1962.

B. Contemporary Prints (post-1950)

(*See also* Section E.)

Amerikanische und Englische Graphik der Gegenwart. Hanover: Kestner-Museum, 1974.
Arts Council of Great Britian. *New Multiple Art.* London, 1970.
BLAKEMORE, FRANCES. *Who's Who in Modern Japanese Prints.* New York and Tokyo: John Weatherhill, 1975.
CASTLEMAN, RIVA. *Contemporary Prints.* New York: Viking Press, 1973.
———. *Modern Art in Prints.* New York: Museum of Modern Art, 1973.
FIELD, RICHARD S. *Recent American Etching.* Middletown, Conn.: Davison Art Center, 1975.
Fourteen Big Prints. London: Bernard Jacobson, 1972.
GILMOUR, PAT. *Graveurs Anglais Contemporains.* Geneva: Cabinet des Estampes, Musée d'Art et d'Histoire, 1974.
———. *Modern Prints.* New York: Dutton/Vista Picturebacks, 1970.
HASLEM, JANE. *The Innovators: Renaissance in American Printmaking.* Washington, D.C.: Haslem Fine Arts, 1973.
Heckscher Museum. *Artists of Suffolk County: Part 6, Contemporary Prints.* Huntington (N.Y.), 1972.
JOHNSON, DIANA L. *Selection III: Contemporary Graphics from the Museum's Collection.* Providence: Rhode Island School of Design, 1973.
JOHNSON, ELAINE L. *Contemporary Painters and Sculptors as Printmakers.* New York: Museum of Modern Art, 1966.
JOHNSON, UNA E. *Ten Years of American Prints: 1947–1956.* New York: Brooklyn Museum, 1956.
LYNTON, NORBERT. *Order and Experience: A Guide to the Exhibition of American Minimialist Prints.* London: Arts Council of Great Britain, 1975.
Print Council of America. *American Prints Today / 1959.* New York, 1959.
SOLOMON, ELKE. *Oversize Prints.* New York: Whitney Museum, of American Art, 1971.
TANCOCK, JOHN L. *Multiples—The First Decade.* Philadelphia: Philadelphia Museum of Art, 1971.

Tousley, Nancy. *Prints: Bechner LeWitt Mangold Marden Martin Renouf Rockburne Ryman.* Toronto: Art Gallery of Ontario, 1976.

C. Posters

Abdy, Jane. *The French Poster: Chéret to Cappiello.* London: Studio Vista, 1969.

Barnicoat, John. *A Concise History of Posters.* New York: Harry N. Abrams, 1969.

Cirker, Hayward and Blanch. *The Golden Age of the Poster.* New York: Dover Publications, 1971.

Gallo, Max. *The Poster in History.* Feltham, England: Hamlyn, 1974.

Hillier, Bevis. *100 Years of Posters.* New York: Harper & Row, 1972.

———. *Posters.* New York: Stein & Day, 1969.

Kossatz, Horst-Herbert. *Ornamental Posters of the Vienna Secession.* London: Academy Editions, 1974. New York: St. Martin's Press, 1974.

Maindron, Ernest. *Les Affiches Illustrées.* 2 vols. Paris, 1896.

Malhhotra, Ruth, and Thon, Christina. *Das Frühe Plakat in Europa und den USA.* Vol. 1. Berlin: Gebr. Mann Verlag, 1973.

Margolin, Victor. *American Poster Renaissance.* New York: Watson-Guptill Publications, 1975.

Mourlot, Fernand. *Les affiches originales des Maîtres de l'Ecole de Paris.* Paris: André Sauret, 1959. New York (English—*Art in Posters*): George Braziller, 1959.

The Poster. 5 vols. London, 1898–1901.

Roger-Marx, Claude. *Les Maîtres de l'Affiche.* 5 vols. Paris, 1896–1900.

Wember, Paul. *Die Jugend der Plakata 1887–1917.* Krefeld: Scherpe, 1961.

Wong, Roberta. *American Posters of the Nineties.* Boston: Boston Public Library, 1974.

D. Print Collecting

Bachler, Karl, and Dünnebier, Hans. *Bruckmann's Handbuch der modernen Druckgraphik.* Munich: Verlag F. Bruckmann F. G., 1973.

Buchsbaum, Ann. *Practical Guide to Print Collecting.* New York: Van Nostrand Reinhold Co., 1975.

Foster, Donald L. *Prints in the Public Library.* Metuchen (N.J.): Scarecrow Press, 1973.

Hayden, Arthur, and Blunt, Cyril G. E. *Chats on Old Prints.* London: Benn, 1957.

Hughes, Therle. *Prints for the Collector: British Prints from 1500 to 1900.* New York: Praeger, 1971.

Hitchings, Sinclair; Lewis, R. E.; Vershbow, Arthur. *Print Collecting Today—A Symposium.* Boston: Boston Public Library, 1969.

Pink, Marilyn. *How to Catalogue Works of Art.* Los Angeles: Museum Systems, 1972.

Rosenwald, Lessing G. *Recollections of a Collector.* Jenkintown (Pa.): The Alverthorpe Gallery, 1976.

Rouir, Eugène. *L'Estampe: Valeur de Placement.* Paris: Guy le Prat, 1973.

Salamon, Fernando. *A Collector's Guide to Prints and Printmakers from Dürer to Picasso.* New York: American Heritage Press, 1972.

Shapiro, Cecile, and Mason, Lauris. *Fine Prints: Collecting, Buying & Selling.* New York: Harper & Row, 1976.

Sharp, Ellen. *Detroit Collects Prints and Drawings.* Detroit: Wayne State University Press, 1972.

Weitenkampf, Frank. *The Quest of the Print.* New York: Charles Scribner's Sons, 1932.

Zigrosser, Carl, and Gaedhe, Christa M. *A Guide to the Collecting and Care of Original Prints.* New York: Crown Publishers, 1965.

E. Print Publishing, Print Workshops, and the Print Market

Allen, Virginia. *Tamarind: Homage to Lithography.* New York: Museum of Modern Art, 1969.

Austellung 1864–1964. Bern: Kornfeld und Klipstein, 1964.

Bachler, Karl, and Dünnebier, Hans. *Bruckmann's Handbuch der modernen Druckgraphik.* Munich: Verlag F. Bruckmann F. G., 1973.

BASKETT, MARY WELSH. *American Graphic Workshops.* Cincinnati: Cincinnati Art Museum, 1968.

BLOCH, MAURICE E. *Tamarind: a Renaissance of Lithography.* International Exhibitions Foundation, 1971.

CASTLEMAN, RIVA. *Technics and Creativity: Gemini G.E.L.* New York: Museum of Modern Art, 1971.

Cimaise No. 113–114. Paris, 4th quarter, 1973.

Die Kunst der Katalogbeschreibung. Düsseldorf: C. G. Boerner, 1973.

FELDMAN, FRANKLIN, and WEIL, STEPHEN E. *Art Works: Law, Policy, Practice.* New York: Practising Law Institute, 1974.

GALERIE NIERENDORF. *1920–1970: Fünfzig Jahre Galerie Nierendorf.* Berlin, 1970.

Gallery Facility Planning for Marketing Original Prints. Los Angeles: Tamarind Lithography Workshop, 1967.

GOLDSMITH, JOHN. *A Management Study of an Art Gallery.* Los Angeles: Tamarind Lithography Workshop, 1966.

GOODMAN, CALVIN J. *A Study of the Marketing of the Original Print.* Los Angeles: Tamarind Lithography Workshop, 1964.

———. *Acquiring an Inventory of Original Prints.* Los Angeles: Tamarind Lithography Workshop, 1968.

JOHNSON, UNA. *Ambroise Vollard, Editeur.* New York: Wittenborn & Co., 1944.

KNIGIN, MICHAEL, and ZIMILES, MURRAY. *The Contemporary Lithography Workshop Around the World.* New York: Van Nostrand Reinhold Co., 1974.

LARSON, PHILIP. *Prints from Gemini G.E.L.* Minneapolis: Walker Art Center, 1974.

"L'enluminure de pochoir" in *Nouvelles de l'estampe* No. 22. Paris, May–June 1975.

MOURLOT, FERNAND. *Souvenirs et portraits d'artistes.* Paris: Alain Mazo, 1975.

"Répertoire des Editeurs d'Estampes Français 1972" in *Nouvelles de l'estampe* No. 6. Paris, Nov.–Dec. 1972.

"Répertoire des Imprimeurs de Gravures en France" in *Nouvelles de l'estampe* No. 16. Paris, July–Aug. 1974.

"Répertoire des Imprimeurs Lithographes en France" in *Nouvelles de l'estampe* No. 24. Paris, Nov.–Dec. 1975.

Spencer, Charles. *A Decade of Printmaking.* London: Academy Editions, 1973. New York: St. Martin's Press, 1973.

VOLLARD, AMBROISE. *Recollections of a Picture Dealer.* Boston: Little, Brown & Co., 1936.

F. Printmaking

ANTREASIAN, GARO Z., and ADAMS, CLINTON. *The Tamarind Book of Lithography: Art and Techniques.* New York: Harry N. Abrams, 1971.

BIEGELEISEN, J. I. *Screen Printing.* New York: Watson-Guptill Publications, 1971.

BRUNNER, FELIX A. *A Handbook of Graphic Reproductive Processes.* New York: Hastings House, 1962. 3d ed., 1968.

DANIELS, HARVEY. *Printmaking.* New York: Viking Press, 1971.

FIELD, RICHARD S., and SPERLING, LOUISE. *Offset Lithography.* Middletown (Conn.): Davison Art Center, 1973.

HAYTER, STANLEY WILLIAM. *New Ways of Gravure.* London: Oxford University Press, 1966.

HELLER, JULES. *Printmaking Today: A Studio Handbook.* New York: Holt, Rinehart & Winston, 1972.

LOCHE, RENÉE. *La Lithographie.* Geneva: Editions de Bonvent, 1971.

PETERDI, GABOR. *Printmaking Methods Old and New.* New York: Macmillan Company, 1971.

RHEIN, ERICH. *The Art of Print Making.* New York: Van Nostrand Reinhold Co., 1966. Ravensburg (German): Otto Maier Verlag, 1956.

ROSS, JOHN, and ROMANO, CLARE. *The Complete Printmaker.* New York: Free Press (Macmillan Company), 1972.

ROTHENSTEIN, MICHAEL. *Relief Printing.* New York: Watson-Guptill Publications, 1970.

RUMPEL, HEINRICH. *Wood Engraving.* Geneva: Editions de Bonvent, 1973.

RUSS, STEPHEN. *A Complete Guide to Printmaking.* New York: Viking Press, 1975.

ZIGROSSER, CARL, and GAEHDE, CHRISTA M. *A Guide to the Collecting and Care of Original Prints.* New York: Crown Publishers, 1966.

G. Print Connoisseurship

1. GENERAL

IVINS, WILLIAM M., Jr. *How Prints Look.* New York: Metropolitan Museum of Art, 1943. Reprint. Boston: Beacon Press, 1968.

FIELD, RICHARD S. *Everything you always wanted to know about prints. . . .* Middletown (Conn.): Davison Art Center, 1973.

LUGT, FRITS. *Les marques de collections de dessins et d'estampes.* Amsterdam: Vereenigde Druckkerijen, 1921. Reprint. San Francisco: Alan Wofsy Fine Arts, 1975. Supplement. The Hague, 1956.

2. PAPER

FIORE, QUENTIN. "Paper" in *Industrial Design,* Nov. 1958. New York: Whitney Publications Inc. Reprint. Los Angeles: Tamarind Lithography Workshop, 1958.

HUNTER, DARD. *Papermaking.* New York: Alfred A. Knopf, 1967.

LABARRE, E. J. *Dictionary of Paper and Papermaking Terms.* Amsterdam: Swets & Zeitlinger, 1952.

Papermaking. Washington, D.C.: Library of Congress, 1968.

Tamarind Lithography Workshop, Inc. *The beauty and longevity of an original print depends greatly on the paper that supports it.* Los Angeles, 1962.

3. WATERMARKS

BRIQUET, C. M. *Les Filigranes.* Paris, 1923. Reprint. 4 vols. New York: Hacker Art Books, 1966.

CHURCHILL, W. A. *Watermarks in the XVII and XVIII Centuries.* Amsterdam, 1935. Reprint. Amsterdam: Menno Hertzberger & Co., 1965.

HEAWOOD, EDWARD. *Watermarks, Mainly of the 17th and 18th Centuries.* Hilversum, 1950. Reprint. 1969.

4. FAKES AND FORGERIES

ARNAU, FRANK. *Art of the Faker.* Boston: Little, Brown & Co., 1961.

DRUICK, DOUGLAS, and GORDON, MARTIN. *Buyer Beware!* New York: Martin Gordon Gallery, 1970.

KURZ, OTTO. *Fakes.* New Haven, 1948. Rev'd ed. New York: Dover Publications, 1967.

MELOT, MICHEL. "Les frontières de l'originalité et les problemes de l'estampe contemporaine" in *Revue de l'Art* No. 21. Paris, 1973.

SACHS, SAMUEL, and JOHNSON, KATHRYN C. *Fakes and Forgeries.* Minneapolis: Minneapolis Institute of Arts, 1973.

SEIDLITZ, W. de. "La proprieté artistique et la contrefaçon" in *Gazette des Beaux Arts* No. 14. Paris, 1895.

H. Care and Conservation of Prints

BARROW, W. J. *The Barrow Method of Restoring Deteriorated Documents.* Richmond, Va.: W. J. Barrow Restoration Shop, 1973.

CLAPP, ANNE F. *Curatorial Care of Works of Art on Paper.* Oberlin, Ohio: Intermuseum Laboratory, 2d rev. ed., 1974.

DOLLOFF, FRANCIS W., and PERKINSON, ROY L. *How to Care for Works of Art on Paper.* Boston: Museum of Fine Arts, 1971.

FELLER, ROBERT L. "Control of Deteriorating Effects of Light upon Museum Objects" in *Museum,* Vol. XVII, No. 2, 1964.

GAEHDE, CHRISTA M. "The Care and Conservation of Fine Prints" in Zigrosser, Carl, and Gaehde, Christa M. *A Guide to the Collecting and Care of Original Prints.* New York: Crown Publishers, 1966.

GLASER, MARY TODD. "Framing & Preservation of Works of Art on Paper." New York: Parke Bernet Galleries, 1971.

International Institute for Conservation of Historic and Artistic Works. *Control of the Museum Environment.* London, 1967.

KING, ANTOINETTE. "Care and Conservation of Prints" in Castleman, Riva. *Modern Art in Prints*. New York: Museum of Modern Art, 1973.

Tamarind Lithography Workshop. *Questions to ask your framer and Answers you should get*. Los Angeles, 1962.

WEIDNER, MARILYN KEMP. "Damage and Deterioration of Art on Paper Due to Ignorance and the Use of Faulty Materials" in *Studies in Conservation*, Vol. 12, No. 1.

II. CATALOGUES AND MORE SPECIALIZED TEXTS: OLD MASTER PRINTS

A. General Scholarly References and Treatises

ADHÉMAR, JEAN. *Graphic Art of the 18th Century*. Paris: Editions Aimery Somogy, 1964.

BLUM, ANDRÉ. *Les Origines de la Gravure en France*. Paris & Brussels, 1927.

COBLENTZ, SUZANNE. *La Collection d'Estampes Edmond de Rothschild au Musée du Louvre*. Paris: Editions des Museés, 1954.

P. & D. Colnaghi & Co. Ltd. *Mannerism and the North European Tradition: Prints from c.1520–1630*. London, 1974.

EMILIANI, ANDREA, and BERTELÀ, GIOVANNI G. *La Raccolta della Stampe di Benedetto Lambertini*. Bologna: Edizioni Alfa, 1970.

FIELD, RICHARD S. *Fifteenth-Century Woodcuts and Metalcuts*. Washington, D.C.: National Gallery of Art, 1965.

FISCHER, OTTO. *Geschichte der deutschen Zeichnung und Graphik*. Munich, 1951.

GEISBERG, MAX. *Die Anfänge des Kupferstichs* (Meister der Graphik II, 2d ed.). Leipzig, 1923.

———. *Geschichte der deutschen Graphik vor Dürer*. Berlin, 1939.

HIND, ARTHUR M. *A History of Engraving and Etching: From the 15th Century to the Year 1914*. Boston, 1924. Reprint. New York: Dover Publications, 1963.

———. *An Introduction to a History of Woodcut*. London, 1935. Reprint. 2 vols. New York: Dover Publications, 1963.

HOFER, PHILIP. *Baroque Book Illustration: A Short Survey*. Cambridge: Harvard University Press, 1951. Reissue, 1970.

JEAN-RICHARD, PIERETTE. *Les Incunables de la collection Edmond de Rothschild*. Paris: Editions des Musées Nationaux, 1974.

KRISTELLER, PAUL, *Kupferstich und Holzschnitt in vier Jahrhunderten*. Berlin, 4th ed., 1921.

Late Gothic Engravings of Germany and the Netherlands: 682 Copperplates from the "Kritischer Katalog" by Max Lehrs. New York: Dover Publications, 1969.

LAWRENCE, H. W. and DIGHTON, B. L. *French Line Engravings*. London, 1910.

MONGAN, ELIZABETH, and SCHNIEWIND, CARL O. *The First Century of Printmaking*. Chicago: Art Institute of Chicago, 1941.

SHESTACK, ALAN. *Fifteenth-Century Engravings of Northern Europe*. Washington, D.C.: National Gallery of Art, 1967.

STRAUSS, WALTER L. *Chiaroscuro: The Clair-Obscur Woodcuts by the German and Netherlandish Masters of the XVIth and XVIIth Centuries*. New York: Abaris Books, 1973.

———, ed. *The Book of Hours of the Emperor Maximilian the First*. New York: Abaris Books, 1974.

TALBOT, CHARLES, and SHESTACK, ALAN. *Prints and Drawings of the Danube School*. New Haven: Yale University Press, 1969.

B. Old Master Prints: *Sets of Catalogues Raisonnés and Basic Sources*

ANDRESAN, ANDREAS. *Der Deutsche Peintre-Graveur*. 4 vols. Leipzig, 1864–1878. Reprint. 5 vols. New York: Collectors Editions, 1969.

BARTSCH, ADAM. *Le Peintre graveur*. 21 vols. (15–17th centuries). Paris, 1801–1821. Reprint. 22 vols. in 4. Nieukoop (Neth.): De Graaf, 1970. Karpinski, Caroline, ed. *Le Peintre Graveur Illustré: Volume I: Italian Chiaroscuro Woodcuts (Bartsch Volume XII)*. University Park (Pa.): Pennsylvania State University, 1971.

BAUDICOUR, PROSPER DE. *Le Peintre-Graveur Continué* . . . Paris, 1859.
BÉRALDI, HENRI. *Les Graveurs du XIX^e Siècle*. 12 vols. Paris: L. Conquet, 1885–92.
BERTELÀ, GIOVANNI GAETA, and FERRARA, STEFANO. *Incisori Bolognesi Ed Emiliani del sec. XVI–XVII* (Catalog Generale della raccolta di stampe antichi della Pinacoteca Nazionale di Bologna, Gabinetto delle Stampe). Bologna: Francesco Francia, 1973–75.
DE VESME, ALESSANDRO B. *Le Peintre Graveur Italian*. Milan, 1906.
DUTUIT, EUGÈNE. *Manuel l'amateur d'estampes*. 5 vols. Paris, 1881–1885.
GEISBERG, MAX. *Der deutsche Einblatt-Holzschnitt in der ersten des XVI. Jahrhunderts*. Munich, 1924–30. Strauss, Walter L., ed. *The German Single-Leaf Woodcut: 1500–1550*. 4 vols. (Geisberg, revised and illustrated). New York: Hacker Art Books, 1974.
HIND, ARTHUR M. *Early Italian Engraving*. 7 vols. London and Washington, D.C., 1938–48. Reprint. Nandeln, Lichtenstein: Kraus Reprint Co., 1970.
HOLLSTEIN, F. W. H., et al. *Dutch and Flemish Etchings, Engravings and Woodcuts ca. 1450–1700*. Amsterdam: A. L. Van Gendt & Co. B.V., 1949 ff.
——, et al. *German Engravings, Etchings and Woodcuts ca. 1400–1700*. I–X, XVI and XVII to date. Amsterdam: A. L. Van Gendt & Co. B.V., 1954 ff.
L'Inventaire du Fonds Français du XVII^e Siècle. 6 vols. (completed through de la Ruelle). *L'Inventaire du Fonds Français du XVIII^e Siècle*. 12 vols. (completed through Launay). Paris: Bibliothèque Nationale.
LE BLANC, CHARLES. *Manuel de l'amateur d'estampes*. Paris, 1854–59.
LEHRS, MAX. *Geschichte und Kritischer Katalog des Deutschen, Niederländischen und Französischen Kupferstichs im XV. Jahrhundert*. 9 vols. Vienna, 1908–34. Reprint. 10 vols. New York: Collectors Editions Ltd., 1973. (See Geisberg, *Geschichte* for reattributions)
LEVENSON, JAY A.; OBERHAUSER, KONRAD, and SHEENAN, JACQUELINE L. *Early Italian Engravings from the National Gallery of Art*. Washington, D.C., 1973.
NAGLER, G. *Die Monogrammisten*. 5 vols. Munich, 1858–79. Reprint. Nieuwkoop (Neth.): De Graaf, 1966.
PASSAVANT, J. D. *Le Peintre-Graveur*. 6 vols. (update to Bartsch). Leipzig, 1860–64.
PORTALIS, ROGER, and BÉRALDI, HENRI. *Les Graveurs du Dix-huitième Siècle*. 3 vols. Paris, 1880–82.
ROBERT-DUMESNIL, A. P. F. *Le Peintre-Graveur Français*. 11 vols. Paris, 1835–1871. Reprint (with de Baudiocour, P. *Le Peintre-Graveur Français Continué* . . .). 13 vols. in 7. Paris: F. de Nobele, 1967.
SCHREIBER, WILHELM. *Handbuch der Holz- und Metallschnitte des XV Jahrhunderts*. 8 vols. Leipzig, 1926–30.
STRAUSS, WALTER L., ed. *The German Single-Leaf Woodcut—1550–1600*. 3 vols. New York: Abaris Books, 1976.

C. Old Master Prints: *Standard Monographs and Catalogues on Specific Artists*

(*All cross-references are to pertinent sets of catalogues raisonnés or basic sources.*)

ALTDORFER, ALBRECHT (1480–1538)
WINZINGER, FRANZ. *Altdorfer Graphik*. Munich: R. Piper & Co. Verlag, 1963.
BALDUNG GRIEN, HANS (1480?–1545)
CURJEL, HANS. *Hans Baldung Grien*. Munich, 1923.
(*See also* Hollstein vol. II *and* Geisberg)
BEHAM, HANS SEBALD (1500–1550) and BARTHEL (1502–1540)
PAULI, G. *Hans Sebald Beham*. Strassburg, 1901. Supp., 1911. Reprint & Supp. RÖTTINGER, HEINRICH. Baden-Baden: Verlag Valentin Koerner, 1974.
PAULI, G. *Barthel Beham*. Strassburg, 1911.
(*See also* Hollstein vols. II and III)
BELLANGE, JACQUES (1594–1638)
WALCH, NICOLE. *Die Radierungen des Jacques Bellange*. Munich: Robert Wölfe, 1971.
(*See also* Robert-Dumesnil)
BLAKE, WILLIAM (1757–1827)
EASSON, ROGER R. and ESSICK, ROBERT N. *William Blake: Book Illustrator*. Normal (Ill.): The American Blake Foundation, 1972.

BENTLEY, G. E., JR. *The Blake Collection of Mrs. Landon K. Thorpe*. New York: The Pierpont Morgan Library, 1971.

BINYON, L. *The Engraved Designs of William Blake*. 1926. Reprint. New York: Da Capo Press, 1967.

Cornell University. *William Blake; an Annotated Catalogue*. Ithaca, New York: Andrew D. White Museum of Art, 1965.

KEYNES, GEOFFREY. *William Blake: Poet-Printer-Prophet*. New York: The Orion Press, 1964.

MONGAN, ELIZABETH. *The Art of William Blake*. Washington, D.C.: The National Gallery of Art, 1957.

KEYNES, GEOFFREY L. *Engravings by William Blake: The Separate Plates, A Catalogue Raisonné*. Dublin: Emery Walker, 1956.

KEYNES, GEOFFREY L. and WOLF, EDWIN. *William Blake's Illuminated Books*. New York: The Grolier Club, 1953.

BONNET, LOUIS-MARIN (1736–1793)

HÉROLD, JACQUES. *Louis-Marin Bonnet, Catalogue de l'oeuvre gravé*. Paris: la Société pour l'étude de la gravure Française, 1935.

BOUCHER, FRANÇOIS (1703–1770)

MUSÉE DU LOUVRE. *F.B.: gravures et dessins provenant du cabinet des dessins et de la collection Edmond de Rothschild au Musée du Louvre*. Paris, 1971.

BRUEGHEL, PETER THE ELDER (1525?–1569)

BASTELAER, RENÉ VAN. *Les Estampes de Peter Brueghel l'ancien*. Brussels, 1908.

LARI, GIULIO. Catalogo completo dell'opera di *Brueghel*. Milan: Salamon e Agustoni editori, 1973.

LEBEER, LOUIS. *Catalogue raisonné des estampes de Brueghel l'ancien*. Brussels: Bibliothéque Royale Albert Ier, 1969.

(*See also* Holstein vol.)

CALLOT, JACQUES (1592–1635)

LIEURE, JULES. *Jacques Callot: La vie artistique et catalogue raisonné*. 5 vols. Paris, 1924–1929. Reprint. 8 vols. New York: Collectors Éditions Ltd., 1970.

RUSSELL, H. DIANE. *Jacques Callot: Prints & Related Drawings*. Washington, D.C.: National Gallery of Art, 1975.

CANALETTO (ANTONIO CANALE) (1697–1768)

BROMBERG, RUTH. *Canaletto's Etchings*. London: Sotheby Parke Bernet, 1974.

PALLUCHINO, R. and GUARNATI, G. F. *Le aqueforte del Canaletto*. Venice, 1944.

(*See also* de Vesme)

CASTIGLIONE, GIOVANNI BENEDETTO (1616–1670)

PERCY, ANN. *Giovanni Benedetto Castiglione: Master Draughtsman of the Italian Baroque*. Philadelphia: Philadelphia Museum of Art, 1971.

(*See also* Bartsch *and* de Vesme)

CRANACH, LUCAS THE ELDER (1472–1553)

JOHN, JOHANNES. *Lucas Cranach der Alte: Das gesamte graphische Werk*. Reprint. Munich: Rogner & Bernhard, 1972.

(*See also* Geisberg *and* Hollstein vol. VI)

DEBUCOURT, PHILIBERT-LOUIS (1755–1832)

FENAILLE, M. *L'Oeuvre gravé de P.-L. Debucourt*. Paris, 1899.

DELLA BELLA, STEFANO (1610–1664)

MASSAR, PHYLLIS DEARBORN. *Stefano della Bella*. New York: Collectors Editions, Ltd., 1971.

DEMARTEAU, GILLES (1722–1776)

LEYMARIE, L. DE. *L'Oeuvre de Gilles Demarteau l'Aîné*. Paris, 1896.

DÜRER, ALBRECHT (1471–1528)

Albrecht Dürer: 1471–1971. Nuremberg: Germanische Nationalmuseum, 1971.

Albrecht Dürer: Master Printmaker. Boston: Museum of Fine Arts, 1971.

ALVIN, LOUIS J. *Catalogue raisonné de l'oeuvre de trois frères Jean, Jerome, et Antoine Wierix*. Brussels, 1966. Supplements.

BOON, KAREL G., and SCHELLER, ROBERT W. *The Graphic Art of Albrecht Dürer, Hans Dürer and the Dürer School*. (Vol. VII of Hollstein) Amsterdam: Van Gendt & Co., 1971.

DODGSON, CAMPBELL. *Albrecht Dürer: Engravings and Etchings.* London, 1926. Reprint. New York: Da Capo Press, 1967.

Dürer Through Other Eyes: His Graphic Work Mirrored in Copies and Forgeries of Three Centuries. Williamstown (Mass.): Sterling and Francine Clark Art Institute, 1975.

FIELD, RICHARD S. *Albrecht Dürer 1471–1528: A Study in Print Connoisseurship.* Philadelphia: Philadelphia Museum of Art, 1970.

HELLER, JOSEPH. *Das Leben und die Werke Albrecht Dürer's.* Bamberg, 1827.

KURTH, WILLI. *The Complete Woodcuts of Albrecht Dürer.* New York: Bonanza Books, 1946.

MEDER, JOSEPH. *Dürer-Katalog: Ein Handbuch über Albrecht Dürers Stiche, Radierungen, Holzschnitte, deren Zustände, Ausgaben und Wasserzeichen.* Vienna, 1932. Reprint. New York: Da Capo Press, 1971.

PANOFSKY, ERWIN. *The Life and Art of Albrecht Dürer.* Princeton: Princeton University Press, 1943. Reprints. 1945, 1948, 1955, 1971.

PRÉAUD, MAXIME, ed. *Albrecht Dürer.* Paris: Bibliothèque Nationale, 1971.

STRAUSS, WALTER L. *Albrecht Dürer, Woodcuts and Wood Blocks.* New York: Abaris Books, 1977.

TALBOT, CHARLES W., ed. *Dürer in America: His Graphic Work.* Washington, D.C.: National Gallery of Art, 1971.

DYCK, ANTOINE VAN (1599–1641)

Mauquoy-Hendrickx. *L'Iconographie d'Antoine Van Dyck.* Brussels, 1956.

(*See also* Hollstein vol. VI)

DUVET, JEAN (1485–1561?)

POPHAM, A. E. *"Jean Duvet"* in *The Print Collector's Quarterly,* vol. VIII (pp. 123–50), 1921.

(*See also* Robert-Dumesnil *and* Passavant)

FRAGONARD, HONORÉ (1732–1806)

WILDENSTEIN, G. *Fragonard, aquafortiste.* Paris, 1956.

(*See also* Portalis-Béraldi *and* Baudicour)

FRIEDRICH, CASPER DAVID (1774–1840)

BÖRSCH-SUPAN and JÄHNIG, K. W. *Casper David Friedrich: Gemälde, Druckgraphik und Zeichnungen.* Munich: Prestel-Verlag, 1973.

GAINSBOROUGH, THOMAS (1727–1788)

HAYES, JOHN. *Gainsborough as Printmaker.* New Haven: Yale University Press and London, 1972.

GELLÉE, CLAUDE (LE LORRAIN) (1600–1682)

BLUM, A. *Les Eaux-Fortes de Claude Gellée.* Paris, 1923.

(*See also* Robert-Dumesnil)

GÉRICAULT, THÉODORE (1791–1824)

SPENCER, KATE H. *The Graphic Art of Géricault.* New Haven, Conn.: Yale University Gallery, 1969.

DELTEIL, LOYS, ed. *Le Peintre-Graveur Illustré: Théodore Géricault.* Vol. 18. Paris, 1924. Reprint. New York: Da Capo Press, 1969.

GOLTZIUS, HENDRICK (1558–1616)

STRAUSS, WALTER L. *Hendrick Goltzius, Master Engraver.* New York: Abaris Books, 1977.

———. "The Chronology of H. Goltzius' Chiaroscuro Prints," in *Nouvelles de l'estampe,* No. 5. Paris, Sept.–Oct., 1972.

HIRSCHMANN, OTTO. *Verzeichnis des graphischen Werkes von Hendrick Goltzius.* Leipzig, 1921. Reprint, 1975.

Hendrick Goltzius & the Printmakers of Haarlem. Storrs: William Benton Museum of Art, 1922.

(*See also* Hollstein vol. VIII)

GOYA Y LUCIENTES, FRANCISCO JOSÉ DE (1746–1828)

SAYRE, ELEANOR A. *The Changing Image: Prints by Francisco Goya.* Boston: Museum of Fine Arts, 1974.

HARRIS, TOMÁS. *Goya: Engravings and Lithographs.* 2 vols. Oxford: Bruno Cassirer, 1964.

DELTEIL, LOYS, ed. *Le Peintre-Graveur Illustré: Goya.* Vols. 14, 15. Paris, 1922. Reprint. New York: Da Capo Press, 1969.

HIRSCHVOGEL, AUGUSTIN (1503–1553?)

SCHWARZ, KARL. *Augustin Hirschvogel*. Berlin, 1917. Reprint. 2 vols. New York: Collectors Editions Ltd., 1970.

(*See also* Bartsch *and* Nagler)

HOGARTH, WILLIAM (1697–1764)

PAULSON, RONALD. *Hogarth's Graphic Works*. 2 vols. New Haven: Yale University Press, 1964. 2nd ed., rev. New Haven: Yale University Press, 1970.

HOLBEIN, HANS THE YOUNGER (1497?–1543)

HOFER, PHILIP. *Hans Holbein the Younger: The Dance of Death*. Boston: Cygnet Press, 1974.

GUNDERSHEIMER, WERNER L. *The Dance of Death by Hans Holbein the Younger*. New York: Dover Publications, 1971.

WOLTMANN, A. F. G. A. *Holbein und seine Zeit*. Leipzig, 1874–76.

(*See also* Passavant)

HOLLAR, WENCESLAUS (1607–1677)

PARTHEY, G. *Wenceslaus Hollar, Catalogue*. Berlin, 2d ed. 1858. Supp. Borovsky, F. A. Prague, 1898.

(*See also* Hollstein vol. IX)

JANINET, JEAN FRANÇOIS (1752–1814)

BÉRALDI, HENRI, and PORTALIS, ROGER. *Les graveurs du XVII^e Siècle*. Vol. 2. Paris: D. Morgand and C. Fatout, 1880–1882.

LAUTENSACK, HANNS (1524–1563)

SCHMITT, ANNEGRIT. *Hanns Lautensack*. Nürnberg: Selbstverlag des Vereins für Geschichte der Stadt Nürnberg, 1957.

MASTER E.S. (1400?–1467?)

SHESTACK, ALAN. *Master E.S.* Philadelphia: Philadelphia Museum of Art, 1967.

(*See also* Lehrs)

MASTER LCz (active c. 1480–1505) and MASTER WB (15th Century)

SHESTACK, ALAN. *Master LCz and Master WB*. New York: Collectors Editions Ltd., 1970.

NANTEUIL, ROBERT (1623?–1698)

PETIJEAN, CHARLES, and WICKERT, CHARLES. *Catalogue de l'oeuvre gravée de Nanteuil*. 2 vols. Paris: Delteil & Le Garrec, 1925.

OSTADE, ADRIAEN VAN (1610–1685)

GODEFROY, LOUIS. *L'Oeuvre gravée de Adriaen van Ostade*. Paris, 1930.

TRAUTSCHOLDT, EDUARD. *Austellung: A. Ostade, C. Bega, Corn. Dusart*. Düsseldorf: C. G. Boerner, 1965.

(*See also* Hollstein vol. XV)

PIRANESI, GIOVANNI BATTISTA (1720–1778)

HIND, ARTHUR M. *Giovanni Battista Piranesi: A Critical Study, With a List of All His Published Works of the Prisons and the Views of Rome*. London, 1922. Reprint. New York: Da Capo Press, 1967.

Etchings by Giovanni Battista Piranesi: 1720–1778. London: P. BL. D. Colnaghi & Co., 1974.

FOCILLON, HENRI. *Giovanni Battista Piranesi: essai de catalogue raisonné de son oeuvre*. Paris, 1918. Reprint. Paris: Laurens, 1964.

ROBISON, ANDREW. *Prolegomena to the Princeton Collections*. In *Princeton University Library Chronicle*, Vol. XXX, No. 3, 1970.

———. "The 'Vedute di Roma' of *Giovanni Battista Piranesi*: Notes Towards a Revision of Hind's Catalogue," in *Nouvelles de l' Estampe* No. 4. Paris, 1970.

REMBRANDT HARMENZ. VAN RIJN (1606–1669)

BARTSCH, ADAM. *Catalogue Raisonné de toutes les estampes qui forment l'Oeuvre de Rembrandt, et ceux de ses principaux Imitateurs*. Vienna, 1797.

BIORKLUND, GEORGE, AND BARNARD, OSBERT H. *Rembrandt's Etchings: True and False*. Stockholm, London, New York, 1968.

HIND, ARTHUR M. *A Catalogue of Rembrandt's Etchings*. London: Methuen and Co., 2d ed. 1923. Reprint. New York: Da Capo Press, 1967.

NOWELL-USTICKE, G. W. *Rembrandt's Etchings: States and Values.* Narbeth (Pa.): Livingston Publishing Co., 1967.
Nowell-Usticke Collection of Rembrandt Etchings, The. 2 vols. New York: Parke-Bernet Galleries, 1967 and 1968.
Rembrandt: Experimental Etcher. Boston: Museum of Fine Arts, 1969.
WHITE, CHRISTOPHER. *Rembrandt as an Etcher: A Study of the Artist at Work.* 2 vols. University Park (Pa.): Pennsylvania State University Press, 1969.
WHITE, CHRISTOPHER, and BOON, KAREL G. *Rembrandt's Etchings: An Illustrated Critical Catalogue.* [Vols. XVII–XVIII of Hollstein series]. 2 vols. Amsterdam: Van Gendt & Co., 1969.
Viscount Downe Collection of Rembrandt Etchings, The. 2 vols. London: Sotheby & Co., 1970 and 1972.

RIBERA, JOSÉ (JUSEPA) DE (1588–1652)
BROWN, JONATHON. *José de Ribera: Prints and Drawings.* Princeton: Princeton University Press, 1973.
(*See also* Bartsch)

ROBETTA, CRISTOFANO (1462–1522?)
BELLINI, PAOLO. *Catalogo completo dell'opera grafica del Robetta.* Milan: Salamon e Agustoni editori, 1973.
(*See also* Hind *and* Levenson)

ROSA, SALVATOR (1515–1573)
ROTILLI, MARIO. *Salvator Rosa incisore.* Soc. Editorci Napoletana, 1975.
(*See also* Bartsch, Nagler, *and* Le Blanc)

SCHONGAUER, MARTIN (bef. 1440–1491)
SHESTACK, ALAN. *The Complete Engravings of Martin Schongauer.* New York: Dover Publications, Inc., 1969.
MINOTT, CHARLES ISLEY. *Martin Schongauer.* New York: Collectors Edition, 1971.
(*See also* Lehrs)

SCHOOL OF FONTAINEBLEAU (mid-16th Century)
ZERNER, HENRI. *The School of Fontainebleau: Etchings and Engravings.* New York: Harry N. Abrams, 1970.

SEGHERS, HERCULES (1590?–1645?)
HAVERKAMP-BEGEMANN, EGBERT. *Hercules Seghers: The Complete Etchings.* Amsterdam: Scheltema and Holkema, 1973.

STUBBS, GEORGE (1756?–1815)
TAYLOR, BASIL. *The Prints of George Stubbs.* London: Paul Mellon Foundation for British Art, 1969.

TIEPOLO, GIOVANNI BATTISTA (1696–1770) and
GIOVANNI DOMENICO (1727–1804)
RIZZI, ALDO. *The Etchings of the Tiepolos.* London: Phaidon Publishers, 1971.
RUSSELL, DIANE. (National Gallery of Art). *Rare Etchings by Giovanni B. and Giovanni Domenico Tiepolo.* New York: Macmillan Company, 1971.
(*See also* De Vesme)

VELDE, JAN VAN DE (1593?–after 1641)
FRANKEN, D., and VAN DER KELLEN, J.-PH. *L'Oeuvre de Jan van de Velde.* Amsterdam and Paris, 1883.
(*See also* Bartsch)

WATTEAU, JEAN-ANTOINE (1684–1721)
DACIER, ÉMILE, and VUAFLART, A. *Jean de Jullienne et les graveurs de Watteau au XVIIIᵉ siècle.* 4 vols. Paris: Société pour l'Etude de la Graveur Française, 1921–1929.
GONCOURT, EDMOND DE. *Catalogue raisonné de l'oeuvre peint, dessiné et gravé d'Antoine Watteau.* Paris: Rapilly, 1875.

III. CATALOGUES AND MORE SPECIALIZED TEXTS: MODERN (1850–1950) AND CONTEMPORARY (POST-1950) PRINTS

A. General Scholarly References

American Prints in the Library of Congress: A Catalog of the Collection. Compiled by Karen F. Beall. Baltimore: Library of Congress, Johns Hopkins Press, 1970.

Arntz-Bulletin: Dokumentation der Kunst des 20 Jahrhunderts. 8092 Haag (Oberbayern): Verlag Gertrud Arntz-Winter, commencing 1968.

BÉRALDI, HENRI. *Les Graveurs du XIXᵉ Siècle*. 12 vols. Paris: L. Conquet, 1885–92.

BOLLIGER, HANS, and KORNFELD, E. W. *Austellung Künstlergruppe Brücke: Jahresmappen 1906–1912*. Bern: Kornfeld und Klipstein, 1958.

DELTEIL, LOŸS. *Le Peintre Graveur Illustré*. 31 vols. Paris, 1906–26. Reprints. New York: Collectors Editions Ltd. and Da Capo Press, 1969.

GEMINI G. E. L. *Catalogue Raisonné*. (Gemini publications.) Los Angeles, 1966 to date.

L'Inventaire du Fonds Français. Paris: Cabinet des Estampes, Bibliothèque Nationale. After 1800 series completed through Lys.

JOHNSON, UNA E. *Ambroise Vollard, Editeur 1867–1939*. New York: Wittenborn & Co., 1944.

Kovler Gallery. *Forgotten Printmakers of the 19th Century*. Chicago: 1967.

———. *The Graphic Art of Vallotton and the Nabis*. Chicago: 1970.

LEYMARIE, JEAN, and MELOT, MICHEL. *Les Gravures des Impressionistes*. Paris: Arts et Métiers Graphiques, 1971. New York (English—*The Graphic Works of the Impressionists*): Harry N. Abrams, 1972.

Maeght Editeur. *10 Ans D'Editions: 1946–1956*. Paris, 1956. Catalogues of Maeght publications: annually from 1957 to date.

PETERS, H., ed. *Die Bauhaus Mappen: Neue Europäische Graphik 1921–1923*. Cologne: Galerie Czwiklitzer, 1957.

STEIN, DONNA. *L'Estampe Originale: A Catalogue Raisonné*. New York: Museum of Graphic Art, 1970.

WINGLER, H. M. *Graphic Work from the Bauhaus*. Greenwich: New York Graphic Society, 1965. Mainz (German): Florian Kupferberg, 1965.

B. Modern and Contemporary Prints: *Catalogues and Treatises on Modern Illustrated Books (Livres de Peintres)*

Carus Gallery. *Russian Avant Garde: Graphics & Books*. New York, 1975.

ENGELBERTS, EDW., and KORNFELD, E. W. *Les Peintres et le Livre* (auction catalog). Bern: Kornfeld und Klipstein, 1974.

Fendrick Gallery. *The Book as Art*. Washington, D.C., 1975.

Fondation Maeght. *Peintres-Illustrateurs: Le Livre illustré moderne depuis Manet*. St. Paul de Vence, 1969.

GARVEY, ELEANOR M., and HOFER, PHILIP. *The Artist and the Book, 1860–1960*. Boston: Museum of Fine Arts, 1961. 2d ed., 1972.

Hommage à Tériade. Paris: Centre National d'Art Contemporain, 1973.

Kornfeld und Klipstein. *Illustrierte Bücher* (auction catalogs). Bern, 1965, 1966, 1968, 1969, 1971, 1972, and 1976.

LANG, LOTHAR. *Expressionist Book Illustration in Germany, 1907–1927*. Boston: New York Graphic Society, 1976.

Librairie Alexandre Loewy. Sales Catalogs. 85, rue de Seine, 75006 Paris.

RAUCH, NICOLAS. *Les peintres et le livre: 1867–1957*. Geneva: 1957.

SKIRA, ALBERT. *Anthologie du livre illustré par les peintres et sculpteurs de l'Ecole de Paris*. Geneva: Editions Albert Skira, 1946.

———. *Vingt Ans d'Activité*. Geneva: Editions Albert Skira, 1948.

STRACHAN, W. J. *The Artist and the Book in France*. New York: George Wittenborn, 1970.

WOIMANT, FRANÇOISE. "Trois grands éditeurs de notre temps," in *Nouvelles de l'estampe* No. 15. Paris, May–June 1974.

C. Modern and Contemporary Prints: *Standard Monographs and Catalogues Raisonnés on Specific Artists*

(Cross-reference—as "Peters"—is to pertinent general scholarly reference.)

ABRAHAMS, IVOR (1935–)
KÖLNISCHER KUNSTVEREIN. *Ivor Abrahams*. Köln, 1973.
ALBERS, JOSEF (1888–1976)
MILLER, JO. *Josef Albers Prints 1915–1970*. New York: Brooklyn Museum, 1973.
(*See also* Wingler)
ALECHINSKY, PIERRE (1927–)
RIVIÈRE, YVES. *Pierre Alechinsky, Les Estampes de 1946 à 1972*. Paris: Weber, 1973.
AMIET, CUNO (1868–1961)
VON MANDACH, C. *Cuno Amiet: Vollständiges Verzeichnis der Druckgraphik des Künstlers*. Bern: Schweizer. Graph. Ges., 1969.
ANTES, HORST (1936–)
GALLWITZ, KLAUS. *Horst Antes: Das lithographische Werk*. In preparation.
HERMANN, WOLF. *Horst Antes*. Bremen: Städtische Galerie Rosenheim, 1974.
GERCKEN, GÜNTHER. *Horst Antes: Catalog of Engravings 1962–1966*. Munich: Galerie Stangl, 1968.
APPIAN, ADOLPHE (1818–1898)
GRUYER, JACQUES. "L'Oeuvre Gravé d'Adolphe Appian." PROUTÉ, PAUL. "Supplément au catalogue des eaux-fortes d'Appian." MELOT, MICHEL. "Les Monotypes d'Adolphe Appian," in *Nouvelles de l'estampe* No. 25. Paris, Jan.–Feb. 1976.
CURTIS, ATHERTON. *Adolphe Appian: son oeuvre gravé et lithographié*. Paris: Paul Prouté, 1968.
ARCHIPENKO, ALEXANDER (1887–1964)
KARSHAN, DONALD. *Archipenko: The Sculpture and Graphic Art*. Boulder: Westview Press, 1975.
(*See also* Peters *and* Wingler)
ARMS, JOHN TAYLOR (1887–1953)
New York Public Library. "Chronological list of the prints of John Taylor Arms, from the studio of John Taylor Arms, Greenfield Hill, Fairfield, Conn." Unpublished manuscript. Catalog of the published plates. 1962.
TRUESDELL, W. P. "Catalogue Raisonné of the Aquatints of John Taylor Arms." *The Print Connoisseur* 1 (1920): 112–121.
"List of the Etchings of John Taylor Arms." *The Print Connoisseur* 5 (1925): 292–304.
ARP, HANS (JEAN) (1887–1966)
VERLAG GERTRUD ARNTZ-WINTER. "Hans (Jean) Arp." *Arntz-Bulletin* [Haag/Oberbayern, Germany] Vol. 1, parts 3–10, 1968–1969.
KLIPSTEIN, AUGUST, and KORNFELD, EBERHARD W. *Hans Arp: Graphik 1912–1915*. Bern, 1959.
AVATI, MARIO (1921–)
PASSERON, ROGER. *L'oeuvre gravé de Mario Avati*. 2 Vols.: 1955–67. Paris: La Bibliothèque des Arts, 1973 and 1974.
Grunwald Graphic Arts Foundation. *Avati: Prints from 1957–1967*. Los Angeles: Dickson Art Center, University of California, 1967.
AVERY, MILTON (1893–1965)
LUNN, HARRY H., JR., and GETLEIN, FRANK. *Milton Avery: Prints 1933–1955*. Washington, D.C.: Graphics International Ltd., 1973.
BAJ, ENRICO (1924–)
PETIT, JEAN. *Baj: catalogue de l'oeuvre gravé et lithographié*. 2 Vols: 1952–70 and 1970–73. Geneva: Rousseau, 1970 and 1975.
BARGHEER, EDUARD (1901–)
ROSENBACH, DETLAV. *Eduard Bargheer: Das Graphische Werk*. Hannover: Galerie Rosenbach, 1974.

BARLACH, ERNST (1870–1938)
SCHULT, FRIEDRICH. *Ernst Barlach Werkverzeichnis: Das Graphische Werk.* Vol. 2. Hamburg: Dr. Ernst Hauswedell and Co., 1958. Supplement in Vol. 3: 281–88. Hamburg: 1971.
BARNET, WILL (1911–)
Associated American Artists. *Will Barnet: Etchings, Lithographs, Woodcuts, Serigraphs: 1932–1972.* New York, 1972.
BARYE, ANTOINE-LOUIS (1796–1870)
DELTEIL, LOŸS, ed. *Le Peintre-Graveur Illustré: Rude, Barye, Carpeaux, Rodin.* Vol. 6. Paris, 1910. Reprint. New York: Da Capo Press, 1969.
BASKIN, LEONARD (1922–)
ROYLANCE, DALE. *Leonard Baskin: The Graphic Work 1950–1970.* New York: FAR Gallery, 1970.
BAUER, RUDOLF (1889–1953)
(*See* Peters)
BAUMEISTER, WILLI (1889–1955)
SPIELMANN, H. "Willi Baumeister, das Graphische Werk." *Jahrbuch der Hamburger Kunstammlungen* 8 (1963), 10 (1965), 11 (1966). (Compendium of 8, 10 & 11—1972). *Arnzt-Bulletin.* "Willi Baumeister." Haag (Oberbayern): Verlag Gertrud Arnzt-Winter, 197.
(*See also* Peters *and* Wingler)
BAYER, HERBERT (1900–)
HAHN, PETER. *Herbert Bayer: das druckgrafische Werk bis 1971.* Berlin: Bauhaus-Archiv, 1974.
BECKMANN, MAX (1884–1950)
Tucson Art Center. *Max Beckmann: Graphics.* Tucson, Ariz., 1973.
GALLWITZ, KLAUS. *Max Beckmann: Katalog der Druckgraphik: Radierungen, Lithographien, Holzschnitte, 1901–1948.* Karlsruhe: Badischer Kunstverein, 1962.
BELLMER, HANS (1902–1975)
GRALL, ALEX, ed. *Hans Bellmer.* New York: St. Martin's Press, 1972.
MANDIARGUES, ANDRÉ PIEYRE DE. *Hans Bellmer: Oeuvre Gravé.* Paris: Ed. Denoêl, 1969.
BELLOWS, GEORGE W. (1882–1925)
BEER, THOMAS, and BELLOWS, EMMA S. *George W. Bellows: His Lithographs.* New York and London: Alfred A. Knopf, 1927.
BENSON, FRANK W. (1862–1951)
PAFF, A. E. M. *Etchings and Drypoints by Frank W. Benson.* 1917. Reprint. Boston and New York: Houghton Mifflin Co., 1959.
BENTON, THOMAS HART (1889–1975)
FATH, CREEKMORE. *The Lithographs of Thomas Hart Benton.* Austin, Texas and London: University of Texas Press, 1969.
BERNARD, ÉMILE (1869–1941)
Bibliothèque Nationale, Cabinet des Estampes. *Emile Bernard: Catalogue of an Exhibition at Kunsthalle, Bremen.* Paris, 1967.
BESNARD, ALBERT (1849–1934)
DELTEIL, LOŸS, ed. (Louis Godefroy). *Le Peintre-Graveur Illustré: Besnard.* Vol. 30. Paris, 1926. Reprint. New York: Da Capo Press, 1969.
BEUYS, JOSEPH (1921–)
SCHELLMANN, JÖRG, and KLÜSER, B. *Joseph Beuys: Multiples.* 2 vols. Munich: Ed. J. Schellmann, 1972 and 1973.
BEVAN, ROBERT (1865–1925)
Robert Bevan 1865–1925. London: P & D. Colnaghi & Co. Ltd., 1974.
DRY, GRAHAM. *Robert Bevan: Catalogue Raisonné of the Lithographs and Other Prints.* London: Maltzahn Gallery, Ltd., 1968.
BILL, MAX (1908–)
KUNSTHALLE NÜRNBERG. *Max Bill: Das druckgraphische Werk bis 1968.* Nürnberg: Albrecht Dürer Gesellschaft, 1968.
BISSIER, JULIUS (1893–1965)
SCHMALENBACH, WERNER. *Julius Bissier.* Cologne: DuMont Schauberg, 1974.

BLAMPIED, EDMUND, R.E. (1886–1966)
DODGSON, CAMPBELL. *A Complete Catalogue of the Etchings and Drypoints of Edmund Blampied,*
R.E. London: Halton and Truscott Smith, 1926.

BO, LARS (1924–)
MADSEN, F., and GIRAUD, R. *L'Oeuvre gravé de Lars Bo.* Copenhagen: Galerie Carit Ander-
sen, 1965.

BOCCIONI, UMBERTO (1882–1916)
BELLINI, PAOLO. *Umberto Boccioni: Catalogo completo dell-opera grafica.* I classici dell' Incisione
series, vol. 2. Milan: Salamon e Agustoni, 1972.
TAYLOR, J. C. *The Graphic Work of Umberto Boccioni.* New York: Museum of Modern Art,
1961.
(*See also* Peters *and* Wingler)

BONE, MUIRHEAD (1876–1953)
DODGSON, CAMPBELL. "Later Drypoints of Muirhead Bone." *Print Collector's Quarterly* 9
(1922): 173–200.
————. *Etchings and Drypoints by Muirhead Bone.* London: Oback & Co., 1909.

BONNARD, PIERRE (1867–1947)
ROUIR, EUGÈNE. "Lithographs by Bonnard." *Print Collector* No. 3. Milan, 1973.
ROGER-MARX, CLAUDE. *Bonnard Lithographe.* Monte Carlo: André Sauret Editions du Livre,
1952.
————. *Les Artistes du Livre: Pierre Bonnard.* Paris: Henry Babou, Ed., 1931.
FLOURY, J. *Catalogue de l'oeuvre gravé,* in *Bonnard,* by C. Terrasse. Paris, 1923.

BONTECOU, LEE (1931–)
FIELD, RICHARD S. *Prints and Drawings by Lee Bontecou.* Middletown: Davison Art Center,
1975.

BOYS, SHOTTER (1803–1874)
GROSCHWITZ, GUSTAVE VON. "The Prints of Thomas Shotter Boys," in *Prints.* Carl Zigros-
ser, ed. New York: Holt, Rinehart and Winston, 1962.

BRACQUEMOND, FÉLIX (1833–1914)
BÉRALDI, HENRI. *Les Graveurs du XIXᵉ Siècle.* Vol. 3. Paris, 1885.

BRADLEY, WILL (1868–1962)
HORNURG, CLARENCE P. *Will Bradley: His Graphic Art.* New York: Dover Publications,
Inc., 1974.

BRANGWYN, FRANK WILLIAM (1867–1956)
GAUNT, W. *Etchings of Frank Brangwyn, R.A., A Catalogue Raisonné.* London: The Studio,
1926.

BRAQUE, GEORGES (1882–1963)
WÜNSCHE, HERMANN. *Georges Braque: Das Lithographische Werk.* Bonn: Galerie Wünsche,
1971.
MOURLOT, FERNAND. *Braque Lithographe.* Monte Carlo: Sauret, 1963.
HOFFMAN, WERNER. *Georges Braque: His Graphic Work.* London, 1962. Lausanne: Clairefon-
taine, 1962.
ENGELBERTS, E. *Georges Braque, Oeuvre graphique Originale.* Genève: Musée d'art et d'his-
toire, et Galerie Nicolas Rauch, 1958.

BRAUER, ERICH (1929–)
KOSCHATZKY, WALTER. *Erich Brauer: Das Graphische Werk von 1951 bis 1974.* Glarus: Gra-
phische Sammlung Albertina, 1974.

BREMER, UWE (1940–)
ROSENBACH, DETLAV. *Uwe Bremer: Werkverseichnis der Radierungen 1964–1973.* Hanover:
Galerie Rosenbach, 1974.

BRESDIN, RODOLPHE (1822–1885)
VAN GELDER, DIRK. *Rodolphe Bresdin: Monographie & Catalogue Raisonné de l'Oeuvre Gravé.* 2
vols. The Hague: Martinus Nijhoff, 1976.
ADHÉMAR, J., and GAMBIER, A. *Rodolphe Bresdin, 1822–1885.* Paris: Bibliothèque Nationale,
1963.
JOACHIM, HAROLD. "Rodolphe Bresdin," in *Odilon Redon-Gustave Moreau-Rodolphe Bresdin.*
New York: Museum of Modern Art, 1962.

Art Institute of Chicago. *Exhibition of Etchings, Lithographs and Drawings by Rodolphe Bresdin.* Chicago, 1931.
NEUMANN, J. B. *Rodolphe Bresdin.* The Art Lover Library, Vol. 1. New York, 1929.
BROCKHURST, GERALD L. (1890–)
WRIGHT, HAROLD J. L. "Catalogue of the Etchings of G. L. Brockhurst, A.R.A., R.E." *Print Collector's Quarterly* 22 (1935): 63–77.
————. "The Later Etchings of Gerald L. Brockhurst, A.R.A." *Print Collector's Quarterly* 21 (1934): 317–336.
BUFFET, BERNARD (1928–)
REINZ, GERHARD F. *Bernard Buffet: Engravings, 1948–1967.* New York: Tudor Publishing Co., 1968. Cologne (German): Orangerie, 1968.
MOURLOT, FERNAND and SIMENON, GEORGES, *Bernard Buffet: Ouevre gravé: Lithographies 1952–1966.* Paris: Mazo, 1967. New York (English): Tudor Publishing Co., 1968.
BUHOT, FELIX HILAIRE (1847–1898)
BOURCARD, G. *Félix Buhot, Catalogue Descriptif de Son Oeuvre Gravé.* Paris: H. Floury, 1899.
CADMUS, PAUL (1904–)
JOHNSON, UNA, and MILLER, JO. *Paul Cadmus: Prints and Drawings, 1922–1967.* New York: Brooklyn Museum, 1968.
CAMERON, DAVID YOUNG (1865–1945)
RINDER, FRANK. "Cameron Etchings: A Supplement." *Print Collector's Quarterly* 11 (1924): 45–68.
————. *D. Y. Cameron: An Illustrated Catalogue of His Etched Work.* Glasgow: J. Mackhose and Sons, 1912.
CAMPENDONK, HEINRICH (1889–1957)
ENGELS, MATHIAS TONI. *Heinrich Campendonk: Holzschnitte.* Stuttgart: Kohlhammer, 1959.
CARPEAUX, JEAN-BAPTISTE (1827–1875)
DELTEIL, LOŸS, ed. *Le Peintre-Graveur Illustré: Rude, Barye, Carpeaux, Rodin.* Vol. 6. Paris, 1910. Reprint. New York: Da Capo Press, 1969.
CARRIÈRE, EUGÈNE (1849–1906)
DELTEIL, LOŸS, ed. *Le Peintre-Graveur Illustré: Carrière.* Vol. 8. Paris, 1913. Reprint. New York: Da Capo Press, 1969.
CARZOU, JEAN (1907–)
FURHANGE, MAGUY. *Carzou: Graveur et Lithographe; Catalogue raisonné et commente de l'oeuvre gravé.* Vol. 1 (1948–1962). Nice: Editions d'Art de Francony, 1971. Vol. 2 (1963–1968), 1975.
CASSATT, MARY (1845–1926)
BREESKIN, ADELYN D. *The Graphic Work of Mary Cassatt: A Catalogue Raisonné.* New York: H. Bittner, 1948.
CASTELLON, FEDERICO (1914–1971)
Associated American Artists. *Recent Etchings and Lithographs by Federico Castellon.* New York, 1966.
CÉZANNE, PAUL (1839–1906)
SALAMON, HARRY. "Paul Cézanne: Critical Notes and Catalogue of His Engravings." *Print Collector* No. 4. Milan, 1973.
LEYMARIE, JEAN, and MELOT, MICHEL. *The Graphic Works of the Impressionists: the Complete Prints of Manet, Pissarro, Renoir, Cézanne and Sisley.* New York: Harry N. Abrams, 1972.
ADHÉMAR, JEAN. *Inventaire du Fond Français du Cabinet des Estampes de la Bibliothèque Nationale, Gravures après 1800.* Vol. 4. Paris, 1949.
VENTURI, L. *Cézanne: son Art, son Oeuvre.* 2 vols. Paris: Paul Rosenberg, 1936.
CHAGALL, MARC (1887–)
SORLIER, CHARLES, and MOURLOT, FERNAND, *Chagall Lithographe 1969–1973.* Vol. 4. Monte Carlo: Sauret, 1974. New York (English): Crown Publishers, 1974.
KORNFELD, EBERHARD W. *Verzeichnis der Kupferstiche, Radierungen und Holzschnitte von Marc Chagall: Vol. 1: Werke 1922–1966.* Bern: Kornfeld and Klipstein, 1970.
MOURLOT, FERNAND. *Chagall Lithographe: 1962–1968.* Vol. 3. Monte Carlo: Sauret, 1969. Boston (English): Boston Book and Art Shop, Inc., 1969.

LEYMARIE, JEAN. *Marc Chagall, Monotypes: 1961–1965.* Geneva: Galerie Gérald Cramer, 1966.
MOURLOT, FERNAND. *Chagall Lithographe: 1957–1962.* Vol. 2. Monte Carlo: Sauret, 1963. Boston (English): Boston Book and Art Shop, Inc., 1963.
————. *Chagall Lithographe: 1922–1957.* Vol. 1. Monte Carlo: Sauret, 1960. New York (English): George Braziller, 1960.

CHAHINE, EDGAR (1874–1947)
BLAIZOT, CLAUDE, and GAUTROT, JEAN-EDOUARD. *Catalogue Raisonné de l'Oeuvre Illustré de Chahine.* Paris: Librairie Auguste Blaizot, 1974.
TABANELLI, M. R. *L'Oeuvre gravé de Chahine.* Milan: Il Mercante di Stampe, 1976.

CHARLOT, JEAN (1898–)
MORSE, PETER. *Jean Charlot's Prints: a catalogue raisonné.* Honolulu: Jean Charlot Foundation, 1974.

CHASSÉRIAU, THÉODORE (1819–1856)
SANDOZ, MARC. *Chassériau: Catalogue raisonné des peintres et estampes.* Paris: Arts et Métiers Graphiques, 1974.
BÉRALDI, HENRI. *Les Graveurs du XIXᵉ Siècle.* Vol. 4. Paris: L. Conquet, 1886.

CHÉRET, JULES (1836–1933)
MAINDRON, ERNEST. *Les Affiches Illustrées: 1886–1895.* Paris, 1896.

CIRY, MICHEL (1919–)
PASSERON, ROGER. *Michel Ciry: L'oeuvre gravé.* 3 vols. Paris: La Bibliothèque des Arts, 1968, 1969 and 1970.

CLAVÉ, ANTONI (1913–)
SEGHERS, PIERRE. *Antoni Clavé: Gesamtkatalog.* Geneva: Weber S.A., 1971.

CORINTH, LOVIS (1858–1925)
MÜLLER, HEINRICH. *Die Späte Graphik von Lovis Corinth.* Hamburg: Lichtwarkstiftung, 1960.
SCHWARZ, KARL. *Das Graphische Werk von Lovis Corinth.* 2 vols. Berlin: Fritz Gurlitt, 1917 and 1922.

CORNELL, THOMAS (1937–)
BOWDOIN COLLEGE MUSEUM OF ART. *Thomas Cornell: Drawings and Prints.* Brunswick, Me., 1971.

COROT, JEAN-BAPTISTE CAMILLE (1796–1875)
DELTEIL, LOŸS, ed. *Le Peintre-Graveur Illustré: Corot.* Vol. 5. Paris, 1910. Reprint. New York: Da Capo Press, 1969.

COURTIN, PIERRE (1921–)
RIVIÈRE, YVES, ed. *Pierre Courtin: L'Oeuvre gravé, 1944–1972.* Paris: Weber, 1973.

CRAIG, EDWARD GORDON (1872–1966)
MACFALL, HALDANE. "Concerning the Woodcuts of E. Gordon Craig." *Print Collector's Quarterly* 9 (1922): 407–432.

CURRY, JOHN STEUART (1897–1945)
COLE, SYLVAN. *The Lithographs of John Steuart Curry.* New York: Associated American Artists, 1976.

DAUBIGNY, CHARLES FRANÇOIS (1817–1878)
DELTEIL, LOŸS, ed. *Le Peintre-Graveur Illustré: Charles Daubigny.* Vol. 13. Paris, 1921. Reprint. New York: Da Capo Press, 1969.

DAUMIER, HONORÉ (1808–1879)
DELTEIL, LOŸS, ed. *Le Peintre-Graveur Illustré: Honoré Daumier.* Vols. 20–29. Paris, 1926–1930. Reprint. New York: Da Capo Press, 1969.

DAVIES, ARTHUR B. (1862–1928)
PRICE, FREDERIC NEWLIN. *The Etchings and Lithographs of Arthur B. Davies.* New York and London: M. Kennerley, 1929.

DEGAS, EDGAR (1834–1917)
ADHÉMAR, JEAN, and CACHIN, FRANÇOISE. *Edgar Degas: Gravures et Monotypes.* Paris: Arts et Métiers Graphiques, 1973. New York (English), 1974.
DELTEIL, LOŸS, ed. *Le Peintre-Graveur Illustré: Edgar Degas.* Vol. 9. Paris: 1919. Reprint. New York: Da Capo Press, 1969.

JANIS, E. PARRY. *Degas Monotypes: Essay, Catalogue and Checklist.* Cambridge, Mass.: Fogg Art Museum, Harvard University, 1968.

DE KOONING, WILLEM (1904–)
LARSON, PHILIP. "Willem de Kooning: The Lithographs." *Print Collector's Newsletter* 5 (1974): 6–7.

DELACROIX, EUGÈNE (1798–1863)
DELTEIL, LOŸS, ed. *Le Peintre-Graveur Illustré: Ingres and Delacroix.* Vol. 3. Paris, 1908. Reprint. New York: Da Capo Press, 1969.

DELAUNAY, ROBERT (1885–1941)
LOYER, JACQUELINE, and PERUSSAUX, CHARLES. "Robert Delaunay: Catalogue de Son Oeuvre Lithographique," in *Nouvelles de l'estampe* No. 15. Paris, May– June, 1974.

DELVAUX, PAUL (19 –)
JACOB, MIRA. *Paul Delvaux: l'oeuvre gravé.* Paris: le Bateau Lavoir, 1976. New York (English): Rizzoli, 1976.

DENIS, MAURICE (1870–1943)
CAILLER, PIERRE. *Catalogue raisonné de l'oeuvre gravé et lithographie de Maurice Denis.* Geneva: Editions Pierre Cailler, 1968.

DERAIN, ANDRÉ (1880–1954)
ADHÉMAR, JEAN. *Derain: Peintre-Graveur: Catalogue de l'Exposition.* Paris: Bibliothèque Nationale, 1955.

DEXEL, WALTER (1890–)
DITT, WALTER. *Walter Dexel: Werkverzeichnis der Druckgraphik von 1915–1971.* Cologne: Walther König, 1971.

DINE, JIM (1935–)
GALERIE MIKRO. *Jim Dine: Complete Graphics.* Berlin, 1970.

DIX, OTTO (1891–1969)
KARSCH, FLORIAN. *Otto Dix: das Graphische Werk 1913–1960.* Hanover: Fackelträger-Verlag Schmidt-Küster, 1970.

DORÉ, GUSTAVE (1832–1883)
FORBERG, GABRIELE, and METKEN, GÜNTHER. *Gustave Doré: Das Graphische Werk.* 2 vols. Munich: Rogner et Bernhard, 1975.
LEBLANC, HENRI. *Catalogue de l'oeuvre complet de Gustave Doré.* Paris: C. Bosse, 1931.

DUBUFFET, JEAN (1901–)
LOREAU, MAX. *Catalogue des travaux de Jean Dubuffet.* 26 vols. Paris: J. J. Pauvert, Editeur (Vol. XVI: les Phénomènes, 1964).
MCNULTY, KNEELAND, et al. *The Lithographs of Jean Dubuffet.* Philadelphia: Philadelphia Museum of Art, 1964.

DUCHAMP, MARCEL (1887–1968)
SCHWARZ, ARTURO. *The Complete Works of Marcel Duchamp.* New York: Harry N. Abrams Inc., 2d ed. 1970.

DUNOYER DE SEGONZAC, ANDRÉ (1884–1974)
LIORÉ, A. and CAILLER, P. *Catalogue de l'Oeuvre gravé de Dunoyer de Segonzac.* Vols. 1–8. Geneva: Editions Pierre Cailler, 1958–70.

ENSOR, JAMES (1860–1949)
TAEVERNIER, AUGUST. *Graphic Work of James Ensor.* Brussels, 1973.
DELTEIL, LOŸS, ed. *Le Peintre-Graveur Illustré: Leys, Braekeleer, Ensor.* Vol. 19. Paris. 1925. Reprint. New York: Da Capo Press, 1969.
CROQUEZ, A. *L'Oeuvre Gravé de James Ensor.* Geneva and Brussels: Editions Pierre Cailler, 1947.

ERNI, HANS (1909–)
CAILLER, PIERRE. *Catalogue Raisonné de L'Oeuvre Lithographié et Gravé de Hans Erni.* 2 vols. Geneva: Editions Pierre Cailler, 1969 and 1971.

ERNST, MAX (1891–1976)
LEPPIEN, HELMUT R. *Max Ernst: Das Graphische Werk,* Köln: Verlag M. DuMont Schauberg, 1975.
BRUSBERG, DIETER. *Dokumente 3: Max Ernst, Jenseits der Malerei, das graphische Oeuvre.* Hanover, 1972.

GOERG, CHARLES. *Max Ernst: Oeuvre Gravé.* Geneva: Musée d'Art et d'Histoire, 1970.
ESCHER, MAURITS C. (1898–1972)
LOCHER, J. L., ed. *The World of M. C. Escher.* New York: Harry N. Abrams, 1972.
EVERGOOD, PHILIP (1901–1973)
LIPPARD, LUCY. *The Graphic Work of Philip Evergood.* New York: Crown Publishers, 1966.
FANTIN-LATOUR, IGNACE HENRI (1836–1904)
FANTIN-LATOUR, VICTORIA, ed. *Catalogue de l'Oeuvre Complet de Fantin-Latour 1849–1904,* Paris: Floury, 1911.
HÉDIARD, GERMAIN. *Les Maîtres de la lithographie: Fantin-Latour, catalogue de l'oeuvre lithographique.* Paris: Librairie de l'art ancien et moderne, 1906.
FEININGER, LYONEL (1871–1956)
Associated American Artists. *Catalogue of Exhibition: Lyonel Feininger Woodcuts Used as Letterheads.* New York, 1974.
PRASSE, LEONA E. *Lyonel Feininger: A Definitive Catalogue of his Graphic Work.* Cleveland: Cleveland Museum of Art, 1972.
FELIXMÜLLER, CONRAD (1897–)
SÖHN, GERHART. *Conrad Felixmüller: Das Graphische Werk 1912–1974.* Düsseldorf: Graphik-Salon Gerhart Söhn, 1975.
FINI, LEONOR (1908–)
GUIBBERT, JEAN PAUL. *Léonor Fini: Graphique.* Lausanne: Editions Clairfontaine, 1971.
FONTANA, LUCIO (1899–1968)
FONTANA, LUCIO et al. *Lucio Fontana.* 2 vols. Brussels: Edition de la Connaissance, 1974.
FORAIN, JEAN-LOUIS (1852–1931)
GUÉRIN, MARCEL. *Jean-Louis Forain: Aquafortiste.* 2 vols. Paris: H. Floury, 1912.
———. *Jean-Louis Forain Lithographe.* Paris, 1910.
FRIEDLAENDER, JOHNNY (1912–)
SCHMÜCKING, ROLF. *Johnny Friedlaender: Radierungen 1930–1972.* Braunschweig: Galerie Schmücking, 1973.
FUCHS, ERNST (1930–)
WEIS, HELMUT. *Ernst Fuchs: Das Graphische Werk.* Vienna: Verlag für Jugend und Volk, 1967.
GAUGUIN, PAUL (1848–1903)
FIELD, RICHARD S. "Gauguin's Noa Noa Suite," in *Burlington Magazine.* London, Sept., 1968.
EDWARDS, HUGH. *Gauguin's Prints.* Chicago: Art Institute, 1959.
GUÉRIN, MARCEL. *L'oeuvre gravé de Gauguin.* 2 vols. Paris: H. Floury, 1927.
GAVARNI, GUILLAUME SULPICE CHEVALIER (1804–1866)
LEMOISNE, P.-A. *Gavarni: Peintre et Lithographe.* 2 vols. Paris, 1924–28.
ARMELHAUT, J., and BOCHER, E. *L'Oeuvre de Gavarni.* Paris, 1873.
GIACOMETTI, ALBERTO (1901–1966)
LUST, HERBERT C. *Giacometti: The Complete Graphics and 15 Drawings.* New York: Tudor Publishing Company, 1970.
ALBERT GLEIZES (1881–1953)
LOYER, JACQUELINE. "Catalogue des Estampes et des Illustrations d'Albert Gleizes," in *Nouvelles de l'estampe* No. 26. Paris, March–April, 1976.
GOGH, VINCENT VAN (1853–1890)
MONTFORT, JULIANA. "Van Gogh et la gravure, histoire catalographique," in *Nouvelles de l'estampe No. 2.* Paris, March–April, 1972.
FAILLE, J. B. de la. *The Works of Vincent Van Gogh.* Amsterdam: Meulenhoff International, New York: Reynal and Co., 1970.
GRAMATTÉ, WALTER (1897–1929)
C. G. BOERNER. *Walter Gramatté 1897–1929: Druckgraphik und Zeichnungen.* Dusseldorf, 1976.
ECKHARDT, FERDINAND. *Das Graphische Werk von Walter Gramatté.* Zürich: Amalthea-Verlag, 1932.
GRIESHABER, HELMUT A. P. (HAP) (1909–)
Städtische Kunstgalerie Bochum. *Grieshaber 60.* Bochum, 1969.

Fürst, Margot. *HAP Grieshaber: der Holzschneider.* Stuttgart: Gerd Hatje, 1964.
 GRIS, JUAN (1887–1927)
Kahnweiler, Daniel-Henry. *Juan Gris. Sa Vie, Son Oeuvre, Ses Ecrits.* Paris: Gallimard,
 1946. London (English), 1947; New York, 1969.
 GROMAIRE, MARCEL (1892–1971)
Galerie Carré. *Oeuvre gravé de Gromaire.* Paris, 1956.
 GROPPER, WILLIAM (1897–)
Associated American Artists. *William Gropper: Etchings.* New York, 1965.
 GROSZ, GEORGE (1893–1959)
Dückers, Alexander. *George Grosz: Frühe Druckgraphik, Sammelwerke, Illustrierte Bücher
 1914–1923.* Berlin: Berlin-Dahlem Museum, 1971.
 HADEN, FRANCIS SEYMOUR (1818–1910)
Harrington, H. N. *The Engraved Work of Seymour Haden. An Illustrated and Descriptive Cat-
 alogue.* Liverpool: H. Young & Sons, 1910.
 HAMAGUCHI, YOZO (1909–)
Nantenshi Gallery. *Yozo Hamaguchi: Graphic Works.* Tokyo, 1973.
 HAMILTON, RICHARD (1922–)
Davison Art Center. *The Prints of Richard Hamilton.* Middletown, Conn.: Wesleyan Uni-
 versity, 1973.
 HARTUNG, HANS (1904–)
Schmücking, Rolf. *Verzeichnis der Graphik 1921–1965.* Braunschweig: Galerie Schmücking,
 1965.
 HASSAM, CHILDE (1859–1935)
Griffith, Fuller. *The Lithographs of Childe Hassam: A Catalogue.* Bulletin no. 232. Washing-
 ton, D.C.: U.S. National Museum, Smithsonian Institution, 1962.
Leonard Clayton Gallery. *Handbook of the Complete Set of Etchings and Drypoints of Childe Has-
 sam, N.A. from 1883–1933.* New York, 1933.
Cortissoz, Royal. *Catalogue of the Etchings and Drypoints of Childe Hassam.* New York and
 London: Charles Scribner's Sons, 1925.
 HAUSNER, RUDOLF (1914–)
Rudolf Hausner: Werkverzeichnis der Graphik. Offenbach: Volker Huber, 1972.
 HAYTER, STANLEY WILLIAM (1901–)
Associated American Artists. *Stanley William Hayter: Nine Engravings 1933–1946.* New
 York, 1974.
Corcoran Gallery of Art. *Stanley William Hayter: Paintings, Drawings and Prints 1922–1950.*
 Washington, D.C., 1973.
La Tortue Galerie. *S. W. Hayter: Engravings, Etchings and Lithographs 1939 to 1969.* Santa
 Monica, 1970.
Reynolds, Graham. *The Engravings of S. W. Hayter.* London: Victoria and Albert Mu-
 seum, 1967.
 HECKEL, ERICH (1883–1970)
Dube, A. and W. D. *Erich Heckel, das graphische Werk.* 3 vols. New York: Ernest Rathenau,
 1964 and 1974.
 HELLEU, PAUL-CÉSAR (1859–1927)
Knoedler Gallery. *Paul-César Helleu: Glimpses of the Grace of Women.* New York, 1974.
Lumley Cazalet Ltd. *Paul Helleu: Drypoints.* London, 1970.
Bibliothèque Nationale. *Helleu: exhibition catalogue.* Paris, 1957.
Montesquiou, Robert de. *Paul Helleu Peintre et Graveur.* Paris: Floury, 1913.
 HEYBOER, ANTON (1924–)
Anton Heyboer. Stedelijk Museum, 1968.
 HIRSCH, JOSEPH (1910–)
Cole, Sylvan, Jr., ed. *The Graphic Work of Joseph Hirsch.* New York: Associated American
 Artists, 1970.
 HNIZDOVSKY, JACQUES (1915–)
Associated American Artists. *Hnizdovsky: Ten Years of Woodcut 1960–1970.* New York,
 1971.

HOCKNEY, DAVID (1937–)
BONIN, WIBKE VON, and GLAZEBROOK, MARK. *David Hockney: Paintings, Prints and Drawings 1960–1970.* Boston: Boston Book and Art, 1970. London: Whitechapel Art Gallery, 1970.
HOFER, KARL (1878–1955)
RATHENAU, ERNEST, ed. *Karl Hofer: das graphische Werk.* Berlin: Euphorion Verlag, 1969.
HOMER, WINSLOW (1836–1910)
GELMAN, BARBARA. *The Wood Engravings of Winslow Homer.* New York: Crown Publishers, Inc., 1969.
GOODRICH, LLOYD. *The Graphic Art of Winslow Homer.* New York: The Museum of Graphic Art, 1968.
HOPPER, EDWARD (1882–1967)
ZIGROSSER, CARL. *The Complete Graphic Work of Edward Hopper: Catalogue of the Exhibition.* Philadelphia: Philadelphia Museum of Art, 1962.
————. "The Etchings of Edward Hopper," in *Prints.* New York: Holt, Rinehart and Winston, 1962.
HRDLICKA, ALFRED (1928–)
SCHMIED, WIELAND and STUBBE, WOLF. *Alfred Hrdlicka: Das Graphische Werk.* Berlin: Propyläen, 1973.
HUNDERTWASSER, FRIEDRICH (1928–)
The Albertina Exhibition of Hundertwasser's Complete Graphic Work 1951–1975. Glarus (Switz.): Gruener Janura AG, 1975.
IKEDA, MASUO (1934–)
CASTILE, RAND. *Ikeda & Ida: Two New Japanese Printmakers.* New York: Japan Society, Inc., 1974.
MILLER, JO. *Masuo Ikeda: Etchings and Lithographs from 1968 to 1970.* New York: Associated American Artists, 1970.
INDIANA, ROBERT (1928–)
Robert Indiana Graphics. Notre Dame: Saint Mary's College, 1969.
KATZ, WILLIAM. *Robert Indiana. Druckgraphik und Plakata 1961–1971.* Stuttgart: Edition Domberger, 1971.
INGRES, JEAN AUGUSTE DOMINIQUE (1780–1867)
SMITH, ROBERT. "Was Ingres a Portrait-Lithographer? Some Re-attributions to Géricault," in *Nouvelles de l'estampe.* No. 10. Paris: July–Aug., 1973.
DELTEIL, LOŸS, ed. *Le Peintre-Graveur Illustré: Ingres and Delacroix.* Vol. 3. Paris, 1908. Reprint. New York: Da Capo Press, 1969.
ITTEN, JOHANNES (1888–1967)
ITTEN, ANNELIESE, and ROTZLER, WILLY. *Johannes Itten: Werk und Schriften.* Zurich: Orell Füssli, 1972.
JANSSEN, HORST (1929–)
BROCKSTEDT, HANS. *Horst Janssen: Landschaften (Radierung)-Radierung.* Hamburg: Galerie Brockstedt, 1971. Berlin: Propyläen Verlag, 1971.
SCHMIED, WIELAND, ed. *Horst Janssen: Ballhaus Jahnke, Radierungen* (C. Vogel collection). Frankfurt: Insel, 1969.
VOGEL, CARL. *Verzeichnis der Druckgraphik Horst Janssen 1951–1965* (in exhibition catalogue of Kestner-Gesellschaft). Hannover: Kunstamt Berlin-Tempelhof, 1965.
JAWLENSKY, ALEXEI VON (1864–1941)
WEILER, CLEMENS. *Alexei Jawlensky: With a Catalogue of Works.* Cologne, 1959.
JOHN, AUGUSTUS (1878–1961)
P. & D. Colnaghi and Company. *Augustus John: Early Drawings and Etchings.* London, 1974.
DODGSON, CAMPBELL. "Additions to the Catalogue of the Etchings by Augustus John, R.A." *Print Collector's Quarterly* 18 (1931): 271–287.
————. *A Catalogue of Etchings by Augustus John, 1901–1914.* London: Chenil & Co., 1920.
ALLHUSEN, E. L. "Etched Work of Augustus John." *Print Collector's Quarterly.* 7 (1917): 91–102.

JOHNS, JASPER (1930–)
FIELD, RICHARD S. *Jasper Johns: Prints 1960–1970.* New York: Praeger, and Philadelphia: Philadelphia Museum of Art, 1970.
JONES, ALLEN (1937–)
STÜNKE, HEIN. *Allen Jones: Das Graphische Werk.* Köln: Galerie der Spiegel, 1969.
JONGKIND, JOHAN BARTHOLD (1819–1891)
DELTEIL, LOŸS, ed. *Le Peintre-Graveur Illustré: Jongkind.* Vol. 1. Paris, 1906. Reprint. New York: Da Capo Press, 1969.
ROGER-MARX, CLAUDE. "The Engraved Work of Jongkind." *Print Collector's Quarterly* 15 (1928): 111–130.
JORN, ASGER (1914–1973)
Asger Jorn: Die gesamte Druckgraphik. Munich: Galerie van de Loo, 1973.
KANDINSKY, WASSILY (1866–1944)
ROETHEL, HANS K. *Kandinsky: Das Graphische Werk.* Cologne: Verlag Du Mont Schauberg, 1970.
KATZ, ALEX (1947–)
FIELD, RICHARD S., and SOLOMON, ELKA M. *Alex Katz: Prints.* New York: Whitney Museum of American Art, 1974.
KAUS, MAX (1891–)
Altonaer Museum in Hamburg. *Max Kaus Graphik* (Sammlung Bachheim). Feldafing: Buchheim Verlag, 1973.
KELLY, ELLSWORTH (1923–)
WALDMAN, DIANE. *Ellsworth Kelly: Drawings, Collages, Prints.* Greenwich, Conn.: New York Graphic Society, 1972.
KENT, ROCKWELL (1882–1971)
JONES, DAN BURNE. *The Prints of Rockwell Kent: A Catalogue Raisonné.* Chicago: University of Chicago Press, 1975.
KIRCHNER, ERNST LUDWIG (1880–1938)
DUBE-HEYNIG, ANNEMARIE and WOLF-DIETER. *Ernst Ludwig Kirchner: Das Graphische Werk.* 2 vols. Munich: Prestel-Verlag, 1967.
———. *Kirchner: His Graphic Art.* Greenwich, Conn.: New York Graphic Society, 1965.
KITAJ, R. B. (1932–)
Marlborough Fine Art, Ltd. *R. B. Kitaj: The Complete Graphic Works 1963–1970.* London, 1971.
KLEE, PAUL (1879–1940)
KORNFELD, EBERHARD W. *Verzeichnis Des Graphischen Werkes von Paul Klee.* Bern: Kornfeld and Klipstein, 1963.
KLINGER, MAX (1857–1920)
BEYER, CARL. *Max Klingers graphisches Werk, von 1909–1919.* Leipzig: P. H. Beyer and Son, 1930.
SINGER, H. W. *Max Klingers Radierungen, Stiche und Steindrucke.* Berlin: Amsler and Ruthardt, 1909.
KOKOSCHKA, OSKAR (1886–)
WINGLER, H. M., and WELZ, F. *Oskar Kokoschka: das Graphische Werk.* Salzburg: Galerie Welz, 1975.
KOLLWITZ, KÄTHE (1867–1945)
University of Connecticut. *The Landauer Collection of Käthe Kollwitz Prints.* Storrs, Conn.: University of Connecticut Museum of Art, 1968.
KLIPSTEIN, AUGUST. *Käthe Kollwitz: Verzeichnis des graphischen Werkes.* Bern: Kornfeld und Klipstein, 1955.
KUBIN, ALFRED (1877–1959)
RAABE, P. *Alfred Kubin: Leben, Werk, Wirkung: With a Catalogue of Works.* Hamburg: Rowohlt, 1957.
KUHN, WALT (1877–1949)
Harlan Gallery. *Walt Kuhn as Printmaker.* Tucson, Ariz., 1974.

Kennedy Galleries. *Walt Kuhn as Printmaker.* New York, 1967.
KUNIYOSHI, YASUO (1893–1953)
"The Graphic Work of Yasuo Kuniyoshi." *Journal of the Archives of American Art* 5, No. 3 (1965).
LAAGE, WILHELM (1868–1930)
HAGENLOCHER, ALFRED. *Wilhelm Laage: Das Graphische Werk.* Munich: Karl Thiemig, 1969.
LABOUREUR, EMILE (1877–1943)
LOYER, JACQUELINE. *Laboureur, oeuvre gravé et lithographié.* Paris, 1962.
GODEFROY, LOUIS. *L'oeuvre gravé de Jean-Emile Laboureur.* Paris, 1929.
LASANSKY, MAURICIO (1914–)
LASANSKY, PHILLIP, and THEIN, JOHN. *Lasansky: Printmaker.* Iowa City: University of Iowa Press, 1975.
LAURENS, HENRI (1885–1954)
DOBEI and LEIRIS, MICHAEL. *Henri Laurens: oeuvre gravé.* Zurich, 1960.
LE CORBUSIER (EDOUARD JEANNERET) (1887–1965)
GALERIE WOLFGANG KETTERER. *Le Corbusier: Lithographien-Radierungen.* Munich, 1970.
Le Corbusier: Oeuvre Lithographique 1954–1961. Zurich: Centre Le Corbusier.
LÉGER, FERNAND (1881–1955)
SAPHIRE, LAWRENCE. *Fernand Léger, The Complete Graphic Work.* New York: Blue Moon Press, 1974.
LEHMBRUCK, WILHELM (1881–1919)
PETERMANN, ERWIN. *Die Druckgraphik von Wilhelm Lehmbruck.* Stuttgart: Gerd Hatje, 1964.
LEWIS, MARTIN (1881–1962)
McCARRON, PAUL. *Martin Lewis: The Graphic Work.* New York: Kennedy Galleries, 1973.
LICHTENSTEIN, ROY (1923–)
BIANCHINI, PAUL. *Roy Lichtenstein: Drawings and Prints.* New York: Chelsea House, 1970.
LIEBERMANN, MAX (1847–1935)
SCHIEFLER, GUSTAV. *Das Graphische Werk von Max Liebermann.* 2nd ed. Berlin, 1923.
LISSITSKY, EL (1890–1941)
KARSHAN, DONALD. "Lissitzky: The Original Lithographs: An Introduction," in *El Lissitzky.* Cologne: Galerie Gmurzynska, 1976.
LISSITSKY-KÜPPERS, SOPHIE. *El Lissitsky: Maler, Architekt, Typograf, Fotograf.* Dresden, 1967.
LOZOWICK, LOUIS (1893–1973)
Whitney Museum of American Art. *Louis Lozowick: Lithographs.* Introduction by Elke M. Solomon. New York, 1973.
McBEY, JAMES (1883–1959)
CARTER, CHARLES, ed. *Etchings and Dry Points from 1924 by James McBey (1883–1959).* Aberdeen, 1962.
HARDIE, MARTIN. "The Etched Work of James McBey: 1925–1937." *Print Collector's Quarterly* 25 (1938): 421–445.
———. *James McBey: Catalogue Raisonné 1902–1924.* London, 1925.
MACKE, AUGUST (1887–1914)
(*See* Peters *and* Wingler)
MAILLOL, ARISTIDE (1861–1944)
GUÉRIN, MARCEL. *Catalogue Raisonné de l'oeuvre gravé et lithographié d'Aristide Maillol.* 2 vols. Geneva: Editions Pierre Cailler, 1965 and 1967.
WOFSY, ALAN. *Aristide Maillol: The Artist and the Book.* San Francisco: Alan Wofsy Fine Arts, 1975.
MALEVICH, KASIMIR (1878–1935)
KARSHAN, DONALD. *The Graphic Work of Kasimir Malevich.* Jerusalem: The Israel Museum, 1976.
ANDERSEN, T. *Malevich: Catalogue Raisonné of the Berlin Exhibition of 1927.* Amsterdam, 1970.
MANET, ÉDOUARD (1832–1883)
LEYMARIE, JEAN and MELOT, MICHEL. *The Graphic Works of the Impressionists: The Complete Prints of Manet, Pissarro, Renoir, Cézanne, and Sisley.* New York: Harry N. Abrams, 1972.

HARRIS, JEAN. *Edouard Manet: Graphic Works: A Definitive Catalogue Raisonné*. New York: Collector's Editions, 1970.

GUÉRIN, MARCEL. *L'Oeuvre Gravé de Manet*. Paris, 1944. Reprint. New York: Da Capo Press, 1969.

MANZÙ, GIACOMO (1908–)

CIRANNA, ALFONSO. *Giacomo Manzù: Catalogo delle Opere Grafiche (Incisioni e Litografie) 1929–1968*. Milan, 1968.

MARC, FRANZ (1880–1916)

BAIRATI, ELEONORA. "Franz Marc: Critical Notes and a Catalogue of His Graphic Work," in *Print Collector* No. 10. Milan, 1974.

LANKHEIT, KLAUS. *Franz Marc: Katalog der Werke*. Cologne: Dumont Schauberg, 1970.

MARCKS, GERHARD (1889–)

Gerhard Marcks: Frühe Holzschnitte. New York: Ernest Rathenau, 1972.

MARCOUSSIS, LOUIS (1883–1941)

Scott Elliot Gallery. *Louis Marcoussis: Checklist*. January, 1974.

ADHÉMAR, JEAN. *Marcoussis*. Paris: Cabinet des Estampes, Bibliothèque Nationale, 1972.

LANFRANCHIS, J. *Marcoussis: sa vie, son oeuvre*. Paris: Les Editions du Temps, 1961.

MARIN, JOHN (1872–1953)

ZIGROSSER, CARL. "Errata in the Catalogue of the Etchings of John Marin." *Print Collector's Newsletter* 1 (1970): 82–83.

——. *The Complete Etchings of John Marin: Catalogue Raisonné*. Philadelphia: Philadelphia Museum of Art, 1969.

MARINI, MARINO (1901–)

SAN LAZZARO, GUALTIERI DI. *Marino Marini: Complete Works*. New York: Tudor, 1970.

CARANDENTE, GIOVANNI, and TONINELLI, L. F. *Marino Marini: Lithographs 1942–1965*. New York: Harry N. Abrams, 1967.

MARSH, REGINALD (1898–1954)

SASOWSKY, NORMAN. *The Prints of Reginald Marsh*. New York: Clarkson N. Potter, 1976.

MARTIN, JOHN (1789–1854)

FEAVER, WILLIAM. *The Art of John Martin*. Oxford: Clarendon Press, 1975.

MASSON, ANDRÉ (1896–)

PASSERON, ROGER. *André Masson: The Engravings 1924–1972*. Fribourg, Switzerland: Office du Livre, s.a., 1973.

MATARÉ, EWALD (1887–1965)

PETERS, HEINZ. *Ewald Mataré: das graphische Werk*. 2 vols. Cologne: C. Czwiklitzer, 1957–58.

MATISSE, HENRI (1869–1954)

SCHNIEWIND, CARL O. Unpublished catalogue of Matisse's graphic works (by plate number) established by his family. New York: Museum of Modern Art.

Reiss-Cohen Gallery. *Henri Matisse: The Graphic Works*. New York, 1972.

GUICHARD-MEILI, JEAN, and WOIMANT, FRANÇOISE. *Matisse: l'oeuvre gravé*. Paris: Bibliothèque Nationale, 1970.

HAHNLOSER-INGOLD, MARGRIT. *Henri Matisse: Gravures et Lithographies de 1900 à 1929*. Pully, and Bern, Switz.: Kornfeld et Klipstein, 1970.

LIEBERMAN, WILLIAM S. *Etchings by Matisse*. 1955. 2nd printing. New York: Museum of Modern Art, 1965.

——. *Matisse: Fifty Years of His Graphic Work*. New York: George Braziller, 1956.

MATTA ECHAURREN, ROBERTO SEBASTIAN (1911–)

SABATIER, ROLAND. *Matta: Catalogue raisonné de l'oeuvre gravé (1943–1974)*. Paris: Visat, 1975. Stockholm: Sonet, 1975.

MECKSEPER, FRIEDRICH (1936–)

SCHMÜCKING, ROLF. *Meckseper: Werkverzeichnis der Radierung 1956–1975*. Braunschweig: Verlag Galerie Schmucking, 1975.

MENZEL, ADOLF VON (1815–1905)

BOCK, ELFRIED. *Adolf von Menzel: Verzeichnis seines graphischen Werkes*. Berlin, 1923.

MERYON, CHARLES (1821–1868)

BURKE, JAMES D. *Charles Meryon Prints and Drawings.* New Haven: Yale University Art Gallery, 1974.

WRIGHT, HAROLD J. L., ed. *Catalogue Raisonné of the Etchings of Charles Meryon, by Loÿs Delteil.* London and New York: Winfred Porter Truesdell, 1924.

MILLET, JEAN-FRANÇOIS (1814–1875)

DELTEIL, LOŸS, ed. *Le Peintre-graveur Illustré: Millet, Rousseau, Dupré, Jongkind.* Vol. 1. Paris, 1906. Reprint. New York: Da Capo Press, 1969.

MILTON, PETER (1930–)

Corcoran Gallery of Art. *Peter Milton: Etchings.* Washington, D.C., 1972.

MIRÓ, JOAN (1893–)

QUENEAU, RAYMOND. *Joan Miró Lithographe.* Vol. 2. Paris: Maeght Editeur, 1975. New York (English): Léon Amiel Publisher, 1975.

Miró: l'oeuvre graphique. Paris: Musée d'Art Moderne de la Ville de Paris, 1974.

LEIRIS, MICHEL, and MOURLOT, FERNAND. *Joan Miró Lithographs 1930–1952.* Vol. 1. New York: Tudor Publishing Co., 1972.

HUNTER, SAM. *Joan Miró: His Graphic Work.* New York: Abrams, 1958.

WEMBER, PAUL. Joan Miró: das Graphische Werk. Krefeld: Kaiser Wilhelm Museum, 1957.

MODERSOHN-BECKER, PAULA (1876–1907)

WERNER, WOLFGANG. *Paula Modersohn-Becker: Gemälde, Zeichnungen, Oeuvre-verzeichnis der Graphik.* Bremen: Graphisches Kabinett und Kunsthandlung Ursula Voigt, 1968.

MOORE, HENRY (1898–)

CRAMER, GÉRALD, ed. *Henry Moore: The Graphic Work.* 2 vols. (1931–73 and 1973–75). Geneva: Galerie Gérald Cramer, 1973 and 1976.

GILMOUR, PAT. *Henry Moore: Graphics in the Making.* London: Tate Gallery, 1975.

MORANDI, GIORGIO (1890–1964)

VITALI, LAMBERTO. *L'Opera grafica di Giorgio Morandi.* rev. ed. Turin: Einaudi, 1964.

MOTHERWELL, ROBERT (1915–)

COHEN, ARTHUR A. *Robert Motherwell: Selected Prints: 1961–1974.* New York: Brooke Alexander, Inc., 1974.

MUCHA, ALPHONSE MARIA (1860–1939)

HENDERSON, MARINA and MUCHA, JIRI. *The Graphic Work of Alphonse Mucha.* New York: St. Martin's Press, 1974.

MÜLLER, OTTO (1874–1930)

KARSCH, FLORIAN. *Otto Mueller: Das Graphische Gesamtwerk.* Berlin: Galerie Nierendorf, 1975.

MUNCH, EDVARD (1863–1944)

SCHIEFLER, GUSTAV. *Verzeichnis des Graphischen Werke Edvard Munch bis 1906.* Berlin: Cassirer, 1907. Reprint. Oslo: J. W. Cappelen, 1974.

———. *Edvard Munch das Graphische Werk 1906–1926.* Berlin: Euphorion, 1928. Reprint. J. W. Cappelen, 1974.

JENTSCH, RALPH and RÖTTGER, FRIEDHELM. *Edvard Munch Lithographien Holzschnitte Radierungen.* Esslingen: Kunstgalerie Esslingen, 1974.

KORNFELD, EBERHARD W. *Graphik von Edward Munch-Henri de Toulouse-Lautrec* (auction catalog). Bern: Kornfeld und Klipstein, 1973.

TIMM, WERNER. *The Graphic Art of Edvard Munch.* Greenwich, Conn.: New York Graphic Society, 1969 and London: Studio Vista, 1969.

WILLOCH, SIGURD. *Edvard Munch: Etchings.* Oslo: G. Tanum, 1950.

MÜNTER, GABRIELE (1877–1962)

HELMS, SABINE, ed. *Gabriele Münter: Das Druckgraphische Werk.* Munch: Städtische Galerie im Lenbachhaus, 1967.

MUSIĆ, ZORAN (1909–)

SCHMÜCKING, ROLF. *Zoran Musić: Das graphische Werk 1947–62.* Braunschweig: Verlag Galerie Schmücking, 1962.

NADELMAN, ELIE (1862–1946)

KIRSTEIN, LINCOLN. *Elie Nadelman* [at pp. 319–20]. New York: Eakins Press, 1973.

NASH, PAUL (1889–1946)

POSTAN, A. *The Complete Graphics of Paul Nash.* London: Secker and Warburg, 1973.

NESCH, ROLF (1893–)

HENTZEN, ALFRED and STUBBE, WOLF. *Rolf Nesch: Drucke.* Frankfurt: Ullstein/Propyläen, 1973.

Detroit Institute of Arts. *Prints by Rolf Nesch.* Detroit, 1969.

NEVELSON, LOUISE (1900–)

BARO, GENE. *Nevelson: The Prints.* New York: Pace Editions, 1974.

NOLDE, EMIL (1867–1956)

JENSEN, JENS CHRISTIAN, URBAN, MARTIN and REUTHER, MANFRED. *Emil Nolde: Graphik.* Kiel: Kunsthalle and Schleswig-Holsteinischer Kunstverein, 1975.

SCHIEFLER, GUSTAV, and MOSEL, CHRISTEL. *Emil Nolde: Das Graphische Werk.* 2nd ed., 2 vols. Cologne: Dumont Schauberg, 1966–67.

OLDENBURG, CLAES (1929–)

Margo Leavin Gallery. *Claes Oldenburg: Works in Edition 1971–1972.* Los Angeles, 1972.

BARO, GENE. *Claes Oldenburg Drawings and Prints.* London and New York: Chelsea House Publishers, 1969.

OROZCO, JOSÉ CLEMENTE (1883–1949)

HOPKINS, JON H. *Orozco: A Catalogue of His Graphic Work.* Flagstaff, Arizona: Northern Arizona University Publications, 1967.

PALMER, SAMUEL (1805–1881)

LISTER, RAYMOND. *Samuel Palmer and His Etchings.* New York: Watson-Guptill, 1968.

PAOLOZZI, EDUARDO (1924–)

WHITFORD, FRANK. *Eduardo Paolozzi.* London: Tate Gallery, 1973.

Eduardo Paolozzi Complete Graphics. Berlin: Galerie Mikro and London: Petersburg Press, 1969.

SELZ, PETER, and FINCH, CHRISTOPHER. *Eduardo Paolozzi, A Print Retrospective.* Berkeley: University of California and London: Editions Alecto, 1968.

PASCIN, JULES (PINCAS) (1885–1930)

VOSS, HANS. *Julius Pincas.* Frankfurt: Breidenstein/Brönners, 1956.

PEARLSTEIN, PHILIP (1924–)

DÜCKERS, ALEXANDER. *Philip Pearlstein: Drawings and Prints 1946–1972.* Berlin: Staatliche Museum, 1973.

PECHSTEIN, MAX (1881–1955)

FECHTER, PAUL. *Das Graphische Werk: Max Pechsteins.* Berlin: Verlag Gurlitt, 1921.

PENNELL, JOSEPH (1857–1926)

WUERTH, LOUIS A. *Catalogue of the Lithographs of Joseph Pennell.* Boston: Little, Brown and Co., 1931.

————. *Catalogue of the Etchings of Joseph Pennell.* Boston: Little, Brown and Co., 1928.

PETERDI, GABOR (1915–)

PETERDI, GABOR. *Gabor Peterdi: Graphics 1934–1969.* New York: Touchstone Publishers, 1970.

PICASSO, PABLO (1881–1973)

BERN-RAU. *Pablo Picasso: Das Graphische Werk.* Stuttgart: Gerd Hatje, 1975.

GALERIE LOUISE LEIRIS. *Picasso: 156 Gravures Récentes.* Paris, 1973.

BLOCH, GEORGES. *Picasso: Catalogue de l'oeuvre gravé et lithographié 1966–1969.* Vol. 2 Bern: Kornfeld und Klipstein, 1971.

CZWIKLITZER, CHRISTOPHER. *Picasso's Posters.* New York: Random House, 1970. Paris (French): Editions Art-C.C., 1970.

MOURLOT, FERNAND. *Picasso Lithographs 1919–1969.* Boston: Boston Book and Art Publisher, 1970.

KARSHAN, DONALD H. *Picasso Linocuts: 1958–1963.* New York: Tudor Publishing Co., 1968.

BLOCH, GEORGES. *Picasso: Catalogue de l'oeuvre gravé et lithographié 1904–1967.* Vol. 1. Bern: Kornfeld und Klipstein, 1968.

GEISER, BERNARD. *Picasso, Peintre-Graveur: Catalogue illustré de l'oeuvre gravé et lithographié 1932–1934.* Vol. 2. Bern: Kornfeld et Klipstein, 1968.

———. *Picasso, Peintre-Graveur: Catalogue illustré de l'oeuvre gravé et lithographié* 1899—1931. Vol. 1. 2d ed. Bern, 1955.

PISSARRO, CAMILLE (1830—1903)

SHAPIRO, BARBARA, and MELOT, MICHEL. "Les Monotypes de Camille Pissarro," in *Nouvelles de l'estampe* No. 19. Paris, Jan.–Feb. 1975.

SHAPIRO, BARBARA S. *Camille Pissarro: The Impressionist Printmaker.* Boston: Museum of Fine Arts, 1973.

LEYMARIE, JEAN, and MELOT, MICHEL. *The Graphic Works of the Impressionists: The Complete Prints of Manet, Pissarro, Renoir, Cézanne and Sisley.* New York: Harry N. Abrams, 1972.

DELTEIL, LOŸS, ed. *Le Peintre-Graveur Illustré: Pissarro, Sisley, Renoir.* Vol. 17. Paris, 1923. Reprint. New York: Da Capo Press, 1969.

CAILAC, JEAN. "The Prints of Camille Pissarro: A Supplement to the Catalogue by Loÿs Delteil." *Print Collector's Quarterly* 19 (1932): 75–86.

POLIAKOFF, SERGE (1906–1969)

RIVIÈRE, YVES, ed. *Serge Poliakoff: Les Estampes.* Paris: Arts et Métiers Graphiques, 1974.

POLLOCK, JACKSON (1912–1956)

CIRANNA, ALFONSO. "Jackson Pollock: Catalogue of His Graphic Works and Critical Notes." *Print Collector* No. 14. Milan, 1975.

POSADA, JOSÉ GUADALUPE (1851–1913)

Posada: Illustrador de la Vida Mexicana. Fonda Editorial de la Plastica Mexicana, 1963.

GAMBOA, F. *Posada: Printmaker to the Mexican People.* Chicago: Art Institute of Chicago, 1944.

PRENDERGAST, MAURICE (1859–1924)

PHILLIPS M. *Maurice Prendergast, The Monotypes.* New York: Bard College, 1967.

PURRMANN, HANS (1880–1966)

WEBER, WILHELM. *Hans Purrmann: Das Druckgraphische Werk.* Pfälzischen Landesgewerbeanstalt, 1963.

RAFFAËLLI, JEAN-FRANÇOIS (1850–1924)

DELTEIL, LOŸS, ed. *Le Peintre-Graveur Illustré: Raffaëlli.* Vol. 16. Paris, 1923. Reprint. New York: Da Capo Press, 1969.

RAUSCHENBERG, ROBERT (1925–)

FOSTER, EDWARD A. *Robert Rauschenberg: Prints 1948/1970.* Minneapolis: The Minneapolis Institute of Arts, 1970.

RAY, MAN (1890–)

ANSELMINO, LUCIANO. *Man Ray: Opera Grafica.* Florence: Centro Di, 1973.

REDON, ODILON (1840–1916)

MELLERIO, ANDRÉ. *Odilon Redon.* Paris, 1913. Reprint. New York: Da Capo Press, 1968.

RENOIR, PIERRE-AUGUSTE (1841–1919)

STELLA, JOSEPH G. *The Graphic Art of Renoir.* New York: Abner Schramm, 1975.

LEYMARIE, JEAN, and MELOT, MICHEL. *The Graphic Works of the Impressionists: The Complete Prints of Monet, Pissarro, Renoir, Cézanne and Sisley.* New York: Harry N. Abrams, 1972.

DELTEIL, LOŸS, ed. *Le Peintre-Graveur Illustré: Pissarro, Sisley, Renoir.* Vol. 17. Paris, 1923. Reprint. New York: Da Capo Press, 1969.

ROGER-MARX, CLAUDE. *Les lithographies de Renoir.* Monte Carlo: A. Sauret, 1951.

RODIN, AUGUSTE (1840–1917)

THORSON, VICTORIA. *Rodin Graphics: A Catalogue Raisonné of Drypoints and Book Illustrations.* San Francisco: The Fine Arts Museums, 1975.

DELTEIL, LOŸS, ed. *Le Peintre-Graveur Illustré: Rude, Barye, Carpeaux, Rodin.* Vol. 6. Paris, 1910. Reprint. New York: Da Capo Press, 1969.

ROHLFS, CHRISTIAN (1949–1938)

VOGT, PAUL. *Christian Rohlfs: das graphische werk.* Recklinghausen: A. Borgers, 1960.

ROPS, FELICIEN (1833–1898)

EXSTEENS, MAURICE. *L'Oeuvre Gravé et Lithographié de Félicien Rops.* Paris: Editions Pellet, 1928.

ROSENQUIST, JAMES (1933–)

BUDDE, R. *James Rosenquist: Gemälde, Räume, Graphik.* Cologne: Wallraf-Richartz-Museum, 1972.

ROUAULT, GEORGES (1871–1958)
Definitive catalogue in preparation by Isabelle Rouault.
WOFSY, ALAN. *Georges Rouault: The Graphic Work.* San Francisco: Alan Wofsy Fine Art, 1976.
ROUIR, E. "Georges Rouault: A Catalogue of the Lithographs Published by E. Frapier," in *Print Collector* No. 8. Milan, 1974.
AGUSTONI, F. and BELLINI, PAOLO. *Georges Rouault: Uomo e Artista.* With catalogue of graphics. Milan, 1972.
AGUSTONI, F. "The Graphic Work of Georges Rouault," in *Print Collector* No. 1. Milan, 1972.
KORNFELD und KLIPSTEIN. *Georges Rouault: Graphik und Illustrierte Bücher.* Bern, 1966.

ROUSSEAU, THÉODORE (1812–1867)
DELTEIL, LOŸS, ed. *Le Peintre-Graveur Illustré: Millet, Rousseau, Dupré, Jongkind.* Vol. 1. Paris, 1906. Reprint. New York: Da Capo Press, 1969.

ROUSSEL, KER XAVIER (1867–1944)
CHARTIER, ÉMILE [ALAIN], and SALOMON, JACQUES. *L'Oeuvre Gravé de K. X. Roussel.* Paris: Mercure de France, 1968.

SCHIELE, EGON (1890–1918)
KALLIR, OTTO. *Egon Schiele: The Graphic Work.* New York: Crown Publishers, 1970. Vienna (German): Paul Zsolnay, 1970.

SCHLEMMER, OSKAR (1888–1943)
SCHLEMMER, TUT. "Oskar Schlemmer: Ein Oeuvre-Katalog" in Grohmann, Will. *Oskar Schlemmer: Zeichnungen und Graphik-Oeuvre Katalog.* Stuttgart: Gerd Hatje, 1972.

SCHMIDT-ROTTLUFF, KARL (1884–1976)
VIOTTO, PAOLA. "Karl Schmidt-Rottluff: his 1905 woodcuts," in *Print Collector* No. 13. Milan, 1975.
BRÜCKE-MUSEUM. *Karl Schmidt-Rottluff: Das Graphische Werk Zum 90.* Berlin (Dahlem), 1974.
WIETEK, GERHARD. *Schmidt-Rottluff: Graphik.* Munich: Karl Thiemig, 1971.
SCHAPIRE, ROSA. *Karl Schmidt-Rottluffs graphisches Werk bis 1923.* Berlin: Euphorion-Verlag, 1924. Reprint. Hamburg: Dr. Ernst Hauswedell, 1971.
RATHENAU, ERNST. *Karl Schmidt-Rottluffs: das graphische Werk seit 1923.* New York, 1964. Reprint. Hamburg: Dr. Ernst Hauswedell, 1976.

SCHRAG, KARL (1912–)
Syracuse University. *Karl Schrag: A Catalogue Raisonné of the Graphic Works 1939–1970.* Syracuse, N.Y., 1972.

SCHREYER, LOTHAR (1886–1966)
(*See* Peters *and* Wingler)

SCHWITTERS, KURT (1887–1948)
BOLLIGER, HANS. "Veröffentlichte Original-Graphik von Kurt Schwitters" in Schmalenbach, Werner. *Kurt Schwitters: Leben und werk.* Cologne: Du Mont Schauberg, 1967.
(*See also* Peters *and* Wingler)

SEEWALD, RICHARD (1889–)
JENTSCH, RALPH. *Richard Seewald: Das Graphische Werk.* Esslingen: Verlag Kunstgalerie Esslingen, 1973.

SEGAL, ARTHUR (1875–1944)
NATHANSON, RICHARD. *A Collection of Woodcuts by Arthur Segal.* London, 1972.

SELIGMANN, KURT (1900–1964)
La Boetie Gallery. *Kurt Seligmann: His Graphic Work.* New York, 1973. Chicago: Allan Frumkin Gallery, 1973.

SEVERINI, GINO (1883–1966)
(*See* Peters *and* Wingler)

SHAHN, BEN (1898–1969)
PRESCOTT, C. W. *The Complete Graphic Works of Ben Shahn.* New York: Quadrangle Books, 1973.

SICKERT, WALTER RICHARD (1860–1942)
MURRY, J. MIDDLETON. "The Etchings of Walter Sickert." *Print Collector's Quarterly* 10 (1923): 31.

GAUNT, W. "The Etched Work of W. Richard Sickert." *Studio* 97 (1929): 337.

SIGNAC, PAUL (1863–1935)

KORNFELD, EBERHARD W., and WICK, PETER A. *Catalogue Raisonné de l'oeuvre gravé et lithographié de Paul Signac.* Bern: Editions Kornfeld et Klipstein, 1974.

SINGIER, GUSTAVE (1909–)

SCHMÜCKING, ROLF. *Das graphiscle Werk.* Braunschweig: Galerie Schmücking, 1958.

SISLEY, ALFRED (1839–1899)

LEYMARIE, JEAN and MELOT, MICHEL. *The Graphic Works of the Impressionists: The Complete Prints of Manet, Pissarro, Renoir, Cézanne, and Sisley.* New York: Harry N. Abrams, 1972.

DELTEIL, LOŸS, ed. *Le Peintre-graveur Illustré: Pissarro, Sisley, Renoir.* Vol. 17. Paris, 1923. Reprint. New York: Da Capo Press, 1969.

SLEVOGT, MAX (1868–1932)

SIEVERS, JOHANNES, and WALDMANN, EMIL. *Max Slevogt: Das Graphische Werk.* Heidelberg and Berlin: Impuls-Verlag Heinz Moos, 1962.

RÜMANN, ARTHUR. *Verzeichnis der Graphik von Max Slevogt in Büchern und Mappenwerken.* Hamburg: Gesellschaft der Bücherfreunde zu Hamburg, 1936.

SLOAN, JOHN (1871–1951)

MORSE, PETER. *John Sloan's Prints: A Catalogue Raisonné of the Etchings, Lithographs, and Posters.* New Haven: Yale University Press, 1969.

SOULAGES, PIERRE (1919–)

RIVIÈRE, YVES, ed. *Soulages: Eaux-Fortes, Lithographies, 1952–1973.* Paris: Arts et Métiers Graphiques, 1974.

SOYER, RAPHAEL (1899–)

COLE, SYLVAN, JR. *Raphael Soyer: Fifty Years of Printmaking, 1917–1967.* New York: Da Capo Press, 1967.

STEINLEN, THÉOPHILE ALEXANDRE (1859–1923)

CRAUZAT, ERNEST DE. *L'oeuvre gravé et lithographié de Steinlen.* Paris: Société de propagation des livres d'art, 1913.

SUMMERS, CAROL (1925–)

Associated American Artists. *Carol Summers: Checklist.* New York, 1972.

SUTHERLAND, GRAHAM (1903–)

MAN, FELIX H., ed. *Graham Sutherland: Das Gesamt graphische Werk 1922–1969.* Munich: Galerie Wolfgang Ketterer, 1970.

TANGUY, YVES (1900–1955)

HAYTER, STANLEY W. *Yves Tanguy—Gesamte Druckgraphik.* Düsseldorf: W. Wittrock Kunsthandel, 1976.

TÀPIES, ANTONIO (1923–)

GALFETTI, M. and VOGEL, C. *Antonio Tàpies: Obra Grafica, 1947–1972.* St. Gallen: Erker Verlag, 1975.

THIEBAUD, WAYNE (1920–)

Corcoran Gallery of Art. *Wayne Thiebaud: Graphics. 1964–1971.* New York: Parasol Press, Ltd., 1971.

THOMA, HANS (1839–1924)

BERINGER, J. A. *Hans Thoma: Radierungen.* Munich: F. Bruckmann, 1923.

TISSOT, JAMES JACQUES JOSEPH (1836–1902)

TUNICK, DAVID. *Twenty-one Prints by Tissot.* New York, 1972.

WENTWORTH, M. *James Jacques Joseph Tissot: A Retrospective Exhibition.* Providence, R.I.: Museum of Art, Rhode Island School of Design and Toronto, Ontario: The Art Gallery of Ontario, 1968.

BÉRALDI, H. *Les Graveurs du XIX^e Siècle.* Vol. 12. pp. 125–134. Paris, 1892.

TISSOT, J. J., and YRIANTE, CHARLES. *Eaux-Fortes, Manière Noire, Pointes Sèches.* Paris, 1886.

TOOROP, JAN THEODOOR (1858–1928)

RIJKSPRINTENKABINET. *De grafiek van Jan Toorop.* Amsterdam, 1969.

TOULOUSE-LAUTREC, HENRI DE (1864–1901)

KORNFELD, EBERHARD W. *Graphik von Edward Munch–Henri de Toulouse-Lautrec* (auction catalog). Bern: Kornfeld und Klipstein, 1973.

ADHÉMAR, JEAN. *Toulouse-Lautrec: His Complete Lithographs and Drypoints.* New York: Harry N. Abrams, 1965. Paris (French): Arts et Métiers Graphique, 1965.
BODELSEN, MERETE. *Toulouse-Lautrec's Posters.* Copenhagen: The Museum of Decorative Arts, 1964.
ADHÉMAR, JEAN. *Elles.* Monte-Carlo: André Sauret, 1962.
JULIEN, EDOUARD. *Les Affiches de Toulouse-Lautrec.* Monte-Carlo: André Sauret, 1950.
DELTEIL, LOŸS, ed. *Le Peintre-Graveur Illustré: Toulouse-Latrec.* Vols. 10 and 11. Paris, 1920. Reprint. New York: Da Capo Press, 1969.

TURNER, JOSEPH MALLORD WILLIAM (1775–1851)

FINBERG, A. J. "Turner's 'Southern Coast'." *Print Collector's Quarterly* 16 (1929): 165–181.
A Catalogue of the Collection of Prints from the Liber Studiorum of Joseph Mallord William Turner: A Catalogue Raisonné Showing the Various States of the Prints. Boston, 1916.
RAWLINSON, W. G. *Engraved Work of J. M. W. Turner.* 2 vols. London, 1908–1913.
————. *Turner's Liber Studiorum: A Description and a Catalogue.* London, 1878.

VALADON, SUZANNE (1865–1938)

PÉTRIDÈS, PAUL. *L'Oeuvre complet de Suzanne Valadon.* Paris: Compagnie Française des arts graphiques, 1971.

VALLOTTON, FÉLIX (1865–1925)

VALLOTTON, MAXIME, and GOERG, C. *Félix Vallotton: Catalogue raissoné de l'oeuvre gravé et lithographié. Catalogue Raisonné of the Printed Graphic Work.* Geneva: Les Editions de Bonvent, 1972.
GODEFROY, LOUIS. *L'Oeuvre gravé de Félix Vallotton.* Paris, 1932.

VAN VELDE, BRAM (1895–)

RIVIÈRE, YVES, ed. *Bram Van Velde: Les Lithographies, 1923–1973.* Paris, 1973.

VASARELY, VICTOR (1908–)

VASARELY, VICTOR. *Serigrafen* (1949–66). Amsterdam: Stedelijk Museum, 1967.

VILLON, JACQUES (GASTON DUCHAMP) (1875–1963)

GINESTET, DE. *Villon catalogue raisonné des dessins et de l'oeuvre graphique.* 2 vols. In preparation.
Lucien Goldschmidt Gallery. *Jacques Villon: A Collection of Graphic Work 1896–1913 in Rare or Unique Impressions.* New York, 1970.
WICK, PETER. *Jacques Villon: Master of Graphic Art.* Boston: Museum of Fine Arts, and New York: October House, 1964.
AUBERTY, J. and PERUSSEUX, C. *Jacques Villon: Catalogue de son oeuvre gravé.* Paris: Prouté, 1950.

VLAMINCK, MAURICE DE (1876–1958)

WALTERSKIRCHEN, K. VON and POLLAG, S. *Maurice de Vlaminck: das Graphische Werk.* Bern: Benteli Verlag, 1974. Paris (French): Flammarion, 1974.

VUILLARD, EDOUARD (1868–1940)

ROGER-MARX, CLAUDE. *L'Oeuvre Gravé de Vuillard.* Monte Carlo: André Sauret Editions du Livre, 1948.

WARHOL, ANDY (1930–)

CRONE, RAINER. *Andy Warhol.* New York: Praeger, 1970.

WEBER, MAX (1881–1961)

Associated American Artists. *The Lithographs of Max Weber.* New York, 1970.
Max Weber Woodcuts and Linoleum Blocks. New York: E. Weyhe, 1956.

WENGENROTH, STOW (1906–)

STUCKEY, RONALD and J. JOAN. *The Lithographs of Stow Wengenroth.* Barre, Mass.: Barre Publishers, 1974.

WHISTLER, JAMES ABBOTT McNEILL (1834–1903)

LEVY, MERVYN. *Whistler Lithographs.* London: Jupiter Books, 1975.
NAYLOR, MARIA. *Selected Etchings of James A. McN. Whistler.* New York: Dover Publications, 1975.
KENNEDY, EDWARD GUTHRIE. *The Etched Work of Whistler: Illustrated by Reproductions in Collotype of the Different States of the Plates.* 6 vols. New York: Grolier Club, 1910. Reprint. New York: Da Capo Press, 1975.

WAY, THOMAS ROBERT. *Mr. Whistler's Lithographs: The Catalogue*. London: G. Bell and Sons, 1896. 2d ed., 1905.
WOLS (WOLFGANG SCHULZE) (1913–1951)
GROHMAN, WILL. *"Das Graphische Werk von Wols"* in *Quadrum: Revue internationale d'Art moderne* No. 6. Brussels, 1959.
WUNDERLICH, PAUL (1927–)
BRUSBERG, DIETER. *Paul Wunderlich: Werk verzeichnis der Lithographien von 1949–1971.* Hanover: Verlag der Galerie Dieter Brusberg for Propyläen Verlag, 1971.
ZADKINE, OSSIP (1890–1967)
CZWIKLITZER, CHRISTOPHE. *Ossip Zadkine: le sculpteur-graveur de 1919–1967. Première partie: eaux-fortes. Deuxième partie: lithographes.* Paris: Fischbacher, 1968.
ZAO, WOU-KI (1920–)
CAILLOIS, ROGER. *Zao Wou-Ki: Les Estampes, 1937–1974.* Arts et Métiers Graphiques, 1974.
JACOMETTI, N. *Catalogue raisonné de l'oeuvre gravé et lithographié 1949–1954.* Bern: Gütekunst u. Klipstein, 1955.
ZORN, ANDERS (1860–1920)
ASPLUND, KARL. *Zorn's Engraved Work: A Descriptive Catalogue.* 2 vols. Stockholm: P. A. Norstedt, 1920–21.
DELTEIL LOŸS, ed. *Le Peintre-Graveur Illustré: Zorn.* Vol. 4. Paris, 1909. Reprint. New York: Da Capo Press, 1969.

IV. DEALER AND GALLERY DIRECTORIES AND PRICE INDEXES

The Art Gallery Scene in *The ART Gallery* magazine. Monthly. Hollycroft Press, Inc., Ivoryton, Conn. 06442.
Art-Prices Current. Annual. The Art Trade Press Ltd., 23 Wade Court Road, Havant, Hants., England.
Art Sales Index. Monthly and Annual. Pond House, Weybridge, Surrey, KT13, England.
Arts Review Yearbook and Directory. Annual. Richard Gainsborough Periodicals Ltd., 8 Wyndham Place, London W1H 2AY, England.
CUMMINGS, PAUL, ed. *Fine Arts Marketplace.* Annual. R. R. Bowker Company, 1180 Avenue of the Americas, New York, N.Y. 10036.
Guide Européen de l'Antiquarie (Guide Emer). Annual. Paris, France.
International Auction Records. E. Mayer, ed. Annual. Editions Publisol, 185 E. 85 St., New York, N.Y. 10028.
International Directory of Arts. Annual. Verlag Müller KG, D-6 Frankfurt/Main, West Germany. New York: Editions Publisol, 185 E. 85 St., N.Y. 10028.
Locus (New York gallery guide). New York: Filsinger & Co., 150 Waverly Place, New York, N.Y. 10014.
l'Officiel des Galeries (Paris gallery guide). 15 rue du Temple, 75004 Paris, France.
Verband Deutscher Antiquare E.V. (German-language prints, illustrated book dealers, etc.) 757 Baden-Baden, Ybergstrasse 36, West Germany.

V. BIBLIOGRAPHIES

BÉNÉZIT, F. *Dictionnaire des Peintres, Sculpteurs, Dessinateurs, et Graveurs.* 8 vols. Paris, 1948.
BOLLINGER, HANS. *Dokumentations-Bibliothek zur Kunst des 20. Jahrhunderts* (auction catalogs). Vols. I–V. Bern: Kornfeld und Klipstein, 1957, 1958, 1968, 1969, and 1976.
———. *Katalogs: Dokumentation-Kunst und Literatur des 20. Jahrhunderts* (sales catalogs). Zurich, 1970–1975 (annually).
COHEN, ARTHUR. *Ex Libris* (sales catalogs). New York, 1974– .
LARAN, JEAN. *L'Estampe.* Paris: Presses Universitaires de Paris, 1959. Vol. 1, pp. 263–414.
LEVIS, HOWARD. *A Descriptive Bibliography of the Most Important Books in the English Language Relating to the Art and History of Engraving and the Collecting of Prints.* London, 1912.

MASON, LAURIS. *Print Reference Sources: A Select Bibliography 18th–20th Centuries.* Millwood, N.Y.: Kraus-Thomson Org. Ltd., 1975.

THIEME, U., and BECKER, F. *Allgemeinis Lexikon der bildenden Künstler.* 37 vols. Leipzig, 1907–50. 6 vols. of additions. Leipzig, 1953–62.

Werkkataloge zur Kunst des 20. Jahrhunderts. Haag (Oberbayern): Verlag G. Arntz-Winter, 1974.

Appendix Five

Directory of Print Publishers in the United States and Great Britain

There are graphics publishers, including publishing workshops, in virtually every country of Western Europe, the United States, and Canada. The publishers situated in France have been fully listed and described in Issue No. 6 (December 1972) of *Nouvelles de l'Estampe*, which may be obtained from le Comité National de la Gravure Française, 58, rue de Richelieu, 75084 Paris. The publishers issuing prints in German-language countries are reported quarterly in *Magazin Kunst*, available by subscription from Alexander Baier-Presse, 65 Mainz, Postfach 1308, West Germany.

What follows is a list of the principal print publishers in the United States and Great Britain, with a representative selection of the artists whose prints they have published in recent years. The list is of necessity incomplete. Print publishers are legion, since any art dealer—indeed, any person, company, or institution—can publish an edition. Some dealers and galleries publish fairly regularly; some people and firms are print publishers by profession; and some printshops function as publishing ateliers. But there are also many fly-by-nighters, art dealers, and entrepreneurs that publish prints sporadically, and printshops that from time to time venture jointly with another publisher. The list is also somewhat tentative, since an indeterminate number of publishers will both materialize and become defunct in ensuing years. No attempt has been made to categorize or rate publishers by their taste, ethics, integrity, competency, celebrity, or the quality of the graphics they offer to the public.

The names themselves have been divided into three categories: (1) those marked with an asterisk (*) are *publishing ateliers* that may or may not make their printmaking facilities available to other publishers on a contract basis; (2) those marked with a dagger (†) are publisher-distributors that have no workshop and primarily sell wholesale to retail galleries; and (3) those left unmarked are publishers without integrated work-

shops that offer both their own editions and prints by other publishers at retail prices and might distribute their own editions through other retail dealers as well.

Publisher	Representative Artists Published
*ADI/Triad Workshop 530 McAllister San Francisco, Calif. 94102 (415) 621-0602	Hackman, Krushenick, Levine, Lew, Rodman
†Abrams Original Editions 110 East 59 St. New York, N.Y. 10022 (212) 758-8600	Beardon, Calder, Christo, Delaunay, Frankenthaler, Grooms, Jenkins, Kaprow, Marini, Marisol, Nevelson, Rubin, Siquieros, Soyer, Tamayo, Trova, Wesley
Brooke Alexander, Inc. 20 West 57 St. New York, N.Y. 10019 (212) 757-3721	Beal, Haas, Ives, Katz, Motherwell, Nesbitt, Porter, Welliver, Zox
†Leon Amiel Publisher 31 West 46 St. New York, N.Y. 10036 (212) 575-0010	Agam, Bolotowsky, Calder, Chagall, Dali, Delaunay, Ernst, Magnelli, Man Ray, Marini, Minaux, Miró, Rubin, Sutherland
†Anderson-O'Day (formerly, Modern Prints) 34 Tournay Road London SW6 7UF (01) 385-4797	Ackroyd, Griffin, Millington, Stevens
Associated American Artists 663 Fifth Ave. New York, N.Y. 10022 (212) 755-4211	Appel, Hirsch, Klabunde, Lucioni, Soyer, Wunderlich, many others
Castelli Graphics 4 East 77 St. New York, N.Y. 10021 (212) 288-3202	Castelli stable of painters: Artschwager, Johns, Lichtenstein, Oldenburg, Stella, Warhol, and others; co-publishers with Multiples Inc.
Circle Gallery Ltd. (American Atelier) 100 East Walton St. Chicago, Ill. 60611 (312) 943-1835 (galleries in other cities also)	Dali, Gallo, Neiman, Rattner, Rockwell
*Cirrus Editions 708 North Manhattan Place Los Angeles, Calif. 90038 (213) 462-1157	California artists: Alexander, Allen, Anderson, Baldessari, Balog, Card, Carson, Celmins, Chicago, Cooper, Delap, Edge, Holland, Moses, Price, Ruscha, Wiley
The Curwen Gallery (and Curwen Studio) 1 Colville Place, Charlotte St. London W1P 1HN (01) 636-1459	Inexpensive editions by U.K. artists
†D'Arc Press, Inc. 340 West 72 St. New York, N.Y. 10023	Denes, Fahlen, Kuehn, Levine, Morley, Oppenheim, Sonfist, Welch

Publisher	Representative Artists Published
*Edition Domberger American agent: Ellen Sragow Ltd. 105 Hudson St. New York, N.Y. 10013 (212) 966-6403	Anusckiewicz, Bannard, G. Davis, Dzubas, Goodnough, Held, Kruschenick, LeWitt, Porter, Snyder, Welliver, Young, Yrisarry, Zox
*Editions Alecto Limited 27 Kelso Pl. London W8 5QG (01) 937-6611 American agent: Modernart Editions 200 East 58 St. New York, N.Y. 10022 (212) 421-3272	Denny, Leverett, McKinnon, Paolozzi, Phillips, Procktor, Self, Stevens
*Editions Press 621 Minna St. San Francisco, Calif. 94103 (415) 626-1846	Appel, Cuevas, Nesbitt, Scholder, Tamayo, Zuñiga
†G. W. Einstein & Company, Inc. 243 East 82 St. New York, N.Y. 10028 (212) 628-8782	Kepets, Stevens
*Gemini G. E. L. 8365 Melrose Ave. Los Angeles, Calif. 90069 (213) 651-0513	Albers, R. Davis, Francis, Hockney, Johns, Kelly, Lichtenstein, Motherwell, Oldenburg, Price, Rauschenberg, Serra, Stella
HKL/Ltd. 167 Newbury St. Boston, Mass. 02116 (617) 262-4483	Albers, Anuszkiewicz, Bannard, G. Davis, Diao, Dzubas, Held, Goodnough, Krushenick, LeWitt, McCracken, Porter, Shields, Snyder, Stroud, Welliver, Young, Yrisarry, Zox
†HMK Fine Arts, Inc. 15 Gramercy Park South New York, N.Y. 10003 (212) 982-4800	Dewasne, Martin, Rauch, Soisson; copublishes with Editions Lahumière, Paris
†Horn Editions 30 Fifth Ave. New York, N.Y. 10011 (212) 674-8755	Friedlaender
*Impressions Workshop 27 Stanhope St. Boston, Mass. 02116 (617) 262-0783	Jackson, Milton, Peterdi, Yunkers, many others
*International Institute of Experimental Printmaking 310 Coral Santa Cruz, Calif. 95060 (408) 426-4551	Brown, Heller, Neri, Nevelson, Oliveira, Schnoor, Tullis, Zajac
Martha Jackson Graphics 32 East 69 St. New York, N.Y. 10021 (212) 988-1800	Appel, Brooks, Hultberg, Jenkins, Johnson, Pond, Scott, Tápies, Toledo; primarily stable artists

Publisher	Representative Artists Published
†Bernard Jacobson Ltd. 3 Mill St. London W1R 9TF (01) 493-7629	Abrahams, Caulfield, Denny, Goode, Moses, Smith, Tillyer
*The Jones Road Print Shop and Stable Box 259, Route 1 Barnweld, Wis. 53507 (608) 924-2598	Gilliam, Greenberg, Richardson, Shields
Kennedy Graphics 40 West 57 St. New York, N.Y. 10019 (212) 541-9600	Baskin, Calder, Levine
*Landfall Press 63 West Ontario St. Chicago, Ill. 60610 (312) 787-6836	Christo, Cottingham, Leslie, Nice, Oldenburg, Pearlstein, Stark, Stein, Tworkov, Wiley
†Lublin Graphics Inc. 135 East Putnam Ave. Greenwich, Conn. 06803 (203) 869-4954	Abrahami, Brillant, Carcan, DeButler, Friedlaender, Gropper, Peterdi, Peycere, Rodo-Boulanger, Rundell
Marlborough Graphics Ltd. 17/18 Old Bond St. London W1X 4BY (01) 629-5161 *New York gallery:* 40 West 57 St. New York, N.Y. 10019 (212) 541-4900	Bayer, Chadwick, D'Arcangelo, Dorazio, Genoves, Gottlieb, Hepworth, House, Jones, Katz, Kitaj, Kokoschka, Moore, Motherwell, Nicholson, Nolan, Pasmore, Richards, Rivers, Piper, Stamos, Soto, Sutherland, Tilson
†Multiples, Inc. 55 East 80 St. New York, N.Y. 10021 (212) 988-2200	Arakawa, Hamilton, Judd, Lichtenstein, Morris, Oldenburg, Rauschenberg, Rosenquist, Ruscha, Warhol, Wesselman
Pace Editions Inc. 32 East 57 St. New York, N.Y. 10022 (212) 421-3292	Breiger, Dubuffet, Goodnough, Hall, Hinman, Krushenick, Loring, Nesbitt, Nevelson, Riley, Samaras, Segal, Trova, Youngerman
*Petersburg Press 59A Portobello Rd. London W11 3DB (01) 229-8791 *New York office:* 17 East 74 St. New York, N.Y. 10021 (212) 249-4400	Caulfield, G. Davis, Dine, Hockney, Ham- ilton, Johns, Kitaj, Oldenburg, Paolozzi, Rosenquist, Rot, R. Smith, Stella, Tobey
†Parasol Press 289 Church St. New York, N.Y. 10013 (212) 431-9387	Bochner, Close, Estes, LeWitt, Mangold, Marden, Martin, Nice, Renouf, Rockburne, Ryman, Thiebaud

Publisher	*Representative Artists Published*
*Pyramid Arts, Ltd. 7710 Nebraska Tampa, Fla. 33604 (813) 231-7111	Dine, Rosenquist
Editions Denise René (New York gallery) 6 West 57 St. New York, N.Y. 10019 (212) 765-1330	Agam, Cruz-Diez, Gerstner, Herbin, Oehm, Soto, Stanczak, Vasarely, Xiko, Yvaral
Ferdinand Roten Graphics 866 Third Ave. New York, N.Y. 10022 (212) 935-3285	Restrikes; inexpensive graphics
†Nathan Silberberg Fine Arts (distributor for Sala Gaspar, Barcelona) 507 Fifth Ave. New York, N.Y. 10017 (212) 661-3665	Agam, Clavé, Dali, Ernst, Miró; Spanish artists
*Tamarind Institute 108 Cornell Ave. Albuquerque, N.M. 87506 (505) 277-3901	Dasburg, Gilot, Scholder; Western artists and many others
†Transworld Art 600 Fifth Ave. New York, N.Y. 10021 (212) 757-2700	Agam, Baj, Bearden, Bellmer, Calder, Dali, Delaunay, Malta, Ortega, Pucci, Rubin, Tamayo, Tobey
*Tyler Graphics Ltd. P.O. Box 644 Bedford Village, N.Y. 10506 (914) 234-9446	Albers (J. & A.), R. Davis, Hamilton, Lichtenstein, Motherwell, Stella
*Universal Limited Art Editions 5 Skidmore Place West Islip, N.Y. 11795 (516) 669-7484	Johns, Dine, Francis, Frankenthaler, Bontecou, Glarner, Hartigan, Marisol, Motherwell, Newman, Rivers, Rosenquist, Twombly
Leslie Waddington Prints Limited 34 Cork St. London W1X 1PA (01) 439-1866	Blake, Caulfield, Celice, Cohen, Denny, Fedden, Frink, Frost, Haden, Heron, House, Hoyland, Knowles, Lijn, Lim, Monro, Olitski, Ovenden, Scott, Smith, Trevelyan, Tucker, Turnbull

Appendix Six

Print Conservators and Restorers

The list that follows consists of the names of members of the American Institute for the Conservation of Historic and Artistic Works specializing in the restoration of prints at the time this book was published. A more up-to-date list, as well as one giving the names of those who have been certified as paper conservators by the Institute, may be obtained from a conservator on the staff of a major museum or library, who normally does no work for private clients but is available for advice and consultation, or from the Institute itself, care of Mrs. Charlotte Burk, Executive Secretary, 1725 19 St., N.W., Washington, D.C. 20009.

Miss Konstanze Bachmann
H. F. duPont Winterthur Museum
Winterthur, Del. 19735

Miss Louise G. Bluhm
Fogg Art Museum
Harvard University
Cambridge, Mass. 02138

Mrs. Brigitte Boyadjian
43 Fern Street
Lexington, Mass. 02173

Miss Madeleine Braun
10 West 16th Street
New York, N.Y. 10011

Mrs. Margaret R. Brown
502 Independence Ave., S.E.
Washington, D.C. 20003

Mr. David A. Chandler
Art Institute of Chicago
Michigan at Adams
Chicago, Ill. 60603

Miss Anne F. Clapp
Curatorial Division
Henry F. duPont Winterthur Museum
Winterthur, Del. 19735

Mrs. Marjorie B. Cohn
Associate Conservator
Fogg Museum of Art
Harvard University
Cambridge, Mass. 02138

Miss Kathryn Cronan
99 Dowling Avenue, Apt. 210
Toronto 3
Ontario, Canada

Mr. Francis W. Dolloff
10 Glen Circle
Waltham, Mass. 02154

R. R. Donnelley & Sons Company
350 East 22nd Street
Chicago, Ill. 60616

Mr. David Dudley
Canadian Conservation Institute
National Museums of Canada
Ottawa
Ontario KIA OM8, Canada

Miss Katherine G. Eirk
Conservation Analytical Lab., HTB
Smithsonian Institution— AB070
Washington, D.C. 20560

Mrs. Stephanie Ewing
86 Tilehurst Road
Reading, Berkshire
England

Ms. Shelley Fletcher
#501, 2100 Connecticut Ave., N.W.
Washington, D.C. 20003

Mr. Paul A. Foulger
Historical Dept.
50 East North Temple Street
Salt Lake City, Utah 84150

Mrs. Christa M. Gaehde
55 Falmouth Road
Arlington, Mass. 02174

Mrs. Mary Todd Glaser
73 East Linden Avenue
Englewood, N.J. 07631

Ms. Barbara Gould
627 North Carolina Ave., S.E.
Washington, D.C. 20003

Mr. William Hanft
Department of Prints and Drawings
Brooklyn Museum
188 Eastern Parkway
Brooklyn, N.Y. 11238

Mr. Robert A. Hauser
Merrimack Valley Textile Museum
800 Massachusetts Avenue
North Andover, Mass. 01845

Mrs. Maria Kielmansegg Hitchings
35 Paine Avenue
New Rochelle, N.Y. 10804

Mrs. Florence Hodes
145 Central Park West
New York, N.Y. 10023

Mrs. Elizabeth C. Hollyday
Colonial Williamsburg
Williamsburg, Va. 23185

Mrs. Carolyn Horton
430 West 22nd Street
New York, N.Y. 10011

Mrs. Virginia N. Ingram
Ohio Hist. Soc. Archives &
Mss. Div.
171 and 17th Ave.
Columbus, Ohio 43211

Mr. Douglas Kenyon
Art Institute of Chicago
Michigan at Adams
Chicago, Ill. 60603

Mrs. Keiko Mizushima Keyes
Box 469
Woodacre, Calif. 94973

Mrs. Antoinette G. King
Museum of Modern Art
11 West 53rd Street
New York, N.Y. 10019

Mr. John Krill
National Gallery of Art
Washington, D.C. 20565

Mr. Murray Lebwohl
48 Palm Avenue
Sarasota, Fla. 33577

Mrs. Mary Wood Lee
Pacific Reg. Conservation
Center
Bishop Museum, P.O. Box
6037
Honolulu, Hawaii 96818

Ms. Elizabeth Lunning
Harvard University
Fogg Art Museum
Department of Conservation
Cambridge, Mass. 02138

Mr. R. A. McCarroll
2201 Riverside Drive
Ottawa, Ontario K1H SK9,
Canada

Mrs. Edith MacKennan
11 Rosalind Road
Poughkeepsie, N.Y. 12601

Miss Eleanor McMillan
Conservation Analytical Labo-
ratory
Smithsonian Institution
Washington, D.C. 20560

Mrs. Diane S. O'Neal
88 Central Park West
New York, N.Y. 10023

Mrs. Helen K. Otis
Paper Conservation Lab.
Metropolitan Museum of Art
New York, N.Y. 10028

Ms. Marian Peck
Restoration Office
Annex Bldg., Library of
Congress
Washington, D.C. 20540

Mr. Roy L. Perkinson
Calif. Palace of the Legion of
Honor
Lincoln Park
San Francisco, Cal. 94121

Mrs. Wynne H. Phelan
3721 Ella Lee Lane
Houston, Texas 77027

Mrs. Patricia Reyes
The Pierpont Morgan Library
29 East 36th Street
New York, N.Y. 10016

Mrs. Shirley J. Riddick
6561 Hil-Mar Drive, #203
Forestville, Md. 20028

Ms. Sarah Chapman Riley
644 Massachusetts Avenue,
N.E.
Washington, D.C. 20002

Mr. Roger Roche
Canadian Institute for Conser-
vation
National Museums of Canada
Ottawa, Ontario K1A OM3
Canada

Mr. Mervyn Ruggles
National Gallery of Canada
Ottawa 4, Ontario
Canada

Ms. Susanne Schnitzer
325 West 84th Street
New York, N.Y. 10024

Ms. Trudy I. Schwartzman
Conservation Center
1 East 78th Street
New York, N.Y. 10021

Miss Linda Shaffer
827 Ocean Front Walk
Venice, Cal. 90291

Mr. Stephen D. Shapiro
Daedalus Fine Art Restoration
6020 Adeline Street
Oakland, Cal. 94603

Mrs. Marjorie N. Shelley
Paper Conservation Lab.
Metropolitan Museum of Art
5th Avenue at 82nd Street
New York, N.Y. 10028

Mr. Franklin Shores
c/o Peale House
1811 Chestnut Street
Philadelphia, Pa. 19103

Mr. Willman Spawn
American Philosophical Society
Library
105 South 5th Street
Philadelphia, Pa. 19106

Mr. John Washeba
79 Otis Street
Medford, Mass. 02155

Mrs. Marilyn Weidner
612 Spruce Street
Philadelphia, Pa. 19106

Mr. Robert Weinberg
R.R. Donnelley & Sons Com-
pany
2223 Martin L. King Dr.
Chicago, Ill. 60616

Mrs. Martina Yamin
206 E. 30th Street
New York, N.Y. 10016

Mr. Alexander J. Yow
Pierpont Morgan Library
29 East 36 Street
New York, N.Y. 10016

Appendix Seven

Directory of Print Dealers and Galleries

The following directory is composed of the names of the principal print dealers and galleries in the United States, Canada, and Europe.

I have tried to make this listing as inclusive as possible. I have excluded a number of dealers and galleries that in my personal judgment are markedly deficient in the qualities of a good art dealer, as explained in Chapter 9. (On this count I would hope to have erred, if at all, on the side of magnanamity. To satisfy regional needs, I have included some establishments outside the major art centers that might have been omitted if located within a major art metropolis. I also trust that the reader, whether buyer or seller, will himself at this point be competent to judge dealers against the standards set forth in this book.) I have also excluded—unless worthy of special notice as the result, say, of a substantial inventory—any printseller who has not been tested in the marketplace for at least three years. Moreover, the name of a dealer in paintings who also carries prints is included only if the print stock is worth a special visit. I shall refine, prune, and supplement the directory, partly with the help of justifiable complaints, in later editions of this book.

In using the directory, one should therefore understand that the absence of a name may connote my opinion of the missing printseller's worth as a printseller; but it may also be the result of the geographical location, longevity, inventory, and other subjective discriminations I have chosen and imposed as guidelines—or of my own negligence.

The following symbols have been used to designate the general character of the stock of a dealer or gallery:

OM —Old Master and early 19th century	C —Contemporary (post-1950)
M —Modern (1850–1950)	CA —Contemporary American
MA —Modern American	CE —Contemporary European
ME —Modern European	P —Fine Posters

Printsellers are categorized by geographical location in the following order:

United States	Germany	Spain
(alphabetically, by state)	Switzerland	Sweden
Canada	Italy	Norway
London	Austria	Denmark
Paris	Netherlands	Japan

The names of the leading printsellers in the world, in size, wealth, and quality of stock, established reputation and expertise, have been printed in boldface type.

UNITED STATES

Arizona

Elaine Horwitch Gallery (M, C)
4200 North Marshall Way
Scottsdale, Ariz. 85251
(602) 945-0791

RST galerie (M, C)
7120 East Indian School Rd.
Scottsdale, Ariz. 85251
(602) 945-4557

California

ADI Gallery (CA)
(Stephen Foster & David C. Temple)
530 McAllister
San Francisco, Calif. 94102
(415) 621-0602

ADI South
2511 So. Winchester
Campbell, Calif. 95008
(408) 374-6441

Hank Baum Gallery (CA)
Graphics Gallery
1 Embarcadero Ctr.
San Francisco, Calif. 94111
(415) 989-7876

Also, 2040 Ave. of the Stars
Century City
Los Angeles, Calif. 90067
(213) 277-3777

John Berggruen Gallery (CA)
228 Grant Ave.
San Francisco, Calif. 94108
(415) 781-4629

Cirrus Editions, Ltd. (CA)
(Jean R. Milant)
708 N. Manhattan Place
Los Angeles, Calif. 90038
(213) 462-1157

Contemporary Graphics Center (CA)
(affil. with Santa Barbara
Museum of Art)
(Betty Klausner)
1120 State St.
Santa Barbara, Calif. 93101
(803) 965-3458

De Vorzon Gallery (M, C)
744½ N. La Cienega Blvd.
Los Angeles, Calif. 90069
(218) 659-0555; (213) EL 5-2800

Eliane Ganz Gallery (C)
3450 Sacramento St.
San Francisco, Calif. 94118
(415) 931-7542

Jack Glenn Graphics, Inc. (CA)
2831 E. Coast Highway
Corona del Mar, Calif. 92625
(714) 675-8020

Also, 424 Fashion Valley
San Diego, Calif.
(714) 291-5970

Hansen Fuller (CA)
228 Grant Street
San Francisco, Calif. 94108
(415) 982-6177

G. Ray Hawkins Gallery, Inc. (C)
9002 Melrose Avenue
Los Angeles, Calif. 90069
(213) 550-1504

Heritage Gallery (M)
(Benjamin Horowitz)
718 North La Cienega Blvd.
Los Angeles, Calif. 90069
(213) 652-7738

Jeffrey Horvitz (ME)
1155 North La Cienega Blvd.
Los Angeles, Calif. 90069
(213) 451-1023

The Image & the Myth (ME)
9843 Santa Monica Blvd.
Beverly Hills, Calif. 90212
(213) 553-5728

Pasquale Ianetti (ME)
Suite 201
560 Sutter St.
San Francisco, Calif. 94102
(415) 433-2771

Also, 1155 North Cienega Blvd.
Los Angeles, Calif. 90069
(213) 659-7822

Marjorie Kauffman Graphics (ME, C)
2320 Westwood Blvd.
Los Angeles, Calif. 90064
(213) 475-3573

Margot Leavin Gallery (CA)
812 North Robertson Blvd.
Los Angeles, Calif. 90069
(213) 273-0603

Raymond E. Lewis (OM, M)
P.O. Box 72
Nicasio, Calif. 94946
(415) 456-6393

R. M. Light & Co., Inc. (OM, M)
(Robert M. Light)
P.O. Box 5597
Santa Barbara, Calif. 93108
(805) 969-0257

Maxwell Graphics, Ltd. (M)
(Mark Hoffman)
551 Sutter St.
San Francisco, Calif. 94102
(415) 421-5193

The Merryman Collection (C)
(Nancy Merryman)
Box 2842
Stanford, Calif. 94305
(415) 326-3060

Malvina Miller Gallery (CA)
1150 Union St.
San Francisco, Calif. 94109
(415) 441-1150

Phoenix Gallery (M, C)
(Simon Lowinski)
257 Grant Ave.
San Francisco, Calif. 94108
(415) 982-2172 (2171)

O. P. Reed, Jr. (OM, ME)
521 N. La Cienega Blvd.
Los Angeles, Calif. 90048
(213) OL 2-5500

William Sawyer (CA)
3045 Clay St.
San Francisco, Calif. 94115
(415) 921-8974

Thackrey & Robertson (ME, P)
2266 Union St.
San Francisco, Calif. 94123
(415) 567-4842

Union Street Graphics (ME, C)
(Stephen Newstedt & Armida Blasi)
1690 Union St.
San Francisco, Calif. 94123
(415) 771-8180

Walton Galleries, Inc. (M, C)
(Walter F. Maibaum, Paul Hertzmann &
 Melton Magidson)
575 Sutter St.
San Francisco, Calif. 94102
(415) 391-8185

Daniel Weinberg Gallery (CA)
560 Sutter St.
San Francisco, Calif. 94102
(415) 391-6241

Alan Wofsy Fine Arts (OM, M)
150 Green St.
San Francisco, Calif. 94111
(415) 986-3030

Zeitlin & Ver Brugge (OM, M)
(Marilyn Pink)
815 N. La Cienega Blvd.
Los Angeles, Calif. 90069
(213) 655-7581

Connecticut

June 1 Gallery (MA)
Bellamy Lane
Bethlehem, Conn. 06751
(203) 266-7191

The Print Cabinet (OM, M, C)
(Jo Miller)
Tiny House
Cannon Crossing
Wilton, Conn. 06897
(203) 762-9893

District of Columbia

Franz Bader (OM, M)
2124 Pennsylvania Ave., N.W.
Washington, D.C. 20037
(202) 337-5440

Fendrick Gallery (CA)
(Barbara Fendrick)
3039 M St., N.W.
Washington, D.C. 20007
(202) 338-4544

Jane Haslem Gallery (MA)
2121 P St., N.W.
Washington, D.C. 20037
(202) 338-3014

Lunn Gallery Inc. (M, C)
(Harry H. Lunn, Jr.)
Graphics International Ltd.
3243 P St., N.W.
Washington, D.C. 20007
(202) 338-5792

Middendorf Gallery (MA)
(Chris Middendorf)
2028 P Street, N.W.
Washington, D.C. 20036
(202) 785-3750

Florida

Madden & Wechsler Galleries (CA)
3490 Main Highway
Coconut Grove, Fla. 33133
(305) 445-7333

Georgia

Mint Graphics (CA)
Suite 2406
229 Peachtree St., N.E.
Atlanta, Ga. 30303
(404) 659-3770

Illinois

Gilles A. Abrieux (C)
415 West Aldine St.
Chicago, Ill. 60657
(312) 871-3161

Benjamin Galleries (M, C)
(Neva Krohn)
Suite 318
900 N. Michigan Ave.
Chicago, Ill. 60611
(312) 337-1343

Joseph Faulkner–Main Street Galleries (M)
100 East Walton Place
Chicago, Ill. 60611
(312) 787-3301

Allan Frumkin Gallery (M)
(Alice Adam)
620 North Michigan Ave.
Chicago, Ill. 60611
(312) 787-0563

Richard Gray Gallery (M, C)
620 North Michigan Ave.
Chicago, Ill. 60611
(312) 642-8877

R. S. Johnson International Gallery
 (OM, M)
(Robert S. Johnson)
645 North Michigan Ave.
Chicago, Ill. 60611
(312) 943-1661

Marshall Field & Company (M)
(Florence Dauber)
111 North State St.
Chicago, Ill. 60690
(312) 781-4281

Dorothy Rosenthal Gallery (M, C)
233 East Ontario
Chicago, Ill. 60611
(312) 664-3224

Samual Stein Fine Arts (M, CE)
Suite 340
620 N. Michigan Ave.
Chicago, Ill. 60611
(312) 337-1782

Van Straaten Gallery (C)
646 N. Michigan Ave.
Chicago, Ill. 60611
(312) 642-2900

Kansas

Douglas Drake Gallery (CA)
4500 State Line
Kansas City, Kan. 66103
(913) 831-3880

Louisiana

Tahir Gallery (M)
823 Chartres St.
New Orleans, La. 70116
(504) 525-3095

Maryland

Jem Hom, Fine Arts (M)
19113 North Kindly Ct.
Gaithersburg, Md. 20760
(301) 926-4988

Ferdinand Roten Galleries, Inc. (M, C)
123 West Mulberry St.
Baltimore, Md. 21201
(301) 837-7723

Massachusetts

The Alpha Gallery (M)
(Alan Fink)
121 Newbury St.
Boston, Mass. 02116
(617) 536-4465

Childs Gallery (MA)
(D. Roger Howlett)
169 Newbury St.
Boston, Mass. 02116
(617) 266-1108

Graphics 1 & Graphics 2 (M, C)
168 Newbury St.
Boston, Mass. 02116
(617) 266-2475

Gropper Art Gallery (M)
(Joseph Gropper)
58 Day St.
P.O. Box 326
W. Somerville, Mass. 02144
(617) 666-5644

HKL/Ltd. (CA)
127 Newbury St.
Boston, Mass. 02116
(617) 262-4483

Halpern-Tyler Graphics (M)
35 Morissey Blvd.
Boston, Mass. 02116
(617) 469-0438

Impressions Workshop & Gallery (CA)
27–29 Stanhope St.
Boston, Mass. 02116
(617) 262-0783

Kanegis Gallery (M)
244 Newbury St.
Boston, Mass. 02116
(617) 267-6735

The Nasrudin Gallery (M, C)
161 Newbury St.
Boston, Mass. 02116
(617) 247-2747

Nielson Gallery (ME, C)
179 Newbury St.
Boston, Mass. 02116
(617) 266-4835

Pucker/Safrai Gallery (C)
171 Newbury St.
Boston, Mass. 02116
(617) 267-9473

Angus Whyte Gallery (M, C)
121 Pinckney St.
Boston, Mass. 02114
(617) 723-9607

Michigan

Gertrude Kasle Gallery (CA)
808 Fisher Bldg.
Detroit, Mich. 48202
(313) 875-9006

Lakeside Studio (OM, M, C)
150 South Lakeshore Rd.
Lakeside, Mich. 49116
(616) 469-1377

London Arts, Inc. (ME)
321 Fisher Bldg.
Detroit, Michigan 48202
(313) 871-3606

Michael S. Sachs (ME, CE)
216 North State St.
Ann Arbor, Mich. 48108
(313) 665-9388

Minnesota

Peter M. David Gallery, Inc. (C)
Suite 101
430 Oak Grove St.
Minneapolis, Minn. 55403
(612) 870-7344

John C. Stoller (CA)
2500 Humboldt Ave. South
Minneapolis, Minn. 55405
(612) 377-8380

Missouri

Dietrich-Stone Ltd. (M)
Le Chateau Village
10411 Clayton Road
St. Louis, Mo. 63214
(314) 991-5188

Nancy Singer Gallery (CA)
31 Crestwood Dr.
St. Louis, Mo.
(314) PA7-1830

New York

Brooke Alexander, Inc. (CA)
20 West 57 St.
New York, N.Y. 10019
(212) 988-2056

Associated American Artists
(OM, M, C, P)
(Sylvan Cole, Jr.)
663 Fifth Ave.
New York, N.Y. 10022
(212) PL 5-4211

Timothy Baum (ME)
920 Park Ave.
New York, N.Y. 10028
(212) 879-4512

Blue Moon Gallery (ME)
(Lawrence Saphire)
9 E. 84 St.
New York, N.Y. 10028
(212) 628-8673
By appointment

La Boetie (ME)
(Helen Serger)
9 East 82 St.
New York, N.Y. 10028
(212) 535-4865
By appointment

Brewster Gallery (ME, CE)
1018 Madison Ave.
New York, N.Y. 10021
(212) 472-9481

Aldis Browne Fine Arts Ltd. (M)
20 East 53 St.
New York, N.Y. 10022
(212) 593-3560
By appointment

Todd Butler (OM)
240 East 79 St.
New York, N.Y. 10021
(212) 288-3508

Carus Gallery (ME)
(Dorothy Carus)
1044 Madison Ave.
New York, N.Y. 10028
(212) TR 9-4660

Castelli Graphics (CA)
(Antoinette Castelli)
4 East 77 St.
New York, N.Y. 10021
(212) 288-3202

Richard A. Cohen (ME)
1 West 64 St.
New York, N.Y. 10023
(212) 799-6675

Delphic Arts, Inc. (OM, ME)
(Herman Shickman)
929 Park Ave.
New York, N.Y. 10028
(212) 249-3855

Theodore B. Donson (OM, M)
50 West 57 St.
New York, N.Y. 10019
(212) 581-3541
By appointment

Dorsky Galleries (ME, CE)
111 Fourth Ave.
New York, N.Y. 10003
(212) 473-0887

Lynn G. Epsteen (ME)
219 East 69 St.
New York, N.Y. 10021
By appointment
(212) 753-2408

Ex Libris (M)
(Arthur A. Cohen)
25 East 69 St.
New York, N.Y. 10021
(212) 249-2618

Ronald Feldman Fine Arts, Inc. (CA, ME)
33 East 74 St.
New York, N.Y. 10021
(212) 249-4050

Fitch-Febvrel (CE)
(Andrew Fitch)
601 West 115 St.
New York, N.Y. 10025
(212) 666-0550

Getler/Pall (CA)
(Helen Getler & Helen Pall)
50 West 57 St.
New York, N.Y. 10019
(212) 581-2724

Gimpel & Weitzenhoffer Graphics (CE)
1040 Madison Ave.
New York, N.Y. 10021
(212) 628-1897

Golden Lion Fine Prints (MA)
1437 First Ave.
New York, N.Y. 10021
(212) 861-0270

Lucien Goldschmidt, Inc. (OM, ME)
1117 Madison Ave.
New York, N.Y. 10028
(212) TR 9-0070

James Goodfriend (OM, M)
309 West 104 St.
New York, N.Y. 10025
(212) 663-7095

James Goodman Gallery/Goff Fine Arts,
Inc. (C)
(William M. Goff)
55 E. 86 Street
New York, N.Y. 10028
(212) 427-8383

Martin Gordon (M)
1000 Park Ave.
New York, N.Y. 10028
(212) 249-7350

Harbor Gallery (MA)
43 Main St.
Cold Spring Harbor, N.Y. 11724
(516) 692-9526

Lillian Heidenberg Gallery, Ltd. (CE)
50 West 57 St.
New York, N.Y. 10019
(212) 586-3808

The Huntington Gallery (M)
P.O. Box 430
Bayshore, N.Y. 11706
(516) 665-4600 or (516) 587-7847
By appointment

Isselbacher Gallery (ME)
(Alfred M. Isselbacher)
1223 Madison Ave.
New York, N.Y. 10028
(212) 831-4741

Martha Jackson Graphics (M, C)
32 East 69 St.
New York, N.Y. 10021
(212) 988-1800

Kahan/Esikoff Fine Arts Ltd. (ME, CE)
922 Madison Ave.
New York, N.Y. 10021
(212) 744-1490

Kennedy Galleries
Kennedy Graphics (OM, M, C)
40 West 57 St.
New York, N.Y. 10019
(212) 541-9600

M. Knoedler & Co., Inc. (C)
21 E. 70 St.
New York, N.Y. 10021
(212) 628-0400

Lefebre Gallery (CE)
47 East 77 St.
New York, N.Y. 10021
(212) 744-3384

Paul McCarron Fine Prints (M)
P.O. Box 735
Brooklyn, N.Y. 11202
(212) 858-5024

Kathryn Markel Fine Arts (CA)
50 West 57 St.
New York, N.Y. 10019
(212) 581-1909

Marlborough Graphics (C)
40 West 57 St.
New York, N.Y. 10019
(212) 541-4900

Mason Fine Prints (MA)
(Donald & Lauris Mason)
Quaker Ridge Drive
Glen Head, N.Y. 11545
(516) 681-4284

Modernart Editions, Inc. (CE)
(Elaine & David Lingwood)
200 East 58 St.
New York, N.Y. 10022
(212) 421-3272

Multiples, Inc. (CA)
(Marian Goodman)
55 East 80 St.
New York, N.Y. 10021
(212) 988-2200

Pace Editions, Inc. (CA)
(Richard Solomon)
32 E. 57 St.
New York, N.Y. 10022
(212) HA 1-3237

Poster Source (P)
(Bernard & Suzanne Lander)
636 East Penn St.
Long Beach, N.Y. 11561
(516) GE 1-5510

Reiss-Cohen, Inc. (M)
(Wallace Reiss)
25 East 83 St.
New York, N.Y. 10028
(212) 628-2496

Reinhold-Brown Gallery (P)
(John Bennett Reinhold & Robert K. Brown)
26 E. 78 St.
New York, N.Y. 10021
(212) RE 4-7999

Galerie Denise René (CE)
6 W. 57 St.
New York, N.Y. 10019
(212) 765-1330

Ann Kendall Richards Gallery (M, C)
54 East 92 St.
New York, N.Y. 10028
(212) 534-5536
By appointment

Robley Gallery (C)
(Roberta Frank & Shirley Janowitz)
1362 Old Northern Blvd.
Roslyn, N.Y. 11576
(516) 484-5960

Saidenberg Gallery (ME)
(Eleanor Saidenberg)
16 E. 79 St.
New York, N.Y. 10021
(212) BU 8-3387

Galerie St. Etienne (ME)
(Otto Kallir & Hildegard Bachert)
24 West 57 St.
New York, N.Y. 10019
(212) CI 5-6734

Margo Pollins Schab, Inc. (ME)
1000 Park Ave.
New York, N.Y. 10028
(212) 861-1816

William H. Schab Gallery, Inc. (OM, M)
(Frederick Schab)
37 West 57 St.
New York, N.Y. 10019
(212) 758-0327

Judith Selkowitz (C)
219 East 69 St.
New York, N.Y. 10021
(212) UN 1-0147

Sindin Galleries (M, C)
(Edward Sindin)
1035 Madison Ave.
New York, N.Y. 10021
(212) 288-7902

Solomon & Co. Fine Art (ME, CA)
959 Madison Ave.
New York, N.Y. 10021
(212) 737-8200

Ellen Sragow Ltd. (C)
105 Hudson St.
New York, N.Y. 10013
(212) 966-6403

Galerie Sumers (M)
(Martin Sumers)
50 West 57 St.
New York, N.Y. 10019
(212) 861-1163

Suzuki Graphics, Inc. (C)
(Kasuko Suzuki)
797 Madison Ave.
New York, N.Y. 10021
(212) 249-5244

John A. Torson (M, C)
340 East 63 St.
New York, N.Y. 10021
(212) 751-4975

David Tunick, Inc. (OM, M)
12 E. 80 St.
New York, N.Y. 10021
(212) 861-7710

The Uptown Gallery (M)
1194 Madison Ave.
New York, N.Y. 10028
(212) 722-3677

Barney Weinger (C)
225 West 57 St.
New York, N.Y. 10019
(212) 581-7866

Weintraub Gallery (ME)
992 Madison Ave.
New York, N.Y. 10021
(212) 879-1195

Weyhe Gallery (M)
(Gertrude Weyhe Dennis)
794 Lexington Ave.
New York, N.Y. 10021
(212) TE 8-5478

Ohio

Carl Solway (M, C)
204 West 4 St.
Cincinnati, Ohio 45202
(513) 621-0069

Pennsylvania

Ira & Toni Genstein (ME)
Morningside, Laburnum Lane
Wyncote, Pa. 19095
(215) TU 4-3076

Marian Locks Gallery (CA)
1524 Walnut St.
Philadelphia, Pa. 19102
(215) 546-0322

Mersky Gallery (M, C)
1832 Delancey
Philadelphia, Pa. 19103
(215) 732-1300

The Print Club (CA)
1614 Latimer St.
Philadelphia, Pa. 19103
(215) PE 5-6090

Texas

Delahunty (CA)
2611 Cedar Springs
Dallas, Texas 75201
(214) 744-1346

Hooks-Epstein Galleries (M)
1200 Bissonnet
Houston, Texas 77005
(713) 522-0718

Marjorie Kauffman Graphics (M)
5015 Westheimer
Houston, Texas 77027
(713) 622-6001

Washington

Davidson Galleries (OM, M, C)
116½ S. Washington St.
Seattle (Pioneer Square), Wash. 98104
(206) 624-7648

Dootson/Calderhead Gallery (CA)
311½ Occidental South
Seattle, Wash. 98104
(206) 623-8431

Wisconsin

Irving Galleries (M, C)
(Irving Luntz)
400 East Wisconsin Ave.
Milwaukee, Wis. 53202
(414) 296-5730

CANADA

Galerie B (ME, C)
2175 Crescent
Montreal, Que. H3G 2C1
(514) 844-6950

Waddington Galleries (ME, C)
1456 Sherbrooke St. W.
Montreal, Que. H3G 1K4
(514) 844-5455

Albert White Gallery (M, C)
25 Prince Arthur Ave.
Toronto, Ont.
(416) 923-8804

Equinox Gallery (CA)
Third Floor Penthouse
1525 West 8th Ave.
Vancouver, B.C. V6J IT5
(604) 736-2405

LONDON

Thos. Agnew & Sons Ltd. (OM, ME)
43 Old Bond Street
London W1X 4BA
01-629-6176

Anschel Gallery (C)
(Klaus Anschel)
33e King's Road
London SW3 4LZ
01-730-0444

Baskett and Day (OM)
(Richard Day and John Baskett)
173 New Bond Street
London W1
01-629-2991

Todd Butler (OM)
119 Oakwood Court
London W. 14
01-602-2289
By appointment

John Campbell (ME, P)
68 Rosslyn Hill
London NW3
01-794-5482

Also, 164 Walton St.
London SW3
01-584-3648

P. & D. Colnaghi & Co. Ltd. (OM, ME)
(Adrian Eeles)
14 Old Bond Street
London W1X 4JL
01-497-7408

Colour Print (C)
(Brenda Rawnsley)
2 Motcomb Street
London SW1
01-235-4567

Craddock & Barnard (OM, ME)
32 Museum Street
London, WC1A 1LN
01-636-3937

Curwen Gallery (CE)
1 Colville Place, Charlotte Street
London W1P 1HN
01-636-1459

DM Gallery (C)
72 Fulham Rd.
London SW3 6HH
01-589-8208

Andrew Dickerson (CE)
52 St. Mary's Mansions
St. Mary's Terrace
London W2 ISH
01-262-4004
By appointment

Christopher Drake Ltd. (OM, ME)
10 Maddox St.
London W1R 9LD
01-493-9014

Editions Graphiques (ME)
3 Clifford St.
London W1
01-734-3944

Fischer Fine Art Ltd. (ME)
(Harry R. Fischer & Dr. Wolfgang G.
 Fischer)
30 King St., St. James's
London SW1
01-839-3942

Ganymed (ME, CE)
11 Great Turnstile
London WC1V 7HJ
01-405-9836/7

Bernard Jacobson Ltd. (CE)
3 Mill St.
London W1R 9TF
01-493-7629

Kinsman Morrison Gallery (CE)
29 Maddox St.
London W1R 9LD
01-499-9849

Leicester Galleries (ME)
22A Cork St.
London W1
01-437-8995

Lords (P)
26 Wellington Rd.
London NW8
01-722-4444

Lumley Cazalet Ltd. (ME)
(Camilla Cazalet, Caroline Lumley,
 Catherine Hodgkinson)
24 Davies St.
London W1
01-499-5058

Maltzahn (CE)
24 Brendon St.
London W1
01-437-6851

Marlborough Fine Art (London) **Ltd.**
 (ME)
39 Old Bond St.
London W1X 4BY
01-629-5161

Marlborough Graphics Ltd. (CE)
(Barbara Lloyd)
17–18 Old Bond St.
London W1X 4PH
01-629-5161

Christopher Mendez (OM, ME)
51 Lexington St.
London W1
01-734-2385

Achim Moeller Ltd. (ME)
8 Grosvenor St.
London W1X 9FB
01-493-7611
01-493-4591

Frederick Mulder (OM, ME)
3 Aberdeen Court
68 Aberdeen Park
London N5 2BH
01-226-7927

Desmond Page (CE)
32 Campden Grove
London W8 4JQ
01-937-0804
By appointment

Redfern Gallery (ME, CE)
(Michael J. Ashby)
20 Cork St.
London W1X 2HL
01-734-1732/0578

Paul Rice (CE)
52 Draycott Place
London SW3
01-589-0759
By appointment

Patrick Seale Prints Ltd. (CE)
2 Motcomb St.
Belgrave Square
London SW1X 8JU
01-235-4567

Somerville & Simpson Ltd. (OM, ME)
11 Savile Row
London W1X 1AE
01-437-5414

Leslie Waddington Prints Ltd. (ME, CE)
(Leslie Waddington and Alan Cristea)
34 Cork St.
London W1X 1HB
01-439-1866

Warwick Gallery (ME, CE)
14 Smith St.
Warwick CV34 4HH
01-926-4588

William Weston Gallery (ME)
38 Albemarle St.
London W1X 3FB
01-493-0722

PARIS

Antarès (OM, ME)
(Guy Prouté & Jacqueline Ezratty)
15, rue du 18 juin
92210 Saint-Cloud
(01) 602-04-33

Art Bureau Cheneau Delille (CE)
36, rue des Saints-Pères
75007 Paris
222-12-32

Art Conseil (M, CE)
122, rue la Boétie
75008 Paris
225-05-35

Jean-Louis Barbéry (ME)
2, rue des Grands-Degrès
75005 Paris
325-33-76

Le Bateau-Lavoir
(Mira Jacob)
16, rue de Seine
75006 Paris
033-96-83

Berggruen & Cie (ME, CE)
(Heinz Berggruen)
70, rue de l'Université
75007 Paris
222-02-12

Galerie Bonaparte (CE)
(Gayzag Zakarian)
15, rue Bonaparte
75006 Paris
033-72-97

Bouquinerie de l'Institut (ME)
(Alain C. Mazo)
3, Quai Malaquais
75006 Paris
326-63-49

Paule Cailac (ME)
13, rue de Seine
75006 Paris
DAN-98-88

Galerie André Candillier (OM, ME)
26, rue de Seine
75006 Paris
033-59-24

La Demeure Graphique (CE)
6 Place St. Sulpice
75006 Paris
326-02-74

Galerie Documents (ME, P)
(Michel Romand)
53, rue de Seine
75006 Paris
033-50-68

Liliane François (C)
15, rue de Seine
75006 Paris
326-94-32

Galerie Furstenberg (ME, CE)
8, rue Jacob
75006 Paris
242-34-97

Galerie Guiot (ME)
(Robert Guiot)
18, av. Matignon
75008 Paris
359-65-84; 266-65-84

La Gravure (ME, CE)
41, rue de Seine
75006 Paris
326-05-44

La Gravure Médicis (OM, ME)
9, rue Médicis
75006 Paris
325-25-53

Pierre Hautot S.A. (CE)
36, rue de Bac
75007 Paris
548-26-41; 548-00-37

La Hune (CE)
170, Blvd. St.-Germain
75006 Paris
548-35-85

Galerie Marcel Lecomte (ME)
17, rue de Seine
75006 Paris
326-85-47

Galerie Louise Leiris (ME, CE)
(Daniel-H. Kahnweiler & Maurice Jardot)
47, rue de Monceau
75008 Paris
522-57-35

Librarie Alexandre Loewy (ME)
85, rue de Seine
75006 Paris
033-11-95

Adrien Maeght (ME, CE)
42, rue du Bac
75007 Paris
548-45-15

Maeght Editeur (CE)
13, rue de Téhéran
75008 Paris
387-61-49; 522-13-19

Galerie R.-G. Michel (OM, ME)
(Pierre Michel)
17, Quai Saint-Michel
75005 Paris
ODE-77-75

Le Nouvel Essor (ME)
(J. Candillier)
40, rue des Saint-Pères
75007 Paris
LIT-94-02

La Nouvelle Gravure (CE)
42, rue de Seine
75006 Paris
633-01-92

Oeuvres Graphiques Contemporaines (CE)
31, rue des Bergers
75015 Paris
577-93-79

Galerie des Peintres Graveurs (ME)
(Jacques Frapier)
159 bis, Bd. du Montparnasse
75006 Paris
326-62-29

Henri-M. Petiet (ME)
8, rue de Tournon
75006 Paris
ODE-68-55

Galerie La Pochade (CE)
157, Bd. St.-Germain
75006 Paris
548-00-14

Also, La Pochade-Marais (CE)
6, rue Pavée
75004 Paris
272-18-17

Paul Prouté S.A. (OM, ME)
(Hubert Prouté)
74, rue de Seine
75006 Paris
326-89-80

Robert Prouté (OM, ME)
12, rue de Seine
75006 Paris
DAN-93-22

Galerie des 4 Mouvements (C)
46, rue de l'Université
75007 Paris
548-65-93

Editions Denise René (CE)
124 rue la Boétie
75008 Paris
359-93-17

Also, 196 Blvd. Saint-Germain
75006 Paris
222-77-57

Galerie Romanet (ME, CE)
30–34, rue de Seine
75006 Paris
326-46-70

Galerie J.-P. Rouillon (OM, ME, CE)
27, rue de Seine
75006 Paris
326-73-00

Maison Maurice Rousseau (OM, ME)
(Denise Rousseau)
42, rue La Fayette
75009 Paris
770-84-50

Sagot–Le Garrec (ME, CE)
(Jean-Claude Romand)
24, rue du Four
75006 Paris
326-43-38

Galerie Seder (ME, CE)
25, rue des Saints-Pères
75006 Paris
260-76-11

"Sources" (ME, CE)
(Henri Cazer)
49, rue de Seine
75006 Paris
326-45-19

Editions de la Tortue (CE)
11, rue Jacob
75006 Paris
326-09-85

Galerie Vision Nouvelle (ME, CE)
31, rue du Colisée
75008 Paris
720-70-49

GERMANY

Baden-Baden

Elfriede Wirnitzer (ME)
Ludwig-Wilhelm-Strasse 17A
7570 Baden-Baden
(07221) 2 67 25

Berlin

Edition René Block (CE)
Schaperstr. 11
Berlin 15
211 31 45

Edition Hundertmark (CE)
Kolonie Kleeblatt
Blumenweg 12
D-I Berlin-42
703 77 32; 751 77 32

Galerie Mikro (C)
(Michael S. Cullen)
Carmerstr. 1
1 Berlin 12
(0311) 312 58 65

Galerie Nierendorf (ME)
(Florian Karsch)
Hardenbergstr. 19
1 Berlin 12
(030) 785 60 60

Galerie Pels-Leusden (ME)
Kurfürstendamm 59/60
1 Berlin 15
883 30 19

Bonn

Galerie Pudelko (ME, CE)
Königstr. 33
53 Bonn
(02221) 22 66 44; 22 66 44

Galerie Wünsche (ME, CE)
Poppelsdorfer Allee 19
53 Bonn 1
(02221) 63 41 98

Braunschweig

Galerie Schmücking (CE)
Lessingplatz 12
33 Braunschweig
(0531) 4 49 60

Cologne

Galerie Ambaum (OM, ME)
Lindenstr. 22
5 Cologne 1
(0221) 24 74 46

Galerie Dreiseitel (ME, CE)
Richmodstr. 25
5 Cologne 1
(0221) 24 41 65

Galerie Gmurzynka (ME)
Schaafenstr. 67
5 Cologne 1
(0221) 23 66 21/22

Orangerie (ME, CE)
Helenenstr. 2
5 Cologne 1
(0221) 23 46 84/85

Galerie Wilbrand (ME, CE)
Lindenstr. 20
5 Cologne 1
(0221) 24 49 04

Galerie Rudolf Zwirner (C)
Albertusstr. 18
5 Cologne 1
(0221) 23 58 37/38

Dortmund

Galerie Schmücking (CE)
Klosterstr. 6
D-46 Dortmund
(0231) 57 19 48

Düsseldorf

C. G. Boerner (OM, ME)
(Ruth-Maria Muthmann)
Kasernenstr. 13, I
4 Düsseldorf 1
(0211) 37 49 81

Kunsthaus F. G. Conzen (ME, CE)
Kasernenstr. 13
4 Düsseldorf 1
(0221) 1 34 47

Conzen im Kö-Center
Königsallee, Königstr.
4 Düsseldorf
(0211) 1 34 47

Galerie Ludorff (ME)
Königsallee 22/III
4 Düsseldorf
(0211) 32 65 66

Galerie Denise René Hans Mayer (CE)
(Simon Passage)
Kö-Center
Martin-Luther-Platz 32
4 Düsseldorf
(0211) 1 97 95

Graphik-Salon Gerhart Söhn (ME)
Poststr. 24
4 Düsseldorf 1
(0211) 32 66 62

Galerie Alex Vömel (ME, CE)
Kö-Center, Pavillon
Königsallee 34
4 Düsseldorf
(0211) 32 74 22

Wolfgang Wittrock Kunsthandel (ME)
Sternstr. 16
4 Düsseldorf
(0211) 46 23 83

Esslingen

Kunstgalerie Esslingen (ME)
(Ralph D. I. Jentsch)
Hölderlinweg 136
73 Esslingen
(0711) 37 19 85

Frankfurt-am-Main

Joseph Fach (OM)
(Werner Rolf Fach)
Fahrgasse 8
6 Frankfurt/Main
(0611) 28 77 61

Frankfurter Kunstkabinet (ME)
(Hanna Becker vom Rath GMBII)
Börsenplatz 13–15
6 Frankfurt/Main
(0611) 28 10 85

H. H. Rumbler Gallery (OM, ME)
(Helmut H. Rumbler)
Braubachstr. 36
6 Frankfurt/Main
(0611) 29 11 42

Karl Vonderbank (OM, ME)
Goethestr. 11
6 Frankfurt/Main
(0611) 28 24 90

Hamburg

Brinke & Riemenschneider (ME)
Bueschstr. 9
2 Hamburg 36
(040) 34 64 70

Galerie Hans Brockstedt (CE)
Magdalenenstr. 11
2 Hamburg 13
(040) 4 10 40 91/92

Evelyn Hagenbeck (CE)
Oddernskamp 27
2 Hamburg 54
(040) 56 49 26

Dr. Ernst Hauswedell und Ernst Nolte
(ME, CE)
Buch-und Kunstauktionen
Pöseldorfer Weg 1
2 Hamburg 13
(040) 44 83 66

Galerie Hans Hoeppner (ME, CE)
Rothenbaumchaussee 103
2 Hamburg 13
(040) 45 33 62

Galerie Kammer (C)
Magdalenenstr. 44
2 Hamburg 13
(040) 45 94 27

Galerie Levy (CE)
Magdalenenstr. 26
2 Hamburg 13
(040) 45 91 88

Galerie Lochte (CE)
Magdalenenstr. 64
2 Hamburg 13
(040) 10 42 52

Also, Jungfernsteig 50
2 Hamburg 36
(040) 35 25 77

Galerie von Loeper (CE)
Doormannsweg 22
2 Hamburg 19
(040) 40 50 05

Galerie Neuendorf (CE)
4 Feldstr., Hochtts. 1
2 Hamburg
(040) 43 59 66/68

Wolf Uecker (ME, P)
Badestr. 21
2 Hamburg 13
(040) 4 10 52 35

Galerie Wentzel (C)
(Bogislav v. Wentzel)
Agnestr. 49
2 Hamburg 60
(040) 47 99 09

Galerie Wünsche (ME, CE)
Magdalenenstr. 22
2 Hamburg 13
(040) 4 10 24 79

Hanover

Galerie Dieter Brusberg (CE)
Uhlemeyerstr. 21 and Friedrichswall 13
3 Hanover
(0511) 32 66 23

Galerie Koch (ME)
Theaterstr. 15
3 Hanover
(0511) 32 20 06

Galerie Detlav Rosenbach (ME)
Walderseestr. 24
3 Hanover
(0511) 66 93 48

Munich

Art in Progress (CE)
Maximilianstr. 25
8 Munich 22
(089) 22 50 21

Dr. Margret Biedermann (CE)
Maximilianstr. 22
8 Munich 22
(089) 29 72 57

Studio Bruckmann (CE)
Nymphenberger Str. 84
8 Munich 19
(089) 1 25 71

Galerie Gunzenhauzer (ME)
Maximilianstr. 10
8 Munich 22
(089) 29 30 30

Galerie Dr. R. P. Hartmann (CE)
Franz-Joseph-Str. 20
8 Munich 40
(089) 34 79 67

Michael Hasenclever (ME)
Cuvilliésstr. 5
8 Munich 80
(089) 98 47 00

Heseler-Edition (CE)
Maximilianstr. 13
8 Munich 22
(089) 29 96 61

Galerie Hans Hoeppner (CE)
33 Oskar-von-Miller-Ring
8 Munich
(089) 28 43 26

Jasa Fine Art (CE)
Maximilianstr. 21
8 Munich 22
(089) 29 21 04

Galerie Wolfgang Ketterer (ME, CE)
Prinzregentenstr. 60, Villa Stuck
8 Munich 60
(0811) 47 20 83

Galerie Klihm (ME, CE)
Franz-Joseph-Str. 9
8 Munich 13
(089) 33 15 88

Stefan Lennert (ME)
Barerstr. 64
8 Munich 40
(089) 28 06 19

Galerie Pabst (ME)
(Michael Pabst)
Stollbergstr. 11
8 Munich 22
(089) 29 29 39

Galerie Ilse Schweinsteiger (ME)
Stollbergstr. 11
8 Munich 22
(089) 22 50 48

Galerie Thomas (ME, CE)
Maximilianstr. 25
8 Munich 22
(089) 29 55 17

Nuremberg

Erwin & Rolf Kistner (OM)
Breite Gasse 52154
85 Nuremberg
(0911) 22 55 89

Stuttgart

Bühler Graphics (ME)
Kunsthaus Bühler
Wagenburgstr. 4
7 Stuttgart 1
(0711) 24 01 07

Edition Domberger (CE)
Hölderlinstr. 4–8
7026 Bonlanden bei Stuttgart
(0711) 77 10 77/78

Galerie Valentien (ME, CE)
Königsbaul
7 Stuttgart 1
(0711) 22 16 25

SWITZERLAND

Basel

Galerie Schmücking (CE)
Leonhardsgraben 52
CH-4000 Basel
(061) 25 37 05

Bern

Loeb Gallery (CE)
Gurtengasse 4
CH-3001 Bern
(031) 22 73 21

Galerie Schindler Bern (L'Oeuvre Gravée)
(CE)
Münstergasse 36
CH-3011 Bern
(031) 22 50 71

Also, Marktgasse 38
(031) 22 81 37

Campione d'Italia (Lugano)

Galleria Henze (ME, CE)
(Dr. Wolfgang Henze and Ingeborg Henze)
Via Marco da Campione 16
CH-6911 Campione d'Italia
(091) 8 65 33

Galeria Roman Norbert Ketterer (ME)
Via Marco da Campione 16
CH-6911 Campione d'Italia
(091) 68 76 83

Geneva

Galerie Eva Callejo-Spierer (CE)
13, av. Bertrand (2ᵉ Etage)
CH-1206 Geneva
(012) 46 29 71

Galerie Cour Saint-Pierre (CE)
25, rue du Perron
CH-1204 Geneva
(022) 25 41 71; 28 57 83

Galerie Cramer (ME, CE)
(Patrick Cramer)
13, rue Chantepoulet
CH-1201 Geneva
(022) 32 54 32

Galerie Engelberts (ME)
11, Grand'Rue
CH-1204 Geneva
(022) 24 79 65

Galerie Georges Moos (ME)
(Maryam Ansari)
2, Grand'Rue
CH-1204 Geneva
(022) 21 56 72

Lausanne

A et G de May (ME, C)
6, Chemin des Sorbiers
CH-1012 Lausanne
(021) 21 96 08

Neuchatel

Galerie Ditesheim (ME, CE)
Terreaux 5
Neuchatel
(038) 24 57 00

Zurich

L'Art Ancien S.A. (OM, ME)
(Eva Winkler-Dencker)
Signaustr. 6
CH-8008 Zurich
(01) 47 92 29

Galerie Suzanne Bollag (CE)
Limmatquai 116
CH-8001 Zurich
(01) 47 20 25

Hans Bolliger (ME)
Lenggstr. 14
CH-8008 Zurich
(01) 53 58 88

Galerie Semiha Huber (CE)
Talstr. 18
CH-8001 Zurich
(01) 23 33 03

Galerie Daniel Keel (ME, CE)
Rämistr. 33
CH-8001 Zurich
(01) 32 31 82

Galerie Kornfeld Zurich (ME, CE)
(Christoph Von Albertini)
Titlesstr. 48
CH-0832 Zurich
(051) 32 03 60

August Laube (OM, ME)
Trittligasse 19
CH-8001 Zurich
(01) 32 85 50

Maeght Zurich (CE)
Predigerplatz 10–12
CH-8001 Zurich
(01) 32 11 20

Marlborough Zurich (C)
Villa Rosau
Glärnischstr. 10
CH-8002 Zurich
(01) 36 34 90

Hellmut Schumann (ME)
Rämistr. 25
CH-8024 Zurich
(0 04 11) 32 02 72

ITALY

Bologna

Galleria D'Arte D'Azeglio (OM)
Via M. D'Azeglio 14
40123 Bologna
26 66 90

Arte Grafica (OM)
(Giuseppe Cucchio)
Via Farini
401243 Bologna
23 73 51

Stamparte (ME, CE)
P.O. Box 749
Bologna I-40100
(051) 22 19 13

Milan

Galleria Ciranna (ME, CE)
(Dr. Alfonso Ciranna)
Via Gastone Pisoni 2
20121 Milan
653. 393

Il Gabinetto delle Stampe (OM, ME)
(Harry Salamon)
Via Montenapoleone, 3
20121 Milan
70 80 82

Galleria Milano (CE)
Via Manin 13
Milan
65 03 52

Il Mercante di Stampe (ME)
(M. R. Tabanelli)
29 Corso Venezia
Milan
70 44 02

Nello Spada (ME, CE)
via Rasori 13
20145 Milan
48 40 27

Quattrifolio (OM, ME)
(Pierro Bella)
Via S. Cecilia 2
20122 Milan
78 14 98; 78 20 09

Galleria delle Stampe (OM)
(Ruth Bromberg)
Corso Italia 22
Milan
89 88 20; 87 57 27

Transart (CE)
Via Sacchi 1 e 3
20121 Milan
89 99 50

Reggio

Libreria Prandi (ME, CE)
Viale Timavo 75
42100 Reggio Emilia
34 9 73

Rome

L'Arco, studio internazionale d'Arte
 Grafica (CE)
Via Mario de'Fiori
39 A Rome

2 RC Editrici (C)
(Valter Rossi)
Viclo Astalli 5
Rome

Turin

Libreria Antiquaria Pregliasco (OM)
Via Accademia Albertina 3 bis
10123 Turin
87 71 14

Galleria D'Arte (CE)
Piazza Carlo Felice, 19
Turin

Galleria Il Fauno Grafica (CE)
Piazza Castello, 51
Turin

AUSTRIA

Galerie Ariadne (CE)
(George McGuire)
A-1010 Vienna 1
Bäckerstrasse 6
52 88 51

Donald Corcoran (ME)
Maysedergasse 2
Vienna I
52 63 30

Christian Nebehay (ME)
Annagasse 18
Vienna A-1015

Michael Pabst (ME, P)
Habsburgergasse 10
A-1010 Vienna I
52 69 48 (22 41 88)

Michael Steinbach (ME, P)

Galerie im Grünen
Salmanndorfer Str. 64
1190 Vienna

NETHERLANDS

Arta (CE)
Kazernestraat 58
The Hague

S. Emmering (OM)
N. Z. Voorburgwal 304
Amsterdam-C.
23 14 76

Galerie Espace nv (CE)
(Eva Bendien & R. N. Hegt)
Keizersgracht 548
Amsterdam
020-24 08 02

De Graaf (OM, ME)
Zuideinde 40, P.O.B. 6
Nieuwkoop
01725/1461

Henk J. Stokking (OM)
Nieuwe Spiegelstraat 40
Amsterdam 1002
020-27 99 82

SPAIN

Sala Gaspar
42, Rambla de Catalunya
Barcelona

SWEDEN

Galerie Börjeson (CE)
(Per-Olov Börjeson)
Hamngatan 4
Malmö
040-711 00

NORWAY

Galleri KB (ME)
Kaara Berntsen A/S
(Arnstein Berntsen)
Universitetsgaten 12
Oslo 1
20 34 29

DENMARK

Ars Studio, DK 1263 (C)
Esplanaden 7
1263 Copenhagen K
01-11 92 22

JAPAN

Galleria Grafica Tokio (C)
Watanabe-Bldg.
2-2 Yurakucho Chiyodaku Tokyo
03 573 77 31

Nantenshi Gallery (ME, C)
(Haruo Aoki)
3-11 Kyobashi Chuo-ku
Tokyo
563-3511

The Red Lantern Shop (C)
236 Shimmonzen St.
Higashiyama-ku
Kyoto 505
075-561-6314

Yoseido Gallery (C)
5-15 Ginza 5-chome
Chuo-Ku
Tokyo

Appendix Eight

A Trilingual Lexicon

A. FRENCH-ENGLISH-GERMAN

FRENCH	English	German
ACCIDENT	damage, fault	Beschädigung
LÉGERS——S	slight——	leicht——
QUELQUES——S	some——	etwas——
SANS——S	without——	tadellos
ACCIDENTÉ	damaged, uneven	beschädigt, uneben
ACIÉRAGE	steelfacing	Verstähling, Stählüberzung
AVANT——	before——	vor——
AFFICHE	poster	Plakat
ALBUM	portfolio, series	Mappe
À L'ENVERS	in reverse	seitenverkehrt
AMATEUR	collector, connoisseur	Sammler
ANCIEN	early, old, former	früh, alt, früher
ANGLE	corner	Ecke, Winkel
L'—— INFÉRIEURE DROIT	lower right-hand——	unter rechts——
L'—— SUPÉRIEURE	upper——	oben——
ANNÉE	year	Jahr
ANNOTÉ	marked, designated, numbered	bezeichnet, numeriert
APRÈS	after, following	nach, folgend
AQUAFORTISTE	etcher	Atzer
AQUARELLE	watercolor	Aquarell, Wasserfarbe
AQUATINTE	aquatint	Aquatinta
ARRIÈRE-PLAN	background	Grund, Hintergrund
ART	art	Kunst
ARTISTE	artist	Künstler
ATELIER	workshop, studio	Atelier, Druckerei
AU DESSOUS	below, beneath	unterhalb, unter
AUTOGRAPHE	signature	Signatur, Unterschrift
AVANT	before	Vor
—— L'ADRESSE	—— address	——der Schrift
—— LA LETTRE	—— inscription (early state)	ohne der Schrift
AVEC LA LETTRE	with inscription	mit der Schrift
BARBES	burr	Graten
QUELQUES ——	traces of——	Gratspuren
RICHE EN ——	rich with——	mit vielen (reichem) Graten
BAS	bottom	Grund
AU ——	at the——	auf dem——
BEAU (BELLE)	fine, good	Schön, vorzüglich, vortrefflich
BEAUCOUP DE	many, multiple	mehrmals, mehrfach
BEAUTÉ	fineness, beauty	Schönheit
DE LA PLUS GRANDE ——	of the greatest ——	von grosser ——
BIFFÉ	canceled, scored	rayiert, zerstört, durchgestrichen

French	English	German
AVANT QUE LE CUIVRE NE SOIT ——	before the canceling of the plate	vor de Zerstörung de Platte, vor de Rayierung der Platte
PLANCHE ——	canceled (scored)	zerstörte Platte
BISEAU	beveling (of the plate)	Schräge
BLANC	white	weiss
BOIS	block (wood), woodcut	Stock, Holzschnitt
BOÎTE	box, case	Schachtel
BON	good	gut
ENCORE ——	fairly ——	nag ——
—— À TIRER	right to print proof	Gut zum Druck
BORD	edge, side, margin	Blattkante, Ende, Seite, Rand
—— DE LA MARGE	—— of the margin	Blattkante
BROCHÉ	bound, sewn	beigeheftet, eingeheftet
BURIN	engraving (copper)	Kupferstich
CACHE SEC	drystamp	Trockenstempel
CACHET SEC	blind stamp, chop	Blindstempel, Trockenstempel
CAISSE	box, case	Schachtel
CAMAÏEU	chiaroscuro woodcut	Clair-obscur (Holzschnitt), Helldunkel Holzschnitt
CARTON	cardboard, mat	Karton
CASSURE	crack	Beschädigung
CATALOGUE RAISONNÉ	catalogue of graphic works	Graphikkatalog
CENTRE	center	Mitte
—— PLI	—— fold	Mittelfalte
CHACUN	each	einzeln
CHEF D'OEUVRE	masterpiece	Haupblatt, Hauptwerk
CHINE	China paper	China
—— APPLIQUÉ, COLLÉ	very thin laminating tissue	China appliqué, Chine collé
—— VOLANT	very thin China paper	sehr dünn China
CLAIR OBSCUR	chiaroscuro woodcut	Clair-obscur, Helldunkel Holzschnitt
COLLE	paste	klebe Paste, Kleber
COLLÉ	pasted	geklebt
COLLECTION	collection	Sammlung
—— PARTICULIÈRE	private ——	privat ——
COLORIÉ	colored	Koloriert
COMMISSION	commission (order)	Auftrag, Komission
COMPLÉTÉ	completed, repaired	ergänzt
COMPRIS	included (in same lot)	dabei
CONDITION	condition (preservation)	Erhaltung
BON ——	nice ——	sauber in der ——
EXCELLENTE ——	faultless ——	tadelloser ——
PARFAITE ——	perfect ——	gezeichnete ——
MAUVAISE ——	poor ——	schlecht
CONDITIONS DE LA VENTE	conditions of sale	Auktion Bedingungen
COPIE	copy (facsimile)	Kopie
CÔTÉ	side	Seite
COULEUR	color	Farbe
EN —— S	in ——	farbig
COUPÉ	cut, trimmed, clipped	gerschnitten, beschnitten
—— COURT	—— close	verschnitten
COUVERTURE	cover	Umschlag

FRENCH	English	German
CRAYON	pencil	*Bleistift*
—— DE COULEUR	colored ——	*Farbstift*
CUIVRE (V. PLANCHE)	copperplate, plate	*Kupferplatte, Platte*
D'APRÈS	after (a graphic copy of)	*nach, folgend*
DE	from, of	*aus*
DECHIRÉ	torn	*gerissen*
DÉCHIRURE	tear, split, crack	*Ritz, Riss, Knickfalte*
DÉCRIT	recorded	*beschreiben*
NON ——	un ——	*un ——*
DÉDICACÉ	dedicated	*gewidmet*
DÉDICATION	dedication	*Widmung*
DÉFAUT	defect, flaw	*Mängel*
DÉFAUTS	damage	*Beschädigung*
LÉGERS ——	slight ——	*leicht ——*
QUELQUES ——	some ——	*etwas ——*
SANS ——	without any ——	*tadelloser Erhaltung*
DESSIN À LA PLUME	drawing (pen and ink)	*Federzeichnung*
DESSIN AU CRAYON, DESSIN À LA MINE DE PLOMBE	drawing (pencil)	*Bleistiftzeichnung*
DESSOUS	below, beneath	*unterhalb, unter, unten*
DÉTRUIT	destroyed	*zerstört*
DIMENSIONS	dimensions	*Grösse*
DOS	back (blank side), verso	*Rücken, Rückseite*
DOUBLE	duplicate	*Doppel*
DOUBLÉ	laid down (backed)	*aufgezogen*
À DROIT	right	*rechts*
EAU-FORTE	etching	*Radierung*
ÉDITÉ	published	*erschienen*
ÉDITEUR	publisher	*Verlag, Verlager*
ÉDITION	edition, printing	*Auflage, Ausgabe*
—— COURANTE	regular ——	*Normal ——*
—— DE LUXE	special ——	*Vorzugs ——*
ÉGRATIGNURE	scratch, slipped stroke	*Ritz, Kratzer*
ENCADRÉ	framed	*umrahmt, gerahmt*
ENCRAGE	inking	*Einfärbung*
ENCRE	ink (printing)	*Druckfarbe*
—— DE CHINE	India ——	*indische Tusche*
EN HAUT	at the top	*oben*
ENTAMÉ	cropped, clipped, trimmed	*beschnitten, geschnitten, verschnitten*
ENVIRON	approximately	*nahezu*
ÉPIDERMÉ	skinned	*dünn*
EPIDERMURE	thin spot	*Dünnstelle*
ÉPREUVE	proof	*Abzug, Abdruck*
—— D'ARTISTE	artist's ——	*Kunstlerexemplar*
—— D'ESSAI	trial ——	*Probedruck*
—— D'ÉTAT	state ——	*Zustandsdruck*
—— D'IMPRIMEUR	printer's ——	*Abzug des Druckers*
ÉRAILLURE	scratch, slipped stroke	*Ritz, Kratzer*
ESTAMPE	print	*Druck*
———	after (a graphic copy of), following	*nach, folgend*
ESTAMPILLE	cipher, stamp	*Eigendruck*

French	English	German
ÉTAT	state	*Zustand*
EXEMPLAIRE	copy (impression)	*Abdruck, Exemplar*
EXPOSITION	exhibition	*Austellung*
EXTRAORDINAIRE	unusual	*ausserordentlich*
EXTRÊMEMENT	extremely	*extrem, grössten*
FEUILLE	leaf, sheet of paper	*Blatt*
FILET DE MARGE	thin margin, thread margin	*kleiner Randchen*
FILET D'ENCADREMENT	frame line (around image)	*Leiste*
FILIGRANE	watermark	*Wasserzeichnen*
FOND	background	*Grund, Hintergrund*
PLANCHE DE ——	—— plate	*Tonplatte*
FORT	strong, stout	*fest*
FRISÉ	frazzled (edge)	*ausgefraust*
FROISSÉ	creased, crumpled	*knittrig*
FROTTEMENTS	rub marks, abrasions	*Radierspuren, radierte Stellen*
GAUCHE	left	*links*
GAUFFRAGE	embossing	*Prägedruck*
GRAVÉ	engraved, graphic	*graviert, radiert, graphische*
GRAVEUR	engraver, printmaker	*Radierer, Drucker*
—— SUR BOIS	woodcutter	*Formschneider, Holzschneider*
GRAVURE	intaglio	*Tiefdruck*
—— À LA POINTE SECHE	drypoint	*Kaltnadelradierung, Kalte Nadel*
—— AU CRIBLÉ	metal cut	*Metalschnitt, Schrotblatt*
—— AU POINTILLÉ	stipple engraving	*Punkstich*
—— EN TAILLE DE BOIS	wood engraving	*Holzstich, Hirnholzstich*
—— EN TAILLE DOUCE	line engraving	*Strichgravur*
—— SUR ACIER	steel engraving	*Stahlstich*
—— SUR BOIS	woodcut	*Holzschnitt*
—— SUR BOIS DEBOUT	wood engraving	*Holzstich, Hirnholzstich*
—— SUR CUIVRE	engraving (copper)	*Kupferstich*
—— SUR LINOLÉUM	linocut	*Linolschnitt*
GRIFFE	signature stamp	*Stempelsignatur*
HACHURE	crosshatching	*Schraffur*
HORS	outside, apart from	*ausserhalb*
—— DE COMMERCE (H.C.)	—— regular edition (artist's proofs, etc.)	—— *des Handels*
ILLUSTRATION	illustration, plate	*Illustration, Tafel*
IMPRESSION (V. TIRAGE)	copy (impression)	*Druck, Abdruck, Exemplar*
—— ENCORE BONNE	fair ——	*noch gut*
—— EN CREUX	intaglio	*Tiefdruck*
—— EN RELIEF	relief printing, letterpress	*Hochdruck*
IMPRIMÉ	printed	*gedruckt*
—— EN NOIR	—— in black and white	—— *in schwarz-weiss*
IMPRIMEUR	printer	*Drucker*
INÉDITÉ	unpublished	*nicht editierten, unveröffent- licht*
INFÉRIEURE	lower	*unten*
INTÉRIEUR	inside	*innerhalb*
JAPON	Japan paper	*Japan*
—— NACRÉ	pearly ——	*genarbt* ——

FRENCH	English	German
SIMILI- ——	imitation ——	Simili- ——, imitiertes ——
—— PELURE	very thin ——	sehr dunn ——
JAUNIE	yellowed	vergilbt
JUSTIFICATIF	colophon	Impressum
LAVIS	wash (tint)	Lavis
LÉGER	minor, slight	leicht, gering
LETTRES	letters, inscription	Schrift, Unterschrift, Inschrift
AVANT LA LETTRE	before ——	ohne der ——
AVEC LA LETTRE	with ——	mit der ——
LIGNE	line	Linie
LINOGRAVURE	linocut	Linolschnitt
LITHOGRAPHIE	lithograph	Steindruck, Lithographie
LIVRE	book	Buch
HORS ——	unbound (separate from book)	neben ——
LOT	auction lot	Konvolut
MACULATURE	stain, soil	Fleck
MAIN	hand	Hand
MANIÈRE ANGLAISE	mezzotint	Schabkunst
MANIÈRE CRIBLÉE	dotted print	Schrotblatt
MANIÈRE DU CRAYON	crayon-manner engraving	Croyon manier, Croyon technik
MANQUE	loss (of paper)	mangels (Papier)
MARGE	margin	Rand
À GRANDES ——S	large ——s	breiter——, grosser ——er
À PETITES ——S	small ——s	schmaler——, kleiner ——chen
BORD DE LA ——	edge of the ——	Blattkante
FILET DE ——	thin——,	kleiner Randchen
—— EXTÉRIEURE	outer ——	äusseren Rand
—— INFÉRIEURE	lower ——	unterer Rand
SANS ——	without ——s	ohne Rand
—— SUPÉRIEURE	upper ——	oberer Rand, Oberkante
TOUTES ——S	full (wide) ——	sehr Breitrandig, Vollrandig
MARQUE DE COLLECTION	collector's mark	Sammlerstempel
MÊME	same	Dasselbe
MERVEILLEUX	magnificent, splendid, rich, outstanding (in quality)	prachtroll, herrlich, trefflich
MESURES	dimensions	Grösse
MINCE	thin	dünn
MONOGRAMMÉ	monogrammed	monogrammiert
MONTAGE	window mat, mount	Passepartout
MOUILLURE	water stain	Wasserfleck
NOIR	black	schwarz
NUMÉRO	number, issue	Nummer
——TÉ	——ed	numeriert
OEUVRE	body of work	Werk, Arbeiten
ORDRE D'ACHAT	commission (order)	Auftrag, Komission
OXYDATION	oxidation	Oxydierung
PAGE	page	Seite
PAPIER	paper	Papier

French	English	German
—— À LA CUIVRE (CUVE)	hand-made (deckle-edged) paper ——	handgemacht——, umranded——
—— À DESSIN	drawing ——	Zeichen——
—— À REPORT	transfer ——	Umdruck——
—— MÉCANIQUE	machine-made ——	Maschinen——
—— VÉLIN	wove ——	velin ——
—— VERGÉ	laid ——	geripptes——, Butten
PARAPHÉ	countersigned	monogrammiert, paraphiert
PARCHEMIN	parchment	Pergament
PARFAIT	magnificent, splendid, rich, outstanding	prachtvoll, herrlich, trefflich
PAS	not	nicht
—— DE VENDRE	—— for sale	——verkäuflich
PASSE-PARTOUT	frame (wooden, etc.)	Rahmen
PÉRIODIQUE	art magazine	Zeitschrift
PETIT	small, minor, slight	Klein, leicht
PHOTOTYPIE	collotype	Lichtdruck
PIERRE	stone	Stein
PIQÛRE	puncture, fly speck, wormhole	Nadelloch, Nadelstich, Wurm-loch
PLANCHE	plate, woodblock	Platte, Holzstock
—— BIFFÉE, RAYÉE	canceled ——	zerstörte ——
COUPE DE —— TÉMOIN	——mark	Facettenrand, Plattenrand
—— DE FOND	background ——	Tonplatte
PLI	crease, fold	Knitt, falten
PLIÉ	creased, folded	knittrig, gefaltet
PLUME	pen	Feder
POCHOIR	stencil print	Schablone
POINTE-SÈCHE	drypoint	Kaltnadelradierung, Kalte Nadel
POINTILLÉ (ESTAMPE)	stipple print	Punctiermanier
PONTUSEAUX	chain lines	Querrippen
PORTRAIT	portrait	Bildnis
—— D'ARTISTE	self- ——	Selbst——
POUSSIÈRE	dirt, soil, dust	Schmutz
PREMIER	first	erst
—— TIRAGE	early proof	Frühdruck
PUBLIÉ	published	erschienen
RARE	rare	selten
EXTRÊMEMENT ——	extremely ——	von der grössten ——heit
TRÈS ——	very ——	sehr——
RAYÉ	scored (canceled)	gestrichen, rayiert
RARETÉ	rarity	Seltenheit
RECUEIL	restrike, reprint	Nachdruck, Neudruck
RECTO	front (image side), recto	rechte Seite, Vorderseite
REHAUSSÉ	heightened, embellished	gehöht
RÉIMPRESSION	restrike, reprint	Nachdruck, Neudruck
RELIURE	binding	Bindung, Umschlag
REMARGÉ	remargined	neu umrändert
RENFORCÉ	reinforced	verstärkt
RENFORCEMENT	reinforcement	Stärkung
RÉPARÉ	repaired	repariert, ergänzt, restauriert
REPRODUCTION	reproduction	Abbildung
RÉSERVAGE, RÉSERVE AU SUCRE	lift ground etching	Aussprengverfahren

French	English	German
RESTAURATION	repair	*Reperatur*
PETITE ——	minor ——	*klein* ——
RETOUCHÉ	retouched	*überarbeitet*
RETROUSSAGE	plate tone	*Plattenton*
REVUE	art magazine	*Zeitschrift*
RIGID	rigid, stout, strong	*fest*
ROGNÉ	cropped, clipped, trimmed (without margins)	*beschnitten, verschnitten, geschnitten*
ROUILLE	rust	*Rost*
ROUSSEURS	reddish stains	*rötliche Flecken*
SALISSURE	dirt spot, stain	*Schmutzfleck, Fleck*
SÉRIE	series, suite, set	*Serie, Folge*
SÉRIGRAPHIE	silkscreen, screenprint, serigraph	*Siebdruck, Serigraphie*
SIGNATURE	signature	*Signatur, Unterschrift*
SIGNÉ	signed	*signiert, unterschreiben*
SOIE, FRAME DE	silkscreen (screenprint), serigraph	*Siebdruck*
SOUILLÉ	stained	*fleckt*
SPÉCIAL	special	*sonder*
EDITION ——	—— edition	—— *nummer*
SPLENDID	magnificent, splendid, rich, outstanding (in quality)	*prachtvoll, herrlich, trefflich*
SUITE	suite, set, series	*Folge, Serie*
SUJET	image (composition)	*Darstellung*
EN PLUS DU ——	outside the ——	*ausserhalb der* ——
PLUS PETITES QUE LE ——	within the ——	*innerhalb der* ——
SUPERB	superb, splendid	*prachtvoll*
SUPÉRIEURE	upper	*ober*
SUPPLÉMENT	supplement	*Nachtrag*
SUPPLÉMENTAIRE	additional	*zusätzlich*
TACHE	stain, blemish, spot	*Fleck, Punkt*
—— D'ACIDE	acid stain	*Tonflecken, Atzfleck*
—— DE ROUILLE	rust stain	*Rostfleck*
—— D'HUMIDITÉ	foxing	*Flecken, Stockfleck*
TACHÉ DE ROUX	foxed	*stockfleckig*
TAILLE	stroke (line)	*Schnitt, Streich, Schlag*
TAXE	tax, charge	*Aufgeld, Spesen*
TEINTÉ	tinted	*getönt*
TEMPS	period (time)	*Zeit*
TEXTE	book	*Buch*
HORS ——	unbound (separate from book)	*neben* ——
TIMBRE	stamp	*Stempel*
SEC ——	dry ——, blind——	*Trochen* ——, *Blind* ——
TIMBRÉ	stamped	*gestempelt*
TIRAGE	printing, publication, edition	*Ausgabe, Auflage*
PREMIER ——	first edition	*Erstdruck*
TOUT PREMIER ——	early impression	*Frühdruck*
—— ANCIEN	early proof	*Frühdruck*
—— NOUVEAU	modern impression	*Neudruck*
—— POSTÉRIEUR	late impression	*Spätdruck*
TIRÉ	printed (struck)	*gedruckt*

FRENCH	English	German
TITRE	title	*Titel*
PAGE DE ——	—— page	—— *seite,* —— *blatt*
TOME	volume	*Band*
TOUS	all	*alle*
TOUTES MARGES	full (wide) margins	*sehr Breitrandig, Vollrandig, breiten Rändern*
TRACE	evidence	*Beweis*
—— DE	minor, light	*leicht, gering*
TRAIT CARRÉ	borderline (square or rectangular)	*Einfassunglinie, Umrandung*
TRAVAUX	additions, reworking, repairs	*Ergänzungen, Uberarbeitung*
TRÈS	very	*sehr*
TROU	hole	*Loch*
PETITS ——S	tiny ——s	*kleine Locher*
——S D'AIGUILLES	pin——s	*Nadelstich*
——S DE VERS	worm——s	*Wurmloch*
VÉLIN	wove paper	*Velin*
VENTE	sale	*Verkauf*
—— AUX ENCHÈRES	auction ——	*Versteigerung, Auktion*
VERDÂTRE	greenish	*grünlich*
VERGÉ	laid paper	*Bütten, geripptes Papier*
VERGEURES	laid lines	*Händsrippen, Langsrippen*
VERNIS MOU	soft ground etching	*Vernis mou, Weichgrund*
VERS	near	*gegen*
VERSO (AU)	verso, back (blank side)	*Rücken, Rückseite*

B. GERMAN-ENGLISH-FRENCH

GERMAN	English	French
ABDRUCK	copy (impression), proof	*impression, exemplaire, épreuve*
ABBILDUNG	reproduction	*réproduction*
ABZUG	proof	*épreuve*
—— DES DRUCKERS	printer's ——	——*d'imprimateur*
ALLE	all	*tous*
ALT	old	*ancien*
AQUARELL	watercolor	*aquarelle*
—— IERT	—— ed	*aquarellé*
AQUATINTA	aquatint	*aquatinte*
ARBEITEN	body of work	*oeuvre*
ATELIER	workshop	*atelier*
ATZER	etcher	*aquafortiste*
ÄTZFLECK	acid stain	*tache d'acide*
AUFGELD	tax, charge	*taxe*
AUFGEZOGEN	laid down (backed)	*doublé*
AUFLAGE	edition, printing	*édition*
AUFTRAG	commission (order)	*commission, ordre d'achat*
AUKTION	auction	*vente aux enchères*
—— BEDINGUNGEN	conditions of sale	*conditions de la vente*
AUS	from, of	*de*
AUSGABE	edition, printing, publication	*tirage, édition*
NORMAL——	regular ——	——*courante*
VORZUGS ——	special ——	——*de luxe*

GERMAN	English	French
AUSGEFRAUST	frazzled (edge)	*frisé*
AUSSERHALB	outside, apart from	*hors*
—— DES HANDELS	—— the numbered edition	——*de commerce (H.C.)*
AUSSPRENGVERFAHREN	lift ground etching	*réservage, réserve au sucre*
AUSTELLUNG	exhibition	*exposition*
BAND	volume	*tome*
BEIGEHEFTET	sewn	*broché*
BREIT	full, wide	*tout*
BREITRANDIG	—— margins	*toutes marges*
BESCHÄDIGUNG	crack, fault, damage	*cassure, défauts, accidents*
BESCHNITTEN	cut, cropped, trimmed	*rogné, coupé, entamé*
BESCHREIBEN	recorded	*décrit*
BEWEIS	evidence	*trace*
BEZEICHNET	marked, designated	*annoté*
BILDNIS	portrait	*portrait*
BINDUNG	binding (book)	*reliure*
BLATT	sheet of paper	*feuille*
—— KANTE	edge, side, margin	*bord*
BLEISTIFT	pencil	*crayon*
—— ZEICHNUNG	—— drawing	*dessin au ——, dessin à la mine de plombe*
BLINDSTEMPEL	blindstamp, chop	*cachet sec, timbre sec*
BUCH	book	*livre, texte*
NEBEN ——	separate from ——	*hors ——*
BÜTTEN	handmade paper, laid paper	*vergé*
CHINA	China paper	*Chine*
SEHR DÜNN ——	very thin ——	——*volant*
CLAIR-OBSCUR (HOLZSCHNITT)	chiaroscuro woodcut	*clair obscur, camaïeu*
CROYON MANIER, CROYON TECHNIK	crayon-manner engraving	*manière de crayon*
DABEI	also, included (in same lot)	*compris*
DASSELBE	same	*même*
DOPPEL	duplicate	*double*
DRUCK	impression, print	*impression, tirage, estampe*
FRÜH——	early ——	*tout premier ——*
NEU——	modern (recent) ——	*nouveau ——*
SPÄT——	late ——	——*postérieur*
GUT ZUM ——	right-to-print proof	*bon à tirer*
DRUCKER	printer, printmaker	*imprimeur, graveur*
DRUCKEREI	printshop	*atelier*
DARSTELLUNG	image, composition	*sujet*
AUSSERHALB DER ——	outside the ——	*en plus du ——*
INNERHALB DER ——	within the ——	*plus petites que le ——*
DÜNN	thin, skinned	*mince, épidermé*
DÜNNSTELLE	thin spot	*épidermure*
DURCHGESTRICHEN	canceled, scored	*rayé, biffé*
ECKE	corner	*angle*
EDITION	printing, publication, edition	*édition*
EDITIERT	published	*édité*

GERMAN	English	French
EIGENDRUCK	cipher, stamp	estampille
EINFÄRBUNG	inking	encrage
EINFASSUNGLINIE	borderline (around image)	trait carré
EINGEHEFTET	sewn	broché
EINRISS	split, crack	déchirure
EINZELN	each	chacun
ENDE	edge, side	bord
ERGÄNZT	completed, repaired	complété, reparé
ERGÄNZUNGEN	additions	travaux
ERHALTUNG	condition (state of preservation)	condition
AUSGEZEICHNETE ——	excellent ——	excellente ——, parfaite ——
TADELLOSER ——	faultless ——	sans defauts
SAUBER IN DER ——	nice ——	bonne condition
ERSCHIENEN	published	publié, édité
ERST	first	premier
‚ERSTDRUCK	first edition	premier tirage
ETWAS	somewhat	quelque
EXEMPLAR	copy (impression)	exemplaire, impression
EXTREM	extremely	extrêmement
FACETTENRAND	platemark	coupe de planche (cuivre) témoin, témoin de cuivre
FALTE	fold	pli
GE——T	—— ed	——é, froissé
MEHRMALS GE——T	—— ed several times	
ZWEIMAL GE——T	—— ed in two	
FARBIG	in color	en couleurs
FARBSTIFT	colored pencil	crayon de couleur
FARBE	color	couleur
FEDER	pen	plume
—— ZEICHNUNG	—— and-ink drawing	dessin à la ——
FEST	stout, rigid	rigid, fort
FLECK	stain, staining, soil, spot	tache, maculature, salissure
FLECKEN	foxing	taches d'humidité, piqûres
RÖTLICHE ——	reddish stains	rousseurs
FLECKT	stained	souillé
FOLGE	set, suite, series	suite, série
FOLGEND	after (a graphic copy of)	d'après, estampe
FORMSCHNEIDER	woodcutter	graveur sur bois
FRÜH	early, old	ancien
GEDRUCKT	printed, struck	tiré
GEGEN	near	vers
GEHÖHT	heightened, embellished	rehaussé
GEKLEBT	pasted	collé
GENARBT	pearly Japan paper	Japan nacré
GERAHMT	framed	encadré
GERING	minor, slight	trace de, léger
GERIPPTES PAPIER	laid paper	vergé
GERISSEN	torn	dechiré
GESCHNITTEN	cut, trimmed, cropped	coupé, rogné, entamé
GESTEMPELT	stamped	timbré

GERMAN	English	French
GESTRICHEN	scored, canceled	rayé, biffé
VOR DER —— EN PLATTE	before the plate was ——	avant que le cuivre ne soit ——
GETÖNT	tinted	teinté
GEWIDMET	dedicated	dédicacé
GRAPHISCHE	graphic	gravé
GRATEN	burr	barbes
MIT VIELEN (REICHEM)——	rich with ——	riche en ——
GRATSPUREN	traces of burr	quelques barbes
GRAVIERT	engraved	gravé
GRÖSSTEN	extremely	extrêmement
GRÖSSE	dimensions	mesures, dimensions
GRUND	background	fond
AUF DEM ——	at the bottom	au bas
GRÜNLICH	greenish	verdâtre
GUT	good	bon
NOG ——	fairly ——	encore ——
HAND	hand	main
HÄNDSRIPPEN	laid lines	vergeures
HAUPBLATT, HAUPTWERK	masterpiece	chef d'oeuvre
HELLDUNKEL HOLZSCHNITT	chiaroscuro woodcut	clair obscur, camaïeu
HERRLICH	splendid, rich, outstanding	splendid, superb, merveilleux
HINTERGRUND	background	fond, arrière-plan
HINTERLEGT	backed, laid down	doublé
HIRNHOLZSTICH	wood engraving	gravure sur bois debout, gravure en taille de bois
HOCHDRUCK	letterpress, relief printing	impression en relief
HOLZSCHNITT	woodcut	bois, gravure sur bois
HOLZSTICH	wood engraving	gravure sur bois debout, gravure en taille de bois
HOLZSTOCK	woodblock	planche
IMITIERTES JAPAN	imitation Japan paper	simili-Japon
IMPRESSUM	colophon	justificatif
INDISCHE TUSCHE	India ink	encre de Chine
INNERHALB VON (INNERE)	inside of, within	à l'intérieur de
INSCHRIFT	letters, inscription	letters
KALTE NADEL, KALT-NADELRADIERUNG	drypoint	pointe-sèche, gravure à la pointe-sèche
KANTE	edge, margin	bord, marge
BLATT ——	—— of the sheet	——
OBER ——	upper ——	—— supérieure
KARTON	cardboard, mat	carton
KLEBE PASTE	paste	colle
KLEIN	tiny, small, minor	petit, léger
KNICKFALTE	split, crack	déchirure
KNITT	crease, fold	pli
KNITTRIG	crumpled, folded	froissé
KOLORIERT	colored	colorié
KOPIE	copy (facsimile)	copie
KONVOLUT	auction lot	lot
KRATZER	scratch, slipped stroke	éraillure, égratignure
KUNST	art	art

GERMAN	English	French
KÜNSTLER	artist	*artiste*
KÜNSTLEREXEMPLAR	artist's proof	*épreuve d'artiste*
KUPFERPLATTE	copperplate	*cuivre*
KUPFERSTICH	engraving (copper)	*burin, gravure sur cuivre*
LÄNGSRIPPEN	laid lines	*vergeures*
LAVIS	wash (tint)	*lavis*
LEICHT	slight, minor	*léger, trace de*
LEISTE	frameline (around image)	*filet d'encadrement, trait d'encadrement*
LICHTDRUCK	collotype	*phototypie*
LINIE	line	*ligne*
LINKS	left	*à gauche*
LINOLSCHNITT	linocut	*linogravure, gravure sur linoléum*
LOCH	hole	*trou*
KLEINE——ER	pin——s	*petits ——s*
MAPPE	portfolio, series	*album*
MASCHINENPAPIER	machine-made paper	*papier mécanique*
MEHRMALS, MEHRFACH	many, a lot	*beaucoup*
MÄNGEL	defect	*défaut*
MANGELS (PAPIER)	loss (of paper)	*manque*
METALDRUCK	metal print	*gravure*
METALSCHNITT	metal cut	*gravure au criblé*
MIT	with	*avec*
MITTE	center	*centre*
MITTELFALTE	centerfold	*centre-pli*
MONOGRAMMIERT	monogrammed	*monogrammé*
NACH	after (a graphic copy of), following	*d'après, estampe*
NACHDRUCK	restrike, reprint	*réimpression, receuil*
NACHTRAG	supplement	*supplément*
NAHEZU	approximately	*environ*
NEBEN	separate, apart	*hors*
—— BUCH	—— from the book	*——livre, ——texte*
NEUDRUCK	restrike, reprint	*réimpression, receuil*
NICHT	not	*pas*
NADELLOCH, NADELSTICH	pinhole	*trou d'aiguille, piqûre*
NUMERIERT	numbered	*numéroté, annoté*
NUMMER	number, issue	*numéro*
OBEN	at the top	*en haut*
OBER	upper	*supérieure*
OFFSETDRUCK	offset lithograph	*impression offset*
OHNE	without	*sans*
—— DER SCHRIFT	before letters	*avant la lettre*
OXYDIERUNG	oxidation	*oxydation*
PAPIER	paper	*papier*
GERIPPTES——	laid——	*——vergé*
VELIN——	wove——	*——vélin*
PARAPHIERT	countersigned	*paraphé*
PASSEPARTOUT	mount, mat	*passe-partout*

GERMAN	English	French
PERGAMENT	parchment	*parchemin*
PINSEL	brush	*pinceau*
PLAKAT	poster	*affiche*
PLATTE	plate	*planche*
PLATTENRAND	platemark	*coupe de témoin, témoin de cuivre*
PLATTENTON	plate tone	*retroussage*
PRACHTVOLL	superb, outstanding	*superb, parfait, splendid*
PRÄGEDRUCK	embossing	*gauffrage*
PROBEDRUCK	trial proof	*épreuve d'essai*
PUNKT	spot	*tache*
PUNKTIERMANIER	stipple engraving	*estampe au pointillé*
QUERIPPEN	chain lines	*pontuseaux*
RADIERER	etcher	*graveur*
RADIERSPUREN, RADIERTE STELLEN	rub marks, abrasions	*frottements*
RADIERT	etched	*gravé*
RADIERUNG	etching	*eau-forte*
RAHMEN	frame	*passe-partout*
RAND	margin (of paper)	*marge*
BREITER——, GROSSER ——ER	large——s	*à grandes ——s*
KLEINER ——CHEN, SCHMALER ——	small——s, thread——s	*à petites ——s, filet de ——*
VOLL——IG, SEHR BREIT ——IG	full——s	*toutes ——s*
ÄUSSERN ——	outer——	*——extérieure*
OBERER ——, OBERKANTE	upper——	*——supérieure*
UNTERER ——	lower——	*——inférieure*
OHNE ——	without——s	*sans ——, rogné*
NEU UM——ERT	remargined	*remargé*
RAYIERT	canceled, scored	*rayé, biffé*
RECHTE SEITE	front, recto	*recto*
RECHTS	right	*à droit*
UNTEN ——	lower —— -hand corner	*à l'angle inférieure droit*
REPARIERT	repaired, restored	*réparé*
RESTAURIERT	restored	*restauré, réparé*
RISS	tear, split	*déchirure*
RITZ	scratch, slipped stroke, crack, abrasion	*éraillure, égratinure, écorchure*
ROST	rust	*rouille*
—— FLECK	—— stain	*tache de ——*
RÜCKEN, RÜCKSEITE	back, verso	*dos, verso*
SAMMLER	collector	*amateur*
—— STEMPEL	——'s mark	*marque de collection*
SAMMLUNG	collection	*collection*
SCHABKUNST	mezzotint	*gravure à la manière noire, manière anglaise*
SCHABLONE	stencil print	*pochoir*
SCHACHTEL	box, case	*boîte, caisse*
SCHLAG	stroke, line	*taille*
SCHLECHT	poor (condition)	*mauvaise (condition)*

German	English	French
SCHMUTZ	dirt, stain, dust	poussière, tache
——IG	dirty, soiled	sale
——FLECK	spot, stain	salissure, maculature
SCHNITT	stroke, line	taille
SCHÖN	fine, good	beau (belle)
SEHR ——	very ——	très ——, superb
SCHÖNHEIT	beauty, fineness, richness	beauté
VON GROSSTER ——	of the greatest ——	de la plus grande ——
SCHRAFFUR	crosshatching	hachure
SCHRÄGE	beveling of the plate	biseau
SCHRIFT	letters, inscription	lettres
MIT DER ——	with the ——	avec la lettre
OHNE DER ——,	before ——	avant la lettre
VOR DER ——		
SCHROTBLATT	dotted print, metal cut	manière criblée, gravure au criblé
SCHWARZ-WEISS	black and white	en noir
SEHR	very	très
SEITE	side (edge), page	bord (coté), page
SEITENVERKEHRT	in reverse	à l'envers
SELBSTBILDNIS	self-portrait	portrait d'artiste
SELTEN	rare	rare
SELTENHEIT	rarity	rareté
VON DER GROSSTEN ——	extremely rare	extrêmement rare
SERIE	set, series, suite	suite, série
SIGNIERT	signed	signé
VOLL ——	fully ——	tout ——
SIEBDRUCK	silkscreen (screenprint), serigraph	trame de soie, tamis, sérigraphie
SIMILI-JAPAN	imitation Japan paper	simili Japon
SONDER	special	spécial
SPESEN	charge, tax	taxe
SPUREN	remains, residue	restes, débris
STAHLSTICH	steel engraving	gravure sur acier
STAHLÜBERZUNG	steelfacing	aciérage
STÄRKUNG	reinforcement	renforcement, accentuation
STEIN	stone	pierre
STEINDRUCK	lithograph	lithographie
STEMPEL	stamp	timbre
——SIGNATUR	signature——	griffe
SAMMLER——	collector's ——	marque de collection
TROCHEN——	dry ——	—— sec, cachet sec
STOCK	block (wood), woodcut	bois
STOCKFLECK	foxing	taches d'humidité, piqûres
——IG	foxed	taché de roux
STREICH	stroke, line	taille
STRICHGRAVUR	line engraving	gravure en taille douce
TADELLOS	faultless	sans défauts, excellente condition
TIEFDRUCK	intaglio	gravure, impression en creux
TITEL	title	titre
——BLATT, ——SEITE	——page	page de ——
TONFLECKEN	acid stain	tache d'acide
TONPLATTE	background plate	planche de fond
TREFFLICH	outstanding, rich	superb, merveilleux

German	English	French
ÜBERARBEITET	retouched (renovated)	*retouché*
ÜBERARBEITUNG	rework	*travaux*
UMRAHMT	framed	*encadré*
UMRÄNDERT	margined	*margé*
NEU ——	re ——	*re——*
UMRANDUNG	borderline	*trait carré*
UMSCHLAG	cover	*couverture*
UNBESCHREIBEN	unrecorded	*non décrit*
UNEBEN	uneven	*accidenté*
UNTEN	lower	*inférieure*
UNTER, UNTERHALB	below, beneath	*au dessous*
UNTERSCHRIFT	text, inscription	*texte*
VELIN	wove paper	*vélin*
VERGILBT	yellowed	*jauni*
VERKAUF	sale	*vente*
NICHT ——LICH	not for ——	*pas de vendre*
VERLAG, VERLAGER	publisher	*éditeur*
VERNIS MOU	soft ground etching	*vernis mou*
VERSCHNITTEN	cut close, trimmed	*coupé court, rogné, entamé*
VERSTÄHLUNG	steelfacing	*aciérage*
VOR ——	before——	*avant l'——*
VERSTÄRKT	reinforced	*renforcé*
VERSTEIGERUNG	auction sale	*vente aux enchères*
VORDERSEITE	front, recto	*recto*
VORTREFFLICH	fine	*beau (belle)*
VORZÜGLICH	fine	*beau (belle)*
WASSER	water	*eau*
——FARBE	——color	*aquarelle*
——FLECK	——stain	*mouillure*
——ZEICHNEN	——mark	*filigrane*
WEICHGRUND	soft ground etching	*vernis mou*
WEISS	white	*blanc*
WERK	body of work	*oeuvre*
GRAPHISCHE ——	graphic——	*l'—— graphique*
WIDMUNG	dedication	*dédication*
WURMLOCH	wormhole	*trou de vers, piqûre*
ZEICHENPAPIER	drawing paper	*papier à dessin*
ZEITSCHRIFT	art magazine	*revue, périodique*
ZERSTÖRT	canceled, scored, destroyed	*rayé, biffé*
ZERSTÖRUNG	canceling, scoring	*rayant, biffant*
VOR DER —— DER PLATTE	before the —— of the plate	*avant que le cuivre ne soit rayé (biffé)*
ZUSÄTZLICH	additional	*supplémentaire*
ZUSTAND	state	*état*
——DRUCK	——proof	*épreuve d'——*

Appendix Nine

Art Booksellers

Many catalogue raisonnés, books about prints, and museum and auction catalogs are missing from the shelves of general bookstores. The best place to find them is at one of the art booksellers listed below, many of whom regularly issue catalogs. (Scarce art books also appear at auction; see Chapter 10.) The most likely places to have that hard-to-find art book or catalog have been marked with an asterisk.

NEW YORK CITY

Brentano's Inc.
586 Fifth Ave.
New York, N.Y. 10036
(212) 757-8600

Brown & Delhi Bookshop
57 Fifth Ave.
New York, N.Y. 10003
(212) 242-7760

*Ex Libris Books
(Arthur A. Cohen)
25 East 69 St.
New York, N.Y. 10021
(212) 249-2618

Lucien Goldschmidt, Inc.
1117 Madison Ave.
New York, N.Y. 10028
(212) 879-0070

*Hacker Art Books, Inc.
(Seymour Hacker)
54 West 57 St.
New York, N.Y. 10019
(212) 757-1450

*Jaap Rietman, Inc.
167 Spring St.
New York, N.Y. 10012
(212) 966-7044

Rizzoli International Bookstore
712 Fifth Ave.
New York, N.Y. 10022
(212) 245-0400

*Strand Book Store
828 Broadway
New York, N.Y. 10003
(212) 473-1452

Ursus Books Ltd.
(T. Peter Kraus)
667 Madison Ave.
New York, N.Y. 10021
(212) 838-1012

*E. Weyhe, Inc.
(Deborah Dennis)
794 Lexington Ave.
New York, N.Y. 10021
(212) 838-5466

*Wittenborn and Company
1018 Madison Ave.
New York, N.Y. 10021
(212) 288-1558

Irving Zucker
256 Fifth Ave.
New York, N.Y. 10001
(212) 679-6332

WASHINGTON, D.C.

Franz Bader
2124 Pennsylvania Avenue, N.W.
Washington, D.C. 20037
(202) 337-5440

CALIFORNIA

Laurence McGilvery
P.O. Box 852
La Jolla, Calif. 92037
(714) 454-4443

John Alan Walker, Bookseller
P.O. Box 4841
Panorama City, Calif. 91412
(213) 990-5572

LONDON

*W. & G. Foyle Ltd.
119 Charing Cross Road
London WC2, England
(01) 437-5660

*St. George's Gallery Books Limited
8 Duke Street, St. James's
London SW1, England
(01) 930-0935

Marlborough Rare Books Ltd.
35 Old Bond St.
London W1X 4PT, England
(01) 493-6993

Bernard Quaritch Ltd.
5–8 Lower John Street
Golden Square
London W1R 4AN, England
(01) 734-2983

Clare Warrack & Geoffrey Perkins
South Leigh Manor
South Leigh near Witney
Oxfordshire, England
(0993) 2838

John Sims and Max Reed
31 Sackville Street
London W1X 1DB, England
(01) 439-7305
(01) 734-3822

*A. Zwemmer Ltd.
76–80 Charing Cross Rd.
London WC2H OBH, England
(01) 836-4710

PARIS

Librairie Auguste Blaizot
164, faubourg St.-Honoré
75008 Paris, France
359-36-58

Galerie Fischbacher
33, rue de Seine
75006 Paris, France
326-84-87

Gibert Jeune
23 Quai St. Michel
75005 Paris, France
033-57-32

Also, 5 Place St. Michel
75005 Paris, France
325-70-07

La Hune
170, Blvd. Saint-Germain
75006 Paris, France
548-35-85

Léonce Laget
54, rue Bonaparte
75006 Paris, France
033-62-47

*Galerie Marcel Lecomte
17, rue de Seine
75006 Paris, France
326-85-47

*Librairie "Les Arcades"
8, rue de Castiglione
75001 Paris, France
260-62-96

Librairie Les Mains Libres
(Jean Petithory)
2, rue de Père Coretin
75014 Paris, France
707-89-56

*Bernard Loliée
72, rue de Seine
75006 Paris, France
326-53-82

*Librairie F. de Nobele
35, rue Bonaparte
75006 Paris, France
326-08-62

*Librairie des Quatre Chemins
3, Place St. Sulpice
75006 Paris, France
033-40-73

*"Sources" (Henri Cazer)
49, rue de Seine
75006 Paris, France
326-45-19

BERLIN

Wasmuth Antiquariat KG
Hardenbergstrasse 9a
1 Berlin 12
West Germany
(030) 31 69 20

MUNICH

Theodore Ackermann
Promenadeplatz 11
8 Munich 2
West Germany
(089) 22 65 60

Helmut Bolenz
Oberachweg 9
8183 Rottach-Egern
(080) 22 63 94

H. Hauser
Schellingstrasse 17
8 Munich 40
West Germany
(089) 28 11 59

*Heinrich Hugendubel KG
Salvatorplátz 2
8 Munich 1
West Germany
(089) 22 66 26

*Hartung und Karl
(auctioneers)
Karolinenplatz 5a
8 Munich 2
West Germany
(089) 28 30 24

Gerhard Scheppler
Giselastrasse 25
8 Munich 40
West Germany
(089) 34 81 74

*Robert Wölfle OHG
Amalienstrasse 65
8 Munich 40
West Germany
(089) 28 36 26

HAMBURG

Amelang Antiquariat
Cranachstrasse 45
2 Hamburg 52
West Germany
(040) 89 74 84

*Dr. Ernst Hauswedell & Ernst
Nolte (auctioneers)
Pöseldorfer Weg 1
2 Hamburg 13
West Germany
(040) 44 83 66

HEIDELBERG

*Dr. Helmut Tenner
(auctioneers)
Bahnhofstrasse 63
69 Heidelberg
West Germany
(0 62 21) 2 42 37

KÖNIGSTEIN IM TAUNUS

*Antiquariat Jurgen Holstein
Gerichtsstr. 7a, Postfach
6240 Königstein im Taunus
West Germany
(061) 74 36 93

ZURICH

*Hans Bolliger
Lenggstrasse 14
CH-8008 Zurich
Switzerland
(01) 53 58 88

Hellmut Schumann AG
Rämistrasse 25
CH-8024 Zurich
Switzerland
(0 04 11) 32 02 72

Index

(Page numbers in italic refer to illustrations.)